TITIAN

Also by Sheila Hale

Florence and Tuscany (1983 and subsequent editions)

Venice (1984 and subsequent editions)

Verona (1991)

The Man Who Lost His Language (2002)

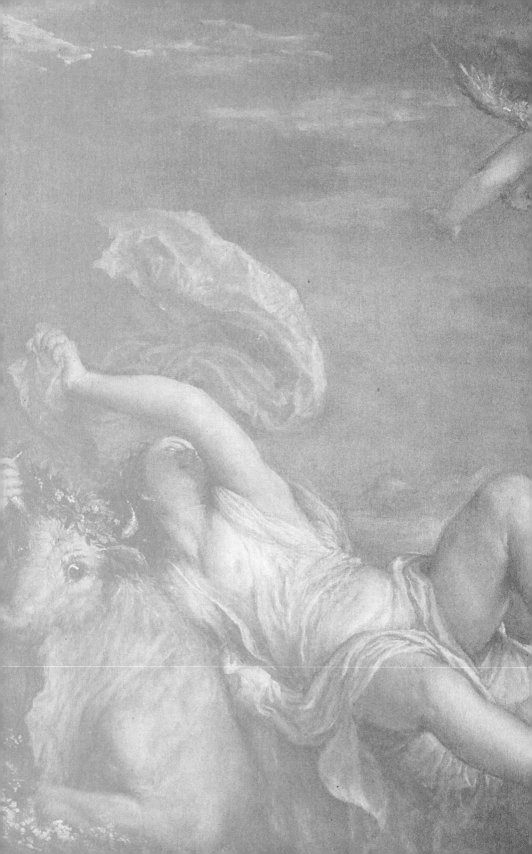

TITIAN

his life

SHEILA HALE

HARPER
An *Imprint* of HarperCollins*Publishers*
www.harpercollins.com

HarperCollins books may be purchased for educational, business, or sales promotional use. For information, please write: Special Markets Department, HarperCollins Publishers, 10 East 53rd Street, New York, NY 10022.

First published in Great Britain in 2012 by HarperPress, an imprint of HarperCollins Publishers.

FIRST U.S. EDITION

Titian's family tree © 2008 by Charles Hope

Maps by John Gilkes, redrawn from *The Imperial Age of Venice, 1380–1580,* by D. S. Chambers, Thames & Hudson Ltd., London.

Title page: *Rape of Europa* (detail), © Isabella Stewart Gardner Museum, Boston © The Bridgeman Art Library

Endpapers: *Madonna and Child with Saint Francis and the Donor Luigi Gozzi with Saint Alvise* (detail). Ancona, Pinacoteca Comunale. © 2012. Photo Scala, Florence

Library of Congress Cataloging-in-Publication Data has been applied for.

ISBN: 978-0-06-059876-1

12 13 14 15 16 OFF/RRD 10 9 8 7 6 5 4 3 2 1

In memory of John

Titian was the sun amid small stars not only among the Italians but all the painters of the world.

—Giovanni Paolo Lomazzo, *Idea del Tempio della Pittura*, 1590

A work of art is an act of cooperation, often of reluctant cooperation like an awkward marriage, between the author and the kind of society he lives in. When we know something of the character of this aggravating partner, that which was once stiff and monumental becomes fluid and alive.

—V. S. Pritchett, *In My Good Books*, 1942

CONTENTS

INTRODUCTION

> Any style involves first of all the artist's connection to his or her
> own time, or historical period, society, and antecedents: the
> aesthetic work, for all its irreducible individuality, is nevertheless a
> part – or, paradoxically, not a part – of the era in which it was
> produced and appeared.
>
> EDWARD S. SAID, *ON LATE STYLE*, 2006

Titian lived and painted in tremendous times. In the decades before
he was born, in a remote province of the Venetian Empire, the inven-
tion of movable type in Germany had unleashed an unprecedented
and unstoppable spread of ideas and information across Europe and
beyond. Columbus' maiden voyage from Spain to the new world in
1492, when Titian was a small child, changed the European conscious-
ness of the size and shape of the planet; and the bullion imported
from the Americas brought with it massive inflation and eventually
shifted the balance of trade and wealth from the Mediterranean to the
Atlantic. In 1513, when Machiavelli published *The Prince*, the first
modern work of political philosophy, Michelangelo had recently
completed the ceiling of the Sistine Chapel, Raphael was at work on
the four Stanze in the Vatican, and Leonardo da Vinci was an old man
living in Rome. Four years later in the German town of Wittenberg
Martin Luther, reacting against the sale of indulgences by Pope Leo X,
posted his Ninety-Five Theses on the castle door. Few at the time
predicted the consequences. Luther himself had not envisaged a split

with the Catholic Church, and the word Protestant was not used until 1529. But by 1563 when Titian was in his early seventies and the Council of Trent sat for the last of the three sittings that set the agenda for the Catholic Reformation, northern Europe was irredeemably divided between Catholics and Protestants; and Venice, which had been the most independent of all the Italian city states and the least prescriptive about matters of religion, began to pay heed to the dictates of the Roman Catholic Church.

When Titian died in Venice in 1576 he was in his late eighties, and the Most Serene Republic had begun its long slow decline as a great trading power and artistic centre. He had spent the whole of his work-ing life there, travelling as little as possible and only twice outside the Italian peninsula for two short visits to Germany. He had produced some 500 or 600 paintings of which about half survive.[1] They are now scattered around the globe, most of them in public galleries from New York to California and Brazil; and across Europe from St Petersburg to Vienna, Berlin, Florence, London and Madrid, to mention only the largest collections. Despite frequent temporary exhibitions of his pictures it would be difficult for any one person to see all the originals and follow the extraordinary transformation of Titian's style from the radiant, minutely realized masterpieces of his youth to the more freely painted works of his middle years, to the dark, tragic, sometimes terrifying visions of his last years.

More has been written about Titian than about any other Renaissance artist apart from Michelangelo. There were two biog-raphies of him in his own lifetime: the Venetian writer Lodovico Dolce's *L'Aretino* published in 1557 and Giorgio Vasari's 'Life of Titian' in the second, 1568, edition of his *Lives of the Artists*; two more in the next century by an anonymous writer who may have been a distant relative (1622) and by Carlo Ridolfi in his *Marvels of Art* (1648), as well as numerous letters written to, by and about him. Over successive centuries writers and artists have explored and described his paintings and the spell they cast. This book, however, is the first documented attempt since the pioneering Anglo-Italian art historians J. A. Crowe and G. B. Cavalcaselle published their *Titian: His Life and*

Times as long ago as 1877[2] to chart Titian's stylistic development through the story of his life and of the century in which he became the most famous artist in Europe, painter to its most powerful rulers.

Since Crowe and Cavalcaselle, art history has been taught in schools and universities as a specialized subject, and Titian Studies have become something of an academic industry. Archives in Venice and elsewhere have yielded much more evidence than was available in the nineteenth century, so that we now know more about Titian's personality, family, friends, finances and relationships with his patrons than we do about most other Renaissance artists. Modern scientific techniques, furthermore, have enabled painting conservators to follow Titian's working methods by looking beneath the surface of his paintings.[3] Nevertheless, since no one person can do justice to an artist as great, protean and complex as Titian, I have allowed some of the many voices that have explored, praised – and very occasionally doubted – his genius to have their say.

I have tried where possible to correct errors of fact about Titian that have been repeated so often that they've become almost canonical. There are, however, still blanks in our knowledge. Perhaps some will be filled as new evidence and paintings thought to have been lost are discovered. Nothing, however, will diminish the sheer visceral pleasure, the shock of recognition that we are looking at a kind of truth that few other painters have communicated, that has fascinated Titian's admirers and followers for more than five centuries.

A NOTE ON MONEY

Most European currencies after Charlemagne's reform of the monetary system were accounted in pounds, shillings and pence: £ s d, or 1 lira = 20 soldi = 240 denari, like the British pound sterling before it was decimalized in 1971. Every country, and every one of the numerous Italian states, used its own silver-based coins for everyday transactions such as buying food or paying wages. Different countries also issued gold coins, which were the currency of international trade and were used for reckoning wealth on paper. During Titian's lifetime the Venetian gold ducat and the Spanish gold scudo were of equal value, each worth six lire and four soldi.

It is not possible to give modern equivalents of purchasing power in the sixteenth century for reasons that may be apparent from the following examples. A standard tip given by grandees for small services was one ducat, which was approximately the weekly wage of a master carpenter, but in the 1530s could buy twenty-eight chickens, ten geese or fifty kilos of flour. A university professor earned something between 100 and 140 ducats a year, a senior civil servant about 250. A Venetian with an income of 1,000 ducats would have been considered prosperous.

LIST OF ILLUSTRATIONS

Jacopo de'Barbari: Bird's-eye view of Venice from the south © The
Trustees of the British Museum
Madonna della Misericordia, Galleria Palatina, Palazzo Pitti, Florence
© The Bridgeman Art Library

Plate sections

Tribute Money, Gemäldegalerie Alte Meister, Dresden © Staatliche
Kunstsammlungen, Dresden/The Bridgeman Art Library
Gypsy Madonna, Kunsthistorisches Museum, Vienna © Artothek/
The Bridgeman Art Library
Man with a Blue Sleeve, The National Gallery, London © The
Bridgeman Art Library
Miracle of the Speaking Babe, Scuola del Santo, Padua © The
Bridgeman Art Library
Flora, Galleria degli Uffizi, Florence © The Bridgeman Art Library
Pesaro Altarpiece, Santa Maria Gloriosa dei Frari, Venice
© Cameraphoto Arte Venezia/The Bridgeman Art Library
Three Ages of Man, Edinburgh, Scottish National Gallery
(Bridgewater Loan, 1945)
Sacred and Profane Love, Galleria Borghese, Rome © Giraudon/The
Bridgeman Art Library
Assumption of the Virgin, Venice, Church of Santa Maria Gloriosa
dei Frari © Universal Images Group/Photoservice Electa/Getty
Images

Noli me tangere © The National Gallery, London/akg-images

Portrait of Federico Gonzaga, Prado, Madrid © The Bridgeman Art Library

Man with a Glove, Louvre, Paris © The Bridgeman Art Library

Presentation of the Virgin, Gallerie dell' Accademia, Venice © Cameraphoto Arte Venezia/The Bridgeman Art Library

Ranuccio Farnese, The National Gallery of Art, Washington, Samuel H. Kress Collection (1952.2.11). Image courtesy of The National Gallery of Art, Washington DC

Pope Paul III, Museo e Gallerie Nazionale di Capodimonte, Naples © Alinari/The Bridgeman Art Library

Pietro Aretino, Palazzo Pitti, Florence © The Bridgeman Art Library

Equestrian Portrait of Charles V at Muehlberg, 1548. Madrid, Prado © 2012. Photo Scala, Florence

Portrait of Prince Philip, Prado, Madrid © The Bridgeman Art Library

Rape of Europa © Isabella Stewart Gardner Museum, Boston © The Bridgeman Art Library

Entombment, Prado, Madrid © Giraudon/The Bridgeman Art Library

Diana and Actaeon © The National Gallery, London/akg-images

Diana and Callisto. Purchased jointly by the National Galleries of Scotland and the National Gallery, London, with contributions from the National Lottery through the Heritage Lottery Fund, the Art Fund, The Monument Trust and through private appeal and bequests, 2012

Danaë receiving the Shower of Gold, Prado, Madrid © Bridgeman Art Library

Reclining Venus, Lutenist, Fitzwilliam Museum, University of Cambridge © The Bridgeman Art Library

Wisdom, Biblioteca Marciana, Venice © The Bridgeman Art Library

Portrait of Jacopo Strada, Kunsthistorisches Museum, Vienna © 2012. Photo Austrian Archives/Scala, Florence

St Sebastian, St. Petersburg, Hermitage Museum © 2012. Photo Scala, Florence

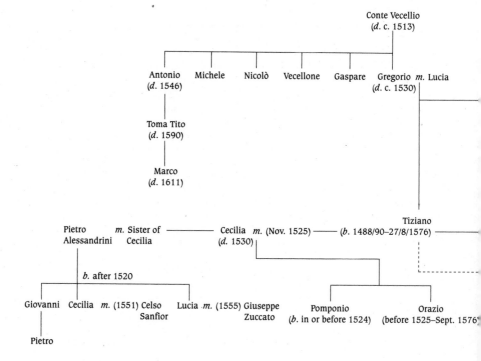

Conte Vecellio
(*d*. c. 1513)

Antonio Michele Nicolò Vecellone Gaspare Gregorio *m*. Lucia
(*d*. 1546) (*d*. c. 1530)

Toma Tito
(*d*. 1590)

Marco
(*d*. 1611)

Tiziano
(*b*. 1488/90–27/8/1576)

Pietro *m*. Sister of ———— Cecilia *m*. (Nov. 1525) ———
Alessandrini Cecilia (*d*. 1530)

b. after 1520

Giovanni Cecilia *m*. (1551) Celso Lucia *m*. (1555) Giuseppe Pomponio Orazio
 Sanfior Zuccato (*b*. in or before 1524) (before 1525–Sept. 1576)

Pietro

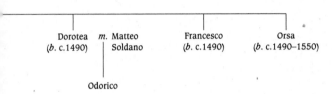

Dorotea *m.* Matteo Francesco Orsa
(*b.* c.1490) Soldano (*b.* c.1490) (*b.* c.1490–1550)

Odorico

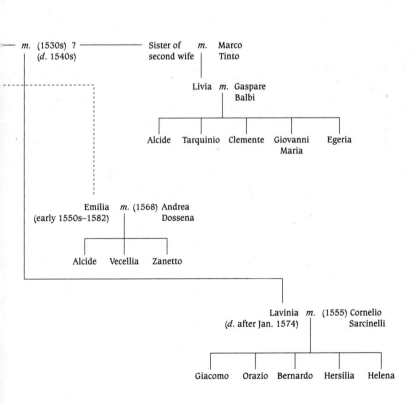

— *m.* (1530s) ? ———————— Sister of *m.* Marco
 (*d.* 1540s) second wife Tinto

Livia *m.* Gaspare
 Balbi

Alcide Tarquinio Clemente Giovanni Egeria
 Maria

Emilia *m.* (1568) Andrea
(early 1550s–1582) Dossena

Alcide Vecellia Zanetto

Lavinia *m.* (1555) Cornelio
(*d.* after Jan. 1574) Sarcinelli

Giacomo Orazio Bernardo Hersilia Helena

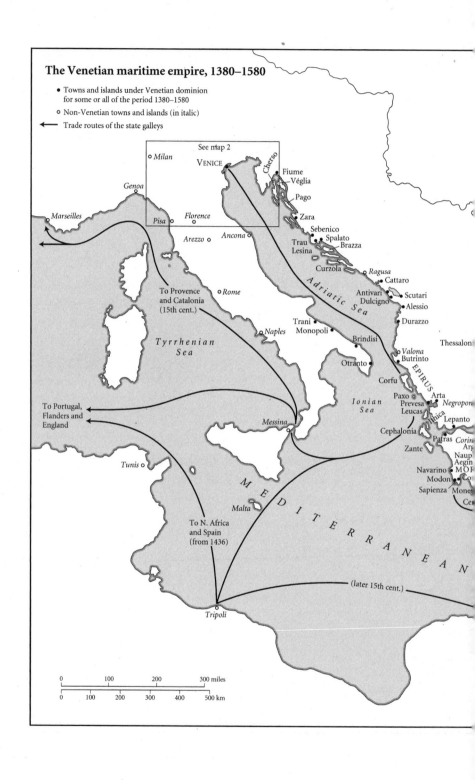

The Venetian maritime empire, 1380–1580

- Towns and islands under Venetian dominion
 for some or all of the period 1380–1580
- ○ Non-Venetian towns and islands (in italic)
- ← Trade routes of the state galleys

See map 2

○ *Milan*

VENICE

Cherso

Fiume
Véglia

○ *Genoa*

Pago

Marseilles

Zara

Pisa

○ *Florence*

Sebenico

○ *Arezzo*

Ancona ○

Spalato
Trau
Lesina
Brazza

Adriatic Sea

Curzola

○ *Ragusa*

Cattaro

To Provence
and Catalonia
(15th cent.)

○ *Rome*

Antivari
Dulcigno

Scutari

Alessio

*Tyrrhenian
Sea*

Trani
Monopoli

Durazzo

Naples

Brindisi

Thessalon

To Portugal,
Flanders and
England

Otranto

Valona
Butrinto

EPIRUS

Corfu

*Ionian
Sea*

Paxo ○
Prevesa
Leucas

Arta

Negropo

Messina

Itbica

Lepanto

Cephalonia

Patras *Corii*
Arg

Zante

Naup
Aegin

Tunis ○

Navarino
Modon

MO*F*
Co

Sapienza

Mone

Ce

MEDITERRANEAN

Malta

To N. Africa
and Spain
(from 1436)

(later 15th cent.)

Tripoli

0	100	200	300 miles

0	100	200	300	400	500 km

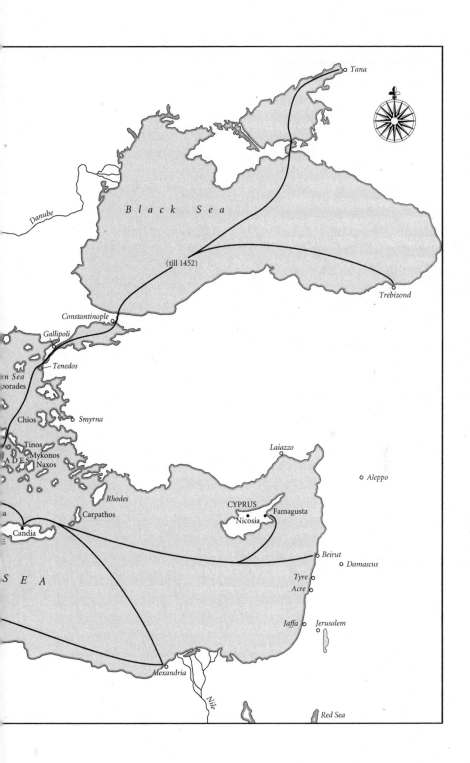

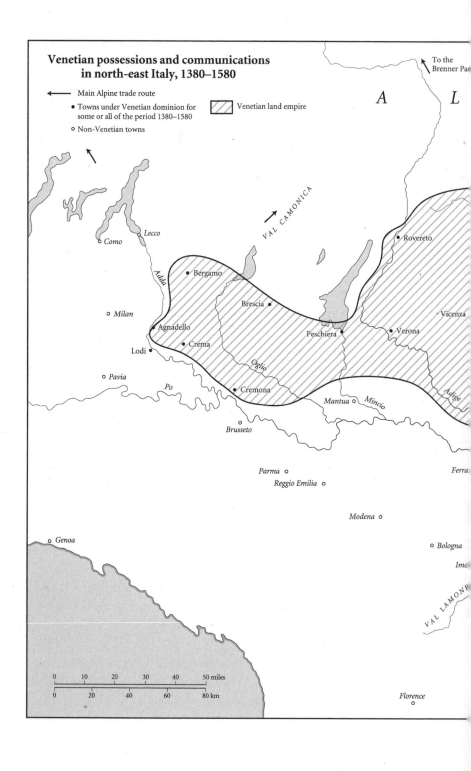

Venetian possessions and communications in north-east Italy, 1380–1580

← Main Alpine trade route

• Towns under Venetian dominion for some or all of the period 1380–1580

○ Non-Venetian towns

▨ Venetian land empire

To the Brenner Pass

A L

VAL CAMONICA

Adda

○ *Como*
Lecco

• Bergamo

○ *Milan*

Brescia •

• Agnadello
Lodi ○
• Crema

Oglio

Peschiera •

• *Roveretó*

· Vicenza

• Verona

○ *Pavia*

Po

• Cremona

Mincio

Mantua ○

Adige

○
Brusseto

Parma ○

Reggio Emilia ○

Modena ○

○ *Genoa*

○ *Bologna*

Imo

VAL LAMONE

Ferra

| 0 | 10 | 20 | 30 | 40 | 50 miles |
| 0 | 20 | 40 | 60 | 80 km |

Florence
○

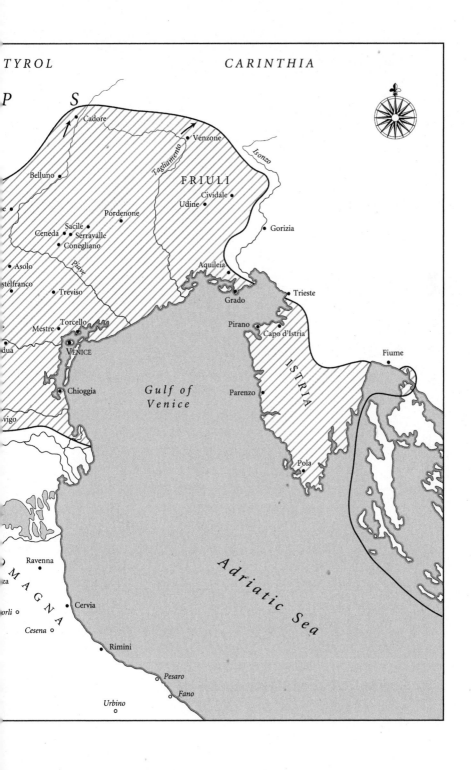

PART I

1488/90–1518

Titian may be said to have remodelled the language of painting, just as Dante established the language of Italy; there remains also the richness of emotion which expresses the man behind the work.

CHARLES RICKETTS, *TITIAN*, 1910

ONE

Mountains

Might not this 'mountain man' have been something of a
'canny Scot' or a 'shrewd Swiss'?

JOSIAH GILBERT, *TITIAN'S COUNTRY*, 1869

On a clear day in Venice when the wind blows the mist from the
lagoon, you can see the distant mountains 110 kilometres to the north
where Titian Vecellio was born into a large and locally prominent
family in the little township of Pieve di Cadore, close to the border
with Habsburg Germany. It was remote, sparsely populated country
whose inhabitants were necessarily tough, hard working and used to
rationing and penny-pinching. In summer and autumn there was
plenty of milk, cheese, butter and fruit from the lush pastures and
orchards. But the thin mountain soil did not produce enough grain
to last through the long winters, when supplies had to be hauled up
through snow-covered valleys on sleds drawn by horses either from
Germany or from the fertile Venetian plain. The communal grain
stores were closely supervised by the local authorities, who controlled
prices for the poor.

A loyal outpost of the Venetian land empire since 1420, the region
of Cadore was divided for administrative purposes into *centurie* or
'centuries'. And the location of Pieve, where an escarpment rises
sharply above the then navigable River Piave, was important to Venice
as a control point for one of the trading routes between its overseas
dominions in the Levant and transalpine Europe. Convoys of pack

animals and carts drawn by oxen or horses, one behind to act as a break when descending steep hills, criss-crossed the surrounding valleys. Merchants from the Habsburg Empire, the German kingdoms, Poland, Hungary and Bohemia carried silver, gold, copper, iron, sheets of tin, metal products, hides, worked leather, furs, coarse cloth and minerals to Venice, where the German exchange house, the Fondaco dei Tedeschi, 'would by itself', so it seemed to one Jerusalem pilgrim in Venice at the turn of the fifteenth century, 'suffice to supply all Italy with the goods that come and go'.[1] Produce from the north was traded at the Fondaco for luxury goods made in Venice – glass and mirrors from Murano, refined soaps, richly worked and dyed silks and satins – or imported into Venice from the Levant: preserved fruits, molasses, wine and olive oil; seed pearls, ivory; and the products known as spices, a term that covered a wide range of goods from peacock feathers, fine-spun Egyptian cottons and the ingredients of pigments used by artists and dyers to flavourings (cardamom, cinnamon, ginger, pepper, saffron, frankincense, myrrh) that were also essentials as the bases of the only drugs available in Renaissance Europe.

Timber and to a lesser extent iron mining were the principal local industries. Wood in this densely forested area was a precious export commodity, not to be wasted unnecessarily on domestic fires. Venice depended for its very survival on a steady and copious supply of wood from its hinterland, which was imported in vast quantities for building and fitting out the war and trading galleys; for the small boats that plied its waterways; for dykes, palisades and the pilings on which the foundations of its buildings rested; for stoking industrial furnaces and for the unusually numerous domestic fires. Venetians, as we can see from the multitude of conical chimneys in contemporary paintings, liked to keep their houses warmer than those in other northern cities.

Timber was in Titian's blood. He inherited ancestral sawmills near Perarolo, where the River Boite joins the Piave, and later in life ran a timber business in partnership with his brother Francesco and his son Orazio. Rough-cut trunks of larch, red and white fir, beech, birch and alder from the forests of Cadore were floated downriver to Perarolo.

Here they were sorted, milled, lashed together as rafts, sometimes loaded with iron ore, wool and hides, and transported downriver to Venice where they were parked along the Zattere – the 'rafts' as the quays along the Giudecca Canal are still called – before the wood was sent on for unloading and storage in the timber yard on the northern lagoon, next to the church of San Francesco della Vigna, which the Venetian government, in recognition of the importance of its wood, had granted to Cadore in 1420. It was a privilege that would cause Titian to fall out with the local government later in his life. Cadore supplied Venice with wood into the early twentieth century; and even today you can occasionally hear the buzz of saws in Cadore, in the Parco Rocciolo – the park of rough-cut timber – at the base of the castle hill, just above a little piazza, then as now called Piazza Arsenale after an antique arsenal.

Titian was born in this piazza, probably some time between 1488 and 1490 in a house facing a spectacularly jagged fringe of mountains known as the Marmarole, and he spent his early childhood here with his father Gregorio Vecellio, his mother Lucia and their three younger children: Dorotea, born around 1490, Francesco, born not long after 1490,[2] and Orsa, the youngest born around 1500. A modest cottage of a kind that has now mostly disappeared, it was rediscovered behind a later extension in the early nineteenth century by scholar detectives who identified it from its description in a sale document of 1580.[3] The ground floor, now a little museum, was originally used for storage and in winter for stabling farm animals, whose bodies acted as under-floor heating for the rooms above. The living space on the first floor consists of four small rooms including a kitchen with a flagstone floor and a stove for cooking and heating which would have been kept lit at all times. The other three rooms are wooden boxes, entirely lined with pine for insulation – some of the original ceiling panels cut from giant pine trees are as much as one and a half metres wide. All the windows are small, and the only staircase is external to save space indoors and to act as a fire escape.

Surrounded by dense forests, and guardian to one of the gateways into Italy, the province of Cadore was inevitably subject to frequent

fires and to skirmishes with the German and Turkish armies that threatened the borders of the Venetian state. It must have been during one of the sieges by the Habsburg emperor Maximilian I in the years between 1508 and 1513 that the parish register of births, baptisms, marriages and deaths was lost, leaving posterity with no certain evidence of the date of birth of Titian, his siblings or indeed anyone else born in Cadore in the previous decades. Titian scholars have been searching without success for this book for at least two centuries. Unfortunately, since Titian in his later life exaggerated, or perhaps forgot, his age, it is unlikely that we will ever have certain evidence of his exact date of birth. Like many people at the time Titian may not have known or cared exactly when he had been born (neither did Giovanni Bellini or Giorgione, or if they did they left no record of their ages). It would have suited him to exaggerate his age when he was a young artist seeking work in Venice, and again later in life when extreme old age was a rare achievement that commanded great respect. His two earliest biographers, Lodovico Dolce and Giorgio Vasari, both of whom knew him personally, imply that he was born in the late 1480s, and something between 1488 and 1490 is the date that is now, after long and heated controversy, accepted by most author-ities. However, his seventeenth-century biographers – an anonymous writer commissioned by a distant relative of Titian[4] and Carlo Ridolfi – gave 1477, a date which, like so much misinformation about Titian's life, remains to this day in some of the literature.[5]

Apart from the dramatic mountain scenery and the house where he was born, there isn't much left of Titian's Cadore. The parish church of Santa Maria Nascente where he hoped to be buried and for which he designed a set of frescos towards the end of his life was torn down in 1813 when remains of the old castle were used to build the bulky neo-Renaissance replacement you see today. The life-sized bronze statue of Titian in the main square, Piazza Tiziano, was erected in the late nineteenth century after Pieve had become part of the newly united Italy. He glares down from his pedestal displaying the gold chain presented to him by the emperor as the insignia of his knighthood, the cap that probably concealed a bald spot[6] and the

fiercely down-turned mouth,[7] and wielding palette and brushes like a protective shield against inquisitive posterity. He looks about fifty, still lean and tough, although one can imagine that the rough mountain edges of his voice and manners have been smoothed away. Titian by this time has painted most people of consequence in the Europe of his day. He has a kind of Olympian wisdom, a detached view of the world unencumbered by any particular political or religious agenda (unlike his hero and rival Michelangelo) and a profound understanding of people and how they work. He is regarded almost as a demi-god, an Atlantis, or a reincarnation of Apelles, painter to Alexander the Great. It's hard to imagine him smiling, but on the rare occasions when he does turn up the corners of his mouth it must seem like a gift to the men, and of course the women, he charms with his wit and his self-assured good manners.

If the emperor Charles V really did pick up Titian's paintbrush as Ridolfi tells us,[8] perhaps he was being rewarded for one of those smiles. Both of his contemporary biographers described his charm. 'In the first place,' says Dolce:

> he is extremely modest; he never assesses any painter critically, and willingly discusses in respectful terms anyone who has merit. And then again he is a very fine conversationalist, with powers of intellect and judgement that are quite perfect in all contingencies, and a pleasant and gentle nature. He is affable and copiously endowed with an extreme courtesy of behaviour. And the man who talks to him once is bound to fall in love with him for ever and always.

But elsewhere Dolce uses the verb *giostrare*, to joust, to indicate a competitive streak. Vasari, who as a Tuscan had reservations about the Venetian way of painting, described him as 'courteous, with very good manners and the most pleasant personality and behaviour', an artist who had surpassed his rivals 'thanks both to the quality of his art and to his ability to get on with gentlemen and make himself agreeable to them'. An anonymous biographer writing in the seventeenth century described him as of a pleasing appearance, circumspect and sagacious

in business, with an uncorrupted faith in God, loyal to the Most Serene Republic (a courtesy title given to other European states but most often to Venice, which was widely known as La Serenissima in its strongest period) and especially to his homeland of Cadore. He is candid, open-hearted, generous and an excellent conversationalist. 'Titian', wrote his other posthumous biographer Carlo Ridolfi, echoing Vasari, 'had courtly manners ... by frequenting the courts, he learned every courtly habit ... People used to say that the talent he possessed was a particular gift from Heaven, but he never exulted in it.' Yet Ridolfi gives us a hint of rough edges to the polished surface of his subject's character. Titian, he tells us, was dismissive of lesser talents, and the highest praise he could bestow on a painting he admired was that it seemed to be by his own hand. What none of his early biographers mention is the lifelong loyalty and devotion to friends and family, the capacity for enjoying himself in company or the dry sense of humour, which must have been one of the qualities that made him such agreeable company. None of them – perhaps because they were all, apart from Vasari, themselves Venetians – says how typically Venetian he was: good humoured, thrifty to the point of stinginess, sweet-tempered but manipulative when necessary for his own ends, and very much his own man.

If you spend a day or two in Cadore you will see Titian's features again: the long bony face, the slightly hooked nose, the fierce gaze. Natives of Cadore are the first to tell you that they look like Titian, and a surprising number bear the name Vecellio – there is a trend in small isolated communities for surnames carried on the male line to increase over centuries. By the time Titian was born, the Vecellio were already one of the largest and most distinguished old families in Cadore. Vasari described the family as 'one of the most noble', a word that was used in the annals of the Vecellio, although no member of the family was of the patrician class and none before Titian himself actually received an imperial title. But his upbringing as a member of a prominent family proud of its long lineage and history of public service might go some way towards explaining the social confidence and the ease with which he acquired those

pleasing manners, which were unusual if not unique for an artist at that time.

The Vecellio of Cadore can be traced back to the second half of the thirteenth century. Most were notaries who occupied important positions in the local government. To qualify as a notary it was necessary to be nominated by a count palatine, a man given that title by the emperor, then to satisfy the local authorities, many of whom were also notaries, of competence by delivering before them an eloquent dissertation in Latin in the style of the great Roman advocate Cicero. Notaries were therefore by definition reasonably well connected and educated men. In remote communities like Cadore they fulfilled the roles of attorney, accountant and broker. Their signatures on wills, inventories, powers of attorney, dowry agreements and sales of property gave such documents, theoretically at least, international validity. One of them, a certain Bartolomeo, was also a timber merchant who owned sawmills at Perarolo that Titian would later inherit. Titian's grandfather, known as Conte and one of the most remarkable of the Vecellio clan, must have made a strong impression on the young Titian. He was a shrewd businessman who knew how to manipulate the price of imported grain and a forceful diplomat who on one occasion managed to persuade the Venetian government to lift from Cadore a punitive tax imposed on outlying regions to finance a war against the Turks. From 1458 until his death around 1513 at what must have been a very advanced age he served the local administration as court auditor nineteen times, and often as delegate to Venice. As well as these and other high public and military offices he led the local militia in skirmishes on the north-east borders of the Venetian Republic, as captain against the Turks and as commander in chief in a war between Venice and Austria.

Conte owned a group of properties in Piazza Arsenale, including the house where Titian was born, which he either gave or loaned to Titian's father Gregorio. Although one of Conte's least successful sons,[9] Gregorio seems to have been a nice man whose 'goodness of soul did not yield to a sublime intellect', as a relative put it long after his death.[10] Unlike most of the family he did not qualify as a notary,

and his municipal jobs – overseer of the corn stores, councillor, super-intendent of the castle repairs, inspector of mines (the latter appointment given him by the doge of Venice as a favour to Titian) – were honourable but minor positions. But as captain of the militia of Pieve he fought bravely in the Battle of Cadore in 1508, and it was as a soldier in armour that Titian painted his portrait (Milan, Ambrosiana) shortly before his death. Virtually nothing is known about Titian's mother Lucia, aptly named, according to an oration given long after her death by a Vecellio relative, because as the mother of Titian and his brother Francesco she cast a radiant light (*luce*) on herself and her homeland. It has been suggested, without the slightest documentary foundation, that she was a servant from Cortina d'Ampezzo, and the model for the old egg-seller who sits on the steps in Titian's *Presentation of the Virgin* and/or for the *Old Woman* attributed to Giorgione (both Venice, Accademia).

Conte's generosity extended to his grandchildren. He provided Dorotea with a handsome dowry on her marriage to Matteo Soldani, a notary, in 1508. We know the details of Dorotea's marriage settlement from a rare document that survives from 1539, by which time Dorotea was widowed and there was a claim against the estate of her late husband. Two-thirds of the value of dowries were by law required to be returned to wives after the death of their husbands. But the notarized evaluation of Dorotea's dowry had been lost during one of Maximilian's invasions. Titian, fearing that without evidence of its value, on which his sister depended for her living, it might be considered part of the contested estate, arranged for three witnesses who had been present on the day of Dorotea's marriage to testify before a notary. The document opens a precious window on the domestic life of the Vecellio. The witnesses agreed that the dowry was worth between 700 and 800 lire. One of them, who identified himself as a nephew of Vendramin Soldani, a parish priest and archdeacon with whom Matteo Soldani had been living before his marriage, visited Conte's house on the day of the wedding. He described the scene.

I saw many moveable furnishings, a bed, blankets, many sheets, clothing of all sorts as well as other requirements of a woman, which seemed to me a very fine dowry.

Later that evening I asked my uncle what he thought it was worth. He replied that it was certainly a beautiful dowry, worth more than 700 lire, more than you would have thought … I'm sure there was a notary taking notes, but I don't remember who he was. When I saw the things being evaluated there were only the two old men present, that is the priest messer Vendramin and ser Conte, as well as the notary whose name I don't recall. It's true that I also saw ser Gregorio, the son of ser Conte and father of the bride, who was walking back and forth, up and down, but he never stood still.[11]

Gregorio was evidently restless, as any father might be on his daughter's wedding day. But the fact that it was Conte who was presiding over the evaluation of the dowry is one of the clues that suggest that he was the head of the family. Was he, as Titian would be, an overbearing father capable of crushing the spirits of his weaker sons?

Two of Titian's biographers[12] tell us that he was educated under his father's roof. Ridolfi wrote that he attended a local school for well-born boys, in which case he didn't profit much from it because Ridolfi also said that Titian 'was not well versed in literature'. Titian's sister Dorotea was illiterate, and so in all likelihood were Orsa and their mother. Judging from his few extant autograph letters and from other documents written in his hand Titian was not more than adequately literate, about average for an artist at that time. A nineteenth-century scholar, after examining one of Titian's receipts for payment, commented that the grammar and syntax of the artist who handled a paintbrush like a god was more like that of a man who was less than a boy.[13] Nevertheless, although most of his mature correspondence would be composed and penned by friends and secretaries, he was more than literate and numerate enough to manage his own and his family's business affairs with dedication and acumen. And his handwriting, although he rarely used it, was confident, steady and legible.

Although everyone heard the mass in Latin, it was not formally taught to boys under the age of ten or twelve, the age at which Titian, like most artists, began his apprenticeship. Later in life Titian picked up a smattering of what Ben Jonson, referring to Shakespeare's lack of formal education, called 'small Latin and less Greek'. He gave his sons the classical names Pomponio and Orazio, and in the 1530s favoured the Latin spelling Titianus for his signatures – everyone from popes, princes and noblemen down to town councillors and soldiers liked to see their names in Latin. But the assertion, usually made by scholars who have themselves enjoyed a classical education, that Titian must have read the original texts of the Latin or Greek stories he immortalized in paint fails to take account of the way artists actually worked. No Renaissance artist, with the exception of Andrea Mantegna, was able to read or write Latin. Leonardo da Vinci (who also came from a family of provincial notaries) tried to learn Latin as an adult but without success, as did Isabella d'Este, who was one of the great Renaissance patrons of artists and a collector of classical manuscripts. Mythological imagery was disseminated not by texts but by artists inspired by the antique sculptures that were being unearthed from Italian soil, and from the translations of classical texts that were increasingly available in print from the late fifteenth century. When Dolce dedicated to Titian a volume of classical texts he had translated into Italian, he wrote in the preface that he had done so because Titian would not have been able to understand the originals.[14]

Titian's earliest visual education was limited to the art he saw in the churches and public buildings of Cadore: fourteenth- and fifteenth-century frescos and crude Alpine altarpieces by the German artist Hans Klocker – there were two paintings by Klocker in the parish church of Pieve – and by Gian Francesco da Tolmezzo. Antonio Rosso, whose few surviving paintings[15] look like uncertain attempts to combine fifteenth-century northern European and Venetian influences, was born around 1440 in Tai, a village only a few kilometres from Pieve. He painted altarpieces in and around Pieve, where a street is named after him today. Scholars in the eighteenth and early

nineteenth centuries liked to imagine that it must have been Rosso who spotted and nurtured the young Titian's talent. If so, there is nothing in what little we know about Rosso's style that looks like Titian's early paintings.

How then did it come about that a half-educated boy from an isolated mountain community, born into a family of notaries, soldiers and public servants with no time or inclination, as far as we know, for artistic pursuits, was sent to Venice to study painting? Within fifty years of Titian's death an answer to this question was provided by the anonymous biographer who had evidently visited Cadore and may have been repeating a family tradition: the boy had astounded everyone by painting an image of the Madonna on a wall using as his colours the nectar of flowers. The tale of the untutored child artist who demonstrates God-given skill has roots that go back at least as far as classical antiquity. The most famous example is Vasari's account of Cimabue's discovery of Giotto drawing sheep on a rock. Vasari applied the same story to the childhoods of Pordenone, Beccafumi, Andrea Sansovino and Andrea del Castagno. Ridolfi credited Giorgione and Tintoretto as well as Titian with the same precocity. The legend was later applied to Poussin, Zurbarán, Goya and the self-trained eighteenth-century Japanese artist Okyo Maruyama.[16] The story about Titian was later taken seriously enough for some earnest believers to imagine that a damaged fresco, painted some time in the sixteenth century on the wall of a villa behind Titian's family cottage, might have been his very first essay.

Like all persistently recurring fables the one about artistic genius as a birthright works on a number of levels. It fills vacuums in our knowledge. It satisfies a psychological need to believe that the achievements of remarkable men and women are predetermined, whether by divine right, fate or genetic predisposition. The legend of Titian's precocious Madonna is persuasive because children, after all, do draw on walls. A child deprived of coloured pencils or paints might well try to squeeze colour from flowers. Genius, even at a very early age, often has an urgent need to express itself, and Titian may well have shown enough talent for his family to make the unusual decision to send him

to Venice, as the anonymous biographer tells us, 'so that he could learn from some skilled master the true principles and bring to perfection the disposition he had demonstrated to practise the noble calling [of painting]'.

Titian set off for Venice shortly before the end of the fifteenth century, possibly with Francesco or joined by him soon after. The journey – now a matter of two hours at most by road or railway, both of which span the deepest valleys – took several days. Although the route was well travelled the beaten tracks were often churned up by heavy rain or the gun carriages of armies. Titian's contemporaries – not least the peripatetic Erasmus of Rotterdam, 'citizen of the world … stranger to all' – sometimes groaned about the discomforts of travelling anywhere in Europe at a time when the choice was between riding a horse or mule or having one's bones shaken in a carriage with no springs for long distances over uneven ground.

Nevertheless, the journey to and from Cadore was one Titian would make over and over again throughout his life. He was not the only great Renaissance artist to emerge from a remote rural background, but no others remained as attached to their homeland as Titian. Cadore and his extended family remained the two constants of his personal life. Il Cadorino, as he is still often called in Italy, would sign paintings, letters and receipts for payments 'Titianus di Cador' or 'Titianus Cadorinus'. He would marry a girl from Perarolo, where the family timber business had started. When, in the 1520s, he repainted the landscape of Giovanni Bellini's *Feast of the Gods* he 'signed' it with an escarpment that looms over the composition just as the castle hill of Pieve dominated his native town.

He never really identified as much with Venice and rarely set his paintings in the city apart from a now lost history painting for the doge's palace. But two haunting views of the distant skyline survive. In the first, completed in 1520 for a merchant in Ancona and often known as the Gozzi altarpiece (Ancona, Museo Civico), Venice is silhouetted at sunset against a gilded sky from which the Ascending Virgin looks tenderly down on her specially favoured city. Three years later he painted the fresco that still survives in the doge's palace of the

gigantic figure of St Christopher, patron saint of travellers, who wades through the lagoon with the Christ child on his shoulders, towering over a ghostly view of the bell tower and domes of San Marco and the doge's palace with the craggy mountains of Titian's homeland in the far distance.

Even in the most demanding times when he was behind with fulfilling important commissions, he escaped to Cadore for a holiday or on family business. The house in Venice on the north-east lagoon where he lived the last forty-five years of his life commanded a view of his mountains and was always full of members of his extended family. He adapted one of the greatest and best known of his last paintings, the autobiographical *Pietà* (Venice, Accademia), to fit the high altar of the parish church of Pieve,[17] where the chapel dedicated to his patron saint, San Tiziano, had been financed by his great-great-grandfather, and where he would have been buried had circumstances at the time of his death been different. Titian would so often repeat the journey he first made as a boy of ten or twelve that he could relive it with eyes closed, recalling every twist and turn of the road, every valley and vista of the Venetian plain to the south and the mountains of his homeland to the north rinsed in the azurite distance, every farmhouse, copse of trees, cluster of wild flowers. A nineteenth-century traveller in what he called 'Titian's Country'[18] counted 400 different species of indigenous flora in his paintings. Scholars today are at loggerheads about whether or not Titian stopped to sketch as he travelled. If so, very few of his undisputed drawings survive.

He travelled down the Piave Valley to Perarolo, the last place before Venice where you can see majestic Antelao and the two peaks of the Pelmo, the other presiding mountain of his Dolomites, which they call the Throne of God or the Doge's Hat. The locals say the mountains turn red at sunrise and sunset and blue – as Titian painted them – after a storm. Through the pass at Longarone, so narrow that it could not be negotiated by carts or carriages; then a few miles east to the lakes and the gorge that leads to the gentle Cenedese Hills, the 'footstool of the Alps',[19] where the less hospitable Dolomites finally give way to the soft, lush landscape of the Venetian lowlands. It was

here that the boy Titian had his first sight of the Venetian plain with the Euganean Hills above Padua to the west and the Piave, now in the far distance, snaking its way towards the lagoon. The party would have stopped to feed and water the animals and spend their last night at Serravalle, then a staging post for travellers and merchant convoys on their way to and from Venice, now united with its neighbouring town Ceneda and renamed Vittorio Veneto. Many years later Titian would become attached to this area by numerous family links. He would build himself a holiday villa in the Cenedese Hills, paint an altarpiece in the church of Serravalle and marry a daughter to a gentleman farmer whose handsome house still stands there. Then on down to the lagoon by way of Conegliano and Treviso, birthplace of the first painter who would take him as an apprentice in Venice, through fields planted with vines, mulberries and Indian corn, past jutting rocks, wooded glades, flashing streams, grazing sheep, castellated farm buildings and the bell towers of small parish churches sounding the hours.

Titian mastered the art of painting landscapes early in his career, before he was entirely confident with the human figures he placed in them. But his landscapes are not so much literal views as accumulations of the features and contours of the countryside he knew so well; they record the pleasure of seeing a landscape modelled by light and shadow.[20] Stimulated by Flemish and German examples,[21] by his first Venetian rival Giorgione of Castelfranco, by the pastoral literature being published in Venice when he was still an apprentice, and perhaps by Leonardo, whose notes are full of discussions about landscape painting, he conjured out of the Cenedese Hills an Arcadia inhabited by Madonnas and saints, lovers and pagan deities, where fleeting shafts of golden light on green meadows, shadows cast by passing clouds and trees tossing in the wind act like choruses, setting the mood and enhancing the drama. Titian's brush describes the weather, forecasting how it will change as the day goes on and his models, sumptuously dressed in silks and satins, the ultramarine of the Madonna's cloaks echoed by azure mountains and skies, have moved on to another place.

In the *Holy Family with a Shepherd* (London, National Gallery), and more obviously in the later *Three Ages of Man* (Edinburgh, National Gallery of Scotland), the sun rises above the plain where the Piave winds downstream towards the lagoon in the far distance. In remoter parts of the Veneto there are still clusters of homely farm buildings very like those Titian liked to incorporate in his landscapes, often reusing the same group of buildings for different paintings. Those in the background of *Tobias and the Angel Raphael* are the same as the buildings in the *Baptism of Christ* (Rome, Pinacoteca Capitolina) and similar to those in his woodcuts of the *Triumph of Christ* and *Submersion of Pharaoh's Army in the Red Sea*. The buildings in the *Sleeping Nude in a Landscape* (Dresden, Gemäldegalerie) reappear in the *Noli me tangere* (London, National Gallery) which Titian set on a plateau overlooking the plain. The two landscapes in *Sacred and Profane Love* (Rome, Galleria Borghese) evoke the same place in the golden light of sunset with the same buildings in reverse order, looking north, back towards the lakes and Alpine foothills above Serravalle and Ceneda.[22]

Titian's landscapes inspired a succession of artists from Poussin and Rubens to Constable and Turner, as well as writers trying to explain or capture their magic in words. Constable, who sometimes improved his compositions by borrowing Titian's trees, saw 'the representative of nature' in every touch of his landscapes. The Milanese painter and writer Giovanni Paolo Lomazzo wrote that Titian, so loved by the world, was hated by jealous nature.[23] Ridolfi began his biography of Titian with praise for his 'conquest' of nature,

who had before considered herself insuperable, was now conquered and gave in to this man, receiving laws from his industrious brush, with the appearance of new forms in his work that rendered the flowers more beautiful, the meadows more brilliant, the plants more delightful, the birds more charming, the animals more pleasing, and man more noble.

The concept of great art as triumphant over nature was a borrowing from Vasari, who had in turn borrowed it from Aristotle, and was one of the commonplaces of Renaissance critical theory. We may have more sympathy with the early nineteenth-century essayist William Hazlitt who used the word 'gusto' to evoke a quality of Titian's landscapes that impressed him: 'a rich taste of colour is left upon the eye, as if it were the palate, and the diapason of picturesque harmony is felt to overflowing. "Oh Titian and Nature! Which of you copied the other?"' And he added: 'We are ashamed of this description, now that we have made it, and heartily wish somebody would make a better.'[24]

Perhaps the most successful translation of Titian's painted landscapes into words was written in the early 1540s by his closest friend and most sensitive critic, the writer, journalist and failed painter Pietro Aretino, in a letter about a visit he had recently made to an idyllic countryside. Although the place he had visited was actually Lake Garda, the landscape he described could, as Aretino knew better than anyone, have been painted only by Titian, the greatest master of the alchemical art of transforming real, raw nature into high art. Aretino painted in words the abundance of flowers, the trees, songthrushes escaping from their branches 'to fill the sky with harmony', racing rabbits, a church, a wine press, the ring of a lake 'fit to be worn on the right hand of the world … I walked for miles, but my feet didn't move, behind hares and hounds, around clumps of mistletoe and netted partridges. Meanwhile I thought I saw something that I might have, but did not, fear: beyond the dense undulating mountains, and hills full of game, were a hundred pairs of spirits obedient to the power and magic of art.'[25]

The Most Triumphant City

The city is about 7 miles in circumference; it has no surrounding
walls, no gates which are locked at night, no sentry keeping watch
as other cities have for fear of enemies; it is so very safe at present,
that no one can attack or frighten it. As another writer has said its
name has achieved such dignity and renown that it is fair to say
Venice merits the title 'Pillar of Italy', 'deservedly it may be called
the bosom of all Christendom'. For it takes pride of place before
all others, if I may say so, in prudence, fortitude, magnificence,
benignity and clemency; everyone throughout the world
testifies to this. To conclude, this city was built more by
divine than human will.

MARIN SANUDO, *THE CITY OF VENICE*, 1493–1530[1]

Great men built Rome, but Venice was built by gods.

JACOPO SANNAZARO,
FROM THE *OPERA LATINA*, 1535[2]

Titian had often heard about Venice from the men in his family who
travelled back and forth on government business. Nothing, however,
can have prepared a boy of only nine or ten[3] who had never seen any
city for the one that even today out-dazzles all others. He was met off
the boat at the Rialto by an uncle[4] who had agreed to care for him
while he served his apprenticeship. We can imagine a lanky boy, from

a cramped house in a small village in the mountains, his provincial clothes creased from the long journey, taking it all in with that disarmingly hawkish gaze: the massive doorways to the Gothic buildings, the towering masts of ships, the women teetering by on their platformed shoes. And we can assume that the uncle was kind to him – it was a close family – and that when Conte was in Venice a year or two later he saw to it that his grandson lacked for nothing.

Venice in 1500 was the wealthiest, most glamorous, most sophisticated, most cosmopolitan, most admired – and most hated – metropolis in Europe, centre of the only empire since ancient Rome to be named after a city rather than a dynasty. After a century of successful conquests on the mainland, or terraferma, the Venetian land empire stretched nearly as far Milan to the west, across Friuli and the Istrian Peninsula, while the sea empire extended as far as Cyprus on the eastern edge of the Mediterranean. Copies of the bell tower in the Piazza San Marco, and images of St Mark, are still to be seen throughout the far-flung Venetian domains. The Venetian arsenal, the greatest industrial complex in the world, pioneered methods of prefabricated construction that, at its peak, could assemble galleys at the rate of one every few hours. The round-bottomed trading ships of the Most Serene Republic sailed to and from ports in the Levant, in the western Mediterranean, and through the straits of Gibraltar to Portugal, England and Flanders.

All commodities that passed through the Adriatic had to pass through Venice: pepper, nutmeg, cinnamon, ginger, sugar; drugs, dyes, pigments; wheat, fortified wines, raisins, dates, oil, meat, caviar, cheeses; slaves as well as falcons, leopards and other exotic animals; wax, linen, leather, wool, raw and finished silk; iron, gold, silver, jewels; precious marbles and antique sculptures. Venetian long-haul trade, according to a late fifteenth-century estimate, brought in on average a 40 per cent return on investment. Since the middle of the fourteenth century the Venetian gold ducat had been the most stable, in value and weight, and most welcome currency in the Mediterranean basin. Imitated all over the world from Europe to India, its appearance remained unchanged until the fall of the Republic; and the

treasury of San Marco in the Palazzo dei Camerlenghi at the foot of the Rialto Bridge was so famous that it was a priority for visiting VIPs on sightseeing tours. Venice, floating in its protective ring of shallow water at the head of the Adriatic, was the entrepot of the world.

A French diplomat, Philippe de Commynes, who was in Venice in 1494 as the envoy of the French king, left us with one of the most famous of the many descriptions of the city as Titian first saw it. The worldly Commynes was as amazed as any modern tourist to see 'so many steeples, so many religious houses, and so much building, and all in the water ... it is a strange sight to behold so many great and goodly Churches built in the sea'. He added:

> I was conducted through the principal street, which they call the Grand Canal ... It is the fairest and best-built street, I think, in the world, and goes quite through the city. The buildings are high and stately, and all of fine stone. The ancient houses are all painted, but the rest that have been built within these hundred years, have their front all of white marble ... and are beautified with many great pieces of Porphire and Serpentine ... In short, it is the most triumphant City that I ever saw ... governed with the greatest wisdom, and serving God with the greatest solemnity.

Although encomiums of great cities were standard Renaissance rhetoric, Venice was the most described and praised of all, not least by its own propagandists. And no Renaissance city was portrayed in such detail or on such an enormous scale as Venice in a map published in 1500, which invites us to explore the streets and waterways of the city that Titian knew as a boy. The map was made by a Venetian painter and printmaker known as Jacopo de' Barbari, 'of the barbarians', a name he seems to have adopted even before he started working for patrons north of the Alps. The publisher of his map, a German merchant by the name of Antonio Kolb, was not exaggerating when he boasted, in his application to the government for permission to print, of 'the almost unattainable and incredible skill required to make such an accurate drawing' on this enormous scale, 'the like of

which was never made before … and of the mental subtlety involved'. Printed from six blocks, which are preserved in the Correr Museum in Venice, the de' Barbari map measures some 2.75 metres by 1.20. It is inevitably used to illustrate books about Venice, and you can buy scaled-down facsimiles in Venetian bookshops. But to enjoy this remarkable portrait of Venice on the eve of the most artistically dynamic period of its history you have to examine it in its original proportions.

The de' Barbari map of Venice.

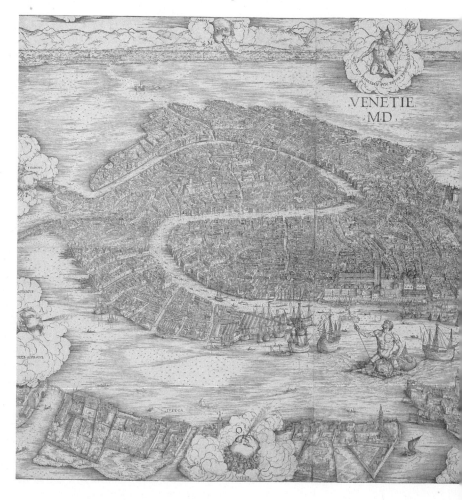

De' Barbari imagined himself floating above the city from a fixed point to the south and several hundred metres into the sky. Nearly every building that could be seen from this perspective is recorded: houses large and small complete with windows, timber roof terraces and conical chimney pots designed to catch sparks from domestic fires; well heads in private courtyards and public campi;[5] the square bricks that paved some of the larger campi; many churches facing every which way and their bell towers. It is still primarily a Gothic city, although some of the newest buildings have rounded windows, and some brick bridges have already replaced the old wooden fire hazards

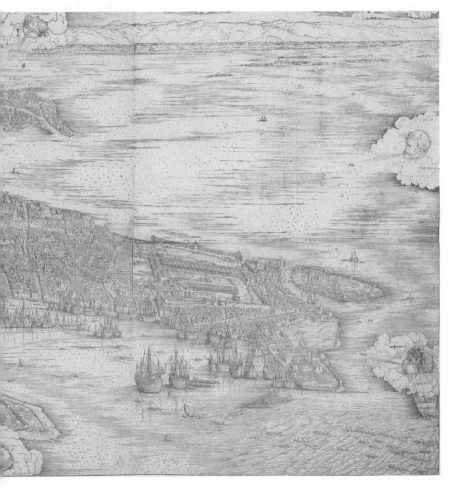

(although the wooden Rialto Bridge, which had been rebuilt in 1458, was not replaced with the stone bridge until after Titian's lifetime). Around the perimeters of the city there are orchards, vineyards, long open-sided sheds for drying dyed cloth, and large monastic houses with their herb gardens.

De' Barbari took special care with the details of the two great preaching churches, the largest in Venice and, as usual in Italian cities, at opposite ends of the city. The Franciscan Santa Maria Gloriosa dei Frari, for which Titian would paint two of his most innovative altarpieces, stands to the west of the Rialto; the Dominican Santi Giovanni e Paolo, where his Death of St Peter Martyr was his most admired and famous work before it was destroyed by fire in the nineteenth century, is on the edge of the north lagoon, with some timber yards just to the east. De' Barbari even managed to squeeze into his drawing of the campo the equestrian monument to the mercenary soldier Bartolomeo Colleoni and the illusionist façade of the Scuola di San Marco, both completed only a few years before his map was published.

The focal point of the map is of course Piazza San Marco, the religious and political hub of the empire and the only open space in Venice that was and is called a piazza rather than a campo. The bell tower, which had been struck by lightning in 1489, has a flat top in the first edition, but a second state printed in 1514 shows the restored spire. The west end of the piazza is closed by the church of San Geminiano, replaced in the early nineteenth century by the neoclassical Napoleonic wing that now houses the Correr Museum. The clock tower framing the entrance to the Mercerie had been completed just in time for the mid-millennium, but the Procuratie Vecchie, the arcaded terrace that extends along the north side of the piazza, which was let out by the procurators as shops and offices, was rebuilt in a similar style after a fire in 1514. On the south side you can make out the jumbled roofs of the procurators' old residences and of some hostelries of dubious reputation, which were gradually replaced by the present Procuratie Nuove from the 1540s and not completed until after Titian's death.

Meanwhile de' Barbari did his best to dignify the moneychangers' booths and bakers' shops and the web of narrow alleys that hemmed

in the base of the bell tower. He cleared away from his bowdlerized portrait of the Piazza and the adjoining Piazzetta a notoriously disgusting latrine, the cheese and salami shops on the lagoon side of the old mint, the gambling tables and food stalls between the great granite columns facing the harbour, a stone-cutter's yard, the stalls of the notaries and barber-surgeons who conducted their business under the portico of the doge's palace; and the last of the trees and bushes, vestiges of an old monastic garden, which were cut down a few years later to make way for the three bronze flag stands in front of the basilica. Rowing boats and sailing boats of all sizes and shapes make their way up and down the Grand Canal. In the distance, towards Torcello, men in small boats are out fishing or hunting duck. On the outlying islands of Murano and Giudecca you can see the façades of the *delizie*, summer residences where wealthy Venetians escaped from the heat of the city centre to enjoy themselves on warm evenings. A regatta just disappearing from view on its way to the Lido ruffles the water.

Although you could still find your way around Venice with de' Barbari's neat black and white map, his perspective inevitably distorts the scale of some areas of the city. Nor could any map convey the strange beauty, the pungent odours and the sounds – the footsteps, the clip-clop of horses' hooves and the shouts of merchants and gondoliers – echoing in the narrow streets, that assaulted the senses of new arrivals. The façades of palaces, frescoed in bright colours like stage sets or inlaid with precious marbles, were reflected in canals that served as open sewers – and sometimes for the disposal of human and animal corpses – their stench mixing in the humid air with the fragrant odours of spices in the markets and the musky perfumes of inviting women. The palaces had glazed windows – a luxury more common in Venice than anywhere else in Europe – which were lit up during the late-night parties for which Venice was famous by torches and by Murano chandeliers hung from gilded ceilings.

The patrician diarist Marin Sanudo tells us that house prices were 20,000 ducats downwards on the Grand Canal, but most cost between 3,000 and 10,000. Elsewhere in the city:

there is an infinite number of houses valued at upwards of 800 ducats, with rooms having gilded ceilings, staircases of white marble, balconies and windows all fitted with glass. There are so many glass windows that the glaziers are continually fitting and making them (they are manufactured at Murano as I will tell below); in every district there is a glaziers shop. Many of these houses are rented out to whoever wants them ... some for 100, some for 120 and more ducats a year.[6]

The wealthy rode around the city on horseback or by boat, the most fashionable means of transport being the gondola, recently made comfortable and private with the addition of the covered cabin, or *felze*, that you see in paintings by Canaletto but were then a novelty. Gondolas, Sanudo tells us,

are made pitch black and beautiful in shape; they are rowed by Saracen negroes or other servants who know how to row them ... There is such an infinite number of them that they cannot be counted; no one knows the total ... And there is no gentleman or citizen who does not have one or two or even more boats in the family ...[7]

The sky was periodically darkened by smoke from fires and industrial explosions. Fires set off by an overturned lamp, a spark from a chimney, a foundry or baker's oven skipped from roof to roof, floated on oil slicks down the canals, feeding on wooden beams, bridges and timber stores. Visitors commented on the night skies lit by fireworks, torches, bonfires on church towers: beautiful fire hazards. The worn-out sails of boats were set on fire. And in the arsenal it took nothing more than the spark from a hammer or the iron shoe of a horse to ignite a store of gunpowder. Titian did not invent his dramatic, fiery skies, but he was the first artist to paint skies that Turner would describe as 'rent by rockets'.[8]

In an age at least as obsessed by material consumption as our own, visitors to Venice were most astonished by the shopping. Titian's Venice was *the* 'Renaissance emporium of things'.[9] If you wanted to buy the finest damasks, velvets, satins, coloured silk sewing threads,

the sweetest-smelling beeswax candles, the best-quality white soap, or choose from the largest selection in Europe of printed books, dyes and artists' pigments, you went or sent for them to Venice. It was worth the cost of the trip because once such luxury items were re-exported the price rose. Over 75 per cent of the population were artisans or shopkeepers, and no neighbourhood was without its warehouses, shops and markets – one of the biggest markets was held on Wednesdays in Campo San Polo near the house where Titian lived in the 1520s. Even boats tied up at quays were rented out as shops. And Venice was a major art market, especially for ancient Greek sculptures, which were collected by the very rich or imported from the overseas dominions for resale. A Milanese priest stopping in Venice in 1494 on his way to a pilgrimage in the Holy Land was nearly at a loss for words:

> And who could count the many shops so well furnished that they also seem warehouses, with so many cloths of every make – tapestry, brocades and hangings of every design, carpets of every sort, camlets of every colour and texture, silks of every kind; and so many warehouses full of spices, groceries and drugs, and so much beautiful white wax! These things stupefy the beholder, and cannot be fully described to those who have not seen them.[10]

The goods were weighed, passed through customs, sold in the markets or stored in great warehouses and hangars. Iron, wine and coal – *ferro*, *vino*, *carbon* – had their own dedicated wharves, and are still named after them. Merchants from all over the world congregated at the Rialto – 'the richest spot in the world' according to Marin Sanudo – where passengers and goods from the mainland and continental Europe were disembarked and unloaded, where the trade banking houses were located, and where anything from slaves (price 40–50 ducats for females) to exotic animals and trading galleys was bought and sold at auction. The food halls further upstream were like gardens where caged birds, a Venetian delicacy then as now, sang among the fruit and vegetables, while an abundance of silvery fish fresh from the

lagoon glittered on marble slabs in the *pescheria*. Across the bridge the Merceria, the shortest pedestrian route to the Piazza San Marco, was lined with drapers' shops, high-fashion boutiques selling women's clothes and accessories, picture galleries, shops selling books and prints. 'Here', Sanudo exclaimed, 'is all the merchandise that you can think of, and whatever you ask for is there.'

The basin of San Marco was the harbour for goods and passengers from overseas. Bales, sacks and crates were loaded on to wharves in front of the doge's palace. There was another customs house here, and more warehouses. The mint, where the gold and silver coins of the Republic were struck, was in the Piazza, as were the banks that managed long-term deposits of state and private capital. It was also the venue of a regular Saturday market and an annual trade fair in May that attracted shoppers and merchants from all over Europe and the Levant. Bewildered visitors from overseas alighting on what Petrarch had called 'San Marco's marble shore' were greeted by pimps, cardsharps waiting at gambling tables, and tourist guides offering a boat trip up the Grand Canal, a tour of saints' relics and body parts stolen from the Holy Land, or a visit to the glass factories on Murano. Other amusements on offer included brothels to satisfy all sexual tastes, jousting, bull baiting, musical entertainments of all kinds. Venice – itself 'the most splendid theatre in all Italy', as Erasmus wrote in 1533 – was famous for its theatrical productions and pageants, which, like its prostitutes, outclassed and outnumbered those to be seen in any other city. The vibrant theatricality of Titian's paintings must have been encouraged by the spectacular performances he saw as a boy in Venice.

Some 100,000 residents, nearly twice as many as today, were crammed into the water-bound city where domestic accommodation competed for space with industrial and mercantile buildings. Many, perhaps as many as half of the population at any one time, were foreigners. Some came from Europe – Germany, England, France, Flanders, Spain, and other parts of the Italian peninsula. Greeks formed the largest immigrant community in the sixteenth century, but there were also large

numbers of Turks, Slavs, Armenians and Jews. Some black slaves were imported from Africa, as we can see, for example, from the smartly dressed black gondolier in Vittore Carpaccio's delightful painting of the Rialto Bridge (1494). But most immigrants came of their own free will to find jobs, to seek fortunes or to take refuge from less tolerant regimes. Early sixteenth-century Venice, like nineteenth-century New York, another great port city floating on islands free from the mainland, welcomed into what was something akin to a globalized economy foreigners whose primary allegiance if they had one was often to their homeland. The state was generous to them in the interests of maintaining public order and because immigrants provided useful labour. Those who came as refugees were often successful in petitions to the Senate for public offices or military commissions, licences to trade or compensation for lost goods or property. But refugee women, who had fewer opportunities for work, were often left destitute by the system.

Some well-born and wealthy immigrants from the imperial domains married into patrician families. For the less privileged, manual labour, although not well paid – a master shipwright in the arsenal, which employed some 4,000 specialized workers, earned no more than fifty ducats a year[11] – was easy to find, and food was usually inexpensive, although prices could spiral out of control in wartime. Foreign workers were needed for domestic and hard labour, to serve in the army and navy, to assemble the galleys and build new buildings. The more talented brought with them useful skills and improved technologies for the manufacture of everything from wool and silk to gun carriages and printing presses. Mauro Codussi, the great idiosyncratic architect of the first Venetian Renaissance, was born near Bergamo. The architect and sculptor Pietro Lombardo, who introduced the Tuscan Renaissance style to Venice and Padua, came, as his name suggests, from Lombardy. Later, the Flemish composer Adrian Willaert, as choirmaster of San Marco's, would make Venice the European centre of polyphonic music. Without the Flemish painters who introduced oil paint to Venice in the 1460s, without Giorgione of Castelfranco, Titian of Cadore, his two great Tuscan friends the architect Jacopo Sansovino and the writer Pietro Aretino, his younger

contemporary Paolo Veronese – and many other foreign artists and artisans who have never been identified – there might not have been a 'golden age' of Venetian art.

And the government never made the mistake of expelling Jews for long. Jews, as Sanudo put it, were 'as necessary as bakers'. After 1516, when refugees from wars in northern Italy had inflated the Jewish population, they were confined in the first of all ghettos (named after an abandoned iron foundry on the site). Nevertheless, Jews continued to arrive from all over Europe and the Levant. Some, who did not wish to be recognized as Jewish, were successful in petitions to release them from the obligation to wear the Jewish hat. Many of the most illustrious Venetian doctors, philosophers and printers were Jews; and some German Jews made small fortunes in the antiques and second-hand trade after they were granted the exclusive privilege of furnishing all ambassadorial apartments. Those who converted to Christianity were nevertheless regarded with suspicion, less because of their race than because being polyglot their identities were difficult to fix. But, in a city whose wealth depended on trade with the Muslim Levant and which accommodated so many non-Christian inhabitants, attitudes to religious practice were on the whole more relaxed than elsewhere in Europe. The journey between Venice and Constantinople was the most described of all voyages in the Renaissance, and many Venetians who made it recorded their admiration for the cleanliness, order and beauty they found in the Ottoman Empire. Some converted to Islam and occupied high positions in the sultanate.

The art of printing was introduced to Venice by German, French and Syrian immigrants, some of them Jews, who built presses in the late 1460s, only two decades or so after the invention of movable type by Johannes Gutenberg, and soon produced the first printed editions of Pliny the Elder's *Natural History* and of the erotic love poems of Catullus, making them widely available to those who could read Latin and afford the price of a book. By 1500 about half of the books produced in Italy, and a sixth of those in Europe, were printed in Venice, perhaps as many as 1,125,000 volumes.[12] With something between one and two hundred print shops in early sixteenth-century

Venice[13] the prices went down while the quality of woodcuts and engravings improved. The educated classes from all over Europe came to Venice to buy their books and prints, while the printing trade enriched the population mix by creating a demand for literate workers who could edit, commission, proofread, translate or plagiarize. Some were inevitably hacks, but others were intellectuals who encouraged the development of a high humanistic culture of the kind that had flourished in central Italy and the university town of Padua for more than half a century.

The Venetian presses produced the first printed editions of everything from musical scores, an exposition of double-entry bookkeeping, manuals about sewing and lace making to the Koran, while Venetian woodcuts of mythological subjects provided artists and craftsmen north and south of the Alps with ideas for the design of every kind of object, from hatbands and wedding chests to garden statues and easel paintings. Entrepreneurial publishers also commissioned single woodcuts, impressions of which were sold in large editions on the international market as decorative objects, to be mounted on canvas or pasted directly on the walls of houses. (It is likely that Jacopo de' Barbari's enormous map, which is far too large to be carried round the city as a guide, was intended for display in this way.) The young Titian was more widely known for his woodcuts[14] than for his oil paintings.

Italian translations of classical texts, some of them free interpretations or conflations of more than one original story, made them accessible to people who could not read Greek or Latin. Ovid's enjoyable tales of lustful gods and goddesses and terrible punishments had been told and depicted since the Middle Ages, but it was not until 1497 that the first Italian translation of the *Metamorphoses*, published in Venice as a prose paraphrase and illustrated with fifty-three woodcuts, enabled artists with no classical languages to read the stories for themselves. Contemporary writers evoked their own idealized versions of a pastoral antiquity.[15]

Aldo Manuzio, a publishing genius who came to Venice in the 1490s from a small village near Rome, set up shop in Campo San

Agostino in 1502 and made his Aldine Press the most commercially successful as well as the most scholarly of some 500 editorial houses in the city. Venetians – despite the elite taste for collecting ancient Greek sculptures and the presence in the city of educated Greek refugees after the Turkish conquest of Constantinople in 1453 – had until then shown little interest in the Greek literature, science and philosophy that made one of the most significant contributions to the mindset of the European Renaissance. Humanists read the work of the ancient Greek mathematician Pythagoras, who had discovered that the intervals in the Greek musical system could be measured in space, and the account by his follower Plato[16] of the rational order of a divinely created universe. Both of these influenced not just architects but also, it has been suggested,[17] the compelling intervals and rhythms of some of Titian's paintings. Nevertheless, the fate of a great library of ancient Greek manuscripts left to the Venetian state in 1468 by the Greek cardinal John Bessarion testifies to the intellectual provincialism of the Republic at a time when Roman and Florentine scholars had been reading Greek texts for at least two decades. Although one of the conditions of Bessarion's bequest was that the library should be open to the public, the codices were left in crates in a hall in the doge's palace where some were damaged and some 'borrowed' and sold without anybody noticing. It was not until 1530 that Pietro Bembo, the newly appointed librarian of St Mark, began promoting the idea of a purpose-built library, which was begun seven years later but not finished until the end of the century. Meanwhile Aldo, who launched his press with a Greek grammar, published some of the Bessarion manuscripts, and soon became the leading European publisher of Greek texts. Aristotle and Plato had been available in Latin translations since the early fifteenth century, but Aldo was the first to publish them in the original Greek. By the time he died in 1515 he had printed twenty-eight editions of Greek classics, including the complete works of Aristotle in five volumes, and the first complete editions of the tragedies of Euripides, Sophocles and Aeschylus, as well Erasmus' translation into Latin of Euripides' *Hecuba* and *Iphigenia in Aulis*. Although Titian was unable to read Greek or Latin, Manutius

stimulated a new interest in Greek tragedy, and staged performances in Italian would exercise a profound influence on his treatment of mythological subjects.

The Aldine classics were printed in beautiful deluxe or affordable pocket editions – the pocket classic was Aldo's invention. His contemporary list was no less impressive. Some of the ablest humanist scholars of the day came to Venice to see their books through the Aldine Press. Erasmus of Rotterdam, the most brilliant and later most influential leader of northern European humanism and Catholic reform, was in Venice in 1508 supervising the Aldine publication of his *Adagia*, the book that made him famous. He became a family friend – although he complained about the food in the Manutio household – and a friend, too, of the patrician Venetian writers and humanists Andrea Navagero and Pietro Bembo. Bembo was the greatest Venetian writer of his day and the only one who is still read outside academic circles. His use of Tuscan, the language of Dante, which he claimed made a sweeter sound than his native Venetian, established the norm for literary Italian for centuries to come. He also edited famous editions of Dante and Petrarch for the Aldine Press. Petrarch, who celebrated the ideal of a woman who is both chaste and an object of male desire, was especially popular, and Bembo, who greatly admired him but who was a relentless womanizer, resolved the paradox of chaste desire with a Neoplatonic interpretation that excuses carnal love as a first step on the ladder to the sexless Platonic ideal. His *Asolani*, published by the Aldine Press in 1505 at a time when he was suffering from disappointment in love, is set in Asolo, the hill town north of Venice, at the court of Caterina Cornaro, the deposed Queen of Cyprus. Its protagonists, six fictitious young Venetians, three men and three women, enjoy the *dolce far niente* – the sweetness of doing nothing – while they discuss the philosophy of love.

Bembo and the Latin poet and patrician Andrea Navagero were among the founding members of the Aldine Academy, where meetings conducted in Greek were attended by learned members of the ducal chancery, some of whom worked part time for the press. But Aldo took his logo, an anchor intertwined with a dolphin, from an

illustration in his first book in Italian, which he hoped would be a bestseller. The *Hypnerotomachia Polifili* (The Dream of Polifilo) is a coffee-table-sized book by Francesco Colonna, a Dominican monk from Treviso, which was published in 1499. Set in the Veneto in the 1460s and illustrated with 174 superb woodcuts, some explicitly erotic, the *Hypnerotomachia* is a weird stream-of-consciousness novel revolving around a passionate love story between Polifilus and Polia. Full of digressions, codes, riddles, bizarre episodes and passages in obscure ancient languages, it may have been intended, or partly intended, as a satire of pedantic humanism. (A favourite joke of one Venetian senator was to dismiss long-winded verbiage as 'words of Polifilo'.) Although the first edition seems not to have been a commercial success the author's obsessions with architecture, gardens and above all sex (in one episode Polifilo makes love to a building, to their mutual satisfaction) had an impact on Renaissance thinking,[18] and the woodcut of the naked, reclining Venus, who blesses the love of Polifilo and Polia, anticipates the naked Venuses that became familiar subjects of Venetian painting.[19]

Venus, the incomparably beautiful goddess of sex and the third brightest planet in the night sky after the sun and the moon, was inextricably interwoven with the legendary foundation of Venice. Like Venice she had been born from the sea, and, so the poets liked to say, she gave her name to the city. She was usually portrayed naked – and never more enticingly than by Titian – or was used as an excuse for paintings of naked women that bore none of her attributes. The classical sources are confused about whether to condemn her nudity as that of a serial adulteress and founding mother of prostitution or to approve of it as representing the unadorned truth, either about the joys of uninhibited sexual love or about the higher, purer and more enduring love that follows marriage. Plato, in the *Symposium*, had resolved the dilemma by positing two Venuses, one heavenly and chaste, the other earthly and lustful. So she became, as well as the patron goddess of virginal Venice, the patroness of both whores and brides. The dualism, well suited to the Venetian predilection for

having things both ways, reflected an ambivalent attitude to sex. Physical beauty was celebrated and its sexual consequences condoned by the intellectual elite. According to the medical wisdom of the day passionate sex leading to simultaneous orgasm produced the best babies. But the science, as it was thought to be, clashed with a deep-seated fear of sex outside marriage, which upsets the order of society, and with the teaching of the Church, which dictated that passion should be reserved for the worship of God.

Nevertheless, in a port city frequented by tourists, foreign merchants and pilgrims on their way to the Holy Land, who often had to wait for a month or more for the tide to carry their galleys on their ongoing journeys, prostitution flourished. From the middle of the fourteenth century the government had decreed that prostitutes were entirely necessary to the state and founded a public brothel near the Rialto. Prostitution soon employed a significant proportion of the population – if we include pimps, innkeepers and servants as well as the whores themselves.[20] Most street prostitutes were poor young working-class women for whom the oldest profession was more profitable than domestic service or making sails for the arsenal for a salary of twelve ducats a year. But some went about so well dressed that they were confused with respectable ladies. Occasional legislation to force them to wear distinguishing marks, to ban soliciting on the streets or from gondolas and to forbid cross-dressing, a favourite technique of seduction, was half-heartedly enforced by a government that was concerned less with moral questions than with protecting its own members from syphilis, the 'French disease' that had invaded Italy with the armies of Charles VIII. 'Our praiseworthy prostitutes',[21] as a frank official called them, were recognized as a necessary outlet for bachelors, good for the tourist trade and a douceur that could be offered to visiting dignitaries. Red-light districts were under the control of the state, and there was no move towards suppressing a – possibly tongue-in-cheek – tariff of whores printed in 1535 that gave the names, addresses, prices and specialities of 110 prostitutes. Prostitution, however, is always a dangerous job, and women who took money for sex had no recourse to the law if they were hurt or

maimed. Angela Zaffeta, the most beautiful courtesan in Venice, was, according to a pornographic fantasy written in the early 1530s,[22] taken to an island in the lagoon and raped by a succession of patricians in order of their social position.

The distinction between common whores and high-class courtesans – some of the latter educated and talented women kept by rich men – was first established at about the time Titian was making his name as a young painter. The most successful courtesans dressed and decorated their houses in the same fashion as wealthy married women. Some had been brought to Venice by their fading prostitute mothers from less sexually tolerant cities. Some were talented singers, actresses or poets. A few came from respectable Venetian families. Some courtesans became the long-standing mistresses of married noblemen. Marin Sanudo recorded a wedding between a widowed nobleman and a certain Cornelia Grifo, 'a most beautiful and sumptuous widowed prostitute':

> She is rich and has been publicly kept by Ser Ziprian Malipiero, and for a while she belonged to Ser Piero da Molin dal Banco, and to others, who have given her a dowry of [blank] thousand ducats. The wedding was held at the monastery of San Zuan on Torcello and has cast great shame on the Venetian patriciate.[23]

Shortly after that the Council of Ten, one of the most powerful of the government committees, clamped down on such intrusions into the patrician bloodline with a law requiring the registration of all noble marriages within one month of the ceremony.

Prostitutes and courtesans nevertheless continued to serve the needs of the large percentage of Venetian men who remained unmarried. The population, which had tripled in the previous hundred years, was also proportionately younger, but competition for wives was intense, and men rarely married until they had inherited from their parents or established careers, by which time they were likely to be at least in their forties. Until the Counter-Reformation marriage was a secular arrangement, not celebrated in church but established

by contract between families whose only considerations were financial and social. Those able to provide a daughter with a large dowry could be selective about the social status and wealth of the groom. But dowry inflation, which was rampant throughout the sixteenth century, meant that even well-off families could not necessarily afford to marry more than one daughter. It was a problem for all Venetian fathers who hoped to marry their daughters well, one that the Senate tried to control in the case of patrician families because it transferred a high proportion of their wealth, which might otherwise have been spent on investment and mercantile activity, to daughters, who were sometimes left so dowry-rich after the deaths of their husbands that they were in a position to lend back to their brothers and fathers.

Unmarried girls, who were on the shelf by twenty-five at most, were often placed in convents, some of which had reputations as high-class bordellos. Titian's friend Pietro Aretino, who occasionally wrote pornography, described a convent[24] where the abbess presided over group orgies, the walls were frescoed with erotic scenes, and the nuns were pleasured by lusty young friars and supplied with baskets of dildos made of the finest Murano glass. Although this was, of course, another fantasy (and was deliberately set not in Venice but in Rome), young nuns, often with the support of their families, did resist attempts to curtail their freedom of behaviour. One disapproving member of government identified more than fifteen convent-brothels, and recommended burning them to the ground along with the nuns, 'for the sake of the Venetian State'.[25]

In the oriental tradition passed down from the city's Byzantine past, respectable women were supposed to be kept at home or closely chaperoned on permissible outings. Some of the sequestered women must have led very boring lives. The two sulky ladies on a terrace in Carpaccio's famous painting, which is now thought to portray a bride and her companion, might have looked less miserable had they been the courtesans they were once thought to be. In the upper panel their men are enjoying a day out duck hunting in the lagoon. Even the shopping for groceries was done by the men of the household, who could be seen strolling or riding on horseback through the markets,

judging value for money with the trained eyes of professional merchants, while their housebound women supervised the cleaning or did it themselves; although there were fewer domestic servants than one might expect in a wealthy city, foreigners commented on the spark-ling cleanliness of Venetian houses. When they did go out, perhaps to church or to attend a wedding or to shop for clothes and accessories in the boutiques on and off the Merceria, they teetered along on their *zoccoli*, the ridiculously high-platformed clogs that restricted their pace and emphasized their vulnerability, making them look like dwarfs on stilts and requiring the support of servant chaperones: the longer the train of servants the higher the status of the woman.[26]

Venetian women's addiction to the latest bizarre fashions may in some cases have been a compensation for otherwise dull lives, but it would be anachronistic to infer that the displays of breasts and jewels were primarily intended to brand women as their husband's sexual property. Their dowries, the larger part of which was returned to them as pensions on the death of their husbands, meant that wives and widows enjoyed a high degree of economic independence. It says something about their literacy and the respect accorded them by their husbands that women were increasingly designated as executors of their husbands' estates; and since their husbands were usually at least twenty years older, there were a good many rich Venetian widows. Some women discovered along with their freedom a talent for invest-ing in property and made money on their own account. Venetian women of all classes, although certainly not 'liberated' in our sense of that condition, were more active in business than women in other cities. Despite a dictate issued by the Council of Ten in 1506 imposing penalties on husbands who permitted their wives to dine out and attend theatrical entertainments alone, there were at least some independent-minded wives who defied the sanctions against appear-ing unchaperoned in public. Foreigners were surprised to see women dining out alone. And as early as 1487 a German guest at the monas-tery of Santi Giovanni e Paolo was astonished to observe elegantly dressed young women moving openly in and out of the dormitories and cells of the monks.

The Milanese priest who had described the shopping opportun-
ities, and who evidently had a practical mind, wondered how the
women kept their dresses from falling off their shoulders. But if the
older generation of Venetian patricians disapproved of the bizarre
fashion for veiled faces and bosom-revealing bodices worn by women
whose bodies, perfumed with amber, musk and civet, could be scented
from a distance, sumptuary legislation failed to make much difference
to their showy dress sense, and there was no law against décolletage
until 1562. Sanudo was impressed by the size and value of women's
jewellery:

> The women are truly very beautiful; they go about with great pomp,
> adorned with big jewels and finery. And ... adorned with jewels of
> enormous value and cost, necklaces worth from 300 up to 1000 ducats,
> and rings on their fingers set with large rubies, diamonds, sapphires,
> emeralds and other jewels of great value. There are very few patrician
> women (and none, shall I say, so wretched and poor) who do not have
> 500 ducats worth of rings on their fingers, not counting the enormous
> pearls, which have to be seen to be believed.[27]

The erotically charged atmosphere in early sixteenth-century Venice
is almost palpable in the paintings by Giorgione, Giovanni Cariani,
Palma Vecchio, Titian and others of women whom we can no longer
identify but whose inviting eyes and bared breasts leave no room for
doubt about their availability. Titian was not the first artist to paint
naked women, but he was the first to use live models, and to paint
them lying down. Lightly draped or naked, Titian's anonymous
women, as real to us today as when his contemporaries thought they
saw the blood pulsing beneath their trembling flesh, display an overt
sexuality that had never been seen before in painting.

On his map of Venice Jacopo de' Barbari enlarged the scale of the
arsenal to emphasize its importance. But there are fewer warships
than would have been present at a time when Venice was at war
with the Ottoman Turks. At the top of the map Mercury, god of

communications and commerce, emerges from a cloud. Neptune, god of the sea, rides on his sea monster among trading galleys that are coming and going, riding at anchor, preparing to unload passengers and goods on to lighters. But a third tutelary deity of Venice, Mars, god of the wars fought in order to expand and maintain its trading empire, is absent. De' Barbari's black and white dolls' city is at peace with itself and the world, serene, silent and inhabited only by a few stick people to indicate the scale of the buildings.

The true situation was very different. The mid-millennium, when soothsayers all over Europe were predicting the end of the world, was actually a troubled time for the Most Serene Republic. In 1498 reports had reached the Rialto of Vasco da Gama's exploratory voyage around the Cape of Good Hope, and three years later the worst fears were confirmed by news that twelve Portuguese ships had been spotted in Aden and Calicut. The threat to the Venetian monopoly of the spice trade, which had already been disturbed for several years by the disruption of overland routes during wars in northern Italy and Turkish wars in Persia, had been followed in 1499 by a series of bank failures, which ruined some of the wealthiest patrician owners of the trading galleys.

It was in that same annus horribilis that one of the largest war fleets ever prepared in the Venetian arsenal suffered a catastrophic defeat by the Turks. Two Venetian gunships were blown up and the Turkish cavalry invaded the Friuli as far as the River Isonzo (where Titian's grandfather Conte took part in the defence). 'Tell your government that they have done with wedding the sea,' the Turkish vizir gloated to the Venetian ambassador in February 1500, adding that it was the sultan's turn now to be the bridegroom in the annual symbolic ceremony of the doge's marriage to the sea. The Turk – 'signor tremendo' as Marin Sanudo dubbed the increasingly militant Ottoman Empire – had been harassing Venetian trading convoys since the Turkish conquest of Constantinople half a century earlier. It had been mostly a cold war, but now flared up into four years of fighting, during which the Venetians lost more essential naval bases in Greece and Albania, and it led to a temporary halt of Venetian trading in the Levant.

The setback to overseas trade was not the mortal blow that some historians have made out. Revenues from the terraferma – 'the most delightful, populous, and fertile part of Europe … the flower of the world', as it was described by a Vicentine nobleman in 1509[28] – were about twice those from the sea empire. Nevertheless, taxation and customs duties on the oriental spices that passed through the mainland accounted for a large proportion of the state income, and the interruptions to overseas trade were at the time cause for deep concern. The reaction was swift and dramatic. All but the most profitable of the shipping lanes – those that went to and from Beirut and Alexandria – were abandoned. The ruling class relinquished its long-cherished exclusive right to own and profit from the trading galleys, and more of the merchant noblemen who had formerly spent much of their lives at sea stayed at home and spread their risks by investing in manufacturing, and in agriculture, property, mining and other industrial enterprises on the mainland. Venetians made new fortunes from expanded industries: the weaving and dyeing of silk and wool, the manufacture of fine soaps, leather working and sugar refining, all profitable commodities in the home and export markets. The fine-spun Venetian glass produced by forty or so furnaces on Murano was increasingly exported to the rest of Italy and the Levant and as far as Portugal, Spain and the Indies. Nevertheless, the diarist Girolamo Priuli was pessimistic about the shift from overseas trade to agriculture and industrial production: 'In losing their shipping and their overseas Empire, the Venetians will also lose their reputation and renown and gradually, but within a very few years, will be consumed altogether.'[29]

But the economy recovered. The seriously rich indulged themselves in ways that rivalled the behaviour of our most outrageously ostentatious twenty-first-century hedge-fund managers. At a wedding in 1507, a total of 4,000 ducats, which was only part of the bride's dowry, the bulk of which was in property, decorated the banqueting table in six basins, one containing gold coins, the rest silver.[30] By the 1560s more pepper and cotton was being re-exported from Venice than in the early fifteenth century.[31] And in 1605, a little more than a century

after the wide-eyed Milanese priest had marvelled at the goods on offer in the greatest of all emporia, the political commentator Giovanni Botero wrote a nearly identical account in which he described Venice as 'a summary of the universe, because there is nothing originating in any far-off country but it is found in abundance in this city'.

Titian arrived in a Venice that was enjoying what has been called its first Renaissance.[32] There was an awakening appetite for learning and art. A small elite of connoisseurs began to collect cabinet paintings from avant-garde artists – almost all of Giorgione's paintings and Titian's earliest portraits were private commissions. Oak piles were being driven into the bed of the lagoon to make the foundations for new buildings that would gradually obliterate inner-city fields, orchards, vineyards and gardens recorded by de' Barbari's map. Sanudo described the building materials piled up in campi and on quays: bricks, terracotta and mortar from Padua, Treviso and Ferrara; sand from the Brenta or the Lido; wood from Cadore and around Treviso; hard white stone for foundations and façades from the Istrian Peninsula; fine marbles from Verona, Greece, Egypt and India.

The population was rejuvenated thanks to milder than usual plagues in the late fifteenth century, which had spared the babies and young children who were the usual first victims. The old certainties were called into question by new men facing up to new economic, political and religious challenges, new patterns of trade, new ways of thinking about a world that had grown larger after the discovery of the Americas, the rounding of the Horn of Africa, and invasions of Italy by other European powers. The younger generation, which had a different perspective of its place in the world, thumbed its nose more often at the values of the old, seafaring empire-builders, whose philistinism and puritanical ideas about moderation clashed with a growing tendency to enjoy life, display wealth and collect works of art.

Titian would spend his entire professional life, travelling as little as possible except for frequent trips to Cadore and his mainland properties, in this growing, changing Venice. The population of the city increased in his lifetime from around 100,000 at the beginning of the

century to around 175,000, with some two million inhabitants of the terraferma. With inflation rampant all over Europe official dowry limits set by the Venetian government had to be raised from 3,000 ducats in 1505 to 5,000 in 1551, and by 1560 sometimes reached 25,000. In those years Titian invented a way of painting pervaded by a sense of excitement and daring that reflects the dynamism of the Venice in which he lived and worked. His genius transcends time and place, but he could not have painted as he did in another time or place. That is the paradox that confronts all biographers of great artists. We are at least fortunate that the Venice he knew by heart has survived so well that we can still follow his footsteps along the calli, across the campi and canals, past the same churches, grand palaces and little houses. We can imagine him striding along sumptuously attired, wearing his signature cap and gold chain, his mind full of stories, figures and images, and marvel with him at the shifting Venetian light that he distilled and trapped between the layers of his paint.

THREE

The Painter's Venice

One should know how to simulate the glint of armour, the gloom
of night and the brightness of day, lightning flashes, fires, lights,
water, earth, rocks, grass, trees, leaves, flowers and fruits, buildings
and huts, animals and so on, so comprehensively that all of them
possess life, and never surfeit the admirer's eyes.

LODOVICO DOLCE, *L'ARETINO*, 1557

However much talent he may have demonstrated as a child in Cadore,
Titian had much to learn before he would be experienced enough to
collaborate with a master or turn out paintings in the style of that
master's studio. And so, Dolce tells us, an uncle took Titian along to
the workshop of Sebastiano Zuccato, and asked him 'to impart to
Titian the basic principles of art'. Sebastiano was a minor painter from
Treviso,[1] where the Vecellio men stopped on their journeys between
Venice and Cadore and may have got to know the Zuccato family.
Sebastiano's two sons, Valerio and Francesco, later became the leading
mosaicists of Venice.[2] Although they were a generation younger than
Titian, who didn't stay in their father's studio for long, they became
lifelong friends. Valerio, who was a talented actor in staged comedies,
married Polonia, the pre-eminent Venetian actress in the 1530s. He
also designed women's hats and clothes, which he sold in a boutique
off the Merceria.

Like most Venetian artists Sebastiano Zuccato probably lived and
worked in the same premises in the vicinity of the Rialto, in a campo

or on a quay where pictures could be set out to dry, and with easy access to a canal to facilitate taking delivery of supplies and dispatching paintings.[3] Some artists' workshops used slave labour for unskilled jobs, but most employed boys who worked in return for instruction and a small wage. Sebastiano Zuccato would have taught Titian the basics: how to prepare a panel and stretch canvas; how to size the support with a thin layer of gypsum mixed with warmed rabbit glue; how to grind pigments, clean the grinding stones, wash brushes with lamp oil. Although Sebastiano was probably too limited an artist to teach the new techniques of painting with oils, Francesco and Valerio affected Titian's artistic development by inspiring an interest in the art of mosaic. He would design some of the cartoons – which would have been on paper, to scale and in colour – for their mosaics in the basilica of San Marco. And his understanding of mosaics, which had to be seen in dim, flickering light, was to be useful when he came to compose paintings for difficult locations. Later in his career it may have affected the impressionistic technique – which Vasari described as 'executed … in patches of colour, with the result that they cannot be viewed from near by, but appear perfect from a distance'.

But, in his first months with Sebastiano Zuccato, just running to the shops to buy supplies was an education in itself for a fledgling painter. Venice offered the most various and least expensive selection of high-quality artists' materials in the world. Linen canvas was available in a variety of weights and weaves – fine, heavy, twilled or herringbone – from specialist shops that also supplied the sail-makers in the arsenal. Canvas, which was beginning to be used as a support for large-scale works, particularly in Venice where fresco deteriorated rapidly in the damp climate, encouraged painters to experiment with the rough texture it could contribute to their works. Gradually it would be used in preference to panel because if primed with a flexible gypsum it allowed paintings to be rolled for transport. The mineral, vegetable and insect ingredients of pigments and dyestuffs, which were essential for the manufacture of glass, ceramics and textiles as well as for painters, were imported into the city in industrial quantities from the Levant, from northern Europe and later in the century

from the new world. Venetians experimented with more intense colours, like the brilliant orange produced when realgar was mixed with orpiment, new paint mixtures such as red lakes with copper-green glazes and orange mixed with blue paint. Visiting artists took advantage of the pre-export prices to stock up with colours, which were sold, not by apothecaries as elsewhere in Italy, but by specialist colour sellers, the *vendecolori*,[4] whose shops were also meeting places where artisans and artists exchanged information and ideas about the uses of new and familiar materials. The *vendecolori* also stocked linseed and walnut oil, glue, brushes, cloth for cleaning rags, and the gums and resins used as varnishes or to refine or manufacture pigments, as well as unusual substances, such as the pulverized glass or sand some painters used to add vibrant reflections, to speed up drying time and to enhance transparency.

The air of the dark, dusty, busy colour shops was spiced with warmed vinegar in which lead and copper were steamed to produce lead white and verdigris. Their shelves and backrooms were piled with dried insects, herbaceous perennials, metals and minerals: yellow orpiment and orange realgar, which was also used for making fireworks; cinnabar and the tiny bodies of female insects imported from India that produced the finest crimson glazes; malachite from Hungary; earth colours from Siena and Umbria; softwood pitch, a by-product of charcoal making, used for brown glazes. Of the pigments manufactured locally, Venice was well known for its vermilion, its lead-tin yellow and especially its lead white, which was exported to England in such quantities that it was known there as Venetian white. Venetians used it as a priming coat, greyed or browned by the addition of particles of charcoal or lamp black, for modelling or impasto highlights, or mixed with other pigments to intensify their colour and enhance their reflective properties.

The most precious pigments were sold by the ounce or half-ounce. Venice had a virtual monopoly on lapis lazuli. The most expensive artists' material after gold, lapis lazuli was mined in the mountainous caves of Badakhshan (in present-day Afghanistan), which were accessible for only a few months in the year. The extraction of ultramarine

– *oltremare di Venezia* – from lapis lazuli was a laborious procedure, which involved hammering and kneading the ground stone with wax, resins and oils, which was then soaked in water for several days until the precious pigment floated to the surface. Lapis was sometimes used in combination with azurite, which was known as German blue because the best-quality crystals were mined in Germany, where they were ground and graded before export to Venice to be made into pigment, some of which was returned across the Alps.

Dyestuffs used for glass and textiles coloured the lakes, which, applied over lighter opaque layers of pigment, act like coloured filters, enriching tone and adding to the sense of light emerging from within the painting. Many years after Titian had run errands for Sebastiano Zuccato he sent to Venice from Germany, where he was working on a portrait of the emperor Charles V, for half a pound of red lake, 'so fiery and splendid in its madder colour that by the side of it the crimson of velvet and silk become less beautiful'. (Titian, in other words, would outshine the most precious fabrics by painting with the same dyestuffs – madder was one of the most costly – in which they had been dipped.) By mid-century there were some twenty *vendecolori*, some of them also providing ready-mixed colours, in and around the Rialto. It is possible that Titian's fine portrait of a man with a palm and a box of colours (Dresden, Gemäldegalerie), dated 1561,[5] is one of them, displaying the high-quality ready-to-use pigments that they increasingly prepared in their shops.

Nevertheless, although it was often said, by Leonardo among others, that colours are beautiful in themselves, it was the handling of pigments, not the use of brilliant colours, that set the greatest artists apart. Dolce objected to those who praised Titian as a colourist, pointing out that if that was all there was to him many women would be his equals. In the seventeenth century Marco Boschini, a Venetian poet, painter, engraver and art dealer, attributed to Titian the remark that a painter needs only three colours: white, black and red. But it takes time to understand how colours work together. The implication for those who knew their Pliny was that Titian was even more skilled at mixing colours than Apelles[6] and the other ancient Greek painters,

whose palettes were supposedly limited to four colours: white, black, red and yellow.

Titian's practice of superimposing over opaque body colour layer upon layer of transparent glazes and semi-opaque scumbles – veils of paint that create tonal unity, and a cool, hazy, subdued effect when painted over a darker underlayer – would intrigue and inspire some of the greatest painters of successive centuries. Unfortunately, however, glazes and scumbles are subject over time to discolouration, abrasion and often to clumsy restoration. In some cases cleaning has stripped away centuries of accumulated dirt to reveal something closer to Titian's original intentions. Too often, alas, he has been compromised to a greater or lesser extent by the loss of some of the paint that made his pictures, in the eyes of his contemporaries, not just stupendous but miraculous.

Once he had qualified as a master painter, probably around 1506, Titian joined the painters' guild and later served on its board. Membership of the guild, the oldest and most conservative of its kind in Italy, was compulsory; and although it was small and poor it controlled everything from technical standards and the size of studios to the length of holidays. It provided security for its members, who were expected to look after one another in difficult times, and was highly protectionist. Albrecht Dürer, although welcomed by Venetian society, was fined by the guild for practising painting in Venice. The guild did not represent figure painters alone but also textile designers, miniaturists, gilders and painters of playing cards, stage sets, furniture, shields, wheels, bulkheads and barges, saddles and banners (the gilding and painting of embossed leather was a highly prized speciality). A Venetian college of figure painters was not founded until the seventeenth century; nor, until the eighteenth century, was there a Venetian academy that represented both painters and sculptors. Renaissance Venice, unlike Florence, never produced a painter who was also a sculptor, possibly because Florentine artists often began their training as goldsmiths, which could take them either way, while Venetian painters developed in isolation from the other arts.

Painting in any case was the art that most appealed to the Venetian taste for surface decoration. 'Is there a man, finally,' asked Dolce, 'who does not understand the ornament that painting offers to any object at all':

> For though their interior walls be dressed in extremely fine tapestries, and though the chests and tables be covered with most beautiful cloths, both public and private buildings suffer a marked loss of beauty and charm without some painting to ornament them. Outside, too, the façades of houses and palaces give greater pleasure to the eyes of other men when painted by the hand of a master of quality than they do with incrustations of white marble and porphyry and serpentine embellished with gold.

Decorative objects were usually more highly valued in inventories and wills than easel paintings, which are often identified in surviving documents by their subjects or by the value of their frames rather than by the names of the artists who painted them – a habit that has created difficulties for art historians searching for attributions and dates, and which may conceal the names of artists whose works are now hesitantly given to those painters whose names we do happen to know. The problem is exacerbated by the similarities between the paintings of Giorgione and those of the young Sebastiano Luciani and Titian, now the starring names of the first decade of the century, who may well have shared assistants. Artists better known today for their easel paintings and altarpieces were in any case not above turning their hands to decorative jobs. Several panels of scenes from Ovid, probably painted on domestic storage chests, have been attributed to the young Titian,[7] although the only widely accepted candidate is the damaged but delightful *Orpheus and Eurydice* (Bergamo, Accademia Carrara). Frescoing the façades and courtyards of houses, sometimes for a special occasion such as a wedding or the visit of a foreign dignitary, offered painters, including Giorgione and Titian, the opportunity to work on a large scale and to proclaim their talents for all the world to see, at least for as long as the frescos lasted in the humid

saline air of the lagoon, polluted as it was even then by industrial fumes.

Titian came to study painting in a Venice that was only just emerging, generations after the Florentine rediscovery of classical antiquity, from what has been described as 'the last, stiff, half-barbaric splendours of Byzantine decoration'.[8] Unlike the city states of central Italy, Venice had never had a princely or papal court or the equivalent of the Medici family to encourage rivalry and sophisticated innovation. While Florentine artists thrived on competition – Donatello, working in the Venetian university town of Padua, complained of the absence there of the artistic rivalry that sharpened the ambitions and talents of his fellow Florentines – Venetian studios were by and large run as family partnerships passed down from one generation to another. They were commercial enterprises that aimed to provide conservative patrons, whose minds were preoccupied with empire building and commerce, with familiar products rather than to challenge existing norms. The Vivarini family, which supplied Venice, the empire and beyond with religious paintings throughout the second half of the fifteenth century, worked in such similar styles that the hand of one Vivarini cannot always be distinguished from another.

In Florence – that small, brown, restless, cerebral, idealistic city dominated by the cranial shape of its cathedral dome – Leon Battista Alberti's *Della Pittura* of 1436, the first modern theoretical treatise on painting, had provided painters with a framework of concepts and precepts about preparatory drawing and perspective. In Venice critical theory about painting lagged behind execution; painters painted without the benefits and constraints of written guidelines. The first fully articulated Venetian treatises on painting, written by Paolo Pino and Lodovico Dolce, did not appear until the middle of the sixteenth century, and did not so much prescribe as describe the qualities that distinguished the work of the greatest Italian painters.[9] Dolce's *L'Aretino*, into which his biography of Titian is incorporated, is a fictional dialogue between Titian's most articulate admirer, Pietro Aretino, and a Tuscan grammarian, Giovanni Francesco Fabrini, who acts as spokesman for the Florentine point of view. 'Aretino', speaking

for Venice, proposes three guidelines by which a painting should be judged:

> The whole sum of painting is, in my opinion, divided into three parts: invention, design and colouring. The invention is the fable or history which the painter chooses on his own or which others present him with, as material for the work he has to do. The design is the form he uses to represent this material. And the colouring takes its cue from the hues with which nature paints (for one can say as much) animate and inanimate things in variegation.[10]

The ultimate goal of painting, he continues, is to astonish and give pleasure by rivalling the illusionist feats performed by ancient Greek artists (whose painted grapes were so lifelike that birds pecked at them, whose horses made real horses neigh, whose statues of Venus caused men to ejaculate, and so on) and which were routinely used to describe the sense of the real world evoked by Renaissance painters starting with Giotto, who was supposed to have painted a fly on one of Cimabue's figures so lifelike that Cimabue tried to brush it off.

The *Aretino* was intended as a riposte to the first, 1550 edition of Vasari's *Lives of the Artists,* from which he had excluded living painters with the single exception of Michelangelo. While Venetians aimed to rival nature by imitating it, Vasari's anthropomorphic scheme placed art in its most mature phase – of which the greatest exemplars were Michelangelo and Raphael – as its own master, not reflecting but triumphant over nature. For him, as for all Florentines, the essential basis of all the high arts was *disegno. Disegno* – the word meant both draughtsmanship and design of a composition – was the father of the three arts of sculpture, architecture and painting. A painting was 'a plane the surface of which is covered by fields of colours ... bound by lines ... which by virtue of a good drawing of circumscribed lines defines the figure'. A good painting, in other words, was a good drawing filled in by colour; and young Florentine artists were not permitted to hold a paintbrush until they had learned to draw.

For Venetians contour lines were increasingly to be avoided because they were not seen in nature, which was more readily evoked by shading and blending colours applied directly on to the support, allowing the viewers to fill in lost outlines with their own imaginations, as we do in the real world. The dichotomy between Florentine and Venetian methods was of course exaggerated. Any figure painter must master both. But in an age when critical language about art was limited it was a useful and much used distinction. Vasari claimed that Michelangelo, upon seeing a painting by Titian,[11] had commented that it was a pity Titian had learned to paint in Venice where artists were not taught how to draw. Tintoretto posted a note in his studio reminding himself to rival 'the *disegno* of Michelangelo and the *colorito* of Titian'.

'The things obtaining to colouring are infinite,' wrote Pino, 'and it is impossible to explain them in words.' Modern art historians try to meet that challenge by employing a more sophisticated specialist vocabulary than was available to sixteenth-century critics, most of whom were trained to write about literature and tended to restrict their comments about paintings to generalizations, classical tropes and a simplistic binary device, the *paragone*, borrowed from literary dialogues and treatises, which compared the relative merits of painting or sculpture, painting or poetry, *colorito* or *disegno*, literature or the visual arts,[12] Florentine or Venetian art. But even today it is not possible to explain in words our visceral response to Venetian paintings, which are more about illusion than construction, about execution more than concept, and which speak more directly to the emotions and the senses – not only of vision and hearing but for some people of touch, even of taste[13] – than to the intellect. We can criticize Titian for his lack of interest in deep space and linear perspective, but we are still dealing with a mystery, which Dolce called 'that whatever it is … that fills the soul with infinite delight without our knowing what it is that gives us such pleasure'.

Venetian painters, many of whom were also musicians, seem to have been aware that colour like music can induce distinct moods. Vasari tells us that Giorgione played the lute 'so beautifully to accompany his own singing that his services were often used at music

recitals and social gatherings'; and that Sebastiano Luciani, whose first profession was not painting but music, was an accomplished singer, adept at various instruments, especially the lute. Ridolfi wrote that Tintoretto played the lute 'and other strange instruments of his own invention'. In the 1540s Titian had a harpsichord made for his house in return for a portrait of the man who built it. In Veronese's *Wedding Feast at Cana*, painted in 1563 for the refectory of San Giorgio Maggiore, Titian performs on the viola da gamba in a string quartet with the other greatest Venetian artists of the time, Tintoretto, Jacopo Bassano and Veronese himself.

The enchanting musical angels perched on the steps of the Virgins' thrones in fifteenth-century paintings are among the most popular Venetian postcards. Titian's musicians are not so innocent. Their recorders, flutes and organs are charged with eroticism, sublime but transient like their music. Music, like feminine beauty and life itself, can exist only in time, while painting captures and fixes the momentary exaltation for ever. Titian's *Concert* (Florence, Galleria Palatina), whatever else its much debated significance may be, is about collaborative music making, as is the enigmatic *Concert Champêtre* (Paris, Louvre).[14] His ruined *Portrait of a Musician* (Rome, Galleria della Spada) anticipates the Romantic conception of wild, self-forgetful genius by several centuries. Some people even today who are sensitive to Titian's works imagine that they can hear sounds within his paintings: his leaves rustling in the wind, the voices of his protagonists, and above all their music making, music being the art that since antiquity had been thought to reflect the harmony of the planets and the rational order of the universe.

Albrecht Dürer, who was in Venice in 1505–6, about the time Titian was emerging as an independent painter, heard some viola players who were moved to tears by the beauty of the music they were performing. Despite being fined by the painters' guild, having his prints plagiarized by Venetian publishers and suffering the accusation that his work was insufficiently cognizant of antique models, Dürer seems to have enjoyed himself in Venice, where the doge paid him a state visit in his lodgings in the German exchange house and where

he was befriended 'by so many nice men among the Italians who seek my company, more and more every day which is very pleasing to me: men of good sense and knowledge, good lute-players and pipers, judges of painting, men of much noble sentiment and honest virtue; and they show me much honour and friendship'.[15] Dürer's surprise at finding himself so warmly received in Venice suggests that the social status of artists was higher there than in his native Germany. 'Here I am a gentleman,' he wrote home to Nuremberg. 'At home I am a bum.'

Once he had taught him everything he could, Sebastiano Zuccato found Titian a place in the studio of Gentile Bellini, who was the foremost gentleman artist of Venice. The Bellini family were *cittadini*, a rank that was something like what we would call middle class but was more clearly defined; and Gentile, who was the first of the European diplomat painters before Rubens, was also the first Italian artist to be knighted, and not once but twice: in 1469 by the emperor Frederick III, and again a decade later by the Turkish sultan Mehmet II, 'The Conqueror', during a visit to Constantinople, where he had been sent by the Venetian government as a gesture of political good-will, and where he painted the portrait of the sultan now in the London National Gallery. Gentile was a sociable man and well connected in Venice where, as a board member of the Scuola di San Marco, he was in frequent contact with the rich businessmen, civil servants, industrialists and merchants who were potential patrons. His studio was a good place for an ambitious young unknown from the provinces to make useful contacts and observe the intricacies of Venetian powerbroking.

Gentile and his younger brother Giovanni were the premier artists and teachers of Venice. By the time Titian entered their orbit, they had been active as independent artists for over forty years, and although their birthdates are unknown, they must by that time have been in their late sixties. The family practice had been founded in the 1420s or 1430s by their father Jacopo, whose remarkable and suggestive sketchbooks,[16] which passed after his death to Gentile and then to Giovanni, contained drawings of classical fantasies and buildings

decorated with antique statues and relief carvings, as well as religious subjects, textile designs, coins, animals, brooding landscapes and pastoral scenes with woods, barns and cottages. In 1454 their sister Nicolosia had married the Paduan painter Andrea Mantegna, whose interest in classical archaeology and the 'stony manner' (as Vasari described it) made more of an impression on the young Giovanni than on Gentile.

The brothers were apparently fond of one another. The worldly and sociable Gentile protected and cared for the more talented but retiring Giovanni, who eventually chose to be buried next to his brother in the cemetery of the church of Santi Giovanni e Paolo. They were, however, so different temperamentally and artistically that they seem to have made a conscious decision to maintain separate studios and to specialize in different types of painting. Although both Bellini supplied history paintings to the doge's palace (they were destroyed by a fire later in the century), and both painted portraits, it was Gentile who invented the large, painted descriptions of processions and ceremonies in the city. Carpaccio, who contributed fantasy to the genre, probably studied with Gentile, but it is hard to see what Gentile could have taught Titian, whose early paintings show no signs of his influence. It may, however, have been in his workshop that Titian saw his first examples of classical art, including a head of Plato and a statue of Venus ascribed to Praxiteles.[17]

Gentile is nowadays sometimes dismissed by academic art historians as a 'grand decorator'.[18] Dolce called him 'that clodhopper', adding that Titian 'could not bear to follow that arid and laboured line of Gentile's. Instead, he made designs boldly and with great rapidity. When Gentile saw, therefore, that Titian was diverging from his own track, he told him that there was no prospect of his making good as a painter.' (Titian may have told Dolce this story years later when he was the most successful painter in Europe – it would have appealed to his well-developed sense of irony; or Dolce, always intent on emphasizing the superiority of Titian over all other painters, may have invented it.) Their artistic incompatibility, in any case, put an end to the relationship, and Titian moved on to study with Giovanni.

Giovanni Bellini was not only the greatest Venetian painter of his day, he was also the most generous teacher. His studio in the now rather forlorn Campo Santa Marina – which must have been a livelier square before its church was demolished by the occupying Austrians in 1820 – was the largest in Venice, probably in Italy. He had trained or influenced in one way or another all Venetian painters of his own and successive generations: Bartolomeo Montagna, Cima da Conegliano, Vittore Carpaccio, Marco Basaiti, Sebastiano Luciani (better known today as Sebastiano del Piombo) and Giorgione. Those of his students born a decade or so before Titian – Vincenzo Catena, Jacopo Palma ('il Vecchio'), Lorenzo Lotto – shared and may have stimulated his interest in artistic currents outside Venice. In his later years, some of his former pupils assisted him and relieved him of his teaching load even after they were established as independent artists: Carpaccio was in his forties when he worked as his assistant around 1507.

Although Giovanni, like his brother, kept sketches and gessos of antique figures in his studio, he found a way of expressing in paint a sense of flesh-and-blood humanity and a response to the natural world that had not been seen before in Venice. In his studio gold grounds gave way to sunlit meadows, farmyards, plains and mountains; stiffly posed saints became real people. Giovanni was the first Venetian to paint a naked Christ child; the first to bring his Madonnas down from their thrones into a naturalistic countryside built by colour and light. The *Madonna of the Meadow* gazes down at the sleeping baby sprawled across her lap, as He will be in death, against a background of a muddy farmyard with cows, oxen, goats and sheep tended by a man in Levantine dress. The *Madonna with Two Saints* is poised above a landscape so abstract that it could almost have been painted by Cézanne. And yet, innovator though he was, Giovanni never entirely abandoned the neo-Byzantine sensibility that infuses his Madonnas with their iconic stillness. Between 1488, when he painted the jewel-like triptych for the sacristy of the Frari and 1505 when he finished his last sacred conversation,[19] the *Madonna and Four Saints* for the church of San Zaccaria, Giovanni Bellini laid the foundations of an artistic revolution that Titian would complete. And yet

both Madonnas are enthroned, in the Byzantine tradition, beneath gilded mosaic semi-domes; and both retain a transcendent spirituality that has not lost its power to soothe troubled hearts in our frantic, disillusioned age.

Giovanni was the first Venetian to recognize the full potential of oil-based paint and glazes. While northern European painters had bound their pigments with oil for centuries, Italians had on the whole preferred the drier, more precise finish of egg-tempera, which has to be applied with a soft brush in small strokes, and is suitable for filling in the drawn outlines preferred by Florentine painters. In the 1460s and 1470s, Giovanni had been inspired to experiment with the oil medium by paintings imported from northern Europe; and the visit in 1475–6 of the Sicilian painter Antonello da Messina, the first Italian painter to adopt the minute oil technique favoured by Flemish painters, contributed to the refinement of his technique. The polished surface of oil mixed with pigments reflects natural light in a way that tempera does not. Diluted to varying degrees of transparency it allows the light to penetrate, giving an impression of depth, and encourages what we call atmospheric perspective or tonal painting by which the separation of pictorial elements is achieved by colour rather than line. Oil is also more malleable and slower to dry than tempera and therefore more forgiving. Mistakes can be scraped off or reworked. Colours can be blended and worked together directly on the support. In some paintings by Giovanni Bellini and Titian you can see where they have modelled the soft paint with fingers, palms, rags, scraped it with the handle of a brush, or swept across the damp surface with a dry brush. In the hands of Giovanni and his successors oil paint encouraged experimentation and an unprecedented freedom of gesture. It gave them the freedom, as Bembo once described Giovanni's way of working to Isabella d'Este,[20] 'to wander at will'; to create softer contours; to build naturalistic landscapes with light and colour; to create a rich range of blacks, and of pearly, buttery or iced whites; to imitate the textures and tones of textiles, glass, trees, sky, clouds, and the nuanced tones of 'the substance rather than the shape of flesh';[21] to suggest detail with a flick of paint or well-placed daubs of impasto. Giovanni's

portrait of the emaciated old doge Leonardo Loredan, 'all spirit and grand stature' as a chronicler described him after his election in 1501, is one of his masterpieces. His gold and white damask robe of state is an especially fine example of the use of heavily applied paint, in this case lead white and lead-tin yellow, to suggest rather than describe.

Early in his career Giovanni had mixed his mediums, sometimes establishing the composition in tempera and finishing it with oil glazes. The first work in which he fully exploited the potential of oil paint and glazes was the *Coronation of the Virgin*, a watershed in the history of Venetian painting commissioned by Costanzo Sforza, lord of Pesaro, probably between 1472 and 1475. The *Resurrection*, *St Francis in the Desert* and the *Transfiguration* from later in the decade show Bellini's increasing mastery of the technique, although the drying cracks that can be seen to a greater or lesser degree in many of his early oil paintings indicate that he was not yet entirely accustomed to the chemistry of the medium. When Titian joined Giovanni as an apprentice some three decades later no up-and-coming Venetian artist used anything but oil paint. So Titian had the advantage over his master of early training in a medium that was still new and exciting enough to invite further experimentation. Like many good teachers, Giovanni was as ready to absorb lessons from his best pupils as to impart them: it has often been said that the paintings of his later years show indebtedness to the examples of Titian, Giorgione and Sebastiano Luciani. The colouristic freedom of his *St Christopher* in the church of San Giovanni Crisostomo is so close to Titian that one Italian scholar[22] has been tempted to speculate that Titian might have had a hand in it. The curtain behind Giovanni's *Young Woman with a Mirror* that divides her private space sharply from the landscape is a device Titian had used several years earlier.

By the time Titian came to him as a pupil Giovanni was something of a living national treasure. From 1479 until his death in 1516 he received from the state the much coveted *sanseria*, a sinecure in the form of an honorary tax-free brokerage in the German exchange house awarded by the government-controlled Salt Office to various individuals including a number of artists who supplied paintings to

the doge's palace. More indicative of his status was an unprecedented exemption from membership of the painters' guild granted in 1480. It was a privilege that was not given again to any other Italian artist before Michelangelo sixty years later. Sought after by the foreign aristocracy and the small circle of Venetian patricians who were beginning to collect cabinet paintings, Giovanni was by no means unaware of his value.

His studio, like most Venetian studios, was run as a business. While he preferred to work on original paintings in private, his assistants were employed in turning out copies or variants of his Madonnas, which were so greatly in demand that purchasers were either prepared to accept workshop versions or unable to recognize that they were not entirely by the master's hand.

Giovanni's usual practice seems to have been to provide cartoons as templates for the Madonnas – in some paintings the pounced marks from the transfer process can be detected by infrared imaging techniques – to be traced by assistants and then to paint the side figures and landscapes himself. Although there is not enough documentation to provide precise information about his prices there are indications that he charged something between 100 and 300 ducats for altarpieces. Isabella d'Este beat him down from 150 ducats to 100 for an allegory, and from 100 to 50 for a devotional painting for her bedroom. And yet, despite his genius and typically Venetian head for money, he remained a modest and essentially private man who was, as far as we can tell, universally liked. Dürer, who was treated badly by other artists in Venice, certainly liked and admired him. 'Everyone tells me what an upright man he is,' he wrote in one of his letters home in 1506. 'I am genuinely fond of him. He is very old, and yet he is still the best in painting.' Pietro Bembo, a close friend who described visits to his studio and had him portray his married mistress, Maria Savorgnan, referred to him affectionately as 'il mio Giovanni' – 'my Giovanni'.

He had had a good start working with his father, a fine draughtsman of original subjects but not an overshadowing genius as a painter, who must have recognized and encouraged his son's superior talent.

But Giovanni's life had not been entirely untroubled. Since he was not mentioned in his parents' will, we can guess that he was illegitimate. A more serious stigma, if we are to believe the evidence of a Latin poem composed by a friend around 1507, would have been that he was apparently bisexual, although if the authorities knew about his homoerotic inclinations it would not have been the only time they chose to ignore that most heinous crime, as they saw it, in the case of a prominent and valuable Venetian. The poem, which was suppressed by a shocked librarian of the Marciana library in the early nineteenth century, was rediscovered and published in 1990 by an English scholar.[23] It describes him in bed with a boy whose body is compared to the marble of Greek sculptures, and was evidently not intended as a criticism, let alone an exposé or for circulation. Whatever the truth about his sexuality it had not prevented him from marrying well. His wife Ginevra Bocheta, a relative of the Zorzi family of dyers, had brought him the substantial dowry, for an artist at that time, of 500 ducats. They had one son, Alvise. Since the poem was written after his wife's death it is possible that he turned to boys only as an aged widower.

Some time around 1502 Giovanni bought a house on the mainland. But he was not a traveller and rarely left the Veneto unless tempted by irresistible commissions. The last of these came from Alfonso d'Este, Duke of Ferrara, for whom in 1514, two years before his death, he painted the *Feast of the Gods*, his first and last major mythological painting, parts of which would later be repainted by Titian. Giovanni's last work, the *Young Woman with a Mirror*,[24] was completed in 1515. It was the year before his death when he was well into his eighties. He signed it 'Joannes bellinus faciebat M.D.X.V.' Signing a painting as though it were still in progress was a trope, used by other artists including Michelangelo and, later, by Titian, referring to Pliny who had written in the preface to his *Natural History* that great art was never finished and that the greatest artists did not claim that a painting was finished to their satisfaction.

The subject of a young woman seated at her dressing table with a mirror was, like the reclining nude, a Venetian invention. Giovanni

may have seen Titian's *Young Woman with a Mirror* (Paris, Louvre).[25] The underdrawings of the woman's contours, which are unusually spare for Giovanni, suggest that he was experimenting with Titian's technique of painting with only summary guidelines, but his use of a textured layer of underpaint in the background was his own innovation. This beautiful painting has been described as an 'apotheosis of seeing' and as one of the purest expressions in Venetian art of idealized nudity.[26] The woman's expensive headdress probably indicates that she was married. Her torso, which is usually thought to have been conceived after a statue or fragment, lacks the erotic appeal of Titian's clothed beauty, who wrings her long, loose golden blonde hair like a Venus rising from the sea.

Giovanni, supreme master though he was, lacked Titian's genius for drama and his penetrating understanding of human nature. His feasting gods for the Duke of Ferrara appear to be acting out rather than taking part in Ovid's story of an orgy and attempted rape. (Either on his own initiative or at his patron's request he lowered the necklines of the women in an attempt to make them more desirable.) His landscapes, enlivened though they are by charming naturalistic detail, have none of the poetry that Titian saw in distant mountains and lost horizons. Giovanni was essentially a religious painter, and the range of his subject matter, and of the emotions he conveyed, was narrower than those of his greatest pupil. And so it happened that Giovanni Bellini's reputation was eclipsed soon after his death by Titian's more sophisticated, dynamic and protean oeuvre. Vasari, whose sharp eye for quality was sometimes clouded by his commitment to Florentine painting and the Aristotelian theory of art as progressive, dismissed Giovanni for his 'arid, crude and laboured manner'. Titian's friend Pietro Aretino likened him to a poet who puts 'perfumes in his inks and miniatures in his letters'. He was not rediscovered until the late nineteenth century when Ruskin pronounced the Frari and San Zaccaria altarpieces to be the two best pictures in the world,[27] a judgement that encouraged Henry James's rapturous description of the Frari altarpiece:

Nothing in Venice is more perfect than this. It is one of those things that sum up the genius of a painter, the experience of life, the teaching of a school. It seems painted with molten gems, which have only been clarified by time, and it is as solemn as it is gorgeous and as simple as it is deep.[28]

But Ruskin loved Giovanni for the wrong reasons, seeing him as the last of the pure, godly masters 'who did nothing but what was lovely, and taught only what was right', rather than as the founding father of the golden age of Venetian painting. If Giovanni Bellini struggled to keep pace with Titian, Titian could hardly have liberated himself immediately from such a master, whose example continued to haunt his early works; and to whom he would pay homage in his last painting, the *Pietà*, in which the Virgin cradles her dead Son beneath a mosaic semi-dome, which deliberately refers to the – by then archaic – neo-Byzantine settings of Giovanni's many depictions of the Virgin and Her Son.

Although the absence of documentation makes the chronology of Titian's earliest paintings notoriously impossible to establish – dating of the undocumented paintings was not even attempted until the late nineteenth century, when the invention of photography made stylistic comparisons feasible – Titian's votive picture of *Jacopo Pesaro Presented to St Peter by Pope Alexander VII* (Antwerp, Koninklijk Museum) is traditionally supposed to be his first surviving work, possibly painted while he was still in Giovanni Bellini's studio or shortly after he left it. Jacopo Pesaro was a Venetian patrician and papal legate, who adopted the nickname Baffo after he was appointed Bishop of Paphos in Cyprus. The simulated *all'antica* reliefs on the podium of St Peter's throne seem to depict a story about Venus, to whom Paphos was sacred because after her birth from the sea she was blown on to its shore in the half-shell. The naval battle in the background refers to Pesaro's role as commander of the papal fleet in the recapture of the Greek island of Santa Maura (modern Lefkas) from the Turks in August 1502. He posed for Titian grasping a banner that

bears the Borgia coat of arms while kneeling before St Peter – who resembles some of Giovanni Bellini's figures – to whom he is presented by the Borgia pope Alexander VI, who wears full papal regalia painted in an archaic manner that Titian would soon abandon.

Although the earliest record of the existence of this painting is a drawing of it by Van Dyck made in Venice in 1623 – and the inscription bearing Titian's name is later than the picture – no one has ever doubted that it is by his hand. The problem is not whether but when he painted it. It is unlikely to be earlier than 1503, when Alexander VI died. It could have been painted in or shortly after 1506, when Jacopo Pesaro is first known to have returned to Venice. Pesaro was born in 1460, and this portrait looks like a man in his mid-forties, which fits a date around 1506.[29] There are some awkward passages – the perspective of the floor and sea doesn't quite work – that are understandable in an artist not yet twenty trying his hand at a complex and ambitious composition. But, for all its faults, it is a remarkable painting. Evidently it satisfied its patron who years later would commission from Titian another altogether more masterly celebration of the same victory over the Turks.[30]

Another candidate for Titian's earliest painting is now, after a thorough restoration, the *Flight into Egypt*, which came to the Hermitage palace in the late eighteenth century, when it was subjected to one of the destructive treatments that were characteristic of the period. Although mentioned by Vasari as a commission from Andrea Loredan for his palace on the Grand Canal (now the Ca' Vendramin Calergi), the picture was dismissed by some modern scholars[31] on account of the muddy colouring of its landscape and procession of awkward figures. The restoration[32] in the Hermitage laboratory, which was completed in 2011, removed layers of discoloured varnish and insertions by other hands, reattached the paint layer where it had come loose from the primer and closed horizontal seams that had opened where the three pieces of the canvas support had been stitched together. The picture is now much easier to read, and many, but not all, scholars are convinced that it is a very early work by Titian, possibly painted even before he entered Giovanni Bellini's studio.

Exhibitions of Titian's paintings often begin with the *Gypsy Madonna* (Vienna, Kunsthistorisches Museum), so called because of the young Virgin's dusky complexion, as the most striking example of Titian's debt to and liberation from the example of Giovanni Bellini. Technical investigations show that it started as an attempt to understand by imitation Giovanni's later way of treating the subject. Beneath the finished painting is a different Madonna, which is very close to Bellini's *Virgin and Child* of 1509 in the Detroit Institute of Arts. Titian cancelled that homage to his great master. His Virgin and Child are set against a landscape with a soldier and fortress in the far distance and a brand-new cloth of honour, its crisp folds indicating that it has just that minute been shaken out. Their faces are plump, as though modelled in low relief, while their lowered eyelids invite us to meditate on the humanity of the two central figures of the Christian story. Whereas Giovanni's Madonnas were usually carefully underdrawn, Titian in this painting used as his guidelines only summary strokes made with a fairly wide brush with thin wash shading applied at the underdrawing stage. He made changes as he painted: his first Madonna seems to have had a different face, and her hair was tied with a ribbon; the fingers of the Christ child were first stretched, then covered with the Madonna's red robe and repainted. The result looks like nothing that had been painted by the hand or studio of Giovanni Bellini. With the *Gypsy Madonna* Titian proved to himself that he had learned everything he needed from that source. By then he had fallen under the spell of a different Venetian painter, who became for a while his alter ego. Giorgione (the name means 'Big George') of Castelfranco, who was closer to Titian's age than Giovanni Bellini, introduced Titian to what Vasari called 'the modern manner', the style that, for want of a better adjective, art historians to this day call Giorgionesque.

FOUR

Myths of Venice

The order with which this holy Republic is governed is a wonder
to behold; there is no sedition from the non-nobles, no discord
among the patricians, but all work together to [the Republic's]
increase. Moreover, according to what wise men say, it will last for
ever ...

MARIN SANUDO, *THE CITY OF VENICE*, 1493–1530[1]

As Titian explored the incomparably beautiful city that would nurture
his genius he came upon allegorical images in stone and paint of
beautiful women representing peace, harmonious administration,
prudence and justice. His uncle would have told him that these were
the political virtues that set Venice apart from all other cities at a time
when the rest of Italy was plagued by upheaval and foreign interven-
tion, and that many great writers and thinkers, foreign as well as
Venetian, extolled the unique stability and independence of the Most
Serene Republic. As the first republic to govern a large empire on land
and overseas since the fall of republican Rome, Venice saw itself as a
new, Christian Rome, founded by God in the fifth century AD so that
a Christian empire would rise from the ruins of the pagan civilization.
After the fall of Constantinople to the Ottoman sultan Mehmet II the
Conqueror in 1453, and the subsequent immigration of exiled Greek
scholars, Venice styled itself also as the New Byzantium and the New
Athens. Venice, as one historian has put it, 'claimed the bones, the
blood, and the culture of ancient Greece and Rome'.[2] But it did so in

the name of God and its own special patron saints. The Republic enjoyed the protection and favour of many saints, of whom St Mark was the most important. The Evangelist, whose body, smuggled from his tomb in Alexandria by two Venetian merchants, reached Venice in 828 – an event known as the *translatio*, the transfer – was the alibi and protector in whose name the Republic conquered and defended its religious integrity, and whose symbol of a winged lion was emblazoned on banners carried into battle and installed all over the city and throughout the empire. Marin Sanudo, on an official tour of the mainland empire, noted an inscription on the walls of Pirano in Istria that read: 'Behold the winged lion! I pluck down earth, sea, and stars.'

Venice was governed as a republic by an oligarchy of some 2,500 patricians, about 5 per cent of the male population, who ruled according to an unwritten constitution designed to prevent the rise to power of any individual or faction.[3] Membership of the patrician class was strictly by inheritance. Until long after 1381, when some new men were admitted to the patriciate in recognition of their contribution to the Venetian war against Genoa, no amount of money or service to the state could buy entrée. Regime-change in Republican Venice was made impossible by a unique system of checks and balances. No equivalent of the Florentine Medici family was able to take control of a hermetically sealed governing caste defined by lineage. No Savonarola, however charismatic, could influence the structure or policies of government.

Thanks to the survival of government records and to Venetian patrician chroniclers, whose shared identity was defined by their hereditary right and obligation to rule, we know in some considerable detail about the day-to-day business of the Venetian government and the events, both trivial and important, that coloured life in Titian's adopted city.[4] The two most informative of the patrician diarists in the first decades of the sixteenth century were Girolamo Priuli and Marin Sanudo, neither of whom had especially brilliant political careers. Priuli, head of one of the great Venetian banking houses, was the gloomy conscience of his class. His diaries are full of threnodies about the sinful and luxurious habits that in his view were responsible

for all the natural disasters and defeats in war that afflicted Venice in his lifetime. Sanudo, Priuli's temperamental opposite, enjoyed the pleasures and display of wealth that Priuli condemned. Garrulous and sociable, he kept a collection of objects of interest from all over the world and a library of 6,500 books and manuscripts which made his house in the Calle Spezier behind the Turkish warehouse one of the essential sights of Venice, along with the arsenal and the Palazzo dei Camerlenghi, for VIPs in Venice.

Sanudo was an obsessive recorder of minutiae. He wrote poetry, plays, a history of the doges and an account of the invasion of Italy by the French king Charles VIII, which led to decades of war on Italian soil between the French and the Habsburg empire. Today he is best known for his panegyric *Of the Origins, Site and Government of the City of Venice*,[5] and above all for his diaries,[6] which were notes for an official history of the Republic that he was to his great disappointment never called upon to write. Too much of a prattler for his own political good, he was forever pacing the corridors of the ducal palace, eavesdropping at the Rialto on news from abroad, continually in the public squares investigating every occurrence, no matter how minimal, how unimportant it was. He jotted down the incessant recordings that were for him 'both wife and magistrate' in a vernacular style that he himself described as 'coarse, unadorned and low'; but it is precisely because he never polished or edited them that they are the richest and most reliable source we have for the political and social history of Venice and of the European powers with which Venice was involved in the first third of the sixteenth century. In the *City of Venice*, which he wrote in parallel with the diaries, he noted the prices of commodities: oil and candles both fixed by law at four soldi a pound; mutton at three soldi a pound; a cartload of wood at twenty-eight soldi; fresh water imported during times of drought eight buckets for one soldo. He gave the location of brothels and made a list of the varieties of fish sold at the Rialto. He couldn't resist informing posterity that his family owned an inn at the Rialto called The Bell, with shops on the ground floor, which brought in 800 ducats a year in rent, 'which is a marvellous thing and a huge rent'.

Once they reached the age of twenty-five, all men of noble birth were required when not away on business to sit on the Great Council, the sovereign body of government, which met on Sundays to deliberate and vote. The Great Council, which existed primarily as a check on the power of individual members of government, had to pass all constitutional changes and new laws. It elected the members of the most important government offices, and the governors and administrators of the dominions on the terraferma and overseas. Members of the higher government councils and magistracies served for short periods, between three months and two years, although in practice the same men were often re-elected, especially during wars and other emergencies. Virtually all decision-making committees, as well as military commands and ambassadorial posts, were filled by experienced politicians in their middle age or older. Venetian ambassadors, trained by obligatory participation in government for the whole of their adult lives, acquired political and diplomatic skills that set them apart from the representatives of other Italian and European states. They were everywhere, and their preserved reports, which were confidential newssheets that ran to many pages, enrich our understanding of the political atmosphere of sixteenth-century Europe with details about the character and demeanour, as well as the policies and motives, of the rulers of the Renaissance world.

But when Titian was growing up in Venice a government that was in effect a gerontocracy – the average age of doges in the sixteenth century was seventy-five – was beginning to cause some resentment among the younger noblemen. The young men wearing parti-coloured tights and dashing short jackets who can be seen in the 'eyewitness' paintings by Carpaccio, Mansueti and Gentile Bellini are patricians not yet old enough to sit on the Great Council. They are wearing the uniform of one of the *compagnie delle calze*, the companies of the hose, which, in the absence of a princely court, were responsible for organizing and providing the decorations for parties, weddings, festivals and theatrical entertainments. There were twenty or so of these companies, whose membership was predominantly restricted to the patrician class. They were chartered and supervised

by the Council of Ten, who kept them well away from unmarried young women.

The structure of the Venetian government has often been described as a pyramid, with the Great Council at the base and the doge and his Collegio, or cabinet, at the top. It is a helpful simplification but misleading because the organization was more flexible and more complex than the comparison implies. The shape and balance of power shifted over time according to circumstances, and its adaptability is one of the factors that explain its remarkable stability. In Titian's day the most authoritative body in the structure of councils and magistracies was the Collegio, which comprised the doge and his personal councillors, one from each of the six districts, or *sestieri*, into which Venice was and still is divided; the Savi, or wise men, who advised the Senate about the execution of policy decisions; the heads of the Council of Ten; and the three heads of the Quarantia, the forty-man court of appeals. The doge also chaired the Senate, the hub of government where foreign, economic, military, domestic, mainland and overseas concerns were debated and decided. The members of the Senate were elected annually by the Great Council, which usually re-elected them for a second year at least. The senators in turn elected the Savi, and the Provveditori, commissioners with various spheres of administrative responsibility, the most important of whom represented the state in military and naval affairs.

The division of power and responsibility between the Senate and Council of Ten was not entirely clear-cut. Described by Sanudo as 'a very severe magistracy of top nobles', the Ten, which despite its name was usually larger, was responsible for state security: the quashing of treason, the vetting of foreigners employed by the state, and the conduct of diplomacy considered too sensitive for the larger numbers of senators. It employed a corps of spies, informers and assassins, and had its own armoury and its own prison for state offenders. While ordinary suspects were entitled to representation by their own lawyers and were tried in public by a committee of state attorneys, defendants brought before the Ten were denied the right to independent counsel and were tried in private by a committee of masked members. By

Titian's day the Ten had extended its functions to matters of foreign policy and finance, including overseeing the revenues of the Salt Office, which paid for the upkeep and decoration of the doge's palace. It was to the Council of Ten that Titian would address his first petition to paint for the palace.

Apart from the doge, the only patricians who kept their jobs for life were the procurators of San Marco, the most important officials after the doge. The procurators were career politicians, usually elderly and supposedly, but not necessarily always, of impeccable respectability. They lived rent-free in ancient and increasingly decrepit houses on the south side of the Piazza, which were not replaced until later in the century by the dignified Procuratie Nuove, the new procurators' residences that still line the Café Florian wing of the Piazza. They also owned and let out a number of properties in and around the Piazza, including some hostelries that also served as brothels, and the northern wing now known as the Procuratie Vecchie, the old procuracy. The procurators were responsible for the care of the basilica of San Marco and the land around it, for the administration of legacies and for the care of orphans. Although their personal allowances were modest, their control of large sums of money gave them considerable financial power. They had automatic seats in the Senate, were often employed as ambassadors, and the special advisers attached to the Senate, the Council of Ten and the doge known as the *zonte* (Venetian for *giunte*, meaning additions) were usually drawn from their ranks. All doges since the fourteenth century had previously served as procurators.

The power of the doge, who was elected by a stupendously complicated system of balloting, was defined and constrained by prohibitive oaths, the *promissioni ducali*, to which each doge was required to agree on his accession. But, although his rule was far more restricted than that of other Renaissance princes, the doge, as primus inter pares, was not a mere figurehead. A talented and determined doge who lived long enough in office could make a difference. He was, furthermore, the head of a state that maintained a degree of independence from the Holy See in Rome that was unique in Italy. Many a pope was enraged by the Venetian tradition of controlling its own ecclesiastical patronage,

even appointing its patriarchs from the ranks of its own patriciate. Papal nuncios in Venice regularly denounced the anomalous wish of the doge to be both prince and pope, but they complained in vain.

To worship God in Venice was also to worship Venice, God's most sublime and improbable creation. In Venice, as a fifteenth-century Venetian humanist observed, 'Republican virtues are identified with divine virtues, and God and the State, patriotism and religion, are metaphorically fused.'[7] The religious heart of the city was San Marco's basilica, which was both the state church and the doge's private chapel. St Peter's church, nominally the cathedral until 1807, was located far away on its remote island in Castello. The dress and behaviour of the doge retained a Byzantine appearance; and the neo-Byzantine style of churches with open naves and domed Greek cross-plans further asserted Venice's religious independence from Rome. In Titian's first altarpiece, *St Mark Enthroned with Sts Cosmas, Damian, Roch and Sebastian* (Venice, Church of Santa Maria della Salute), St Mark occupies the high throne normally reserved for St Peter.

Once a Venetian nobleman had entered the Great Council he became a *togato*, obliged to wear a robe known as the toga at meetings of the Great Council and on official visits to the terraferma. Sanudo described the basic class code of Shakespeare's 'togaed consuls'[8] right down to their underclothes:

[They wear] long black robes reaching down to the ground, with sleeves open to the elbows, a black cap on the head and a hood of black cloth or velvet. Formerly they wore very large hoods, but these have gone out of fashion. They wear trimmings of four sorts – marten, weasel, fox or even sable ... Soled stockings and clogs are worn in all weathers, silk undershirts and hose of a black cloth; to conclude, they wear black a lot.[9]

The more important members of government were required, sometimes on pain of fines, to wear the special colours of their offices – scarlet, crimson or a deeper violet-crimson known as *pavonazzo* with stoles in the same or a contrasting colour.[10] White or cloth of gold was

worn only by the doge and Venetian knights. Close attention was paid to the colour and cut of official robes, which could indicate mood or subversive tendencies as well as status. The cut of sleeves inset into robes varied. The more modest ones were straight and narrow. Some were voluminous and gathered at the wrist like bags. The most important sleeves were bell shaped and open at the wrist to show off expensive fur linings, the widest and grandest of all being the *dogale*, or ducal sleeves, a sartorial privilege the doge shared with procurators, doctors of medicine, ambassadors and governors on the mainland.

The civil servants who administered the day-to-day business of government wore the same basic black toga as nobles without office – it was something like the equivalent of the bowler hat and umbrella that professional Englishmen used to wear. They were drawn from the *cittadini originari*, native-born citizens, who formed the next caste down from the nobles. Since only 5 per cent of the male population were *cittadini* and since they had no vote, they were hardly what we would call citizens; their status was more that of second-rank nobility, and they sometimes married patrician wives. The *cittadini* notaries who comprised the ducal chancery – which consisted of the grand chancellor, the four secretaries of the Council of Ten and eight secretaries of the Senate – served for life and were thus in a position to influence long-term policy-making. The grand chancellor, whose position commanded a salary of 300 ducats a year plus 50 as a housing allowance, was the most powerful man in Venice after the doge and the procurators. Known as the 'people's doge', he preceded the doge in ceremonial processions, dressed in scarlet, and accompanied him on his daily rounds of government departments, attending the Collegio in the mornings, meetings of the Senate or Council of Ten after lunch, and the Great Council on Sunday afternoons.

The *cittadini* civil servants were on the whole better educated and more cultivated than their patrician employers. In the chancery school at San Marco they were taught the core subjects of sixteenth-century learning: grammar, rhetoric, history, poetry and moral philosophy based on the study of ancient Latin and Greek authors, as

well as calligraphy to ensure that their handwriting reflected well on the state, and modern languages to enable them to act as interpreters and to translate letters from foreign governments that could not be entrusted to outsiders. There was a strong emphasis on rhetoric, which was taught by imitating Latin models, especially Cicero. Previous education was not a prerequisite, but some entered the chancery after attending the state-run University of Padua. Although their education was primarily intended to equip them with practical skills, some were connoisseurs of modern art who admired and befriended Titian, helped him in his negotiations with government and sat to him for their portraits.

The *cittadino* caste was not entirely impermeable. It was sometimes possible for wealthy immigrants to attain that rank, which gave them, as well as social standing, certain legal rights, business contacts and trading concessions. But it was a process that could take twenty years or more of residence, and normally required them to own a prominent palace in the city. These new *cittadini* further established their positions in Venice through generous patronage of the arts – Titian would count several of them among his patrons; and many served as officers in the Scuole Grandi, the charitable confraternities that were a distinctive feature of Renaissance Venice and a powerful force for social stability. Membership of the Scuole, which was mostly restricted to *cittadini* and richer members of the lowest class, the *popolani*, was a mix of businessmen, artists, artisans, industrialists, merchants and state functionaries. In Titian's day patricians sometimes acted as patrons of the Scuole, but were explicitly prohibited from membership later in the century.

The Scuole Grandi were unique to Venice and distinct from the Scuole Piccole, smaller brotherhoods devoted to particular religious rites or trades, or representing foreign communities, which numbered over 200 by mid-century. In Titian's youth there were five Scuole Grandi, each with a membership of five or six hundred: Santa Maria della Carità (the oldest of the foundations, now the Accademia Gallery), San Giovanni Evangelista, Santa Maria della Misericordia, San Rocco and San Marco. A sixth, San Teodoro, was founded in 1552.

About 10 per cent of the male population belonged to one or another of the Scuole, which were administered by a rotating governing board, or *banca*, of *cittadini*, elected by the membership and chaired by a *grand guardiano*, who had to be over fifty and served for one year. The Scuole Piccole were run along similar lines except that the chief executive was usually called a *gastaldo*. All the Scuole were highly competitive and vied with one another to commission, often with the aid of government grants, the most magnificent buildings, decorations and paintings. Titian, who joined the Scuola di San Rocco in 1528 and was later a board member, would paint for two Scuole Piccole, and for two Scuole Grandi, including his *Presentation of the Virgin* for the boardroom of the Scuola della Carità.

Francesco Sansovino, author of the first guidebook to Venice,[11] described the Scuole as representing 'a certain type of civil government in which, as if in a republic of their own, the citizens enjoy rank and honour according to their merits and qualities'. As well as looking after their poorer members, they ran almshouses and hospitals, administered private estates and trusts, and in wartime supplied men for the army and galleys. As representatives of the state, their chief officers wore crimson or *pavonazzo* in processions on feast days or in celebration of victories. The members of the Scuola Grande di San Giovanni Evangelista can be seen gliding through the city on Corpus Christi Day in the narrative cycle painted by Gentile Bellini, Giovanni Mansueti, Vittore Carpaccio and other Venetian artists between 1494 and 1500.

Venetians who were neither patricians nor *cittadini* were *popolani*, which meant everyone from immigrant labourers living in shantytowns to merchants, industrialists, artisans and great artists (although the Bellini brothers and Carpaccio were *cittadini originari*). Some members of this diverse lowest class made fortunes – in 1506 a rich merchant *popolano* died without heirs leaving 60,000 ducats to the procurators to distribute to charity. But unlike the working classes of other Italian cities, where the members of guilds had at least in theory a voice in government, the *popolani* of Venice didn't even have a distant memory of democratic or quasi-democratic government.

Some foreign observers wondered at their failure to rise up and demand a say in the way they were governed. According to Luigi da Porto, a nobleman from the neighbouring city of Vicenza, their passive acceptance was due to the high proportion of foreigners in the city:

> apart from a few [Venetians] with long-established citizenship ... all the rest are such new people that there are very few of them whose fathers were born in Venice; and they are Slavs, Greeks, Albanians, come in other times to be sailors, or to earn money from the various trades pursued here ... These people are so obsequious towards the nobles that they almost worship them. There are also many people who have come from diverse places for dealing and warehousing, as from Germany and all of Italy, and have thereafter stayed on to make money and been residents a long time; but the majority also have families in their own countries, and many after a little while leave for home, and in their place send others, who care for nothing except making money; and so from them can come no disturbance whatever.[12]

But there are other explanations for the absence of social unrest. Cramped living conditions enforced at least a degree of interaction between the classes and foreign residents. Throughout the city the little houses of the poor were clustered around the great palaces. Rich and poor, patricians and *popolani* attended the same parish church, sometimes sharing the cisterns that were the only supply of fresh water. Everyone marked the passage of time according to the same rhythms in an age when time was a flexible dimension and the hours sounded by church bells varied in length according to the season. The twenty-four-hour clock began at sunset, the working day at sunrise. Sanudo tells us that the bells of the campanile of San Marco could be 'heard all over the city and also many miles away'.

A succession of spectacular public pageants glorifying the government of the Most Serene Republic became more numerous and more elaborate throughout Titian's lifetime. Ritual celebrations defined

everyone's calendar year and served to focus the attention of all Venetians on their common heritage and destiny. Recent victories were proclaimed by trumpets and fifes in the Piazza while church bells rang all over the city. Every significant event, long past or recent – religious, historical, quasi-historical, legendary; peace treaties, conquests, the arrivals of foreign ambassadors and visiting royalty – was celebrated with a procession, pageant or regatta, all accompanied by the singers and instrumentalists for whom Venice was famous throughout Europe. Carnival, which lasted from 26 December until the first day of Lent, was a psychological safety valve, a time when men and women, patricians, *cittadini* and *popolani*, were allowed to mock one another, dress up as one another and get a taste of how the other half lived. Masked criminals could more easily escape detection during the season, but the revelry never led to mob violence against the state.

The Assumption of the Virgin (the subject of Titian's immense and explosively innovative early painting for the high altar of the church of the Frari) was celebrated on the fortieth day after Easter Sunday with a ceremony that was the most symbolically complex fusion of religion and patriotically adjusted history in the Venetian calendar. On the day of the *sensa*, as it was known, the doge was rowed on the state barge, the elaborately carved and gilded *Bucintoro*, into the Adriatic, where he cast a gold ring into the waters. The marriage to the sea, the 'carefully orchestrated apogee of the state liturgy',[13] commemorated, as well as the Assumption, the most important Venetian secular legend, according to which Doge Sebastiano Ziani in 1177 had acted as peacemaker between Pope Alexander III and the German emperor Frederick Barbarossa. The rewards were the Republic's perpetual dominion over the sea and independence in perpetuity from both pope and emperor. Titian's two large canvases for the doge's palace of episodes from the Alexandrine story were among the tragic losses to fire in the 1577. The *sensa* was also the biggest tourist attraction of the year and the occasion of a major fair in the Piazza.

Of course Venice was far from the perfect state as idealized by its contemporary and later mythmakers.[14] Two-thirds of the population,

including increasing numbers of patricians, were at risk of poverty. In a corrupt and violent age, Venice was not much less corrupt and probably more violent than other Italian cities. Clientism, intrigue and fraud were by no means unknown in government. Although patricians were strictly forbidden to solicit for votes, they struck deals in an area of the Piazzetta known as the *brolio* – hence the word imbroglio for complicated political intriguing. The crime rate was high. Three patricians who served on a rotating basis as Officials of the Night (Sanudo was one of them for a six-month period) prowled the streets after dark with the authority to search any house, and take a cut in any fines they imposed. But they never succeeded in preventing armed criminals from the Romagna and Marches from sneaking into the city by night. Gangs of bored, arrogant members of the companies of the hose behaved as privileged young dandies do in class-conscious societies, accosting strangers with ironic courtesies that could turn nasty. In 1503 a man was condemned to death for selling cooked human flesh. One of Titian's servants was murdered in 1528 when he was living in the parish of San Polo, and another later in his life after he had moved to north-east Venice.

Rape, especially of poor women, sometimes by their fathers or putative husbands, was a frequent occurrence that was not always punished. The humblest victims were often too frightened to appeal to the law, and when they did so their assailants were on the whole let off remarkably lightly. The courts, which were of course entirely male, presumably chose to believe that any women foolish or brave enough to venture out alone was asking for it. Perhaps, like St Augustine in his commentary on the story of the rape of Lucretia, they shared the belief that the violation of a woman's body cannot take place without giving her some physical pleasure. (When Titian was an old man, in three legendary rapes he painted for the delectation of the King of Spain, the *Rape of Europa*, the *Rape of Lucretia* and *Danaë*, the voluptuous victims do not look as displeased by their situation as they should have done.)

The government was far more concerned with sodomy, even within marriage, where it was practised everywhere in Europe as a form of

birth control. Doctors were required by law to investigate and report any evidence of heterosexual sodomy, for which the punishment was decapitation followed by burning of the remains. Homosexuality, which was seen as a challenge to the very order of Creation, was condemned in all Christian countries. But in Venice, where charges of sodomy were investigated by the Council of Ten, homosexuals were pursued and punished with even more rigour than elsewhere in Europe, possibly because homosexual networks, which tend to be secret cabals in homophobic societies, were felt to threaten the authority and stability of the Republican government. Some sodomites were left to die in cages hung from the bell tower in the Piazza while the populace was encouraged to throw rubbish at them from below. The obsession with homosexuality made it an easy charge to make against an enemy, and accusations, some probably trumped up, were frequent. Nevertheless, if we are to believe Priuli, who was one of the Venetian patricians most obsessed by sodomy, by 1509:

> the vice had now become so much a habit and so familiar to everyone, and it was so openly discussed throughout the city, that there came a time when it was so commonplace that no one said anything about it any more, and it neither deserved nor received any punishment – except for some poor wretch who had no money, no favours, no friends and no relations: justice was done on people like that, and not on those who had power and money and reputation, and yet committed far worse crimes.[15]

It has been suggested that some of Titian's portraits – the three men in the *Concert*, the *Man with a Quilted Sleeve*, the *Man with a Glove*, the *Portrait of Tommaso Mosti*, the *Bravo*[16] and the later *Portrait of a Young Englishman* have been singled out – have homoerotic overtones.[17] There is no way of proving or disproving the idea, but given Titian's sensitivity to the personalities of his subjects it is not impossible.

Of all the publicly enacted non-liturgical ceremonies for which Venice was famous throughout Europe, executions were the most

frequent and popular.[18] Punishments for crimes, by mutilation, hanging and/or burning at the stake, which in other cities took place outside the walls, were carried out at the foot of the Rialto Bridge near the market stalls or on the Piazzetta between the two granite columns bearing statues of St Theodore and the lion of St Mark (Venetians to this day avoid walking between the columns). The punishment varied to suit the crime, but in a typical ritual described by Sanudo in 1513 a serial rapist, robber and murderer was transported 'in the usual manner' by raft down the Grand Canal to Santa Croce, where he was disembarked then dragged through the city by horse to San Marco, where he was decapitated and quartered, the quarters hung on the scaffold between the columns of the Piazzetta.

The bloodlust extended to what must have been one of the most grotesque rituals enacted in any Renaissance city. On the morning of Giovedì Grasso, the Thursday before Lent, one bull and twelve pigs were solemnly condemned to death by the doge and the highest government dignitaries, who watched as the animals were chased round the Piazza and then decapitated between the columns on the Piazzetta. The ceremony was in memory of an annual tribute supposedly exacted in the twelfth century from the then independent patriarch of Aquileia. But for more than a century after the patriarch's temporal dominion was abolished in 1420 it continued by popular demand, and the sacrificial animals had to be bought with money from the public purse.

If the real Venice was never the tranquil utopia eulogized by its propagandists, its self-image as a virgin city was justified. Protected from foreign invasion by its shallow ring of water, it had no need of the defensive walls that encased other cities; and the government that sat in the smiling, unfortified pink and white doge's palace was strong enough to resist insurrection from within as well as from without. By the early sixteenth century, however, the reputation of the Most Serene Republic was tarred by its own myths and actions. In the rest of Italy and Europe it was a commonplace that, after a hundred years of unchecked imperial expansion on the mainland, Venice, the

self-styled New Rome, aimed to absorb the entire peninsula in a Venetian-led Italian empire. The spies and diplomats of Venice failed to take account of the hatred and fear that was to culminate in a crisis that was the closest it came to annihilation before Napoleon finally put an end to the Republic in 1797.

The storm had been brewing since the autumn of 1494 when the French king Charles VIII had crossed the Alps at the head of a large army aiming to reactivate a shaky claim as a descendant of the Angevins to the throne of Naples. Charles's invasion unleashed an unprecedented succession of wars and shifting alliances among European powers seeking dynastic control in Italy, which did not finally begin to peter out until 1530. The French descent into Italy encouraged the Republic's territorial ambitions, which aggravated the other powerful states more than ever. The long-standing fear that Venice intended to extend its rule over the whole of Italy and perhaps even beyond the Alps seemed to be confirmed when in 1498 the Republic formed an alliance with the new French king, Louis XII, and provided substantial military support for a French occupation of Milan. 'You Venetians', roared Lodovico Sforza, Duke of Milan, 'are wrong to disturb the peace of Italy, and not to rest content with the fine state that is yours. If you knew how everyone hates you, your hair would stand on end.'[19] In 1503 the Republic took advantage of the power vacuum in Rome created by the death of the Borgia pope Alexander VI and the illness of his son Cesare to enlarge its grain supplies and trading opportunities by occupying the papal territories in the Romagna of Forlì, Cesena, Rimini, Faenza and Imola. It was a move that incurred the implacable rage of Alexander's bellicose successor Pope Julius II. Niccolò Machiavelli, in Rome on a mission for the Florentine government, spoke for many Italians when he wrote in a dispatch: 'One finds here a universal hatred of them ... and to sum up, one draws the conclusion that the campaign of the Venetians ... will either throw open to them the whole of Italy, or lead to their ruin.'[20]

While Julius II bided his time, Maximilian I of Habsburg, Holy Roman Emperor presumptive, and the French king Louis XII were

the first to react. In September 1504 they met at the French court at Blois where they signed a treaty of alliance, which contained a hidden clause providing for an attack on Venice. Maximilian struck first. It was his intention to make his way to Rome to be crowned Holy Roman Emperor by the pope and to assess what the French were up to in Italy. When the Venetian government refused him safe passage, in 1508 he assembled an army of 6,000 men, crossed the pass above Cortina d'Ampezzo and trained his guns on Titian's hometown Pieve di Cadore. The Venetian commander who resided in the castle surrendered without conditions, and Maximilian tried to persuade the local authorities to accept incorporation into the Tyrol. But a committee of fifteen Cadorines, including three senior members of the Vecellio family – Titian's grandfather Conte, Conte's brother Andrea, and Andrea's son Tiziano – urged resistance and got word of the invasion through to Venice. On 2 March a Venetian army, led by the commander in chief Bartolomeo d'Alviano and equipped with mountain guns and an escort of cavalry, made its way up the Piave and crossed the bridge over the Boite river. Joined by a contingent of men from Cadore that included Titian's father, they surprised the German army at Valle, below the slopes of Monte Antelao a few miles to the west of Pieve. At the end of a bloody battle, which raged all night in freezing mist, the German guns were all taken, their army routed, and those who tried to escape were massacred by the Venetian cavalry. D'Alviano went on to force the surrender of imperial possessions in the Friuli. It was the most successful military campaign Venice had fought – or would fight – for a long time, and by 5 June Maximilian was left with no choice but to sign a three-year peace treaty with Venice.

The victory of 1508 remained a source of local and family pride in Cadore for many years to come, and the first-hand descriptions of the battle that Titian heard from relatives and family friends who had fought in it stuck in his mind and furnished the setting for a different, legendary battle he would paint thirty years later for the doge's palace. (The painting no longer exists, but a vivid preparatory sketch set on the bridge over the Boite below the slopes of Monte Antelao survives.)

It was not, however, the last Cadore would see of Maximilian, who broke his truce with Venice and returned to the Friuli, sacking and burning to the ground whole villages in western Cadore, occupied Cortina d'Ampezzo (which remained Austrian until 1918) and finally succeeded in storming the castle of Pieve.

Nevertheless a treaty was formulated on 10 December 1508 at Cambrai, a conference centre in north-east France. Instigated by Pope Julius, ostensibly for the purpose of a crusade against the Turks, the hidden agenda at Cambrai was in the first instance a pact of aggression aimed at clipping the wings of the mighty St Mark. The leading members of what became the League of Cambrai were Louis XII, Julius II, Maximilian on behalf of the empire, Ferdinand of Aragon for Spain, Gianfrancesco Gonzaga, Marquis of Mantua, and Alfonso d'Este, Duke of Ferrara. The estates of both the latter two shared a boundary with the Venetian domain and both had lost territory to Venice during its land-grabbing campaigns. They agreed:

> to put an end to the losses, the injuries, the violations, the damages which the Venetians have inflicted, not only on the Apostolic See but also on the Holy Roman Empire, the House of Austria, the Dukes of Milan, the Kings of Naples and divers other princes, occupying and tyrannically usurping their goods, their possessions, their cities and castles, as if they had deliberately conspired to do ill to all around them ...
>
> Thus we have found it not only well advised and honourable, but even necessary, to summon all people to take their just revenge and so to extinguish, like a great fire, the insatiable rapacity of the Venetians and their thirst for power.

On 27 April of the following year Julius excommunicated the doge and imposed an interdict on the city. On 14 May French troops led by Louis XII moved east from Milan to Agnadello, where they inflicted a resounding defeat on a Venetian army. Four thousand Venetians were gunned down and the Venetian commander, Bartolomeo d'Alviano, who had made the strategic mistake of crossing the River Adda into

French-occupied territory, was taken prisoner. Sanudo, who was in the ducal palace when the news arrived, described the reaction:

> a secretary came running in with letters in his hand from the battle-field, with many gallows drawn on them. Thereupon the doge and the Savi read the letter and learned that ... our forces had been routed ... And there began a great weeping and lamentation and, to put it better, a sense of panic ... Indeed they were as dead men.

Two days later when a raging wind blew out a glass window in the Great Council Hall and tore off one of the wings of the lion of St Mark on its column in the Piazzetta, Sanudo interpreted the freak summer storm as a portent of worse to come. He was right. The remains of the League's army moved eastwards on to Padua, the university city only a few miles up the Brenta from Venice, where an imperialist faction opened the gates and declared Padua a republic under the protection of Maximilian. Venice, stripped of all its mainland possessions except Treviso, saw the farms and villages across the lagoon in flames, heard the guns of an apparently unstoppable enemy and prepared for siege.

'To tell the truth, as I am bound to do,' wrote Girolamo Priuli, 'no one would ever have imagined that the Venetian mainland state could be lost and destroyed within fifteen days, as we have now seen ... There was no human mind or intellect which would have considered it, nor any astrologer, nor philosopher, nor necromancer, nor expert practitioner in predicting the future who would have considered it nor prophesied it ...'[21] Speaking as the head of one of the three Venetian banks at the time, he added that the value of state bonds had plummeted to 40 per cent of their pre-war value and that the state was no longer able to pay interest. Priuli maintained that in turning its face from the sea to the mainland and giving way to dissolute habits Venice had courted its own doom. Over and over again his diaries examine the causes of the shocking reversal of God's goodwill: mal-administration, delays in the dispensation of justice, corruption, sumptuary laws not enforced and soon forgotten. The habit of

wearing what he thought were French fashions at a time when Venice was at war with France was unpatriotic as well as frivolous and corrupt. His fellow patricians had grown flabby as well as prey to disgusting vices. Sodomy had 'become so habitual that it was more highly regarded than having to do with one's own wife'.

With the roads blocked on the mainland it was difficult for small merchants to conduct business. After six months of war a Venetian merchant of modest means wrote in a letter to his brother, who was trying to do business in the Levant: 'One can think and talk of nothing but of war, plague and scarcity, but most of all about the war. The war makes us forget the plague because the time has come about which our forefathers said that the living will envy the dead.' At the end of December 1509 he described how the soaring cost of living had affected his household: 'For more than half the week we must get along without meat, and I must confess that I mix water in the wine when the wine is still in the casket.'[22] The doge, Leonardo Loredan, was criticized for his apparent inertia. Sanudo wrote that he was 'more dead than alive', and Priuli that he seemed mentally and physically ill.[23]

As the war progressed Priuli described the worsening economic climate: 'There is almost no business any more; no trade can develop because the roads are interrupted and often entirely blockaded. Taxes are not paid. The poor cannot pay them and the rich are exhausted, and everyone complains endlessly. Alone the customs produce some income ... but that is not enough for expenses required by the war ... The Venetian senators are in great desperation and almost worried to death to find *one* ducat.'[24] The tax screw had become unbearable. Indirect taxes had a negative effect on business and made it harder for the people to pay direct taxes. Government officials and members of the ruling nobility were required to pay in tax 50 per cent of the fees for special services with which they traditionally supplemented their modest salaries. Jews, always required to pay for the privilege of living in Venice, now paid even more dearly. With the supply of food from the terraferma unreliable, grain, cattle and wine had to be brought in by ship, and the consequent higher prices were all the harder to bear when most people's incomes were diminished.

Forced loans were extracted from those who could afford them, and were rewarded by high offices. By 1515, the government went so far as to publish the names of those nobles who had made loans, the sums they had donated and the names of those who had refused. But the most shocking measure to raise money for the war effort, because it went against the grain of long-cherished republican values, was the introduction of the sale of offices in March 1510. For those young patricians whose families were prepared to pay 100 ducats, the age restriction for membership of the Great Council was dropped from twenty-five to seventeen. Two hundred ducats could buy election as one of the Savi. A more substantial offering could smooth even admission to the ranks of the procurators, supposedly the most honourable of all offices but now to be had for 12,000 to 100,000 ducats, while the membership was enlarged to forty. The unprecedented policy of cash for honours scandalized Sanudo. 'And so', he sighed, 'everything is up for sale.' Nevertheless in 1516 Sanudo, who was not rich, managed to scrape together a loan of 500 ducats which bought him a seat in the Senate. And the sale of offices would remain an accepted practice for years to come.

The war dragged on for nine years. As the members of the League inevitably fell out among themselves, Venice dodged and wove, forming an alliance in 1510 with the pope against the French, in 1513 with the French against the pope and emperor. Thanks more to diplomacy, statesmanship and good luck than to military victories, Venice regained virtually the whole of its terraferma by 1517. Although the conclusion of the war was not the end of Venetian involvement in the wars of Italy, it was nevertheless quickly incorporated into the myth of Venice as a state dedicated to peace. Venice was once again God's chosen city, saved and eternally blessed by Christ and the saints. No other state, not even those of the ancient Athenians and Romans, had ever succeeded in defending itself against so many powerful enemies. The intervening years, however, had been the most testing and psychologically shocking in the history of the Republic. For many years afterwards Venetians spoke of the days before or after 'the War', and nothing after it was quite the same. And it was during those

fearful times, when the very existence of his adopted home was threatened, that Titian emerged as an independent master and painted his radiantly serene early masterpieces.

The Fondaco, Giorgione and the Modern Manner

Paintings make no claims, Ma'am. They do not purport to be
anything other than paintings. It is we, the beholders, who make
claims for them, attribute a picture to this artist or that.

'ANTHONY BLUNT' TO 'HER MAJESTY THE QUEEN',
ALAN BENNETT, *A QUESTION OF ATTRIBUTION*, 1991

The building opposite the Rialto markets and just upstream from the
bridge is one of the largest and plainest of the palaces that line the
Grand Canal. After centuries of neglect and radical restorations it is a
mere shell of its former self, and most tourists passing it by water are
unaware of its former significance.[1] Under the Republic it housed an
institution that was key to the city's fabulous wealth: the Fondaco dei
Tedeschi. The Venetian Fondaco – the word was an adaptation of the
Arab *fondouk*, meaning exchange house or trading centre – was the
residence, warehouse and trading post of the German and Germanic
merchants. And of all the frescos that lit up the architecture of the
painted city, those executed on its façades by Giorgione and Titian
were the most spectacular for their unprecedented monumentality,
colour, movement and fantasy.

A German exchange house had occupied the site since the thir-
teenth century. Trade with northern Europe, the complement to the
overseas market, was an essential base of the Venetian economy, and
the government exercised strict controls over the merchants to ensure
that duties and tolls payable on imports and exports were not evaded.

They were obliged by law to rent lodgings and warehouse space in the Fondaco, and Venetian merchants were prohibited on pain of criminal charges from crossing the Alps for the purpose of buying or selling direct. The inmates of the Fondaco were closely supervised by Venetian administrators and spies. Packers, weighers, auctioneers, brokers and the notaries, clerks and servants of residents of the Fondaco were all cleared and appointed by the Salt Office, the government agency responsible to the Council of Ten for its management. Each German merchant was assigned a Venetian broker, chosen by lot to prevent collusion, who acted as his minder. The brokers, known as *sansali*, negotiated and registered all sales, on which they received a commission, and accompanied their clients when they made purchases to make sure that they bought only from native-born Venetians. There were thirty such brokerages, or *sanserie*, some of which were sold or awarded as sinecures to people who employed agents to do the actual work. Some were used to pay artists working in the doge's palace, who received 100 ducats a year tax free. Giovanni Bellini and Titian later in his career were beneficiaries of the system.

The task of frescoing the exterior of the Fondaco was Titian's first public commission, and he came by it as the result of a fire. On 28 January 1505 the old Fondaco – the one you see on the de' Barbari map – burned to the ground taking many German lives, consuming thousands of ducats' worth of merchandise and upsetting the complex mechanism of government control over transalpine trade. Sanudo saw the disaster as one of the many bad omens in the uneasy times that preceded the Cambrai war. While temporary lodgings above the Rialto markets were found for the surviving merchants, the government decided within a week to build a new Fondaco at its own expense and as quickly as possible. Land adjacent to the old site was purchased, and in June Giorgio Spavento and Antonio Scarpagnino were appointed architects of an enlarged building, which was constructed with flat façades that were intended as surfaces for frescos. The foundations were laid and the first floor raised within a year at a cost of 300 ducats a month. The upper storeys, which took the best part of another year, cost 600 a month. The roof was constructed by 5 April

1507; in the following year a celebratory mass was sung in the court-
yard, and Venetian shopkeepers signed leases granted by the govern-
ment for shop spaces on the ground floor opening directly on to the
street. Rooms in the newly appointed residential quarters, which were
so luxuriously appointed that they were described as having walls like
marble, were offered to the German merchants at between eight and
twelve ducats a year, payable to the government of St Mark, the rent
to exclude supplementary expenses such the usual duties, stewards'
fees and storage.[2] In early August 1508 Sanudo reported that the
building was now in use, but that the painters were still at work on the
exterior frescos and rents for the ground-floor shops would not start
being paid until 1 March 1509 (the first day of the year according to
the Venetian calendar). He was evidently well informed because on 18
February of that year the German merchants celebrated the comple-
tion of the new Fondaco with a party at which the most important
members of the government were entertained by a transvestite ballet,
allegorical masques and the spectacle of a greased pig being chased
around the courtyard by blindfolded men.

Although the German emperor Maximilian had joined the League
of Cambrai the previous December, he was still theoretically at peace
with Venice according to the truce he had been forced to sign after the
rout of his troops at Cadore in March 1508. It was only after the
Venetian defeat at Agnadello on 14 May, followed by Maximilian's
occupation of the key Venetian towns on the terraferma, that the
German merchants departed, and the Fondaco was turned into a
hostel for war refugees from the mainland. The merchants were not
gone for long. Within weeks some of them had returned, having been
granted safe conduct through the war zones by the emperor and the
Republic. The spices on which Venice held a monopoly were essential
commodities, used as preservatives and drugs as well as for flavour-
ing. Northern Europe needed Venetian spices, and Venice, its econ-
omy severely threatened by an expensive war, needed the northern
European markets more than ever.

Although Titian's Fondaco frescos are the first of his works that can
be securely dated within a few years, the question of when, exactly, he

and Giorgione executed them is one of those tantalizing puzzles about his early career and his artistic relationship with Giorgione that will never be solved to the satisfaction of all scholars because most of the documentary clues about the frescos, although copious for the building itself, are missing. The only areas of agreement are that the painters could have started work in May 1507, soon after the roof was finished and while the scaffolding was still in place; that Giorgione finished before November 1508; that he painted the façade facing the Grand Canal and Titian the south-facing land entrance; and that Titian began working on his façade later than Giorgione did on his.

We know that on 4 August 1507 Giorgione was paid an advance of twenty ducats to supply a painting for an audience chamber in the doge's palace, and that the picture, which does not survive, was finished a few months before January 1508, when he received a final payment of twenty-five ducats. He was therefore busy during this period. Vasari said that Titian was recommended for the job of frescoing the side façade by a friend of his, a member of the noble Barbarigo family whose portrait he painted. But, although nobody has ever doubted that Titian frescoed the land entrance to the Fondaco, he is not mentioned in any relevant document. Giorgione's name appears in connection with the frescos only because of a dispute with the Salt Office about his payment. He had received a down payment of 100 ducats, but according to a document dated December 1508 a committee of four artists – Giovanni Bellini, Lazzaro Bastiani, Vittore Carpaccio and Vittore Belliniano – revalued them at 150 ducats. Giorgione settled for 130 including painting materials, possibly as a compromise between the minimum agreed payment and the revaluation.[3] The document doesn't say when he completed the frescos, but similar cases of disputed payment took a year or more to be processed, which suggests that he could have finished his façade by late autumn 1507. In that case the painters whom Sanudo mentioned as being still at work in August of the following year would have been Titian and his team of assistants working on the south-facing land entrance.

The only survivals of the frescos today are some ghostly detached ruins (the Titians in the Ca' d'Oro, Franchetti Gallery; a standing

nude by Giorgione in the Accademia Gallery).[4] Titian's land entrance being less exposed was better preserved than Giorgione's on the Grand Canal, which has disappeared altogether apart from the standing nude woman, which is scarcely legible apart from the reddish tint of her flesh, which Antonio Zanetti, writing in the eighteenth century, described as 'fiery'. Zanetti's hand-coloured etchings and written descriptions, first published in 1760, are the most complete records we have of the appearance of the frescos. Although large sections were missing by then, it is evident from his and other prints, paintings and descriptions that their most remarkable feature was a series of life-size and lifelike figures. Some were male and female nudes in dynamic poses suggested by classical sculpture, which have been compared to Michelangelo's nudes on the ceiling of the Sistine Chapel. They were the first realistic nudes to appear on a public building anywhere, and the first in the line of sensuous Venetian nudes by Giorgione, Titian and their followers. Other figures depicted by Titian represented familiar Venetian characters: a Levantine, a Swiss mercenary soldier; young Venetian aristocrats of about Titian's own age wearing the striped hose and colourful short jackets of a *compagnia della calza*, representing nobility, peace and prosperity. There was a portrait of a certain Zuan Favro, a well-known and popular adventurer who several years later was convicted of smuggling spices. Sanudo described him as a most valiant man, a person of outstanding ability.

If there was a programme or any kind of predetermined scheme for the frescos, none has ever been suggested. Vasari, who first saw them on a visit to Venice in 1541 when they were already fading, thought that Giorgione had painted some of Titian's figures and wrote that those in charge of the project had given Giorgione (and by implication Titian) an entirely free hand, 'provided only that he did all in his power to create a first-rate result':

So Giorgione started work. But he thought only of demonstrating his technique as a painter by representing various figures according to his own fancy. Indeed, there are no scenes to be found there with any

order or representing the deeds of any distinguished person, of either the ancient or the modern world. And I for my part have never been able to understand his figures nor, for all my asking, have I ever found anyone who does. In these frescos one sees, in various attitudes, a man in one place, a woman standing in another, one figure accompanied by the head of a lion, another by an angel in the guise of a cupid; and heaven knows what it all means.

Titian painted his most prominent figure in full colour over the main land entrance (now marked by a lion of St Mark above the door) where she interrupted a frieze in grisaille of military trophies and fanciful scenes of combat, one between putti and animals, another between sea monsters. She was a seductive, elaborately dressed woman seated on a ledge, trampling a decapitated head with her bared left leg while she brandished a sword over the head of a soldier in armour who had an innocent expression but concealed a dagger behind his back.[5] Vasari[6] thought she was by Giorgione and that she represented Judith 'speaking to a German standing below her'; but he confessed that he was unable to interpret the meaning 'unless Giorgione meant her to stand for Germania'. Perhaps Vasari did not know or had forgotten that at the time Titian painted her Venice was on the verge of war with the German emperor Maximilian I, whose armies had been laying waste to Titian's homeland. So, far from representing Germany, the story of Judith – the Jewish heroine who decapitated the invading general Holofernes – would have had a special significance for Titian and for the Venetian Republic, one that carried a double meaning as an allegory of Venice as Justice or Fortitude, intended as a warning to the German merchants as they entered their Fondaco.

Seen from Campo San Bartolomeo – as it could be throughout Titian's lifetime before it was hemmed in by later buildings[7] – Titian's south-facing façade must have looked like a billboard proclaiming an overt sensuality, a sense of fun and a confident classicism that had not been seen before on this scale, let alone on the façade of a building. The frescos were the talking point of the city, and everyone without

exception whose written comments survive considered Titian's to be superior to Giorgione's.[8] The rumour went round[9] that some wags congratulated Giorgione on Titian's work, saying how much he had improved since he painted the Grand Canal façade. The older master, hurt to the quick, sulked in his house, refusing to go out and saying that he would never again have anything to do with that upstart.

The story, true or false, is interesting as being the first about rivalry between Venetian artists. Biographies of artists in other times and places are liberally spiced with anecdotes about artistic competition. Apelles and Protogenes competed to see who could draw the thinnest line. Wu Tao-tzu, the greatest Chinese painter of the Tang dynasty, murdered a rival, just as Andrea Castagno was supposed by Vasari to have assassinated his friend and collaborator Domenico Veneziano (who in fact outlived him by four years). Donatello strove to outdo Brunelleschi and made wittily disparaging comments about the work of Nanni di Banco and Paolo Uccello. Michelangelo, the arch-rival of Raphael, destroyed pictures by Dürer out of envy. And so on.[10] But the rivalrous instinct, and the artist's passionate identification with his work that it implies, seems to have been lacking in conservative, family-oriented Venetian studios until Titian's independent and competitive spirit kick-started the rapid development of Venetian art.[11]

Giorgione's posthumous reputation did not merely survive the setback; it mushroomed after his death, when he became increasingly famous as the most enigmatically romantic of Renaissance painters, in a way that is without parallel in the history of art. Apart from Vasari's not entirely accurate 'Life of Giorgione', which was published four decades after the painter's death, we know very little else about him, except that in the seventeenth century his family name was said to be Barbarella, that he was referred to in his lifetime as Giorgio rather than Giorgione, that the contents of his house suggest that he was by no means a rich man and lived in some disarray; and that he kept a separate studio.[12]

Although Vasari said Giorgione was born in Castelfranco in 1477 or 1478, he may in fact have been closer to Titian's age because his first

securely datable work is the *Portrait of a Man* of 1506, by which time, according to Vasari, he would have been nearly thirty. He died during a plague in 1510, not in 1511 as Vasari claimed. Vasari was, however, right in saying that, by giving his pictures more softness and greater relief, he was the first Venetian artist to create the 'modern style', far outstripping Giovanni Bellini and all other Venetian painters of the older generation, and that the finished pictures of Giorgione and Titian were for a while so similar as to be indistinguishable. In fact, although the mood of their pictures is similar, there were differences in the way they planned and painted them. The *Three Philosophers*, for example, which is one of the paintings that is confidently attributed to Giorgione at least in part – and one of the most closely studied by modern scientific investigations – reveals underdrawings, some in bold outlines using a large brush, some loosely drawn in stiffer lines. This careful planning is very different from the cursory drawings beneath Titian's earliest paintings, which were conceived almost entirely in paint.

The problem of attribution to one or the other, or to Sebastiano Luciani, or to other artists some of whose names have not survived, continues even today to exercise scholars, critics, museum curators and dealers. They were all painted for young Venetians whose imaginations had been recently liberated by the classical stories and pastoral romances published by the Aldine Press, and who were ready for a new, unconventional way of painting. Ridolfi wrote that their portraits were also difficult to distinguish: 'many portraits are identified with some confusion and no distinction, now as the work of one, now as the work of the other'. But since neither Vasari nor Ridolfi nor any other early writer was specific about the portraits in question, the only two that can be given to Giorgione on sound evidence are the *Portrait of Laura*, so called from the spray of laurel branches behind her head, and possibly the first of the Venetian portraits of anonymous seductive women, which is inscribed on the back of the panel, 'On 1 June 1506 this was made by the hand of maestro Giorgio from Castelfranco the colleague of maestro Vincenzo Catena'; and the *Portrait of a Man*, which is also signed on the reverse, and seems to be

a portrait of the physician Gian Giacomo Bartolotti da Parma, who was also the subject of a later portrait by Titian.

Apart from those two portraits, the public commissions for the Fondaco frescos and the lost painting for the doge's palace, there are two other pictures that are so distinctive that they can be identified from the notes of a Venetian nobleman, Marcantonio Michiel, who wrote, mostly in the late 1520s, about the pictures he saw in eleven collections in Venice and Padua.[13] One is the *Tempesta*, then in the collection of Gabriele Vendramin, which Michiel described as 'The little landscape on canvas with a storm, with a gypsy and a soldier ... By the hand of Giorgio of Castelfranco'. The other is the *Three Philosophers*, which he saw in the house of his friend Taddeo Contarini in 1525 and described as 'The canvas in oil of Three Philosophers in a Landscape, two standing and another seated, who contemplates the rays of the sun, with a painted rock that is miraculously rendered. It was begun by Zorzo of Castelfranco and finished by Sebastiano the Venetian.' Both descriptions are so precise that they put the attributions beyond reasonable doubt, although modern scientific studies show no evidence that the *Three Philosophers* was finished by Sebastiano.

The Giorgione or Titian question[14] remains so contentious that professional art historians use the phrase 'according to my Giorgione' in wry acknowledgement of the inevitable subjectivity of attributing any painting to a particular artist by connoisseurship alone. The problem is complicated by other possible contenders, some anonymous because Venetian painters seem rarely to have entered into notarized contracts for their work, as was the norm in the rest of Italy, or if they did the notarial records have survived less well than elsewhere. Giorgione, furthermore, worked mostly for high-born patrons, and the earliest accounts of his style were written by people, Vasari included, who did not have easy entrée to patrician collections and therefore didn't know what his cabinet pictures looked like. The exception was Marcantonio Michiel, who, as a nobleman himself, had access to patrician collections, although his laconic notes were not always accurate. Michiel recorded fourteen Giorgiones. Vasari gave

him about twelve. In the next century Ridolfi mentioned about sixty-five, already an impressive opus for an artist cut off in his prime by death.[15]

Over successive centuries the volume of Giorgiones expanded, the inflationary optimism of connoisseurs fuelled by a burgeoning art market whose interests were served by exploiting the fascinating qualities of early sixteenth-century Venetian painting that are difficult to define – except as 'Giorgionesque', meaning a style characterized by informal grouping of figures, gentle transitions of colour, dreamy landscapes and idiosyncratic or enigmatic subject matter that seem to reflect the mood of the pastoral poetry of the period. Giorgione, as a connoisseur of Venetian painting observed in 1877,[16] had become 'a sort of impersonation of Venice itself, its projected reflex or ideal, all that was intense or desirable in it crystallising about the memory of this wonderful young man'. By the early nineteenth century it is said that some 2,000 'Giorgiones' passed through the London salerooms. They included paintings now more securely attributed to other artists including Titian. It was only from the second half of the nineteenth century, when more informed connoisseurship was facilitated by the invention of photography, the spread of railways, the growth of public museums and the opening of the Italian state archives, that the Giorgione bubble began to deflate.[17] By the early twentieth century some 'Giorgiones' had been restored to the artists who painted them, and the numbers have continued to decline with colour photography, loan exhibitions and the expansion of art history as an academic subject. But there are still a number of paintings that art historians have continued to shift back and forth between Giorgione and the young Titian, and sometimes Sebastiano, or to a collaboration of two of them or all three.

Depending on the Giorgione of which modern scholar you consult, there could be anything up to about forty surviving works. They include a number that some scholars prefer to give to Titian, including the *Christ Carrying the Cross* (Venice, Scuola di San Rocco), the *Allendale Nativity* (Washington, DC, National Gallery of Art); and the *Sleeping Nude in a Landscape* (Dresden, Gemäldegalerie), which is the

first extant reclining nude in Western art and one of the most famous of early sixteenth-century paintings. It has traditionally been assumed that the beautiful nude was painted by Giorgione and the landscape in which she lies finished after his death by Titian. However, after long and complicated detective work by scholars and restorers it now seems more likely that the entire painting is by Titian.

The most interesting problem of attribution, for historians of the vagaries of taste, and perhaps the most contentious in the whole of Italian Renaissance art[18] concerns a painting recently described as 'the greatest erotic masterpiece in the history of Western painting'[19] but which was dismissed by some of the leading connoisseurs of the late nineteenth century as too feeble to be by either Giorgione or Titian. Despite the negative academic judgements of the *Concert Champêtre*, its quality was defended by the independent-minded Walter Pater,[20] and it inspired painters on both sides of the Channel, from Watteau to Turner and the Pre-Raphaelites, although in different ways. Manet took it as the model for his slice-of-life *Le Déjeuner sur l'herbe* of 1863. It was the subject of Dante Gabriel Rossetti's sonnet 'For a Venetian Pastoral by Giorgione' (1849) about the sadness of a moment of perfect bliss that must pass with time. Two naked women and two fully clothed men make music in an Arcadian landscape on a late summer's day. The naked women may be nymphs, personifications of the landscape and therefore invisible to the men,[21] who do not look at them. Whoever painted it, this mysterious, erotic, beautiful picture is an epitome of what we think of as 'Giorgionesque'. Nevertheless, since 1976 the *Concert Champêtre* has been given to Titian by a majority of scholars,[22] partly on the grounds that technical investigation has revealed a large number of the changes of plan that were characteristic of Titian's working method.

There is in fact no undocumented Venetian painting that looks like Giorgione or Titian or both – or in some cases not very much like either – that has not been the subject of prolonged scrutiny and sometimes bitter debate. But any amateur art lover who tries to follow the ins and outs of all the arguments is at risk of drowning in oceans of spilled ink. There are even some art historians who say that there is

really no point in speculating about the dates or attributions of the disputed early paintings, and particularly the *Concert Champêtre*, without comparing them to the first of Titian's works about which we know for certain exactly when, where and for whom they were executed. They are the frescos still in the Scuola di Sant'Antonio in Padua, where Titian worked in the spring and early summer of 1511.

SIX

Miracles and Disasters

Often the high and broad trees produced by nature in the fearful
mountains tend to please spectators more than the cultivated
plants, pruned by learned hands in ornamented gardens ... And
who doubts that a fountain that naturally comes out of living
rocks, surrounded by a little greenery, is more pleasant to human
minds than all the others made with art from the whitest marble,
resplendent with a lot of gold?

JACOPO SANNAZARO, *ARCADIA*, 1504[1]

On 1 December 1510 Titian received a visit from a certain Nicola da
Stra, the *guardiano*, or chief executive, of the Confraternity of St
Anthony in Padua, who had come with a proposal that no young
artist in those lean times could afford to refuse. A programme of
frescos depicting miracles performed by St Anthony, patron saint of
Padua, was under way in the recently built chapter room on the
upper storey of the confraternity. Titian, for a fee of twelve ducats,
including an advance of twenty-four lire, the rest to be paid in instal-
ments, agreed to contribute a fresco depicting the miracle of St
Anthony's jawbone (a fragment of which was preserved in a jewelled
reliquary in the basilica of St Anthony). Stra would reserve for it the
first large space to the right of the entrance to the new hall. The
relevant entries in the confraternity account book for the next
months are the earliest surviving records in which Titian's name
appears.[2]

Padua was the left bank of Venice and cultural jewel of the Venetian land empire. The Venetian intellectual elite were educated at its university, which was financed by the central government and was one of the oldest in Italy. The city's Roman remains – including the first-century AD amphitheatre that is now the site of the Arena Chapel – bore witness to the ancient civilization that had flourished there at a time when Venice was a wilderness of mud banks inhabited by fishermen. The miracle-working St Anthony, a disciple of St Francis, was, and is, one of the most popular of all Christian saints. His shrine, the basilica of St Anthony, known simply as Il Santo, had been begun the year after his death in Padua in 1231, and has been visited ever since by pilgrims from the far corners of Christendom. The confraternity, which is adjacent to the Santo, was well endowed, with a distinguished membership. So the commission to contribute a fresco carried considerable prestige.

Although Titian had recently demonstrated his prodigious talent for creating dynamic figures in fresco on the façade of the Fondaco, the confraternity must have taken advice before employing an artist still in his early twenties. Jacopo Pesaro, his former and future patron and a prominent devotee of St Francis, would have given him a warm reference. Pietro Bembo, who had known Titian from the days in Giovanni Bellini's studio, kept a house in Padua with his father Bernardo where they made their collection of coins, medals, antiquities and plaster casts of antiquities available for study by artists. The confraternity must also have consulted that fascinating Renaissance man and distinguished Paduan Alvise Cornaro. Cornaro, after enjoying a dissipated youth, regretted his wasteful life, wrote a treatise advocating moderation and sobriety and made a fortune as a technologist and agricultural reformer – 'holy agriculture', as he called it. (Tintoretto portrayed him in robust old age.) A man of wide-ranging interests and abilities – his passion for classical architecture would later encourage the young Palladio – he kept open house to gentlemen farmers, scientists, architects, writers, sculptors and painters. Titian, during his stay in Padua, frescoed the exterior of his house near the Santo.[3]

The choice of an up-and-coming Venetian artist was also an expedient political gesture of loyalty to the Venetian government at a time when Padua was under a cloud of justified suspicion. Since taking control of the town in 1405 Venice had ruled there with a relatively light hand. But Padua had betrayed that trust. Members of the old governing aristocracy continued to harbour imperialist sympathies and some had advocated joining the League of Cambrai against Venice. Their chance had come on 6 June 1509, only a few weeks after the catastrophic Venetian defeat at Agnadello, when the remains of the League were welcomed into Padua, which declared itself an independent republic under the protection of the emperor Maximilian. The occupation lasted for forty-two days before the city was recaptured on 17 July by Venetian forces under the command of the brilliant soldier (and future doge) Andrea Gritti, with the help of Venetian loyalists in the city. The siege of Padua was one of the most violent actions of the Cambrai war, not least because of the use of a terrifying novelty known as 'Greek fire' which stuck to the bodies of its victims and could not be extinguished by water. The recovery of the city was celebrated in Venice with a magnificent procession led by the doge, which remained a regular event in the Venetian calendar for centuries to come. And when on 15 September a League army once again reached the walls of Padua the city was so well defended that after two weeks of bombarding the walls with heavy artillery Maximilian abandoned the siege and retreated towards the Alps.

When Titian started work in the confraternity in April 1511, Padua and Treviso and the swathe of territory between them were the only mainland possessions still in Venetian hands. Some leading imperialist partisans had been singled out by the Venetian government as examples and had been executed by hanging, their families fined or imprisoned and their property confiscated. Padua was a garrison city and headquarters for the duration of the war of the Venetian light cavalry, the *stradiotti*. The gates were guarded and the streets patrolled by able-bodied Venetian conscripts of all classes and occupations – patricians and their servants, peasants, guild members, even the entire crews of merchant galleys were given incentives by the government to

occupy and defend the city. The surrounding suburbs and farms had been destroyed to provide a clear line of fire, and property within the city pulled down to speed up communication between threatened points. The population was swollen by refugees from the enemy-occupied territories around Vicenza and Verona. The university was closed.

Titian, his formidable energy undiminished by the depressing mood of the city and bursting with ideas, studied the outstanding examples of central Italian art that Paduan patrons, more sophisticated and cosmopolitan than their Venetian contemporaries, had commissioned since the early fourteenth century when Giotto frescoed the Arena Chapel with scenes from the lives of St Joachim, St Anne and the Virgin, and from the life and passion of Christ. Donatello's monument to the mercenary commander Erasmo Gattamelata, the first of the great Renaissance equestrian statues, occupied a place of honour in front of the Santo, where his bronze sculptures for the high altar included four relief carvings of the miracles of St Anthony. Mantegna's frescos in the Ovetari Chapel, strongly influenced by Donatello, were the first paintings in the Veneto to adopt the idiom of the fifteenth-century Tuscan Renaissance.

The members of the confraternity were lay brothers – and indeed sisters since women were admitted, although not into the chapter room. As family men required to conduct exemplary Christian lives, they understood the need to resist and to disclaim the passions, misunderstandings and temptations that can destroy the best of marriages – of the seventeen frescos in the chapter room, eight are about family matters. And it may have been for that reason that it was decided at some time during their early discussions with Titian that he would paint, instead of the miracle of the saint's jawbone, the *Miracle of the Speaking Babe*, a story of domestic discord which doubtless appealed more to his sense of drama. A woman in thirteenth-century Ferrara is wrongly accused of adultery by her husband, a distinguished aristocrat who is convinced that another man has fathered their child. The supposed lover is identified by his striped hose as one of the young *compagnie delle calze* who organized

theatrical events and were notorious womanizers. The woman protests her innocence, but a judge is unable to reach a decision. St Anthony gives the baby the gift of speech, allowing it to reveal its legitimate paternity to its father and assembled witnesses. The accused young man rushes forward in relief.

Titian based his composition on one of Giotto's frescos in the Arena Chapel. The frieze-like arrangement of the figures seems also to have been inspired by Donatello's miracles and by Antonio Lombardo's relief carving of the same subject, which had been installed in the Santo only a few years before Titian painted his fresco. The group of three women on the right is a direct quotation from Sebastiano's altarpiece, finished only a month or so earlier, in the Venetian church of San Giovanni Crisostomo. But it is the lighting and the striking composition of the fresco that account for its dramatic tension. Titian realized the sky, the landscape and the upper part of the church in a single working session or *giornata* – the time, that is, that it takes the fresh wet plaster on which true fresco is painted to dry. The fresco is divided vertically in half by the edge of the dark church, identified as such by a red cross in a blind arch. The device of splitting his compositions in this way was one he would use again over the next decades, and with stunning effect only a few years later for the impeccably polished *Virgin and Child with St Catherine, St Dominic and a Donor* (Parma, Fondazione Magnani Rocca).[4]

On the church Titian propped a fictive statue of the Roman emperor Trajan,[5] copied from a plaster cast or wax model of a Roman relief, which had recently been discovered in Ravenna.[6] Although he would later occasionally incorporate *all'antica* inventions to give added meaning to his subjects, as he already had in the *Jacopo Pesaro before St Peter*, the figure of Trajan is the first instance in his career of his portraying a real antique model. It referred to a story told by Dante and in *The Golden Legend*[7] that was often used at the time to decorate wedding chests as a symbol of marital concord. Trajan, although hastening to battle, was persuaded by a grieving widow whose child had been slain to stop and administer justice. Centuries later Pope Gregory the Great saw a sculpted frieze depicting the *Justice*

of Trajan and was so moved by the story that he prayed for the pagan Trajan to be baptized as a Christian by his tears and thus, unlike other pagans, who were automatically sent to hell, placed in Purgatory. Titian probably used it here to reinforce the visual message that Venice, like St Anthony, was dedicated to the administration of justice.

Titian finished the *Miracle of the Speaking Babe* in early May 1511. Later in the month he was commissioned to paint two smaller frescos for eighteen ducats, with a down payment of ten ducats.[8] On 22 May we have the first record of Titian's brother Francesco, who was in Padua where he witnessed a document in the office of the confraternity, signing himself as a master painter resident in Venice at the Rialto, and where he may have acted as Titian's assistant. The *Miracle of the Repentant Son* – in which a bad-tempered boy who has kicked his mother cuts off his foot in remorse, and St Anthony restores the foot when the boy's mother begs that he be forgiven – was executed in eight *giornate*. The miracle is witnessed by the first of the portraits of real people – probably members of the confraternity – to whom Titian liked to give roles in his theatrical productions. The only figures who seem to be unaware of the miracle are two soldiers, one in armour looking away from the performance of the miracle, the other seated in the distance.

The *Miracle of the Jealous Husband*, painted in six *giornate*, is the most turbulent of Titian's trilogy of love stories. Possibly the first depiction in Renaissance art of an emotionally driven assault on a real, ordinary woman, the wind-blown landscape that echoes the violent act contradicts the written version of the story which takes place in a domestic setting. It is also one of Titian's most theatrical early paintings.[9] An insanely jealous husband, convinced of his wife's infidelity, knifes her to death. The murder takes place in the foreground of the fresco, in the shadow of a rocky outcropping, while St Anthony, having resurrected the wife, is seen only in the distance forgiving the husband. In an age when extreme violence was commonplace, although rarely represented in Italian art, and women were regarded as the property of their fathers and husbands, Titian's empathy with a woman violated by male intemperance is remarkable. As

the model for the innocent wife sprawled in agony on the ground Titian quoted, in reverse, the pose of Michelangelo's dramatically foreshortened figure of Eve from the *Fall of Man* on the Sistine Chapel ceiling[10] or of the Virgin in his earlier *Doni Tondo*. Thus this most Venetian of painters made use of the two outstanding painters of the Florentine Renaissance, Giotto its founding father and Michelangelo the supreme genius of its maturity. Nor was this the last time Titian would quote Michelangelo, although that greatest of central Italian artists had probably not yet heard of the Venetian painter who would become his artistic opposite and principal rival. Titian executed the three Paduan frescos at top speed and apparently with no cartoons and only sketchy *sinopie* or underdrawings.[11] The lay brothers' request for domestic subjects gave him the opportunity to express for the first time his precocious understanding of the human heart, but he did so without a trace of rhetoric or religiosity, while his Shakespearean capacity to absorb, synthesize and enliven ideas borrowed from other artists transformed Venetian narrative painting, introducing a sense of naturalistic excitement that rendered obsolete the charming but static processions of Gentile Bellini and Carpaccio.

Titian left Padua shortly after 19 July 1511, the day on which he received his last-recorded payment there. It was not until 2 December, a year after he had accepted the commission, that Antonio da Cesuna, the steward of the confraternity, brought the final instalment of four ducats to Titian's house[12] in Venice. Titian's receipt to the confraternity survives only in a nineteenth-century facsimile, which is however consistent with genuine examples of his handwriting. He signed it 'Tician depentor', Tician being the Venetian spelling of his name.[13] *Depentor* signified merely that he was qualified to paint by membership of the painters' guild. It wasn't until much later that he signed himself *pittore*, painter.

Titian was back in Venice in time to say goodbye to the convivial Sebastiano Luciani, who sailed away to Rome in August with Agostino Chigi, who had made an enormous fortune for himself and was collecting artists to work on the decorations of his Villa Farnesina.

Banker to the pope and reputedly the richest man in the world – he once told Pope Leo X that he didn't know how much he was worth – Chigi had been in Venice negotiating a loan to the cash-strapped government, which was struggling to raise the funds and armies it was expected to contribute to Pope Julius' Holy League against the French. Also on board were the Venetian state jewels, which the banker took as security, and his young Venetian mistress, Francesca Ordeschi, whom he would marry eight years later. Sebastiano did not reappear in Venice, and then only temporarily, for seventeen years. His departure, which was followed in September by the death of Giorgione, left Titian in a lonely position, without the stimulus of a competitor close to his own age, cut off by the war from his family in Cadore, and from Francesco who in the spring of 1512 joined a squadron commanded by two condottieri[14] as a footsoldier fighting in Vicenza and Verona. Titian had managed to send money home from Padua to a nephew.[15] But communications became more difficult in October when Maximilian's army took control of the Alpine passes, sacked those villages that had been spared by previous campaigns and forced the surrender of the castle of Pieve. In a message to the doge the citizens of Cadore wrote that they hoped to resist and rebuild the castle but were living meanwhile in huts and caves without even the basic necessities.[16]

Venice was crowded with peasants whose farmsteads on the mainland had been destroyed by the warring armies and who flocked into the city in ever greater numbers, wandering around half starved with their animals. The refugees were housed in monasteries deserted by monks who had escaped the hardships of the city in wartime, but the presence of so many needy mouths put a strain on the already severely limited supplies of food. The Aldine Press was closed. Horses capable of pulling artillery had been conscripted. The city was uncannily quiet. The plague, which claimed Giorgione as one of its victims, intensified in the summer and autumn after Titian's return when it coincided with an even more lethal epidemic of fever. Nor, unusually, was it checked by winter. It persisted throughout 1511–12 and then, in a milder form, for two more summers. Titian's first altarpiece, *St*

Mark Enthroned, was commissioned during the plague by the monks of the church of Santo Spirito in Isola. St Mark's head and left shoulder are in shadow. He is accompanied by Sts Cosmas and Damian, the physicians, and Sts Sebastian and Roch, protectors against plague. St Roch, an aristocrat who survived a plague, was most famous for his miraculous ability to cure' other victims. St Sebastian, a Roman soldier, a captain of the praetorian guard who converted many others to Christianity, was associated with the plague because the wounds of the arrows that pierced his body resembled the lumps that were the first symptoms of bubonic plague. He is always shown young and naked, and Titian's marvellous figure is his first male nude. Once again he looked to the example of Sebastiano, this time for the pose of St Mark on his high throne, which is very close to the figure of Solomon in Sebastiano's unfinished *Judgement of Solomon*.

But war and plague were not the only disasters sent by God to punish Venice. Halfway through the previous Lent, when Titian was preparing to leave for Padua, Venice had been shaken by a tremendous earthquake, the first in living memory. Sanudo described the disaster, which hit the city on 26 March 1511, the day after the feast of the Annunciation, which marked the Venetian new year.

> It seemed as though the houses were collapsing, the chimneys swaying, the walls bursting open, the bell-towers bending, objects in high places falling, water boiling, even in the Grand Canal, as though it had been put on fire. They say that, although it was high tide, when the earthquake came some canals dried up as though there had been a tremendous drought. The bells in their towers rang by themselves in many places, especially at St Mark's, a terrifying thing to happen.[17]

The statues that toppled from the façades of San Marco and the doge's palace were read as omens. That *Prudence* was among those that fell was a warning that the rulers of Venice must learn to be wiser than in recent years. It augured well, however, that some stone lilies fell from the roof of the ducal palace, just above the balcony of the Great Council Hall, and smashed in the courtyard: the lily being the heraldic

emblem of the French king, the destruction of the lilies was a sign of God's will that the French 'barbarians' would be driven out of Italy by the pope's Holy League. The statue of St Mark stayed intact, a prediction that Venice would continue to be the preserver of the Catholic faith and defender of the Church. Some fanatical preachers put the blame for hard times on the Jewish war refugees from the terraferma, but what might have developed into a wave of anti-Semitism was immediately stemmed by order of the Council of Ten. Nevertheless, although given some protection, Jews were ordered to leave Venice within a month and meanwhile to stay indoors except for two hours in the morning and two hours in the afternoon.

On the day after the earthquake, the patriarch, addressing the steering committee of the Senate, proclaimed that the catastrophe was God's punishment for the sins of Venice, and the worst of them (as usual) was sodomy. Sodomy had become so rampant that the female whores had sent to him to say they could no longer make a living. He had heard in confessions that fathers were interfering with their daughters, brothers with sisters. He ordered three days of fasting on bread and water with penitential processions morning and evening. The government strengthened the already punitive legislation against homosexuality and blasphemy, passed more stringent laws against sexual relations with nuns and promised to ensure that justice was dispensed more quickly than had become the custom. Crowds processed through the city chanting litanies and imploring God's forgiveness. The churches were full, and many more people than usual went to confession.

Although for most Venetians the outbreak of religious observance was a temporary reaction, the disastrous times had a more profound effect on the thinking of a small group of intellectuals from distinguished patrician families. Their spiritual guide and mentor was Tommaso Giustiniani, who after a mysterious visit to the Holy Land had been seized by an urgent need to atone for his hedonistic youth. His most prominent disciples were Vincenzo Querini who, as Venetian ambassador to Germany before the war, had become aware of the illwill against Venice and warned the doge of its possible

consequences; and Gasparo Contarini, the son of a wealthy merchant who had studied with some of the greatest scholars of his day and was the youngest and later the most famous of these three. They retreated to an austere monastery on Murano for discussion, prayer, meditation and readings of the Bible and classical texts, and became convinced, at a time when Martin Luther was still an obscure theology professor at the University of Wittenberg, of such proto-Lutheran beliefs as the value of preaching and reading the Bible in the vernacular and of the necessity of ridding the Roman Church of worldly abuses. Giustiniani and Querini, who had come to the conclusion that the war was a sign of the futility of life on this earth, rechristened themselves Peter and Paul, and became hermit monks in the monastery of Camaldoli in the wilderness of the Apennines, from which, in 1513, they presented Pope Leo X with proposals for radical reform of the Church.

Contarini wavered. Although deeply troubled by the spiritual condition of the Christian world – 'our age sins badly' he wrote later – he had agonizing doubts about his religious vocation and about the value of retreat and penance. They culminated on the Easter Saturday after the earthquake when he confessed to a sympathetic monk an insight that anticipated Martin Luther's vision in the tower of two years later. Contarini had reached the conclusion that no amount of self-punishment would compensate for his past sins. Justification in the eyes of God was not to be achieved by penance but by deep, abiding love of Christ and gratitude for His suffering and self-sacrifice on behalf of mankind. Having decided to pursue a worldly career, he went on to serve the Venetian government in a number of important posts, notably as ambassador to Charles V during the diplomatically sensitive period in the 1520s when Venice switched its allegiance from France to the emperor. When in 1535 he was unexpectedly made a cardinal by Pope Paul III, the appointment was taken as a sign that the Church intended to institute reforms, and he did play a crucial role as a reforming humanist at the papal court. His famous idealized description of the republican government, *De magistratibus et republica venetorum*, was published posthumously in 1543.

Meanwhile, in the summer of 1511, only a few months after the resolution of his spiritual crisis, we find Contarini taking part in a jousting tournament at Mestre as one of eight nobles dressed in magnificent armour and silken doublets – the prize was a horse worth forty ducats. Venetians, after all, needed to cheer themselves up in those grim times. While modest merchants watered their wine and struggled to put food on their tables, wealthy members of the government suffered far less from the war. Inside information about troop movements on the mainland made it possible to import agricultural produce from their country estates into the city at inflated prices. Venetian estates overseas were undisturbed while the Turks concentrated on consolidating their Islamic dominions in the Levant. Venice had been at peace with the Ottoman Empire since 1503 and in 1513 obtained the renewal of its commercial privileges in the Ottoman territories. So overseas trade continued, albeit at a slower pace. Although most merchants dealt in quantities too small to justify the risk of re-export, the trading galleys of the richest sailed into the harbour of San Marco with cargoes of essential spices large enough to obtain guarantees of safe conduct through the war zones and into the transalpine markets. The rich and privileged, as Sanudo repeatedly informs us, continued to enjoy the luxurious habits that the rest of the population believed were offensive to God.

In the first winter after the defeat at Agnadello all classes had enjoyed an unusually entertaining and riotous carnival. But in 1511 the season was altogether more muted after the Council of Ten, fearing violence or even insurrection from a discontented population, issued a decree in early February that forbade the wearing of masks and other disguises. It was unanimously signed by the Collegio and was followed a few days later by an official warning to all Venetians who continued to offend God by indulging in ostentatious displays of wealth:

> Although we are in great danger, as everyone knows, there are many
> who in disregard of God and of the obligations to Him and in disre-
> gard of the honour and the needs of our republic ... continue to spend

MIRACLES AND DISASTERS

high, unnecessary sums of money. By this they do damage to them-
selves and cause general resentment; they show little love for their
fatherland since many spend this money without having paid their
taxes, which are imposed to preserve this state and to secure the exist-
ence of us all.[18]

The enforcement of sumptuary laws, already the strictest in Europe,
was tightened. Dress should be simple; the wearing of pearls and
expensive fabrics was prohibited. There were specific instructions
about the kinds of foods and numbers of courses to be served at
dinners. And yet it was only days after the restrictions on carnival and
the recent warning against unnecessary expenditure that the high-
ranking and immensely wealthy nobleman Antonio Grimani, who
had made his fortune in commodity dealing, hosted a lavish dinner in
honour of Agostino Chigi. Just twelve years earlier Grimani, who had
been elected naval commander in the Turkish war in return for a loan
to the state of 16,000 ducats, had been arrested for failing to engage a
Turkish fleet off the southern coast of Greece and for not disciplining
his subordinate officers. The case was so sensitive that it took twenty
sessions of the Great Council to reach a verdict of treasonable incom-
petence. Sentenced to exile, Grimani went to live in Rome with his son
Domenico, for whom he had shrewdly purchased a cardinal's hat for
25,000 ducats some years earlier. In 1509, thanks to his vast wealth and
useful papal connections, his reputation was restored by an over-
whelming vote in the Great Council. He returned to Venice where he
was made a procurator of San Marco, and in 1521 at the age of eighty-
seven the former incompetent traitor Antonio Grimani was elected
seventeenth doge of Venice. Domenico, who had amassed one of the
most important collections of ancient Greek and Hellenic sculptures,
gave part of it to Venice on Antonio's death, possibly as a gesture of
gratitude for his father's return to power. The pieces were housed in
the doge's palace where they could be studied by Venetian artists, not
least Titian. Some are still in the Venice Archaeological Museum.

Antonio Grimani's dinner for Agostino Chigi was attended by
fashionably dressed ladies dripping in jewels and by some of the

111

highest-ranking members of the Republican government, several of them bankers, who were served numerous lavish courses of the finest forbidden delicacies. We can imagine how the younger male guests might have dressed from Titian's early portraits of fashionable young men. Not only is the shirt worn by the *Man with a Quilted Sleeve* (London, National Gallery) gathered in what was thought of as the French way, his sleeves defy an order by the Senate issued in 1512 which explicitly forbade the wearing of *ziponi* made of expensive quilted materials.[19]

In another time and place the Grimani dinner might have been enough to spark a revolution. The majority of ordinary Venetians certainly agreed with the official government line that the behaviour of a minority who ignored the proscriptions against feasting and fine clothes had brought disaster upon their city. There was widespread resentment that some of the wealthiest and most influential members of the ruling class avoided military service and the payment of taxes and forced loans, and that some used their money to buy offices for themselves and their sons. But if the government feared insurrection, it never happened. When in August 1511 Maximilian broadcast a message from Innsbruck to the Venetian *popolani*, inviting them to rise up against the 'insatiable cupidity and avarice of the so-called gentlemen and rulers' and to bear in mind that, 'should you not be liberated, their pride and conceit will be such that you and your fortunes will soon be utterly destroyed and ruined by them',[20] his appeal was ignored.

Although we know very little about Titian's private commissions at this time, it is a safe assumption that his Venetian patrons were among the small elite who were in a position to indulge themselves during a war that impoverished the majority of Venetians, threatened the very existence of the Republic as an imperial power and saw some of the bloodiest military encounters that had so far been fought. The development of artillery after Charles VIII's invasion of 1494 meant unprecedented casualties in battles, and some were on a scale no less shocking at the time than the slaughters in the world war of 1914–18

still seem to us. In February 1512 a five-day siege of Brescia, the Venetian gun-manufacturing town, by French and German armies left 15,000 corpses. In a battle fought at Ravenna a few months later on Easter Day between Spain and the pope on one side and France allied with Ferrara on the other, so many were killed that the following day the corpses lay thick on the ground so that for miles it was said to be impossible to walk without treading on them. Closer to home Venetian soldiers whose pay was delayed were forced to live off the land, where they looted the smallholdings of peasants. 'All the soldiers', wrote Sanudo, 'act in their habitual way, dressing up in cloth of gold, and if they are not paid in time by the government, they do so much harm among the villages that they come out very well from it and rejoice, wanting the war to drag on as it does.'

Titian's paintings of sexy girls, well-dressed young men and Madonnas and saints dressed as though for banquets, conducting their sacred conversations in an unspoiled Veneto, give no hint, apart from the odd soldier resting in the background, that Venice at the time he painted them was at war. His terraferma – which was in reality devastated by warring armies, its farmhouses, fields and vineyards plundered by unpaid Venetian mercenaries as well as by enemy troops – remains a fertile Arcadia into which his patrons could imagine themselves escaping on a fine morning to make love in the open air or pray to the Virgin, her Child and the adoring saints for the return of peace and prosperity. Italian artists, unlike their German counterparts, rarely portrayed the realities of war, and Titian was no exception. 'Painting', Dolce wrote several decades later, 'was invented primarily in order to give pleasure; by this token, then, if the artist fails to please, he remains unnoticed and devoid of reputation.' If Titian's wealthy patrons needed an excuse for taking pleasure in his paintings they could always invoke the Neoplatonic theory that the contemplation of beauty, recently given a heterosexual slant by Pietro Bembo, was a first step towards higher wisdom. Beauty was in itself a sign of virtue; and female beauty, which was rare and fleeting at a time of disfiguring illnesses and of primitive medicine, dentistry and cosmetics, was its ultimate expression. The cult of beauty put women

on pedestals next to saints and as allegorical representatives of Venetian civic virtues.

Titian's religious paintings are realized in the same pastoral setting, the sacred figures sometimes taken from the same models, as the secular subjects. The *Noli me tangere* (London, National Gallery) and the *Baptism of Christ* (Rome, Pinacoteca Capitolina), both painted just before or after the Padua frescos, are too small to have been intended for church altars, where the pastoral landscapes, which could suggest pagan revelries, would not have been acceptable. For the highly erotic *Three Ages of Man* (Edinburgh, National Gallery of Scotland), which is about the same scale and date, he used the same model for the shepherd as for the Baptist in the *Baptism of Christ* and the same model for the blonde girl who is in the act of initiating passionate sex with her naked shepherd for the St Catherine in the *Virgin and Child with St Catherine, St Dominic and a Donor* (Mamiano, Parma, Fondazione Magnani Rocca). This is one of the most gorgeous sacred conversations ever painted, the reds, blues, mauves and whites worn by the lovely dark-haired Virgin and glamorous St Catherine glow against their dark-curtained enclosure while the black and white robes of St Dominic and the donor to whom he introduces the splendid vision are silhouetted against the peacefully receding landscape. If we didn't know the Christian story we might imagine that the men had come upon a harem. Such paintings would have been commissioned by private patrons who were steeped in the pastoral stories of Jacopo Sannazaro and his imitators and who were perhaps sophisticated enough to enjoy the teasing play of an Arcadian landscape as it could have been in the golden age of pagan revelry with the golden age in which Christ was born.[21]

Nevertheless, although Titian has sometimes been accused of shallow religious beliefs, at least in his early life, no artist of little faith could have painted the intensely moving *Entombment of Christ* (Paris, Louvre),[22] a painting that glimmers with what has been aptly described as a 'mysterious weirdness',[23] in which Giorgionesque dreaminess gives way to the tumultuous emotion of each mourner as the slack but perfect body of Christ, already cast in shadow, is lowered into the

tomb. This intensely moving study in grief has been unjustly neglected, possibly because until recently it hung next to the *Mona Lisa* and was difficult to see through the crowds determined to focus their attention on the most famous painting in the world.[24] The patron is unknown, but if, as has been suggested,[25] Titian portrayed himself as the young bearded mourner who supports Christ's legs[26] it is not unreasonable to speculate that he identified with this sacred subject, one to which he would return later in life.

At around the same time Titian was working on these paintings he was also designing one of the most astonishing of all visual celebrations of the Christian faith. It is not a painting but a woodcut illustrating the *Triumph of Christ*;[27] and like all of Titian's woodcuts he drew it directly on the blocks in collaboration with the master cutter. Although the sources differ about exactly when Titian began the composition, the first multiple impressions were sold in 1517, at the end of a war in which the forces of evil had tried and failed to destroy God's chosen city. The main inscription describes the Saints singing of how Christ has triumphed over death and is leading all to peace through the gates of heaven. The 'infinity of figures', as described by Vasari, are taken from the Old Testament and the Gospels: 'the first parents, the patriarchs, the prophets, the sibyls, the innocents, the martyrs, the apostles, and Jesus Christ on the triumphal car, drawn by the four evangelists and the four doctors, with the holy confessors behind …'. The woodcut, which is made from ten blocks, incorporates motifs borrowed from several other artists: Mantegna, Michelangelo, Raphael. Titian probably intended it as an answer to Jacopo de' Barbari's three-block *Triumph of Man over Satyrs* and to rival Dürer's woodcut-in-progress of the *Triumph of Maximilian*, begun in 1512. The subject may refer to Savonarola's famous treatise, *The Triumph of the Cross*, published in Florence in 1497, the year before his execution. If so it conveys a different message. Savonarola describes Christ wearing a crown of thorns, holding the Bible in His right hand and in His left the cross and instruments of His Passion. In Titian's image Christ carries only a sceptre, the sign of the worldly domination of His Church, as He

returns in triumph from a victorious campaign against the forces of evil.

The *Triumph of Christ* was commissioned by an entrepreneurial publisher, Gregorio de' Gregoriis. Although it is the only masterpiece de' Gregoriis ever published, he did not mention Titian's name in his application for copyright. Perhaps he banked on the subject more than the artist to appeal to an international market large enough to bring a return on his considerable investment. All woodcuts were expensive to produce, Titian's *Triumph of Christ* was unusually elaborate, and since he had not yet established an international reputation de' Gregoriis doubtless decided that his name would not encourage buyers. De' Gregoriis, in any case, cannot have anticipated the huge success of the woodcut. Although the impressions can't have been cheap to buy, Titian's image of the triumphant Saviour restoring order to the Christian world was an international bestseller, hung or pasted on the walls of domestic households throughout Christendom by people who had never heard of Titian and who would never see his paintings. Later in the century motifs from it were used for a stained-glass window in Burgundy.[28] It was copied in a painting in the cathedral of Prague, and became so popular that six separate woodcut versions of it were produced in the decades that saw Titian's fame as the greatest colourist in Europe soar above his genius for designing complex images in black and white.

'Some Little Bit of Fame'

Since childhood, Most Serene Prince and Most Excellent Lords, I
TICIAN, your servant from Cadore, have devoted myself to
learning the art of painting, not so much from the desire for profit
as to acquire some little bit of fame, and to be counted among
those who at the present time practise this art as a profession.

PETITION BY TITIAN TO THE COUNCIL OF TEN,

MAY 1513

Titian in his mid-twenties was not yet internationally famous, but he
was the best-known young painter in Venice. His frescos on the
German exchange house were one of the talking points of the city;
and his only rival as the painter of choice for wealthy clients was the
aged Giovanni Bellini. Some of his keenest admirers were members
of the ruling nobility, not least Pietro Bembo and Andrea Navagero,
prominent intellectuals and connoisseurs of modern art. In the spring
of 1513 Bembo invited Titian to join him in Rome, where he had been
appointed secretary to Pope Leo X, the second son of Lorenzo de'
Medici, who had been elected to the papacy on 4 March following the
sudden death from fever of Julius II. Titian had been in touch with the
Bembo family since his days in Giovanni Bellini's studio and later in
Padua. The exhilarating although now damaged and overpainted
Tobias and the Angel Raphael (Venice, Accademia)[1] bears the Bembo
coat of arms prominently displayed next to the little dog – the first of
Titian's delightful portraits of animals.[2] The apocryphal story of

Tobias' journey in search of a cure for his father's blindness was a popular subject in Renaissance mercantile communities, but more so in fifteenth-century Florence than in Venice. The main figure is always the archangel Raphael, the guide and guardian of Tobias, who is his identifying attribute. Bernardo Bembo, who served as Venetian ambassador in Florence, and his son Pietro, who had been educated there, might well have appreciated the Tuscan theme and style of the painting. Vasari said that Bembo had sat for Titian before the invitation to Rome, but his only surviving portrait by Titian is the much later one of 1539 (Washington, DC, National Gallery of Art), when he was nearly seventy, wearing the scarlet cape and hat of a cardinal, a position to which he had been elevated by Pope Paul III.[3]

As a young man Bembo had hoped to follow the example of his father by serving the Republic as an ambassador. But five attempts to obtain an ambassadorship were voted down in government, each time by a large majority. He was considered too young for a responsible position in government; and he spent too much time away from Venice gallivanting in the princely courts of Italy where he had numerous affairs, some no doubt platonic. He pursued Maria Savorgnan, the love of his life, to Ferrara, where he also fell in love with Lucrezia Borgia, the beautiful daughter of Pope Alexander VI, who had recently married Alfonso d'Este, the future Duke of Ferrara. In 1506, after the publication of *Gli Asolani*, which he dedicated to Lucrezia Borgia, Bembo decided to devote more time to his writing while pursuing a career in the Church, which he hoped would make fewer demands on his time than a career in politics. He spent seven years at the splendid court of the Duke of Urbino. Called to Rome by Leo X he secured a living as a cleric after taking the vow of chastity, and then produced three children by his Roman mistress, Morosina, the younger sister of a courtesan serving the Vatican.

His libidinous behaviour as a young man would not have bothered the ebulliently hedonistic Leo, to whom a Venetian ambassador in Rome later attributed the famous remark: 'Since God has given us the papacy, let us enjoy it.' Best known to posterity as the pope whose sale of indulgences to fund the rebuilding of St Peter's caused Martin

Luther to publish his Ninety-Five Theses and thus precipitated the Reformation, Leo made Bembo his secretary because he enjoyed the company of literary men. But when he renewed the alliance with Maximilian against the Republic Bembo found himself technically in the service of an enemy of his country. The association with Leo would not have been regarded as exactly traitorous in that age of continually shifting alliances. But it was a card for Titian to keep up his sleeve.

As Dolce tells the story, the great lyrical poet Andrea Navagero, who understood Titian's painting 'just as if it were poetry, and particularly Latin poetry, which was such a great forte of his', tried to dissuade him from accepting Bembo's invitation because he feared that 'Venice, in losing him, would be despoiled of one of its greatest adornments'. Navagero, who was a master of Latin rhetoric as well as poetry, is less read today than Bembo, who made his name writing in a Tuscan Italian that is still accessible. But at the time, although thirteen years younger than Bembo, Navagero commanded at least as much respect in intellectual and artistic circles, and more as a reliable member of the Venetian government.

Titian must have been tempted to pay at least a short visit to Rome, the city that under Julius II had replaced Florence as the leading artistic centre of Italy. Michelangelo, Raphael and Leonardo da Vinci, the creators of the Italian High Renaissance, were only the starring geniuses among scores of talented artists attracted to the papal court from elsewhere in Italy. Michelangelo had only just finished the Sistine Chapel ceiling. The young prodigy Raphael was completing the decorations of the first of the papal apartments, the Stanze della Segnatura, with a team of assistants that included the wandering Venetian painter Lorenzo Lotto. Leonardo arrived later in 1513 to work for Giuliano de' Medici, the pope's brother and captain general of his militia, and spent most of the next three years living in the Belvedere, the pope's summer residence, while bickering with Leo, who complained not without reason that Leonardo never finished anything. Rome, then, was the place to be: to meet and learn from the greatest living artists; and to study and draw the ancient buildings and the antique relief

carvings and sculptures that were causing sensations as they were discovered beneath the ground of the Holy City and that were considered an essential part of a young artist's formative education.

The single most exciting archaeological discovery in the entire Renaissance of classical art and literature was the late Hellenistic sculpture of a group of writhing figures unearthed in a Roman vineyard in 1506, when the subject was purportedly identified by Michelangelo as the unfortunate Trojan priest Laocoön and his sons wrestling with snakes. According to the story as told by Virgil in the *Aeneid* Laocoön was punished by the Roman goddess Minerva for warning the Trojans that the wooden horse the Greeks had brought into their city was a trick. The sculpture group had been praised by Pliny as one of the greatest of all antique sculptures, and for the rest of the sixteenth century and into the next writers, sculptors and painters vied with one another to find ways of evoking the dynamism, and the sexual connotations, of the writhing, twisting figures.

Although it was later said that Titian would have been an even greater painter had he seen the antiquities in Rome as a young artist, he demonstrated that he could work just as well from sketches and models. Long before he finally saw the originals many years later, he incorporated in his pictures references to the *Laocoön* and other antique sculptures, as well as figures from paintings by central Italian artists that he knew only from sketches or cartoons. In Rome, furthermore, Titian would have been one of many, while in Venice he was in a unique position. Giorgione was dead, Sebastiano was in Rome, Giovanni Bellini was very old, and Cima da Conegliano and Carpaccio had failed to keep pace with the modern manner. Titian had a clear field and good connections in high places. He could paint more or less at his own pace free from the pressures to meet deadlines and to paint banners and theatrical sets at the whim of a prince, and free from the personality clashes that complicated the lives of artists at the papal court. Even Raphael, the very paradigm of a courtly artist, had been known to complain that he had sacrificed his freedom by attending the court of Julius II.[4] Titian in any case never liked to be too far away from Cadore, or from Francesco.

Despite the hard times, there were still private patrons in Venice who could afford to buy or commission paintings. And the Venetian government needed painters to complete the cycle of canvases for the Great Council Hall[5] depicting that fundamental self-glorifying Venetian legend according to which a Venetian doge in 1177 had made peace between the two top rulers of the world, Pope Alexander III and Emperor Frederick Barbarossa, and was rewarded by the pope with a series of gifts symbolizing Venice's role as peacekeeper and that of the doge as the equal in power and status of both pope and emperor. The story was of course especially appropriate at a time when Venice was at war against a modern pope and emperor.

On 31 May 1513 when, following the treaty of alliance with France negotiated at Blois two months earlier, the government was in a more optimistic frame of mind than it had been since the beginning of the war, a petition was read out to the Council of Ten on Titian's behalf. Although he may have had help in phrasing it, perhaps from Navagero or another of his literary friends in high places, and the record of the petition is not in his hand, it is precious as the first document that reveals Titian's confidence in his own powers and his skill in manipulating powerful patrons.

Since childhood, Most Serene Prince and Most Excellent Lords, I TICIAN, your servant from Cadore, have devoted myself to learning the art of painting, not so much from the desire for profit as to acquire some little bit of fame, and to be counted among those who at the present time practise this art as a profession. And even though I have been insistently requested, previously and even now, both by His Holiness the Pope and by other lords to go and serve them: nevertheless, as Your Sublimity's most faithful subject, and desiring to leave some memorial in this illustrious city, I have resolved, if it seems feasible, to paint in the Great Council Hall and to put into that task all my intellect and spirit for as long as I live, beginning, if it please Your Sublimity, with the canvas of the battle for the side facing the Piazza which is the most difficult and which no man until now has had the courage to attempt.

Titian then turned to the terms he hoped to be granted:

I, Most Excellent Lords, will be content to receive in compensation for the work I will do whatever payment is judged proper and much less. But because, as I have said above, I value nothing more than my own honour, and wish only to have enough on which to live, may it please Your Sublimity to award me for my lifetime the first *sanseria* [brokerage] in the Fondaco dei Tedeschi that becomes vacant, irrespective of other requests, and on the same terms, conditions, obligations and exemptions as Mr Giovanni Bellini, that is: two young men whom I wish to keep with me as assistants to be paid by the Salt Office, together with the colours and other necessities, as in the past months were awarded by the above mentioned Illustrious Council to Mr Giovanni. In return for which I promise your Most Excellent Lords to make this work, and with such speed and excellence that you will be very happy with it. To whom I beg to be humbly recommended.

It was a bold proposal. Not only would Titian be the youngest artist ever to paint in the ducal palace, he was requesting the same terms as the venerable Giovanni Bellini, including the *sanseria*, an honorary brokerage in the Fondaco worth an annual tax-free income of something in excess of 100 ducats. It was customary, but not a contractual obligation, that an artist receiving the brokerage would also contribute to the cycle of paired portraits of doges that since the ninth century had been placed in a frieze that ran above the main cycle of history paintings.[6] The holders of *sanserie*, of whom there were only thirty at any one time, were in effect tax farmers. They paid an agent to collect money from the German merchants on behalf of the government and in return were allowed to keep a certain proportion of the funds. Although both Bellini brothers had enjoyed these lucrative brokerages, Alvise Vivarini, who had joined them as an assistant in 1488, had asked to be paid in cash for each completed picture, while Carpaccio, Giovanni Bellini's assistant and some twenty-five years older than Titian, had only a *spettativa*, an indication that he would receive the next available brokerage. Titian's request is all the more striking

considering that the Bellini brothers and Carpaccio were members of the *cittadini* caste while he was an outsider from a deeply provincial background. Nevertheless, he, Titian of Cadore and proud of his origins, intended to demonstrate his patriotism by serving Venice rather than the pope and other foreign lords who were *insistently* requesting him to paint for them. The scene he proposed to paint was the Battle of Spoleto, an episode in the Alexandrine legend in which Spoleto was destroyed by Barbarossa for its loyalty to the pope, who had previously taken refuge in Venice. Although Titian didn't say as much, the subject of a battle would give him the opportunity to compete with Michelangelo and Leonardo, both of whom had begun, but never finished, battle scenes for the Great Council Hall of Florence. The painting required courage because it would be hung high up on the south wall between windows facing the lagoon and thus would have to be seen against dazzling light flooding into the Hall.

Although there is little doubt that Titian believed he could meet the challenge, his promise to complete the battle scene speedily was perhaps disingenuous. He was probably aware that the brokerage he was requesting was usually paid for as long as an artist could convince the Council of Ten that he was working on canvases for the palace. This forgiving approach encouraged procrastination and if cleverly negotiated could amount to a sinecure for life. The government had shown no sign that it was in any great hurry to complete the redecoration programme of the Great Council Hall, which was intended more for propaganda purposes than for the pleasure of the noisy throng of mostly philistine patricians who assembled there on Sunday afternoons. The Hall, which had been built in 1340, was cold and draughty in winter, and a heat trap in summer. The higher elected officials and their secretaries spent most of their time in the more comfortable surroundings of their offices and smaller council chambers. Thus the campaign to replace with canvases the ruined medieval frescos of episodes from the Alexandrine legend had been progressing slowly despite the occasional efforts of the Council of Ten to move things along. In the early 1490s Sanudo had boasted that the ceiling of the Great Council Hall was 'all done in gold, which cost more than 10,000

ducats'.[7] By 1494, however, the programme of replacing the medieval frescos with canvases by modern artists was so far behind schedule that the Umbrian painter Perugino, who was then most famous for his frescos in the Sistine Chapel, was offered 400 ducats to paint the Battle of Spoleto. He had refused, and that was the scene that Titian now proposed to provide in return for a studio of his own, two assistants, colours and the first available brokerage.

The Council of Ten voted, by ten to six, to accept Titian's proposal. Eight days later a further resolution ordered the Salt Office to pay his two assistants four ducats a month but not until they had started work on the battle scene. On 1 September 1513 Titian employed Luca Antonio Buxei and Lodovico de Zuane, who had previously worked on paintings for the Council Hall, and moved his practice into a set of spacious warehouses on the premises of the unfinished Ca' del Duca – the palace so called because it had once belonged to Francesco Sforza, Duke of Milan – where the government gave working spaces to artists employed by the state.[8] (It is the building with the heavily rusticated base at the bend of the Grand Canal opposite the Accademia Gallery.) But then, just as he was settling into the new studio, the Republic suffered the most catastrophic reversal of the entire war. On 6 June a French army that was supposed to come to its aid was defeated at Novara by Swiss mercenaries in the service of Massimiliano Sforza, who governed Milan under Swiss protection provided by the emperor. Sforza allowed free passage to Spanish and imperial troops, who laid siege to Treviso and Padua, penning in the inadequate Venetian army. With Louis XII suffering from what seems to have been premature senility the French alliance was all but useless. Venice was alone. In July the normally reticent Doge Loredan addressed the Great Council, beginning his speech with the familiar threnody about the arrogance and sinful habits of the patricians as the cause of disasters and defeats. He threatened to dismiss from office those patricians who were delinquent in the payment of their taxes, and appealed to them to join the army in defence of Padua and Treviso.

By September a Spanish army had reached the edge of the lagoon and aimed their cannon at the Virgin City, which was saved from

bombardment only by the four kilometres of shallow water that put it beyond the reach of contemporary firepower. Once again, as in 1509, Venetians saw their mainland towns, villages and farms in flames. On 26 September Sanudo climbed to the top of the bell tower of San Marco to survey the devastation.

> I saw the terrible destruction wrought by the enemies, who, if they had been Turks, could not have done worse ... and everywhere one saw enormous fires that were billowing smoke, so that at the twenty-third hour the sun was as red as blood from the smoke of so many fires ... It has been heard around town that the enemy front has crossed the Brenta, burning everything as they go, and that tonight they will burn Mestre and the villages and dwellings and whatever they find ...

Yet another sign that God had withdrawn His protection from His once chosen city came on a freezing night in January when an oil lamp overturned in a canvas depot at the Rialto. The flames were spread across the Rialto by a high wind, and by the time the firefighters had arrived shops, warehouses, banks, merchants' lodgings and thousands of ducats' worth of merchandise had been destroyed. Sanudo devoted ten double-columned pages of the printed edition of his diary to a vivid eyewitness account of the catastrophe, which he compared to the Fall of Troy and the recent sack of Padua. The work of putting out the fire was impeded by the throngs of Venetians trying to rescue what they could and by looters, some but not all of them foreigners. The wind did not die down until morning, when the doge sent his senior officials to bring order. Among the crowds who assembled to watch the spectacle Sanudo saw many foreigners, including 'our rebel Paduans ... and in my heart I believe that it gave them great joy to see our ruination'. It was, however, a good omen that the little church of San Giacomo al Rialto, the oldest Christian foundation in Venice, was miraculously saved despite its proximity to the source of the fire.

On 20 March 1514 the Council of Ten took the decision to revoke the terms of Titian's petition. He would have to wait his turn for a

vacant *sanseria* like everyone else, and to save the state money they cancelled the salaries of his two assistants. Titian wisely bided his time. It might have seemed small-minded and unpatriotic to contest the decision when the state finances were overstretched by rebuilding the Rialto as well as by the soaring expense of the war. He waited until 28 November that year to present a revised petition to the Council of Ten in which he accepted that he would have to wait for his *sanseria* until the death of Giovanni Bellini unless one became available earlier. Meanwhile, he hoped that the Salt Office would resume paying for his assistants' salaries and for his colours. He claimed that he had begun work on the battle scene, which would have been well in hand had it not been for the 'skill and cunning of some who do not want to see me as their rival'. He added that without the promised expenses he would die of hunger. Although he did not name his enemies he must have been referring to Carpaccio,[9] who was now in his fifties and out of fashion although ahead of Titian in the queue for the next vacant brokerage. (Carpaccio lived into the 1520s but never worked in the palace again.) The next day the Council of Ten agreed to the revised terms, this time by the narrow margin of seven to six votes, and ordered the Salt Office to pay the assistants, to provide Titian with pigments as required and to repair his workshop in the Ca' del Duca, which was letting in the rain and might damage his preparatory sketches for the battle scene, thus delaying its completion.

Another year passed. The government, desperate to economize wherever possible, filled loopholes in the taxation system, tightened the supervision of accounting methods and appointed special committees to eliminate all unnecessary expenditure. At the end of December 1515 an official from the Salt Office was given the task of auditing the accounts relating to the canvases for the Great Council Hall. He reported that as much money had been spent on them as would have completed the redecoration of the entire palace. Two canvases, for which there were only preliminary sketches, had cost more than 700 ducats, while there were masters willing to paint one canvas for 250

ducats. All the artists working in the Hall were immediately dismissed so that the terms of their employment could be renegotiated.

The new conditions suited Titian very well. Although he may or may not have been one of the artists who had offered to paint a canvas for 250 ducats, his nose for business told him that he could do better. On 8 January 1516 a new proposal from Titian, this one addressed directly to the doge, was read out at a meeting of the Collegio. He had been working on the battle scene for two years. It was the most difficult situation in the entire room, but he would finish it for 400 ducats, half the amount, so he claimed, that Perugino had refused. The Collegio, whose members were presumably aware that Perugino had been offered 400 ducats, not 800, voted to give Titian 300 on completion of the painting, as well as his colours and the monthly four-ducat salary for one assistant while he worked on it.

He was allowed to keep the government studio in the Ca' del Duca, and it was here that he painted the succession of masterpieces that would make him rich enough by 1531 to buy a studio and house of his own. In the absence of detailed contemporary descriptions or inventories of Titian's working environment we can only deduce from such scraps of information as we have, and from descriptions of other artists' workshops, what his studio might have been like. Giovanni Paolo Lomazzo,[10] a Milanese painter who turned to writing after losing his sight, said that Titian kept models of wood, plaster, terracotta and wax, as well as sketches of contemporary and antique works. Among them, we can be sure, were sketches and perhaps small models of the *Laocoön*. And then there were the luscious girls, naked or *en négligée*, whom, according to a report written in the early 1520s by the Ferrarese ambassador in Venice, 'he often paints in different poses and who arouse his desires, which he then satisfies more than his limited strength permits; but he denies it'.[11]

The meticulous account books kept by Titian's contemporary Lorenzo Lotto from 1538 are the most informative source we have for the contents and atmosphere of a Venetian painter's studio. Lotto, like Titian and indeed all sixteenth-century painters, worked from wooden lay figures, plaster and wax models of relief carvings, cameos and

engravings, as well as from live models. He paid his models, usually poor people (he provided a bath for at least one girl), eight soldi for religious subjects, sometimes less to prostitutes who posed in the nude, although on one occasion he paid twelve soldi 'for undressing a woman only to look'. His studio was equipped with powdered lapis lazuli (which he distilled himself), other colours, varnishes, oils, wax, glues, lacquers, mastic, turpentine, pitch and a stone mortar and pestle for grinding pigments.

The atmosphere in Titian's studio must have been something like the back-stage of a theatre, full of props and costumes and models in various states of undress practising their poses. Unfortunately for us, however, sixteenth-century writers on art thought it inappropriate to describe the physical act of painting. Leonardo, in his campaign to promote painting as a more gentlemanly art than sculpture, described the painter who sits 'in great comfort before his work, well dressed, and wields his light brush loaded with lovely colours. He can be dressed as well as he pleases, and his house can be clean and filled with beautiful paintings. He often works to the accompaniment of music, or listening to the reading of many fine works.' Sculpture, by contrast, was an exhausting labour during which the artist is covered with dust and sweat, 'so that he looks more like a baker'. Even Titian's best friend Pietro Aretino, who knew very well how Titian worked, refrained from mentioning his messy habit of using his fingers. It was not until the seventeenth century that Marco Boschini[12] recognized Titian's intensely physical way of painting as evidence of his creativity when he attributed to him the observation that a timid artist who is afraid to experiment with mixing his colours in case he makes a mess will end up soiling his clothes, with nothing to show for his efforts. But even in the nineteenth century, when Christina Rossetti dreamed up a Pre-Raphaelite atelier for Titian in her short story 'Titian's Studio',[13] the reality of the messy work involved in producing a painted work of art – the noise of assistants grinding pigments, the smell of oils, the paint-spattered clothes – was considered unacceptable.

Titian ran his workshop in the Venetian tradition, as a business. He was not as patient or generous a teacher as Giovanni Bellini, and kept

his shop relatively small. The only early assistants for whom we have names are Luca Antonio Buxei and Lodovico de Zuane. But it is likely that Domenico Campagnola, who had worked alongside Titian in Padua, also joined the studio for a while, until Titian discovered that Campagnola was forging what he passed off as preliminary drawings for Titian's woodcuts by drawing on lightly printed counterproofs.[14] Like all painters of the time, Titian used his assistants to do the preliminary preparations of his supports. It was not long, however, before he required them to collaborate with him on making copies, variants or paraphrases of what he considered to be his most marketable paintings destined for clients whom he knew would not object to the participation of his workshop, especially if a patron of high rank had commissioned the original. The earliest examples of this practice, which would later, with increasing fame, become an essential way of meeting the demand for his work, are the multiple versions of the *Young Woman with a Mirror* (two painted around 1513–15 are in the Munich Alte Pinakothek and the Paris Louvre).[15]

The most reassuring and trusted presence was that of his brother Francesco, the better part of himself and the only rival he feared, or so he apparently liked to say.[16] Towards the end of the Cambrai war Francesco was wounded fighting bravely in hand-to-hand combat near Vicenza, but he recovered and returned to Venice in 1517. In the coming years he would divide his time between Venice, where we can assume he shared the studio with Titian and helped with its management, and the family home in Cadore, where he occupied increasingly important offices in the communal government while working in partnership with Titian on the expansion of the timber business and on investments in landed property. Of all the Vecellio clan of minor painters he was the most prolific, and continued painting at least until 1550, occasionally with what looks like some improving help from Titian, as an independent artist specializing in altarpieces which were extremely popular on the provincial mainland. Examples of his work can be seen in churches around Cadore, Belluno and Vittorio Veneto, as well as in the Venetian church of San Salvatore, the Berlin Staatliche Museen and the Texas Museum of Fine Arts in Houston. His style, at

least compared to that of his brother, seems clumsy, retardataire and wholly lacking in originality or dynamism, which did not prevent Titian from calling on him for assistance from time to time.

Girolamo Dente, who entered the studio as an apprentice in the early 1520s, was to be the most faithful and the longest-lasting of Titian's *garzoni*, so much so that he became almost one of the family and was often known as Girolamo da Tiziano. Like Francesco, he fulfilled commissions on the mainland as an autonomous painter, helped by his close association with the master. A story (for which there is no evidence) has it that the more ambitious and talented young Paris Bordone also worked for Titian. Not only did Titian refuse to teach him, he snatched from the hapless Bordone the commission for a Madonna and Saints from the monks of the Frari for the high altar of their Oratory of San Nicolò ai Frari. Bordone stalked out of the studio but remained, according to Vasari, 'the one who more than all the others imitated Titian'. The Madonna and Saints remained in Titian's studio until the early 1530s when, probably in collaboration with Francesco, Titian overpainted it with the different version, the *Madonna in Glory with Six Saints* (Vatican City, Pinacoteca Vaticana).[17]

It seems that The Battle of Spoleto, the canvas he was supposed to be painting in return for his government studio, had gone stale on him. It was to be in a difficult position, as he had occasion to point out more than once, and medieval history paintings were not his forte. The more he thought about it the more his imagination was fired by a different battle, the Old Testament battle in which the Israelites are saved by God from Pharaoh's army. Titian had already proved himself a master designer of woodcuts with the *Triumph of Christ*, and the *Submersion of Pharaoh's Army in the Red Sea*, to which he now turned his attention, is arguably the greatest and most dramatic woodcut ever made[18] and is certainly one of the greatest of all depictions of war. It measures 1,225 mm by 2,215 made from twelve blocks, a scale never before or after attempted for a Venetian figurative woodcut. Although there is no proof that Titian intended this heroic image as an allegory of the war that was threatening the Republic of Venice with extinction,

the relevance at that time of the story of the salvation of God's chosen people and the destruction of their enemies might have seemed especially moving. Titian chose the episode from Exodus chapter 14 when Moses, having parted the waters to allow the retreating Israelites to escape from the Egyptian army, is instructed by the Lord to stretch out his hand over the sea, 'that the waters may come again upon the Egyptians, upon their chariots, and upon their horsemen … And the waters returned, and covered the chariots, and the horsemen, *and* all the host of Pharaoh that came into the sea after them; there remained not so much as one of them.'

It may have been a coincidence but was nonetheless appropriate that the *Submersion of Pharaoh's Army in the Red Sea* was completed by February 1515.[19] On 1 January the Venetian alliance with France had been given new life when the vigorous twenty-one-year-old Francis I succeeded Louis XII on the French throne. Francis declared himself duke of Milan, and in August crossed the Alps with the largest army ever assembled up to that time. In September, at Marignano (now Melegnano), sixteen kilometres south-east of Milan, the French army with some assistance from Venetians won a resounding victory against the combined forces of the pope, imperial Spain and the Swiss mercenaries who occupied Milan on behalf of the emperor. It was the final battle of the war of Cambrai. With all the remaining enemies who had determined 'to extinguish, like a great fire, the insatiable rapacity of the Venetians and their thirst for power' routed, it was left to diplomats to settle the terms of a peace, which two years later restored the greater part of the Venetian terraferma to the protection of the lion of St Mark.

While Venice celebrated what it saw as its victory, Erasmus of Rotterdam, in a letter written in 1517, rejoiced in the peace from a loftier international perspective. He foretold 'the approach of a new golden age, so clearly do we see the minds of princes, as if changed by inspiration, devoting all their energies to the pursuit of peace'. He gave most of the credit to Francis, King of France:

There is nothing this king does not do or does not suffer in his desire to avert war and consolidate peace; submitting, of his own accord, to conditions which might be deemed unfair, if he preferred to have regard to his own greatness and dignity rather than to the general advantage of the world; and exhibiting in this, as in everything else, a magnanimous and truly royal character.

He also praised the leaders of the other states that had formed the league of aggression against Venice nine years earlier, giving special mention to 'Maximilian Caesar, whose old age, weary of so many wars, has determined to seek rest in the employments of peace, a resolution more becoming to his own years, while it is fortunate for the Christian world'. Erasmus did not in this letter mention Venice as one of the peacemakers. Nor did he foresee that one of the 'pious princes', Francis I, and the grandson of Maximilian Caesar would be once again at war within a few years and that their long fight for dominance in northern Italy would delay the harmonious international relations that he had so earnestly anticipated.

'His Industrious Brush':
Pentimenti and Portraits

Confronted by a rival, whose name may be Pordenone or
Michelangelo, Titian responds by engorging him. He appropriates
his opponent's style, or some part of it, which remains, for a
brief moment, undigested within his own ... The result is not, as
with Hogarth or Renoir, disappointing: it is harrowing and
short-lived. Titian works through the challenge, and his style
reasserts itself.

RICHARD WOLLHEIM, *PAINTING AS ART*, 1987

When Titian was in his sixties he told a doctor that there were some
days when he couldn't paint at all and others when he could do and
think of nothing else. Although his style changed radically in old age,
his working habits were formed early in his career. When he was
stimulated by competition or by the threat of losing a commission or
by painting in fresco, he could work fast. But while the biographers of
artists across different times and civilizations have told stories about
wizardly speed of execution, as though the artists' hands were directed
by some supernatural force,[1] Titian was known for his slowness and
the procrastinations that stretched the patience of his patrons. He
liked to work concurrently in different styles on paintings of different
genres, stacking pictures that failed to satisfy him against a wall, leav-
ing them unfinished or returning to them months, years or in some
cases decades later. With growing success came the habit of taking on
more tasks than he could realistically finish to a deadline. And he was

capable of producing indifferent work on an off day or if the fee wasn't high enough to merit his full attention: there are dull paintings – some come on the market or are stored in the basements of public galleries – that can be securely attributed to Titian, as well as some that are given to him without documentary evidence on the grounds of their high quality alone.

Painting conservators can detect the layers of dust that accumulated while he set his paintings aside until he had solved a problem or could no longer put off the demands of a patron. He made his alterations over dry paint, cancelling out previous attempts with white lead paint, which shows up on X-rays. Joshua Reynolds, who claimed to have taken a painting by Titian to pieces to discover the elusive 'Venetian secret', would have envied our up-to-date technologies, which allow us to watch Titian at work, rearranging, adding and cancelling, searching for the composition and the tonal relationships in his mind's eye. Titian was an explorer in paint, trying out new ideas, striking out in new directions, assimilating lessons from other masters and quoting them before discarding their example to find his own way into an unmapped future. Although he frequently quoted motifs from paintings by Michelangelo and Raphael, the story goes that later in his life he once said to an imperial ambassador in Venice, 'who saw him use a brush as big as a birch-broom', that he wished to paint in a manner different from that of Raphael or Michelangelo, because he was not content to be a 'mere imitator'.[2] He was, as his contemporaries liked to say of him, an exemplar of the Renaissance ideal of *sprezzatura*, the art of concealing the effort that goes into great art.[3] But the false starts and the pentimenti – changes of plan while he worked on a painting[4] – that can be detected beneath the assured surfaces of his masterpieces give us an idea of just how great the effort was. Bellini and Giorgione had taken advantage of the slow-drying property of oil paint to make changes, but Titian's more numerous changes were so characteristic of his working methods that they have become a hallmark for distinguishing autograph Titians from imitations or mainly studio works.

Although some of Titian's compositions look as though he must have worked them out on paper before starting to paint, the majority

of the preparatory sketches, if they existed, have long since disappeared, as have all but a few dozen of his other drawings, many of which are of debatable attribution. The whole question of Titian's drawings, and what use he made of them, is one of the more vexed issues of Titian scholarship. The surviving sketches and drawings that are accepted, at least by some authorities, as autograph cover a wide variety of subjects – landscapes, animals, anatomical studies, sketches for portraits, studies for the benefit of assistants. But very few preliminary sketches for paintings have been identified, which, even allowing for the vulnerability of work on paper, is a tiny proportion of the 500 or so paintings he produced in the course of his long career. From the evidence we have, it seems that his painting technique from the beginning was to work and rework a compositional framework directly on to the primed support either in paint or black chalk and then more often than not ignore his own outlines. This does not mean, as his central Italian critics maintained, that Titian could not draw. Some of his sketches are masterpieces in their own right. One in particular, a *Portrait of a Young Lady* (Florence, Uffizi) of about 1511–12, in black chalk on blue paper covered with a yellowish wash, stands out from the other drawings not only because it is unique in his surviving oeuvre but because of its breathtaking beauty, the characterization of its moody introspective subject, and its vigorous and assured pictorial technique that looks strikingly modern when seen next to central Italian drawings of the same period. The rounded Slavic face of the model, whoever she was, evidently intrigued Titian at this time because it was a type he used also for the so-called *Gypsy Madonna* and the painting known as *La Schiavona*.

A nineteenth-century restoration of the *Madonna of the Cherries* (Vienna, Kunsthistorisches Museum) provided one of the first modern revelations of Titian's way of working. When the painting was transferred from canvas to panel the conservators could see that the figure of the Madonna had been achieved only after trial and error while Titian tried different outlines with rough sketches, which he modified for the final design. Since he borrowed the motif of St John the Baptist grasping cherries from Dürer's *Madonna of the Siskin*,

which was painted in Venice in 1506, it is likely that he began his picture not long after he saw the Dürer. Then he seems to have lost interest or inspiration – or a patron – and abandoned the canvas. The two fathers, St Zacharias behind the Baptist and St Joseph behind the Christ child, were added, possibly at the request of a new patron, more than a decade later.

A restoration in the 1970s revealed that the *Madonna in Glory with Six Saints*[5] is executed over two previous paintings.[6] The first was a subject that included trees and water,[7] which he never finished. He extended and reused the same panel for a new painting, which was commissioned for the high altar of the Oratory of San Nicolò ai Frari.[8] This he set aside after sketching in rough outlines the figures of saints and filling in areas of colour before elaborating their poses or deciding how they would be arranged. He then abandoned the project for some years before in the 1530s completing on the same panel the painting we see today, with the help of an assistant, probably his brother Francesco. The thrifty habit of reusing the supports of discarded paintings continued throughout his career, even after he became well paid and famous.

In the *Noli me tangere*,[9] the first and most delicate of his portrayals of the whore who was redeemed by her love for Christ, Titian evokes their close relationship during His lifetime, her yearning for Him and the drama of His miraculous reappearance to her after His Crucifixion with the balletic geometry of their poses, their limbs, Christ's hoe and the tree planted in the centre of the painting which sways in counterpoint to Christ's leaning torso. Here, as one writer put it, European painting has 'become the richer by a new aerial quality due to nimbleness or expression in the touch itself'.[10] Some scholars insist he must have worked out this highly complex composition on paper. There is no way of settling the question, but scientific examination has shown up the numerous changes that lie beneath the finished painting. A first attempt at a design evidently dissatisfied him because he cancelled part of it with a layer of white lead, apparently applied with a palette knife, and started again. He moved the ridge and buildings from lower down on the viewer's left to their present position on the right, lopped

off a branch of the tree, which was originally much smaller, and recast the agile figure of Christ, who originally wore a gardener's hat and was shown upright and striding towards us away from the Magdalen rather than stepping towards her. The underdrawings sketched directly on the prepared canvas support are fine, free but very cursory scribbles describing some of the main elements, such as the curve of Christ's back, hip and thigh but leaving details incomplete.[11] The subject was so unusual in early sixteenth-century Venice and Titian treated it in such a wholly original manner that it is possible that he painted it for his own satisfaction without a commission as a way of exploring a depiction of the event that would emphasize the depth of feeling between the two protagonists.

The *Three Ages of Man*,[12] the sexiest of all Venetian pastoral romances, was realized after unusually numerous revisions even by Titian's standards. In a previous plan Cupid's quiver was suspended from the top of the shattered tree; there was a tower in the central background; the old man holding two skulls was surrounded by four. The couple in the foreground – a naked young man and a girl who has not yet removed her white undershift, her pale bare arm resting on the brown flesh of his thigh while she points her flute at his groin – make love in the open air like the pagan shepherds and shepherdesses of the golden age described by Virgil and Ovid. But it was with one simple change – by twisting the girl's head away from its original position facing the spectator towards her adoring lover so that, as Richard Wollheim put it, 'their eyes copulate'[13] – that he transformed a Giorgionesque mood painting into a Shakespearean poem about the most important and overwhelming of human emotions, for as long as youth and beauty last.

The *Three Ages of Man* (a seventeenth-century title) was commissioned by a goldsmith, Emiliano Targone,[14] whom Benvenuto Cellini called 'the finest jeweller in the world'. Vasari, who saw it in the late 1540s in the house in Faenza of Targone's son-in-law Giovanni da Castel Bolognese, described it as 'a naked shepherd and a country girl who is offering some pipes for him to play, with an extremely beautiful landscape'. A literary source has of course been endlessly discussed

137

by modern scholars, but as with all Giorgionesque pastoral paintings it has never been possible to match the *Three Ages of Man* precisely to a particular text that would have been known at the time, and most of us are happy to accept it, with Titian's nineteenth-century biographers,[15] as a tale 'merely half told ... treated with such harmony of means as to create in its way the impression of absolute perfection'.[16]

It is in fact far from technically perfect. Titian, unable to fit in the girl's legs, left the lower part of her body in an ungainly pose covered by the skirt of her red dress. The placing of the figures defies perspective: the old man is too small, the sleeping cupids too large. This is one of the first paintings in which Titian attempted the difficult challenge of grouping large figures seated directly on the ground within a landscape – a format that later became a hallmark of Venetian sixteenth-century painting but which continued to trouble Titian, who, even in his otherwise more assured pastoral paintings of the early 1530s,[17] did not always quite bring off the anatomy of his seated figures. He had a similar problem with the Virgin's pose in the *Holy Family with a Shepherd* of about the same date or a few years earlier,[18] in which the disproportionately large head of St Joseph (apparently taken from the same model as St Mark in the *St Mark Enthroned*) looks as though it had been added on as an afterthought, perhaps for a patron or carpenters' guild devoted to the popular cult of St Joseph. It was around the same time, or perhaps a few years earlier, that Titian painted the *Baptism of Christ*[19] for Giovanni Ram, a Spanish collector resident in Venice who is portrayed in profile as the donor. The grandiose figures of Christ and the Baptist strike complicated, stagey poses, which look as though Titian was working from sketches or descriptions of classical and central Italian prototypes he had not seen in the original.[20] The portrait of Ram is executed in a tight, explicit way that harks back to Giovanni Bellini.

If Titian in his twenties was still feeling his way in such paintings, he was already secure in the art of portraiture, which was a new genre in Venice – Vasari gave Giovanni Bellini the credit for starting what was evidently an unusual custom. It is our bad luck that the identities of

most of Titian's earliest sitters are lost, probably because portraits seem rarely to have been commissioned with written contracts. According to Vasari one of them was of Titian's friend, a member of the noble Barbarigo family, who recommended Titian for the job of frescoing the Fondaco. Vasari wrote that he painted this portrait when he was no more than eighteen, 'at the time he first began to paint like Giorgione', and that it was held to be:

> extremely fine, for the representation of the flesh-colouring was true and realistic and the hairs were so well distinguished one from the other that they might have been counted, as might the stitches in a doublet of silvered satin which also appeared in that work. In short the picture was thought to show great diligence and to be very successful.

It is possible that this is the painting now known as the *Man with a Quilted Sleeve*. Although the sleeve is actually blue it may be that Vasari was referring to silvery light playing on it before the surface of the painting was abraded over time. Nevertheless, it is remarkably assured for the date Vasari suggests, which would date it in or before 1508.

A doublet with voluminous sleeves was in any case the kind of luxurious garment that was frowned upon by the older, stricter seafaring generation. It went against the long-standing Venetian tradition of moderation intended to minimize jealousy within and without the ruling class. At a time when Venice was engaged in a crippling war, lavish clothes and foreign fashions were especially unpatriotic and indeed dangerous because offensive to God. Members of the patrician class, furthermore, were supposed to wear the toga or the robes that indicated higher office. In Titian's portraits members of the nobility who had withdrawn from active trade and wished to be portrayed as gentlemen of refined taste are dressed instead in fashions that prevailed elsewhere in Italy and Europe. Some may indeed have been foreigners – Titian's studio was already one of the many attractions of the much-visited city. But others were young Venetians emulating an ideal of how a gentleman should look and behave in a way that was gaining currency through drafts of Baldassare Castiglione's popular

and influential dialogue *The Courtier*. If some were, like Titian's Barbarigo friend, members of the patrician class, their taste for avant-garde art would have been consistent with a subversive attitude to the dress code thought appropriate by their conservative elders. Perhaps some of them wished to be portrayed as they would like to be remembered before going off to war. The *Man with a Red Cap* (New York, Frick Collection) carries a sword and is dressed in furs, perhaps for campaigning in a northern winter.

When Titian was young most of the men he painted were also young. They generally posed for him in black, with touches of a white shirt showing at the neck. The Spanish fashion for wearing black was recommended by Castiglione as the most suitable attire for courtiers, and black, the most expensive cloth because the dye was difficult to fix, was an indication of the sitter's wealth. Venetians who dressed like foreign aristocrats were making a statement about their status as gentlemen who had abandoned the sea for a more civilized and contemplative life. The expensive clothes, the rings that draw attention to their expressive hands, and their gloves, which would have been scented with musk, further signify their position as aristocrats or quasi-aristocrats. By limiting his palette to the variations of black, white and the flesh tones at which he excelled Titian brought a new drama and mystery to his portraits, which would later inspire painters as different from one another as Frans Hals, Rembrandt, Velázquez and Whistler. The earliest portraits seem to catch their subjects off-guard, 'heads inclined like too heavy flowers',[21] lost in melancholy musing. The gaunt, handsome features of the *Young Man with a Red Sleeve* (Earl of Halifax on loan to the London National Gallery),[22] tired eyes staring into the distance, are those of a man so intensely preoccupied by his own thoughts that we feel he would be startled by the slightest interruption. The initial 'C' on the scroll in the background to his right may give a teasing clue to his identity. One of the earliest extant portraits, the elderly man in Copenhagen (Statens Museum for Kunst) wearing the habit of a lay brother – he could be a member of the confraternity of St Anthony whom Titian knew in Padua[23] – averts his eyes like saints in religious paintings of the previous century. The

Frick *Man in a Red Hat* gazes up and away from the viewer as though he too is absorbed in otherworldly thoughts. Sometimes Titian gives the impression that his gentlemen are about to emerge from their dark backgrounds to go out for the evening, or that they have just returned. The *Young Man with a Red Sleeve* has removed one of his kid gloves and his broad-brimmed hat. The *Man with a Quilted Sleeve* has his black outdoor cloak slung over his left shoulder.

The mysterious *Concert*,[24] Titian's first triple portrait and his last before the unfinished *Paul III with his Grandsons* of more than three decades later, has been one of the most discussed, analysed and admired of Titian's paintings: Walter Pater (who thought it was by Giorgione) called it 'among the most precious things in the world of art'.[25] But after more than a century of conjecture about its meaning and the identity of the three musicians there is no consensus about who or what it represents.[26] Three men of different ages – one elderly, one middle-aged, one young – are absorbed in making music. Their clothes provide the only clues to their identities. The elderly man on the right holding a stringed instrument is dressed as a cleric. The middle-aged man at the keyboard whom he interrupts wears what was thought to be a toga, indicating that he was a member of the government, until a restoration in 1976 showed it to be dark blue rather than black. The young man's fancy hat would have been worn only for a theatrical production, probably during carnival. So is this a rehearsal? Is the oldest man suggesting that they start again from the previous bar while the impassive young man with the plumed hat – presumably a singer – waits for his cue? Did Titian intend his painting to signify, as one art historian has put it, that 'sublime and harmonious time must contend with the powerful interference of real time in the world'?[27] Would an artist still in his early twenties have thought that way? Or is it about the dual purpose of music, which gives both pleasure and spiritual edification?[28] If only we knew who commissioned the *Concert*, we might be able to guess at some answers. As it is we can only marvel at how Titian managed to give, in this as in so many of his paintings, a sense of suspended narrative, akin to the way our memory sometimes condenses a past episode into a single image.

Painting in the hands of a master, as Leonardo had observed, can capture the impression we gain from a single glance just as we do in reality. Titian's sense of the moment, indeed his ability to capture 'The Decisive Moment',[29] has rarely been matched by any photographer or painter, and is all the more impressive because we know from technical investigation that he planned and painted this picture of three figures all at the same time.

Although fewer of Titian's portraits have been scientifically examined than his other paintings, the work that has been done on them demonstrates that he used the same techniques and made similar changes as he went along. One of the portraits that has been thoroughly investigated is the so-called 'The Slav', *La Schiavona*, as it came to be called (London, National Gallery), of about 1511. Although Titian counted women among his close friends – Vasari used the word *compare*, pal or confidante, to describe his relationship with one of them, the beautiful young Giulia da Ponte, who was the subject of one of his lost portraits[30] – there are far fewer identifiable portraits of Venetian women in his surviving oeuvre than of men. Venice, unlike the other Italian city-states, had no court. Female portraits, which elsewhere served to encourage or celebrate dynastic marriages with other courts, were of no use in a city where marriages were contracted within the local patriciate and where the doges and procurators were often very old, celibate or widowed. That women do not even appear in his later group portraits of noble Venetian families may indicate that there was also some prejudice, in the oriental tradition, about display of female features.

La Schiavona, in any case, is his only extant early portrait of a Venetian woman wearing contemporary dress – apart, that is, from the Uffizi drawing of a woman whose features and costume are similar. Her red dress, glazed with costly madder lake, seems to identify her as a member of the upper class. It has been suggested that she may be Caterina Cornaro, the deposed Queen of Cyprus, who died in 1510; or, since he used the same model in profile for the mother in the fresco of the *Miracle of the Speaking Babe* in Padua, she may have been a woman he knew there. She was in any case unique in early

sixteenth-century Venetian painting as a portrait of a woman who was neither an anonymous professional beauty nor the consort of a foreign prince. It is one of the earliest three-quarter-length portraits in Italian painting, and her commanding position, which Titian meant to be seen from below and at a distance, was also unprecedented in European female portraiture. It has been aptly observed that her strong matriarchal features look like 'the early sixteenth-century equivalent of Picasso's Gertrude Stein'.[31]

Given the originality of La Schiavona it is not surprising that the portrait evolved slowly while Titian tried out different ideas for it. He altered the sitter's headdress and the veil on her right shoulder, and deleted a window in the upper-right section of the canvas. The red of her dress can be seen with the naked eye through the marble parapet, which he raised over it and upon which he placed and then erased a skull and a foreshortened dish before resting her hand on it instead. The fictive relief carving of her profile refers to a debate that went back to classical literature about the relative merits of painting and sculpture.[32] In the Renaissance Michelangelo became the representative of the greater integrity of sculpture, while Leonardo championed painting as the art that required more intellect. Vasari was tapping into the argument when he gave Giorgione the credit for proving 'that painting requires more skill and effort and can show in one scene more aspects of nature than is the case with sculpture'. If the contest seems academic to us today, it was one that preoccupied Titian, the most painterly of painters, throughout his career.

On a raised parapet, just to the left of the forehead of the relief profile bust, Titian painted a large V, traces of which can still be detected with the naked eye. The initials V, VV or VVO, which appear on other Venetian portraits of around the same date,[33] have been variously interpreted as indicating *virtus vincit* (*omnia*), virtue is victorious over everything; *vivens vivo*, from life by the living; or *virtus e veritas*, virtue and truth. A single V has also been detected by infrared reflectography in the centre of the parapet of the *Man with a Quilted Sleeve*.

If La Schiavona in its final version was intended as an illustration of the superiority of painting over sculpture – a painter can imitate

sculpture but a sculptor cannot represent a painting – the blue sleeve of the young bearded man known as the *Man with a Quilted Sleeve* of a few years earlier is a demonstration of the power of painting, as celebrated by Pliny in his stories about the realistic paintings of Apelles, to create the illusion of three-dimensionality. Despite fading and abrasions the thrust of the sleeve into the space of the viewer still startles. The sitter, now identified as a member of the Barbarigo family, was thought to be Ludovico Ariosto, author of the famous romantic epic *Orlando Furioso*, until in the 1970s a scholar[34] observed that the swivel and tilt of the man's head are consistent with the pose an artist would adopt while portraying his reflection in a mirror and that his projecting chin and under-hung lower lip resemble the two surviving self-portraits from Titian's old age. Could this arrogant man with the sensuous mouth and the intent gaze be the elusive young Titian? If so, is the portrait of what could be the same man five or ten years older (Munich, Alte Pinakothek) also Titian? In fact the straight nose in both paintings doesn't quite match the more aquiline shape of the later self-portraits. Whoever the sitter, the richly worked quilted protruding sleeve is an early manifestation of Titian's lifelong interest in textiles – later he sometimes invented the designs of his own painted textiles – and may have been intended to advertise his virtuoso talent for imitating fine fabrics to the wealthy textile manufacturers of Venice who were potential patrons.

Although Titian flattered his sitters, and it would be anachronistic to claim that he would have thought in terms of what we call 'psychological insight', his instinctive understanding of human nature does seem to reveal what W. B. Yeats, a great admirer of Titian, called 'the personality of the whole man, blood, imagination, intellect running together'.[35] It is this quality that makes his portraits stand out in picture galleries, and their lost identities especially frustrating. Writers who would like to link him with the most famous men of letters of his youth have proposed, on more or less shaky grounds, that the *Portrait of a Man with a Book* (Hampton Court, Royal Collection) might be the Neapolitan poet Jacopo Sannazaro; and that a *Portrait of a Man* in the Dublin National Gallery is the humanist philosopher and author of

The Courtier, Baldassare Castiglione.[36] We can at least put a name to one of his early sitters, the forceful, bull-necked man with long grey hair in the Vienna Kunsthistorisches Museum.[37] He is Gian Giacomo Bartolotti da Parma, a physician and prolific writer of, among many other texts, an obscene macaronic poem, *Macharonea medicinalis*. He served as physician to the Venetian fleet and prior of the Venetian College of Physicians, and, since Giorgione also painted his portrait (the 'Terris' portrait, San Diego), presumably numbered Venetian artists among his patients. He sat for Titian in 1520 when he was about fifty, a powerful, confrontational personality.[38]

Comparing Titian's Dr Parma with Giorgione's gentler portrait of the same man, seemingly more introverted, painted about ten years earlier, suggests that Titian in his early thirties was abandoning Giorgionesque moodiness to attempt a more intense engagement with the individuality of his sitters. He was also discovering new ways of modelling and structuring portraits while experimenting with the different formats, scales and dimensions that the great Swiss historian of art and culture Jacob Burckhardt called the most important innovation of the sixteenth century.[39] We can see the transition in the marvellously assured pyramidal compositions of the *Flora* (Florence, Uffizi) and the *Portrait of Tommaso Mosti* (Florence, Galleria Palatina), both probably several years later than the *Portrait of Gian Giacomo Bartolotti da Parma*.

In the *Man with a Glove* (Paris, Louvre), his most famous portrait of the early 1520s,[40] everything Titian had achieved in the field of portraiture up to that time – his unrivalled mastery of blacks, whites and flesh tones, the most difficult pigments to manage on an artist's palette; the modelling with light and shade; the tellingly naturalistic action of the exquisitely painted hands; his interest in the personality and status of his sitters – culminates in one of the most beautiful and intriguing of all Renaissance portraits.[41] He borrowed the pose from Raphael's *Portrait of Angelo Doni* of about 1507–8, but probably learned more about patrician restraint and exploration of personality from the same artist's *Portrait of Baldassare Castiglione* (c. 1514–16), now in the Louvre, which he saw during a visit in the winter of 1523

to Mantua where Castiglione, who was at that time in the service of the Gonzagas, kept the portrait in his house. But if Titian's *Man with a Glove* was in part an homage to one of the greatest artists of the central Italian High Renaissance – Raphael had died at the age of thirty-seven only a few years earlier – he looked back in order to paint something so new that we would be forgiven for attributing it to Rembrandt.

It is a moot point whether Titian's paintings of anonymous pretty girls, usually disguised as classical or biblical characters, can be categorized as portraits. The foreign dignitaries to whom some were sold or presented as gifts referred to them simply as 'women'. Whether the models were prostitutes, courtesans, Titian's mistresses or perhaps some of them the mistresses of the young men he portrayed, they would have been hung in the bedrooms of men who we can safely guess were less interested in learned allusions than in the realistic depiction of beautiful young faces, skin, hair and bodies. The Venetians were the first Italian artists known to paint routinely from living models, a practice that was much less common in central Italy where artists were supposed to learn how the body works by study and dissection and how it should ideally look from classical examples. (Raphael, for example, never used human models for his bodies.) Four decades or so after Botticelli painted the first heroic and timeless mythological women of the Italian Renaissance, Titian, as a feminist art historian has put it, 'reinvented womankind'.[42]

Titian warmed the flesh of his women – Dolce quoted Pordenone as saying that Titian put flesh not colour on to a nude – and softened the voluptuous contours of their bodies. Even if some of his models were common whores, their faces tell us that he wanted to explore their personalities as well as their bodies. Seen next to any one of Titian's girls, the numerous beauties painted by his Venetian contemporaries – Paris Bordone, Palma Vecchio or Giovanni Cariani – look like hardened professionals. The *Reclining Nude in a Landscape* (Dresden, Gemäldegalerie) and *Venus Anadyomene* (Edinburgh, National Gallery of Scotland)[43] (*anadyomene* is the Greek word for

'rising from the sea') – which was inspired by Pliny's description of a Venus Anadyomene painted by Apelles, the lower half of which had been damaged – adopt the *pudica* pose of antique sculptures of the goddess, at once voluptuous and modest, the position of their hands drawing attention to what they conceal. The ravishing *Flora*, Roman goddess of flowers and prostitutes, whose name was often adopted by Renaissance courtesans, is only partially successful in preventing her pleated white shift – a costume worn by actresses in the contemporary theatre to identify them as nymphs or goddesses – from tumbling further off her plump shoulders. Her modestly averted glance was a second thought: in the original version she looked straight out at the viewer.

The *Salome* (Rome, Galleria Doria Pamphilj), for which Titian seems to have used the same model who posed for the naked Dresden *Venus*, is not the first Renaissance painting to exploit the erotic subtext of the biblical story,[44] in which the seductive daughter of Herodias displays the decapitated head of St John the Baptist on a salver. But Titian's version, which is based on the composition of a more sombre *Salome* by Sebastiano Luciani of 1510, is surely the most explicitly sensuous of them all. Salome[45] is associated with Venus by the little winged cupid perched on the arch behind her. Like a prostitute in the pornography of the period[46] she allows a lock of hair to stray flirtatiously over her fresh young cheek, while the hair of the decapitated Baptist caresses her bare arm as she clutches his head to her breast. It looks as though Titian, who seems to have enjoyed playing the occasional walk-on role in his productions, may have portrayed himself as the Baptist[47] – the arched nose and the contour of the forehead resemble those in his late self-portraits, and the receding hairline may anticipate early balding. If this is the young Titian, could we be witnessing a private joke between Titian and a sexually voracious mistress? Perhaps the painting was in lieu of payment for her services? Or might she have been a courtesan rich and cultivated enough, as some courtesans were, to commission her own portrait?

Of course writers and critics have been speculating since his lifetime about Titian's relationships with his female models. When in

1522 the Duke of Ferrara's ambassador in Venice reported that he had found Titian looking exhausted, he assumed, although Titian denied it, that he had been sleeping with the models he often painted in provocative poses. Even a diplomat with limited imagination would have guessed that powerfully creative artists usually have powerful libidos, and that the act of tracing the contours of a desirable woman's body with a brush laden with paint is a kind of sublimated love-making. Sperone Speroni writing about love in 1537 named Titian as the painter who best visualized the concept that 'a lover is actually a reflection of that which he loves'.[48] Alas, Titian, the artist who knew better then any other how to paint heterosexual passion, seems only rarely to have written or spoken about his private life and personal feelings, and then mainly about his family and friends. According to Pietro Aretino, the close friend with whom he spent many companionable evenings, Titian seemed never to have met a woman he didn't like, but whereas Aretino claimed to be so fond of brothels that it almost killed him to be elsewhere, Titian, at least when in society, fondled and made a great show of kissing the ladies, and entertained them with a thousand juvenile pranks,[49] but remained faithful to his wife or current mistress.

But the temptation to find and name a mistress for Titian was irresistible, and by the end of the sixteenth century, when Titian and Aretino were both long dead, the pretty redhead with violets tucked into her décolletage in Titian's *Bacchanal of the Andrians* (Madrid, Prado), painted early in his career for Duke Alfonso I d'Este of Ferrara, had given rise to the notion that Titian's beloved was called Violante.[50] In the next century Carlo Ridolfi, in his biography of Titian, wrote that Titian had had an *innamorata* called Violante, who was the daughter of his friend Palma Vecchio. Ridolfi may or may not have picked that idea up from someone who told him about the rumour in Ferrara. But it was his reference that generated claims that Violante was also the model for a number of early sixteenth-century Venetian paintings of women, especially the so-called *Violante* (Vienna, Kunsthistorisches Museum), a hard-faced, bleached blonde, who also has a violet tucked into her bodice, but looks more like the work of

Palma than Titian. The Vienna *Violante* is in any case a different physical type from other candidates who have been proposed for Violante, all of whom, like the girl in the *Andrians*, have auburn hair and brown eyes. One is the beautiful *Flora*. Another is the *Venus Anadyomene*, whose head Titian altered, possibly putting one woman's face on another's body. She appears again in the *Woman with a Mirror*, her long auburn hair over one shoulder like the *Venus Anadyomene*, but now *en négligée* and closely observed by the man who holds a second mirror for her. Although the man looks nothing like Titian, the painting entered the collection of Charles I of England as 'Titian and his Mistress'. But then came the age of legend-busting Titian scholarship, when it was discovered that Palma never married, and that there is no record of an illegitimate daughter. And so, although Titian's women leave us in no doubt that he loved them, blonde or brunette, slim or buxom, whores, courtesans or high-ranking girl-friends of his patrons, we are forced to respect his reticence about his private life. He may, like his great modern admirer Lucian Freud, have needed to sleep with his models before painting them. But we will never know which, if any of them, shared his bed.

NINE

Sacred and Profane

Titian appears, and art takes a step in advance, and we feel
that there may be some further perfection of which as yet
we do not dream.

JOSEPH A. CROWE AND GIOVANNI BATTISTA
CAVALCASELLE, *THE LIFE AND TIMES OF TITIAN*, 1881

The Assumption is a noble picture, because Titian believed in the
Madonna. But he did not paint it to make any one else believe in
her. He painted it, because he enjoyed rich masses of red and blue,
and faces flushed with sunlight.

RUSKIN, *MODERN PAINTERS*, VOL. 5, 1843–60

A year or so after Titian had refused Pietro Bembo's invitation to Rome
and the Council of Ten had voted to accept his proposed battle scene
for the Great Council Hall he received a private commission to paint a
picture for Niccolò Aurelio, a secretary to the Council of Ten. Aurelio
was the civil servant who in 1507 had signed the payment order to
Giorgione for the Fondaco frescos, and it is possible that he helped
Titian with the phrasing of his petition and influenced the Council's
decision in his favour. He had risen through the ranks of the ducal
chancery, starting his career as an advisory notary with a salary of
twenty ducats a year to his present powerful position, which paid 200
plus bonuses. The son of a professor at the University of Padua, he was

an educated man and evidently good at his job, which was one of the most important in the ducal chancery. He was a close friend of Pietro Bembo, who had written him a warm letter of congratulation on his appointment and who, some think, may have devised the Neoplatonic programme for one of Titian's most visually compelling, endlessly fascinating and enduringly popular masterpieces, now known by the much later title *Sacred and Profane Love* (Rome, Galleria Borghese).

Now in his early fifties, Niccolò Aurelio had fallen in love with Laura Bagarotto, a young and beautiful Paduan widow, who on the face of it could hardly have been a less suitable match. Laura's late father, Dr Bertuccio Bagarotto, a Paduan nobleman, had been a lawyer and professor of canonical jurisprudence at the University of Padua, and a man of considerable means. But Dr Bagarotto, and some of her other blood relatives – including her maternal uncle, her cousin, her brother and her illegitimate half-brother – as well as her late husband, Francesco Borromeo, were among the members of the Paduan elite who had been singled out as traitors for supporting the short-lived imperialist occupation of their city in the summer of 1509. Within days of the recapture of Padua the family, including Laura, had been rounded up, sent under guard to Venice and thrown into prison. There was a debate in government about whether, given the status of the family, it would be more appropriate to strangle them privately in prison rather than hang them in public. Some escaped or were pardoned. But Laura's uncle, father and husband were condemned to death, and on 1 December Dr Bagarotto was escorted from prison and hanged between the columns on the Piazzetta. He died protesting his innocence, while Laura and her mother were forced to watch his execution. Her brother, who had been spared, continued to work for the restoration of the family's good name, and he seems eventually to have succeeded because his late father's state pension was restored to him in 1519. Meanwhile, however, the family property, including their house in Padua near the Eremitani and Laura's substantial dowry, was confiscated; and when in 1510 the Council of Ten decreed that the dowries of Paduan rebels be restored to their widows, Laura's was not among them.

On the day before their marriage on 17 May 1514 Aurelio arranged for the return of her dowry. Valued at 2,100 ducats, it consisted of a white satin gown (which she had probably worn for her first marriage), twenty-five pearls and some real estate near Padua. Any increase in the value of her estate would become the property of her husband, and Aurelio did later develop the land with walled stone buildings. Although the Collegio granted approval of the marriage (another indication that there were doubts about the guilt of the family), the marriage of Laura Bagarotto and Niccolò Aurelio was the scandal of the year. Everyone talked about it, as Sanudo indicated when recording the 'noteworthy' event. Had Aurelio married for money? Although his job was well paid, he had no independent means, and his salary was stretched to the limit by the need to provide dowries for two sisters. He had lived with his brother in a house rented for only two ducats a year. Like so many Venetian men he had remained a bachelor, although he had fathered an illegitimate son. Had Laura married him as a means of reclaiming her dowry? Was the young Laura, who had suffered so much tragedy, attracted by the security and respectability of a middle-aged husband with an important job in government? Or was it a marriage of passion? In the three wills he made in the 1520s Aurelio refers to Laura as his most dear, beloved and cherished consort, whom he cannot imagine wanting to remarry after his death. He also expresses tenderness for the entire family, especially their daughter Giulietta, as well as for his natural son Marco and for Francesco, the natural son of his deceased brother Antonio, both of whom Laura had helped to bring up.

In August 1523, nearly a decade after their marriage, Aurelio was elected grand chancellor by the Great Council. It was the top job in the Venetian bureaucracy, carried a salary of 300 ducats per year plus bonuses, and made Aurelio the most powerful man in government after the doge and the procurators. He beat five other candidates – one of whom, Gasparo di la Vedoa, was the doge's favourite. Sanudo described Vedoa's black face when he heard he had failed to carry the election, and such was his distress that he died the next year. Aurelio's victory enraged a cabal of the losers, and less than a year later his

enemies trumped up charges that he had accepted bribes to allow some criminals to escape justice. On 15 June 1524, after attending a banquet with Laura, rumours reached him of a plot. In July he was arrested, tortured on the rack and banished to Treviso for life. But a year later, possibly thanks to an intervention by Bembo, he was permitted to go to Padua, where he was reunited with Laura, who soon bore him a son, Antonio. But Niccolò Aurelio was a broken man. He died on 17 June 1531. Sanudo tells us that Laura honoured his wish to be buried in San Giorgio Maggiore and that it poured with rain on the day of his funeral. She never remarried.[1]

Titian immortalized the love story of Laura Bagarotto and Niccolò Aurelio with a painting that is one of the icons of Italian Renaissance art.[2] The earliest references to it are relatively straightforward. In the years after its arrival in the Villa Borghese in the seventeenth century, it was called 'Beauty Adorned and Unadorned' and 'Divine Love and Profane Love, with Cupid fishing in a basin'. Ridolfi described it as 'two ladies near a spring in which a child is looking at itself'. The title *Sacred and Profane* was attached to the painting in the eighteenth century. But it was not until the end of nineteenth century that art historians educated in the classics began their attempts to possess by explanation this last and greatest of Titian's Giorgionesque secular paintings with more and less arcane theories about its meaning and the classical or Renaissance stories it might illustrate.[3] Although few have doubted that the naked woman in the painting is Venus, some have seen the two women as representing her double role as goddess of both chastity and carnal love. Some, taking their cue from the eighteenth-century title of the painting, have seen the naked Venus as 'sacred' in the sense that she is the celestial goddess of unadorned truth and the higher love, while her clothed counterpart is an earth-bound mortal and therefore 'profane'.

A more recent and more plausible interpretation[4] inverts that theory. Venus may have been the most beautiful of goddesses, but she was notorious for sleeping around and was for that reason the goddess of whores as well as of brides. According to the Neoplatonic theory of love then being propagated by Bembo and Castiglione, carnal love, as

encouraged by Venus and her son Cupid, leads step by step to the ideal love in which raging passion, harnessed by the human intellect and capacity for discipline, ascends to the perfect love of God and to Christian marriage in which the purpose of sexual relations is to produce children. It is the clothed bride in Titian's painting who represents that ideal of what has been called a 'baptized *eros*'.[5] If this is indeed the meaning of Titian's painting it could have been suggested by Pietro Bembo's famous and widely read *Gli Asolani*, in which a party of young friends discuss the nature of profane and sacred love. Bembo was, as it happened, in Venice at the time of the marriage, travelling on a diplomatic mission, and he would certainly have given a wedding present to his friend Niccolò Aurelio. Poems in praise of marriage were traditional wedding gifts. Bembo, who was also acquainted with Titian, and was not lacking in imagination or appreciation for the art of painting, might have decided instead on a painted poem. If so, we have the greatest Venetian poet of his day to thank for the most sublime Venetian painting about love and marriage.[6]

The link with Niccolò Aurelio was not rediscovered until the early twentieth century when Sanudo's diaries were first published[7] and a scholar matched the escutcheon on the front of the fountain to an engraving of the Aurelio family coat of arms. More recently, thanks to the interest of academic historians in the material culture of the Renaissance, scholars have noticed what would have been immediately obvious to any sixteenth-century Venetian who saw the painting in the Aurelio household. *Sacred and Profane Love* is an epithalamium, a poem about a marriage, in the same tradition as Botticelli's *Primavera*.[8] Venetian brides did not necessarily wear white. Their wedding dresses could be any colour, the main requirement being that they were made of expensive materials and worn with ornate jewellery.[9] Titian originally dressed his bride in the red that can still be detected beneath the white he painted over it. She wears the belt, or *ceston*, that refers to the girdle of Venus, which had the power to bestow sexual attraction on its wearer, but was also a sign of the bride's chastity; it would have been sent by her betrothed as a tribute

of love and a token of marital fidelity. The *ceston*, like the crown of myrtle in her hair, had been associated with sex and marriage since antiquity. Her hands are protected by gloves, which will be removed just before the ring is slipped on her naked finger. The pot she holds in her gloved left hand was a traditional wedding gift from the husband, associated with childbirth. The fluted silver bowl, the bride's gift to the groom, would be inscribed with her coat of arms.[10] It might be used for sweetmeats, for washing her hands after childbirth or for the baptism of the baby. The fictive relief carving on the sarcophagus of an unharnessed horse was a familiar symbol of unbridled passion – horse, *cavallo*, was a euphemism for phallus, *fallo* – which would be tamed by marriage just as the flames of the smoking torch held by Venus have been doused.

Cupid stirs the water in the sarcophagus, which is transformed by the power of love into a life-giving fountain. The water falls through a brass spigot on to the rose bush, the rose being a flower sacred to Cupid's mother because she pricked her foot on a rose thorn and her blood stained some of the white roses red.[11] Rabbits, little symbols of fecundity, race across the beautiful landscape lit by the slanting rays of the evening sun, where a couple embracing in the far distance are pursued by huntsmen chasing after love. Even the lake calls to mind the lake in Venus' garden at Paphos. The bride, however, seems to be unaware of where she is or of the presence of the goddess who gazes at her encouragingly but must remain invisible to a mortal.

The two women are linked by the similarity of their features – a typical compliment to a bride who in the eyes of her husband is as beautiful as Venus; and by one of Titian's simplest and most effective chromatic schemes: blood red, the colour of passion, for Venus' cloak and the bride's sleeves; the chaste white of her wedding dress echoed by the veil that covers the mons veneris of the goddess. We know from a cleaning and relining completed in 1995[12] that Titian did not decide on the final colours and composition without his usual trial and error and that he used a canvas on which he seems to have begun a painting of a different subject. He began with the sarcophagus and a naked standing figure in profile on the right. Originally he placed the two

girls closer together. There was another large figure behind Cupid. The underdrawings revealed when the old lining was removed are thick and look as though they were rapidly executed with the help of his fingertips. It seems that he worked on the design at speed, propelled perhaps by a rush of inspiration or a deadline. If so, the freshness and originality of the finished masterpiece may owe something to the pressure to complete it on time.

Giovanni Bellini died on the morning of 29 November 1516. He had chosen to be buried in a modest second-hand tomb near the graves of his wife's family and his brother Gentile in a cemetery attached to the Dominican preaching church of Santi Giovanni e Paolo,[13] where he had worshipped and where his funeral was held. 'His fame is known throughout the world, and old as he was he continued to paint excellently,' wrote Sanudo (who unfortunately left a blank space for Giovanni's exact age). Titian, who had not yet delivered the battle scene for the Great Council Hall, may not have received the *sanseria* he had hoped to be awarded on Giovanni's death.[14] He was, however, immediately commissioned to complete the canvas for the Great Council Hall of the *Humiliation of the Emperor Barbarossa*, which Giovanni had left unfinished. But more compelling commissions were piling up.

At the time of Giovanni Bellini's death Titian was also at work across the city in the Franciscan Frari, the other great mendicant church of Venice, on a painting in which Christ's Apostles express their astonishment, joy and thanksgiving as they witness the miraculous Assumption of His Mother into Heaven. Known as Santa Maria Gloriosa dei Frari to distinguish it from the many other Venetian churches dedicated to the Virgin, the Frari was and is the largest and most beautiful Gothic church in the city, with the second tallest bell tower after that of San Marco. The arch of its magnificent fifteenth-century monks' choir, the only one that survives in Venice and one of the few in Italy still in situ, frames the view from the nave of the high altar. Titian had been invited by the energetic new guardian of the church, Brother Germano da Casale, to paint an Assumption of the

Virgin for this prominent position, where it would be seen by congregations composed of every class from the poorest Venetians to visiting dignitaries and the richest and most powerful nobles. Titian must have played a part in the design of the frame, apparently completed in 1516, which determined the dimensions of his enormous painting: seven metres high and three and a half wide, making it the largest altarpiece ever attempted in Venice and the focal point of the Frari, where it dominates the view, framed a second time by the arch of the monks' choir, from the far end of the nave. But size was only one of the challenges Titian would have to meet. His painting would have to be accessible to illiterate worshippers in the congregations of a preaching church. It would have to work against the counter-light streaming through the south-facing lancet windows of the apse. And it would require the ability to organize a team of carpenters to build the support and of assistants to help Titian execute his ideas as the painting progressed.

He decided on panel as a more stable support than canvas, and with his inherited understanding of wood must have enjoyed supervising the carpentry. Twenty-one cedar panels, each three centimetres thick, are held together by sixty walnut pegs and larch struts supported by batons nailed to the back of the support. The nails penetrated the surface of the panel and were renailed backwards at Titian's request.[15] A studio in the convent was set up for him and his team of assistants, where a hundred or more curious friars observed their progress and plagued Titian with their comments before finally recognizing, so Ridolfi tells us, that 'painting was not a profession for them and that knowing their breviaries was very much different from understanding the art of painting'.

The germ of the composition seems to have been one or more of several chalk drawings by Fra Bartolommeo of flying, twisting virgins, which Titian could have seen on the Tuscan artist's visit to Venice in 1508. The arrangement of the Apostles seems to have been suggested by Mantegna's fresco of the Assumption in the Paduan church of the Eremitani. But Titian's *Assunta* (as it is usually called) turned out to be entirely unlike any work of art ever seen in Venice or anywhere else,

a masterpiece that would unsettle some of his contemporaries and change the direction of European art in a way that was not repeated until Picasso reinvented the art of painting four centuries later. We see it through the veil of its powerful influence on Counter-Reformation and Rococo painting. But to appreciate the impact it made at the time one need only take a boat to the island of Murano, where Giovanni Bellini's static and stately version of a similar subject, painted less than a decade earlier, can still be seen in the Franciscan church of San Pietro Martire. Bellini's Virgin stands quietly praying on a cloud-shaped pedestal raised just above the landscape and behind the fathers of the Church, who stand in a semicircle meditating silently on the vision.

Titian's Virgin by contrast is propelled upward to heaven as though by her own spiralling momentum and is surrounded by a swarm of cavorting baby angels, while the miraculous ascent is witnessed by a crowd of amazed, larger-than-life-size Apostles, all in movement. Her robe and cloak billow about her supple body; her face and raised arms express terror and exaltation as she approaches God the Father, Who has burst through what appears to be the black unknown into the halo of celestial light that encircles her still youthful face. According to Franciscan tradition, which had been sanctified as doctrine by the Franciscan pope Sixtus IV in 1477 – but was heatedly contested by Dominicans for centuries to come – the Virgin, like her Son, had been immaculately conceived. Uncorrupted by original sin, she was there-fore not subject to decay and death but was physically assumed into heaven as a young and beautiful woman. Since the question of how she had been transported had never been settled, it was left to artists to depict her Assumption as they or their patrons envisaged it.[16]

One of Titian's most original decisions was to eschew the tradi-tional landscape background. His Assumption takes place, not in the countryside or in a fictive architectural space, but as though in the church itself. His awestruck, gesticulating Apostles, cast in shadow by the silhouette of the ascending Virgin, could have been members of a real congregation. They react to the supernatural event in a two-dimensional space 'as natural as nature'[17] and as solid as a building

that seems to extend the apse beyond its windows. The sharp reds of the robes that mark the base angles and apex of the pyramidal composition flash against the warmer brick and terracotta of the choir and floor of the church. The swag of stormy clouds and rejoicing angels repeats in reverse the arch of the choir screen, thus completing a second full circle around the circle of golden light that out-dazzles the daylight that streams through the apse windows. There cannot be many other works of art that combine such architectonic solidity with such dynamism, or which are in such perfect harmony with the buildings for which they were created.

Dolce, writing nearly forty years after the unveiling of the *Assunta*, was the first to praise it in print:

> It seems that she really ascends, with a face full of humility, and her draperies fly lightly. On the ground are the Apostles, who by their diverse attitudes demonstrate joy and amazement, and they are for the most part larger than life. In the panel are combined the sublime grandeur of Michelangelo, the charm and grace of Raphael, and the true colours of Nature.

But in his eagerness to promote and doubtless to please Titian, Dolce gilded the lily, asserting that Titian had painted the *Assunta* before Giorgione had produced any oil paintings, which would put it a decade earlier than the date that was clearly visible on the frame. He was doubtless right, however, that 'clumsy painters and the ignorant crowd, accustomed to the cold, dead works of the Bellini brothers and Alvise Vivarini, which were without movement and relief, spoke very ill of the finished work'. Ridolfi repeated an old story, that the friars including even the enlightened Fra Germano objected to the excessively large figures of the Apostles, 'thereby causing the artist to endure making no small effort to correct their lack of understanding and to help them comprehend why the figures had to be in proportion to the extremely large location in which they were to be seen, as well as to discuss whether it would be advantageous to make them smaller'. (Ridolfi also claimed that the friars came to value the painting only

after the emperor's ambassador tried to buy it for an enormous sum. But about this he must have been mistaken, because the emperor's ambassador was not in Venice at the time.)

By the time Vasari saw the *Assunta* it was so obscured by an accumulation of dust and candle grease that he guessed it was on canvas and merely reported that it had not been looked after very well and was too dark to make out. When Sir Joshua Reynolds visited the Frari in 1752, he found it 'most terribly dark but nobly painted'. It remained shrouded in grime and difficult to see against the light of the lancet windows until in 1817, during the Austrian occupation of Venice, the *Assunta* was removed from its frame and taken to the newly opened Accademia Gallery where it remained until after the First World War. It was displayed, along with other sixteenth-century paintings brought in from religious foundations and palaces in Venice and the Veneto, in the chapter room of the former Scuola della Carità (the first room at the top of the stairs, now hung with Venetian Primitives), where the ceiling was raised above it to accommodate its height.[18] The sculptor Antonio Canova, who formally opened the room to the public in 1822, described Titian's *Assunta* as the greatest painting in the world. The gallery was thronged. Artists queued up to copy it, writers to describe it. Some imagined they could hear its music.[19]

Now cleaned and well lit, Titian's *Assunta* is no longer a pilgrimage piece. As happens to all successfully original works of art, its impact has to some extent been diluted by its influence. Titian would be dismayed to know that the more popular painting in the Frari is Giovanni Bellini's neo-Byzantine *Sacred Conversation* in the sacristy. But if you stand for a while, perhaps on a winter's afternoon when you might have the church all to yourself, and watch Titian's Virgin flying up to heaven beyond the apse, you will notice a detail that sometimes escapes attention: one of the angels flanking God the Father holds a crown. It is with this that He will crown the Virgin, the protector of Venice, as Queen of Heaven, just as He had made Venice, at the end of the long wars of Cambrai, once again queen of cities. It was a time for Allelujas. And if you listen to the painting you may hear

a chorus singing in the monks' choir, accompanied perhaps by both church organs.

The unveiling took place on 19 May 1518. It was San Bernardino's day, a public holiday, chosen to allow members of the government to attend. We know the date from Sanudo, whose maddeningly laconic diary entry however tells us nothing more than what we can see from Titian's signature, 'Ticianus', and the inscription on the frame that records Brother Germano's inspired patronage: 'In 1516 Fra Germano arranged for the building of his altar to the Virgin Mother of the Eternal Creator assumed into Heaven.' But Sanudo's presence at the ceremony indicates that it was an important social event, attended by foreign dignitaries and members of government in their black togas or the brightly coloured robes and stoles worn by those who held high office. The papal legate to Venice, Altobello Averoldi, was evidently impressed: five months later he ordered an altarpiece from Titian for a church in his native city, Brescia. The following year Titian's first private patron Jacopo Pesaro, to whom Fra Germano had recently conceded patronage rights to an altar in the left nave of the Frari, commissioned Titian to paint the altarpiece for it. Even before the formal unveiling, enthusiastic descriptions of the *Assunta* in progress may have reached the ears of Alfonso d'Este, Duke of Ferrara, a keen patron of contemporary artists who had, however, so far failed to recognize Titian as a painter of the first order.

Titian had worked for the duke in 1516, when he lodged with two assistants in the ducal castle from 22 February until the end of March. (The ducal account book of expenditure for that period records that the party was provided with salad, salted meat, oil, chestnuts, oranges, tallow candles, cheese and five measures of wine.) The visit may have had a diplomatic purpose. As the war of Cambrai drew to a close, the Duchy of Ferrara had been linked to its former enemy Venice by the Franco-Venetian treaty negotiated at Blois in the spring of 1513. After the decisive battle at Marignano in 1515, the pope, Leo X, had no choice but to side with the victorious Francis I, who had taken Alfonso under his wing and was conducting exploratory negotiations about the possibility of restoring Reggio and Modena to Ferrara.

Alfonso, who owed allegiance to both pope and emperor but who had more reason to fear the territorial ambitions of the pope, had minted gold coins the reverses of which were inscribed in Latin with the concluding words of the episode told in the three Synoptic Gospels about a Pharisee who, trying to trick Christ, asked: 'Is it lawful for us to give tribute unto Caesar, or no?' And Christ replied: 'Show me a penny. Whose image and superscription hath it? They answered, and said Caesar's. And He said unto them, Render therefore unto Caesar the things which be Caesar's, and unto God the things which be God's.'[20] This was the story the duke chose for Titian to paint on the door of a cabinet in which he kept his minted coins and collection of antique Roman coins and medals. It was a very rare subject. Titian's *Tribute Money* (Dresden, Gemäldegalerie), indeed, was the earliest Italian rendering of it, and he pulled out all the stops to produce a picture that would allude to the antiquarian interests of the Este dynasty and give an added dimension to the precious contents of the cabinet.

The *Tribute Money* is Titian's sleekest, most polished early work. Ridolfi claimed that when the emperor Charles V's envoy to Ferrara saw it several years later he expressed his surprise that anyone could compete so successfully with Dürer. Vasari – who may have been recording Titian's opinion rather than his own – described the head of Christ as 'stupendous and miraculous', and wrote that all artists who saw it considered it the most perfect painting Titian had ever produced. Although court painters did not normally sign pictures, this was the first of several works for the Duke of Ferrara that Titian, perhaps to emphasize that he was not a court painter, signed 'TICIANUS F'. He placed his signature on the collar of the Pharisee; and if, as has been suggested,[21] this malign figure is a self-portrait, the joke seems remarkably intimate coming from a young painter working for his first foreign prince.

In 1517 Titian received another diplomatic commission from the Venetian government. It was a painting, now lost, of St George, St Michael and St Theodore, which was sent as an official gift to Odet de Foix, the Seigneur de Lautrec, who had commanded the French army

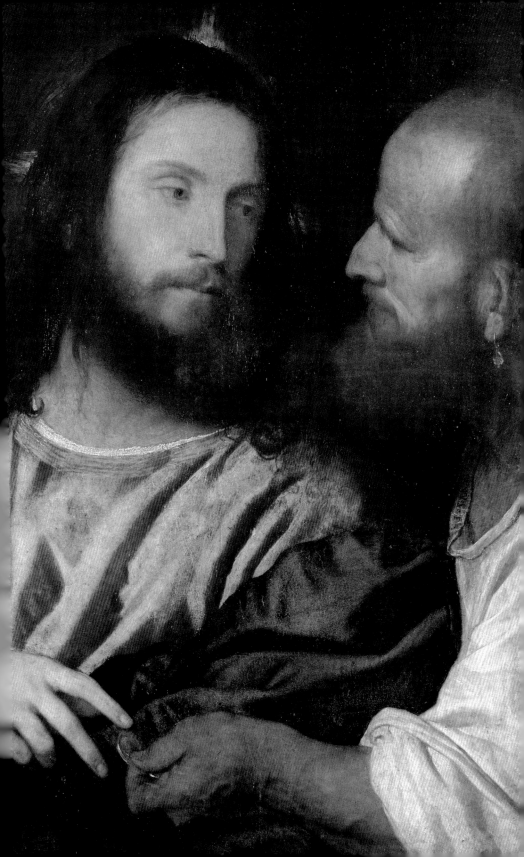

previous page: Tribute Money, panel, 75 x 56 cm

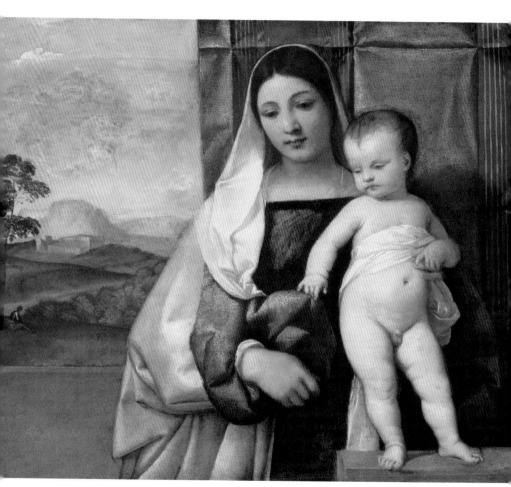

Gypsy Madonna, panel, 63.4 x 81.8 cm

Man with a Blue Sleeve, canvas, 81.2 x 66.3 cm

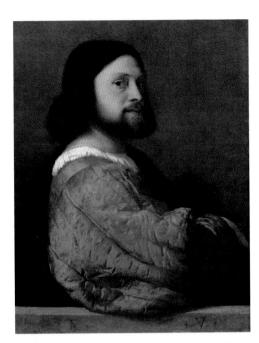

Miracle of the Speaking Babe, fresco, 340 x 355 cm

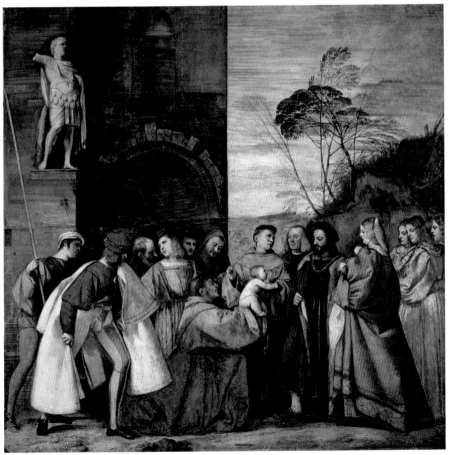

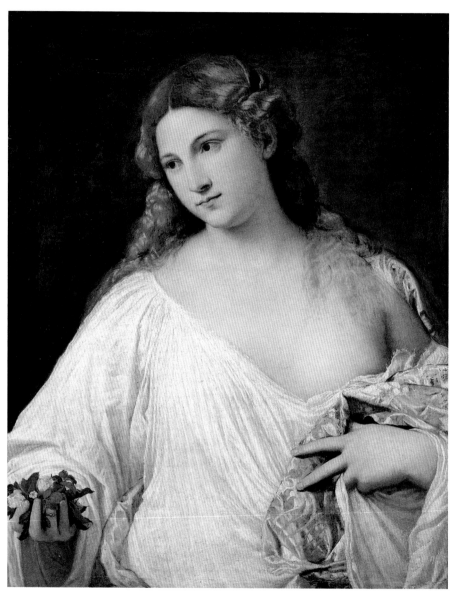

Flora, canvas, 79.7 x 63.5 cm

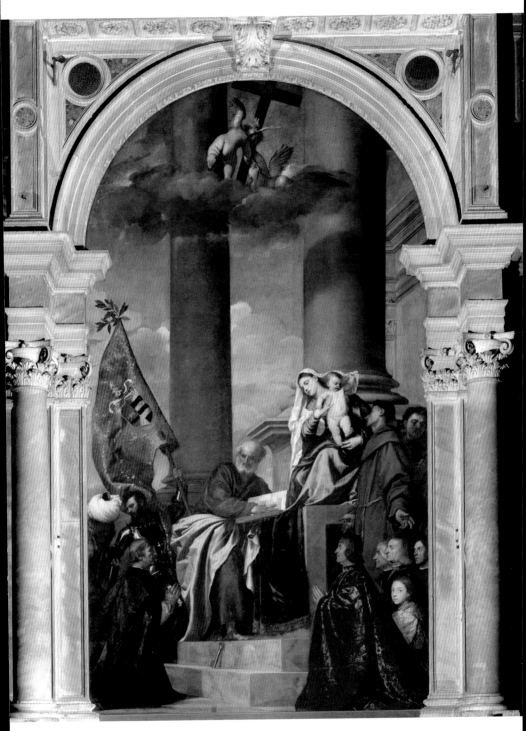

Pesaro Altarpiece, canvas, 478 x 266 cm

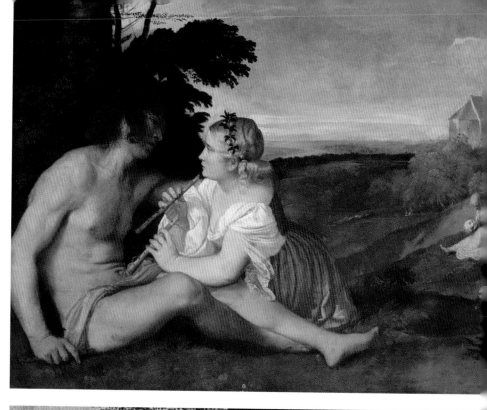

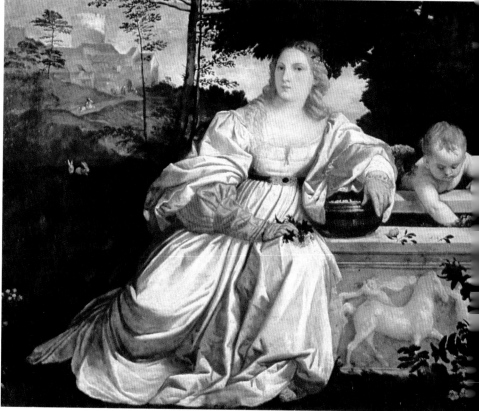

Three Ages of Man, canvas, 90 x 151.7 cm

overleaf: Assumption of the Virgin, panel, 690 x 360 cm

Sacred and Profane Love, canvas, 118 x 279 cm

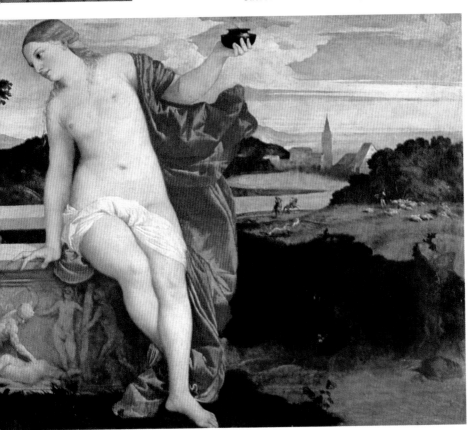

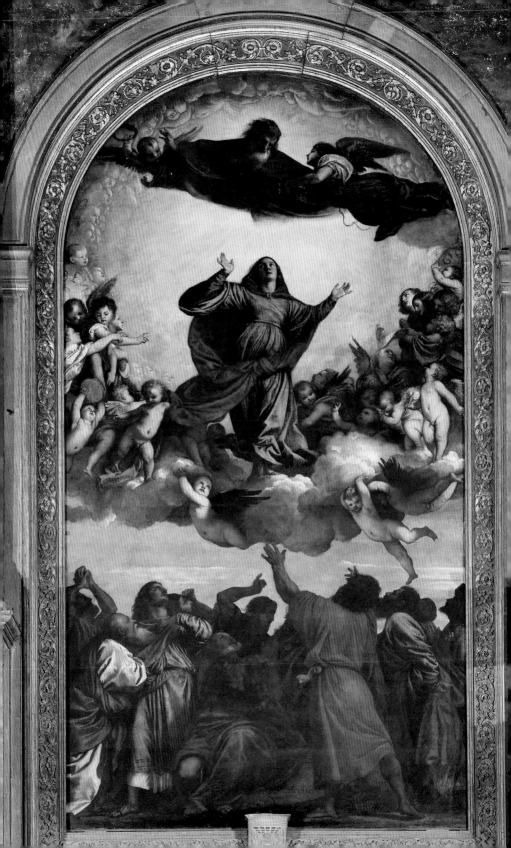

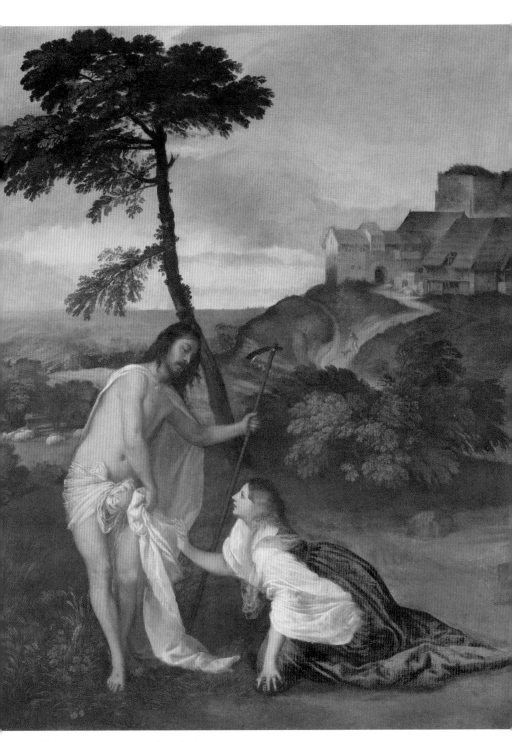

Noli me tangere, canvas, 110.5 x 91.9 cm

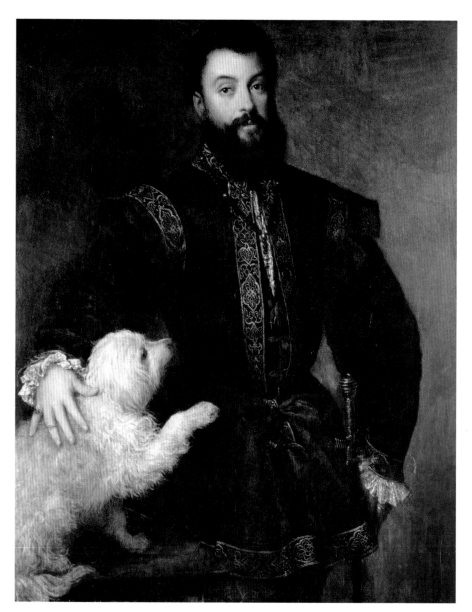

Federico Gonzaga, panel, 125 x 99 cm

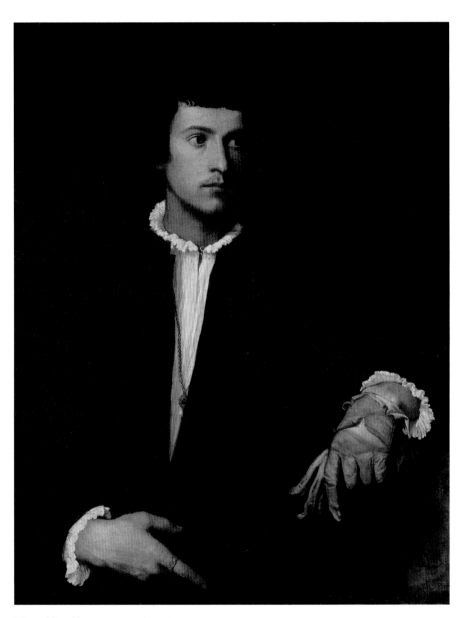

Man with a Glove, canvas, 100 x 89 cm

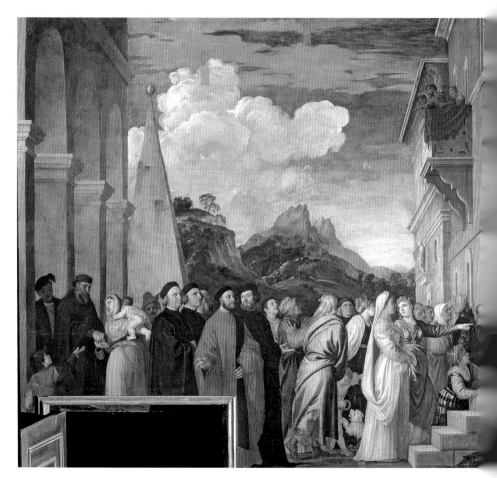

Presentation of the Virgin, canvas, 335 x 775 cm

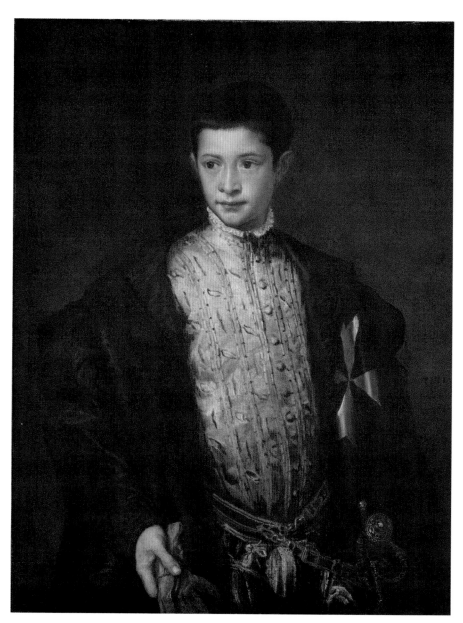

Ranuccio Farnese, canvas, 89.4 x 73.5 cm

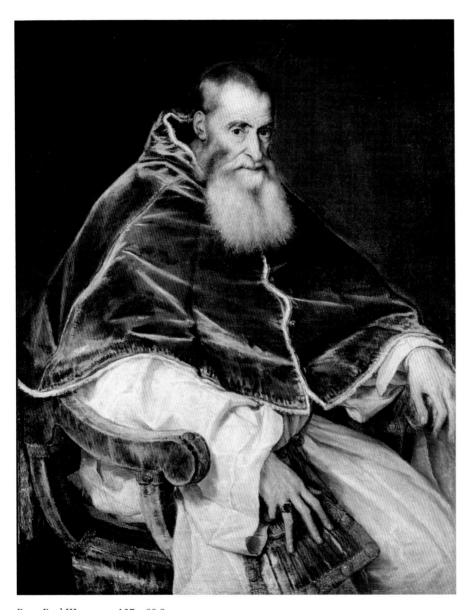

Pope Paul III, canvas, 137 x 88.8 cm

overleaf: Pietro Aretino, canvas, 96.7 x 76.6 cm

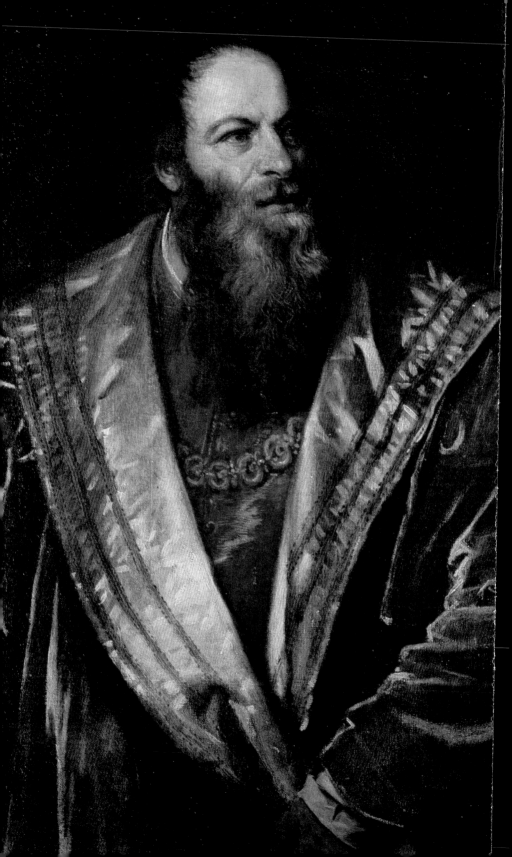

at Marignano and was now governor of Milan. Titian was also doing small jobs for Alfonso d'Este, who in August of that year paid him forty-eight lire for a sketch of a bronze horse. Early in the following winter Alfonso, who was planning to rebuild part of his castle, asked Titian to send him a sketch of a Venetian balcony and to supply him with a painting for the ducal bathroom of nymphs bathing. Titian responded to these requests with a letter – it is not in his own hand-writing – saying that if his sketches of the balcony were not satisfactory he would do others because he was dedicated, breath, body and soul, to serving His Excellency, and he was honoured to obey him whenever and in whatever way he commanded. As for the Bathing Scene, he had not forgotten it, indeed he was working on it daily and the duke need only let him know when he would like it sent.

But a few weeks later Alfonso was persuaded by reports of the *Assunta* to cancel the Bathing Scene and to offer Titian a much more ambitious commission. On 1 April 1518, in a letter addressed to 'the Most Illustrious and Excellent Lord, my Lord Duke of Ferrara' and written by the same hand as the earlier letter about the balcony, Titian acknowledged receipt of a canvas, stretcher and instructions for a painting. Titian's intellectually sophisticated ghost wrote that he found the subject so beautiful and ingenious that the more he thought about it the more he became convinced that the grandeur of the art of the antique painters was due to the generosity of great princes, who had allowed painters to take the credit for works of art which merely gave shape to the ingenuity and spirit of those who had commissioned them. To say that the soul of a work of art resided in its patron while the artist was merely the physical agent was an extraordinary conceit and certainly not one that would have occurred to any painter, let alone one as proud of his powers of invention as Titian. (Giovanni Bellini had refused outright to paint a subject according to a programme described to him by Isabella d'Este.) So whoever composed that letter must have been a friend whose judgement Titian trusted absolutely. Although there is no way of proving the identity of the author of the letter, the most likely candidate is Andrea Navagero, the poet and classical scholar who had persuaded Titian to refuse

Bembo's invitation to Rome in 1513 and who had himself recently returned from Rome to Venice.[22]

On 22 April Jacopo Tebaldi, the Ferrarese ambassador in Venice, reported to the duke that he had paid a visit to Titian. He had given him the 'the sketch of that little figure' and Titian had taken note of the duke's further instructions for his painting. Titian wanted to know exactly where the duke proposed to hang it in relation to the other pictures in the room,[23] and he promised to begin work on it that very morning. There is no record of Alfonso's reply. Perhaps he took the opportunity to answer Titian's question about where the picture would hang, and to see the *Assunta* with his own eyes when he paid a visit to Venice in early June. We can be sure that the duke nagged the painter in person – the sight of Titian's astonishing painting of the Virgin flying up to heaven surrounded by angels can only have inflamed his natural impatience – and that Titian disarmed him with his usual courteous but disingenuous assurances that he would make the painting a priority.

If Titian hoped that the government would continue to excuse his failure to make progress with the battle scene while he satisfied the demands of the Duke of Ferrara, he was mistaken. On 3 July 1518 he received a stern warning from the Salt Office. Unless he began immediately on the canvas for the Great Council Hall, which had been neglected for so many years, and unless he continued to work on it until it was finished, their magnificences would have it painted by another artist at Titian's expense. Titian, who had reason to be confident that there was no other artist capable of or even willing to attempt a painting for the difficult site between the windows facing on to the Grand Canal, seems to have deflected the threat by agreeing to complete Giovanni Bellini's unfinished *Submission of Barbarossa*,[24] which he did not actually get around to for another four years. His private practice was busier than ever before. His mind was racing with fresher and more compelling ideas. Titian would not be rushed, either by his own government or by the Duke of Ferrara.

He did not complete Alfonso d'Este's painting until January 1520, twenty months after he had promised to begin it 'that very morning'.

It would be the first of three canvases for the duke with which the artist who had transformed Christian art with his Ascending Virgin surrounded by angels breathed new life into painted fables about the orgiastic revels of pagan gods and goddesses and their freedom to behave in ways that mortal men could only relive in their classically inspired imaginations. For the *Worship of Venus* (Madrid, Prado) he borrowed his own baby angels from the *Assunta* and let them loose in an apple orchard where he turned them into a swarm of unruly little pagan cupids tumbling and flying about, gathering and throwing apples, shooting arrows, wrestling, hugging, kissing and dancing before a statue of Venus, the goddess of uninhibited sexual love.[25]

Titian's life was about to take a new turn, one that would lead him to international fame and place Venice on the map as an artistic centre to rival the glory days of Florence and Rome. He had never lacked confidence, but now, as he entered his thirties, he knew this about himself: he was more than ready to work for the greatest princely collectors, but he would do so at his own pace; and if he was required to spend time at their glittering courts, he would never stay long enough to be anyone's court painter, always returning as soon as possible to Republican Venice.

PART II

1518–1530

Look at the 'Bacchanals' in Madrid, or at the 'Bacchus and
Ariadne' in the National Gallery. How brim-full they are of
exuberant joy! You see no sign of a struggle of inner and
outer conditions, but life so free so strong, so glowing, that
it almost intoxicates. They are truly Dionysiac, Bacchanalian
triumphs – the triumph of life over the ghosts that love the
gloom and chill and hate the sun.

BERNARD BERENSON, *ITALIAN PAINTERS
OF THE RENAISSANCE*, 1938

Alfonso d'Este, Duke of Ferrara

You see, the Cupids are gathering apples, and you might be surprised
at their numbers, but that they are the offspring of the nymphs and
govern all that is mortal, and their multitude is proportioned to the
varied desires of mankind ... They hang their golden arrows and
quivers on the boughs, and rove in swarms about the place ... Blue,
gold, or coloured are their wings, the hum of which is like music.
The baskets in which they throw the apples are of cornelian, emerald,
or pearl ... Ladders they need not, for they fly into the very heart of
the fruit; they dance and run, or rest, or sleep or sate themselves with
apples. Here are four of the loveliest of them. One throws an apple to
the other; a third shoots his arrow; but there is no wickedness in him
... The riddle which the painter gives us here to solve doubtless
expresses love and longing ...

PHILOSTRATUS, *IMAGINES*, THIRD CENTURY AD[1]

He who rests must take action and he who acts should take rest.

INSCRIPTION ON A CARVING BY ANTONIO LOMBARDO
FOR ALFONSO D'ESTE'S STUDY

Alfonso I d'Este, third Duke of Ferrara and the first in the chain of
Titian's aristocratic foreign patrons, was a rough diamond. He traced
his ancestry back to the knights of King Arthur's round table, but he
dressed carelessly, and his manner was gruff. He enjoyed playing

outrageous practical jokes and working with his hands. When he was a young man it was reported in the Venetian Senate that the heir to the dukedom of Ferrara had the habit of strolling about Ferrara stark naked – 'nudo, nudo'; it was also said that he had fathered several illegitimate children, and contracted syphilis. Even after he had inherited his title and with it the weighty responsibilities of ruling and defending a large and much-contested state, he continued in his spare time to enjoy carpentry, painting pottery, casting in bronze, constructing and playing musical instruments, maintaining a menagerie of exotic hunting animals, fishing for sturgeon in the lagoons at the mouth of the Po, and commissioning works of art.

His special passion and expertise lay in weapons of war, which he collected, designed and helped to construct. His personal device was a smouldering grenade, and he had his court painter Dosso Dossi paint him on a battlefield surrounded by heavy artillery. He nicknamed one of his favourite cannon *Il Diavolo*, the Devil. It may be the weapon with which he posed, his hand resting on its muzzle as though it were a pet dog, for Titian's first portrait of a foreign ruler.[2] Alfonso pioneered some of the new powerful models of guns and cannon that changed the nature of warfare in the Renaissance. The Battle of Ravenna fought on Easter Day 1512, in which he served on the French side as a soldier and technical adviser against a Spanish and papal army, was the most alarming demonstration yet seen of the killing power of gunpowder. The power and deployment of his artillery routed the enemy forces, but killed nearly as many French, with the unintended result that the French were for a time driven out of Italy.

Alfonso was twenty-nine in 1505 when he inherited the Duchy of Ferrara from his father Ercole. For all his eccentric ways he proved to be a reforming ruler of a government that had become corrupt, as well as a brave and resourceful soldier and a shrewd political strategist with an innate sense of timing that told him when it would be opportune to switch into or out of alliances with the larger powers that continually threatened the independence of his duchy. The city of Ferrara had been a self-governing papal fief for centuries before it fell under the control of the Este lords early in the thirteenth century. By

the time of Alfonso's rule the state comprised a vast hinterland, stretching 160 kilometres from the mineral-rich Apennines, where gold and silver were mined, through the productive farmlands of the Po Valley and on down to the Adriatic coast, the Po delta and the valuable salt marshes of Comacchio. It embraced the problematic towns of Reggio and Modena, which were historically imperial possessions. For most of Alfonso's reign Reggio and Modena were used as political currency in the quarrels between successive popes and emperors.

Five years after the death in childbirth of his first wife, Anna Sforza, daughter of the Duke of Milan, Alfonso bowed to the political necessity of marrying Pope Alexander VI's adored twenty-one-year-old daughter, Lucrezia Borgia, in the interests of warding off a threat by the pope to install his son Cesare as ruler of Ferrara. On the eve of their marriage in 1502 Lucrezia's dowry of 100,000 ducats in cash plus 75,000 in jewels and other valuables was carried into the city on seventy-two mules covered with the Borgia colours of black and yellow. Historians differ about how well founded Lucrezia's infamous reputation was – she was supposed to have murdered one or both of her previous husbands and to have had incestuous relations with her father and her brother Cesare. Whatever the truth of the dark rumours, as Duchess of Ferrara she contributed gaiety, fun and style to the court, surrounding herself with artists, musicians and writers – not least Pietro Bembo, who was one of her lovers, whether platonic or not we do not know. Her kindness and generosity won the hearts of the people and eventually, it seems, of her husband.

In 1508 Alfonso joined the League of Cambrai on a promise from Pope Julius II to rid the city of occupying Venetian troops and to restore Rovigo and the Polesine, which had been surrendered to Venice in 1484. In the early stages of the war he fought in person with the French against Venice at the Battle of Agnadello. His brother, Ippolito d'Este, who had been made a cardinal at the age of fourteen and was, like several of Julius' cardinals, a soldier and military strategist as well as a prince of the Church, assisted the emperor Maximilian with the initially successful siege of Padua. In December 1509 the two

brothers commanded a spectacularly successful naval battle at Poleselle on the Po near Rovigo in which a Venetian fleet was routed and all but destroyed. Celebrated by the poet Ludovico Ariosto, who was in the service of Ippolito at the time, it was a turning point in the Cambrai war. But when, less than two years after the resounding Venetian defeat at Agnadello, Venice accepted Julius II's invitation to join a Holy League against France, which the pope now perceived as the greater threat to the stability of Italy, Alfonso refused to join Julius and stuck by his French alliance.

Julius, the 'papa terribile', was easily enraged by opposition. Machiavelli described him in *The Prince* as 'impetuous in everything', a man who 'found the time and circumstances so favourable to his way of proceeding that he always met with success'. Vasari said of Raphael's wonderful portrait of him painted when he was an old man that it made all who saw it tremble. This was the pope who had fathered three daughters while a cardinal, and who, dressed in silver papal armour, had led his troops in mostly successful conquests of cities which resisted his authority. Not a man to cross, he excommunicated Alfonso, imposed an interdict on Ferrara and, in February 1511 – the coldest winter in living memory – ordered two of his cardinal commanders to lay siege to the city. 'I want Ferrara,' he declared to the assembled troops. 'I would rather die like a dog than ever give it up … And if by any chance I am beaten, then I will raise another army and so wear out [the French] that I'll chase them out of Italy.'[3] The interdict hurt, but the siege failed. Alfonso outmanoeuvred the papal troops, inflicted heavy losses on them while the lives of his own men were largely spared, and seized the enemy banners and guns. Julius retreated. Ferrara, in any case, was so well fortified in 1511 that a French commander described it as the greatest fortress in Christianity.[4] Alfonso had further grounds for satisfaction in May when an occupying papal army was driven out of Bologna by French troops with the support of the people. In December the citizens of Bologna celebrated by toppling Michelangelo's enormous bronze statue of Pope Julius from its pedestal on the façade of the church of San Petronio. Some of the metal was taken to Ferrara, where, so the

story went, Alfonso kept the head for his collection and had the rest melted down and reforged as a cannon, which he named *La Giulia*.

Nevertheless, the disastrous Pyrrhic victory on Easter Day 1512 at Ravenna, in which Alfonso played such a crucial role, put him in an exposed position and left him in economic difficulties. With his only allies, the French, temporarily driven out of Italy it would not be long before the papal armies attacked. The cost of refortifying Ferrara had to be met by selling off some of the ducal treasures, including some of Lucrezia Borgia's jewels. When the table silver went too, the court was reduced to dining on ceramic plates and vessels painted by the ducal hand. By June Alfonso recognized the need to make his peace with the pope. Julius provided safe conduct as he travelled to Rome, accompanied by Ludovico Ariosto, to attempt reconciliation with the irate pope. While in the Holy City he took time off to inspect the Sistine Chapel ceiling, climbing the scaffolding with Michelangelo, whom he begged, unsuccessfully, to paint something for him. But he refused to listen to the pope's demands, and the pope refused to be pacified. Alfonso and Ariosto were obliged to flee. Fearing for their lives and living rough, disguised sometimes as priests, sometimes as peasants, they made their way home through Umbria and Tuscany. Julius died in 1513, shortly after Alfonso had returned to Ferrara. But any hopes that the apparently more peaceable Medici pope Leo X would prove less of a threat to Ferrara were soon dashed. Leo, as it turned out, was as obsessed with regaining Ferrara for the papacy as his more openly bellicose predecessor.

While Ferrara remained on a war footing, the warrior duke found time to indulge his keen appetite for acquiring and commissioning works of art. It was a passion he shared with his elder sister Isabella, Marchioness of Mantua and one of the most astute and formidable Renaissance politicians and patrons of art and learning. Their ancestors had collected antiquities and Flemish paintings and nurtured a school of Ferrarese painting that included Cosmè Tura, Francesco del Cossa and Ercole de' Roberti. Immediately after the death of his father, Alfonso began to rearrange and decorate the rooms he had chosen to be his private quarters in the long elevated building known

as the Via Coperta, which links the castle to the ducal palace.[5] A year or two later he brought to Ferrara the sculptor Antonio Lombardo,[6] who spent two or three years carving beautiful relief sculptures for rooms described in later inventories as *camerini d'alabastro*, little alabaster chambers. One of them, a study next to the duke's bedroom that was entirely lined with Antonio's marble carvings, was unique in Italy.[7] Some of the larger panels depict mythological scenes in high relief. Some, of birds and animals, are in low relief. Inscriptions note that the duke's study was a space for rest, relaxation and quiet contemplation – the necessary complements to action for Renaissance man.

Alfonso's court painter Dosso Dossi and Dosso's brother Battista – the sons of a land agent to the court – decorated the rooms in the Via Coperta with painted ceilings and friezes. But it was not until Ferrara was at peace with Venice after the spring of 1513 that the duke was in a position to begin to realize his most ambitious project. It was for a small, intimate room that would be a private showcase for the best representatives of the three principal schools of Italian painting: Giovanni Bellini for Venice, Raphael for Rome, Fra Bartolommeo for Florence, all painters whose works he had admired on his travels. The prototype for such a room was Isabella's *studiolo* in the ducal castle at Mantua, for which she had commissioned two paintings by Mantegna, one by Perugino and two by Lorenzo Costa, all illustrating subjects from classical antiquity. (She had tried unsuccessfully to persuade Leonardo to contribute a painting. Giovanni Bellini also refused because the terms of her commission did not provide him with enough freedom.) Although Alfonso's taste was by no means untutored – he had travelled widely and had an even more perceptive and independent eye than his glamorous and domineering bluestocking sister – he was without intellectual pretensions. Nevertheless, like his nephew, Isabella's son Federico Gonzaga, and his political ally Francis I – and, for that matter, many twenty-first-century tycoon collectors – he was interested in employing top names.

He overlooked Titian in the first instance in favour of the more famous Giovanni Bellini, who agreed to paint the *Feast of the Gods*.

Giovanni took as his source a free translation of a story from Ovid's poetic calendar, the *Fasti*, about a feast given by Cybele, goddess of the harvest and fertility, at which Priapus' attempted rape of the sleeping nymph Lotis is foiled when Silenus' ass brays and wakes her. (Priapus has the ass killed for interfering with his right to satisfy his sexual appetite.) He conflated two separate episodes of the story (which may be the explanation for a subsequent attempt by another painter to bring the figures more in line with one of Ovid's originals). The frieze-like arrangement of his feasting Olympian deities may have been intended to conform with Antonio Lombardo's sculptures. Giovanni set them against a forest with tree trunks extending across the width of the picture, which was later cancelled by repaintings by Dosso Dossi and finally by Titian. But the painting, even after Giovanni had been requested, presumably by Alfonso, to eroticize the goddesses by revising their postures and lowering their necklines, lacks sex appeal.

Giovanni had finished and signed the *Feast of the Gods* by 4 November 1514 when he received a payment of eighty-five ducats. Three years later Alfonso began to plan a radical rebuilding of the Via Coperta. He was impatient to see, on either side of the *Feast of the Gods*, a *Worship of Venus*, which he had commissioned from Fra Bartolommeo, and a *Triumph of Bacchus* promised by Raphael. An exciting source of subjects was available to him in the first ever translation into Italian of the *Imagines* (the *Eikones* in Greek) written in the third century AD by the Greek writer Philostratus.[8] The translation by the scholar Demetrios Moschus had been commissioned by Isabella, who had given it to her brother on loan.[9] Philostratus described in detail sixty-four paintings he purported to have seen in a house outside Naples. No one in the Renaissance had ever seen antique paintings, and since few if any painters could read Philostratus in the original Greek, Isabella's translation was a treasure trove of ideas.

Fra Bartolommeo and Raphael sent sketches of their respective subjects. But Fra Bartolommeo died on 31 October 1517 before he could make a start on his painting. Raphael was given an advance payment early in 1518, but then prevaricated. Alfonso hounded him

through his agents in Rome, who found it increasingly difficult to make contact with that prince of painters. Alfonso flew into rages. Raphael tried to assuage his anger with gifts of preliminary cartoons for some of his other paintings. But in September 1518 Alfonso instructed one of his agents to find Raphael and advise him that his evasive behaviour was not the proper way to treat a person such as himself and if he didn't do his duty, and soon, he would regret it. The correspondence continued in January and March of 1520. And then, on 6 April of that year, in the night of Good Friday, Raphael died, probably from overwork, at the untimely age of thirty-seven.

Titian had agreed in the previous year to take over Fra Bartolommeo's subject and to base his painting on that painter's sketch and on the description by Philostratus of cupids playing love games in front of a statue of Venus. But, although outwardly more accommodating than the more famous Raphael, he also prevaricated. The success of the Frari *Assunta* had attracted other commissions, and his studio was crowded with works in progress. When in late September 1519 he had still not delivered the painting he had promised a year and half earlier to begin that very morning the enraged Alfonso instructed his ambassador in Venice, Jacopo Tebaldi, to warn 'the painter' that it was high time he finished 'that picture of ours'. The ambassador had to find Titian as soon as possible and tell him in no uncertain terms that he, the Duke of Ferrara, didn't like to be disappointed. Tebaldi replied on 3 October that he had been looking for Titian but had been told by his neighbours that he had gone to Padua, promising that on his return he would finish the duke's picture. A week later Tebaldi informed the duke that Titian had given his word that he would come to Ferrara with the picture, which he would finish in situ once he had seen where it was to hang and in what light. But, he added, he had heard by word of mouth that the reason for the delay was that Titian was working on a painting for the Very Reverend —— and that Titian did not deny the rumour.

The name of the Very Reverend is missing from Tebaldi's letter, which was later damaged by fire. But we know that it was Altobello Averoldi, the papal legate to Venice and a member of the nobility of

Brescia, the gun-manufacturing town on the westernmost edge of the Venetian terraferma. As papal legate Averoldi had made it his business to smooth relations between Venice and Rome after the Cambrai war. Titian had gone to Padua, probably encouraged by the Venetian government, to discuss with him a painting for the high altar of the Brescian church of Santi Nazaro e Celso, of which Averoldi was provost. While Titian was in Padua discussing the Brescian commission Averoldi's arch-rival, Broccardo Malchiostro, the canon of the cathedral of Treviso, was celebrating the completion of a new chapel, dedicated to the Virgin Annunciate. We don't know exactly when Malchiostro began the decorations of the chapel, but his choice of Titian to paint an Annunciation for its altar (still in situ) may have been motivated by his intense jealousy of Averoldi – the mutual detestation of the two prelates was such that they had once come to blows during a church service. Malchiostro was in fact generally disliked. His extreme vanity is evident from the frequency with which the Malchiostro coat of arms and initials appeared in the chapel and on Titian's painting. It was also considered inappropriate that he had Titian paint him as the donor facing worshippers at the altar, rather than in the usual position kneeling in profile. But the awkward and apparently malign figure of Malchiostro lurking outside the columns is evidence not of Titian's judgement of the canon's character but of a repainting by another hand after the picture had been attacked by vandals not long after it was finished.

Although Titian, who presumably worked alternately on the Averoldi and Malchiostro commissions, gave less of his attention to Malchiostro's *Annunciation* than to the altarpiece for the papal legate, the Treviso altarpiece was his first treatment of its subject and is full of original ideas. The fictive architecture extends the real space of the chapel; the asymmetrical composition anticipates the *Pesaro Madonna* in the Frari; and the child angel skidding down the elongated perspective of the floor approaches the Virgin from behind, an unusual relationship that was later adopted by Lorenzo Lotto. But the painting doesn't really work, and looks as though Titian tossed it off in a hurry, probably with assistance.

He was far more inspired by a commission from another foreigner, one that carried a political message that would not have been lost on those who saw it after Titian had completed it in 1520. This was the *Madonna in Glory with Sts Francis and Blaise and the Donor Alvise Gozzi* (Ancona, Museo Civico) over the high altar of the church of San Francesco in Ancona. Alvise Gozzi was a nobleman and merchant originally from Ragusa (now Dubrovnik) who had settled in Ancona and made frequent business trips to Venice, where he must have seen Titian's Frari *Assunta*. Ancona and Ragusa, which face the Adriatic from opposite sides, had long been required to pay Venice for the privilege of trading in Venetian waters, until in 1510 Pope Julius II, in gratitude for Ancona's loyalty during the Cambrai war, granted that city the right to trade without paying tribute to Venice. By the time Titian painted Gozzi's altarpiece, the war was over and Venice was once again queen of the Adriatic. The painting is thus a celebration of the renewed hegemony of Venice, of which Titian painted the skyline in the background. St Blaise, patron saint of Ragusa, places one arm around the shoulder of the donor while pointing upwards at the Madonna in Glory, protector of the Republic of Venice, who gazes down from a golden sky on St Francis, patron of the church but also of the city of Ancona. Although Titian modelled the composition on Raphael's *Madonna of Foligno* (c. 1512), his version, with its dynamic figures and spellbinding view of Venice, one of the most hauntingly beautiful passages he ever painted, has an emotional depth and a unity of space and colour that are in an altogether different key from Raphael's more contemplative prototype.

When he was in Venice Titian worked from time to time on the San Nicolò ai Frari altarpiece, which he had grabbed from Paris Bordone, and for which he thriftily reused the panel on which he had begun the Bathing Scene for Alfonso d'Este. The informal grouping of the saints recalls those in the more successful Gozzi altarpiece, but he didn't actually finish the upper part of the painting, and then with the help of an assistant, until the early 1530s when he transformed it into the *Madonna in Glory with Six Saints* (Vatican City, Pinacoteca Vaticana).[10] He did, however, make a start on a more compelling commission, the

second from his old patron Jacopo Pesaro, who wanted another cele-
bration of his victory over the Turks in 1502 – the highpoint in his
otherwise unmemorable career – this one for the altar, which had
recently been granted to the Pesaro family, in the left nave of the Frari.
It was a demanding and unusual order, and not well paid – the instal-
ments Titian received over the seven years it took him to complete the
painting amounted to only 102 ducats. But it gave him a second
opportunity to show in the prominent church dominated from the
high altar by his *Assunta*. Judging by the outcome, which was in its
different way as innovative and subsequently influential as the
Assunta, the *Pesaro Madonna* was often on his mind in the next seven
years, during which he made three radical changes to its composition.
In April and June 1519 he acknowledged his first two payments of ten
ducats each from 'Monsignor the Bishop of Baffo [Baffo was short for
Paphos] of the House of Pesaro'. Since it was his usual practice to
begin work on a painting after he had received a down payment, we
can assume that he made a start on the altarpiece that summer, or at
least by 22 September 1519 when he issued a receipt for six ducats to
cover the costs of the canvas and stretcher.

In October Titian arrived at long last in Ferrara with two assistants
and his unfinished painting for the duke – the court expense account
records that his journey from Venice cost four lire. He spent the better
part of the next three months there, as the fog of winter settled on the
city, completing the *Worship of Venus* in situ. Ferrara is only ninety
kilometres south of Venice but in those days it seemed another world.
With a population of no more than 30,000, some 2,000 of whom were
employed by the court, it was much smaller but not much less cosmo-
politan, prosperous or busy than Venice. Alfonso's father, the spend-
thrift Duke Ercole I, had trebled the size of his city, adding to the old,
cramped medieval centre a spacious garden suburb complete with
orchards, religious establishments, palaces, villas, a hunting park, a
racecourse and some twelve new churches, all enclosed in a massive
circuit of defensive walls. A tributary of the Po curved around the
gloomy fourteenth-century castle, in which two of the duke's

brothers, following a plot to assassinate him, were imprisoned for life in windowless dungeons. Over the coming years, Titian, arriving by barge towed upstream along the Po with his precious cargos of canvases, rolled and packed in specially built crates wrapped in waxed cloth, would become accustomed to the sight of the walls and towers of Ferrara looming across the fields from the port of Francolino. But coming as he did from a city with no court and no need of a castle or walls, his first visits to the best-defended court in Christendom must have been something of a culture shock.

The Francophile Este modelled their court on the royal courts of Burgundy and France. Although Ferrara might have seemed provincial by comparison, it was a lively and important centre of artistic activity, learning, literature, theatre, music and other courtly pleasures. Life there was a round of expensive and showy entertainments of the kind that were discouraged in Venice by sumptuary laws and by perpetual reminders to refrain from conspicuous consumption in the name of God and country. The courtiers of Ferrara, by contrast, were required to dress lavishly; clothes, indeed, were a courtier's single biggest investment. They went jousting and hunting with cheetahs, leopards and panthers. They played real tennis, gambled on the horses and feasted at banquets where course after course of delicacies was served between dancing, concerts performed by Alfonso's orchestra of thirty musicians and theatrical productions. Alfonso's gluttonous cardinal brother Ippolito, who liked to be watched by an audience while he stuffed himself, died in 1520, aged only forty-one, of excessive consumption of roasted crayfish and vernaccia wine. After his death an inventory of his possessions itemized more than one hundred carnival disguises.[11]

Alfonso d'Este gave Titian his first opportunity to satisfy the courtly taste for large painted fables about the sexual exploits of the pagan gods and goddesses. It was a demand that did not exist in Republican Venice, where the preference of private patrons was for pretty girls whose classical disguises were really beside the point. And Titian, who had no previous experience of aristocratic courts, and whose imagination was uncluttered by the first-hand study of the

Roman antiquities that was supposed to be an essential part of a Renaissance painter's education, brought an unprecedented freshness and vitality to the inventions he devised for Alfonso's pleasure, using colour and movement rather than narrative to shape his monumental figures. Without having seen or read the originals he unearthed the very spirit of the antique sculptures and stories in a way that established the interpretation of classical myths for subsequent artists, and especially for his most ardent follower, Rubens. The more experienced and conventionally educated Fra Bartolommeo and Raphael would doubtless have produced magnificent paintings for the duke. But they might have looked academic in comparison with Titian's wholly original, dramatically exciting representations, which continue even today to remind us that those old myths spun by the writers of ancient Greece and Rome lasted as long as they did because they were cracking good stories.

Titian was not the only groundbreaking artist employed by Alfonso's court in the 1520s. Another, the pioneering Netherlandish composer Adrian Willaert, the European master of the new polyphony, is today of interest only to specialists. But the Ferrarese poet and dramatist Ludovico Ariosto[12] is still read, and his vast epic poem, *Orlando Furioso* (Mad Roland), first published in 1516 when the poet was in the service of Ippolito, remains the most romantic and entertaining of all the many versions told over the centuries of the tale of the Carolingian knight who was driven mad by his unrequited love for the princess Angelica. Ariosto, however, paid homage to his employers by making Ruggiero, the virtuous warrior and supposed founder of the Este dynasty, the true hero of his story. The poem is so close in spirit to Titian's poetic paintings that Ridolfi invented a tradition according to which the painter-poet and the poet-painter enjoyed an intellectual partnership: 'Thus, painting fulfils the function of mute poetry, and poetry acts as loquacious painting.' He described an illustration of their companionable relationship, which he claimed would have decorated the catafalque to a plan (never realized) for Titian's funeral, in which Alfonso, with attendant pages, sat listening to Ariosto read aloud while watching Titian paint at his easel.

The poet and painter must have met at least by 1522 or 1523 when Titian portrayed Ariosto as one of a group of prominent men in a canvas, now lost, for the doge's palace.[13] But, although Ariosto may well have advised Titian and the duke about subjects and sources, he did not mention Titian in writing until the third and final edition of *Orlando Furioso*, revised with Bembo's help and published in 1532, in which 'the honour of Cadore' is listed – along with Mantegna, Leonardo, Giovanni Bellini, the Dossi brothers, Michelangelo and Sebastiano – as one of the greatest artists of the time.[14] Titian made a woodcut portrait of the poet for the frontispiece of that edition, but none of his surviving portraits that have been hopefully identified as Ariosto – the *Man with a Quilted Sleeve*, and the portraits of men in Indianapolis (Herron Art Institute) and New York (Metropolitan Museum) – look anything like the woodcut portrait, or for that matter like each other.

They may not have known one another particularly well in the 1520s when both men came and went to and from the court where Ariosto was often employed as an extraordinary ambassador. They were, however, certainly aware of one another, and shared, as well as a vigorously modern spirit, similar tastes in feminine beauty. The golden hair, dark eyes and eyebrows of some of Titian's models are the features that Ariosto most admired in women. For the last edition of *Orlando Furioso* he added a new story, in which the erotic charms of the heroine, Olimpia – her eyes, nose, cheeks, mouth, shoulders, hair, breasts, belly, hips, thighs and 'Those other parts which to conceal she tries'[15] – seem to echo the brazen sexuality of the women Titian painted for the Duke of Ferrara.

On 24 June 1519, in the summer before Titian came to Ferrara to finish his *Worship of Venus*, Lucrezia Borgia died in childbirth of puerperal fever. She was thirty-nine and had borne Alfonso eight children, four of whom would outlive him. Alfonso was beside her at her deathbed and was said to have fainted at her funeral. Nevertheless, at forty-three he knew himself well enough to see that without a consort he would return to his old whoring ways, which, according to his contemporary biographer,[16] he realized 'would not be good for

his reputation nor would it be safe for him to stain the honoured families of citizens with seductions and adultery'. So he took 'as his woman a person of decent habits and of dignified bearing who was, like himself, very fecund'. The woman was Laura Eustochia Dianti, known as *la bella berettarina* because she was the daughter of a hat maker. Nobody knew whether the duke ever made her his legitimate duchess. Vasari and Pietro Aretino thought they were married, but Alfonso described their two sons, born in 1527 and 1530 – and both confusingly named Alfonso – as the natural children of an unmarried woman. Titian's splendid (but now very ruined) *Portrait of Laura Dianti* (Kreuzlingen, Klisters Collection) could have been painted late in her first pregnancy.[17] At a time when childbirth was dangerous, Alfonso, who had lost both his wives to puerperal fever, must have feared for Laura's life and requested from Titian a record of her beauty. Whether or not she was the legitimate Duchess of Ferrara, the bleached skin in Titian's portrait, which he enjoyed contrasting with the black face of her charming little Ethiopian page, was a fashion that signified patrician purity, while her magnificent but provocatively dishevelled dress suggests a favoured mistress. Her piled-up hair is about to escape the pearl and gold headdress fashioned in the shape of a spray of laurel leaves. She has pushed up one sleeve of her jewel-studded blue dress, where Titian placed his signature on the armband.[18]

In the November after Titian's arrival in Ferrara he and Dosso Dossi made a short study visit to nearby Mantua, where they admired the Gonzaga Mantegnas and the paintings in Isabella d'Este's *studiolo* in the ducal palace. Alfonso, who had fallen seriously ill earlier in the month, was somewhat recovered when the two painters returned to his court on 22 November, although his lack of appetite worried his doctors. In January 1520 his condition was still weak enough to prompt Leo X to sponsor an attack on Ferrara and even to try to bribe a corruptible guardian of one of the gates to the city. The plot was foiled by Alfonso's nephew, Federico Gonzaga, the Marquis of Mantua, who had close papal connections and sent a warning through to Ferrara.

The *Worship of Venus* was finished by mid-January, when Titian returned to Venice. It is a close transcription of one of the pictures described in Demetrios Moschos's Italian translation of Philostratus' *Imagines*, which had been commissioned by Alfonso's sister Isabella d'Este: a classical divertissement in which rollicking little cupids imitate the joys and mysteries of every kind of adult erotic experience for a Renaissance patron who imagined he could see and hear in it the very heartbeat of the antique world. To one side of the action two courtesans dressed as nymphs worship a shrine of their patron goddess, the unchaste Venus.[19] The apples with which the cupids play their love games – plucking them from the tree tops, gathering them in bejewelled baskets, biting into them, playing catch with them – would have been interpreted by contemporaries as euphemisms for the female pudenda: in classical texts to catch an apple meant to be smitten with love. One of the cupids has captured a hare, symbol of fecundity, and seems to be riding it. Another bites the ear of his companion, an indication of rule-breaking or homoerotic love, in contrast with the cupids in the foreground happily throwing and catching their apples.

When Raphael died on 6 April without having made a start on the *Triumph of Bacchus*, the duke was so satisfied with Titian's work that he was perhaps not as distressed as he might have been. Raphael's pupils offered to take over his commission, but Alfonso refused the offer, demanded the return of his advance of fifty ducats, and transferred the order to Titian, from whom, however, he requested a different, more unusual episode from the Bacchanalian myth, the story of Bacchus and Ariadne. In Titian, however, the Duke of Ferrara had met his match. The painter's sense of humour was subtler than the duke's; he had better manners and more charm. He was every bit as wily and stubborn as his aristocratic patron, and he continued, just as he had started, to oblige him whenever he asked for small errands while working on the big commissions in his own good time. Now in his early thirties, his international reputation established by the *Assunta*, and the *Worship of Venus* admired by Alfonso d'Este's circle of influential friends, Titian knew that the duke needed him as much as he

needed the duke. And the duke, who would often be reduced to cajoling, threatening and trying to bribe Titian with favours – anything to get him to finish and deliver his paintings – never again referred to him as 'the painter'.

Bacchus and Ariadne

… Mad for you, Ariadne, flushed with love …
And, all around, the maenads pranced in frenzy …
Tossing their heads; some of them brandishing
The sacred vine-wreathed rod, some bandying
Gobbets of mangled bullock, others twining
Their waists with belts of writhing snakes …

CATULLUS, *CARMINA*, FIRST CENTURY BC[1]

He who wraps the vision in lights and shadows, in iridescent or
glowing colour, until form be half lost in pattern, may, as did
Titian in his 'Bacchus and Ariadne', create a talisman as powerfully
charged with intellectual virtue as though it were a jewel-studded
door of the city seen on Patmos.

W. B. YEATS, CITED BY RONALD SCHUCHARD, 'YEATS,
TITIAN AND THE NEW FRENCH PAINTING', 1989

As Alfonso d'Este's ambassador in Venice, Jacopo Tebaldi was
required to spend much of his time shadowing Titian. When Titian
was away Tebaldi made it his business to discover where, why and for
how long. When Titian was in Venice he haunted his studio. He
brought messages from the duke, and sent back up-to-the-minute
reports of Titian's replies, questions, moods and current state of
health. The more Titian procrastinated, the more obsessively the

duke pursued the painter he now recognized as an unequalled master, and the more Tebaldi had to use his diplomatic skills to see through Titian's excuses and think up ways of persuading him to deliver the paintings he had promised the duke. Tebaldi was no more interested in art than most ambassadors then or now, but he was a good detective. Not all of his correspondence with the duke survives, but enough remains to allow us, too, to follow Titian, sometimes week by week, over the next years; and to understand the forceful, self-assured, shrewd and charismatic personality of an artist born in a small house in the mountains who from then on would be pursued by the powerful rulers of his day.[2] Although we know nothing for certain about his physical appearance before the self-portraits painted when he was in his middle and late years, we can deduce from his relationship with the Duke of Ferrara that this was a man who knew his worth as an artist perhaps even more than he genuinely respected his social superiors.

In January 1520, after eighty-six days in Ferrara finishing the *Worship of Venus*, Titian returned to Venice. No sooner was he home again than Alfonso began making further demands on his time through Tebaldi. Titian's studio was crowded with works in progress. He was working concurrently on the altarpieces for Brescia, Ancona, the Frari and probably Treviso, as well as a number of portraits,[3] and, so the duke hoped, his *Bacchus and Ariadne*. But when Alfonso requested him to put down his brushes and arrange for a set of glasses to be made in Murano for the ducal table, Titian ordered the glasses and fixed on a price. The duke wished to know if the furnaces on Murano were capable of producing as well as glass the brightly painted tin-glazed pottery known as majolica ware. By 28 January Titian had prepared the design of a trial vase, which was successfully fired and shown to Tebaldi. On 5 and 11 February Titian and Tebaldi went to Murano where they drew up a contract for twelve vases to be delivered within eight days along with the glasses. The production of majolica had ceased in Ferrara during the Cambrai war, and Alfonso, determined to revive a craft that was particularly dear to his heart, turned to Titian for help. Titian found a master potter and sent him

to Ferrara. Then it seemed that there was no artisan in Ferrara who could be trusted with gilding the frame of the *Worship of Venus*. Titian persuaded an old, experienced master gilder he knew in Venice to go to Ferrara and gild the frame as well as the majolica jars in which the duke's spices were to be stored. So far Titian had accepted such distractions with good humour. He did not, however, conceal his irritation when he heard that an incompetent person had applied to his *Worship of Venus* a coat of varnish that had obscured and in places damaged its surface. He agreed to come to Ferrara to restore the painting, but there is no evidence that he did so.

Meanwhile, it reached the ear of the duke that a curiosity and talking point in Venice was an exotic animal imported by Giovanni Cornaro who kept it in his beautiful palace on the Grand Canal at San Maurizio. Alfonso wrote to his ambassador on 29 May:

> Messer Jacomo. Take care to speak immediately to Titian and tell him to do me a portrait as soon as possible and as though it were alive of an animal called gazelle, which is in the house of the most honourable Giovanni Cornaro. It should fill the entire canvas. Attend to this matter diligently and then send it to us immediately advising us of the cost. And remember to send those spice jars, which were supposed to be sent to us some days ago.

Tebaldi and Titian hastened to Palazzo Cornaro only to learn that the gazelle was dead and its body had been thrown in the canal. They were however shown a painting by Giovanni Bellini in which he had incorporated a portrait of the gazelle, and on 1 June Titian offered to make a copy of it for the duke. If Alfonso accepted the suggestion Titian's gazelle has disappeared, and the Bellini painting, of which there is no record, was presumably lost in the spectacular fire that destroyed the Cornaro palace in 1532.[4]

Although Titian was compliant enough to run such errands for the duke, the summer passed with no sign of the paintings he had agreed to provide before leaving Ferrara. Alfonso lost patience. On 17 November he wrote to Tebaldi:

Messer Jacomo. See to it that you speak to Titian, and tell him from us that when he left Ferrara he promised us many things, and up to now we have not seen that he has kept any of them, and among others he promised to do for us that canvas which we especially expect from him [the *Bacchus and Ariadne*]: and because it does not seem to us worthy of him that he should fail to keep his promises, urge him to behave in a way that will not give us cause to be saddened and angered with him, and to make sure above all that we have the above-mentioned canvas quickly.

Titian replied through Tebaldi that he had not received the canvas and stretcher or the measurements for the *Bacchus and Ariadne* and had therefore assumed that the duke no longer wanted it, but that once he had the necessary materials and information he would finish it by the next Ascension Day, which would fall in May.

Tebaldi knew perfectly well that Titian was playing for time while working instead on the papal legate's altarpiece for Brescia. It was common knowledge that he had finished one of the panels, a depiction of St Sebastian that was the talk of Venice. Tebaldi, who was not a high-ranking diplomat for nothing, wisely made a joke of it, telling Titian that his delaying tactics were every bit as clever as his paintings but that he might as well confess that having tasted priests' money he had lost interest in working for a mere duke. Titian replied that on the contrary he would do anything to please the duke; he would go so far as to make forged money for him. He would never leave the service of the duke, neither for priests nor for friars. He would stand day and night with paintbrush in hand to serve him. But, yes, it was true that he had worked very hard on the *St Sebastian*, which is in fact one of the few figures for which detailed preparatory drawings, in pen and brush, survive (Frankfurt am Main, Städelsches Kunstinstitut). He considered it to be the finest thing he had done up to that time, and itself worth every soldo of the 200 ducats he had been offered for the entire altarpiece.

Tebaldi decided that that he'd best see this great work for himself. In Titian's studio he found himself among a crowd of admirers gazing

at a painting of a muscular, twisting figure that was unprecedented in Venetian art, and which later became one of Titian's most celebrated and copied paintings. He had used as his model a side view of the famous Hellenistic sculpture of Laocoön, of which he would have had a reduced plaster copy in his studio, and may also have seen a sketch of Michelangelo's powerful *Rebellious Slave*, which had itself been inspired by the *Laocoön*. Whereas Florentine painters had achieved anatomical accuracy through dissections of human bodies and study of classical models, Titian, using only sketches and reduced models, had rivalled the greatest antique and contemporary sculpture in paint without seeing the originals in Rome. It was also moderately daring at a time when it was beginning to be considered indecorous to use pagan models for Christian subjects.[5] Tebaldi sent the duke the following description:

> The body is tied to a column[6] with one arm high up, the other low down. The whole figure writhes in such a way as to display almost all of the back. In all parts there is evidence of suffering, and all from one arrow that sticks in the middle of the body. I am no judge, because I do not understand drawing, but looking at the limbs and muscles the figure seems to me to be as natural as a corpse.

On 1 December Tebaldi reported to the duke that he had told Titian that he was throwing it away by giving it to a priest who would only take it off to Brescia. Privately Titian may have agreed. Averoldi had ordered a triptych, a format that had gone out of fashion in sophisticated artistic centres and was wasted on Titian, whose genius was for integrated composition. Nevertheless, when Tebaldi made the shocking, but perhaps not entirely unexpected, proposal that Titian should sell the *St Sebastian* to Alfonso and secretly replace it with a copy for Averoldi, Titian pretended to hesitate. The duke was excited by the thought of possessing a painting that had attracted so much admiration; and on 20 December, after further circuitous conversations with Titian, Tebaldi was able to convey the news that Titian had agreed to the scam, saying, 'The Duke may demand my poor life of me, and

although I would not carry out this swindle [*truffa*] against the Papal Legate for any man in the world, I would gladly do so for His Excellency if he were to pay me 60 ducats for the St Sebastian.' Sixty ducats, he couldn't resist adding, was a bargain considering that the Averoldi altarpiece, for which, as he had previously had occasion to mention, he was to receive 200 ducats, would consist of three figures and the *St Sebastian* was worth all of them.

Three days later Alfonso came to his senses. He had had more than enough experience of the consequences of offending the papacy and realized that the risk of aggravating Pope Leo, whose sights were set on attaching Ferrara and its hinterland to the Papal States, by swindling his legate in Venice was simply too great. He ordered Tebaldi to convey to Titian that he had changed his mind about cheating the legate:

> having thought about that matter of the St Sebastian we have resolved not do this injury to The Most Reverend Legate; and that he, Titian, should think of serving us well with that work which he is supposed to do for us which now weighs more heavily on our mind than anything else, and remind him about that Head[7] which he began for us before leaving Ferrara.

The letter was preceded by the delivery to Titian of the canvas for *Bacchus and Ariadne* and a sweetener of twenty-five scudi.

A few months later it must have occurred to Alfonso that for all the good his sudden rush of common sense had done he might as well have gone along with the *St Sebastian* swindle. By the summer of 1521 Leo X, having enthusiastically formed an alliance with the twenty-one-year-old Habsburg emperor Charles V, was as committed to driving Alfonso's French allies out of Italy as Julius II had been. Leo excommunicated Alfonso and imposed an interdict on Ferrara, and while the French and Venetians dragged their heels, his troops attacked and occupied key territories and towns of the dukedom of Ferrara. Even with the cards so heavily stacked against him, Alfonso refused to surrender or disarm. He was saved only at the last minute

by an event that could not have been predicted. Leo, who was only forty-six, was found dead in bed on the morning of 1 December. He was overweight, drank too much and had been in poor health for some time, but his death was so sudden that poison was suspected, although it seems more likely that he had contracted malaria on a hunting expedition along the Tiber. He had left the papacy all but bankrupt. But what mattered to Alfonso at the time was that Leo's death gave him the opportunity to recapture most of his hinterland, including Reggio and Modena. He celebrated with a minting of silver coins on which a shepherd rescues a lamb from the jaws of a lion with the biblical inscription *de manu leonis*.

Alfonso was less fortunate in his negotiations with Titian, whose work on the *Bacchus and Ariadne* had been delayed by yet another distraction. This time it was an enormous fresco commissioned in the summer of 1521 by the local government of Vicenza for the loggia of their communal palace. The subject was the Judgement of Solomon, an obvious reference to the administration of justice. It was over six metres wide, more than twice the size of his *Miracle of the Speaking Child* in Padua, which probably explains the substantial fee of 100 ducats plus six more for painting the vaults of the loggia, and another ten for expenses and three helpers: his brother Francesco, who worked alongside him for thirty days, a certain Gregorio and a Bartolomeo, a 'master painter'. Nothing more is known about Gregorio and Bartolomeo, who may have been local painters taken on for this job only. Paris Bordone, possibly Titian's former studio assistant, was working on a much smaller Drunkenness of Noah (for which he was paid twenty-one ducats) adjacent to Titian's fresco.[8] If he was still smarting from Titian's treatment of him several years earlier (in connection with the San Nicolò ai Frari altarpiece) he was never able to throw off the master's influence. It was said that when a group of government officials came to survey the completed decorations of the loggia they praised Bordone's fresco as the equal of Titian's. If the story is true it may have reminded Titian of the occasion, more than a decade earlier, when Giorgione had been congratulated for painting Titian's façade of the German exchange house, which everyone

considered superior to his own. Giorgione had sulked. Titian by now was too well established, and far too busy, to worry about rivalry, especially from a painter he knew to be his inferior. Alas, we cannot judge either of their frescos because the loggia was destroyed in 1571 to make way for the one designed by Palladio that we see today.

Alfonso invited Titian to spend that Christmas of 1521 with him in Ferrara and to bring with him the *Bacchus and Ariadne*, which he could finish over the holidays. Titian, caught off his guard, excused himself, pleading pressure of work. He then went off to Treviso to spend Christmas there, perhaps with the Zuccato family. Tebaldi, realizing that it was useless to expect Titian to change his plans, took it upon himself to make another offer, one that he was certain would please the duke and that he hoped Titian would find too tempting to refuse. He remembered that Titian had once mentioned a wish to visit Rome. Alfonso would be travelling to Rome to kiss the feet of the new pope as soon as one was elected. If Titian would come to Ferrara in good time for his departure Alfonso would be glad to take him along. On 26 December Alfonso responded enthusiastically to Tebaldi's latest stratagem:

> M. Jacomo. If you had the vision of a prophet you could not have said anything more true to Titian. Nevertheless, the minute we have heard news about the new pope we wish to go in person to kiss the feet of His Holiness, assuming that nothing prevents us. So please advise Titian that if he wants to come he must come quickly. We would dearly like his company, but tell him he must not speak of this matter to anyone. And perhaps he should dispatch our picture at his earliest opportunity because there will be no question of his doing any work on our journey.

On 3 January 1522 Tebaldi advised his master that Titian had returned to Venice, but was indisposed with a fever. And yet, when he visited him the next day, he found that he had no fever at all. In fact he looked well, 'if somewhat exhausted':

But I suspect that the girls whom he often paints in different poses arouse his appetite, which he then satisfies more than his delicate constitution permits; but he denies it. He says that as soon as he hears the news that a new pope is elected he will, if nothing else prevents it, take a barge and come [to Ferrara] looking forward to accompanying Your Excellency to Rome. But I think he will not bring with him the canvas of Yours. He may change his mind, but he won't confirm it.

The girl who was exhausting Titian at the time of Tebaldi's visit to his studio may have been Cecilia. Titian had brought her to Venice from Perarola di Cadore, the hamlet where the ancestral Vecellio sawmills were located, and where her father was the son of a barber, a respectable profession at a time when barbers were qualified to carry out minor surgical procedures. She was living with Titian in the terraced house behind the Frari that he rented from the Tron family,[9] and she may already have been pregnant with their first child. Since we know that Titian used friends and members of his households as models we are free to speculate that Cecilia might have been the model for his *Flora*, that lovely buxom girl, whose skin has the glow of healthy pregnancy and who points to the bulging waistline under her white shift.[10] Perhaps he used her face again for the *Venus Anadyomene*.[11] Titian altered that head during the painting, and she has the same colouring and features as the *Flora*.[12] But the most that can be said with certainty is that *Flora*'s features and colouring were of a type Titian favoured over a number of years and which we see again in the twinned women in his earlier *Sacred and Profane Love*, in the *Young Woman with a Mirror* and in the Madonna in the Pesaro altarpiece.

Neither Titian nor Alfonso travelled to Rome in January. Although Leo's cousin Giulio de' Medici had been the favourite for the papal throne, it was an outsider, the dour and scholarly sixty-three-year-old Dutch cardinal Adrian Dedal of Utrecht, who was elected by the conclave as Pope Adrian VI on 9 January. Adrian, however, did not arrive in Italy until August. Tebaldi meanwhile thought up a more practical suggestion, one more likely to appeal to Titian's circumstances and temperament. On 4 March he wrote to the duke that he

had not bothered to report his many conversations with 'maestro Titiano', who always assured him that he would finish the *Bacchus and Ariadne*, as he had done yet again that very day, when 'he told me that he wanted to put aside some other pictures and finish Your Excellency's':

> But, my lord, I doubt very much that he will do so, for he is a poor
> fellow and spends freely, so that he needs money every day and works
> for anyone who will provide it, at least as far as I can see. Thus when
> some months ago Your Excellency sent him those twenty-five scudi, he
> began the picture on which he had up to that time done nothing, and
> he worked on it for many days and made good progress, and then left
> it as it is now. It is my opinion therefore that it would be a good idea if
> Your Excellency would send him some scudi, so that he has some
> spending money and can satisfy your wish to have the said painting.[13]

But the painting was still not ready in June when Titian told Tebaldi he wanted to redo some figures that were not up to standard. When he had done that work he would take it to Ferrara and stay there until it was completed. But, no, he couldn't name the date. And then he had the presumption to ask a favour of Tebaldi. Titian had a Venetian friend who wanted to go hunting for birds on the banks of the Po, purely for his own pleasure, certainly not for profit. Would Tebaldi be kind enough to solicit a hunting licence from the duke for his friend and a servant? Tebaldi claimed to be reluctant to request a privilege that was rarely granted to outsiders. Titian, who had reason to be optimistic about the duke's reaction to any suggestion that might hurry him along, assured the ambassador that when he had received such a special indication of the duke's goodwill he would be so happy that he would put all of his skill and ingenuity into drawing and colouring a pair of figures in the *Bacchus and Ariadne*. Tebaldi, who was not amused, told him to stop joking and just take the painting to Ferrara as soon as possible.

These were strenuous times for a painter who was rarely able to work fast. Titian had resumed work on Jacopo Pesaro's altarpiece in

the Frari, which he seems to have put aside shortly after his first payments in 1519. In 1522 he received further instalments in April (ten ducats, six lire and four soldi), May (the same amount) and September (ten ducats). As the only major painter working in Venice and the recipient of a broker's patent he was required by the government, furthermore, to paint his first portrait of a doge, the octogenarian Antonio Grimani, who had succeeded Leonardo Loredan in July 1521, but died after only two years in office. Meanwhile he could not ignore a resolution passed by the Council of Ten on 11 August 1522, a copy of which was delivered to his door by a messenger. The Ten demanded that he complete the canvas 'fourth from the door in the Hall of the Great Council' before the following 30 June under pain of losing his chances of a broker's patent as well as all the advances received so far from the Salt Office. The painting in question was the *Submission of Frederick Barbarossa before Pope Alexander III*, which Giovanni Bellini had not finished before his death. This time Titian took the threat seriously, and began to spend his mornings, so he informed Tebaldi, working in the palace.

Meanwhile Titian had put his best efforts into Averoldi's polyptych for Brescia, which was unveiled over the high altar of Santi Nazzaro e Celso on the saints' feast day in late July 1522.[14] Although he had grumbled to Tebaldi about his payment of 200 ducats it was in fact one of the most expensive altarpieces of the time. The *St Sebastian* that Alfonso d'Este had coveted is the largest figure. The central *Risen Christ* is another of his most powerfully moving figures; and the *Annunciating Angel* is one of his most charming and frequently reproduced angels. To achieve the particular black of the donor's robe as he kneels with the titular saints Titian used no fewer than ten layers of paint and glazes. Since he had accepted the commission it had grown from three to five panels, and the biggest challenge was integrating five separate paintings into a harmonious single polyptych. It was one that he triumphantly met, as he must have thought himself when he signed it 'TICIANUS FACIEBAT/MDXXII' (Titian was making/1522).[15] This was the first time Titian used the reference to Pliny indicating that great art is never finished.

Alfonso's *Bacchus and Ariadne* was still not ready at the end of August, and when Titian showed no signs of moving from Venice there were more irate messages from the duke. On 31 August Tebaldi hastened to Titian's studio to see the much-coveted painting, and wrote to the duke the only specific description we have of a work by Titian in progress.

> Yesterday I saw Your Excellency's canvas, in which there are ten figures, the chariot, and the animals that draw it; and maestro Titian says that he thinks he will paint them all as they are without altering the poses. There will be other heads and the landscape but he says they can be easily finished in a short time, at the longest by next October, when he will have finished everything, in such a way that if Your Excellency does not want additions, the whole thing will be finished and finished well in ten or fifteen days.

Titian, he continues, begs His Excellency to put aside his anger against him, which has made him so afraid that he says, 'not joking and with a solemn oath', that he will never again come to Ferrara 'without a safe conduct in writing' from the duke. Nevertheless, he does greatly regret having aroused such anger and will finish the work in Ferrara by mid-October. 'He has said to me three or four times that if Christ were to offer him work he would not accept anything if he had not finished your canvas first.'

But to Tebaldi's embarrassment Titian did in fact fail once again to keep his word with Alfonso. When he had not met the deadline he had promised to keep with a solemn oath, Tebaldi reported to the duke that he had tried to put the fear of God into Titian with tremendous bravado in the name of His Excellency. But Titian had coolly explained that he had had to change two of the female figures and certain nudes, which he would finish by the end of the month. He would bring the picture then, and finish off some heads and other details in Ferrara. He couldn't come now because here in Venice he had the convenience of whores and of a man who would pose for him in the nude. He was working in the Hall of the Great Council in the mornings, but would

devote the rest of his time to the duke's picture. At the end of the month Tebaldi wrote that Titian had promised that he would embark for Ferrara without fail on the following Sunday evening and had asked him to arrange for a barge. Giddy with relief, he had told Titian that he would provide 'one, two, or more barges, as many barges as he wants', and that he was free to bring along his girls if their presence would calm his spirit. But the duke was to be disappointed yet again. The autumn passed, and Titian failed to take up Tebaldi's desperate offer. He had received the twenty-five scudi by 2 December, and on the 5th he renewed his promise to visit Ferrara and indicated that he might or might not be induced to bring a figure of a woman that he had finished. Once again he spent Christmas in Treviso, probably with the Zuccati.

Alfonso's *Bacchus and Ariadne* was delivered to Ferrara over Christmas by Altobello Averoldi, who had been appointed governor of Bologna and had offered to drop it off on his way to take up his post. Titian, then, may not have been present when his painting, still unfinished, was unpacked from its crate. Although Alfonso had paid for the full range of the most expensive pigments, the overall effect would not be achieved until Titian applied the final scumbles and glazes (most of which have been removed in subsequent restorations).[16] Nevertheless those of us who have stood entranced in front of the *Bacchus and Ariadne* at the London National Gallery may imagine the duke's reaction to his first sight of the picture that had haunted his dreams for more than two years. This time, possibly at Alfonso's suggestion – or perhaps at Ariosto's – Titian had mixed his mythological sources. The subject, like that of the *Worship of Venus*, was taken from Philostratus. In the *Imagines*, however, Ariadne was asleep when Bacchus arrived on the island of Naxos, and his unruly followers were ordered to tiptoe in silence so as not to awake her. Titian would certainly have preferred the more dramatic versions as told by Catullus and Ovid, which permitted him to depict the clashing cymbals and general mayhem of the trail of bacchants accompanying their leader on his way back from India. Bacchus, the embodiment of youth, beauty and enjoyment, sees the despairing Ariadne, who has

been abandoned by Theseus. He leaps from the side of his chariot. Their eyes meet. Ariadne is at once frightened and seduced. He promises that she will be immortalized as a constellation of stars, which appear in the sky above her. In the exact centre of the foreground the drunken baby satyr, dragging the bleeding head of a dismembered bullock like a toy, gives us a knowing stare. (Titian softened the glaze on one of his eyes with the tip of a finger.) The tigers, which Ovid said might frighten the girl, are wittily transformed into cuddly adolescent cheetahs, portraits of two of the hunting animals in Alfonso's menagerie. The bearded bacchant on the right is one of Titian's most obvious quotations of the *Laocoön*,[17] this time snakes and all, and is taken from the same side view he had used for Averoldi's *St Sebastian*. Ariadne's face could be a portrait of Laura Dianti, but the broadshouldered model for her body, the pose of which was much revised, looks more like a man's.

Titian's two assistants delivered another consignment of his effects by 30 January 1523 when the ducal accounts record payments for a barge that had delivered a painting on panel[18] sent from Venice by 'Maestro Titiano to His Most Illustrious Highness', and for the porters who had carried the panel and Titian's trunk from the port of Francolino to the castle. His assistants were lodged at the castle inn, where they consumed twenty-four meals, for which the host was reimbursed from the Este bank on 7 February. Titian meanwhile had made a second brief visit to the court of Alfonso's nephew, Federico Gonzaga,[19] the twenty-three-year-old 5th Marquis of Mantua. He went with Alfonso's permission – it was normal practice for the two courts, which were so closely related by blood and geography, to exchange artists – but on the understanding that the completion of *Bacchus and Ariadne* and other works for the duke must take priority and he could therefore not stay for long in Mantua. He set off from Venice for Mantua on 26 January, carrying with him a letter of recommendation from Federico's ambassador in Venice, Giambattista Malatesta:

> Most Illustrious and Excellent Signor and my most cherished patron. The present bearer is maestro Ticiano, most excellent in his art, and also a modest and gentlemanly person in every respect, who has postponed many of his works of the moment to come to kiss the hand of Your Excellency, as you have deigned to request me. Whereby I cannot do otherwise than recommend him.

The letter was a formality. Federico had been asking Malatesta to invite Titian to his court since Christmas of the previous year, when he had hoped that 'Maestro Tutiano pittor' might spend the holidays with him. Titian had refused but promised the ambassador that he would certainly be in Mantua to kiss the hand of the marquis by the end of the first week in January. When he finally reached Mantua, late as usual, the marquis greeted him warmly, and before he reluctantly allowed him to depart for Ferrara ordered some work, which he seems to have wanted or needed to be done very soon. There is a note of urgency in the letter he wrote to his uncle on 3 February for delivery by Titian along with some presents; and its tone is very different from Alfonso's temper tantrums:

> Most Illustrious and excellent Lord Uncle – Having asked Titian, the bearer of these presents, to execute certain works for me, he declares that he cannot serve me at present because he has promised to do some things for Your Excellency which will take a long time. For this reason I send him to attend you. But I beg you to send him back at once to expedite the work that I want from him, which will take only a few days, and as soon as he has done that he will return to the service of Your Excellency, who will have done me a most singular favour, and to whom I stand greatly recommended.

Federico Gonzaga had come of age less than two years before Titian's visit. Twenty-four years younger than his uncle Alfonso, he was a more sensitive, more self-indulgent and altogether more polished character. While he was still under the regency of his mother Isabella d'Este, Baldassare Castiglione, who would later be Federico's

200

ambassador in Rome, praised him in an early version of *The Courtier* as one of the most gifted of the sons of illustrious lords, 'who may not have the power of their ancestors but make up for it in talent … In addition to his excellent manners and the discretion he shows at so tender an age he is said by those in charge of him to be wonderful in wit, desire for honour, courtesy and love of justice.' He was a godson to Cesare Borgia, and as a boy of only ten had been sent, as a pledge for his father's loyalty, to the magnificent court of Julius II, where he was pampered and indulged by the warrior pope and his cardinals. He developed a taste for luxury, especially the work of goldsmiths and jewellers, and his interest in painting was stimulated by the master-pieces by Michelangelo who was painting the ceiling of the Sistine Chapel, and by Raphael, who made a sketch of him in armour and included a portrait of him in the *School of Athens*. At seventeen his father had contracted for him a dynastic marriage to Maria Paleologo, the eight-year-old daughter of the Marquis of Montferrat, to be consummated when the bride reached fifteen in 1524. (By that time, however, Federico, who was a notorious womanizer, had conceived a passion for Isabella Boschetti, the wife of one of his courtiers.) He and his mother kept a palace in Venice, where they often went for pleasure and where Federico was a member of one of the companies of the hose.

Appointed captain of the Church by Leo X at the age of twenty, Federico had fought enthusiastically with the papal and imperial troops against the French in northern Italy. By the time Titian accepted his invitation to Mantua he had lost his taste for military campaigning and turned his attention to women, to fine food, to buying and breeding rare breeds of horses, dogs and falcons, and to glorifying his reign and dynasty with new buildings and works of art that departed from his mother's more academic tastes. He purchased antiques from Rome, and tried without success to obtain paintings by Sebastiano, Michelangelo and Raphael. (When he tried to purchase Raphael's group portrait of Leo X he was sent a close copy by Andrea del Sarto.) But he did, with Castiglione's help, persuade the architect and painter Giulio Romano to come as his court artist to Mantua,

where Giulio undertook commissions to design everything from jewellery, tapestries, majolica, silverware, furnishings and a marble tomb for one of the marquis's dogs to the extraordinary Mannerist Palazzo Tè, the interior of which he and his assistants painted with the spectacular and explicitly erotic illusionist frescos that are still in situ and where Federico reserved an apartment as a love nest for his assignations with Isabella Boschetti.

Why then was Federico, in the early winter of 1523, so eager to have Titian back in Mantua just for a few days? What was the work he so urgently wanted him to undertake or perhaps to finish? In the absence of any further evidence we can only make an educated guess. Federico's younger brother Ferrante was about to depart for the Habsburg court in Spain, which was a kind of finishing school for the European high aristocracy. As a result of the contacts he made there he later became a prominent member of the international circle of talented nobility who worked in the service of the emperor Charles V and his son Philip II of Spain. A staunchly loyal imperialist, Ferrante went on to play a significant, and sometimes brutal, part in the wars and international politics of the coming decades.[20] But in 1523 he was only sixteen and, since journeys across Europe were long and dangerous, Federico might well have wanted a commemoration of his brother's appearance. The surviving portrait by Titian that most closely fits his style and that of his sitter's dress around 1523 is the *Man with a Glove*,[21] one of the most alluring representations of the polished personality, dress and demeanour of a socially assured young aristocrat of the period. It was painted by an artist who refused to serve any court on a permanent basis, but who was more than enough of a gentleman to put his high-born sitters at ease, and who knew better than any other artist of the time how to convey the dignity of elevated social status. Federico Gonzaga was perhaps not yet mature enough to appreciate Titian's qualities as a portraitist – we do not in any case have a record of his reaction to this portrait. He was, however, the first foreign aristocrat to become his friend. Federico, who liked to be amused, must have enjoyed Titian's intelligence, poise and dry sense of humour. Before the decade was out he would come to understand

and appreciate Titian's temperament and genius in a way that his uncle Alfonso had not, and would open the door that eventually brought the painter to the attention of the emperor himself and would make him the portraitist of choice in the greatest courts of Renaissance Europe.

A New Doge, a River of Wine and Marriage

The stream of wine which is on the island of Andros, and the
Andrians who have become drunken from the river, are the
subject of this painting ... if you have water in mind the quantity
is not great, but if wine, it is a great river – yes, divine! ... These
things, methinks, the men, crowned with ivy and bryony, are
singing to their wives and children, some dancing on either bank,
some reclining ... This is what you should imagine you hear and
what some of them really are singing, though their voices are
thick with wine.

PHILOSTRATUS, *IMAGINES* I, XXV[1]

Titian spent the rest of February 1523 and the first few days of March
in Ferrara finishing *Bacchus and Ariadne,* and probably discussing his
next major order from Alfonso, this one set on the mythological
island of Andros where Bacchus creates a river of wine to celebrate his
arrival by boat, and the inhabitants get madly drunk. There is,
however, no mention of the *Andrians* (Madrid, Prado) in the surviv-
ing correspondence between Alfonso d'Este and his ambassador.
There are in fact no surviving letters between them at all about Titian
until the following March.[2] It may be that the duke had accepted that
it was useless to nag the maestro and trusted him well enough by this
time to give him a freer hand. Alfonso was in any case more preoc-
cupied than ever by the problem of how best to use the struggle
between Francis I and Charles V to protect his state, and particularly

his claim against the papacy to the much-disputed towns of Reggio and Modena.

In the previous November Charles had sent the able Genoese aristocrat Girolamo Adorno to Ferrara with a mission to lay the foundations of an alliance with the duke. Although Adorno suffered from acute attacks of crippling gout he was a shrewd appointment. As an Italian he was welcomed in a way that a Spanish envoy might not have been; and he was liked and admired in aristocratic and intellectual circles, not least by his friend the historian Paolo Giovio, who accompanied him to Ferrara and later described him as 'a singular man on account of the quality of his intellect and his experience in the affairs of war'[3]. Having struck a deal with Alfonso, who, without formally breaking his alliance with France, agreed to allow free passage of imperial troops through his territories in return for possession of Reggio and Modena, Adorno carried on with an entourage of forty men to Venice where, limping after one of his attacks of gout, he was formally presented as the emperor's 'orator' to the very old and doddering Doge Antonio Grimani. In March he sat to Titian for his portrait – possibly the *Portrait of a Man with his Hand in his Belt* (Paris, Louvre), which is Titian's first known attempt at a three-quarter-length pose. But at the end of the month, while the Venetian government was considering his proposals for a formal imperial alliance, he fell gravely ill and died. He was given a magnificent state funeral in the great Gothic church of Santo Stefano, but after his death negotiations about the terms of the alliance lost their momentum.

The debate about the pros and cons of switching to the imperial side continued after the death of Doge Grimani and the election on 20 May 1523 of the sixty-eight-year-old procurator, Andrea Gritti. Gritti assumed his doge's hat at a critical time for the whole of Christian Europe. The Lutheran Reformation in Germany was threatening the monopoly of the Catholic Church. The Turks, after two decades of peaceful coexistence with Europe, had marched into Hungary. The most immediately pressing problem for Venice was the war in Lombardy between the Habsburg emperor and the French

king, who were using Italy as a convenient battleground in their wider struggle for possession of Burgundy and control of the western Mediterranean. The first months of Gritti's reign were dominated by heated, often highly emotional debates in government about the advantages and the morality of breaking with France, the Republic's ally since the closing years of the Cambrai war. Gritti, an outspoken Francophile, probably did his cause more harm than good by defying the traditional requirement that the doge should remain neutral. But at the end of July, when the emperor's Spanish troops had the upper hand in northern Italy, the new doge bowed to the majority decision to form a 'perpetual' alliance with Charles V.

The election of Andrea Gritti, who served the Republic as its most formidable doge until his death in 1538, was a turning point in the political and urban history of Venice and of Titian's career there. Gritti had been angling for the office at least since 1514 when he made sure that Sanudo recorded the comment of a visiting Turkish dignitary who, on a guided tour of the treasury of San Marco, had exclaimed that the doge's cap was made to order for the head of Andrea Gritti. He had, however, lost to Antonio Grimani in 1521, and managed to win the election in 1523 only by a very narrow majority, after the withdrawal of the favourite, Antonio Tron. When the outcome of the balloting was announced in the Piazza, the crowds responded with cries of 'Tron, Tron, Tron.' An anonymous verse was circulated advising the government to save itself by sentencing the tyrant doge to death. He was seen by the *popolani* and in government as high-handed, impatient with the traditional constraints on ducal power, a warmonger, a sycophantic Francophile, a sensualist, too arrogant even to dress properly. Sanudo was shocked by the ducal *bareta* he wore for his first mass as doge, which was far too small. The diarist disapproved, furthermore, of the crimson satin mantle slashed open at the sides to make armholes, like 'a mantle with windows', that he wore in the first two winters of his reign. Later his dress sense improved and his ducal robes set new fashions for the colours old rose and violet. The puritans in government, however, continued to disapprove of his excessive fondness for the pleasures of the table and of his vigorous

and complicated love life – he had fathered four bastards in Turkey and produced at least two more, one by a nun – which he carried on until he was well into his seventies, by which time he had got very fat.

But Andrea Gritti's positive qualities were more significant than his faults. He was a man of the world, highly intelligent, intellectually cultivated, tough minded, completely lacking in self-doubt, physically strong, heroically energetic. He was also a patriot who modelled his behaviour on that of the self-sacrificing heroes of ancient Rome. And he was genuinely concerned about the socially disruptive but growing gap between rich and poor patricians: Sanudo reported him declaring shortly after his election that 'in this state there are rich, middling and poor, and it is very fitting that the rich aid the middling and the middling the poor'. Titian's freely painted, psychologically penetrating posthumous *Portrait of Doge Andrea Gritti*[4] (Washington, DC, National Gallery of Art), from the late 1540s or early 1550s, gives an idea of the mettle of the most enlightened, forceful and longest-serving of sixteenth-century doges, the one who would drag the provincial architecture of urban Venice into a Romanized High Renaissance and steer its government through good times and bad for the next fifteen years.

As a boy Andrea Gritti had been privately tutored in the house of a maternal grandfather, a diplomat who sent him to the University of Padua and took him on missions to England, France and Spain. Twice widowed by the age of twenty-five he spent the next twenty years in Ottoman Turkey, where he made a fortune as a grain merchant in Constantinople, won the friendship of the vizier and the respect of the sultan, and fathered his four bastard sons by a young Greek woman. As the tension between Venice and the Ottoman Empire worsened in the late 1490s he acted as a secret agent for the Venetian government, sending coded messages concealed in consignments of carpets about the movements and sizes of the Turkish fleets and troops. He was arrested, but after thirty-two months in prison – during which he was greatly missed by his many Venetian and Turkish friends, and particularly, so they said, by the numerous women who had fallen in love with him – he was released in order to begin prolonged

negotiations for a peace treaty, which, thanks to his diplomatic skills, his fluent Greek and Turkish and his understanding of the Turkish mentality, was more favourable to Venice than it might have been.

From then on Andrea Gritti was continuously and successfully occupied by high political, diplomatic and military positions. Taken prisoner by the French during their horrific siege of Brescia in 1512, he was welcomed at Lyons by Louis XII as an honoured guest. When he returned, exhausted, to Venice, he reluctantly accepted a commission to take charge of the defence of Padua, having objected to the 500-ducat penalty for refusing the job, which, he said, would have made it difficult for him to refuse a position that it was his duty to fulfil without remuneration. In the spring of 1513 he played a leading role in negotiating the Franco-Venetian alliance at Blois and in the subsequent events that led to the end of the Cambrai war, as ambassador to Milan in 1515 after Francis I reoccupied the city following his victory at the Battle of Marignano, and as commissioner to the army in the reconquests of Brescia and Verona. At the end of the war he drew up a report on the strategic defence of the terraferma, which remained the basis for the Republic's policy for the rest of the century.

Two weeks after Andrea Gritti became doge Titian received a payment of twenty-five ducats for his portrait of his predecessor Antonio Grimani.[5] Although Grimani had died on 7 May, Titian had evidently only just finished the portrait, which at the time of the payment was not yet hung. He was also working flat out to complete Giovanni Bellini's *Submission of Barbarossa* for the Great Council Hall cycle, which he finished by 23 June. The loss of this canvas to the fire of 1577 is all the more frustrating because it included portraits, some by Giovanni Bellini, of distinguished contemporaries: Pietro Bembo, Jacopo Sannazaro, Andrea Navagero, Ludovico Ariosto, Bartolomeo d'Alviano and the Veronese architect and scholar Fra Giocondo being among the many famous Renaissance men gathered to witness the humiliation of the twelfth-century emperor Frederick Barbarossa in front of the basilica of San Marco. Now at last Titian received the *sanseria*, the broker's patent worth 100 ducats a year, which he had requested ten years earlier.

Soon after moving into the ducal palace, the new doge hired Titian to fresco his private chapel and apartments as part of an expensive programme of refurbishment. Whatever Titian may have thought of working again in fresco, he set to the task without delay. It would not have been in his interests to irritate the formidable new doge with his usual procrastinations and transparent excuses. His votive portrait of Gritti was lost in a fire. Of his frescos for the doge only a *Madonna and Child with Angels* and a *St Christopher* survive in another part of the palace. Although it is not possible to judge their quality from the few remaining fragments, Gritti, who recognized Titian as the only world-class artist in Venice, a city that he regarded as artistically provincial, remained his staunch supporter. Two years later he appointed Titian's father Gregorio as inspector of mines in Cadore, and his brother-in-law Matteo Soldano to the position of chancellor of Feltre. It was thanks to Gritti, furthermore, that Titian was able to avoid completing the dreaded Battle of Spoleto while retaining his *sanseria* for another fourteen years.

Meanwhile, Titian was left with the portrait of the late Girolamo Adorno on his hands. His old friend Andrea Navagero – always ready to be of service to the painter he had dissuaded from leaving Venice for Rome ten years earlier, and aware that Adorno had been a favourite at the Gonzaga court – persuaded Isabella d'Este to buy the portrait. She paid 100 ducats for it at the end of June. A few days later, however, she asked for her money back, pleading shortage of funds – her purchasing was often hampered by money problems. If Titian was aggrieved by her change of mind he nevertheless found time to go shopping in Venice for her son Federico. On 24 July Giambattista Malatesta, Federico's ambassador in Venice, reported that Titian had managed to obtain for the marquis some fine Turkish felt of a quality which he himself had been unable to find and was now sending post-haste. In August Federico sent Titian a present of a doublet, for which the recipient expressed eternal gratitude, although he seems to have been reluctant to dispatch the portrait of Ferrante, which he had finished in Venice. It was finally delivered by 15 August when the marquis acknowledged that he had received it, but only at the end of a letter to

Malatesta that was more enthusiastic and specific about two pairs of turtle doves and one of pigeons that had also arrived from Venice, as well as an order for a supply of *zambelloto*, a kind of fabric made from camels' or goats' hair that was imported to Venice from the Far East.

The extant correspondence about Titian between Alfonso d'Este and Jacopo Tebaldi resumes in mid-March 1524 with Tebaldi informing the duke that Titian has been ill. Although the fever recurs every evening, he is nearly recovered, and has given his word to come to Ferrara after the Easter holidays. In order to justify his absence from Venice – presumably to the doge – Titian will, however, have to obtain a doctor's certificate advising a change of air. He has also asked Tebaldi to tell the duke that the merchant who sold the blue pigment he had brought back from Ferrara didn't want to take it back, and he will need another ounce.

He reached Ferrara in mid-April and stayed there until the beginning of July.[6] It was probably during this stay in Ferrara that he finished the *Bacchanal of the Andrians*. A celebration of the power of wine to release inhibitions and transport mortals into the realm of the gods, the *Andrians* gave Alfonso the godlike privilege of witnessing a scene that would ordinarily be invisible to such mortals as the two young courtiers, one wearing fashionable yellow trousers with his arm around a tree, who stand casually chatting as though unaware that an orgy is taking place around them. A river of wine has been created at Bacchus' command by the old river god who lies in the middle distance on a couch of grapes watching the young revellers with his legs spread. A reveller pours wine into a dish held by one of two beautiful girls who have been playing their flutes from the sheet of music in the centre of the foreground. It is inscribed with the signature tune of the painting: one line of a four-part canon sung to the words 'Qui boyt et ne reboyt, il ne scet que boyre soit' ('He who drinks and does not drink again, does not know what drinking is'), possibly a piece by Adrian Willaert. One of the bacchants holds up for our inspection a Venetian glass pitcher half full of the divine liquid. A little boy replenishes the river of wine by urinating into it.

Although the scene is once again set by Philostratus, Titian integrated into the whirling choreography of visiting deities and Andrians a variety of quotations from classical and contemporary art, which proclaim that this painting transcends any previous masterpiece, ancient or modern. The reclining nude with the twisting torso refers to a figure from some fragments of Michelangelo's cartoons for the *Battle of Cascina*, which Titian had seen in Mantua. The urinating baby Bacchus was familiar from ancient sarcophagi (technical examination by the Prado has revealed that he was not part of the original composition). An antique torso in the Grimani collection, which Titian would have seen in the ducal palace after it was displayed there in 1523, seems to have suggested the torso of the graceful dancing girl. The largest figure, the luscious naked girl abandoned in drunken slumber in the right foreground, is also the most original, as Titian emphasized by transforming – after much reworking – the cold marble of a well-known classical statue[7] into the most shamelessly seductive flesh-and-blood girl so far seen in Renaissance art. Nor can it be an accident that he placed her in the same section of the painting as Giovanni Bellini's primly sleeping Lotis in the *Feast of the Gods*, which was hung to the right of the *Andrians*.

With this last, most energetic and spatially complex of his three Bacchanals for Alfonso's little chamber in the Via Coperta Titian seems to be suggesting that he has outdone even himself. The two nymphs from the *Worship of Venus* reappear as the two reclining girls playing their flutes. He has given the one in the red dress and white bodice the face of his naked *Venus Anadyomene*, tucking a violet into her bodice and placing his signature, 'Ticianus F', on its border (the violet prompted Ridolfi to identify her as yet another portrait of Violetta). And he 'signed' it again in the far distance, across the sea where we see Bacchus' boat sailing away, with the jagged blue peaks of his homeland in the Cadorine Dolomites.

Returning to Venice in the heat of high summer, Titian continued what may have seemed the comparatively humdrum task of painting frescos in Gritti's palace. He was also designing cartoons for mosaics in the sacristy of San Marco, a handsome addition to the basilica built

in the 1490s by Giorgio Spavento. In these mosaics, realized by his boyhood friend Francesco Zuccato and two other mosaicists[8] over the next six years, the art form most closely associated with the Byzantine patrimony of the Venetian Republic was brought up to date by the most progressive of Venetian artists. It can come as a surprise even today to recognize dynamic motifs from Titian's past and future paintings incorporated in designs constructed, in the same way as the stiff iconic images in the vaults and domes of the basilica, with tiny squares of coloured Murano glass.[9]

By autumn 1524 Alfonso d'Este was once again impatient to have Titian in Ferrara, and Tebaldi was warning the duke that he was doing his best to urge the master to come to him but could promise nothing. In a letter dated 29 November, he informed Alfonso rather wearily that 'magistro Titiano' had given a hundred promises to come and had broken them all.

> Even today he has given me another assurance, this time that he will depart tomorrow and that I should provide him with a barge. And so that he cannot excuse himself on the grounds that the barge isn't there in the morning I have sent it this evening and it will stay outside his house for twenty-four hours … But I can't guarantee that he will board it, and I won't believe it until I have heard that he is actually on his way to you.

Tebaldi continues by conveying Titian's wish to return to Venice for the holidays, 'so that he can finish certain things on which he is working', adding that Titian has no lack of commitments there, 'and all are of the highest importance because some are to do with making money and others with pleasure … and what greater pleasure than making money?'

The only major oil painting on which Titian is known to have been working at this time was Jacopo Pesaro's altarpiece for the Frari. After more than five years of trying out different ideas he had at last found his extraordinarily original solution and would have been understandably reluctant to tear himself away from it. The Pesaro

altarpiece, however, was not about making money. The fee of 100-odd ducats he had accepted for a painting that included fourteen figures, six of them portraits, was no more than he was able to charge for a single portrait that could be finished in a matter of weeks. The lucrative commissions to which Tebaldi referred must have been some of the portraits of expensively dressed men that are now scattered throughout the picture galleries of the world. Some of them were doubtless, as Tebaldi said, men of the highest importance – rich Venetians, foreign aristocrats like Ferrante Gonzaga or ambassadors like Girolamo Adorno. For Titian, to whom portraiture had always come most easily, welcoming such men into his studio was indeed, as Tebaldi had suggested to the duke, a matter of mixing business with pleasure.

With a guaranteed income from the *sanseria* of 100 ducats a year (for many years to come if he played his cards right) and with the government paying for the upkeep of his busy studio in the Ca' del Duca, Titian was financially more secure than he had ever been. If he enjoyed making money he also enjoyed spending it – on furnishings, clothes, good food and wine, and entertaining his friends. Although Tebaldi never mentioned Cecilia, or anything else about Titian's private life, we can imagine the delight he took in their baby, a boy to whom he gave the classical name Pomponio, and whom he had already destined for a career in the Church. That was an unusual decision at a time when the first sons of most artists became their fathers' assistants and went on to inherit the business; and it was to have baleful consequences. At the time, however, Titian's main concern was for Cecilia, whose health was frail and who was pregnant again with their second son, Orazio.[10] Nevertheless Titian did board the barge provided by Tebaldi, and reached Ferrara by 3 December with three assistants. Judging from the records of wine supplied to the assistants, they, and presumably Titian too, stayed over Christmas after all and did not return to Venice until mid-February 1525. (He was certainly in Ferrara on 11 January when payment was made for an ounce of blue pigment, presumably ultramarine, to be sent to him for paintings for the duke.) But the only clue we have about what he painted

there is a reference in a letter written by Tebaldi four years later to 'three things' Titian said he had done for the duke, each one in his estimation worth 100 ducats but for which he had received only 100 altogether. Two of the 'three things' may have been portraits of Alfonso and his son Ercole, both now lost. Another possibility is the *Portrait of Laura Dianti*, although that is more likely to have been done in late 1527 when Titian seems to have been briefly in Ferrara,[11] possibly called there to commemorate Laura's first pregnancy.

Of the surviving portraits another candidate for one of the 'three things' is the marvellous *Portrait of Tommaso de' Mosti* (Florence, Galleria Palatina), who was one of three brothers in the service of the Este court.[12] In 1524 Alfonso appointed him rector of the church of San Leonardo; and at an unknown later date he took major holy orders and was made archpriest of Ferrara cathedral. It is one of Titian's most sophisticated, beautiful and lucidly characterized portraits of the 1520s, and like the *Man with a Glove* suggests that Titian had been impressed by Raphael's *Portrait of Baldassare Castiglione*. A later inscription on the back of the *Portrait of Tommaso de' Mosti* stating that it was painted by 'Thitiano de Cadore' in 1526 when Tommaso was aged twenty-five[13] suggests a possibility that Titian may have begun it on a quick visit to Ferrara in October 1525[14] and finished it in Venice the following year.

Titian hurried back to Venice, where Cecilia had fallen critically ill. He was never a man to show his emotions, but the possibility of losing her, and of failing to legitimize their sons, shocked him at last into taking the decision to marry her. Twenty-five years later, while testifying on Titian's behalf to the legitimacy of the boys,[15] his brother Francesco remembered the occasion. Titian had come to him saying that he wanted to marry Cecilia, who was very ill, lying in bed, and that he wanted to legitimize Pomponio and Orazio. Francesco replied, 'I am delighted and only wonder why you haven't done it before. This is an excellent plan and I urge you to go ahead with it immediately.' Titian then sent Francesco to invite the priest Paolo di Piero, a family friend originally from Ceneda, who was deacon of the church of San Giovanni Novo in the *sestiere* of Castello. The other guests were

Paolo's fifteen-year-old brother Girolamo Dente, who was Titian's favourite apprentice; a goldsmith, Nicolò della Croce, whom Titian asked to bring a gold ring worth approximately four or five ducats; and Maestro Silvestro de Jacomo, a stonemason. After the ceremony, everyone stayed on for dinner. Since it was not at that time a requirement that priests should consecrate marriages, it may be that Paolo di Piero was called in also to administer the last rites. But Cecilia recovered and survived for another five years during which they had another child, a daughter to whom Francesco Zuccato stood as godfather, but who died in infancy. It was Titian's first personal loss and he remembered it for the rest of his life.

The Fall of a World

I shall go into Italy and revenge myself on those who have injured
me, especially on that poltroon the Pope. Some day, perhaps,
Martin Luther will become a man of weight.

CHARLES V, JANUARY 1525[1]

I will go to Venice maybe, and I will enrich my poverty with her
liberty ... Where is peace if not in Venice? ... Here is the glorious,
miraculous, and great Titian, whose colours breathe no differently
than flesh which pulsates with life ... Here, too, is the good Serlio
... the worthy Sansovino, who has exchanged Rome for Venice,
and wisely, because according to the great Adrian [Willaert],
father of music, she is the Ark of Noah.

PIETRO ARETINO, *LA CORTIGIANA*, 1534

On 27 May 1526 Titian wrote a receipt acknowledging his final
payment from Jacopo Pesaro, Bishop of Paphos, for the Frari altar-
piece he had begun seven years earlier. The painting was in place over
the Pesaro altar in the left nave of the church by 8 December, the feast
day of the Immaculate Conception of the Virgin, when Sanudo
recorded that a service had taken place there. Although Pesaro's altar-
piece was if anything more startlingly original than Fra Germano's
Assunta, nobody seems to have objected this time. Some of the
worshippers in the Frari, however, must have been bemused by

Titian's dramatic glorification of a relatively insignificant event in the history of the Republic that had been the highpoint in the life of Jacopo Pesaro, a patrician whose family were the most important patrons of the church but who was otherwise a person of no particular distinction, best known for his wealth, his stinginess and his meanness to his servants, who heartily disliked him.

Jacopo Pesaro's single moment of glory had been his role as commander of the papal fleet in the successful recapture of Santa Maura in 1502. He had fought under the banner of the Borgia pope Alexander VI, not of St Mark, and Santa Maura had in any case been returned to the Turks in the following year as part of the peace settlement. The pyrrhic victory – which he had celebrated once before when he commissioned the painting of *Jacopo Pesaro Presented to St Peter by Pope Alexander VI*[2] from the young and then unknown Titian – was therefore of little interest to anyone except himself. Now in his early forties, Jacopo Pesaro was burning with indignation at the lack of respect he commanded in government and in the Church, where his several bids for a more powerful bishopric in or near Venice had all failed.

By 1519, when Jacopo agreed to finance the decoration of the Frari altar in return for burial rights for his branch of the family, Pope Alexander was long dead and largely reviled. For those Venetians old enough to remember the capture of Santa Maura, the hero had been not Jacopo but his elder cousin Benedetto Pesaro, who had commanded the Venetian fleet. Although both Alexander and Benedetto had died in 1503, Jacopo remained steadfastly loyal to the despised Borgia pope – so much so that in a will of 1542 he left money to celebrate regular masses for his soul – while continuing to nurse a grudge against Benedetto for having been given the credit for the victory. Benedetto, whose funerary monument surrounds the entrance to the sacristy chapel (itself a Pesaro commission from the 1470s) had also been responsible for contributing to the sacristy chapel Giovanni Bellini's heart-stoppingly beautiful triptych of the *Madonna and Child with Sts Peter and Nicholas, and Benedict and Mark*, signed and dated by the artist in 1488, around the time, that is,

that Titian was born. Giovanni's luminous masterpiece in its lavishly carved and gilded frame had remained the greatest work of art in the Frari until challenged by Titian's revolutionary *Assunta* over the high altar.

As Titian embarked on his second altarpiece for the Frari, he understood that the Bishop of Paphos expected a work that would exact a kind of revenge on Benedetto's posthumous reputation by outshining the treasure he had commissioned from Giovanni Bellini all those years before. Titian, who had accepted the low fee of 102 ducats, payable in instalments, in return for the publicity value of showing again in one of the two most prominent Venetian preaching churches, was the only artist in Venice capable of outdoing his old master, and we have no reason to doubt that he welcomed yet another opportunity to show off his more progressive ideas. The problem in the first instance, however, was to find a way of accommodating the bishop's specific requirements. The terms of the commission required a Madonna and Child with saints worshipped by life-size kneeling portraits of Jacopo Pesaro, his brothers and his young nephews. Thus the painting was to be a sacred conversation as well as a commemoration of the Battle of Santa Maura. Jacopo wanted in addition a depiction of the temporal and spiritual power of the crusading Christian Church; a funerary monument; and a votive picture, not with the usual portrait of one donor but of himself and five other members of his family.

It is not surprising that it took Titian nearly seven years to work out how he could meet so many challenges. But it may well be, given his temperamental preference for working on different kinds of paintings at the same time, that the numerous interruptions – the altarpieces for Ancona, Treviso and Brescia, the Bacchanals for the Duke of Ferrara, the work in the doge's palace, and the money-spinning portraits – stimulated his creative energies, allowing him to address the painting with a fresh perspective each time he resumed work on it. He began by assembling his figures under an open barrel-vault supported by square pillars in the manner of Giovanni Bellini.[3] He then realized that he could achieve a more dynamic illusion by

placing the arch on a diagonal with the Madonna and Child off-centre so that they would seem to be turned towards worshippers walking down the nave from the main entrance. Finally he settled on his boldest and subsequently most influential plan. He painted out the arch and a cloth of honour that hung diagonally above the angled Madonna and Child, and in defiance of tradition and of spatial logic replaced them with the two gigantic columns that rise above the clouds and into the heavens, a reference perhaps to the apocryphal text from Ecclesiasticus 24, associated with the Immaculate Virgin: 'My dwelling place was in the high heavens; My throne was in a pillar of cloud.'

If Titian's architectural solution makes no spatial sense, those towering columns, which are all the more effective for serving no structural purpose, have reappeared in sacred and secular European art so often that we have come to take them for granted. But if we approach the Pesaro altar from the church entrance, as Titian intended, we can still share with his contemporaries the illusion that we have come upon an extraordinary but realistic civic ritual, in which Jacopo Pesaro, the crusading missionary, kneels at the foot of the Virgin's throne facing his four surviving brothers and their favourite nephew, the orphaned ten-year-old Leonardo,[4] who solemnly acknowledges our presence, staring out at us like the little satyr at the centre of *Bacchus and Ariadne*. Jacopo is presented to the Virgin by St Peter, the founder of the Christian Church, into which he will receive the two heathen captives led by a warrior saint wielding the banner of the triumphant Borgia pope. To the right of the throne Sts Francis and Anthony, the two principal saints of the Franciscan order, implore the Christ child to bless the other members of the Pesaro family.

Although the Battle of Santa Maura was by now a mere footnote in the history of the Republic, the subject of a war against the Ottoman Empire was by no means without contemporary relevance. The brothers of Santa Maria Gloriosa dei Frari were active in raising funds and lobbying the government for a crusade against the Turks. Such a campaign had been financially impossible in the aftermath of the ruinous Cambrai war, and unnecessary as long as the Turkish sultan Selim the Grim, who devoted his reign to consolidating his Islamic

dominions, posed no threat to Venetian interests in the Levant. But Selim's son Suleiman, who succeeded him in 1520, was an altogether more ambitious, arrogant and bellicose ruler, who soon adopted the titles Suleiman the Magnificent and Distributor of Crowns to the Monarchs of the World. A Venetian observer of his personality characterized him as proud, hasty, melancholy and addicted to women. Titian later portrayed him at least five times, taking his image from medals and book illustrations.[5] Suleiman had captured Algiers in 1519–20, and the year after his father's death besieged and occupied the Hungarian frontier fortress of Belgrade. In 1522 he launched an attack on Rhodes and expelled the Knights of St John from the island fortress they had occupied for centuries. The fall of Rhodes, although not in itself of more than emotional significance to the Republic, was a warning that further Turkish conquests could threaten Venetian colonies in the Dodecanese.

Suleiman's next onslaught, however, was more immediately alarming. In August 1526, three months after Titian had received final payment for his altarpiece commemorating the Pesaro victory over the Turks, a large Turkish army began advancing up the Danube. At Mohács it inflicted the most terrible defeat suffered in the history of Hungary. The waters of the Danube, according to a contemporary writer, were swollen for a day and a night afterwards by the bodies of men and horses. The archduke Ferdinand of Habsburg, the emperor Charles V's brother and representative in Austria, managed to save some of Hungary's territory, but two-thirds of it was lost to the Turks. Suleiman had chosen to invade at a time when he knew that the European powers were unable to retaliate. Although the defeat focused the emperor's attention on the Turkish threat, he did not have the resources to defend his eastern empire while he was at war in Italy with Francis I. The Venetian treasury was still depleted after the Cambrai war; and the pope was bankrupt and unable to make up his mind whether to trim to the empire or to France.

The indecisive Giulio de' Medici, the illegitimate son of Giuliano de' Medici and nephew of Leo X, was forty-five when he was elected pope as Clement VII on 18 November 1523 after the most bitterly

fought of all papal conclaves. His uncle had made him a cardinal ten years previously – Raphael portrayed him looking rather smug in the background of his portrait of Leo. Although he took the name Clement to signify reconciliation with his enemies in the Church, he was never popular in Rome. Intellectually sophisticated, an able administrator and diplomat and dazzlingly handsome, Clement was also complacent and virtuous to a fault. A contemporary historian[6] described him as not proud, not given to simony, not avaricious, not libidinous, frugal at the table, modestly attired, devoutly religious – everything, in other words, that his uncle Leo had not been. The Venetian ambassador in Rome reported that the new pope had not visited Leo's hunting lodge more than twice, and that he did not care for music or buffoons. If the weight of so much unusual goodness sometimes clouded his judgement – it was Clement who set in motion the English Reformation by his refusal to grant the divorce of Henry VIII from Catherine of Aragon – he was also, like many intellectuals, able to see all sides of a problem and therefore given to changing his mind.

By the autumn of 1524, however, both the pope and the Venetian Republic, alarmed by the successes of the imperial forces in Italy, gave covert military aid to the French, who had managed to reoccupy Milan. On 12 December, the Venetian government – still haunted by memories of Cambrai, with a Francophile doge and disinclined to a break with the head of the Christian Church at a time of renewed threat from the Turks – signed a secret treaty with France and Pope Clement against Habsburg Spain. The timing could hardly have been less judicious. When Charles V heard about the treaty he was not surprisingly enraged by the unforgivable treachery of a pope he had regarded as his protégé. In February 1525 an imperial relief army attacked French troops entrenched in a hunting park just outside Pavia under the personal command of Francis I, with disastrous consequences for the alliance. The French army was annihilated. The French king, who had continued to fight with great gallantry after his horse was shot from under him and his troops had retreated, was captured and taken to prison in Madrid. Andrea Gritti's response was

characteristically cagey: 'Being a friend of both sovereigns, I can only say, with the Apostle, that I rejoice with them that do rejoice and weep with them that weep.'

From the makeshift tent provided for him by his captors, Francis had written, in a famous letter to his mother Louise of Savoy, 'All is lost to me save honour and my body which is unhurt.' Louise, as regent in Francis's absence, then did something that would go a long way towards shattering the ideal of a Europe united by Christendom. She concluded, on behalf of her son, the Most Christian King of France – the country that had so far maintained a stronger hostility to Islam than any other European power – a military alliance with Suleiman, which called for parallel action against the imperial ambitions of Charles V. Lawyers had a field day debating the rights and wrongs of swearing oaths with infidels and whether such action was justified by the common humanity of Christians and Turks. Some French subjects, as a cynical Venetian ambassador put it, found the alliance as shameful as in fact it was, but 'the defenders of the king justify it alleging that the natural rights and canons permit everyone to defend themselves at all costs'. Nevertheless, the Franco-Turkish alliance, which was maintained for another three decades, made nonsense of all the talk of Christendom and crusades, and, although that myth lingered, a new cynicism set in, adding yet another ingredient to the complex international politics of Renaissance Europe.

Held captive in Madrid, Francis was forced to sign a humiliating treaty in January 1526 according to which he agreed to cede his claims to Milan, Flanders, part of the Netherlands, Genoa, Naples and the Duchy of Burgundy. In return he requested and was granted two favours: the hand in marriage of the emperor's sister, Eleanor of Portugal; and release from prison before the treaty was implemented. He was however required to leave his two sons in captivity as hostages. Only four months later, with the full support of Pope Clement, Venice, the Duke of Milan and Florence, Francis repudiated the Treaty of Madrid on the grounds that he had made it under duress. The new alliance between Francis and the leading north Italian powers was formulated at Cognac, where the Venetians played the leading part in

what might have been a momentous decision: they would expel the forces of Charles V from Italy, once and for all. At the demonstration organized in Venice to celebrate the promulgation of the League of Cognac in July 1526 Andrea Gritti, Sanudo tells us, was dressed in gold, 'with a cloak of gold and white over all and his *bareta* of the type that symbolizes peace'.

The so-called Italian League was widely seen as fighting for the liberty from foreign intervention of a fragmented Italy. It was the last attempt before the nineteenth-century Risorgimento to establish an independent and united Italy, and, just as all previous alliances of Italian states had fallen to pieces, the Italian League failed. Clement distrusted his allies and made the mistake of trying to placate Charles, for whom the perfidious behaviour of the French king and the pope was, however, the last straw. While Clement dithered, Charles's reaction led to the most terrible disaster in the history of Renaissance Italy. The time had come to fulfil his threat to take revenge on 'that poltroon the pope'. Charles placed his Spanish troops in Italy under the command of the turncoat Charles de Bourbon, formerly the hereditary constable of France. In January 1527 they were joined by a hoard of German landsknechts, led by the fanatical Lutheran George von Frundsberg.

All eyes were now on the Duke of Ferrara, who was well placed to tip the balance of power between the emperor and the anti-imperial axis. Charles offered the hand in marriage of his natural daughter Margherita for Alfonso's heir Ercole. Clement proposed Catherine de' Medici for Ercole and Ippolito de' Medici for Alfonso's daughter Eleanora. Both League and emperor were eager to entrust the command of their armies to the warrior duke. Alfonso, preoccupied as always by his long-standing quarrel with the pope over possession of Reggio and Modena, opted for the emperor, a decision that was to have important consequences. He opened his gates to the swaggering, undisciplined landsknechts, armed with pikes and swords and all the more ferocious for want of food and wages. He saw to it that the soldiers were fed and provisioned, while Frundsberg was received as an honoured guest and supplied with weapons.

As the emperor's Spanish and German armies continued their descent on Rome,[7] the Italian League, which had begun as an exhilarating promise of freedom from foreign intervention, was in disarray. The commander-general of the Venetian army, the Duke of Urbino, could not agree about tactics with the papal lieutenant general. Francis I made expansive but empty offers of help. The pope was deceived by a trumped-up truce with the imperialists. Frundsberg fell ill six weeks before his troops reached Rome on 6 May, and on that first day the Duke of Bourbon was shot dead on a scaling ladder. Unpaid, leaderless, starving, out of control and braying for blood and plunder, the Spanish and Lutheran invaders went on a killing and looting spree that quickly turned into the most barbaric invasion of the Holy City in the history of the papal monarchy. 'Hell itself', wrote Sanudo as the reports reached Venice, 'was a more beautiful sight to behold.' Clement managed to escape to the relative safety of Castel Sant'Angelo, where he watched the unspeakable carnage, and was kept prisoner until he managed to escape in December disguised as a gardener. The armies slaughtered every Roman they encountered, until they realized that it was more lucrative to take prisoners who could raise ransoms and provide information about the location of hidden treasures. Fidelity to the emperor counted for nothing, except for those who had friends or relatives in command of the imperial army. Isabella d'Este's life was saved thanks only to the intervention of her son Ferrante Gonzaga, who was an imperial commander, but she still had to pay a ransom of 60,000 ducats.

There was scarcely a church or palace or library that was not sacked and pillaged, and some were completely destroyed. In the Vatican, which was almost entirely gutted, the Sistine Chapel was used as a stable; a German soldier scratched 'Martin Luther' into Raphael's Eucharistic fresco of the *Triumph of the Sacrament* (the *Disputa*). The occupiers seized around a million ducats in hard cash and as much again in plunder and extortion. The loss of life was incalculable, and there were further deaths from the plague and typhus that inevitably followed the massacres. The Sack of Rome was a turning point in the history of Italy, 'rather the fall of a world than of a city', as Giorgio

Vasari was to put it. No Italian state was unaffected. But for Venice there were gains as well as losses.

May 1527 was the climax but not the end of the Habsburg–Valois conflict on Italian soil or of Venetian involvement in the wars of Italy. While they continued over the next years, the population of Venice was swollen with war refugees, as it had been during the horrific years of the Cambrai war. They brought plague, typhus and more cases of syphilis. It was a terrible time for the Venetian economy. The production of wool was collapsing, exchange rates were unfavourable, an acute shortage of grain was followed by a depression in the spice trade. There was famine in Venice and on the mainland as the price of commodities soared, the scarcity compounded by unusually severe floods. Provision was made for the poor and the sick; a law specifically requiring support for the poor was passed in 1528. But it was a bleak time for ordinary Venetians and a severe blow to the government, which, lacking the resources to make a significant military contribution to either side, gradually lost its power to influence the outcome.

In the longer term, however, Venice was in many ways the beneficiary of the tragic destruction of Rome and the immeasurable damage inflicted on its cultural life. While Rome lay in ruins, with the pope in exile, the myth of Venice as the New Rome, which had been tarnished by the Cambrai war despite the best efforts of Venetian propagandists, took on a new significance. This time it was Rome that had been punished by God for its sins and excesses. Venice, at peace and with the most stable government in Italy, was now the obvious destination for talented artists and intellectuals. The enlightened doge, Andrea Gritti, welcomed and encouraged foreign arrivals who would realize his vision of Venice as heir to the cultural ascendancy of Rome.

Sebastiano Luciani, Titian's old friend and fellow student from the days in Giovanni Bellini's studio, survived the Sack of Rome by taking refuge with the pope's entourage in Castel Sant'Angelo and fled to Venice by October, but only for a short stay. Although he visited Venice again the following summer, he decided to remain in Rome,

where he could count on the patronage of the pope when he returned from exile, on the friendship of Michelangelo and on the absence of Titian. Pordenone, so called after his hometown in the Friuli, settled in Venice for a few years in 1529 and became, for a short while, the only painter to present a serious challenge to Titian. But while Titian remained the supreme Venetian painter, the presence of three architects, all refugees from the Sack, began to drag a Venice that had clung to its traditional preference for Gothic buildings into the classical High Renaissance. It was to Venice that the Bolognese architect Sebastiano Serlio fled and there that in 1537 and 1540 he published two of his vastly influential Seven Books on Architecture, which diffused the Italian Renaissance language of the classical orders throughout Europe. The Veronese architect and military engineer Michele Sanmicheli, who had been employed in fortifying the Papal States, was appointed *protomagister* of the Venetian water board, with responsibility for defence. He built new bastions for Verona, and later that city's magnificent crisply classical gates, as well as palaces there and in Venice.

The refugee who would make the most significant impact on the urban development of Gritti's New Rome, however, was the Florentine sculptor and architect Jacopo Sansovino, who arrived in August after the Sack and soon became one of Titian's closest friends. Jacopo Sansovino was forty-one when he fled to the Most Serene City. Although he had not completed many buildings in Florence or Rome,[8] he had immersed himself in the study of Rome's classical buildings and knew at first hand the buildings of Michelangelo and Bramante. His reputation, more as a sculptor than as an architect, preceded him – soon after his arrival Lorenzo Lotto described him as 'second only to Michelangelo'. A bachelor and inveterate womanizer, he brought with him to Venice a six-year-old son, Francesco. Although he sometimes said he couldn't be absolutely sure that Francesco was his son, he saw to it that the boy received the first-class education that equipped him later in life to become a prominent literary figure in Venice and the author of, among other works, the first guidebooks to the city.

According to Vasari, who left us with a vivid description of the appearance, character and habits of his friend and fellow Tuscan, Sansovino was of ordinary height, lean with an erect posture, a red beard, pale skin and a redhead's tendency to outbursts of temper that soon passed; 'and very often with a few humble words you could make the tears come to his eyes'. He was handsome, graceful, well dressed and adored by women, including some of high status. As for his qualities of mind, he was prudent, farsighted, always ready to learn from experience and to put his considerable financial acumen to the service of his employers. Although given to excessive habits in his youth, when he was often ill, he was never less than zealous, tireless and absolutely reliable in his work. (Vasari was not the only contemporary who mentioned Sansovino's prudence and circumspection.) In his old age he enjoyed excellent health and perfect eyesight, thanks to restricting his diet in summer to fruits: Vasari claimed that he had seen him eat as many as three cucumbers at a time with half a lemon. He treated people from all walks of life with equal consideration – a rare quality in a period characterized by rigid social distinctions, one that must have helped him get on with the foremen and workers on his building sites, and 'which made him very dear both to the great and to the small, and to his friends'. His death, which came in 1570 when he had reached the great age of eighty-four, 'was a grief to all Venice'.

But Benvenuto Cellini, after dining with Sansovino in Venice many years after his arrival there, recorded a rather different impression of his personality: 'He never stopped chattering about his great achievements, abusing Michelangelo and the rest of his fellow sculptors, while he bragged and vaunted himself to the skies.'

By that time Sansovino had become a leading member of the Venetian artistic establishment and was on his way to realizing Andrea Gritti's ambition to follow the example of the Roman emperor Augustus who had proclaimed at the end of his reign that he had found a Rome of brick and left it a city of marble. In 1527, however, there were not enough gold ducats in the treasury to pay for ambitious new architectural projects, let alone to feed and house the poor

or restore the neglected old building stock of the city. Sansovino planned to return to Rome as soon as it settled down and consider his career options, which included an invitation from Francis I to the French court and the offer of a commission from Henry VIII of England. But, as his son would write many years later, having intended to stay for two weeks, he stayed in Venice for the next forty-seven years. Cardinal Grimani alerted the doge to Sansovino's presence, and Gritti did what he could to make him welcome, giving him the job of restoring the domes of the basilica, which were in danger of collapse.

One of the many friends Sansovino made in Venice was the Flemish composer Adrian Willaert. In December 1527 Andrea Gritti, despite some opposition from·the procurators, succeeded in appointing Willaert choirmaster of the basilica, where the available musical talent had been enriched by refugees who had formerly sung in the Sistine Chapel choir. Willaert was the inventor of what we call stereophonic music. His dramatic arrangements of sung masses performed by split choirs became fashionable entertainments for the nobility, and gave entrepreneurs – always plentiful in Venice – the idea of staging sung music in commercial venues as well as churches. Willaert, who stayed in Venice until his death in 1562, made his adopted city the Italian centre of avant-garde composition. He trained generations of musicians to play and sing in ways that laid the foundations for the operas composed in the next century by Monteverdi, Cavalli and the other baroque Venetian composers.

It was probably the Tuscan writer Pietro Aretino, also a newcomer, although an altogether less reputable one, who played the larger part in persuading Sansovino to remain in the lagoon city and wait for better times. Ten years later when with the return of prosperity Sansovino had founded a High Renaissance school of Venetian sculpture and initiated the most radical rebuilding programme ever seen in a Renaissance city, Aretino was able to describe his friend as Rome's greatest gift to Venice, the supreme example of the good that had sprung out of the evil of the destruction of Rome.

Aretino arrived in Venice six weeks before the Sack. Although he did not witness the event, he had predicted it in writing and later set

one of his books, the pornographic *Ragionamenti* (*Conversations*), in those dark days. He had met Titian in Mantua, and almost immediately after his arrival formed a bond with him and with Sansovino that would last until he died, of laughter so they said, three decades later. He became the closest companion of Titian's life, his most sensitive critic, as well as his adviser, agent, publicist, debt collector, scribe and hanger-on. He broadcast Titian's talent to the world in his plays, sonnets and more than 225 published letters, while using his friend's growing international reputation to gain entrée and gather information for his journalism. When he came to publish a collection of letters written to him by the great and famous men and women of the world he included only two of what must have been hundreds from Titian,[9] presumably because they were of no literary merit and he considered that his pen could do better for a friend whose syntax was as plain and clumsy as his brushes were capable of capturing the very essence of nature. They were useful to one another, but there is no mistaking the real warmth of their relationship, or the pleasure they took in one another's company. It is thanks to Aretino's tireless pen that we know as much as we do about the silent artist whose painting and personality he understood better than any other writer of their day, and perhaps since.

The monumental figure of Pietro Aretino – journalist cum press baron, master of aphorism and hyperbole; pornographer, flatterer and blackmailer; playwright, satirist, versifier, bisexual libertine, connoisseur of art; self-styled political seer, 'fifth evangelist', 'censor of the world', as well as its 'secretary' (meaning depository of its secrets); 'one whose letters are answered even by emperors and kings' – stands out even in a period characterized by extraordinary men. He rejoiced in Ariosto's sobriquet, 'Scourge of princes, the divine Aretino', which he earned by writing and circulating editorials in the form of *pronostici* – the satirical and sometimes libellous mock-prophecies that he issued annually as parodies of the forecasts issued by astrologers – and unsolicited letters to and about every person of consequence, including the Most Christian King of France, the Habsburg emperor Charles V, the Medici pope Clement VII, the Turkish sultan and the King of

Algiers. An avaricious, unscrupulous and highly sexed powerbroker, he recognized his own vices in the Great and Good of the Renaissance world, and used them to manipulate and prise from them rewards and gifts, distributing praise or slander in proportion to the generosity of his victims. Although, like most journalists, he sometimes posed as a defender and Oracle of Truth, he took more pride in his skills as a flatterer and blackmailer: 'If the three Magi had lived in my time they would have had to pay tribute to me.'[10] He described his pen as 'plague-ridden', his ink as 'poisonous', his paper as 'the grave',[11] and wrote that he enjoyed besmirching that paper as others took pleasure in defacing the white walls of hostelries. Nearly half of his letters are about money – one of the many interests he shared with Titian. He claimed that in the years between his arrival in Venice and the mid-1530s he had extracted 10,000 scudi from princes, but at another time he also claimed that he had spent the same amount on helping the poor. Titian called him a brigand chief of letters. 'I am in truth a terrible man,' Aretino once confessed to his publisher, 'since kings and emperors pay me out of fear.'[12] The truth was that he was clever enough to know that flattery is usually a more successful tactic than threats, and took care to praise friends and patrons of all ranks in his letters and plays.

Sanudo deplored his habit of speaking 'ill of nobles and others'. In the nineteenth century he was reinvented, rather like Machiavelli, as a dangerous monster, and all the more fascinating for that. Burckhardt,[13] who called him 'the greatest railer of modern times ... not burdened with principles, neither with liberalism nor philanthropy nor any other virtue', nevertheless admitted to 'His literary talent, his clear and sparkling style, his varied observation of men and things ... the coarsest as well as the most refined malice' and 'a grotesque wit so brilliant that in some cases it does not fall short of that of Rabelais'. Crowe and Cavalcaselle[14] failed to understand how an artist as great as Titian 'came to be connected with such a man, and how, knowing him intimately, he kept up relations with ... a parasite of the most dangerous kind ... Like a fungus on a dunghill he took advantage of a general corruption to live and to fatten, and he was not

the less like a prosperous fungus because he happened to be poison-ous.' From our more liberal perspective, however, he seems not such a terrible man after all. He was steadfastly loyal to his friends, even when they let him down: 'I keep friends as misers hoard their treas-ures.' He was also capable of magnanimity (usually, it must be said, calculated) to his enemies, and was rarely vindictive. In the 1550s his publisher Francesco Marcolini advertised Aretino's books with a letter, supposedly written by him to the author, praising the unstint-ing help he gave to the poor:

> You pay travelling expenses for traders, come to the assistance of unmarried mothers who have been deserted ... clothe the destitute beggars who come to you, taking the hose off your legs, the shirt off your back and your very doublet ... You aid even the poor gondo-liers. It is a fact that I know fifty to whose children you have stood as godfather, giving each of them a handful not of coppers but of silver scudi ...[15]

Aretino, who doubtless dictated this puff, sometimes used his gener-ous treatment of the poor and sick as justification for his endless requests for money from the rich and powerful. In a letter to a former imperial ambassador in Venice[16] who had sent him 500 scudi he proclaimed that needy people of all ranks looked to him for help as though he were the heir to a king's treasury: poor women in child-birth, prisoners in need of bail, soldiers, pilgrims, knights errant. When a man wounded in the street near his house was carried into his apartments he told the assembled crowds: 'I'm well aware that I'm a good host, but I never knew before that I ran a hospital.' But, full of himself as he certainly was, generosity to the poor is a characteristic that runs through the story of his life: six years before his death Titian wrote him a letter saying that he had been telling a mutual friend that Aretino gave everything to the poor, down to the clothes on his back.[17]

This complex character was a phenomenon that could only have existed in Italy, which was well ahead of the rest of Europe in the use

of a literary vernacular (Aretino's native Tuscan) that could be used to treat any subject and which was the lingua franca of all cultivated Europeans. One of the first European writers to live entirely by his pen,[18] and the first to exploit the printing press to strut his opinions and influence the course of events, he issued his editorials as pamphlets or as flyers distributed along city streets and country lanes; and by the time the first volume of his collected letters was published in 1538, he was so popular that it went through ten editions, and was followed by five more (the second dedicated to Henry VIII of England). As a thinker he was not in the same league as Bembo, Ariosto, Machiavelli, Guicciardini or Castiglione, but his more spontaneous pen had a greater influence on the political and social behaviour of the civilized world of his own day. The literate public from Amsterdam to Hungary, Spain, Greece, Turkey and Persia couldn't get enough of the upstart celebrity's amusing, scandal-mongering and perverse rhetoric, his praise of whores, his vivid pornography and above all his apparent intimacy with powerful rulers over whom ordinary people had no control. The world watched in wonder as this man from nowhere dared to advise, flatter, slander and stand up to princes who ruled by divine right.

Unequalled as a self-publicist, he knew the value of projecting images of his face, which was strikingly good-looking in his youth, as widely as possible. He once boasted that he had 'not only been sculpted in lead, silver, bronze, gold, but also painted on canvas, panel, and wall',[19] and was pleased to note that his features appeared even on decorative objects such as mirrors and door knockers. He commissioned nearly as many portraits of himself as did the emperor Charles V of *him*self. Some six of the portrait medals he circulated across the courts of Europe survive; on the obverse of one of them his beard and hair are composed of erect phalluses, another is inscribed with the words 'Truth engenders hatred'. Most of the numerous painted portraits he commissioned – from Sebastiano, Tintoretto, Francesco Salviati, Vasari, Moretto da Brescia and Marcantonio Raimondi, as well as at least three from Titian – have fared less well. But in Titian's freely painted portrait of his friend in vigorous middle age (1545,

Florence, Galleria Palatina) we see all the robust, sensuous, arrogant, maverick, grandiose energy of the man, filling the picture space as he filled rooms, and perhaps sense an element of competition between the wordsmith and the painter he called his brother, pal, unique friend and honoured gossip, but who he knew could say more with a few strokes of his brush than even his words could convey.

The Triumvirate of Taste

Fornication and sodomy, fraud and swagger, high politics, wordy
warfare and material ambition were not the only fields in which
Pietro Aretino, that 'literary brigand', as Titian called him,
operated both as a promoter and censor.

JAMES CLEUGH, *THE DIVINE ARETINO*, 1965

Pietro Aretino landed at the jetty in front of the doge's palace on 27
March 1527. He came with a single servant, a reputation as a loud-
mouthed troublemaker, and the remains of 100 crowns given him by
Federico Gonzaga, whose guest he had been in Mantua, to speed him
on his way. Two of his Medici patrons had recently died, Leo X in 1521
and Leo's cousin Giovanni in 1526. He had grown bored with life at
the provincial Mantuan court. The Marquis of Mantua was glad to get
rid of him for the time being; and Aretino was aware that his free-
wheeling pen, which had been issuing relentless attacks on the pope,
might make his presence in Venice equally inconvenient for Andrea
Gritti's government. When he looked up Titian within days of his
arrival, neither could have guessed that Aretino would become a
fixture in Venice, that their friendship would turn out to be the most
enduring, warmest and most mutually useful relationship in both
their lives, or that Aretino, Titian and Jacopo Sansovino would come
to be known as Andrea Gritti's Triumvirate of Taste.

The story of Aretino's life up to that point was not one that would
have recommended him to a less broadminded doge. He was born on

Good Friday 1492 in a hospital for the poor in Arezzo, the Tuscan town he adopted as his surname. His mother, Tita, was a beauty who modelled for local painters. Her husband, Luca, was a cobbler who was probably Pietro's father, although it sometimes suited him better to claim that he was the bastard son of an Aretine nobleman, Luigi Bacci, who kept Tita as his mistress. Although he learned to read and write and quote the Bible, he liked to boast that he had never gone to school or had a tutor. With no formal classical education to refine his intellect, he developed the fluent, vigorous vernacular Tuscan that he would wield against the rulers of a world that he viewed through the magnifying glass of his own tremendous ego. Although extremely well read he railed all his life against pedantry. Martin Luther, 'the worst pedant of all', had used his 'assassination of the dead' to provoke 'heresy against our Faith'. In a letter[1] entitled 'Against Pedantry' he advised one of the secretaries who had helped him compile the first volume of his published letters, to:

> Use the diction that your own ears have taught you … The best way to rival Petrarch or Boccaccio is to articulate your own ideas in a style as beautiful and skilful as theirs, but not to plunder them of this or that idiom, which today sounds stilted … It is nature, without the slightest effort, that produces the pure metal. There was once a wise painter who, when asked what models he copied, pointed in silence to a group of human beings. He meant that he studied only life. Consider the nerve and the sinew … Be sculptors of what you feel, not painters of miniatures.

Although he shared his dislike of pedantry with his older contemporary Baldassare Castiglione, he was in every other respect the polar opposite, and self-consciously so, of the author of the most influential manual of courtly behaviour ever written. Aretino throughout his life made a point of despising the princely courts that attracted some of the best talents of his day: 'The court … is the hospital of hope, the tomb of life, the wet nurse of hatred, the breeder of envy, the matrix of ambition, the marketplace of lies, seraglio of suspicion, prison of

harmony, the school for deceit, the home of adulation, the paradise of vice, the inferno of virtue, purgatory of goodness, and the limbo of joy ... Life is about not going to court.'[2]

He was thirteen or fourteen when he left home and walked to Perugia, where he tried his hand at painting[3] and at shocking the bourgeoisie with vulgar pranks, such as repainting an image of St Mary Magdalen as the prostitute she had once been and exposing himself at a window, before fetching up in Leo X's Rome where he soon found employment in the household of Leo's banker, the fabulously wealthy Agostino Chigi, who was then building his Villa Farnesina in Trastevere. One of his after-dinner tricks was to have his servants throw the silver plates and dishes into the Tiber (where they were caught in submerged nets). The cardinals, princes, famous writers and artists who attended Chigi's lavish parties were delighted by the handsome young jester, whose witty gossip could make even his blushing targets roar with laughter. At first they didn't mind being lampooned by Pasquino, the 'talking statue' near Piazza Navona, which was the posting place for supposedly anonymous satirical poets with axes to grind; and Aretino didn't bother to hide behind Pasquino: 'Take care that Aretino be your friend/for he's a bad enemy to wrong.' The hedonistic Pope Leo, who revelled in the company of clever men – and who, as a Florentine, had no objection to having Romans lampooned – liked him so much that he invited him to join the papal court.

It was there that Aretino met Leo's cousin, Giovanni de' Medici, the greatest mercenary soldier of his day. The first commander to dress his army in uniform, Giovanni adopted the sobriquet dalle Bande Nere (of the Black Bands) when he changed his army's colours from white to black as a sign of mourning after Leo's death. Six years younger than Aretino, Giovanni quickly became the dearest friend he would have before he met Titian. The writer, who was a physical coward, admired the dashing warrior's raw and reckless courage. It made him feel protected, while the soldier enjoyed the company of the most eloquent and amusing man he had ever met, who could terrify with his pen as he could with a sword; and who shared his taste

for whoring and his impatience with the imprisoning atmosphere of court life. Much later, eleven years after Giovanni had been fatally wounded in battle, Aretino wrote to his friend's son, Cosimo de' Medici, the first Duke of Florence, that he had been Cosimo's father's other father, as well as his brother, friend and servant.

Aretino was already sizing up the potential as a patron of Leo's cousin and most likely successor, the alarmingly virtuous and subtle Cardinal Giulio de' Medici. He composed unsolicited pasquinades supporting the candidature of Giulio and denouncing his rivals, one of whom was the dour Dutch cardinal Adrian Dedal. When Dedal was crowned pope instead of Giulio, the Scourge made off for Bologna, from where he continued his attacks on the killjoy pope. Giulio, as pope in waiting, was in a difficult position. Since he could scarcely afford to make an enemy either of the reigning pope or of his relentless tormentor, he did what he could to keep the loose cannon away from Rome. He persuaded Federico Gonzaga to entertain Aretino at his court in Mantua. When Aretino showed signs of boredom there, he suggested that he should join Giovanni dalle Bande Nere, who was then encamped at Reggio.

Adrian died in September 1523, and when Giulio de' Medici succeeded him in November as Pope Clement VII, nothing could keep Aretino away from Rome, where, however, he made the mistake of alienating the powerful Gianmatteo Giberti, the officer charged with dating and registering all documents issued by the pope. His second miscalculation was a bit of mischief inspired by some sketches tossed off by his old friend Giulio Romano, who was in Rome at that time finishing frescos started by the late Raphael. The sketches, as Vasari described them, illustrated 'the various attitudes and postures in which lewd men have intercourse with lewd women'. *I Modi* (*The Positions*), were engraved by another of Aretino's friends, Marcantonio Raimondi, causing the outraged Clement to throw him into prison and to order that all impressions be destroyed. Aretino intervened successfully with the pope on Marcantonio's behalf, but couldn't resist circulating in manuscript sixteen sonnets to accompany a copy of the engravings.[4] Many years later he justified his pornographic work in a

letter to a friend, a Brescian physician, condemning hypocritical censorship, which 'forbids the eyes to see the very things which most delight them'.

> What evil is there in seeing a man possess a woman? ... It is the very source from which gush forth rivers of people ... the Sansovinos, the Titians, the Michelangelos and after them the popes, the emperors, and the kings. It has begotten the loveliest of children, the most beautiful of women, and the holiest of saints ...

Aretino had gambled that the Church would object less to his texts than to the engravings, which were objectionable because they showed sexual acts considered less likely to produce children than the missionary position. Nevertheless his sonnets gave Giberti exactly the excuse he needed to demand that Clement have Aretino imprisoned or executed as a corrupting influence. Pietro fled home to Arezzo before accepting an invitation from Giovanni dalle Bande Nere to join him at Fano on the Adriatic, where the soldier was engaged in some piracy in order to pay his debts. The two friends galloped north to meet Francis I, who was encamped near Milan. The Most Christian King of France was enchanted by the witty writer's personal charm. Aretino used Francis's favourable opinion of him as a passport to re-enter Rome, where the chameleon pope and Giberti were at that time backing the French presence in Italy. Two sycophantic odes in praise of Pope Clement and another dedicated to Giberti, and by the end of November 1524 Aretino was lording it once again in the Holy City, where Clement made him a Knight of Rhodes and awarded him a fixed pension.

Aretino/Pasquino resumed his attacks on Giberti. And this time he paid the price. In the early hours of the morning of 28 July 1525, while riding home from a late party, Aretino felt the full force of Giberti's anger when a masked man seized the bridle of his horse, stabbed him twice in the chest and severed two fingers of his right hand. He only just survived. Having quickly learned how to write with two fingers and a thumb, he left Rome for the safety of Federico Gonzaga's court

at Mantua, where he spent a dull winter relieved only by the presence of Giulio Romano, who was working with assistants on the frescos for the marquis's Palazzo Tè.

In the summer he escaped the boredom of the court to the camp of Giovanni dalle Bande Nere, who was commanding a large contingent of papal and French forces in Lombardy. By the autumn, when Giovanni had not been paid by either the pope or the French king, he considered joining the imperial ranks. Aretino persuaded him to stay loyal to the pope, but soon had reason to regret his advice. In November 1526 when Giovanni was fighting at Governolo, thirteen kilometres south-east of Mantua, to prevent the advance on Rome of the emperor's landsknechts, Aretino was with him when Giovanni's right thigh was broken by a cannon ball fired by Alfonso d'Este's pro-imperial army. On Aretino's insistence, Giovanni was carried through a blinding snowstorm to Mantua where he died in the night of 30 November. Three weeks later Aretino wrote to Giovanni's treasurer in Florence a long account of the last hours of the beloved friend who had been the light and purpose of his life. The letter is so moving in its sincerity and profound grief that even Aretino's fiercest critics must admit that it goes some way towards redeeming his reputation as a self-serving cynic. When the doctors advised amputation, Aretino reminded his friend that 'wounds and loss of limbs are the collars and the medals of those who serve Mars'.

'Let it be done,' he answered me.

At this the doctors came in, and, praising the fortitude of his decision, gave him some medicine and went to prepare their instruments. At suppertime he began to vomit, and he said to me, 'This was the omen that warned Caesar. I must now think of other things than life.' ... But when the time was come and the surgeons came in with their instruments they asked for eight or ten strong assistants to hold him down during the terrible sawing. 'Not even twenty could hold me,' he said, smiling. Then he sat up and with a perfectly calm face he took the candle in his hand to give light to the doctors. I rushed out of the room and put my fingers to my ears ...

Aretino, Federico Gonzaga and Federico's brother-in-law the Duke of Urbino did what they could to comfort the great commander. In the evening Federico came to his bedside, kissed him and begged him to ask one favour. 'Giovanni said, "Love me when I am dead."' The marquis replied: 'That heroism by which you have gained such glory will make you not merely loved but adored by myself as by all others.' Aretino concluded his tribute with an attack on the pope, whose irresolution and inadequate military support in the face of the imperial and Lutheran advance had allowed a heroic commander gifted 'with as much amplitude of soul as any man that ever lived' to die like a common soldier.

> In short, everyone envied him but no one could imitate him. I only wish I were lying when I say that Florence and Rome will soon find what it means not to have this man among the living. Yet I think I can already hear the cries of the pope who thinks he has won by losing him.

After Giovanni's death Aretino stayed on at the Gonzaga court, entertaining himself and his host by drafting a performance version of his first comedy, entitled *Il Marescalco* (*The Stablemaster*), about a homosexual stablemaster who takes a wife after being tricked into believing that his marriage will please the Duke of Mantua. (In the version written between 1527 and 1530 he took the opportunity, as he often did, to praise his favourite artists: 'Titian, the only rival of nature; Sansovino, the half of a new Michelangelo, and Sebastiano, more than divine'.) While in Mantua he could not resist relieving his feelings of grief with further rages against the pope. He called Clement 'a sorrier wretch than Adrian', and twisted the knife by predicting, in his prognosis for the year 1527, entitled 'The Prophecy of Messer Pasquino, the Fifth Evangelist', the disaster that the emperor's mercenary soldiers would shortly inflict on the Holy City. The Mantuan ambassador in Rome wrote to Federico that he had been informed that a little book by Pietro Aretino that had just appeared in Rome was full of slander about the pope, the cardinals and the other prelates of the pope's court.

It is dedicated to Your Lordship, and has caused much scandal here. It is thought strange that in view of your relations with the Pope and his cardinals as a Captain General of the Church you should allow such a book to be published in Mantua under your auspices and name ...

The marquis was strongly advised to dismiss the Aretine from his court, or, in case the pope did not consider dismissal punishment enough, to prepare to arrange for the slanderer's assassination. Federico had no intention of murdering a guest who amused him and who had promised to glorify his reign with an epic poem, to be entitled *Marfisa*, which was to be based on Ariosto's *Orlando Furioso*. But he was frightened by his ambassador's communication. (He had also been put off, as a robust heterosexual, by a crush Aretino had developed on a young man at court called Bianchino, and had turned down a request to plead with the boy on the writer's behalf.) Aretino, who could also wear a moralist's hat when it suited his mood, shared the widespread disapproval of Federico's depravity, his frivolous, self-pampering way of life, his womanizing and his open adulterous passion for Isabella Boschetti. While Giovanni dalle Bande Nere had been courting death fighting for the pope, the captain of the pope's Church had made excuses to stay at home pleading illness (he did in fact suffer periodically from retention of urine) while enlarging his collection of prize breeds of horses, dogs, falcons and rare animals, dining on the most refined dishes, surrounding himself with every luxury, and offering his sword as Aretino put it, 'to the temple of Venus'. They parted amicably enough nevertheless.

The Sack of Rome, although he genuinely regretted it, had enhanced Aretino's reputation in Venice. He had seen it coming; and the pope, who had not, was a changed man. While in captivity Clement covered his handsome jaw line with the long beard that he wore as a sign of mourning for the rest of his life. He let it be known that he wished he had taken the Oracle's advice. The emperor, for his part, inevitably regretted the devastation wreaked by his armies on the Holy City. Aretino lost no time before taking advantage of their penitential mood. Only weeks after the Sack, when Clement was still

in prison, he addressed from Venice two astoundingly self-important open letters, the first to the emperor, the second to the pope. He advised the emperor to release the pope, to show clemency without which 'fame has no wing ... But who would not set his hopes upon the excellent, courteous and religious majesty of Charles V? He is ever Caesar and ever august.' This was followed by a lecture in writing delivered to the imprisoned Clement, who should turn to Jesus in his prayers and not blame his situation on Fate. Since it was God's will that had delivered him into Caesar's hands His Holiness must think only of forgiveness, not of revenge. The emperor was the cornerstone of the Church, just as Clement was its father, and it was now up to the pope to make the peace.

If either ruler had taken his advice the course of events over the subsequent years would have been very different, and he might have been rewarded with a papal benefice, or even the cardinal's hat that he had his eye on, preposterous though it may seem, then and for years to come. But both emperor and pope ignored his pompous advice, and the doge soon insisted that Aretino should change his tune with the Vicar of Christ, whom Venice needed as a friend. Aretino duly lavished panegyrics on Clement, and by May 1530 had persuaded him that he was a reformed sinner who would from then on be 'the good servant I was when my talents, nourished by your appreciation, took up arms against all Rome during the vacancy of the throne of Leo'. Clement sent him a gold collar and granted him copyright for his epic poem *Marfisa* throughout the Papal States.

In the next few years Aretino attached himself to the circle of scholars and artists around the French ambassador in Venice, while issuing praises of the French king, a campaign of flattery that had the advantage of being in line with Andrea Gritti's Francophilia. But when Francis's promises of a reward came to nothing Aretino warned him that the furnaces of Murano burning in his honour would grow cold unless he kept his word. At last, in November 1533, the king sent him a gold chain weighing five pounds[5] and worth 600 scudi. It was hung with enamelled gold pendants in the form of vermilion tongues inscribed in white lettering with the words

'LINGVA EIVS LOQVETVR MENDACIVM' (His tongue shall speak a lie).[6] Aretino's acknowledgement of the magnificent gift with its ambivalent message was a characteristic mixture of servility, ingratitude and veiled threat.

> Unfortunately, your gifts arrive so late that they are as useful as food is to a man who hasn't eaten for three days: by then he is so frightened that the very smell of the food he cannot taste either kills him or makes him dangerously ill. By God, a lie is as much at home on my tongue as is truth on the tongue of a priest! ... If I say that you possess all the rare virtues, fortitude, justice, clemency, gravity, magnanimity, and knowledge, am I a liar?[7]

The king ignored him, and Aretino announced his intention to move to Constantinople, 'in his miserable old age to seek his bread in Turkey, leaving behind among our holy Christians all the pimps, the flatterers and the hermaphrodites ...',[8] where he would 'preach the charity of Christian princes ... who constrain poor men of merit to go to Turkey where they will find more courtesy and more piety than they find cruelty and asininity here. Thus the Aretinos of this world are forced to worship pashas and janissaries ..."[9] But of course he couldn't tear himself away from the lagoon city, the centre of his world and the best vantage point from which to monitor events unfolding in Europe and decide how they could be turned to the advantage of Venice and himself.

Having convinced Andrea Gritti of his value to the Republic, he never failed in his allegiance to the doge he called his 'father'. Given the formal protection of the government, he had no difficulty in reconciling his own interests with those of the Republic; and he dedicated much of his vast literary output and his unparalleled skills as a propagandist to advertising the virtues of his adopted home and its superiority over the old Rome. Did he also act as a secret agent? If so, any written references to his role, if there were any, were destroyed, and he himself never mentioned in his letters his conversations with patricians in positions of power. But his immunity to charges of

blasphemy, sodomy and failure to pay rent does at least suggest that his journalist's nose for what was going on in Venice and abroad was of value to the state.

When Titian painted his first, now lost, portrait of Aretino shortly after his arrival in Venice, Aretino knew he had found the friendship that would fill the place in his heart previously occupied by Giovanni dalle Bande Nere. 'Titian', as he put it later, 'is I and I am Titian. Titian is another myself.' The painter shared a number of qualities with the heroic soldier: courage, an exceptional mind intensely focused on his particular vocation, and a fiercely independent spirit. Like Giovanni, Titian was a mercenary who would serve the highest bidder without sacrificing his professional integrity. Like Giovanni he had a sense of humour but no head for literature and was therefore all the more impressed by his new friend's wit and talent for verbal spin. Titian and Aretino, furthermore, were both self-made men, groundbreaking originals, and foreigners in a Venice that stimulated and freed their artistic sensibilities and where they preferred to live and work away from the courts on which they nevertheless depended for the lavish way of life they both enjoyed. This is not to say that they were not useful to one another. Aretino, who was aware of a shift of taste in the courts from literature to art, used his friendship with Titian and Sansovino to protect and enhance his reputation. Titian without Aretino might not have had access to the great courts of Europe for which he would paint some of his masterpieces. Their relationship was not without an element of mostly playful competition: Aretino liked to insist that while painting and sculpture represent appearances, it is only writing that can penetrate the minds and souls of men. But Titian was grateful to find an ally, however vulgar and ridiculously egomaniacal, who saw straight into the soul of his painting, and could talk and write about it with an understanding unfettered by sterile theory or scholarly pretensions. Art criticism, before Aretino wrote about it in the vernacular with his heart as well as his head, was written by painters or in Latin, and was therefore accessible to very few people. Titian, however, was bound to be affected by his friend's

sensitive eye and passion for painting, and some of his later religious paintings are so close to the religious works which Aretino began writing in the 1530s that the resemblance cannot be accidental. And Aretino, despite his theories about the superiority of writing, his scene painting, his forte as a writer, often seems to reflect Titian's way of looking at the world: 'Messer Titian's paintbrush is my pen.'[10]

Shortly after his arrival in the lagoon city, Aretino threw himself into managing the career of his 'other self'. In June Titian took up his new friend's suggestion that the two of them should jointly revive their connection with the Marquis of Mantua by presenting him with a gift of two paintings by Titian. Titian, who had been out of touch with the marquis for four years, was easily persuaded that the portrait he had just done of Aretino should be sent to Mantua along with the one of the late Girolamo Adorno, which had been in Titian's studio since Isabella d'Este had decided against the asking fee of 100 ducats. Aretino guessed correctly that it would appeal to her son, who had been impressed by Adorno's diplomatic achievements, intellectual qualities and close relationship with the emperor.

A letter dated 22 June, signed by Titian but surely composed by Aretino, accompanied the portraits. The letter compares Aretino to St Paul, an Apostle and therefore infallible, but even so a lesser being than Federico, from whom he begs praise. He hopes the portrait of Aretino will please him 'because I know how much you love your servant for his many virtues'. This was the first of many portraits of himself that Aretino would send or have sent to princes who were supporting him or from whom he sought support, and the first important letter he ghosted for his less articulate friend. Turning to the portrait of Adorno in the same letter Titian/Aretino continues the flattery by stating, not that the marquis had admired Adorno, but that Adorno had 'adored the marquis'. He also penned under his own name an effusive sonnet professing to 'adore' the Marquis of Mantua whom he compared to Caesar and Homer. Such elaborately gushing sycophancy, ridiculous though it may sound to our ears, was consistent with the etiquette of the time, although Aretino, it must be said, did lay it on thicker than most of his contemporaries.

On 8 July Federico acknowledged the gifts with separate letters to Titian and Aretino expressing his delight in possessing portraits of two such learned and distinguished men. He praised Titian with the usual cliché about the paintings being so natural and lifelike that they could not possibly be bettered. Federico rewarded Aretino with a 'tip' of fifty scudi and a gold doublet, for which Aretino thanked him, suggestively signing the letter 'Titian and I kiss your hand.' Nevertheless, although Aretino nagged the marquis over the coming months about the matter of compensating Titian, it was not until the following March that the painter had reason to thank the Most Illustrious and Excellent Signor for a 'noble and honourable' but unspecified gift. Meanwhile Aretino proposed to Federico two more works by friends in Venice: a sculpture of Venus by Sansovino, 'which will fill you with lust', and a painting by Sebastiano commissioned by Federico three years earlier on the advice of Castiglione, but which Aretino recommended the painter should now execute in a more straightforward way, 'without excessive religiosity [*hipocrisie*] nor stigmata, nor nails'.[11]

Aretino, who had made a number of useful Venetian acquaintances over the years, was staying at that time with the wealthy patrician Cornaro family in their beautiful palace at San Maurizio. It was two or three years before he found a place of his own. It was an apartment in the parish of Santi Apostoli on the lower of two main floors in a small palace on the Grand Canal that belonged to Domenico and Jacopo Bollani.[12] The accommodation, which consisted of a long *portego*, or central hall, and three other rooms, was accessible from a long, dark alley off the little campo on the landward side by what Aretino called a 'bestial staircase'. The best thing about it, apart from its situation on the Grand Canal, was that it was rent-free. How he managed to get away with not paying a penny to the Bollani in all the twenty-two years he lived there is something of a mystery, although it is possible that the mother of the Bollani boys thought that Aretino might be useful in advancing their careers.

Some years after settling in to his apartment Aretino addressed to Domenico Bollani one of the most vivid of his descriptive letters.[13]

The 'heavenly situation', he began, gave him the 'greatest pleasure he had ever known in his life'. He professed to be almost as afraid to start his eulogy of it as he would be if writing to the emperor himself.

> Whenever I look out of my windows at that time when the merchants forgather I see a thousand persons in as many gondolas. To my right are the butchers' and fishmongers' markets; to my left the busy Bridge and the German warehouse. There are grapes in the barges below, game of every kind in the shops, and vegetables laid out on the pavements ... All is tumult and bustle, except where a cluster of sailing boats are moored together, making a sort of island where the crowds count, sniff and weigh, so as to test the quality of the goods. Of the ladies, gleaming in gold and silk and jewels, though they are only housewives, I will not speak, lest I grow tedious ...[14]

The house is still there, where the Rio San Giovanni Crisostomo runs into the Grand Canal at the point where it bends above the Rialto Bridge, although one storey has been added to the original building. Aretino would no longer recognize the interior of his apartment, which had a marble bust of himself at the door, and a glass dome over the main reception room where there was an ebony filing cabinet in which he kept letters received from great rulers, military commanders, artists, bankers and so on. As years went by he improved the apartment with a new fireplace and new floors and furnished it with works of art, many sent as gifts: paintings by Parmigianino, Giulio Romano, Vasari, Sebastiano, Francesco Salviati; and sculptures by Sansovino, Leone Leoni and Alessandro Vittoria. Tintoretto painted a ceiling with the stories of the Flaying of Marsyas, Mercury and Argos, and Salome.

The house is today known as Casa Bollani. But for as long as Aretino resided there it was famous, so a friend once wrote to him, as the Casa Aretino, in the Calle Aretino, on the Rio Aretino. He was eventually in a position, so he boasted, to feed as many as fifty servants and to dress them in livery, and was so renowned for his hospitality that the story went round that some foreigners passing by the

house saw so many people coming and going that they thought it was a tavern, entered with the flow and were given a delicious meal by a handsome servant, who was insulted when they asked for the bill. Titian, who ran an orderly household and was by nature and upbringing thrifty almost to a fault, and Sansovino, who also had a good head for managing money, scolded their friend over the years for his prodigious generosity, and for allowing his servants to rob and cheat him and generally do as they pleased. Aretino replied that it made him happy to have his staff take advantage of him: 'I, who am feared rather than loved by the great ones of the earth, am glad that my grooms and kitchen maids do not respect me. For that situation prevents me from getting a swollen head.'

Some of his servants, male and female, were rough trade, hired mainly for sexual purposes. But however carelessly he managed his domestic affairs, he forbade gambling in his house, and watered his wine, and his guest lists were carefully calculated. He made himself a two-way source of information by cultivating Venetian patricians who had held positions in foreign courts and, on separate occasions, foreign ambassadors in Venice, whose social life was otherwise severely restricted by law. His stairway, he wrote to a friend eight years after he had settled in Casa Aretino, was as worn by the tramping of foreigners as the pavement of the Capitol by the wheels of triumphal cars. 'Nor do I believe that Rome itself ever heard such a conglomeration of languages as resounds in my house. Turks and Jews, Indians and Frenchmen, Germans and Spaniards come to me. So you can imagine how many Italian visitors I have as well.'

Among the Italians were other writers – some jobbing hacks, but some better educated than their host – who had been attracted to Venice by Aretino's example and by the unique freedom of expression allowed in the city. Some acted for a time as his secretary, a role that became increasingly necessary as with age his maimed right hand rendered it more difficult to use a pen. He also made a point of inviting young Venetian noblemen with literary and artistic tastes, who were of course also intrigued by the *succès de scandale* of his reputation. In this way he used the close blood ties within patrician families

to forge connections with the older relatives who occupied senior government positions.

Although Titian met many ambassadors and young patricians through Aretino, he did not attend the literary salons, or if he did Aretino never mentioned his presence at them in his correspondence. But if knowing everybody who was anybody in the political and literary world was a professional necessity for a powerbroking journalist, it was his intense and sensuous response, not only to Titian's painting but to all the visual arts, that gave him the most pleasure. All his life he kept eagerly in touch with artists in other parts of Italy. He annoyed Michelangelo by sharing with him his own vision of the Last Judgement, then rebuking him for exhibiting naked saints and angels in the finished painting, as well as begging him for examples of other works. In Venice he surrounded himself with resident artists and artisans: great masters like Tintoretto whom he dared to criticize and whose violent reaction terrified him, but also lesser artists and artisans working in gold or glass, advising them, acting as their dealer, commissioning or extracting works from them.

But it was Titian and Sansovino who remained his closest friends. Andrea Gritti's Triumvirate of Taste – the Aretine writer, the Florentine architect and the painter from Cadore – spent evening after evening over the nearly thirty years that passed before Aretino's death, gossiping about patrons and mutual friends, making up minor quarrels, laughing, discussing one another's work and how much they were paid for it, and flirting with the pretty girls of whom there was never a shortage in Casa Aretino. Wives, in the oriental tradition, stayed at home, and it was taken for granted that men had a sexual life outside marriage. Although Aretino showed genuine concern for Titian's children, he never mentioned Cecilia in his correspondence, nor Titian's second wife, a shadowy figure who was probably the mother of his daughter Lavinia.[15] The Triumvirate were good conversationalists, Aretino famous for his wit, Titian for his elegant manners, sense of irony and quiet charm, Sansovino, so Vasari reported, for his excellent memory and ability to embellish his stories and anecdotes with examples. The three of them, busy and famous though they became, were

not above relishing the small pleasures of a good life: the cosiness of a winter's evening talking around a roaring fire; the delicious meals prepared from ingredients brought to Aretino, or extracted by him, as gifts.

Titian, who has dropped in before dinner on a winter's evening, sees some thrushes roasting on a spit and, sniffing them, gives one look at the snow and decides to disappoint some gentlemen who are giving a dinner for him. The thrushes are prepared with a bit of beef, two bay leaves and a pinch of pepper. On another occasion the Mantuan ambassador, Pietro Bembo's son Torquato, Sansovino and Titian help to entertain a 'divine young lady' while enjoying a handsome and delectable turkey stuffed with three kinds of meat. But Aretino disapproves of gluttony, and makes fun of a party of 'heirs apparent to every kind of drunken excess' who have filled the bellies of their gross bodies with ortolans, figpeckers, pheasants, peacocks and lampreys.[16] Aretino takes an innocent delight in gifts of flowers, fruit and vegetables, which seem to give him nearly as much pleasure as gold chains and silken doublets. He rejoices in orange blossom and pansies, cherries, artichokes, baby squash (fried), pears, apricots, melons, plums and peaches. He thanks Vittoria Colonna for the lemons, truffles and carp from Lake Garda. He composes a little prose poem in honour of the olives sent by the mother-in-law of one of his girlfriends; gobbles down the snails provided by a physician friend; makes a meal of Sansovino's gifts of suckling pig, tasty jellies and excellent fish from Slavonia. He eats mushrooms from Treviso, but prefers salads, which 'in Nero's opinion were the antipasto of the gods'. The 'unique Titian, to the glory of Cadore', often sends his friend a grouse for his lunch or supper. Two of his women leap for joy when they see ripe cucumbers, which have only just blossomed.

Aretino, if we are to believe him, entertained every class of women from prostitutes to the wives of gondoliers, merchants and tradesmen; his conquests, so they said, included the wife of the architect Sebastiano Serlio; even some members of the aristocracy failed to resist the allure of the man's priapic energy and wicked reputation. (He was less open about the homosexual affairs he carried on at the

same time.) The girls, of whom there were sometimes as many as a dozen at a time living in his house and gracing his parties, were proud to be 'Aretines', as Aretino called them in a letter to his publisher. He made sure they did him credit, dressing them in the latest fashions, providing them with jewels, even supervising their makeup and hair. One was ash blonde, another had black hair and eyes and a terrible temper; one had a comically prudish manner, another a voice like a nightingale; one was so like a boy that Alessandro de' Medici slept with her to find out whether she was a man or a woman. Sansovino, who shared Aretino's voracious sexual appetite, took advantage of his host's generosity with his girls, although once, when they were all getting older, he received a slightly malicious letter from his friend saying that he had dined alone with a beauty called Virginia and kept it a secret from Sansovino and Titian 'out of reverence to the, alas, somewhat advanced age of the pair of you'.

Aretino continued into his old age to boast about his sexual prowess, even to his closest friends, even after he had fallen seriously and in one case painfully in love and fathered two daughters. 'To those who maintain that in following sensual appetite we hasten death,' the Scourge, of pedants and prudes as well as of princes, wrote to the pedantic writer Sperone Speroni in the late 1530s, 'I say that a man prolongs his life precisely in proportion to the extent that he satisfies his desires. And it is I who say this, not Plato!' And to another correspondent he said that if he didn't have forty lovers a month he would start worrying about his health.

As for Titian's sexuality, if anyone would have known all about it that person was his closest friend and most honoured gossip, who when Titian was about sixty wrote in a letter to Vasari that 'Titian, the eminent painter, affirms that he has never seen a lass who does not reveal some lasciviousness in her face.' But Aretino also tells us that although Titian enjoyed flirting with the girls at his parties, caressing them and taking them on his knee, he never went any further with them. It seems that Titian – who had denied sleeping with his models when Alfonso d'Este's ambassador found him looking exhausted in his studio – preferred to keep his personal life to himself. From what

we know about the mothers of his children he seems to have preferred domesticated women who kept a lower profile than Aretino's brazen girls. It could even be that he was satisfied by monogamous relationships. The most we can say is that, although Titian's portrayals of women inviting or – in the case of his two versions of the *Danaë*[17] – actually engaging in the sexual act were painted for rich men to enjoy in private, they are the work of an artist who loved women and understood them with a tenderness and understanding that may have eluded his erotomaniacal best friend, who wore his sexuality like a badge of honour while Titian revealed his in a way that speaks to us across the centuries more persuasively than words.

SIX

Caesar in Italy

What a wonderful thing it is that the king of France, from a desire
to have his sons back, did not refuse anything; that the king of
England, from a wish to disencumber himself of a wife, promised
everything; and that Charles, anxious to place the imperial crown
on his head, conceded more than anyone asked of him.

BENEDETTO VARCHI, *STORIA FIORENTINA*[1]

When in 1525 the Scuola of St Peter Martyr decided to commission a
painting for their altar in the church of Santi Giovanni e Paolo there
was a division of opinion about who the artist should be.[2] On 30
November of that year the executive committee of the Scuola submit-
ted a petition to the Council of Ten in which they stated that some
ordinary members wished to commission the altarpiece from 'people
who were not up to the task'. The people in question were probably
Venetian-born artists of the older generation like Marco Basaiti,
Vincenzo Catena or Giovanni Mansueti, who had never shaken off
the influence of Giovanni Bellini, charged less than Titian and prob-
ably appealed to more unsophisticated tastes. The committee feared
that the result would not be of a quality appropriate either to the
Scuola or to the church, and asked permission to bypass the chapter
by commissioning, at their own expense, one of the outstanding
painters working in Venice. The Council of Ten accepted the petition,
but only on condition that the individual committee members should
pay for a painting that the majority apparently did not want.

One of the signatories of the petition was Jacopo Palma, a disciple of Titian, who put himself forward as a candidate for the commission saying, however, that he wanted to have a competition with Titian *un'opera per uno*, in which each of them would produce a sketch and the better would win.[3] (Formal artistic competitions were rare in Venice, and this is the only known example of one initiated by an artist rather than a patron.) In January 1526 the Council of Ten washed their hands of the dispute between the committee and the ordinary members of the Scuola, leaving it to the Scuola to arrange the matter among themselves. After long negotiations, during which Pordenone was a candidate, Titian was chosen and agreed to paint the altarpiece and construct the panel. The steward of the Scuola, whose name was Jacopo de Pergo, guaranteed a fee of a minimum of 100 ducats, which he would pay in person if the amount could not be raised by other contributions. Titian accepted the fee, although it was no more than he had agreed with the stingy Jacopo Pesaro for the Frari altarpiece, which was smaller and on canvas, and saw no reason to mistrust the word of Jacopo de Pergo. His failure to insist on a formal contract would lead to trouble later on, but he was so eager for the commission that his usual sound business sense deserted him. To be represented in both the great preaching churches of the city, in the Franciscan Frari by the *Assunta* and *Pesaro Madonna* and in the Dominican Santi Giovanni e Paolo, would raise his profile to a degree that could not be resisted. The subject, which was to be the assassination of St Peter Martyr, the Scuola's patron saint, was preoccupying him even as he was finishing the Pesaro altarpiece in the Frari. In the next years he devoted much of the time he spent in his studio in Venice to working on the painting.

Nevertheless, however absorbed Titian was by a work in progress the practicalities of life were never far from the other parts of his mind. In March 1528 he joined the Scuola di San Rocco, which was close to his house behind the Frari and next to the church of San Rocco, for which he had painted his miracle-working *Christ Carrying the Cross* two decades earlier.[4] Membership of a Scuola, as he had perceived long ago as a boy working for Gentile Bellini, was an

excellent way to make contact with the rich businessmen, merchants, lawyers, bureaucrats and industrialists who were potential patrons.

A few weeks later he and Francesco invested in some land in the foothills of the Dolomites near Belluno. Ownership of agricultural land at that time carried with it aristocratic associations. It was also a secure hedge against inflation. In the years to come Titian would buy more property in the Veneto and welcome payments in land rather than cash until by the time of his death most of his estate was in property. This property, which was in an area to the east of Belluno still known as Calordo, consisted of two hectares with a meadow that produced twenty wagons of hay; a house with a fireplace and roofed stone shingles and tiles; stables covered with thatch; and a small yard.[5] The brothers immediately let the property back to the vendor on a long lease and sold it four years later, presumably at a profit. But the configuration of the mountains above Belluno made an impression on him because they appear in the background of some of his paintings of the 1530s. The rounded peak in the distance behind the *Madonna of the Rabbit* (Paris, Louvre) looks like Monte Pizzocco, the presiding mountain of the Bellunesi; the twinned jagged mountains in the landscape background of the *Presentation of the Virgin* are the same shape as those of Monte Tre Pietre seen from the road between Belluno and Feltre.

There is one spot in particular, just a few kilometres east of Belluno on the road to Bolzano, that so closely resembles the landscape of one of his paintings of around 1530 that the similarity cannot be accidental. In the *Virgin and Child with the Infant St John and a Female Saint or Donor*[6] (London, National Gallery) a swathe of pasture flanked by trees leads the eye to an undulating line of blue hills and mountains lightly draped in the haze of early morning. The setting of the painting was discovered in the nineteenth century by Josiah Gilbert,[7] who described the steep path leading downhill from the road to a narrow gorge where there were at that time 'simply a cottage or two, a farm, and a water mill'. After comparing his own sketches to Titian's sacred group he concluded that they agreed exactly, foreground and distance, and that it must therefore be 'almost the only definite statement

connecting the great master's landscape studies with any one scene'. Happily, this part of the countryside has been spared the worst of the urban sprawl around Belluno. The fertile gorge has not changed since Titian painted it around 1530 and Josiah Gilbert described it in the 1860s. The mill is gone, but the place still feels haunted by the Madonna pressing wildflowers into the hand of a chubby young Baptist while the gorgeously dressed St Catherine of Alexandria leans forward to kiss her Child, and an angel emerges from a cloud above the blue mountains.

In the summer of 1528 Titian lost a friendly rival when Palma Vecchio, who was not yet fifty, died leaving his last painting unfinished. Completing the unfinished work of dead artists was a Venetian tradition (Palma's great-nephew Palma Giovane would finish Titian's last work), but Titian's additions to Palma's *Holy Family with Sts Catherine and John* (Venice, Accademia), went further than most. Technical examinations have shown that in Palma's original a donor knelt beside St Catherine, whose figure Titian repainted in a different pose, while also making substantial alterations to Palma's St John. Although Titian used the same pigments as Palma, he built up the cheek and red dress of his St Catherine in many more layers. Where Palma had planned a landscape on the right behind the Holy Family, Titian replaced it with a quotation of his own invention from the *Pesaro Madonna* of a large column without a capital rising out of the picture and into the heavens.

Titian must have enjoyed discussing his work on the St Peter Martyr with Sebastiano Luciani, who paid Venice another visit in the summer of 1528 and stayed long enough to arrange a dowry for his sister and to witness the marriage of Vincenzo Catena, before deciding to settle back in Rome the following March. In the years since he had sailed away to Rome with Agostino Chigi, Sebastiano had become Michelangelo's chief disciple. Michelangelo himself was in Venice in the autumn of 1529. On his way to and from Florence, where he was supervising the strengthening of the Republic's fortifications, he stopped in Ferrara to study that city's famously impregnable walls. In Ferrara he saw Titian's portrait of Alfonso

d'Este, which, so Vasari tells us, he regarded with nothing less than stupefaction.[8] It is tempting to imagine a meeting between Titian, the greatest representative of Venetian painting, and Michelangelo, the supreme artist of central Italy from whom Titian had borrowed ideas over many years. They may have been curious about one another, but they coincided in Venice for only a few days in early October, and there is no evidence that they met before Michelangelo returned to Florence in November.

Titian's progress with the St Peter Martyr had been interrupted in January 1529 by a summons from the Duke of Ferrara to make substantial alterations to Giovanni Bellini's *Feast of the Gods*.[9] Completed fifteen years earlier for Alfonso's little alabaster chamber in the Via Coperta, Giovanni's painting had been looking distinctly old fashioned for some time. Several years after his death a painter, probably Dosso Dossi, had reworked part of the landscape. Even so, Titian's three Bacchanals, which now dominated the room, had succeeded, just as he had intended, in making Giovanni's painting look tame and lacking in emotional energy. Titian, as we learn from a letter from Jacopo Tebaldi to the Duke of Ferrara, promised to embark for Ferrara on a Monday in late January with a certain Gugliemo, whom the duke had sent to Venice to advise him about the purchase of two leopards or cheetahs that were for sale. (Tebaldi reported that Gugliemo had told him that the animals were two years old, the male could not possibly be more beautiful, the female also beautiful but not quite as much so as the male.) Titian, he continued, was complaining that he needed money to support his family in his absence and to buy a dress suit for his appearance at court. He was surprised that he had received only 100 ducats for the three things he had done on his previous visit to Ferrara, although each was worth 100 on its own.[10] He blamed the shortfall not on His Excellency the duke, but on his administrators. Two days after his arrival in Ferrara on 24 January Titian received the equivalent in lire of fifty ducats.

This was to be Titian's longest stay in Ferrara. (The wine records of the court cantina show that Titian and five assistants were there from 24 January to the end of February, and again for ten days between the

end of April and 18 June.) During this time he entirely revised the left side of Giovanni Bellini's landscape, cancelling out a frieze of trees that had once stretched across the canvas, and adding the escarpment that recalls the castle hill of Cadore. Although his landscape made Giovanni's figures look more doll-like than ever, the changes made the *Feast of the Gods* harmonize better with his own three paintings in a way that emphasizes his rhyming of Giovanni's demure little Lotis with his own large, sexually abandoned naked bacchants.[11] What else he was doing during this prolonged visit to Alfonso's court is unknown, although it is likely that he also made revisions or repairs to his own paintings in the room, and possible that it was then that he painted the lost portrait of Alfonso with his hand resting on a cannon, which Michelangelo admired later that year. All that can be said for certain is that when Alfonso wrote to his nephew Federico Gonzaga on 14 March he referred to 'several kindnesses' that Titian had done for him in the days he had been with him so far.

The letter was in reply to a request from Federico for Titian's presence in Mantua.[12] Titian, he wrote,

> has asked leave to come to you in Mantua in order to attend to some necessary business, and I have decided to give it to him because I understand the importance of the matter that brings him to Your Excellency, and because I wish to gratify his wish, and for the esteem in which I hold his talent, I have thought it well to send him with these lines, with which I beg Your Most Illustrious Lordship to consider him recommended not only for the love I bear him, but for the sake of the goodwill which I know Your Lordship bears him also, and the favour it will be to him without further intercession; and the sooner Your Excellency shall deign to send him back, the greater will be the obligation under which you will place myself and him.

We can imagine Titian's heart lifting as he left the Duke of Ferrara's gloomy castle to travel up the Po Valley and across the fertile Lombard plain to meet his younger patron in Mantua, the handsome city he remembered from his two previous short visits. Agriculture and

stockbreeding being mainstays of the Gonzaga economy, the farm-lands through which he passed gave off a healthy country reek of animal manure. The Mincio River runs through an impregnable maze of swampy lakes that surround the city on three sides, and which protected it from full-sale military attack until the seventeenth century. Approaching Mantua from the east Titian could see the enor-mous precinct of the Gonzaga court buildings and a multitude of church towers.

In the fourteenth century, shortly after the Gonzagas became its rulers, Petrarch had famously described Mantua as foggy and frog-infested. But in the next century the Gonzagas had built a great many fine monasteries and churches, of which the most important was Alberti's Vitruvian church of Sant'Andrea, one of the most influential buildings of the fifteenth century and part of an extensive programme of improvements to the town centre. As court painter to the Gonzagas, Andrea Mantegna had commemorated the family in their castle with his frescos in the Camera degli Sposi, the first illusionist ceiling paint-ings of the Renaissance (still one of the major artistic attractions of Italy). Mantegna had also glorified their military campaigns with the eight great canvases of the *Triumphs of Caesar* (now at Hampton Court).

Federico's mother, Isabella d'Este, was now fifty-five, her nose somewhat out of joint at having lost the power she had wielded during the frequent absences of her husband, Gianfrancesco, on mili-tary campaigns and after his death as regent during Federico's minor-ity. But she remained a dominating figure at the court. Cultivated and sharp witted if not learned (she had never succeeded in learning Latin), she played the clavichord, imported musicians from Ferrara and amassed a private treasure trove of gold, silver and bronze medals, vases of semi-precious stones, cameos, bronze and marble sculptures, antique relief carvings, busts of Roman emperors and copies of an-tiquities in the Vatican collection including two of the *Laocoön*. An avid and importunate collector of contemporary art, she relied on the advice of scholars, including her friend Bembo, to devise allegorical programmes for the paintings she commissioned for her *studiolo*,

known as the Grotta, on the ground floor of the palace. But she was mean with her payments, and not all painters took kindly to her dictatorial control over subject matter. Although she obtained allegories from Perugino, Lorenzo Costa and Mantegna, Mantegna's brother-in-law Giovanni Bellini evaded her frequent and insistent requests for a painting. Though far from beautiful, she was vain and had herself portrayed more than most of her contemporaries. Leonardo da Vinci drew her in chalk and pastel on a visit to Mantua in 1500, but never painted her portrait or anything else for her. When she was sixty, five years after Titian had got to know her in Mantua, he would paint her, at her request, as she might have looked as a young woman from a portrait by another artist that was itself based on an earlier portrait by Lorenzo Costa.

In Titian's day Federico's court artist was the painter, architect and designer Giulio Romano, the only Renaissance artist mentioned by Shakespeare,[13] with whom Titian would later collaborate on the decorations of a room in the ducal palace in Mantua. Giulio, as Vasari wrote:

> made for the whole of that city of Mantua … so many designs for chapels, houses gardens and façades and took such delight in embellishing and adorning it, that he transformed it in such a way that where it was formerly in the grip of mud and full of foul water at certain times and almost uninhabitable, it is today, through his industry, dry, healthy and altogether beautiful and pleasing.[14]

Giulio's most famous surviving project is the Palazzo Tè, which Sebastiano Serlio described as 'truly an example of Architecture and painting for our times', a judgement echoed in the late twentieth century by an architectural historian who saw it as 'the embodiment of all the artistic qualities most admired in the middle decades of the Cinquecento: inventive, surprising, elegant, complex but basically unified, allusive, learned, novel but not actually subversive of accepted architectural norms'.[15] It was the perfect building for splendid court entertainments, and was equipped with a tennis court and stable, as

well as with private apartments for Federico and his mistress Isabella Boschetti.

. When Titian reached Mantua, Federico's city, unlike the continually embattled Ferrara, had enjoyed nearly two centuries of security and growing prosperity. As a buffer state between the expanding frontiers of Venice and Milan, its rulers had bargaining power with both. Its location not far south of the Brenner Pass, furthermore, made it a convenient stopping place for German emperors on their way to and from Rome. The Gonzagas had from the earliest days of their reign deferred to the authority of the emperors, who had raised the family to the title of marquis in the early fifteenth century; and they had, unlike the Estes, usually managed to maintain good relations with the Church. Although they could not boast the ancient aristocratic lineage of the Estes, they had increased their prestige and their wealth by offering their services as military commanders to more powerful states and by marrying into more prominent dynasties, German and French as well as Italian.

Titian was still in Mantua on 16 April 1529 when Federico wrote a short letter to his uncle Alfonso saying that although His Excellency must marvel that the master had not yet returned to Ferrara he was detained by finishing a portrait of himself, which he needed urgently. He did not say that he had other plans for Titian as well, but Alfonso understood very well why Titian's portrait of his nephew was so crucially important. The time had come for the Marquis of Mantua, who had reached the age of twenty-nine, to contract one of the dynastic marriages by which the Gonzagas had traditionally enhanced their position. The question of who the bride should be, however, remained open for the time being. Federico had long since lost interest in his first bride, Maria Paleologo. Maria was the daughter of the Marquis of Montferrat in Piedmont, but was unlikely to inherit the wealthy marquisate. Federico had neglected to consummate the marriage when she came of age, while he looked for a better match and continued to make no secret of his adulterous affair with Isabella Boschetti. An unsuccessful attempt to poison Isabella gave Federico just the excuse he needed to get rid of Maria. Although everyone suspected

that Isabella's outraged husband had ordered the poisoning, Federico pointed the finger at the Paleologhi and thus managed to persuade Clement VII to grant an annulment. He was now free to marry again, but while the struggle between Francis I and Charles V continued he could not decide which ruler it would be most politically opportune to consult about the match. Giacomo Malatesta, who had succeeded his brother Giambattista as Mantuan envoy, was dispatched to Paris and to Toledo to test the waters; he reported on his return that both rulers were well disposed towards the marquis, but advised him that since the emperor was planning to come to Italy shortly on a peace-making mission the better strategy would be to bow to his wishes.

The magnificent portrait of Federico Gonzaga (Madrid, Prado) in a blue doublet embroidered with gold that Titian painted in Mantua in the spring of 1529[16] was exactly the reassuring image the marquis wished to project on the eve of a marriage. He wears a gold and lapis-lazuli paternoster around his neck. His concealed left hand rests on the pommel of a sword, the pale skin of the other, highlighted by two jewelled rings, rests on the bright white fur of an adoring Maltese terrier. Federico was certainly more interested in playing with his dogs than in using his sword, but Titian's portrayal of his tender relationship with this little terrier suggests a capacity for domestication, affection and fidelity. The expression of his face is ingenuous, open, almost sheepish.

Soon after Titian arrived at his court in March, Federico had set in motion a plan to help him purchase some farmland in the Veneto. Although the laws of mortmain were vague, the majority of fields and farms throughout Catholic Europe were owned by monasteries. Federico had in mind for his 'friend' – as he referred to Titian anonymously in the early stages of the correspondence – thirty-three contiguous fields near Treviso, including a walled house roofed with thatch, a well and an oven, that belonged to the Benedictine abbey of Santa Maria del Pero, which was under the jurisdiction of the Venetian monastery of San Giorgio Maggiore and ultimately, as an ecclesiastic property in Venetian territory, under the control of the Council of Ten. Although the preliminary negotiations had stalled by the end of

March, Titian wrote to the marquis from Ferrara on 12 June expressing his extreme gratitude, saying that he had no greater wish than to serve the marquis and that 'every hour seemed like a year' while he waited to return to Venice in order to satisfy him by fulfilling his 'obligations' – by which he meant the paintings he had promised to deliver in return for Federico's efforts to obtain the farmland for a bargain price. There is a note of friendly enthusiasm in this letter that we rarely find in his dealings with the prickly and demanding Alfonso d'Este.

Titian returned to Venice from Ferrara on 18 June bearing an effusive letter from Alfonso to Andrea Gritti thanking the doge for having allowed him to remain in Ferrara for so long. There was news, good and bad, of friends. Sebastiano Luciani had returned to Rome in March. Andrea Navagero, the patrician humanist and diplomat who had persuaded Titian to refuse Bembo's invitation to Rome sixteen years earlier, had recently been in Spain as Venetian ambassador to the court of Charles V. When his negotiations with the emperor stalled he had been transferred to the French court at Blois where he died almost immediately after his arrival.

On 7 April Jacopo Sansovino had been appointed *protomagister* – chief architect and supervisor of buildings – to the procurators of St Mark. It was a position that carried a starting salary of eighty ducats a year and a house rent-free near the Piazza. But the job, as he was to discover, would not be plain sailing, even with the support of the doge. He had already begun, with Andrea Gritti's blessings, the difficult job of demolishing and relocating the shops, taverns, hostelries and moneychangers that had littered the Piazza and Piazzetta for centuries. The rents were a source of considerable revenue for the procurators, and the tenants had long-standing rights to their premises, which in many cases had been passed down through generations.

Before Titian could resume work on the St Peter Martyr he was faced with two less demanding tasks. One was a commission from Andrea Gritti for a votive painting of himself as doge being presented to the Virgin (later destroyed by fire). The other was for an altarpiece of the Pentecost for the church of Santo Spirito in Isola (for which he

had painted his *St Mark Enthroned* nearly twenty years earlier). Gritti's painting was installed in the doge's palace in September 1531. There was no contract for the Santo Spirito picture, but the patrons decided to supply Titian with wine and flour in order to reduce the final fee, which would be decided when the picture was completed. But after making a sketch he abandoned it for a year or two, made another sketch and then lost interest until the 1540s when he finally painted a different version. He did not refuse a small job for Alfonso d'Este, who had asked him to have made in Venice a gold goblet with silver feet decorated with low reliefs, which was shipped to Ferrara in September.

That summer of 1529 Federico Gonzaga and Alfonso d'Este, like all the princes up and down the peninsula, were preoccupied by a momentous happening. Peace, at a price, was about to descend on Italy in the person of the emperor Charles V. Charles had never before set foot on the soil of the country he was determined to dominate. Now, after eight years of waging war in Italy against Francis and the papacy, he finally had the upper hand. Francis had never recovered from his defeat at Pavia and the enormous cost of redeeming his sons, who were still held prisoner in Spain as sureties for the Treaty of Madrid. On 15 June Charles concluded an armistice with Henry VIII at Hampton Court. Two weeks later, at Barcelona, he signed a treaty with Clement VII, who, almost as worried by the republican revolution that had expelled his Medici family from Florence in 1527 as by the Sack of Rome in the same year, realized that his only hope lay in alliance with Charles. The pope agreed to support the emperor and receive him in Italy in return for the restoration to the Papal States of Cervia, Ravenna and the Venetian seaports in Apulia, as well as Alfonso d'Este's Duchy of Ferrara and the contested cities of Modena and Reggio. Then, at Cambrai[17] on 3–5 August a peace settlement between Charles and Francis was negotiated in private by two politically gifted women: Louise of Savoy, Francis's mother and regent in his absence; and the Habsburg princess Margaret of Austria, Charles's aunt and regent of the Netherlands. Francis agreed to withdraw his troops from Italy and to renounce previous claims to Genoa, Milan,

Flanders, Asti and Naples; to marry Charles's sister Eleonora; and to pay two million écus, the equivalent of 2.6 tons of solid gold, as ransom for his two sons. He undertook furthermore to help persuade the Venetians to give over their territories in the Kingdom of Naples, and the Florentines to come to terms with the papal–imperial intention to restore the Medici. Charles gave up his cherished dynastic claim to Burgundy but gained far more than he lost. Where so many previous treaties had failed, the Paix des Dames – the 'Ladies' Peace' – succeeded, largely because both sides were short of money after the expense of their wars. For the same reason it lasted for the next seven years.

Charles sent word to Clement that he intended to come to Italy where he wished to be crowned Holy Roman Emperor at the papal city of Bologna. Rome, where the coronation would normally have taken place, was still suffering from the aftermath of the Sack by his troops, and his presence there could look like an apology. He set sail from Spain at the end of July, and on 12 August made a grand maritime entry into Genoa. Sanudo noted in his diary that the salutes of artillery from the fortresses and ships in the harbour sounded 'as though all of Genoa were falling into ruin'. The emperor spent seventeen days in Genoa (where the people were surprised and dismayed by his stinginess) before progressing slowly on towards Bologna, where he planned to take the measure of the pontiff he had never met while conferring with the principal Italian rulers who would be affected by the terms of the Ladies' Peace. Federico Gonzaga, who was unusual among Italian princes in having nothing to fear and much to gain from the imperial visit, rushed to Genoa to pay his feudal respects and present the emperor with two Turkish horses and one Barbary, which he followed with a gift of ostriches for the entertainment of the court when it reached Piacenza on 5 September. A month after their first meeting at Genoa Charles appointed Federico to the position of captain general of the imperial army in Italy, an honour that the marquis did not altogether welcome. He had no intention of exhausting his fragile health, the contents of his treasury or his neutrality by leading military campaigns against Milan, let alone against Venice,

with which he remained secretly on friendly terms. But he looked forward to discussing his marital prospects and asking some other favours at a second meeting with the emperor.

The marquis and the emperor were the same age, both born in 1500. Federico had the impression they had got along well, and was buoyed up by a faction that was trying to persuade Charles, who was tired of dealing with the difficult and ineffectual Francesco Sforza, to assign to him the Duchy of Milan. And so, when the emperor communicated an intention to stop over at Mantua, Federico had what seemed to him an inspired idea. He would present Titian to the emperor, who would be pleased, perhaps, to sit for the artist who had done such a superb portrait of himself, the Marquis of Mantua. On 10 October Federico wrote to Malatesta asking him to make arrangements for Titian's immediate embarkation. The imperial visit to Mantua was, however, postponed.

The next opportunity to introduce Titian to the emperor arose at the end of the month when Charles invited Federico to spend three days with him at Parma discussing his military responsibilities and his marriage. Titian needed no persuading to accompany Federico to Parma,[18] where he admired Correggio's much-criticized frescos in the cupola of the cathedral, which one of the canons had described as 'a hash of frogs' legs'. Titian, to the surprise of the friend who was with him, exclaimed, 'At last I have found a painter!', and went on to proclaim in a loud voice that if he weren't Titian he would want to be Correggio.[19] But Federico's hopes that Charles would be eager sit to Titian were dashed. Not only did the emperor reject the offer, he added insult to injury by dismissing the painter with a tip of one ducat, the amount usually given by princely guests to their hosts' cooks, waiters at table, musicians and buffoons. (The other story about his meanness was that he slept with a different woman every night but never paid more than two ducats.) Five months later, when the emperor had not offered Federico a wife or the Duchy of Milan, and had paid him only 4,000 ducats for his services as captain of the imperial army, the Duke of Urbino's ambassador in Venice wrote a letter to his master describing the episode of the tip, implicitly an

example of the emperor's by now notorious parsimony. The story certainly did the imperial reputation no good in a Venice that was in any case resentful of the losses it was bound to sustain at the Bologna summit.

Charles, to do him justice, could hardly have been expected at that stage in his life to share Federico's enthusiasm for Titian. He had been regularly portrayed since childhood, but his taste in art, such as it was, had been formed in Flanders; and he had spent the previous seven years in Spain. Knowing and caring nothing about Italian painting or the prices it fetched, he may have considered his measly tip as a dismissive joke. And he had a great deal else on his mind. He was preoccupied above all by the news, which had reached him soon after he disembarked at Genoa, that a Turkish army, commanded once again by the Ottoman sultan Suleiman, had recaptured Buda, had slaughtered its defenders and was marching towards Vienna with 100,000 troops. Charles's first instinct was to abandon the Bologna summit and to go instead to Hungary as fast as possible 'to help the king my brother [the Archduke Ferdinand], because his need is so great and the peril so extreme that it does not merely threaten him but places all Christendom at risk. I cannot and must not abandon him.'[20] As it turned out, the Austrian capital was saved by one of the wettest autumns of the century. The 1,500-kilometre march from Istanbul to Hungary took four months instead of the usual six weeks. The delay gave Ferdinand time to strengthen the fortifications of Vienna before the sultan's army reached the city at the end of September. The Turks laid siege to the city for three weeks before Suleiman finally ordered a retreat on 14 October. By the time Charles met Federico and Titian at Parma two weeks later, the pressure to go to the aid of his brother had diminished, but with Vienna not altogether out of danger he was determined to expedite the execution of the Ladies' Peace at Bologna. (The Venetian ambassador to the papal court observed that Suleiman's withdrawal was of course 'good for Christendom' but came at 'a bad time for our present negotiations'.)

Soon after the embarrassing incident of the one-ducat tip in Parma, Federico rounded it up out of his own pocket to 150 ducats,

and Titian persuaded him to resume negotiations for the farmland in the Trevigiana that he had tried and failed to purchase at a bargain price in the spring. Federico had within his domain another important Benedictine abbey, San Benedetto in Polirone, through which he could put pressure on the monks of San Giorgio Maggiore. In a letter to Malatesta written on 13 November he informed the ambassador that he wished to give some thirty fields to the excellent 'maestro Tuciano pictore' whom he sought to repay for the many favours he had done him and would do in the future. Malatesta and the *celerario* (the monk responsible for carrying out St Benedict's orders to care for the sick and the poor) of San Benedetto were to offer the monks of San Giorgio Maggiore a down payment of 300 scudi, to be followed by another payment after one year. The marquis concluded by saying that he needn't remind his ambassador to use all his dexterity and good judgement to expedite the purchase. Malatesta did his best, but negotiations dragged on. The gift of land, like the emperor's portrait, failed for the time being.

From Parma the emperor and his court progressed on into the territory of the Este. Alfonso d'Este had played a major part in the Sack of Rome by allowing the imperial armies free passage and supplementing them with his own crack artillerymen. But in the lull that followed that disaster he had bolstered his relationship with Francis I by agreeing to the marriage of his son and heir Ercole to Renée, the daughter of Louis XII. At Barcelona, Charles had agreed to give Ferrara, Reggio and Modena to Pope Clement, who insisted on them as a punishment for the part Alfonso had played in the Sack. But the forceful Alfonso now made it clear to Charles that without his participation at Bologna there would be no lasting peace in Italy. Emperor and duke travelled together through Modena and Reggio where there was an opportunity to discuss the fate of the contested cities and Charles promised to negotiate with the pope on Alfonso's behalf before the duke joined the imperial procession towards Bologna.

The pontiff and his retinue of cardinals and civic officials were already there. Clement's solemn entry into the city had taken place on

24 October when he was borne through triumphal arches painted with biblical scenes and the papal and imperial arms, blessing the crowds along the way, to the cathedral for the *Te Deum* and then to the civic basilica of San Petronio, which was hung with green garlands and the Medici coat of arms. The pope, at fifty-one, was a decrepit figure. Sebastiano Luciani's unfinished portrait painted a year or two later shows the effects the Sack and its aftermath had had on his health. His skin is yellowed by a liver complaint. There are bags under his right eye, which was almost blind. His penitential beard and the fringe of hair around his otherwise bald head are grizzled. Only the finely cut lips and nose remind us that he had once been the most handsome of all Renaissance popes. He was as indecisive and secretive as ever but if anything more embittered against the Duke of Ferrara, the emperor and the Duke of Urbino, who had let him down on the eve of the Sack. Charles, however, was too shrewd to make the mistake of underestimating Clement's intellect.

The emperor's ceremonial entry into Bologna[21] on 5 November had been carefully stage-managed by his advisers and was a more magnificent and more worldly affair than the pope's. He passed through a gate inscribed 'Ave Caesar, Imperator invicte!' with a procession of important officials and noblemen from Spain, Germany, Flanders and Italy whose participation demonstrated the inter-national extent of his dominions, while his military might was proclaimed by a large body of troops and cannon carried on carts. The emperor himself, erect, auburn haired and blue eyed, cut a fine figure in contrast with the sickly pope. With his protruding lower lip and prominent Habsburg jaw he would never be handsome, but his bearing was every inch that of a king as he nodded courteously to the crowds, paying special attention to the ladies. Dressed in armour, his helmet topped with a golden imperial eagle, he rode a Spanish jennet covered with cloth of gold, his richly woven canopy supported by four knights on foot. An official rode alongside him throwing out gold and silver coins to the crowds from his saddlebags.

Some of the temporary triumphal arches through which he passed, always de rigueur on such occasions, bore medallion portraits of

ancient emperors; one was inscribed with a message from the pope promising greater glory to the emperor when he had overcome the impious Turks and Protestants. In front of the basilica of San Petronio a temporary open-air structure representing the consistory hall of the Vatican palace had been constructed on the orders of the pope, who waited to receive his arch-enemy on a wooden platform covered with crimson cloth. As the emperor knelt at the feet of the Vicar of Christ whose Holy City his troops had destroyed, Clement turned pale and tears streamed down his cheeks as he knelt to kiss Charles in forgiveness.

In the next four months the emperor pressed for Clement's agreement to a General Council of the Church to discuss much-needed reform of Church abuses and, so he hoped, to find common ground with the German Protestants. They discussed the need to contain the militant Ottoman Empire, now allied to France, as well as bargaining with delegates from the Italian states over the new political arrangements in Italy outlined by the Ladies' Peace. But the pope managed to evade the emperor's request for a General Council of the Church, which would weaken his papal authority. They made plans for the imperial coronation, which was to be the climax of this summit of summits. And Charles took time out from the gruelling meetings to create several hundred knights. Bologna during this time was a festival city, the destination for visitors from all over Europe, including many prominent Italian intellectuals. Isabella d'Este and the learned poet Veronica Gambara, sister of the governor of Bologna, entertained writers and humanists. Bembo came from Padua. The historians Francesco Guicciardini and Paolo Giovio joined the pope's entourage. Gasparo Contarini, the Venetian philosopher, statesman and religious reformer, contributed his considerable gravitas to the conversations.

Contarini, who was in Bologna as Venetian ambassador, struggled hard to retain the seaports of Ravenna and Cervia for Venice, on the grounds that it had occupied them for a century. But Clement could not be moved, and the emperor had no reason to cross him in this matter. Contarini did, however, persuade the emperor to restore the

Duchy of Milan to Francesco Sforza, a diplomatic success for Venice that crushed Federico Gonzaga's hopes but enhanced the Republic's reputation as upholder of such little Italian independence as was left – until it became clear only a few months later that Sforza was nothing more than an imperial puppet. A general peace was signed on Christmas Eve by Charles, Venice, Francesco Sforza, the pope, the Archduke Ferdinand's representative, Mantua, Savoy, Montferrat, Urbino, Siena and Lucca. 'Now, indeed,' declared one of the cardinals, 'we can sing the *Gloria* with the angels, since peace and goodwill are restored to men.'[22] Italy, which had been the political football pitch of Europe since Charles VIII of France had marched across the Alps in 1494, was at peace.

No European country was unaffected by the peace. But in the long term it was England that experienced the most profound consequence of the alliance between pope and emperor. Henry VIII, unaware that Spanish and German troops were laying waste to Rome in May 1527, had chosen that very month to petition Clement VII for a divorce from Catherine of Aragon, his wife of eighteen years and Charles V's aunt. Clement, who had so easily granted Federico Gonzaga a divorce from Maria Paleologo, was puzzled by a request that he thought could just as easily be expedited by Henry's chief minister Cardinal Wolsey. Charles, however, saw the request as an insult to his family and was deeply opposed. There was nothing Clement could have done while he was Charles's prisoner, and, appalled by the limitless ambition of Cardinal Wolsey, who had proposed that he should assume papal powers from Avignon during the pope's captivity, he refused to co-operate with the King's Great Matter even after his release. After Bologna Henry's case was hopeless, and he began the long process of separating England from the Catholic Church.

On 1 January 1530 the peace was made public with celebrations in Bologna and in Venice. Sanudo described the events of the day in Venice in his usual detail. The weather was freezing. The French ambassador took part but with evident displeasure. The patriarch said

mass in the basilica, and there was one of those glittering processions around the Piazza for which Venice was renowned, with richly dressed officials of the Scuole bearing their gold and silver vessels and floats carrying allegorical and sacred images. On one of the floats actors posed as Justice and as the five allies – the pope, the emperor, the doge, the Archduke Ferdinand and the Duke of Milan – all seated and accompanied by a standing St Mark. There was not, perhaps, the same sense of relief that Venetians remembered from the celebrations that had marked the end of the Cambrai war. The more recent wars, which had begun before the economy had time to recover from Cambrai, had cost the treasury between four and five million ducats.[23] Although Venice was bankrupt, Sanudo noted that the government had ordered that the proclamation of the Peace of Bologna should be especially spectacular in order to demonstrate to Venetians and to the world that the Most Serene Republic was still wealthy. Florence had failed to send a delegate; and the Venetians, so Sanudo wrote, felt sorry for 'that republic remaining alone to defend itself'. And when later that year Florence finally accepted the seigniorial rule of Alessandro de' Medici, and exiles from its republican government fled to Rome or Venice, the reputation of Venice as the last surviving Italian republic was inevitably enhanced.

The crowds in Bologna who witnessed the coronation of Charles V as Holy Roman Emperor and King of Italy on 24 February 1530, or who read about it in the many descriptions issued in all European languages, could have been forgiven for imagining that the problems of Christendom and Italy were now settled. The most spectacular state occasion of the century – and as it turned out the last coronation of an emperor by a pope – had been scheduled to take place on the emperor's thirtieth birthday and the fifth anniversary of the imperial victory at Pavia. In accordance with previous rituals, which had been carefully researched by the imperial master of ceremonies, it was preceded two days earlier by a complicated private ceremony in the small chapel of the palace at the end of which the pope placed the Iron Crown, which had been brought specially from Monza, the ancient imperial capital in Lombardy, on the head of the emperor.

The second, public coronation was staged in the basilica of San Petronio, which could hold thousands of spectators and had been rearranged to stand in for St Peter's, the mother church in Rome. It was connected to the communal palace, which represented the Vatican, by a raised walkway that allowed the crowds in the Piazza to observe the passage of the pontiff, his cardinals and other officials followed by the emperor wearing the Iron Crown and his attendants. Shortly after the procession reached the safety of the church the walkway collapsed, killing several people. But it was seen as a divine omen that the emperor's life had been spared.

After the ceremony, which was as long, as splendid and as heavy with symbolism as the medieval coronations it was intended to recall,[24] trumpets and salvoes of artillery informed the crowds outside that the crowning had been done. Pope and emperor emerged from the church and rode on richly caparisoned horses to the church of San Domenico, which stood for San Giovanni Laterano, the cathedral of Rome. This was the most spectacular of the coronation parades. The young Holy Roman Emperor and the ailing pope rode side by side under the same golden canopy, which was carried by three Bolognese and three Venetian ambassadors, signifying the agreement of pope and emperor with the Most Serene Republic. As they passed along the streets of Bologna banners of the crusades, the Church, the pope, the empire, the city of Rome, Germany, Spain, the New World, Naples and Bologna fluttered above them. The representatives of Charles's dominions rode with the ambassadors of all the major European powers, including France and England. An imperial herald flung newly minted gold and silver coins bearing the emperor's image to the crowds, shouting 'Larghezza! Larghezza!' Later, while the imperial and papal guests banqueted in the palace, a whole ox stuffed with fowls was roasted in the piazza outside and fountains dispensed unlimited quantities of red and white wine.

On 21 March Charles took charge of the long-standing quarrel between Alfonso d'Este and the papacy. In Italy as elsewhere in his vast and geographically scattered empire he preferred where possible to work with existing rulers. And so he confirmed the Este as dukes of

Ferrara in perpetuity, and bought the disputed cities of Reggio and Modena from Clement for 100,000 scudi. Clement and Alfonso were to refer any further disputes about those cities to adjudication by the emperor. There being no further reason for prolonging his stay in Bologna, Charles left the following day. Although he had urgent business in Germany he was exhausted by four months of negotiations, which had been interrupted only in December by one of the agonizing attacks of gout that would plague him all his life, and he looked forward eagerly to breaking his journey for a holiday hosted by Federico Gonzaga at Mantua, where he intended to rest, enjoy himself and indulge his passion for hunting in the well-stocked forests maintained by the marquis.

Federico had made elaborate preparations for a magnificent welcome. On 25 March the emperor with his huge apparatus of attendants crossed the Po on a bridge of boats into the city, which had been specially decorated by Giulio Romano with triumphal arches and columns. In the next three weeks there was much hunting (one of the hunts employed 3,000 beaters for a party of 10,000 riders), roastings of boars, banquets, balls and theatrical entertainments. For Federico, however, the imperial visit brought bad news as well as good. The two men had discussed his marital prospects at Bologna, and now Charles had reached a decision. Federico's bride was to be Giulia d'Aragona. She was thirty-eight and apparently sterile; and in addition to being an old woman who would produce no heirs, she was the daughter of the deposed King of Naples and therefore without a dowry. The blow was softened on 8 April, four days after the drawing up of the unappetizing marriage contract, when the emperor raised the Marquis of Mantua to the title of duke.

In the course of the imperial holiday Federico, who had introduced Charles to his art-loving mother, Isabella d'Este, on the day of his arrival, took the emperor on tours of his palaces closely watching his reaction to the Gonzaga collections. Assessing and perhaps gently tutoring the unformed imperial taste in art would help him in future to choose the most effective diplomatic gifts. He knew that Charles would be especially interested in the portraits he had commissioned

from Titian, if only because they were all of people well known to him. Federico's younger brother Ferrante (the possible subject of the *Man with a Glove*),[25] who was now twenty-three, was a great favourite of the emperor, who had invested him with the title of duke two years previously. The late Girolamo Adorno had been Charles's ambassador to Venice when the government was wavering between a French and an imperial alliance. Aretino was an all too familiar thorn in his side. And then, of course, there were Titian's portraits of Federico Gonzaga himself. If Federico was shrewd enough to resist pressing again for an imperial portrait by Titian at this stage, he guessed correctly that the portraits Charles saw in Mantua, particularly the one in armour, would stick in the emperor's mind.

Charles left Mantua on 19 April. When two days later he entered Venetian territory at Peschiera, Sanudo was one of four envoys sent to greet him, bringing with them more than a hundred wagons of provisions. Sanudo, who described the meeting at his usual length, noted with pride that '... His majesty truly made a fine smile and spoke some words to me, but I understood few of them because of his speaking in a low voice and because I didn't understand his language, although I saw great evidence of good will ...' By 1 May the emperor was in Germany attending a diet in Augsburg. He stayed in his northern possessions – trying to deal with the growing Protestant rebellion, raising an army against the Turks who attempted a second siege of Vienna – for more than two years before returning to Italy. This time he would not only see the point of Titian: he would embrace him as a friend.

The Most Beautiful Thing in Italy

Of all the pictures painted so far by Titian this is the most
finished, the most celebrated, the greatest and the best
conceived and executed.

GIORGIO VASARI, 'LIFE OF TITIAN', 1568, ON THE
DEATH OF ST PETER MARTYR

In the middle of the thirteenth century a Dominican grand inquisitor
famous for his preaching and conversions and his intolerance of
heretics was riding home from Como with a companion through a
dark forest to his monastery in Milan when he was ambushed and
stabbed to death by assassins hired by two heretical Venetian noble-
men whose property he had confiscated. As he died he wrote the
Apostles' Creed on the ground with his blood while his terrified friend
fled. He was canonized the following year, and became a frequent
subject of paintings commissioned by the Dominican order. Giovanni
Bellini, at around the time Titian left his studio, had set the scene of
the murder in front of a frieze of trees not unlike the one Titian later
abolished from Giovanni's *Feast of the Gods*.[1]

Titian's enormous Death of St Peter Martyr for the confraternity
of the saint owed nothing whatsoever to any previous painted version
of the story. It was installed over the confraternity's altar in Santi
Giovanni e Paolo at the end of April 1530 and, before it was destroyed
by one of the most tragic of all Venetian fires on 16 August 1867, it
was the most admired, most copied, most described single

masterpiece in Europe, a pilgrimage painting that attracted visitors whose education was not considered complete until they had stood before it. Generations of amateur, student and minor artists, as well as a succession of the greatest artists of their day – Benvenuto Cellini, Lodovico Carracci, Domenichino, Rubens, Gainsborough, Constable, Reynolds, Géricault, G. F. Watts – devoted hours to studying or copying it.

There is a lot to see in Santi Giovanni e Paolo, which was the pantheon of Venetian doges; and most visitors today walk straight past the full-scale seventeenth-century copy by Cardi da Cigoli that hangs in place of Titian's masterpiece. Other visual records of the original are engravings made later in the century,[2] and copies including Géricault's of about 1812. We also have numerous verbal descriptions, which echo across centuries with praise for the same qualities: energy, drama, poignancy, realism, colouring, the pallor of the martyr's cheek, the frenzied, twisting figures worthy of Michelangelo, the vibrant colours, the trees swaying in sympathy with the tragedy, and the vastness of the landscape leading the eye to Titian's beloved Dolomites as they could be seen from Venice on a clear winter's day.

All Titian's biographers shared Vasari's opinion that it was Titian's greatest painting. Ridolfi, who insisted that the Death of St Peter Martyr proved that Vasari had been wrong to claim that Titian had suffered from not studying original antique models, concluded his description by informing his readers that 'this highly esteemed panel' was already 'deemed by every intelligent man to be among his finest efforts, and it is thought that Titian reached the most sublime heights of art in this place'. And not long after Ridolfi's biography was published, the poet Marco Boschini[3] claimed that the Venetian government had threatened with the death penalty anyone who dared to move it.

By the nineteenth century this most highly regarded of Renaissance masterpieces had been maimed by many restorations and by 'sponging' by student copyists. Napoleon had taken it to Paris, where it was transferred from panel to canvas[4] before being returned to Venice in 1816. Even so there was enough left to inspire enthusiastic literary

responses. William Hazlitt,[5] writing in the year it was brought back to Venice, saw a landscape background 'where every circumstance adds to the effect of the scene – the bold trunks of the tall forest trees, the trailing ground plants, with that cold convent spire rising in the distance, amidst the blue sapphire mountains and the golden sky'. Burckhardt[6] thought he could hear 'the last call of the Martyr and the shriek of his companion' rising through the vastness of the landscape to the distant peaks of the mountains. Crowe and Cavalcaselle, who were among the last people to see it before the fire, described 'the startling display of momentary action and muscular strength' Titian had taken from Michelangelo.

Aretino was the first to describe it, and as so often it is the elaborately rhetorical voice of Titian's closest friend that best evokes the emotional impact the painting made on all who saw it from then on:

If you were to direct the eyes of your sight and the light of your intellect towards this work you would comprehend all the living terror of death and all the true agonies of life in the face and the flesh of the man on the ground, and you would marvel at the chill and the flush which appear in the tip of his nose and in the extremity of his body; and being unable to restrain your voice you would let yourself exclaim, when you contemplated the companion in flight, that you could perceive in his appearance the pallor of vileness and the whiteness of fear. Truly you would give a just verdict on the merits of the great panel if you told me that there was nothing more beautiful in Italy.[7]

When Titian delivered the St Peter Martyr on 28 April 1530 the members refused to contribute. Although the subsequent universal admiration for the painting makes the wrangling about a relatively small sum of money seem especially bathetic, the negative reaction of the less sophisticated members of the Scuola to the finished painting is understandable. The Scuola had chosen the subject of the assassination by heretics of the patron saint of inquisitors as signifying that they rejected the Protestant heresies that were seeping unchallenged into Venice. Titian had painted the death of their patron saint in a way

that was, if not exactly heretical, in their view indecorous, inappropriate, as shocking to the pious Dominicans as his *Assunta* had been to the Franciscan friars twelve years earlier. The complexity of the composition and the forceful dynamism of Titian's interpretation of a sacred subject for a church altarpiece were at that time unprecedented in Venice and unusual in Italy.[8] The figures were as muscular as Michelangelo's, but their actions were more violent than anything he ever painted.

When Jacopo de Pergo prevaricated about his commitment to pay 100 ducats Titian petitioned for payment through the court. After a series of delays requested by Jacopo, he submitted a revised petition on 16 May 1531 saying that he had now received a total of thirteen ducats, partly in cheese and partly in cash. He may have sympathized with Jacopo's plight because he asked that Jacopo should be required to pay only sixty ducats with an obligation to pay the rest at some future date. The judges accepted Titian's request in full, saying that if the balance of eighty-seven ducats was not forthcoming within a week Jacopo would have to pay at least the sixty ducats on account. But the matter dragged on, and on. By October 1533 Jacopo had appealed successfully against a court decision to make him pay Titian fourteen ducats. It seems that Titian did eventually receive some payment and that Jacopo provided some of it. But even after Jacopo's death in 1540 the executors of his estate tried to assemble enough evidence to recover the money from the members of the board.

The Death of St Peter Martyr was the last of the three great altarpieces Titian painted for Venetian churches and the climax of everything he had discovered so far in the course of a period in Italian art that had seen Raphael's Stanze, Michelangelo's Sistine ceiling, Correggio's frescos in the duomo of Parma, and the catastrophic Sack of Rome. As he was finishing it, the summit meeting at Bologna ushered in a new chapter in the history of Italy. The papal–imperial discussions about the need for a General Council of the Church and the launching of a counter-offensive against the Protestant challenge introduced the most intense period of the age historians define as the Counter-Reformation or the Catholic Reformation. Religion from

now on was the dominant concern in the minds of all thinking men, a preoccupation that may explain the relative delay of scientific and technological progress. After 1529 the word Protestant was applied for the first time to dissenting German principalities and free cities that had previously been regarded as deviant Catholics. The unity of western European Christendom, already shaken by the alliance of the Most Christian King of France with the infidel Turkish sultan, broke down as the Catholic Church split into new orders and the Protestants into new sects, while Charles V set himself up as the temporal leader of a reformed universal Catholicism, an impossible goal that would inevitably be unacceptable both to the papacy and to the German Protestants.

Although the Counter-Reformation is literally defined as a response to the Lutheran apostasy, its roots went back further, to the early years of the century when the unprecedented upheavals of war, papal and clerical corruption and the flow of writings about religion churned out by the new printing presses fuelled a revival of interest in questions about the meaning and practice of Christian devotion. In the decades before Martin Luther posted his Ninety-Five Theses on the university cathedral door in Wittenberg, Catholics who had never given much thought to their faith had begun to question doctrines, dogmas and religious practices they had previously taken for granted. Although few Italians went so far as to embrace Protestantism, the heart of Italian Catholic Evangelism was a shared belief in justification in the eyes of God by faith alone and the Erasmian concern with individual moral reform achieved by following Christ's example as revealed in the Scriptures, which as the source documents of the Christian religion must be read in the vernacular rather than understood second-hand through interpretations by priests or classical authors.

The religious unrest lay deepest in cosmopolitan Venice, which had traditionally maintained a degree of independence from the papacy, where the economy had long depended on tolerance of the heretical faiths of Jews and Turkish traders, and where the printing houses were centres of humanist and religious discussion. And as the debate about Church reform intensified throughout Italy, Venice became its focus.

In June 1527, a month after the Sack of Rome, the members of the strict reformist Theatine order had escaped from the devastated Holy City on a Venetian ship and they settled in the Republic for several years. Chief among them was Gianpietro Caraffa, Bishop of Chieti in the Abruzzi and a co-founder of the order which was named Theatine after the Latin version of his see. In the same year Aretino's old enemy Gianmatteo Giberti took up an appointment as Bishop of Verona with the support of Andrea Gritti. The Catholic reformers were deeply divided among themselves. The Erasmian humanists, of whom Gasparo Contarini was the most respected Venetian leader, were at odds with the blinkered and intolerant Caraffa, a witch hunter who would lead the first Roman inquisition and later become the most detested pope of the sixteenth century.

While few Venetians were tempted by Lutheranism or shared Luther's doubts about the legitimacy of the pope, who is not mentioned in the Scriptures, the Veneto remained the gateway for Protestants from Germany into Italy, and the Venetian government could not immediately be moved from its tradition of religious tolerance. In 1524 Andrea Gritti had paid lip-service to the first of a flood of papal briefs instructing Italian bishops and prelates to take action against Lutheran heretics; but his government resisted papal demands for censorship of its presses and publishing houses and turned a blind eye as Protestantism spilled over the Alps into the Republic. In 1529, during Contarini's negotiations at Bologna for a Venetian–imperial truce, Gritti refused Charles V's request that he should expel the Lutherans and other heretics who had continued to worship freely in Venice and its dominions. There were sound economic reasons for this defiance. Venice could not afford to break its long-standing trading links with German merchants, an increasing number of whom were converting to Protestantism.

After Bologna the wars in Italy gradually petered out, but only because the balance of power in the peninsula now rested with the emperor. Italian intellectuals recognized that the failure of Italy to unite in the face of foreign invasion had been its downfall, and now, as the patrician Florentine historian Francesco Guicciardini put it,

'The emperor's greatness is our slavery.' The Lombard-born phys-
ician, historian and churchman Paolo Giovio lamented 'the sad
change to almost everything' not only in Italy but in the world.
Aretino, who had always made a point of advertising his dislike of
court life, called Charles V's Italy a whore, a metaphor that was picked
up by other Venetian-based critics writing about what they saw as the
most vicious and evil of times for a miserable and unhappy Italy.

Venice, unique among Italian city-states in maintaining its inde-
pendence from the emperor, took up a position of guarded neutrality,
a wise policy at a time when all wars ended in stalemate and bank-
ruptcy. Venice prospered once again. The grain shortage eased, the
spice trade recovered, refugees from the mainland established a thriv-
ing wool industry, demand abroad for Venetian luxury items soared.
Publishing and printing expanded at such a rate that by mid-century
Venetian presses were turning out more than three times the number
of books published in Florence, Milan and Rome combined. For the
independent Republic of Venice there would be no more conquests
on the mainland in the name of St Mark, no more cannon fire blast-
ing from across the lagoon. Venetians built holiday villas on the terra-
ferma and along the banks of the Brenta, where Sanudo had seen the
sun red as blood from the smoke of enemy fires. The landed gentry
made more contacts with foreign princely courts. Venetian patricians
began to behave more like aristocrats and to see distinctions never
made before in the Republic of Venice between merchants and
leisured noblemen. Halfway through his reign Andrea Gritti, the doge
who had originally aimed to lessen the distinctions between rich and
poor members of his government, became obsessed by money and
the status it conferred. To be wealthy was to be a good citizen. To be
able to finance the bankrupt monarchies – France, the empire and the
Apostolic See – became for the Venetian state what one historian has
called 'the symbol of its own brand of statecraft, its special strength,
the substitute for a military power which was lacking and which was
considered neither possible nor profitable to have'.[9]

It was, however, a psychologically uncomfortable time in a Venice
that was pervaded by the sense of fatigue and disillusion that often

follows the conclusion of long and testing wars. As inflation spiralled throughout Europe, the growing distance between the very wealthy and the desperately poor encouraged the criminal behaviour that had always been a problem in Venice. Although the peace was followed by one of the government's occasional campaigns against corruption, the sale of offices was difficult to stamp out at a time when the poorest patricians were susceptible to exchanging their votes for bribes. Power was invested in a smaller number of patricians as quarantine periods were extended or abolished. Some literate members of the *popolani* expressed their discontent by scribbling graffiti on walls, such as 'The people will rise and punish you.'[10] But of course they never did.

For Venice it was not yet the beginning of the end that historians have so often tried to pinpoint. Flexible as ever, the Venetian government bent with the winds of change and found peaceful ways of flexing its muscles as the rest of Italy remained directly or indirectly under imperial control. The Myth of Venice was given a new lease of life in the years to come by Gasparo Contarini's ardent defence of the Venetian constitution, *De magistratibus et republica Venetorum*, which he revised in the year after representing Venice at Bologna. Meanwhile, the Myth was propped up by the brutal conclusion of the Florentine dream of maintaining its last republic.[11] The republican government of Venice, under the guidance of Andrea Gritti, took the decision to preserve its wealth and independence by staying out of power politics while 'supplying the teeth within the fixed smile of armed neutrality'.[12] The arsenal was enlarged in 1535. Foreign dignitaries on guided tours of what was still the most impressive shipbuilding factory in the world were invited to admire a courtyard known as the *giardino di ferro*, the garden of iron weapons. Visitors arriving by sea after mid-century were greeted by the sight of the magnificent stone fortress of Sant'Andrea on the Lido, which was rebuilt by Michele Sanmicheli to withstand the latest developments in artillery power. 'Far better', as Andrea Gritti put it, 'to fight with sword in sheath but with prestige than not to fight at all.'

* * *

Venice more than any other city knew the value of putting on a show, and the most effective showmen of all were Andrea Gritti's Triumvirate of Taste. With the return of peace and prosperity Sansovino was able to begin his transformation of the old Gothic city into a New Rome with buildings that translated the classicizing confidence of the Roman High Renaissance into a uniquely Venetian architectural idiom. The bombastic propagandist Pietro Aretino proclaimed the superiority of the New Rome over all other states, beginning as he meant to go on with a letter to Andrea Gritti circulated in 1530 in which he deliberately echoed Petrarch's encomium of two centuries earlier:

> Heaven has been so generous to her in its gifts that she shines in her nobility, magnificence, dominion, buildings, temples, holy houses, counsels, virtues, riches, fame and glory, more so than any other city that there ever was. She is Rome's reproach because there are no minds that could or would tyrannize over her liberty, or make her a slave in the minds of her people ...

By then Titian's public works – the *Assunta*, the *Submission of Frederick Barbarossa*, the mosaics in the sacristy of San Marco, the *Pesaro Madonna*, the St Peter Martyr – had made Venice an artistic centre to rival Rome. In the following years, however, he was most in demand for the portraits, which, so Aretino boasted, Titian could throw off 'as quickly as another could scratch the ornament on a chest'.[13] His portraits were routinely described as not paintings but mirrors of nature, 'only that the mirror reflects while Titian creates',[14] not portraits but flesh itself, only frustrating the spectator by their refusal to speak. What we call psychological insight, contemporaries described as 'something divine, and as heaven is the paradise of the soul, so God has transfused into Titian's colours the paradise of our bodies'.[15]

The aristocratic portraits of 1520s – the *Man with a Glove*, *Laura Dianti* and the portraits of Alfonso d'Este and Federico Gonzaga – had paved the way to a position almost as an honorary patrician in

his own right. And when Titian's high-born subjects were mean or dilatory with their payments he could make up the shortfall by setting substantial fees for lesser sitters – even Aretino had to pay for the portrait of himself in the Pitti galleries in Florence. Whereas in the early stages of his career he may have practised on Venetian friends of his own age whose names are lost to us, from the 1530s on Titian introduces us to more people we can identify. They range across many nationalities, ages and professions: merchants, lawyers, civil servants, soldiers, cardinals, diplomats; a toddler, an adolescent, an art dealer; as well as Venetian doges[16] and many of the most powerful foreign princes of his day and their consorts (he was the only painter in Europe to portray both an emperor and a pope). Although the well-documented charm and social skills that endeared him to high-born patrons must have included the charismatic quality of being an intelligently attentive listener, some of his subjects were too busy to sit for him for long; and some of his most successful feats of portraiture were especially admired because they were taken from previous portraits, medals or verbal descriptions of subjects he had never or only briefly met. He painted a king, a sultan, the emperor's dead wife and the mistress of the emperor's chief minister, all sight unseen.

Few other great Renaissance artists specialized in portraiture, a genre considered less important than religious, historical or mythological subjects, and which was disdained by Vasari and Michelangelo, who believed that the reproduction of nature was less exalted than the creation of ideal forms and features. Masters of the calibre of the Bellini brothers, Leonardo, Giorgione and Raphael developed Italian portraiture as a sideline. Titian, who was the first Venetian to take advantage of a new appetite for realistic likenesses of prominent people, was unique both for the sheer numbers of his portraits and for the techniques and insights with which he revolutionized the genre. Portraits constitute a greater proportion of Titian's oeuvre than they do of any other artist of the period. Some seventy to a hundred paintings, about a third of his extant works, are portraits, now scattered throughout the picture galleries of the world; and dozens more are known from descriptions, engravings or copies. He used every

format: profile, three-quarter profile or full face; eyes averted as though lost in thought or staring straight out at the beholder; bust length or three-quarters length, and in the early 1540s he began painting his most important subjects full length. Often he eschewed architectural or landscape backgrounds, focusing in close-up on the sitter, whose clothes and demeanour indicated their precise social status. He flattered them, correcting as far as possible the 'mistakes of nature', as a late sixteenth-century writer put it,[17] but usually he captured what seems to us the essence of a real person. Usually, but not always. Given his enormous output and the speed at which he produced portraits it was inevitable that some of them, especially those of less socially exalted sitters, would be duller than others.[18]

He became the portraitist of choice for a European elite familiar with Castiglione's widely influential *Courtier*, which championed the ideal of an aristocracy that would bring order to a tired and confused Italy, and which emphasized the importance of clothes as essential indicators of social status. Although there was some discontent, particularly in Venice, with the increasing class-consciousness in an already rigidly hierarchical society, the majority of men and women accepted the status quo and were impressed by the spectacular shows of power and fabulous wealth when princes made their ceremonial appearances in public. Everyone in Renaissance Europe wanted to know what their rulers, good or bad, looked like; and, obvious though it may be, we sometimes have to remind ourselves of how precious likenesses were before the invention of photography when the insatiable public curiosity about the appearance of famous people gave added value to the painted and sculpted portraits only the very rich could afford. A diplomatic gift of a portrait acted as the surrogate presence of the donor. A portrait, especially one by Titian, who knew so well how to reflect the status of his sitters, conferred a kind of immortality on their subjects and, if the sitter was a ruler, on his state. 'Death', wrote Aretino in a letter to Veronica Gambara, 'should hate the man who secures immortality for those he would kill.'

It has often been said that Titian in his forties rested on his laurels; and it is true that there is nothing in his surviving work from the

1530s that is as groundbreaking as the Venetian altarpieces or the Bacchanals for Alfonso d'Este. It is, however, a misleading anachronism to charge him with what we call elitism for restricting his clientele to people who could afford his high prices and for flattering, rather than sitting in judgement on, tyrannical princes. The object of all Renaissance portraits of men was to record their social status, and Aretino was not the only writer to express the view that persons of the highest social and intellectual rank had the exclusive right to have their portraits painted, that members of the lower orders who wished to be portrayed as important men were merely comical. Italian artists, furthermore, earned their living by working for patrons who could afford to pay them.

Titian had one of the greatest minds of the Renaissance. He expressed, as Bernard Berenson put it, 'nearly all of the Renaissance that could find expression in painting'.[19] But he thought and expressed himself in images that were intended to please or reflect the requirements of his patrons and leave us none the wiser about his political or religious affiliations. The word–image problem, the relationship between what writers and intellectuals think and what painters paint in any period, is particularly teasing for anyone trying to peer behind Titian's paintings into the mind of the man who created them. Titian, unlike Benvenuto Cellini, Leonardo and Michelangelo, was a silent artist. His surviving correspondence is mostly about business matters, and most of his letters were ghosted for him. He was praised in writing more often than any other artist apart from Michelangelo. But although he was in the course of his career acquainted with more than sixty writers, including Ariosto and Bembo as well as Aretino,[20] he seems not to have been particularly interested in the company of wordsmiths, apart of course from Aretino.

None of his literary acquaintances, not even his contemporary biographers Dolce and Vasari, ever mentioned his views about anything except painting. Some modern writers have seen heterodox messages in his late religious paintings, which suggest to them that Titian was in contact with heretics.[21] It was impossible not to be in contact with heretics in Venice, but there is no evidence that he kept

in touch with any who had confessed or been prosecuted. If he had any subversive tendencies, they would surely have been suspected by the sternly pious Gianmatteo Giberti, who offered to pay Titian 100 ducats for a small *Nativity* in 1531–2, and the papal legates with whom he frequently dined.

So we are free to hazard a guess from the dignity his portraits confer on their powerful and well-dressed sitters that the younger Titian remained aloof from the religious unrest and the pessimism about human nature, clerical corruption and the state of the world expressed by the more cynical writers of his times. If Titian's best portraits of the upper classes and aristocracy continue to hold our attention it is because they show us, in a way no painter would do again before Rembrandt, that we are standing face to face with a person who holds a particular profession or social rank, at a particular moment in that person's life, whether it is the little daughter of a banker playing with her dog, a wily old pope who fathered at least four bastards while championing Church reform, an exhausted Holy Roman Emperor riding against a blazing sunset like a triumphant Roman emperor as he returned from a military victory against German Protestants that failed in its purpose, or any of the enormous cast of characters who, thanks to the most Shakespearean of painters, people our understanding of an age that was so different from our own.

PART III

1530–1542

With Titian the expansion of his genius ceases for a while, and his art kept open house with the world, reflecting it not as it was, but as it wished to be.

CHARLES RICKETTS, *TITIAN*, 1900

ONE

The Portrait of Cornelia

The commendatore has found the portrait so lifelike that he does
not cease to marvel at how it can have been achieved, especially as
I have told him that it was painted not only in the absence of the
lady Cornelia but by a painter who had never seen her and
worked only from descriptions of others.

A LETTER ABOUT TITIAN'S PORTRAIT OF CORNELIA
MALASPINA FROM SIGISMONDO DELLA TORRE TO
FEDERICO GONZAGA, 10 OCTOBER 1530[1]

While Titian was applying the final glazes to the Death of St Peter
Martyr in early February 1530 he had at least three other paintings in
progress: a portrait of Federico Gonzaga in armour; a painting of
naked women bathing; and another of Our Lady with St Catherine
and John the Baptist. These pictures were 'favours' for Federico
Gonzaga in return for his continuing help with acquiring the fields
near Treviso at a bargain price. The first of them to be finished, and
the only one that has survived, is now known as the *Madonna of the
Rabbit* after the white rabbit the Madonna holds in place on the hem
of her blue skirt for the entertainment of her Son. For this enchanting
painting Titian looked back with a new, mature perspective to his
earliest Giorgionesque pastoral paintings. The sharply focused details
of the foreground – the passion flower, the rabbit, the basket of fruit
– are like miniature still lifes, while rapidly painted slashes of orange
light the sky at sunset; and the pale azure of the distant foothills flows

into the shawl around the shoulders of the fashionably dressed St Catherine and winds around the arm with which she supports the Christ child. That Titian was able to give such close attention to a small, quiet, intimate painting for one sophisticated patron when he was working concurrently on the enormous and turbulent St Peter Martyr intended for a public setting is one of the telling reminders we have of his extraordinary ability to hold very different images in his mind, turning from one to the other as the mood took him.

Behind the Madonna holding the rabbit, Federico Gonzaga is seated dressed as a shepherd tending his flocks in Arcadia. Castiglione had written that aristocrats disguised as shepherds could behave in licentious ways that would normally be considered inappropriate for men of their station, and since Federico was nothing if not licentious his appearance as a shepherd may have been a private joke between the marquis and the painter he had come to regard almost as a friend. He cannot have failed to be delighted by this gem of a painting which was followed by a 'gift' to Titian of 300 ducats towards the purchase of the farmland near Treviso – which Titian was by now so anxious to obtain that he had begun negotiating for the fields on his own behalf. Titian thanked his 'most singular of patrons' with a letter assuring him that he would finish the painting of the naked women as soon as he had recovered from a painful attack of scabies that made it impossible for him even to move.

Other patrons, not least the Council of Ten and Federico's uncle Alfonso d'Este, had learned to put up with similar excuses. Federico, however, rarely had to wait long for his paintings. Ten years younger than Titian, he treated him, if not as a social equal, with sympathy and even a degree of deference and went out of his way to promote his career and financial wellbeing. Their warm relationship never cooled, despite Titian's sometimes peremptory demands, and in the years before Federico's death in 1540 Titian painted some thirty pictures for him, more than he produced for any other patron.[2]

Benedetto Agnello, who succeeded Giacomo Malatesta as Mantuan ambassador to Venice in June 1530,[3] was the ideal conduit between Federico and Titian. A sophisticated and widely experienced

high-flyer from one of Mantua's oldest families, he moved easily in Venetian intellectual and artistic circles. Although he had a hard time keeping Aretino's malicious slanders against his master in check, he and Titian became close enough to spend time in one another's houses. In the first year of his appointment Federico corresponded with Agnello about no fewer than eight paintings by Titian, as well as about numerous other services he required of the painter. Although the ambassador never pretended to be a connoisseur of painting, he did suggest at least one subject for a portrait by Titian. All Europe was intensely curious about the appearance of Suleiman the Magnificent, the most powerful of Ottoman sultans, who had brought his forces further into central Europe than any of his predecessors. Erasmus in 1530, in a book[4] intended for the instruction of young people, had written that 'Even if the Turk (heaven forbid!) should rule over us, we would be committing a sin if we were to deny him the respect due to Caesar.' It was Agnello's idea that Titian should paint for the duke a version of a previous painting of the sultan that he had taken from a medal, and although both portraits are lost it seems that Titian obliged.[5]

Nevertheless, to judge from the prices Federico was prepared to pay and from his most numerous and detailed instructions to Agnello, he was even more interested in acquiring the finest jewels and jewellery obtainable in Venice than in commissioning paintings by Titian. For a pair of pearl earrings, for example, he offered up to 1,000 scudi, more than three times any of the favours he bestowed on Titian. If the differential bothered Titian there is no sign of it. On the contrary, since Titian was acquainted with the most talented Venetian jewellers, Agnello often turned to him for help and advice. Although 1530 was Federico's most acquisitive year, the purchasing of luxury commodities for himself and his family went on for the rest of his life. He had good reason to trust his ambassador's eye for quality and judgement of value, and Agnello took his role as personal shopper for the duke as seriously as any of his diplomatic tasks. He searched the world's greatest emporium for the best available ginger, Malvasia wine and fruit trees. He advised the duke about purchases of Murano glass and

mirrors, books, clocks, tapestries, cloth of camel's hair and of gold. He alerted him to the arrival on the galleys of imported parrots, ostriches, monkeys, leopards, gazelles, Arabian horses and other more exotic animals. He had Titian paint a portrait for Federico of one 'very strange' creature, perhaps an antelope, that he described as a hoofed quadruped, a bit like a stag but the size of a fawn, with the head and eyes of a horse and the snout of an ox, the teeth of a deer, and horned like a chamois, but a little fatter and larger. Agnello also did what he could to promote the arts in Mantua, sending for example some paintbrushes to Giulio Romano.

What is most remarkable about Agnello's position in Venice – given the restrictions there on social contacts between foreign diplomats and members of the government – is that he befriended many patricians, including members of the doge's family, who leaked to him classified information about events abroad; he knew, for example, a great deal about Henry VIII's marital upheavals. As a closely observant and shrewd outsider he was not altogether impressed by the spectacles and propaganda that served to bolster the Myth of Venice as the perfect state, and noted that doges, despite the legal prescriptions intended to limit their power, actually enjoyed unrivalled authority. He shared with Marin Sanudo, another of his good friends, a sharp ear for the details of intrigues, public spectacles, crimes and disasters. After 1533, when Sanudo finally stopped writing his voluminous diaries, Agnello's official dispatches and informal letters to Federico, and his correspondence with Federico's treasurer Gian Giacomo Calandra and his other friends at the Mantuan court, become our richest source for the politics of the Republic – as well as giving us a lively account of Titian's moods, health, life and work – before the ambassador's much-lamented death in 1556.

By the time Agnello had taken up his post in Venice, Federico was embroiled in an increasingly complicated diplomatic problem in the course of which Titian's skill as a portraitist would play a significant role. Among the unofficial highlights and discussion points of the social whirl around the Bologna summit meeting had been the passionate coup de foudre that pierced the heart of the Spanish

commendatore Francisco de los Cobos when he laid eyes on the tall, willowy and extremely beautiful Cornelia Malaspina. Cobos, who came from a family of poor municipal small gentry in Andalusia, was now in his early fifties. After an education at the royal Castilian secretarial school, where he did not learn Latin or Greek, he had attracted the admiration of the emperor, who, impressed by his charm, his subtle mind, his unswerving loyalty and his honesty (at least by the standards of the day), made him his finance minister and brought him to Italy as his principal adviser along with the French lawyer Nicolas Perrenot de Granvelle. Cobos quickly became Charles's most trusted secretary, his 'prudent integrity and powerful courtesy the key', as Aretino wrote of him six years later, 'to the emperor's secret soul'.

From the moment they met in Bologna in the house of the countess Isabella Gonzaga de' Pepoli to whom Cornelia was lady in waiting, Cobos could not get her out of his mind, and the story of his love for her soon became legendary in imperial circles where she was known as *la illustre* and the name Cornelia was used as an eponym for young women of grace and beauty. In May 1530, when Cobos was on business in Innsbruck, he advised Federico Gonzaga through the imperial ambassador in Mantua that he desired a portrait of the lady Cornelia, to be done by 'that good painter', by which he probably meant one of the artists working under Giulio Romano on the frescos in the Palazzo Tè. It is not surprising that he turned to Federico, who had many artists at his disposal, who was related to the Countess of Pepoli and whose own passionate involvement with Isabella Boschetti was likely to arouse his sympathy. Federico for his part needed no persuading. It was in his interests to do everything he could to please Cobos, who had the emperor's ear and filtered all his incoming correspondence. But Federico had other motives for gratifying the commendatore's slightest wish. In the first place he hoped to promote through Cobos his brother Ferrante's extremely complicated marital ambitions, which were focused at that time on Isabella Colonna, a young and rich Roman heiress who was, however, already secretly married.[6] Within days of Cobos's request for the portrait of Cornelia,

Federico informed the imperial ambassador that it was ready. It wanted only the varnish, but that would depend on good drying weather. Federico hinted that the delivery of the portrait also depended on the emperor's permission for Ferrante's marriage to Isabella Colonna. The plan to barter the portrait of Cornelia in return for Cobos's intervention with the emperor on his brother's behalf was, however, unsuccessful.

But then on 6 June something totally unexpected occurred that caused a U-turn in Federico's plans for his own marriage. Bonifacio Paleologo, the boy marquis of Montferrat in Piedmont, died in a riding accident. Bonifacio's heir was his elder sister Maria, the bride Federico had repudiated when the likelihood of her succession had seemed unlikely. Federico now became obsessed by the urgent need to relegitimize this first marriage to the woman who had so unexpectedly become the Marchioness of Montferrat, which if he succeeded would make the Gonzagas rulers of a second principality. Clement VII, who had granted him the annulment, would be easy enough to fix. Charles V, who had drawn up his marriage contract with Giulia d'Aragona, was another matter. It was a situation that would call upon all of Federico's considerable talents for intrigue.

One of his first moves was to foment a revolt among his subjects against the old and sterile Giulia d'Aragona in favour of his 'real' wife Maria. He also decided that under the radically altered circumstances the portrait of Cornelia, which the anonymous artist had painted from a previous portrait, was not after all a good enough likeness. To make absolutely certain of pleasing Cobos, it was necessary that she be painted from life. Of all the painters at his disposal Titian was the one who could best capture the beauty of the woman who was the 'heart, soul and greatest treasure in the world' of the most trusted adviser to the emperor Charles V – who held the ultimate power to grant or dash Federico's hopes for an extremely advantageous remarriage to his ex-wife. On 8 June Federico instructed Agnello to arrange for Titian's immediate departure for Bologna. But just to make doubly sure, he had also commissioned a small portrait by Francesco Primaticcio, the Bolognese sculptor and painter who had been one of

Giulio Romano's assistants in the Palazzo Tè and who happened to be in Bologna at the time. Since Federico had failed to notify either artist of his back-up plan, the two men were surprised and not altogether pleased to run into one another at Casa Pepoli. But there was worse news. Cornelia was not there.

The humid heat of Bologna in high summer was overpowering. Primaticcio packed up his materials and returned to Mantua. The Countess of Pepoli, who was impressed by Titian's gentlemanly comportment, offered to send a servant to accompany him to Novellara where Cornelia had been taken to convalesce from an illness. But Titian had had enough. On 12 July he addressed to Federico the earliest of the few surviving letters written in his own hand. He had heard that 'this Cobos woman or Cornelia' was still weak, and because he, Titian, was 'overcome by the heat and not feeling very well' he had not followed her to Novellara. Nevertheless, her friends had given him such a good description of her that he could 'risk painting her in such a way that no one who knows her will doubt that I have already painted her several times'. He asks the duke to send him the portrait of her 'by that other painter' and will let him have his own in about ten days. In a postscript he assures the duke that if the portrait is unsatisfactory he will go to Novellara, 'but I think that will not be necessary'. Federico agreed to the proposal, and as soon as Titian returned to Venice Agnello paid him 78½ scudi of the 100-scudi fee for the portrait. He also reported to Federico that maestro Tuciano had arrived 'half ill'.

By the end of the month Cobos was still pressing impatiently for the portrait of his mistress. But Titian had put down his brushes, and the busy studio in Ca' del Duca had gone quiet, watched over in his absence by the faithful Girolamo Dente. The maestro was spending his days and nights in his house behind the Frari watching over his wife Cecilia, who was critically ill. Her health had always been fragile. He had married her during one of her illnesses in order, so he had said at the time, to legitimize their two boys in case of her death. But in five years of marriage it had not occurred to him that she would actually die before him if only because he needed her to raise the children, to

run his domestic life, to be there when he came home to the private place that warmed the part of his personality that he never revealed to his grand patrons or even to Aretino. No doubt he had been harsh with her and the boys – we can see the fierceness and possibly also a temper usually held in check in his later self-portraits. He was a man used to getting his own way, but this time he failed. By early August Cecilia was dead. If he thought at all about the portrait of Cornelia it may have been with envy for Cobos whose own beloved was recovering from her illness.

On 6 August Benedetto Agnello wrote to his friend Gian Giacomo Calandra:

> Our master Ticiano is utterly disconsolate at the death of his wife, who was buried yesterday. He told me that during the troubled time of her illness he was unable to work on the portrait of the lady Cornelia or the painting of the nudes that he is doing for our Most Illustrious Lord, which will be a fine thing and which he expects to finish before the month is out. Meanwhile maestro Ticiano desires to know if our lord is satisfied with the St Sebastian[7] he sent him, even though he admits that it is a mere trifle compared with his other gift of the nudes, only one of which he has produced as an entertainment in token of the devotion that he feels for His Excellency.

For Titian, whose deepest attachments were always to his family, this was the loneliest time he had known since leaving his home in Cadore as a boy. His father Gregorio had recently died,[8] and his brother Francesco had to spend more time in Cadore winding up the estate and attending to the Vecellio timber business. He may not have been able to give enough affection to Pomponio and Orazio, who were about eight and six when their mother died. Children of eight, who are old enough to understand that death is a permanent loss and young enough to be aware of their helplessness, often suffer especially from the premature loss of a parent. Cecilia's death may have been one of the causes of the ineffectual character of her firstborn, whose lifelong unhappiness Titian chose to ignore until, towards the end of

his life, it would lead to an irreconcilable split between father and son. If their mother had survived she might have been able to soften the effects of her husband's overbearing treatment of their sons. But she could never have dissuaded Titian from his iron and, as it would turn out, destructive determination that Pomponio, whether it suited the boy or not, should pursue a career in the Church.

He had decided on a religious vocation for his elder son at birth because the priesthood offered the most respectable opportunity for a boy of relatively humble origins to rise through the social hierarchy as far as his wits could take him. It only required a classical education and good connections, both of which Titian was in a position to provide, to spare Pomponio from the uncertainties of an artist's career, to realize his father's social ambitions for him, and to enrich the family with ecclesiastical benefices, sinecures that were attached to churches or monastic abbeys where the residence of the beneficiary was not necessarily a requirement. The abbeys of Catholic Europe were vastly wealthy thanks to their possession of much of the best agricultural land; and local rulers, in whose keeping many of them were on behalf of the Curia in Rome, had the traditional right to request livings in their domains for favoured clerics. A collection of such benefices could add up to a tidy annual pension for a man of the cloth, who was required to do nothing in return. But obtaining them required a good deal of politicking and palm greasing in the Curia, a bureaucracy that even powerful rulers could not easily penetrate without help from insiders who knew how things worked. Nor was their management a simple matter. Some were encumbered by liens, the right, that is, of a former owner to keep possession until paid off, and once granted these could be exchanged, sold or sublet.

Pursuing and managing benefices for Pomponio was to become something of an obsession with Titian. It may have been true, as he would write to Pomponio many years later, that he had tried, by the sweat of his own brow, to obtain church benefices that would make his son rich and powerful. Pomponio's personal happiness, however, was never a consideration. Each of Titian's three legitimate children was required to fill a role that would enhance the wealth and status of

the entire family: Orazio was destined to remain by his father's side as an amanuensis; and Lavinia, the daughter of his second wife, was to be provided with a dowry, also earned by the sweat of her father's brow, that would secure marriage to a member of the minor nobility. Alas, poor Pomponio, the first son of a famous father, was to be the one who would suffer most.

The first opportunity for a church living arose in the June after Cecilia's death when an Augustinian friar at the monastery of Medole, which was under the jurisdiction of the Duke of Mantua, was thrown into prison and deprived of his benefice for trying to dupe Federico with false prophecies. Titian wasted no time in chasing the benefice for Pomponio, at first through Isabella d'Este who happened to be in Venice at the time visiting the glass factories and to whom he wrote at the end of the month reminding her of her promise to speak to Federico about the benefice – and of the little picture he was painting for her to carry with her on her travels, which, although of course he didn't put it that way, would be his side of the bargain. From the tone of the letter we can speculate that Titian's portrait of the very stout Isabella in red, which we know only from a copy by Rubens, was also painted during this visit.[9] But he underestimated the time, complexity and expense involved in obtaining the necessary papal bull, which involved bribing numerous officials in the labyrinthine bureaucracy of the Curia, who had themselves had to buy their jobs, before the title could be registered by the Apostolic Chamber.

Although work, money and Pomponio's benefice were seldom entirely absent from Titian's mind, he was slowed down by grief following Cecilia's death, by the problems of reorganizing domestic arrangements that had never previously burdened him, and by his awareness that Federico Gonzaga was wholly preoccupied by his scheme to marry the heir to the Marquisate of Montferrat. This was going well. Maria's mother, Anne, having been assured that the Duke of Mantua would make a definitive break with the notorious Isabella Boschetti, had given her approval to a renewal of the marriage contract with Maria. Maria's death on 15 September was a mere hiccup in the proceedings because immediately afterwards Anne

offered Federico the hand of Maria's younger sister Margherita, who was now heir to the marquisate. On 20 September Clement VII re-accredited Federico's original contract with Maria, which passed seamlessly to Margherita.

Everything now depended on obtaining the sanction of the emperor, and that would be altogether more difficult, if not impossible. On his Italian visit earlier in the year Charles, who was now extremely busy dealing with the Protestant problem in Germany, had seen quite enough of Federico's capricious behaviour. He would not even allow the subject of the Gonzaga–Paleologo marriage to be discussed in his presence. Federico, however, had two trump cards up his sleeve. One was the gifted and persistent diplomat Count Nicola Maffei, a Gonzaga relative who as a nobleman would have direct access to the emperor. The other was Titian's portrait of Cornelia, which arrived at long last in Mantua on 18 September. Everybody, including Isabella d'Este, agreed that it looked exactly like its subject. And so on 8 October Maffei left Mantua for Charles's court at Augsburg, preceded by a convoy of mules laden with gifts for the emperor and his courtiers, the most important of which was Titian's precious portrait.

Federico had instructed the bearer who delivered the portrait to Cobos on 10 October to advise him that Titian had painted it without ever having seen Cornelia. This was a boast rather than an admission, and just as Titian had promised Federico that he would modify the portrait if necessary, so Federico, who was certain that it was a perfect if idealized likeness, pretended that he would send Titian to Novellara to paint Cornelia from the life if Cobos was not entirely satisfied. Federico's faith in Titian's genius was wholly justified by the reaction of Cobos, who was all the more impressed that the portrait had been painted in Cornelia's absence. Maffei took matters from there. He had thought to carry with him a letter from Cornelia, and at each meeting with Cobos brought up her name, the very mention of which soon melted the commendatore's resistance to his arguments in favour of Federico's marriage to Margherita Paleologo. On 26 October the emperor more or less gave in, leaving the final decision to the

ecclesiastical tribunal in Rome, which would have to approve the annulment of Federico's marriage to Giulia d'Aragona.

If he had not been sure that his portrait of Cornelia Malaspina would be a resounding artistic and diplomatic success Titian might not have risked behaving as he did in the coming months over the matter of the benefice of Medole for Pomponio. Soon after delivering the portrait he let it be known through Benedetto Agnello that he was suffering from a melancholia that would be speedily relieved by good news about the benefice. No doubt he really was still grieving for Cecilia, but then Titian was not Aretino's friend for nothing. In the years of working for Alfonso d'Este he had learned that merely withholding his presence could have a powerful effect on patrons. When Federico invited him to Mantua in early October Agnello reported that Titian was feeling much better and would come soon but was not in a position to write at the present time. But Titian didn't move until November, by which time his portrait of Cornelia had done its work. On the 15th Federico provided him with a letter to take in person to the vicar of Medole in which he demanded that the benefice should be forthcoming. He also resumed discussions about the purchase of the fields in the Trevigiano, which Federico instructed Agnello to pursue in Venice.

Although neither the benefice nor the farmland was ready by the end of the year, it was not long before the matters that had revolved around Titian's portrait of Cornelia were resolved. Already, in August, Ferrante Gonzaga had been persuaded by Federico and their mother Isabella d'Este to give up hope of obtaining the emperor's permission to marry Isabella Colonna and turn his intentions instead to Isabella of Capua, who as the only daughter of the Duke of Termoli was at least as good a match. The emperor gave his immediate consent, making Ferrante at twenty-three richer for the time being in territorial possessions, as well as in imperial recognition, than his elder brother. Ferrante and Isabella of Capua were married the following April.

Federico Gonzaga celebrated his marriage to the twenty-three-year-old Margherita Paleologo at Casale in Montferrat on 3 October

1531. The continuation of the main branch of the Gonzaga dynasty was ensured by the birth of Francesco, who would become the second Duke of Mantua and was followed by four more healthy children. Titian was called upon to portray the baby Francesco, but the picture has disappeared without trace. Cobos placed the Countess of Novellara under the special protection of the emperor and continued his affair with Cornelia at her house there until 1533, when he returned to Spain. Before leaving he sought Federico's help in contracting Cornelia's marriage to Giovanni Piero de' Vecchi, a land-owner in the territory of Reggio. He made sure that the Duke of Ferrara extended his favours to the couple. Nor did he forget Cornelia's sister, for whom he found a place as maid in waiting to the Duchess Margherita Paleologo Gonzaga. In Spain, where Charles V put him in charge of the government during his frequent absences, Cobos became immensely wealthy with an income of 60,000 ducats, which enabled him to live like an aristocrat. He built himself palaces, amassed a collection of tapestries, paintings and jewels, and married his daughter to a duke and his son to the daughter of a marquis. Although we can safely assume that Cobos kept Titian's portrait of his 'dear little Cornelia' for the rest of his life, which ended in 1547, it had disappeared by the end of the century.[10]

TWO

The House in Biri Grande

She had the greatest delight in the way the breezes played with her tresses, which were not covered with a veil or restrained by netting ... One gust attacked her right eye with a curl, making it close in a way that was lasciviously graceful. Another made a curl encircle her throat like a necklace. Another made her hair snake in and out of her bosom.

A DESCRIPTION OF MARY MAGDALEN

BEFORE HER CONVERSION

PIETRO ARETINO, IN *THE HUMANITY OF CHRIST*, 1535

Mary Magdalen, the gentle and beautiful prostitute who was chosen by Christ to witness His resurrection, has always been the most popular of all the saints. Unlike the martyrs who are identified by the instruments of terrible tortures, her attribute is the jar of unguent with which she anointed the feet of Christ, and her suffering seems more comprehensible because it was brought about by her own decision to repent of her sins. Women identify with her sexual feelings before her conversion, men respond to her beauty, while her self-inflicted penance satisfies the requirements of the strictest Catholic moralists. The cult of Mary Magdalen's exemplary personal conversion and intercession between Christ and His other disciples reached a peak in the sixteenth and seventeenth centuries, when images of 'the favourite saint of the Counter-Reformation'[1] weeping in her grotto were used by the Catholic Church as a propaganda tool against

Protestant heresies that questioned the scriptural basis of the intercession of saints and denied the necessity of penance on the grounds that the rite of baptism washed away the stain of original sin.

Mary Magdalen was especially important in Venice where in the 1530s the leaders of Church reform emphasized the necessity of inner personal conversion. For Catholic humanists she also embodied the Neoplatonic ideal, as popularized by Pietro Bembo, of carnal love as a first step in the spiritual ascent to the chaste and perfect love of God, and was in that guise the Christian counterpart of the morally flexible Venus, the patron goddess of Venice, whose nudity could be interpreted as signifying purity and honesty as well as lust. The Magdalen was also an object of popular veneration who protected, as well as reformed prostitutes in a city renowned for its large population of whores and courtesans, women in childbirth, mothers whose milk dried up, even sailors in danger.

Titian was already working on a Mary Magdalen for an unknown patron in March 1531 when he received a letter from Federico Gonzaga thanking him for a painting of St Jerome[2] and requesting one of Mary Magdalen to be 'as tearful as you can make her' and as beautiful, 'which will not be difficult for you'. The commission had to be treated as a matter of urgency because, so Federico claimed, it was for Alfonso d'Avalos, Marquis of Pescara and of Vasto, who, as captain general of the imperial infantry in Italy, was one of the most important and trusted men in Charles V's Italian entourage. The painting was in truth destined not for the imperial captain but for his relative by marriage Vittoria Colonna, Marchioness of Pescara, the poet and pious widow who a few years later befriended Michelangelo and persuaded him to join the movement for Catholic reform. Colonna, whose poems show an interest in Mary Magdalen as disciple and apostle, had sent Federico some highly scented roses with a request for a painting of the Magdalen by an 'excellent' but unspecified artist. Federico replied that he had given the commission to Titian, 'who is perhaps the most excellent practitioner of the art of painting that can be found in our time, and who is entirely mine and is seeking with great determination to make the most beautiful weeper possible and to let me have it quickly'.

Federico had presumably told Titian that the painting was for Alfonso d'Avalos rather than Vittoria Colonna in order to impress upon the painter the necessity of making haste with it; and Colonna, who used Alfonso's name in the same way at around the same time to obtain a drawing of a *Noli me tangere* from Michelangelo, may have collaborated with or even suggested the deception. Alfonso d'Avalos, the cousin and heir of her late husband, Ferdinando Francesco d'Avalos, was a close friend whom she called her brother. Federico was therefore well aware that by gratifying her wish for a beautiful weeping Magdalen he would also please Alfonso d'Avalos, who in fact agreed to take the painting with him on his next visit to Pescara. The deception – which was not actually very far from the truth – succeeded in prompting Titian to make an early start on the painting, and over the coming weeks Benedetto Agnello kept the duke closely informed about the progress of the Santa Magdalena. Titian, he wrote, had promised that it would be different and more beautiful than the one on which he was working when he received the duke's order.

Federico's excitement when Titian's Mary Magdalen arrived in Mantua on 14 April, accompanied by a letter expressing the artist's extreme humility and devotion, was such that he wrote to Agnello that it had surpassed his expectations by far, and to Titian that it must be:

the most beautiful work that has ever come from your most excellent hands and all the more so because it was done for me, by which I know that pleasing me is dear to you. But I have found it so very beautiful and perfect that truly of all the paintings I have seen it seems to me that this is the most beautiful, and I am more than satisfied. And my most illustrious mother says the same thing, she praises it as a most excellent work and confesses that of all the similar works of art she has seen she has never seen anything that gave her such delight, nor anything that was the equal of this by a long way; and all the others who have seen it say the same, and the more they understand the art of painting the more they praise it ...

This was the most fulsome praise Federico Gonzaga would ever lavish on a work of art. His letter did not, however, mention Pomponio's benefice on Medole for which Titian had been agitating since the June of the previous year. Now Aretino stepped in behind the scenes. If anyone could help Titian extract the benefice for Pomponio it was the man he called the brigand chief of letters. It is possible that without the resounding successes of the portrait of Cornelia and of Vittoria Colonna's Magdalen he would not have allowed Aretino to spill his tainted ink on his behalf. But judging from the tone and strategy of Titian's communications with Federico Gonzaga about the benefice, that is what he decided to do. Aretino, who knew very well that Titian was entirely confident about the quality of his Mary Magdalen, had persuaded him to write the excessively humble and devoted letter that accompanied it, hoping it would be read as a suggestion that he was owed compensation. When this failed they tried a more specific request suggesting that Federico should demonstrate his acceptance of Titian's deep affection by rewarding him with the benefice. When there was no sign of it by 18 July Aretino, who judged that the time had come to take a tougher stance, composed for Titian a letter which, although signed by Titian, bears all the hallmarks of the Scourge's manner of extracting favours.

Most Illustrious Lord

I have been expecting the bull of the benefice of Medole which Your Excellency was kind enough to give me last year for my son Pomponio, and seeing that the matter is delayed for too long and that I have not even received the income of the benefice I find myself the most discontented man in this world, it seeming to me that if the goodness and generosity of Your Excellency is to come to nothing I will be constrained, to my great disgrace and infamy, to change the priest's habit that my boy wears with the greatest pleasure in the world and in the firm hope that he may enjoy this and other benefices from Your Excellency. So I must beg you as humbly as I can to console me by seeing to it that he has this bull, without which I will remain deeply troubled as much for the sake of my boy as for my own honour which

will be compromised now that I have spread the word in Venice about the gift of the benefice made to me by Your Excellency ...

The timing of the letter, and the threat that Federico's reputation might suffer if the bull was not forthcoming, were all the more effective when four days later the tribunal in Rome granted permission for the annulment of Federico's marriage contract with Giulia d'Aragona, which was the only remaining barrier to the emperor's formal sanction of his marriage to Margherita Paleologo. In his euphoria Federico fired off a quantity of letters including one to his ambassador in Rome enclosing eighty scudi with which to bribe the officials in the Curia to make haste with the settlement of the benefice; and one to Titian apologizing for his neglect: he had been so preoccupied by his marriage that sometimes he couldn't even remember who he was, but that very day he had sent money to Rome for the expediting of the bull and promised that half the income would be available within a week. When there was no news of the bull by 31 July Titian/Aretino tried a different tactic from the one they had used in their previous threatening letter. They congratulated the duke on his marriage and expressed enduring gratitude 'on bended knees' for the bull – which had actually not arrived. Federico got the message, and at long last on 7 September Benedetto Agnello advised him that he had given the bull to Titian who had received it with the greatest possible joy and had promised him he would give his immediate attention to the paintings he owed the duke. At the time Titian received the bull on his son's behalf it produced 102 scudi per annum, but since Pomponio was still so young he had to pay out of it a pension of twenty-five ducats to a vicar – a certain Ottaviano Cusatro who would later be a thorn in Titian's side – to administer the benefice for him.

With Titian in his debt Aretino had no difficulty in persuading him to paint a St John the Baptist as a gift to the imperial commander in charge of Milan, through whom he sought to gain favour with the Duke of Milan. The painting was dispatched in October 1531, and just in case its quality should fail to impress the commander he accompanied it with a letter describing 'the beautiful curl of the

Baptist's hair, the fairness of his skin, the richness of his crimson tunic lined with lynx, and the deceptive beauty of the lamb which had caused a sheep to bleat'. (The painting is lost.)

The half-length penitent Mary Magdalen proved to be one of Titian's most successful subjects, so much so that in later life he claimed that the saint had earned him no less than 2,000 scudi. He and his studio produced a number in the 1530s and again in the 1550s and 1560s, many of which survive[3] – in the later versions her breasts are covered, she wears a striped shawl, her face is more lachrymose, and her attributes are a book, or a book resting on a skull, as well as the jar of unguent. All were small intimate cabinet paintings – the repentant but sensuous semi-nude Magdalen was not considered appropriate for large public altarpieces until much later in the Counter-Reformation. Vittoria Colonna's Magdalen is lost. For the earliest extant version painted a few years later (Florence, Galleria Palatina), probably for Francesco della Rovere, Duke of Urbino, Titian may have used the same model – it has been plausibly suggested that she was a prostitute – but removed her clothes and wiped away some of her tears the better to titillate a male patron. The jar of unguent is the only sign we have that this pneumatic naked girl, her flowing red-gold hair encircling her large, firm breasts, is a saint. Titian gave her all the features of the Renaissance ideal of perfect beauty as well as the pose of a Venus Pudica coyly pretending to hide her sexuality.[4] Ruskin, who was easily outraged by what he regarded as art betrayed by vulgarity, was disgusted by this 'stout, red-faced woman, dull, and coarse of feature, with much of the animal in even her expression of repentance – her eyes strained, and inflamed with weeping ... [It is] the only instance, so far as I can remember, of Titian's painting a woman markedly and entirely belonging to the lowest class.'[5]

On 1 September 1531, a week before Pomponio's benefice came through, Titian signed the lease on the large house overlooking the lagoon in the parish of San Canciano where he would live and work for the rest of his life: painting, conducting his business affairs, raising his family and entertaining friends and visiting dignitaries.[6] The area

was known as the Biri after a canal called Biria that divided the district in two parts, Biri Grande, on the side nearest the church of the Gesuiti, and Biri Piccolo closer to Santi Giovanni e Paolo. Titian's new house was on the northern edge of Biri Grande fronting the lagoon. It was a leafy but poor, unfashionable and crime-ridden suburb, but it was not the least of Titian's considerations that its location on the lagoon would facilitate the export of paintings destined for the mainland and the import of materials, and that it was near the timber yards at San Francesco della Vigna, where the community of Pieve di Cadore had long-standing rights to land and store their timber. The house itself, furthermore, had many advantages that made it worth Titian's while to shoulder the considerable rent of forty ducats a year, which rose to fifty after 1536 and sixty after 1549.[7] Known as a *casa grande* or *casa da statio*, indicating that it was an upper-class residence, it had been built four years earlier by a patrician, Alvise Polani, who had originally intended it for his own use, but had died leaving it to his son-in-law Leonardo di Marcantonio Molin, with whom Titian signed the contract for the entire house apart for the time being from two mezzanine flats, and which allowed him to spend 100 ducats on improvements. It was a long, narrow, free-standing block similar to many villas built at that time on the mainland and in rural areas of the lagoon, consisting of a ground floor used for storage and Titian's spacious apartment on the top floor. This had a large reception room for entertaining which was lit by four round-headed windows, and enough side rooms to accommodate his studio as well as the two growing boys, live-in assistants, visiting friends and members of his extended family from Cadore, and the necessary complement of servants.

An external staircase led down to a garden that surrounded the house on all sides where finished paintings could be set out to dry away from the prying eyes and potential hazards of a calle or campo, and where a wood and masonry barn next to the house probably served as a store for materials. But not the least of the attractions of the new house was the view from it. Working in his north-facing studio or enjoying his garden on a clear day in winter when the north

wind blew away the mist from the lagoon, Titian could see, beyond the smoking glass furnaces on Murano and the coastline towards Campalto, the mountains of the Vecellio homeland that he had painted so often from memory: the Civetta with two peaks that look like ears; the Pelmo, shaped like a doge's hat; the jagged Marmarole that framed the view from his family house in Pieve di Cadore; the Antelao, just a few kilometres west of Pieve below which Titian's father had fought in the victorious battle against Maximilian I; and on some days even as far as the snow-capped Marmolada, the highest peak in the Cadorine Dolomites.

Titian was not the only Renaissance artist who cared about his domestic surroundings and could afford to live in style. Vasari had a fine house in Arezzo and Giulio Romano one in Mantua, as did Dürer in Nuremberg and the Cranach family in Wittenberg. But it was unusual for an artist to expend as much time, money and thought on a house as Titian did on his residence in Biri Grande. In the years to come he improved and extended the garden, buying an adjacent plot of land and planting it with trees; he enlarged the hut in the garden and raised its roof; he took a lease on the mezzanine flats whose tenants were annoying him and rented them out to lodgers of his own choosing. He used his connections with local artisans and the eye for decorative objects that he had put to the service of his wealthy patrons to purchase ceramics, glass and furnishings for his own enjoyment. He traded a portrait of a maker of musical instruments for a harpsichord. Less than three years before his death he asked a patron to pay him in lieu of cash with a set of wall hangings or *spalliere*, the attachments, often tapestry or leather, that were placed above pieces of furniture, and which were the most expensive decorative items in any Venetian household. The *spalliere*, he said, would give him more pleasure than a gift of 2,000 scudi.[8]

We can guess from the endearing dogs that appear increasingly in his paintings that he filled the house with dogs. And at some time in the mid-1530s Titian married for a second time, and his third child, Lavinia, was born not long afterwards.[9] Nothing is known about his second wife except that she was probably still alive in 1548 when

Charles V wrote to Ferrante Gonzaga, then governor of Milan, asking that a pension of 100 scudi promised a decade earlier should be paid in order to maintain Titian's wife and family while the artist was at court with the emperor. Even Aretino, who must have known about both his wives and was forever gossiping about his friends' love lives and his own, did not so much as hint at their existence in his writings. We can assume that she was not a person of social consequence in Venice and that Titian, in the old-fashioned Byzantine tradition, kept her strictly at home. Perhaps, like Cecilia before her, she was a girl from Cadore come to Biri Grande as a housekeeper or live-in model.

What little remains of Titian's house can be found with some difficulty in a narrow courtyard called Campo del Tiziano, which is now some way inland from the lagoon. Even before Titian's death the waters had begun to retreat from this part of the city, and by the end of the century the area to the north of his house had been filled in and developed with houses and the quays still known as the Fondamenta Nuove. His house was by no means the only one to be maimed in the nineteenth century by insensitive speculators under the Austrian occupation and left to decay in the sad years of desperate poverty that followed the unification of Italy.[10] The piano nobile was partitioned, and repartitioned, into cheap flats. The external staircase had collapsed by the 1870s.[11] Only two of the original round-headed windows remain on the outside and all but one are blocked on the inside.

During the upheaval of moving house and studio to Biri Grande, Titian found time to finish a large votive portrait of Doge Andrea Gritti with the Virgin and Child and Four Saints, which was installed in the Collegio on 27 September. The painting was destroyed by a fire in 1574, but we have good idea of what it looked like from an anonymous woodcut (in which Gritti's face is replaced by that of a later doge, Francesco Donà) and from a detailed description by Sanudo, who saw it on 6 October: 'The new painting shows the present Most Serene Prince kneeling in front of Our Lady, who holds the child. The doge is presented by San Marco, and behind Our Lady are three saints, Bernardino, Louis and Marina.' Sanudo, who was as usual

more interested in listening to gossip than looking at paintings, went on to record that people were joking that it looked as though an argument had broken out among the saints about which one had contributed most to the election of the Most Serene Prince. Nevertheless, everyone agreed that it was one of Titian's most successful pictures.

The loss of so many of the most admired paintings from the early 1530s – the Death of St Peter Martyr, the portrait of Cornelia, Vittoria Colonna's Magdalen and most of the others commissioned by Federico Gonzaga; the St John the Baptist that Aretino sent to the military commander of Milan; the votive portrait of Doge Gritti – leave us with an unbalanced impression of the quality and range of Titian's work at this time. But those that have survived suggest that in the years following the explosive St Peter Martyr he, and perhaps his patrons, were less interested in innovation, and that Titian, now into his forties and greatly in demand, was sometimes content to look back over his shoulder at past achievements, while relying more heavily on assistants than he had in his younger days.

He seems to have called upon his brother Francesco to help him when he was under pressure to finish the *Madonna in Glory with Six Saints*,[12] which was probably begun before an extended visit to Bologna in 1532–3 and finished by 1535. He reused the panel on which he had painted two unfinished pictures, one probably a bathing scene originally for Alfonso I d'Este who had cancelled the commission in 1518, the other an altarpiece for the Oratory of San Nicolò (the commission he had stolen from Paris Bordone). The upper section of the Virgin and angels floating on clouds is painted in a tightly explicit manner that looks more like Francesco's work than his own. Titian did prepare the composition of the lower half, but the rather flaccid figure of St Sebastian (which he later radically revised for a woodcut by Niccolò Boldrini) looks remarkably weak, especially in contrast with the *St John the Baptist* (Venice, Accademia), probably of around the same date or a little earlier, in which the muscular body of the saint and the chiaroscuro tonality of the landscape are closer to the St Peter Martyr.

The Baptist stands tall and triumphant in a mountain landscape so beautifully evoked that we can almost smell the crisp air. The mountain stream, which Titian indicated simply by combing a little white impasto on to the surface, is a tour de force that was noticed by Ridolfi: 'we can see a gentle trellis of small trees which, as they bend their green branches, seem to be kissing the clear spring that provides a pleasing drink for him, and while it flows through small pebbles, it sprays silver drops of water …'. The painting was commissioned by a Polani relative of Titian's landlord for his chapel on one side of the high altar of the church of Santa Maria Maggiore. The sculptural modelling of the Baptist's body, intended as a pendant to a statue of St Francis in the chapel on the other side of the high altar, may have been inspired by a prototype by Sansovino or Michelangelo.[13] But the painting is also so close to Aretino's description of the Baptist in *The Humanity of Christ* that one wonders which inspired the other.

> Look at John the Baptist, there on a rock with his wild head of hair, horrid beard, and the face of penitence … His arms are naked, his legs undressed, his feet bare. He eats grass, drinks water, sleeps on tree trunks, and with the exclamations that issue from the depths of his soul the woods crash down, the rocks shake, and Echo, aghast, answers him trembling.

Other paintings from these years are less powerful. The *Assumption of the Virgin*, still in the cathedral of Verona,[14] is a simpler composition than the great Frari *Assunta* and its colouring is more subdued. But it is interesting to think that it may have been the first Titian seen by the great colourist Paolo Caliari, known after his birthplace as Veronese, who was only about four when Titian finished it around 1532; and to compare Titian's two beautiful but relatively quiet versions of the *Supper at Emmaus* of around the same date with the more elaborate Suppers that Veronese would paint in the second half of the century, when he made the subject of lavish banquets his own. Titian painted two versions of the story from the gospel according to St Luke (24: 13–32) in which Christ after the Resurrection meets St Cleophas and

another disciple who fail to recognize him and invite him to share their supper at an inn, where he reveals his divinity. One version (Paris, Louvre)[15] was painted for Count Nicola Maffei, Federico Gonzaga's chief minister who frequently acted as Federico's representative in his dealings with Charles V and with Titian. The imperial eagle on the wall refers to Maffei's loyalty to the emperor. Another, weaker version (Liverpool, Walker Art Gallery; formerly the Earl of Yarborough, Brocklesby Park, Lincolnshire) was commissioned by a member of the Contarini family, who presented it to the Republic to hang in the Senate chapel in the doge's palace.

Although Titian was so famous by this time that the subjects and patrons of many of his paintings were recorded, nothing is known about the so-called *Allegory of Marriage* of about 1531–3 (Paris, Louvre), which continues to keep scholars guessing about who the three principal figures might be. One promising explanation is that it was painted in response to a letter from Alfonso d'Avalos to Aretino expressing the desire that before setting off on a campaign against the Turks Titian would paint a group portrait of d'Avalos himself in armour, his wife Maria d'Aragona and their baby son Ferrante as Cupid. The man in armour does not look like Titian's known portraits of d'Avalos, but this could be because he hadn't the time to pose for him before going off to war.[16] He does, however, look remarkably like Titian's later portrait of the mercenary soldier Francesco Maria della Rovere, Duke of Urbino, whom Titian met in 1532. Since the woman holding a globe upon whose breast he lays his left hand bears no resemblance to Francesco Maria's consort, it could be that she is Venus, he is Mars and the Cupid holding a bundle of arrows stands for marital love and fidelity.

Sought after by foreign patrons though he was in the first years of the 1530s, Titian, as a prominent resident of Venice, could hardly have escaped local duties. In 1531, as well as completing the successful votive portrait of Doge Gritti for the Collegio, he was elected by the painters' guild along with Lorenzo Lotto and Bonifazio de' Pitati to the board of executors charged with distributing 200 ducats left in the will of Vincenzo Catena for charitable purposes. The grand

chancellor, Andrea de' Franceschi, who had been elected in 1529 to that most important of positions open to non-nobles, and whom Ridolfi described as 'most beloved of the painter', sat for him twice, in 1532 and a few years later, wearing the red robe and black stole of his office (Washington, DC, National Gallery of Art, and Detroit, Institute of Arts).[17] And at about the same time he portrayed a member of the patrician Dolfin family (Los Angeles, County Museum of Art), also in red with a black stole.

But these rather routine likenesses of high-ranking Venetians show none of the adventurous approach and intimacy with their subjects that we feel in the portraits Titian had painted in his youth when he was exploring what he could do with the genre of which he would prove himself the unrivalled European master at the end of the decade. Their inferior quality compared to the greatest aristocratic portraits of the 1520s – the *Portrait of Tommaso de' Mosti*, the *Man with a Glove*, the *Portrait of Federico Gonzaga in Blue* – suggest that Titian in his middle age, loyal Venetian though he was, had made a conscious decision to reserve his best efforts for foreign aristocrats. At some time between 1530 and 1535 he changed the spelling of his signature from the partly Venetian 'TICIANVS' to the fully Latinized version 'TITIANVS', the first extant appearance of which can be seen on the Vatican *Madonna in Glory*, and which he or his advisers presumably deemed more appropriate to his international status.

After the St Peter Martyr – for which he had to continue suing for his paltry fee – Titian gradually priced himself out of the home market. In the 1530s and early 1540s his fees for altarpieces quadrupled, he relied more on his studio and he painted fewer time-consuming large-scale pictures than at any other time in his career; nor did he return to mythological narrative subjects until the 1550s. If his phenomenal artistic energy and courage were sometimes in abeyance, his genius for portraiture carried him up the social ladder and through the doors of the most powerful rulers in Europe, who would reward him with the cash, favours, land, pensions, flattery, honours and benefices for Pomponio that were beyond the means of chronically stingy Venetian patrons. From now on, with Aretino's

help, he manipulated the princes, the greatest of whom, so the legend went, bent to pick up his paintbrush, and managed his business affairs with a degree of flair and dedication unmatched by any other Renaissance artist.

THREE

The Most Powerful Ruler in the World

As you cannot be everywhere at the same time, the best way of
keeping your kingdoms together is to make use of your children.

FROM CHARLES V'S POLITICAL TESTAMENT FOR
HIS SON PHILIP, 1548

In the autumn of 1532, nearly three years after his coronation by
Clement VII at Bologna, the emperor Charles V returned to Italy from
his possessions in Germany, the Low Countries and Austria. He had,
at the last minute and with some difficulty, persuaded the pope to
confer with him once again at Bologna about the issues that burned
closest to his heart. Chief among them was the Protestant problem in
Germany, which had grown from a movement for reform within the
Catholic Church instigated by Martin Luther in 1517 to an outright
rebellion against exploitation and abuses by the Old Church and the
Habsburg imperialists. The formulation of Lutheran principles had
been presented to Charles at Augsburg in the summer of 1530. They
included the doctrine of justification to God by faith alone, and rejec-
tion of the Catholic rite of Holy Communion and of the celibacy of
the clergy. Charles believed that the Protestant problem could be
resolved at a General Council of the Church at which dogmatic differ-
ences would be discussed and much needed reforms of clerical abuses
agreed. Although Clement was well aware of the need for Church
reform, the emperor's previous attempts to persuade him to summon
a General Council had failed. Like every pontiff in the previous

century he was haunted by the outcome of two such Councils held early in the fifteenth century, which had concluded that a General Council representing the whole Church was superior to the papacy. He had reason to believe that compromise with the Protestants and power sharing with the emperor would weaken papal authority whatever the conclusions of a General Council.

While in Germany, Charles had succeeded in bribing the Catholic electors to vote unanimously for the coronation of his younger brother Ferdinand, Archduke of Austria and King of Bohemia and Hungary, as King of the Romans, a title intended to strengthen Ferdinand's constitutional authority and ensure that he would succeed Charles, in the event of his death, as Holy Roman Emperor. Ferdinand's coronation, however, inflamed the anti-imperialism of the most powerful German Protestant princes and free cities. Under the leadership of Philip, Landgrave of Hesse, and John Frederick, Landgrave of Saxony, they formed a defensive military alliance known as the Schmalkaldic League, so called after the town of Schmalkalden in the German province of Thuringia where they met in February 1531. In the coming years the League would continue to spread the causes of Lutheranism and anti-imperialism in northern Germany. By that time the German presses had churned out some 4,000 vernacular pamphlets. More and more Germans were beginning to share the view of the popular German freethinker who condemned the double-eagle Habsburg crest as 'neither beautiful, well-formed, useful nor edible, but, on the contrary ... ravenous, thievish, solitary, useless, warlike'.[1]

Although Charles much later in his reign recognized the growth of Protestantism in Germany as the most significant challenge of his entire reign, he was deflected by the more immediate threats posed by his struggles against France and the Ottoman Turks. In the early summer of 1532 the Protestant problem was temporarily defused by news of a second Turkish advance on Vienna led once again by Suleiman the Magnificent. At Nuremberg the Protestants agreed to provide an army in return for religious concessions. Charles, joined by Italian troops under the leadership of the young warrior cardinal

Ippolito de' Medici and Alfonso d'Avalos, took personal command of the combined forces. By the time his armies reached Vienna at the end of September the Turks had already retreated – not to return there for more than a century and a half. However, they continued to wreak havoc and terror in the Mediterranean under Suleiman's admiral and viceroy of Algiers, Khair ed-Din, a brilliant naval tactician and pirate, who was known as Barbarossa to the Italians and Spanish upon whose shipping and coastlines he preyed, taking women and children into slavery, seeking out the most beautiful women for the sultan's seraglio, subjecting even Christian babies to atrocities that appalled (and fascinated) Europeans, who were themselves no strangers to extreme violence. Charles's advisers had been counselling him for some time to take action against Barbarossa; and one of the items high on his agenda for the rendezvous with the pope was the necessity of raising a fleet against the pirate king who had become his chief antagonist at sea.

Whenever the emperor travelled, his entire court travelled with him: lawyers, accountants, ambassadors, secretaries, barbers, physicians, artisans, entertainers, tradesmen, servants, the personal staff of guests – all accompanied by mules and carts laden with baggage and provisions and followed by a trail of beggars, whores and other unofficial hangers-on. As the procession entered the Venetian Republic, announced by drummers and infantry carrying light artillery and mounted captains in full armour, the older onlookers were inevitably reminded – some with a frisson of fear, some of the old diehard imperialists with nostalgia – of the invasions by Charles's grandfather Maximilian not so many years before. On this occasion, although there was no love lost between the Habsburg emperor and the doge of the independent Republic of Venice, they exchanged polite messages while the Senate turned a blind eye as provincial governments destroyed bridges along the route to steer the itinerant court with its marauding landsknechts away from their territories.

When the entourage reached Bassano, Sanudo noted in his diary that the emperor was wearing court dress – a doublet of silver brocade, a fur collar, black hat and white shoes and stockings – and that the

crowds of spectators were entertained by the sight of his favourite hunting hound travelling by his side in its own special carriage. Jacob Seisenegger, court painter to Ferdinand, for whom he had already portrayed the emperor four times, was travelling with the imperial party in order to do another portrait of him at Bologna. By then, however, Charles had made up his mind to sit also for Titian. The portraits, particularly the one (now lost) of Federico Gonzaga in armour, that he had seen in Mantua after his coronation had made an impression on him. No doubt he regretted the insulting one-ducat tip he had given Titian at Parma all the more when heard from his closest advisers just how good Titian was: Francisco de los Cobos, Alfonso d'Avalos, Ippolito de' Medici, Ferrante Gonzaga, all of whom understood Italian painting better than he did, were admirers of the celebrated Venetian painter. And the Duke of Urbino, Federico Gonzaga's brother-in-law, for whom Charles had a high regard, had commissioned three paintings from Titian in the previous summer.

The Duke of Urbino and Ippolito de' Medici were with Federico Gonzaga in the party that greeted the emperor outside Vicenza and accompanied him to Mantua, where Charles looked forward to spending another holiday before his rendezvous with the pope. On 7 November, the day after he had entered Mantua with his imperial guest, Federico wrote to Titian, not once but twice:

Messer Titiano. Because it would be very dear to me to have you near me just now I beg you as hard as I can to come here as soon as possible, which would do me a singular pleasure.

And again:

Messer Titiano. I hope you will be content when you come here, as I hope you will for my sake, to have brought with you some fish [*pesce suola*, or sole], which would give me great pleasure and as I expect you shortly I will say no more than that I offer you, etc.

Like everyone who met the emperor in person Titian cannot have failed to be impressed by his extreme ugliness, his dignified bearing, his withdrawn but unfailingly courteous manner, and the eagle eyes upon which his contemporaries often commented. Lanky, pale-skinned with reddish-blond hair, beard and moustache, his nose turned up to a point, his lower lip protruding, Charles sported a Habsburg jaw so prominent that he could hardly close his mouth, his breath stank and his diction was slurred. He had lost his teeth at the age of fifteen in an accident with his litter and his face was often creased by the pain of the agonizing episodes of gout that attacked him with increasing frequency from his twenty-eighth year. Charles is supposed to have said – perhaps he repeated the comment to Titian – that he knew he was ugly but thanks to the painters who had depicted him as even uglier he made a less bad impression on those who saw him for the first time than he might have. Charles was not, however, unconcerned with his personal appearance. Although contemporaries commented on the simplicity of his costume he had his first white hairs removed when he noticed them in 1535.

His earnest and determined mind was not quick, enquiring or cultivated. He had resisted the efforts of his childhood tutors to give him a classical education, and unlike his extrovert brother Ferdinand, who was if anything too talkative and enjoyed making puns, Charles was so hesitant in conversation, so lacking in a sense of humour, at least in public, that some people thought him a little backward. He was also a very different character from his paternal grandfather, the highly educated and forward-thinking Emperor Maximilian, who spoke seven languages including good Latin.[2] Charles, famously credited by Spaniards with the comment that one speaks French with ambassadors, Italian with women, German with stable boys and Spanish with one's God, had been brought up speaking French, learned fluent Spanish and adequate Italian, but never mastered German or enough Latin to understand it when spoken by foreign ambassadors.

Lonely and reserved, the emperor took comfort in women, in music, which he enjoyed and understood more than the visual arts, in

hunting and jousting, and in rich heavy meals accompanied by quantities of Rhine wine or beer. Despite his frail health he was an industrious and if anything over-conscientious statesman – more than 120,000 of his official letters have survived – as well as an expert horseman and a committed soldier. Maximilian, who had had Charles fitted with his first suit of armour when the boy was only twelve, may have regretted his heir's less active mind, but he would have been proud to know that after 1532 his grandson commanded his troops in person.

Perhaps the most distressing of the emperor's afflictions was a tendency to depression and periods of lassitude that was probably inherited from his mother Juana, the daughter of Isabella of Castile and Ferdinand of Aragon, and that would be passed on to his grandson Don Carlos. Juana was already known as Joanna the Mad when, after the unexpected deaths of her older siblings and that of Isabella, the succession to the crown of Castile passed to her and her husband Philip, Duke of Burgundy, and through them to Charles, who was born in that same year; and after Philip's death in 1506 she became completely crazed and incapable of rule. Charles was six when he inherited a claim to Burgundy, one of the richest areas of Europe, which at that time embraced much of what is now the Netherlands and Belgium.

Although Burgundy was neither politically nor economically united – and was at that time in French hands by previous agreement – the late-medieval duchy had created for the rest of Europe the ideal of what a princely court should be. Charles had been born there in Ghent and spent his childhood and early adolescence under the regency of his aunt Margaret of Austria, dowager Duchess of Savoy; and his youthful imagination was shaped by ancestral memories and stories of pomp, Gothic splendour and romance, traditions of chivalric honour, jousting in single combat, crusading knights and pious aristocracy represented by the Order of the Golden Fleece, which had been founded in 1430 by Duke Philip III of Burgundy. In the course of his reign Charles would create eighty-five new members of the order, mostly nobles of Burgundy, Spain and Germany but also some

of his Italian generals including Alfonso d'Avalos and Ferrante Gonzaga; and he remained master of it until the year before his death. His identification with the style of a bygone age went so deep that on two occasions – in 1528 after Francis I had broken the Treaty of Madrid, and in 1536 when Francis tried to take Milan in contravention of the Peace of Bologna – he challenged the French king to single combat. Francis, who was at least as courageous as his arch-enemy and perhaps the better athlete, was merely amused by the suggestion.

It has been said that if Charles V was the last of the medieval emperors he was also the first king of Spain's golden age.[3] He inherited the Kingdom of Spain, its American dominions and its Aragonese possessions of Sicily, Naples and Sardinia on the death of his maternal grandfather Ferdinand in 1516. Spain, although ruled by a single monarchy since the marriage of Ferdinand and Isabella had united Aragon and Castile, was still an association of quasi-independent provinces and noble estates. The two crowns were ruled under different constitutional and administrative systems, and the 'Catholic Kings', as they had been dubbed by Pope Alexander VI, were unable to stem aristocratic factionalism in Castile. Ferdinand furthermore had done everything he could to prevent the succession of his insane daughter and her foreign consort. When Charles arrived in 1517, he found a harsh and, compared to Burgundy, an uncivilized country. The Castilians in particular resented the ugly, inexperienced, teenaged ruler who spoke no Spanish and brought with him a complete retinue of 200 Burgundian counsellors, officials and courtiers, and even a choir of Flemish part-singers and their scores. Three years later an armed revolt of rebel citizens, known as the Comuneros, taught Charles a first lesson in statesmanship. He was abroad at the time – his absence from the kingdom was part of the problem. The revolution was quelled by a royalist army in 1521. But when he returned in the summer of 1522 he did everything within his power to reverse the failures of judgement that had caused the uprising and spent the next seven years in his kingdom, learning Spanish so well that it became his preferred language.

On Maximilian's death in January 1519 Charles inherited the Habsburg possessions of Austria, the Tyrol and parts of southern Germany. It was the same year in which Hernán Cortés began his conquest of Mexico, but Charles and his advisers were more preoccupied by the election campaign for his grandfather's successor as Holy Roman Emperor. The two other contenders were Henry VIII of England and Francis I, who was supported by Leo X. The electors – the German princes who inherited the right to vote for a new emperor – were in practice more like auctioneers who as everyone knew would award the title to the highest bidder. Henry soon dropped out of the race. Charles, who knew that without a Habsburg emperor the Netherlands would be vulnerable to the French and Austria to the German princes, outbid Francis. The election, which he won on 28 June, cost him 850,000 florins, more than one-third of it borrowed from the Fugger bank of Augsburg. It was the beginning of a practice of living on credit that would plague the rest of his reign and those of his heirs. Taxes in Spain and its dominions, and revenues from America, which until the 1550s averaged only some 200,000 to 300,000 ducats a year, were never enough to compensate for expenses. While his personal income rose from one million to one and a half million soldi, his wars in Germany and against France, which continued periodically for most of his reign, drew him deeper and deeper into debt, forcing him to borrow at interest rates that rose from 18 per cent in the 1520s to 49 per cent after mid-century, by which time he was irretrievably mortgaged to his bankers.

Ugly, plagued by mental and physical illness, surrounded on all sides by threats from the German Protestants, the French king and the Turks, Charles was at least extremely fortunate in his private life. When he was not yet two his parents had arranged an engagement to Louis XII's three-year-old daughter Claude. Fortunately, as it turned out, for his personal happiness the negotiations for that and three other dynastically advantageous engagements broke down.[4] Still a bachelor at twenty-six, with a four-year-old illegitimate daughter Margaret by a Flemish girl, he decided in 1526 to marry, sight unseen, his first cousin Isabella, the daughter of Emmanuel of Portugal. She

was a popular choice with his Castilian subjects, who approved the continuation of the policy pursued by Ferdinand and Isabella to bring about a closer association between Castile and Portugal. And she brought with her an enormous dowry worth 900,000 ducats on paper.[5] But when he saw her for the first time at their wedding in Seville, he was stunned by her elegant beauty and regal bearing, and fell immediately and deeply in love with her. Philip, the first of their seven children to survive into adulthood, was born a year after their marriage, Mary a year later and Juana in 1535. Although he strayed on his voyages abroad, Isabella remained the central love of his life. After her death in Toledo in 1539 from a miscarriage he retreated to a convent for seven weeks and for the rest of his life dressed in plain and increasingly threadbare black. Francis I proposed that he marry his daughter Margaret of France (later the Duchess of Savoy), but Charles refused to marry ever again even for sound political reasons.

The emperor whom Titian got to know at Mantua ruled on a scale that would not be matched before Napoleon. The story of his reign is the story of early sixteenth-century Europe, although he is seen in different ways by historians of the countries in which he ruled. Thanks to the dynastic marriages and fortuitous deaths that had given him the Netherlands, Spain and Austria, his monarchy (as it was called by contemporaries) embraced one-fifth of the population of Europe and touched on the Mediterranean, the North Sea and the far side of the Atlantic. But although he owned twice as much of Europe as Francis I, the two monoliths were evenly matched and their ruinously expensive wars would inevitably end in stalemate. France, although ringed by a chain of imperial dominions, had the advantage of administrative and territorial unity. Charles's possessions were so geographically and culturally dispersed – the Holy Roman Empire alone consisted of over 200 princely states and free cities – that he was obliged to respect local laws and customs and they never adopted a common imperial currency. Dealing with a problem in one part of his realm meant that he could not control events elsewhere.

Charles V spent a quarter of his reign on the road ('Kings', he once told his son, 'do not need residences') and devised a courier and postal

service that was the fastest and most secure in Europe. Nevertheless, messages carried by relays of mounted couriers took two weeks to a month between Brussels and Valladolid, and armies moved at a rate of ten to thirteen kilometres per day. He could not have ruled his widely scattered possessions without delegating power, where possible to his relatives: to Ferdinand in Germany, Austria and Hungary; and in the Netherlands to his clever and charismatic aunt Margaret of Austria, who was succeeded as regent after her death in 1530 by his intelligent and energetic but less charming sister Mary, dowager Duchess of Hungary, who ruled the Netherlands for the next twenty-eight years. In all his dominions he pursued a policy of working as far as possible with existing authorities, instituting reforms tactfully and gradually, and flattering the vanity of powerful nobles. Viceroys, whose power was checked by councils directly answerable to the King of Spain, governed Sicily and Naples in his stead. It was the job of the governors of Milan, his power base in northern Italy after it reverted to him as an imperial fief in 1535, to defend the duchy from the threat of French invasion.

The personal device *plus ultra* meaning even further – beyond, that is, the pillars of Hercules which in antiquity had marked the end of the known world – had been suggested to him by his humanist physician when he ascended the Spanish throne to indicate ambitions that stretched beyond those of other men. Although the twin pillars and scroll were later adopted for the American dollar sign, Charles at this time was actually less interested in exploiting his overseas dominions – which would later pay large dividends and fuel inflation throughout late sixteenth-century Europe – than in pursuing what he regarded as his God-given missions: to be the secular leader of a reformed, reunited universal Christendom, to drive the infidel Turks out of Europe and the Mediterranean, and to preserve and extend his dynasty by arranging politically advantageous marriages for his relatives.

The ideal of a Universal Christian Monarchy, as proposed by Dante and by Erasmus – whose writings were more popular with intellectuals in Spain than in any other European country – had been articulated

by his Piedmontese grand chancellor Mercurio de Gattinara, a follower of Erasmus, in a letter to Charles after his election as emperor:

> Sire, now that God in His prodigious grace has elevated Your Majesty above all Kings and Princes of Christendom to a pinnacle of power occupied before by none except your mighty predecessor Charlemagne, you are on the road towards Universal Monarchy and on the point of uniting Christendom under a single shepherd.

It is not easy to define Charles's personal religious beliefs in our own age, a time when Christian faith is regarded as a subjective decision about the existence of God and the tradition in which believers choose to worship. He, as the imperial representative of God on earth, regarded his own faith as a matter between himself and his God; and his few public comments about religion were usually made in a political context. This does not mean, as some historians have concluded, that he was irreligious. Far from it, he was an orthodox Catholic, brought up before Martin Luther and his followers questioned and complicated the traditions of the Catholic Church. It was for that reason that he failed to understand the spiritual and doctrinal bases of the Protestant Reformation; nor was he fully aware of the deep-seated desire for political and economic self-determination that underpinned the Lutheran movement in Germany. Unlike the more sceptical Erasmus – who called 'Caesar' not a doctor of the Gospels but their champion[6] – Charles genuinely believed that reconciliation with the Protestants could be achieved by compromise and reform of Catholic malpractices, and his unwavering faith in the possibility of a reunited Christendom was strong and simple enough to allow him to hope that Pope Clement could be persuaded to share his vision at their second meeting in Bologna, where he also intended to discuss the need to finance a fleet against Barbarossa and the maintenance of the always precarious peace with France.

* * *

But first he took his month's holiday in Mantua where Federico had, as before, spared no expense on preparations for elaborate feasts, dances, hunting parties, court spectaculars, and tennis matches at the Palazzo Tè, where the sound of the balls bouncing off roofs could be heard while Giulio Romano painted his dramatic frescos in the Sala dei Giganti. On this visit the emperor was also entertained by staged comedies for which Titian at Federico's request had found a Venetian scene painter to work on the sets alongside Giulio Romano. Ludovico Ariosto, now within a year of his death, came from Ferrara to present the emperor with a copy of the last edition of his *Orlando Furioso* in which he had added Titian's name to his list of the greatest Italian painters – it was the first mention of Titian in a prominent literary work – and for which Titian had designed Giovanni Britto's woodcut portrait of Ariosto in profile[7] for the frontispiece.

On 6 December 1532 Federico and Charles set off for Bologna where they arrived on the 13th. Federico, who was feeling unwell, returned immediately to Mantua. Although it is possible that Titian travelled with the emperor and the duke, who enjoyed his company, all that can be said with certainty is that he reached Bologna well before 14 January, when Ferrante Gonzaga wrote to Federico that Titian had painted a very lifelike portrait of the emperor and was preparing a copy for Federico. Titian stayed in Bologna until 10 March when he wrote to Federico that he was about to leave for Venice and would take his copy of the portrait of the emperor with him and finish it there.

In his 'Life of Titian' Vasari tells a story about the sitting in Bologna which is probably true since he repeats it in his biography of Alfonso Lombardo in both editions of his *Lives*. Alfonso Lombardo, a Ferrarese sculptor and medallist with an engaging personality, persuaded Titian to allow him to come with him while he portrayed the emperor on the pretence that he was an assistant carrying the master's colours. He brought with him a small wax tablet, and as soon as Titian started to paint, he drew it out of his pocket and quickly sketched the model for a relief portrait of the emperor. Charles saw what he was up to, asked to see the tablet and was so impressed that he asked Lombardo

whether he was a good enough artist to carve the sketch in marble. The sculptor replied that he needed only to be told where he should send the finished work, to which Charles replied that it should be brought to him at Genoa before he embarked for Spain. He was so pleased with Titian's portrait that he paid him 1,000 crowns, but when he saw Lombardo's finished relief carving he made Titian give him half the fee.[8]

Titian's portrait of Charles V in armour is lost; and all the copies or versions he and his workshop made of it – for Ferdinand of Austria, for Francisco de los Cobos, for Federico Gonzaga and for Francesco Maria della Rovere, Duke of Urbino – have also disappeared. We know it only from later copies, including one by Rubens (in a private collection), and from a woodcut by Giovanni Britto and an engraving by Agostino Veneziano. In all of these he is shown three-quarter length in armour, bearded, bare-headed, with his sword raised, wearing the badge of the Burgundian Order of the Golden Fleece, a gold sheepskin suspended from a collar of linked fire steels in the shape of the letter B. Charles kept this portrait in his private apartments for his wife and his son Philip, who grew up with it and later ordered a portrait of himself in armour from Titian.

The *Portrait of Charles V* painted by Seisenegger in Bologna is now in the Vienna, Kunsthistorisches Museum. Like his other portraits of the emperor it is full length, a format that had not yet been adopted in Italy and that Titian would not use for another decade. Charles wears the same court dress with the collar of the Golden Fleece around his neck, and is accompanied by the same adoring hunting hound that Sanudo had seen at Bassano. The Seisenegger would be of no special interest to students of Titian were it not for the existence of a nearly identical but more Italianate copy of it (Madrid, Prado). Unlike the portrait in armour, which was listed in an inventory of Charles's possessions, there is no record of the copy of the Seisenegger before it was discovered in Philip's wardrobe in 1600, two years after his death. Although it could theoretically have been painted at any time before that date, the Prado has never questioned its attribution to Titian, and the majority of Titian scholars remain convinced that

Titian took it from the Seisenegger at the emperor's request as a gift for Ferdinand. (Another theory is that the Prado portrait is the original by Titian and the Vienna portrait by Seisenegger is the copy.) Since there is no evidence about the relationship between the two portraits apart from the obvious fact that one must have been based on the other, we are free to ask ourselves, despite the weight of authoritative opinion in favour of the attribution to Titian, why Charles would have asked Titian to copy a portrait by another artist when he was willing and available to sit for Titian in person. Whatever one may think of the quality of the Prado painting, the vague and lifeless features of the emperor do not correspond to the other well-characterized portraits Titian was painting around the same time.[9]

Titian was so overwhelmed with business at Bologna that he scarcely had time to snatch a meal. Although never good at meeting deadlines, even he could not prevaricate over a portrait of the emperor; and once he had finished it he was besieged by requests from members of the imperial entourage for replicas of it or for portraits of themselves. His practice of keeping records of original paintings in the studio from which assistants could turn out replicas or variants accelerated to meet the demand. The emperor's powerful chancellor, Nicolas Perrenot de Granvelle, commissioned a portrait, possibly of himself or of the emperor. Cobos wanted one of the emperor as well as a Lucretia. Vasari and Ridolfi say that Titian also portrayed at Bologna Antonio de Leyva, the Spanish general whom Charles later appointed governor of Milan. Sadly, there is no trace of the portrait of Leyva, and the others Titian painted at Bologna are also lost.

We don't know exactly when Titian painted his magnificent *Portrait of Alfonso d'Avalos, Marquis of Vasto* (Los Angeles, J. Paul Getty Museum).[10] It may have been at Bologna, or in the previous year when d'Avalos wrote to Aretino to say that he would reward him if he could persuade Titian to visit him at his castle in Correggio. D'Avalos was in many ways a repulsive man: arrogant, bad tempered, ruthlessly ambitious, cruel, foppish and excessively fond of using perfumes with

which he scented his saddles and his letters. But he was also highly cultivated, a poet and author of a volume in Latin about his military exploits, as well as a connoisseur and patron of the visual arts. Ariosto called him the great saviour of Italy.[11] Aretino, who relied on d'Avalos to pay his imperial pension, usually praised him immoderately, but when the marquis failed to deliver the pension on time he ridiculed his effeminate habits. Charles V, impressed by his performance at the Battle of Pavia where he had captured Francis I, had made him captain general of the imperial infantry in northern Italy. Titian portrayed him in an exquisite suit of armour inlaid with gold, very like that worn by the emperor for his portrait, with the collar of the Golden Fleece around his neck and a little page or dwarf gazing up at him awestruck from the bottom left corner.

While Titian was working flat out to satisfy demands for paintings from the emperor and his entourage, he was also involved indirectly in the long-standing struggle between the papacy and his curmudgeonly old patron Alfonso d'Este, Duke of Ferrara, for possession of Modena and Reggio. Although the emperor had incurred Pope Clement's wrath by granting the contested cities to the Este, they were still occupied by imperial garrisons. Early in January 1533 Alfonso, who knew that the emperor would be guided in all Italian matters by Francisco de los Cobos, sent Matteo Casella, one of his agents in Bologna, a list of paintings in the Este collection from which Cobos was to be offered a free selection. The delighted Cobos consulted Titian, who recommended three paintings, a Judith, a St Michael and a Madonna, none of them, as far as we know, by his own hand,[12] and a portrait, now lost, of Alfonso's son and heir Ercole that Titian had painted in Ferrara. Cobos asked that the paintings be dispatched directly from Ferrara to his agent in Genoa for shipping to Spain.

Titian then made a small tactical mistake. He recommended as a fine example of his own work the portrait he had painted in the 1520s of Alfonso with his hand resting on a cannon. It had not been on Alfonso's original list, probably because it showed him wearing the French Order of St Michael, and his agents for that reason did what

they could to dissuade Cobos, saying it was an old likeness. Cobos persisted and gave instructions that the portrait should be sent to Bologna. After a delay, during which Alfonso may have had the badge of St Michael erased, the portrait arrived; and Cobos immediately made a present of it to Charles. On 15 February Casella wrote to Alfonso that Cobos had told him it was already hanging in the emperor's rooms in Bologna and that he wondered what the pope would have to say if he knew. Casella, so he wrote in the letter, had replied that the pope would certainly not be pleased to have the features of his rival, His Excellency the Duke, engraved upon the heart of His Majesty.[13]

The conference at Bologna was not to be the historical landmark the emperor had hoped for. He and the pope agreed to raise a fleet against Barbarossa in the Mediterranean, but also to postpone discussions about the calling of a General Council of the Church. For Titian, however, Bologna was the most fruitful event in his career up to that time. It marked the beginning of a warm friendship with the most powerful ruler in the world that would send mild shockwaves throughout Europe and lead to at least eighty-five commissions from the Habsburg family and entourage.[14] The story Ridolfi told about the emperor stooping to pick up Titian's paintbrush may not be literally true, but nor is it merely one of the legends – Leonardo da Vinci dying in the arms of Francis I or the emperor Maximilian holding Dürer's ladder – that Renaissance apologists invented to promote the idea of the artist as the equal of his aristocratic patrons. Whatever it was about Titian that captivated his other high-born patrons – his self-possessed, gentlemanly manner, his way of showing respect without grovelling, his refreshing lack of an agenda beyond his art and the rewards he knew it deserved, his intelligence, his sense of humour and not least his magician-like genius for conferring immortality on his sitters – it was not lost on Charles V.

Before leaving for Genoa on 28 February the emperor conferred a knighthood on Titian and invited him to his court in Spain. The patent, which is dated 10 May 1533, was sent to Titian from Barcelona,

and is still preserved in the museum in Cadore. It gives Titian the power to appoint notaries and ordinary judges, and to legitimize children born out of wedlock. His own children are raised to the rank of Nobles of the Empire. Titian is described in the document as 'the Apelles of this century', and Charles as following the example of Alexander the Great, who would be painted only by Apelles. The tribute was by then something of a cliché, and the knighthood was not, as imperial honours went, a particularly exalted one, although later in life Titian exercised his powers to appoint attorneys and legitimize bastards. He did not however use the title in letters and only occasionally signed his paintings 'EQVES', knight.

Although no doubt gratified by the emperor's admiration and patronage and the effect it would have on other noble patrons, Titian had no intention of accepting his invitation to Spain, a country that was regarded by Italians as backward and brutal, with bad roads, no proper cities and such a small mercantile and artisan class that it relied on immigrants. Madrid, a dusty provincial town with a population of no more than 4,000, was not an attractive destination for any sophisticated Venetian, let alone one as busy as Titian. And so when in August Charles's ambassador in Venice, Lope de Soria, formally requested a licence for Titian to visit Spain in order to paint the emperor and his wife, Titian persuaded the doge to cover for him with the bogus excuse that his presence was required in Venice while he finished painting 'certain rooms' in the ducal palace. But Charles persisted with his invitations. Lope de Soria reminded the doge that there were plenty of other painters in Venice who could just as easily do the work in the palace. But Titian continued to prevaricate.

He was more interested in investing the money he had earned in Bologna; and as soon as he returned to Venice in March he made enquiries about the farmland near Treviso belonging to the monks of San Giorgio Maggiore for which he had been negotiating on and off with Federico Gonzaga's help for four years. At the end of April he wrote to Federico to say that now that, thanks to him, he had sufficient funds to pay the asking price of twenty-five ducats per field he had discovered that it had risen to thirty-three. He hoped the duke

would intervene on his behalf with those 'oafish and poltroonish priests'. By December, however, the Council of Ten, which had the ultimate authority over Church land in the Republic, had entered the picture. It announced a public auction of the fields with a reserve price of seventy-five ducats per field. The proceeds, as Titian and Federico learned only later, were intended to pay one of the procurators, Andrea Tiepolo, compensation for a group of houses he owned on the island of San Giorgio Maggiore which were blocking the view of the church. The Treviso farmland now became the subject of an imbroglio involving the doge, who supported the decision of the Council of Ten, as did the abbots of Santa Maria del Pero and of San Giorgio, while four of Federico's agents, Benedetto Agnello, his predecessor Giacomo Malatesta, Count Nicola Maffei and Gian Giacomo Calandra, supported Titian's claim. Titian encouraged Maffei by painting for him his beautiful *Supper at Emmaus* now in the Louvre and had his studio make a copy of his Magdalen for Calandra. But by May of 1534 all their attempts to acquire the land for Titian had failed.[15]

Titian, who was left with a substantial amount of ready money on his hands, decided to make up for the loss of the farmland by expanding the family timber business. At the end of September he sent Francesco to Vienna to negotiate with Ferdinand of Austria for rights to cut timber in Botestagno, a castle in the Tyrol just across the Austrian frontier from Cadore on the Boite River. The planks would be floated downriver to the Vecellio sawmills at Perarola where the Boite joins the Piave, and then on down to the timber yards at San Francesco della Vigna. When, on 16 October Ferdinand granted the brothers a concession to export enough timber to make 1,000 planks over the next five years, Titian rewarded him with the promise of portraits of the emperor, the empress and Prince Philip. But Francesco's absence in Austria had also served as yet another excuse for Titian to reject the emperor's pressing invitations to Spain, this time on the grounds that he could not possibly leave the studio in the absence of his brother, who always took his place when Titian was away from Venice. Nevertheless, he did pay a short visit to Cadore

where he had bribed the council with a generous loan to allow him to use its timber yards in Venice at San Francesco della Vigna for his own imported wood, and to seek planning permission to enclose the site and erect sheds on it to protect the timber, something it had done several times without success. The application, however, was unsuccessful, as would be Titian's repeated attempts over the next decades to persuade the Council of Pieve to obtain the necessary permission.

While Titian was attending to the details of business affairs in Cadore, orders for paintings were piling up in the studio in Biri Grande. Even before taking on the raft of commissions from Charles V's entourage at Bologna, he had been working for two other aristocrats: the firebrand warrior Cardinal Ippolito de' Medici, for whom he painted one of the sexiest nudes in sixteenth-century painting; and the peace-loving commander in chief of the Venetian army, Francesco Maria della Rovere, Duke of Urbino, who was to become an important patron. There were also demanding commissions from Federico Gonzaga and from the Venetian Scuola della Carità. So when in March 1535 Lope de Soria issued another invitation on behalf of the emperor to meet him, this time in Italy where he was expected shortly to launch a conquest of Tunis, which had been occupied by Barbarossa,[16] the ambassador reported to Charles V that he remained very doubtful about Titian's departure, 'since I see him so attached to this Venice of his, which he loves and whose praises he is always singing to me ...'.

FOUR

The Venus of Urbino

As for Titian's Venus – Sappho and Anactoria in one – four lazy
fingers buried dans les fleurs de son jardin – how any creature can
be decently virtuous within thirty square miles of it passes my
comprehension. I think with her Tannhäuser need not have been
bored – even till the end of the world: but who knows?

CHARLES ALGERNON SWINBURNE, FROM A LETTER
TO LORD HOUGHTON, 31 MARCH 1864

Cardinal Ippolito de' Medici, the bastard son of Giuliano de' Medici,
Duke of Nemours, was twenty-one when he posed for Titian in Venice
in October 1532,[1] 'looking', as a nineteenth-century writer put it,
'through those he saw, till you turned away from his glance'.[2] He
dressed for his portrait (Florence, Galleria Palatina) as a Magyar: belted
ruby velvet tunic and plumed cap, grasping a mace in one hand and in
the other a scimitar given him by his Hungarian captains. Sanudo, who
followed Ippolito closely while he was in Venice, described him wear-
ing the same or a similar hat with a large feather as he went about the
city 'incognito'. The clasp on the cap bears the motto of the beautiful
and pious widow Giulia Gonzaga, Countess of Fondi, who was the love
of his life. Titian's portrait is so vividly characterized, despite the lack
of detail on the tunic, that one wishes that his other portrait of Ippolito,
in armour, also painted during his Venetian sojourn, had survived.

A swaggering, spoiled, restless young hell-raiser, who refused to
behave or dress like a priest, Ippolito had been installed at the age of

337

eleven along with his cousin Alessandro de' Medici, who was the same age and also illegitimate, as joint leader of Florence and caretaker of the Medici family interests after their cousin Giulio de' Medici was called to Rome as Pope Clement VII in 1523. Clement had given Ippolito his red hat in 1529, two years before he sat to Titian, but the unwilling cardinal was bitterly disappointed when the pope and emperor passed him over in favour of Alessandro (who was said to be the pope's illegitimate son, conceived before he had been made a cardinal) as Duke of Florence and the emperor secured Alessandro's position by arranging his marriage to his natural daughter Margaret. Ippolito asked to be released from holy orders in order to become the martial leader of the Florentine exiles, but Clement deflected him by sending him as papal legate to the armies assembling under the command of Charles V to defend Vienna from Suleiman's attack.

Ippolito arrived in Germany, 'dressed', according to one Venetian ambassador, 'like Jupiter', but, disappointed to find no action at Vienna after the retreat of the sultan, he broke ranks with the emperor's forces. On the way home his Italian troops mutinied and went on a plundering spree that Ippolito did nothing to contain and with which he may indeed have connived. Charles V had him imprisoned but only briefly. It would have been impolitic to hold captive a prince of the Church who was also a relative of the pope with whom he was shortly to confer about important matters at Bologna. So Ippolito crossed the Alps into Italy, where he was invited by the Venetian government to spend some time, officially incognito, in Venice before proceeding to the papal–imperial conference at Bologna.

Ippolito de' Medici was a good friend of Aretino, whom he had known in Rome and who may have suggested to Titian that he should meet the cardinal at Treviso when he arrived there on 16 October 1532 with a view to painting his portrait. Since the cardinal was in charge of a bureaucratic office in the Curia, he might also be persuaded to arrange a church living for Pomponio. Three days later Benedetto Agnello wrote to Gian Giacomo Calandra that Titian had spent a night in Treviso lodging in the same room with the servants of the imperial ambassador there. They had all caught the plague and

Titian was terrified that he might have been infected. But the risk turned out to be worth taking. A hypochondriac at the best of times and often afflicted by minor illnesses, Titian had been exposed to plagues so often in his life that he must have been immunized by then.

Although his court was reputedly more like a seraglio, Ippolito could be discerning in his choice of women. The beauty of his greatest love, Giulia Gonzaga, was celebrated by Ariosto and Bernardo Tasso as well as in portraits by Sebastiano and Raphael and was so famous that Barbarossa tried to capture her as a gift for his sultan Suleiman. Ippolito's list of more casual amorous adventures included an affair with Tullia d'Aragona, the reigning courtesan in Rome, to whom he dedicated a sonnet praising her golden hair, her sweetness and her attractive laugh. In Venice the obvious choice was Angela del Moro, known as Zaffetta, the most charming (and the second-highest-priced) courtesan in the city and a friend and dining companion of Titian and Aretino. Angela, who was no more than eighteen at the time of Ippolito's visit, was the daughter of a policeman, a *zaffo*, hence her professional name. She later inspired a poem, *The Thirty-One of Angela Zaffetta*,[3] in which the writer claimed that he had punished her for jilting him by taking her to Chioggia – he dated the event 6 April 1531 – where he invited a gang of fishermen to rape her. Aretino, who later wrote that Angela had retained her beauty even after she was thirty, gave her the palm in a letter praising her for 'putting a mask of decency on the face of lust' and for not resorting to feigned orgasms: 'You embrace virtue and honour men of virtue, which is alien to the habits and nature of those who sell themselves for the pleasure of others.'[4]

Sanudo tells us that Ippolito spent the night of 20 October with this paragon among courtesans. The following morning he visited the arsenal. But in the afternoon after dinner, the main meal of the day taken in the early afternoon, he managed to shake off the obsessive diarist for a few hours and was late for an appointment in the palace with the doge. The inclement weather on that day provided him with an excuse.

We see the face of the irresistible, laughing, honourable courtesan in Titian's painting known – the title is not strictly accurate – as the *Venus of Urbino* (Florence, Uffizi).[5] At this stage of his career Titian did not often paint without a commission, but it is likely that he guessed (or that Aretino advised him) that a sexy nude that was also a souvenir of his night with Angela would appeal to the young and libidinous cardinal and might serve as a gift that would open the way to a benefice for Pomponio. He may have set the painting in her house; the most successful Venetian courtesans, known as *cortegiane oneste*, lived in a high style indistinguishable from rich patrician women, and it was said that Angela earned so much that she wanted to buy Palazzo Loredan, then as now one of the grandest in the city. But it is tempting to speculate that he posed her (or more probably a model that stood in for her body) in his own house in Biri Grande, which had biforate windows like the one in the background and among its furnishings a cloth,[6] like the one that bisects the composition at precisely the point where the reclining woman fondles her pudenda with her ringed left hand. The little Papillon spaniel was a breed that was fashionable at the time and that appears again with slightly different markings in several of Titian's other paintings.[7] The lovely slender body of the girl is a more relaxed, realistic and womanly derivative of the Dresden *Sleeping Venus* of two decades earlier. But here she is wide awake as she stares out at the viewer, like the little satyr in the centre of Titian's *Bacchus and Ariadne*, inviting us to enjoy what we see or challenging us to be as shocked as Mark Twain famously was when after seeing her in the Uffizi in 1880 he described her as 'the foulest, the vilest, the obscenest picture the world possesses'.[8]

The so-called *Venus of Urbino* (it was only briefly in Urbino and whether or not it represents Venus is debatable) is the first of the nudes that Titian would paint in the course of his subsequent career for princely, ecclesiastical and aristocratic patrons. As we see it today it has been so dimmed and flattened by excessive restoration that it looks better in reproduction.[9] Nevertheless, it remains one of Titian's most popular, written about, copied and controversial paintings.[10] Scholars are divided about whether or not it represents something

more than a pretty naked girl lying on a bed. Some insist that she must be Venus, whose principal attribute is her nudity, and who is further identified by the red roses she clutches in her left hand and the pot of myrtle on the windowsill.[11] Others say she is nothing more or less than a pin-up. Some see the two maids unpacking clothes from one of the two chests in the background as proof that it is a marriage painting because such chests and their contents were often part of a woman's dowry, while others prefer to interpret that little scene as referring to the secular, domestic atmosphere of the house of a rich courtesan. Another interpretation would have it that she is not a goddess or a bride but a parody or ironic spoof, an intentional travesty of the by then anachronistic classical ancestry of the pudica gesture, the drawing attention while pretending to conceal.

Crowe and Cavalcaselle doubted that the lithe and slender woman 'lying as nature shaped her, with her legs entwined' represented anything more or less than youth and beauty 'not transfigured into ineffable noblesse, but conscious and triumphant without loss of modesty'. Édouard Manet evidently had no illusions about her status as a poule de luxe when he paid homage to her with his *Olympia* painted in 1863. And there is a growing number of scholars today who would prefer us to take the *Venus of Urbino* for what it appears to be: a ruined painting of a seductive young woman whose nudity has lost the power to shock in an age when explicitly erotic images are a dime a dozen, but which continues to fascinate nevertheless because of the way it is painted and composed.

She was still in Titian's studio on 20 December 1534 when he wrote – in his own hand but perhaps prompted by Aretino – to Ippolito de' Medici's chamberlain, a certain Messer Vendramo who, judging from the informal and gossipy letter, was one of his close acquaintances in the cardinal's court. Titian asks Vendramo to apologize to the cardinal for his failure to keep a promise to visit him in Rome. He never tires of praising the greatness of Ippolito, nor does Aretino, 'who speaks of His Most Illustrious Lord as he would speak of Christ'. He regrets that their mutual friend Benedetto (presumably another member of the court) will be sorry to learn that his Marcholina has been fucking

around a bit (*se fa un pocho foter*) and got herself pregnant. He sends news of Pomponio and Orazio (this is the first mention in writing that we have of Orazio), who 'are well and learning and grown big, and I hope that with the grace of God and of my patrons they will become proper gentlemen'.

The reason he hasn't come to Rome is that he has been finishing a painting of a woman for Ippolito, which he is certain would have pleased him and will please him. But now he has received a visit from the Most Reverend Lorraine – Cardinal Jean de Lorraine was a powerful official in the court of Francis I – who asked him, in imitation of the Most Illustrious Medici, to paint his portrait.[12]

> … [Cardinal Lorraine] has seen this painting of a woman and he liked
> it so much that he said he must have it at all costs. However, after I told
> him that it was for Cardinal Medici he calmed down. He said the Most
> Illustrious Medici loved him and begged me to do a similar one before
> I send the one for your Lord … And in any case I will serve both of you
> and as soon as I've made the copy I will send it to you …[13]

Neither Ippolito de' Medici nor Jean de Lorraine ever returned to Venice to collect their paintings. Lorraine, who lived until 1550 and occupied a series of important and demanding positions under Francis I where he was in charge of immense revenues, may have been too busy. Ippolito was dead before Titian could send him his 'woman'. In August 1534 news had reached him of Barbarossa's plot to lay siege to Fondi in order to capture Giulia Gonzaga for Suleiman's harem. Ippolito, commanding an army of 5,000 men, put the pirate king to flight while she took refuge in her castle. But he died the following August at Fondi, close to Giulia and with Vendramo by his bedside, poisoned so the rumour went by a former servant employed by his rival Alessandro. Historians say the rumour was probably untrue, even though Ippolito had taken command of the Florentines in exile and tried to persuade Charles V to expel the tyrannous Duke Alessandro and replace him with himself. He had also tried to blow his cousin up with an infernal machine placed beneath his bed.

Alessandro was in fact murdered by a different jealous rival the following year.

Titian used Angela Zaffetta's face for three more paintings of women with different bodies in different stages of dress and undress. Although he may well have been familiar with Pliny's famous story about the naked and clothed Aphrodite sculpted by Praxiteles, it would hardly have required a classical reference for Titian, any more than for the editors of *Playboy* magazine, to appreciate the erotic stimulus of seeing the same woman clothed, half clothed and naked. And so he dressed her, perhaps in the clothes her maids are unpacking while she lies naked and freshly bathed on her couch flirting with her admirers. First he put her in a lavish, elegant and very proper blue court dress with a paternoster round her neck – rosaries of gemstones worn as necklaces, much in vogue at the time, were popular with noblewomen and with prostitutes competing with their social superiors.

Francesco Maria della Rovere, Duke of Urbino, on a visit to Titian's studio in January 1536 to make preliminary arrangements for portraits of himself and his consort Eleonora Gonzaga della Rovere, saw the painting of Angela in blue before it was finished. Judging from his subsequent correspondence with his Venetian agent Gian Giacomo Leonardi about the delivery of the painting now known as *La Bella* (Florence, Galleria Palatina) he was more interested in the dress, which is painted in precious lapis lazuli, and in possessing a painting by Titian than in the woman's identity. If he noticed that his pretty girl in blue had the same face as the naked woman he must also have seen in Titian's studio he seems not to have mentioned the resemblance. In a letter to Leonardi dated 2 May he says he wants Titian to finish 'that picture of that woman in a blue dress' and to do it beautifully and provide a protective cover so he can judge how the 'other paintings' – the portrait of himself and a Resurrection for Eleonora, which was never painted – will turn out. When Titian, dilatory as usual, had not dispatched his by then anonymous beauty by 10 July, the duke prompted him again to finish the painting of the woman. Before letting her go Titian made a replica of

her, which X-rays have detected beneath the *Woman in a Fur Cloak* (Vienna, Kunsthistorisches Museum) in which he stripped off her proper dress, exposed one of her breasts and changed her facial expression and the position of her arms.[14] The third, weaker and now half-ruined version, the *Woman in a Feathered Hat* (St Petersburg, Hermitage), seems to be a variant of the Vienna picture, possibly painted with studio assistance, to which he added the feathered hat as an afterthought.

We hear nothing more about the *Venus of Urbino* until late January 1538 when the Duke of Urbino's son and heir, the twenty-four-year-old Guidobaldo II della Rovere, arrived in Venice for a month's stay with his mother Eleonora. A soldier like his father, Guidobaldo had become a duke in his own right three years earlier on his marriage to the ten-year-old Giulia Varano, daughter of the late Duke of Camerino, who had left no male heir. The papacy had long since claimed lordship of Urbino, the imposing hill town that stands 160 kilometres south of Venice, and Camerino, a neighbouring duchy to the southwest on a spur of the Apennines, both of which were surrounded by the Papal States. The pope was therefore infuriated by a marriage that created an independent duchy large enough to threaten his own territory, which is why Guidobaldo had to travel to Venice through the Papal States secretly in defiance of an interdict. He saw the painting in Titian's studio while sitting for his portrait in armour (lost), and like Cardinal Lorraine before him was struck by a passionate desire to possess her. On 9 March he wrote to Leonardi from Camerino that he was sending a servant to collect Titian's portrait of himself and the painting of 'the naked woman' and requesting him to induce Titian to let the pictures go before being paid for them. Meanwhile Leonardi should pay for the frames he had already ordered for the pictures. His servant would stay in Venice until the pictures were ready. On 11 April Eleonora wrote from Venice to her son to say that she had come by some money and would pay Titian for the portrait and its frame, which were sent to Camerino three days later. But by 1 May Guidobaldo was fretting that Titian might sell the naked woman to another buyer: if necessary he would mortgage some of his

possessions in order to meet Titian's price. Leonardi replied that Titian had said he would gladly keep the picture for Guidobaldo, who did eventually acquire it.

Guidobaldo's father Francesco Maria I della Rovere, Duke of Urbino and lord of Pesaro, was a mercenary soldier best remembered by historians for his failure to prevent the Sack of Rome by repeatedly neglecting to take action against the imperial forces as they descended on the Holy City. He had inherited the Duchy of Urbino when he was eighteen in 1508 from his maternal uncle Guidobaldo da Montefeltro, who had died childless, and with the support of his paternal uncle the della Rovere pope Julius II, for whom he had fought bravely against Venice in the Cambrai war. Driven out of his duchy by Leo X, who gave Pesaro and Urbino to his nephew Lorenzo II de' Medici, he returned to his duchy only after Leo's death in 1521, and moved the capital to Pesaro in 1536. Admirers of Titian know him from his magnificent portrait in polished armour. He holds the baton of his command of the Venetian land forces, a position to which Andrea Gritti had appointed him in 1523. The two batons propped on the wall behind him refer to his service to Julius II and to Florence. Between them is an oak (*rovere*) branch with a scroll bearing his motto 'SE SIBI' (By himself alone). There is no irony in the apparent contradiction between the duke's hyper-cautious approach to engaging in combat – Sanudo called him *pede plumbeo*, lead foot – and Titian's portrayal of him as a heroic career warrior. He was personally brave – and had a warrior's violent temperament. But, unusually for his times, he was experienced and wise enough to know that armed combat was best avoided unless absolutely necessary because, as Sanudo reported him saying, 'the outcome of battle is always uncertain'. It was an idiosyncratic philosophy for a soldier, but one that suited the Venetian government at a time when it was determined to maintain its position of neutrality and never again to risk losing the territories it had regained at the end of the Cambrai war by aggravating potential enemies. The Duke of Urbino was the most trusted Venetian commander of the century, his contract with the Republic was repeatedly renewed, and the government, which accepted that its

commander would have to spend some of his time in his duchy, provided him with a fast cutter in which to travel back and forth, a house at Santa Fosca and a villa on Murano which was a magnet for Venetian intellectuals and writers, including of course Aretino.

Francesco Maria could hardly have failed to be something of a connoisseur of the arts. He had been brought up in Senigallia and at the court of Urbino, a centre of learning and the arts since the fifteenth century, and the setting of Castiglione's *Courtier* in which the author described the town as 'the fairest in all Italy', decked out with 'a wondrous number of ancient images, of marble and metal, very excellent paintings and instruments of music of all sorts'. His formidable mother, Giovanna da Montefeltro, had seen to it that his education was broadened at the court of the French king Louis XII. And he became the son-in-law of Isabella d'Este and brother-in-law of Federico Gonzaga, two of the most avid and sophisticated collectors of the Italian Renaissance. Nevertheless, it took him some years to appreciate Titian's talent to the full. At first he had commissioned only small religious works and portraits from him, and he was a more dictatorial and less original patron than Federico.

After he was introduced to Titian by the architect Sebastiano Serlio at Federico's court in the summer of 1532 he had ordered a *Nativity* (possibly the ruined painting in the Florence Galleria Palatina),[15] the *Bust of Christ* also in the Palatina, and a Hannibal that is now lost. Titian was required to base the *Bust of Christ*[16] on a Flemish or Italian prototype, which was sent specially to Venice by the hand of the architect Sebastiano Serlio. The *Nativity* was to be a gift to Eleonora, for whom the subject had a special meaning because she was expecting a child, but by October 1533, six months after the birth of her son Giulio (the future Cardinal della Rovere), the duke was complaining that while Federico had a lot of paintings by Titian he still didn't have a single one. The *Nativity* finally reached Urbino a month later, and the *Bust of Christ* and Hannibal the following March.

The portraits of the Duke and Duchess of Urbino were the only masterpieces Titian painted for the duke. Francesco Maria cared enough about his portrait (Florence, Uffizi) to postpone a tour of

inspection of fortresses on the mainland in order to do Titian the honour of sitting for him in person before leaving Venice on 2 May 1536, an opportunity that may account for the strongly characterized face and head. The armour, which Titian painted at his leisure later in the summer, was taken from the duke's best cuirass, a very valuable object, which he left on loan in Titian's studio for as long as the artist required it but made a fuss through Leonardi that it must not under any circumstances be damaged and should be carefully packed when the artist was ready to return it.[17]

Francesco Maria's marriage to the beautiful and accomplished Eleonora Gonzaga in 1509 was one of those arranged matches that turned out to be fortunate in every way. Castiglione, who helped negotiate the contract, praised Eleonora's 'wisdom, grace, beauty, genius, courtesy, gentleness and refined manners' as 'a chain adorning her every movement'. The duke certainly had good reason to be fond and proud of her. She administered his estates so wisely and success-fully during his long absences that she was mourned by her subjects as 'the good duchess' when she died in 1550. Eleonora initiated the idea of her portrait in January 1536 when she asked Titian to paint her if he passed through Pesaro. The portrait (Florence, Uffizi), painted as a pendant to the duke's when she was in her mid-forties – Titian gives her flawless skin but an incipient double chin – looks like a testament to her husband's lifelong affection for her. Although there was a precedent for paired portraits of husband and wife in Piero della Francesca's diptych of a previous Duke and Duchess of Urbino, Federico da Montefeltro and his consort Battista Sforza, they were a rarity in Renaissance Italy. Titian took advantage of the unusual opportunity to contrast their roles and characters. While the duke, the choleric man of action, stands, his duchess sits[18] calmly in charge of the well-ordered landscape we see through the aperture behind her. He is stocky, tanned and bearded. She, pale, slender, wearing an elabo-rate dress that we can still recognize as the height of fashion, is given attributes that seem to echo Castiglione's praise of her virtues: a clock representing temperance, the obelisk in the landscape the wisdom of her governance, the little white and tan spaniel fidelity.

The portraits of the duke and duchess arrived at Pesaro in the spring of 1538. Unfortunately, the duke had only months to enjoy them before he succumbed to an illness – he may have been poisoned like so many of his contemporaries by a jealous rival – and died in agony on 22 October. Aretino, who had dedicated the first volume of his letters to the Duke of Urbino, wrote his obituary in the form of a long poem in *terza rima*, beginning:

> Oh Caesar, he is dead, the faithful duke
> Of whom the esteem and the honour
> Will live for ever in the common outcry.

Shortly before Francesco Maria's death Titian had begun work on three portraits for his private gallery of contemporary rulers: a copy or variant of the portrait of Charles V in armour originally painted at Bologna, a portrait of Francis I and one of his portraits of Suleiman the Magnificent (he had seen neither of the last two in the flesh).[19] The only one of these that has survived is the *Portrait of Francis I*, which is probably the one now in the Louvre,[20] although there is a nearly identical one in a private collection in Lausanne that could be the original or a copy.[21] There is a striking although certainly unintentional contrast between this portrait of the dashing, extrovert, unscrupulous, smiling French king whom Titian never met and those he painted of Francis's arch-enemy, the shy, earnest, ugly Charles V. The portrait of Francis was still in Titian's possession in November 1539 – Guidobaldo seems to have had difficulty in finding the money to pay for it – but reached Pesaro some time afterwards. We know from a letter from Benedetto Agnello to Federico Gonzaga written on 23 August 1538 that Titian had nearly completed a portrait of Suleiman based on a medal and a previous portrait. The copy for Francesco Maria was delivered to Guidobaldo the following year.

After his father's death Guidobaldo continued to entertain a mix of literati and patricians in his house in Venice where Aretino, who had become a close friend, was a regular guest. The new Duke of Urbino was given an increased personal command but was not offered a

higher rank until 1546 when he was appointed governor general (not captain let alone commander) of the land forces with a very restrictive contract. The portrait of his wife, Giulia Varano (Florence, Pitti Appartamenti), which is sometimes attributed to Titian's studio, is more likely to have been painted in Urbino or Pesaro by another hand on the basis of Titian's *Portrait of Eleonara Gonzaga* whose pose it repeats exactly. But Guidobaldo remained an affectionate friend and patron of Titian until his death in 1574.

Vasari (who was vague about the della Rovere pictures) probably did not have the opportunity to meet the ageing Guidobaldo or see his paintings when he was in Pesaro in 1563. Later in his 'Life of Titian', however, he described the painting we now know as the *Venus of Urbino* as portraying 'a young reclining Venus'.[22] But in all other descriptions and inventories of the collection she is described merely as a naked woman. In one account made in 1631 when the painting was briefly in Urbino before being moved to Florence,[23] the author refers to it as 'a big picture with a reclining naked woman' and further down the document mentions *La Bella* as 'a portrait of the previously mentioned naked woman, but dressed and more than half length by the hand of Titian'. Nevertheless, by the end of the century a less observant compiler of an inventory described *La Bella* as a young princess. Perhaps it was around the same time that the nudity of Ippolito de' Medici's painting of a Venetian courtesan whose identity had been long forgotten was excused by turning her into the goddess Venus, but whose depiction, whether courtesan or goddess, remains one of the most charming and arousing of all Titian's nudes.

The Roman Emperors

Titian is loved by the world for the life his brush gives to
images of people, and hated by nature because he shames living
senses with artifice.

PIETRO ARETINO IN THE DEDICATION TO THE
EMPRESS ISABELLA OF HIS *POEMS IN HONOUR OF
ANGELA SIRENA*, 1537

Pope Clement VII died on 15 September 1534, and a month later his
chosen successor, Cardinal Alessandro Farnese, was raised to the papal
throne as Paul III at the age of sixty-seven. In the remaining fifteen
years of his life Paul would prove himself to be the ablest and most
effective of Renaissance popes. Shortly after his election the physician,
historian and patron of the arts Paolo Giovio, who had been the doctor
of Julius II and Clement VII but had not yet met his new patient and
was unsure what to expect, declared that with each passing day he
found the pope 'more humane, more courteous, more learned, more
lofty of concept, more Christian, and more just'.[1] The portraits Titian
would paint of him in the 1540s probe deeper into the complex char-
acter of a subtle, learned, decisive politician, who used his extended
family – he had fathered at least four bastard children by the time he
ascended the papal throne – to further worldly ambitions that were
extraordinary even by the standards of the day and whose sincere advo-
cacy of Church reform led to the General Council of the Church that
finally sat for the first time at Trent in 1545 four years before his death.

Titian's involvement with the Farnese pope and his family was still in the future, however, when an important chapter in his career closed a fortnight after Paul's election. On 31 October 1534 Alfonso d'Este died suddenly from indigestion caused, so his doctors said, by excessive consumption of crayfish. Alfonso's son Ercole II, who was twenty-six when he inherited the Dukedom of Ferrara, was perhaps inevitably a very different character from his rough-mannered and bellicose father. Alfonso had compensated for the deficits in his own formal education by ensuring that the boy received the best possible tuition in the humanities and music. But although Ferrara under Ercole's rule remained a centre of fashion, culture and the arts, he was not a gifted governor. He inherited a treasury exhausted by Alfonso's wars and, to avoid conflict, ruled Ferrara as a feudatory vassal of the pope, and Modena and Reggio at the pleasure of the emperor. He was marginalized at court by the more powerful personality of his wife Renée, daughter of the late French king Louis XII, whose first allegiance was to her native country and who surrounded herself with Protestant heretics whose presence offended Ercole's orthodox Catholic beliefs and endangered his relations with the pope.

Soon after inheriting the duchy Ercole commissioned Titian to finish the copy of the portrait of his father that had been taken away to Spain by Francisco de los Cobos. The French Order of St Michael, which Alfonso had had erased from the original so as not to offend the emperor with any indication of his Francophilia, was sent to Tebaldi with instructions, no doubt originating with Renée, that Titian should reproduce it in the copy. Titian received a down payment of fifty ducats on 20 July 1536, but although Tebaldi reported in December that the portrait was finished, as like its subject 'as water to water', and so beautiful that he wondered that His Excellency hadn't sent for it, Ercole waited to see it until he happened to be in Venice in January 1537, when he expressed his admiration and paid Titian a further 200 ducats.[2] According to Aretino, Ercole also presented Titian with a silver vase, which must have been valuable because Titian told him he had never been so well paid for a portrait. Nevertheless, although he honoured a last wish of his father, Ercole preferred Pordenone, who

was known to be more reliable than Titian and was briefly in vogue in Venice when Ercole requested Tebaldi to invite him to Ferrara in December 1538. Although Pordenone died within a month of his arrival there, Ercole never again asked Titian to paint for him.

In 1534, the year that had marked the accession of Paul III and the death of Alfonso d'Este, Federico Gonzaga[3] did not request a painting for himself from Titian and when in September Titian tried to capture his attention with the offer of a pleasing kitten lynx he turned it down with thanks for the thought. Federico was preoccupied by challenges to his right by marriage to the Marquisate of Montferrat, which was contested by neighbouring rulers, and by the citizens of Casale who staged a rebellion against the presumptive foreign duke. But Titian was never entirely absent from Federico's schemes. In February of that year – when Titian's attempts to purchase the farmland near Treviso were still in play – the duke asked his favourite painter on behalf of his brother Ferrante, then a captain of the imperial army, for a Rape of Proserpine and another picture to be sent as gifts to a Spanish official, presumably as a bribe for support with the investiture.[4]

Titian was also working at the time on an independent order from Federico's mother Isabella, who turned sixty that year and had requested a portrait of herself as she had looked – or would have liked to have looked – as a young woman. Isabella had never been a beauty, although Aretino was doubtless exaggerating when he described her at sixty, in a *pronostico* that was circulated in manuscript but never published, as 'indecently ugly', her heavy makeup as 'positively inde-cent', her teeth made of ebony and her eyelashes of ivory. The Scourge of Princes was out of favour in Mantua and probably also aware that Federico was not on the best of terms with his mother. But judging from Rubens's copy of Titian's earlier portrait of her in red – and allowing for Rubens's preference for fleshy women – she had grown positively obese in her old age. Isabella nevertheless had always been extremely concerned with her personal appearance. She devised the formulae for her personal face creams and perfumes, and designed her own clothes and jewelled headdresses. If she didn't like what she saw in the mirror as she grew older, she sustained an image of herself

as a beautiful fashion queen by commissioning nearly as many portraits of herself as did the most powerful rulers of her day.

Isabella had instructed Titian to work from a portrait by the Bolognese painter Francesco Francia painted more than twenty years before and based on a still earlier portrait by her court painter Lorenzo Costa. She borrowed the Francia back from a Ferrarese nobleman to whom she had originally given it in exchange for a precious manuscript. When the owner died a month later his brother and heir asked to have it back immediately. Isabella passed the request on to Titian, who retained it for two more years with no explanation for the delay. He delivered his own portrait of Isabella at the end of May, but did not for some reason return the Francia with it. Although Isabella refused to pay him until he did, she admitted to Benedetto Agnello that she found Titian's portrait 'so pleasing that we doubt that we were ever, at the age that he represents, of such beauty that is contained in it' (she had said the same to Francia). Since Titian's *Portrait of Isabella d'Este as a Young Woman* (Vienna, Kunsthistorisches Museum) does not look like other portraits for which she posed in person, we can take her at her word. The jewelled cap and the cut of her dress hark back to the 1490s when her creations had set fashions for the noble ladies of Italy and Europe. But if we didn't know the circumstances in which the portrait was painted we could be forgiven for thinking, despite the anachronistic costume, that it is one of Titian's anonymous young beauties, like the Duke of Urbino's contemporaneous *La Bella* for which he adopted a similar format.

Titian's most challenging order in 1534 was from the Scuola Grande della Carità, the oldest and wealthiest of the Venetian Scuole, for the *Presentation of the Virgin in the Temple*, which is still in situ in the Accademia Gallery in Venice in its original place in what was the *albergo* or boardroom of the Scuola.[5] It was his only commission for a narrative painting for a Venetian Scuola Grande, and he took immense pains with it over the next four years. In May 1535, while Titian was making a start on the *Presentation*, Charles V, his war chest enriched by a first windfall worth 800,000 ducats from Francisco Pizarro's conquest of Peru, was mustering his troops in Barcelona for

a massive amphibious attack on Tunis, occupied the previous year by Barbarossa. Brandishing an image of the Crucified Christ in the name of whose suffering he, 'God's standard-bearer', would expel the heathen pirate, Charles set sail for the African coast where he took personal command of forces captained at sea by the Genoese admiral Andrea Doria and on land by Ferrante Gonzaga and Alfonso d'Avalos. The siege, launched on 14 July, was followed by furious fighting in the heat of the African high summer. The water ran out, but Charles, despite an attack of gout, fought on the front lines until on 21 July he took control of the vast harbour of Goletta, which had once sheltered the fleets of Roman Carthage.

In the popular imagination, the Caesar of his age had taken possession of a former Roman colony and expelled the heathen Muslim in the name of the Triumphant Christ. The citizens of Messina hailed him with the slogan devised by Virgil for the Emperor Augustus: 'he ruled an empire on which the sun never set'; and Charles adopted the insignia 'Carolus Africanus' as he progressed up the Italian peninsula to be greeted by more cheering crowds and triumphal arches as he passed through Palermo, Naples, Rome, Siena, Florence, Lucca and Genoa. Although in his later years he remembered the conquest of Tunis as the most personally satisfying event of his reign,[6] Charles was aware at the time that his victory was incomplete as long as Barbarossa, who had slipped away to his lair in Algiers, was on the loose. But his men were exhausted and the campaign had already cost one and a half million gold scudi, which Charles tried to recoup from his Italian dominions. The Barbary Coast remained in Turkish hands, and Barbarossa immediately resumed his raids on the coastlines of Italy and Spain. It was only a matter of time before the war would resume.

In the March before Tunis, when rumours of an impending campaign in Algiers were circulating, Titian had promised Lope de Soria that he would meet the emperor wherever he landed in Italy and present him with a portrait of himself and his consort. The promise was reiterated after the victory in July, but Apelles was not there to kiss the hand of Alexander when he disembarked at Trapani on 22 August. If the emperor was disappointed by the painter's absence, he had

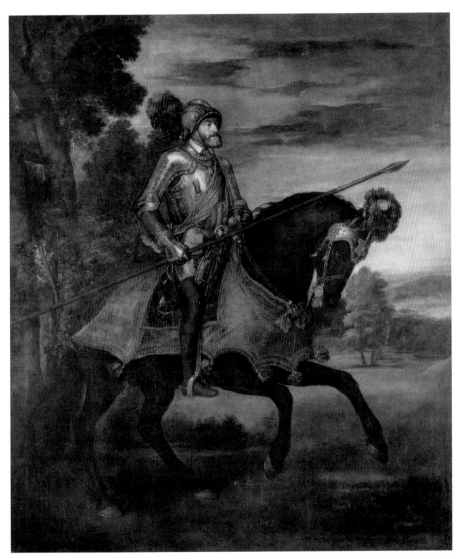

Charles V on Horseback, canvas, 332 x 279 cm

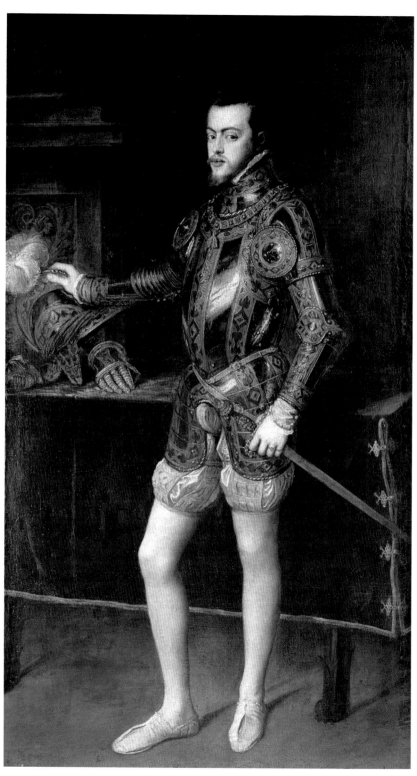

Prince Philip, canvas, 193 x 111 cm

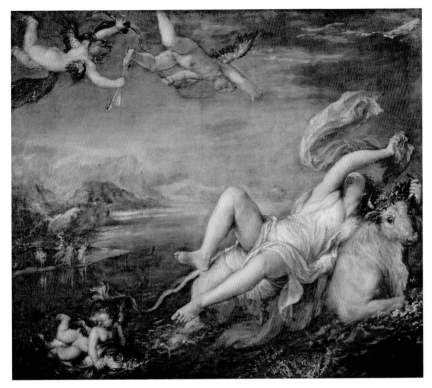

Rape of Europa, canvas, 185 x 205 cm

Entombment, canvas, 137 x 175 cm

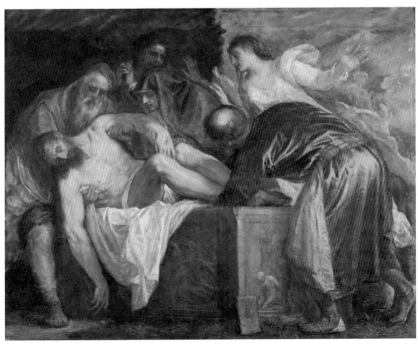

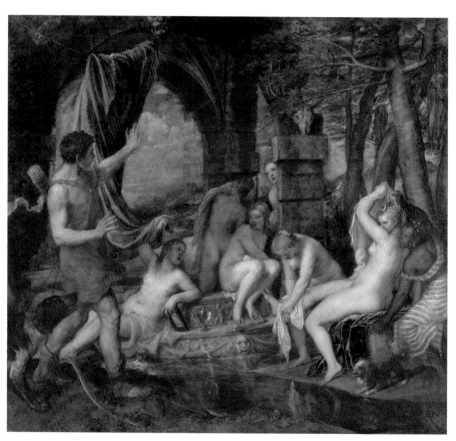

Diana and Actaeon, canvas, 184.5 x 202.2cm

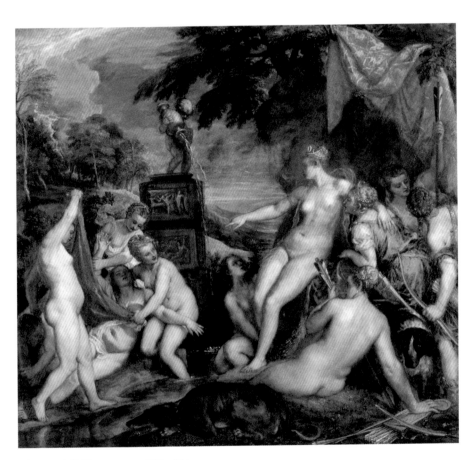

Diana and Callisto, canvas, 187 x 204 cm

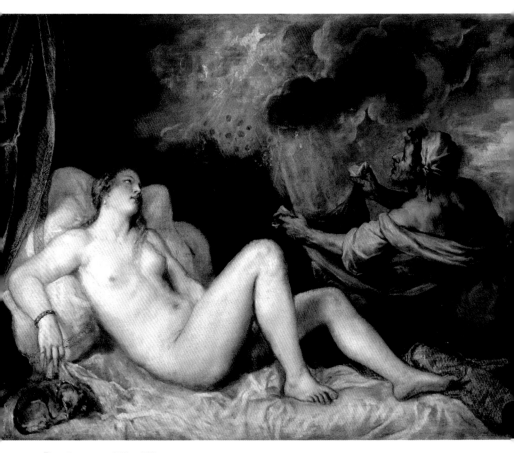

Danaë, canvas, 129 x 180 cm

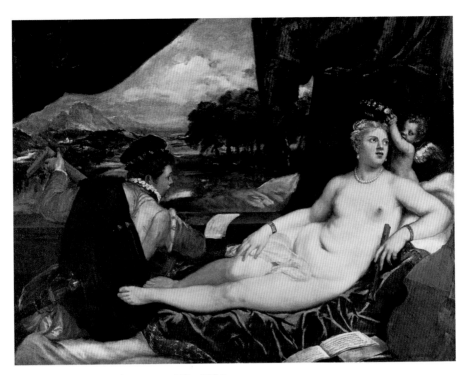

Reclining Venus, Lutenist, canvas, 150 x 196.8cm

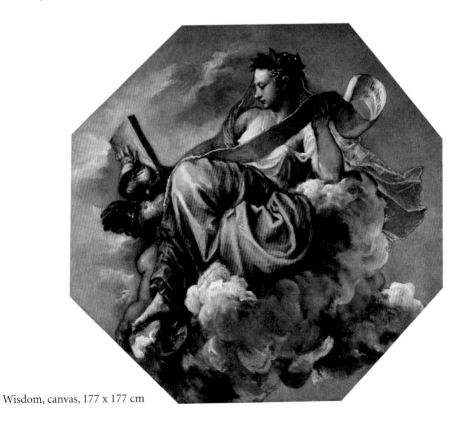

Wisdom, canvas, 177 x 177 cm

Jacopo Strada, canvas, 125 x 95 cm

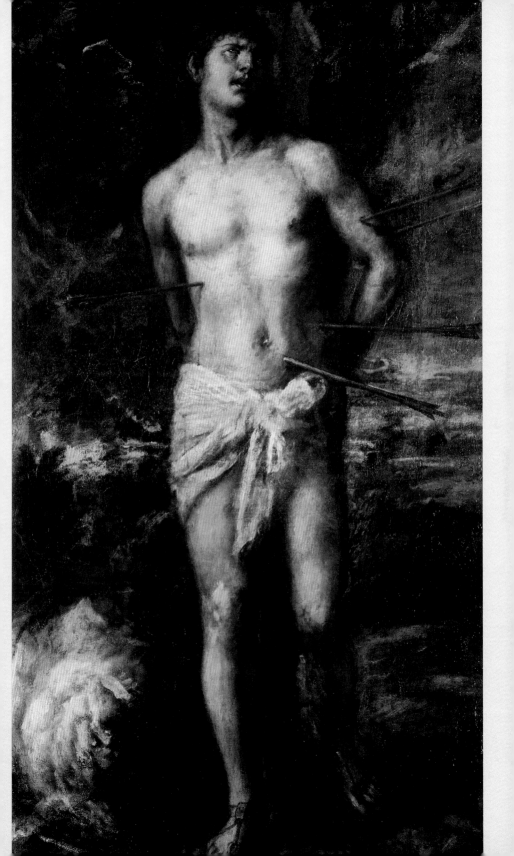

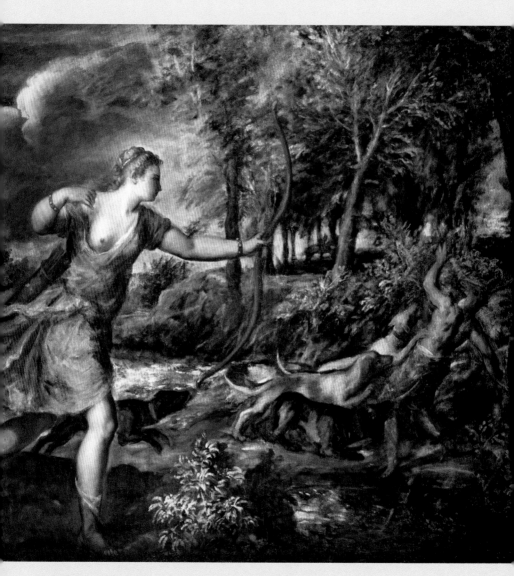

Death of Actaeon, canvas, 178.8 x 197.8cm

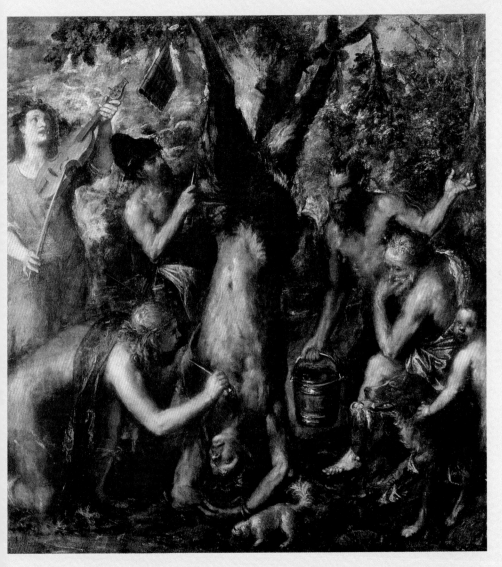

Flaying of Marsyas, canvas, 220 x 204 cm

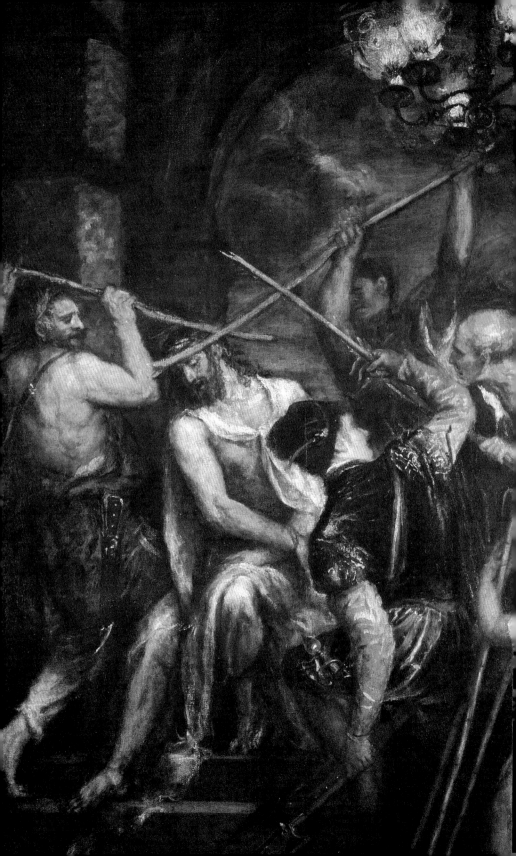

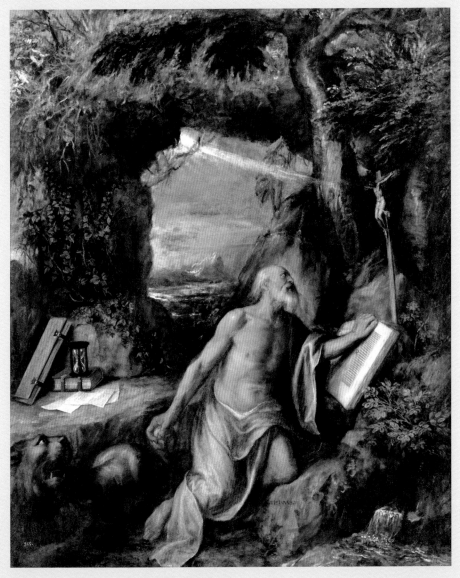

St Jerome in Penitence, canvas, 217 x 175 cm

Pietà, canvas, 378 x 347 cm

overleaf: Self-portrait, canvas, 86 x 65 cm

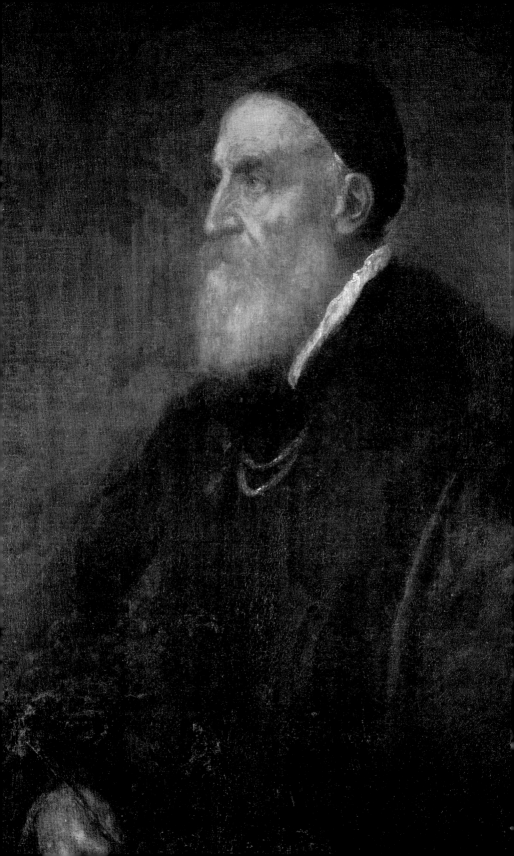

more than enough business to distract him on his first visit to his Aragonese dominions. There was more empty talk about Titian meeting him in Palermo, where Charles spent two months during which he made Ferrante Gonzaga his viceroy in Sicily. He then travelled up the peninsula to Naples where he arrived on 25 November to spend Christmas and Carnival. Although rumours that Titian would meet him in Naples failed to materialize, Charles requested his Spanish viceroy there to award 'Messer Tician de Vecelli, our first painter' for past and future services with a permission to export annually 300 cartloads of grain free of duty, which would allow Titian at least in theory to sell at a profit.

Federico Gonzaga, who had been following Caesar's progress with a view to advancing his claim to the Marquisate of Montferrat, had offered to visit him when he reached Naples. But an unforeseen event, one that threatened to compromise the peace in northern Italy, caused him to change his plans. On 1 November 1535 the feeble Francesco Sforza, puppet duke of the key city of Milan, the Habsburg military and bureaucratic power base in Italy, died without heirs. Charles assumed direct control of Milan and appointed the Spanish general Antonio de Leyva as his governor. But it would not be long before Francis I, who had endured six frustrating years of watching Charles strengthen his position in Italy, would assert his own claim to Milan.

Under the circumstances Federico decided it would make a better impression to stay in northern Italy and offer his services to the emperor should they be needed in case of a French attack on Lombardy. He dispatched to Naples in his stead his aristocratic ambassador extraordinary Nicola Maffei with letters to the emperor expressing profuse congratulations, apologies for not having taken part in the Tunis campaign, and assurances of his undying loyalty. Maffei was preceded by a lavish array of extravagant gifts carefully chosen to soften opposition of the emperor and his councillors to the investiture of Montferrat. Ignoring a warning from the sober diplomat Lope de Soria that attempts to bribe the emperor might backfire, Federico sent horses and edible delicacies – pork sausages, pressed tongues, sweets made of quinces and peaches that were a speciality of

the Gonzaga chefs, fennels, cheeses and olives (the olives went down especially well with the court). But most marvellous for a campaigning emperor who had grown up wearing armour were the suit of armour, the light helmet, the round shield and the beautifully crafted weapons. Charles unpacked the swords one by one, testing their weight and the strength of their blades, and pronounced a finely engraved dagger the most beautiful work in the world and one that could not be improved upon by a painter.

Although opposition to the investiture of Montferrat was already evaporating in the heat of imperial greed, not to mention common sense – Charles needed a loyal ruler who would defend the marquisate from French interference – Federico held the trump card up his sleeve. He had already, the previous August, written to Titian, his 'excellent and dearest friend', requesting a Christ, based on a previous image he had given to Federico, to be finished by the Feast of the Madonna on 8 September.[7] It was a highly suitable gift for an emperor who had conquered in the name of Christ, but when it arrived on time Federico did not send it on to Naples: he wanted to present it in person on his next encounter with Charles, who would be passing through northern Italy on his way to Genoa for embarkation to Spain. Federico also had reason to believe that he would find a way of presenting Titian, who owed him so much and who had turned down so many invitations from the emperor, to join him.

In February 1536 Francis I formalized his alliance with the Turkish sultan. 'I cannot deny', he explained half apologetically, 'that I very much want to see the Turk powerful and ready for war, not for his own sake, for he is an infidel and the rest of us are Christians, but to erode the power of the emperor and involve him in crippling expense.'[8] At the end of March he claimed the Duchy of Milan for his son Henry of Orleans, and a French army occupied Savoy and Turin in contravention of the Ladies' Peace that he had signed seven years earlier. Charles reached Rome on 5 April in time for Easter and spent the next fortnight in conference with Paul III. He warned the pope of the potentially disastrous consequences for Europe of the Franco-Turkish alliance. Paul would not take sides in the dispute over Milan and flatly

refused to listen to Charles's sincere if ridiculous offer to spare the lives of imperial and French soldiers by engaging the French king in single combat. But the pope did agree to call the General Council of the Church for which Charles had repeatedly and unsuccessfully pressed the less decisive Clement VII.

On 27 April, nine days after Charles had left Rome for northern Italy, Federico Gonzaga put a fast cutter at Titian's disposal and asked him to come to Mantua with a portrait of the emperor. Three days later Benedetto Agnello advised Federico that the portrait was on its way but that Titian was delayed in Venice by other business (he did not explain that the Duke of Urbino was sitting to him for his portrait). At last, on 24 May, Titian and Federico joined the emperor and his court at Alessandria and rode on with them to Asti with Titian's Christ and portrait of the emperor in their baggage. Unfortunately for Federico's scheme to nail the investiture and for Aretino, who was in the process of switching his allegiance from Francis I to the emperor in the hope of an imperial annuity, the timing of the meeting was not propitious, as Titian explained in the letter he wrote on 31 May 'to Signor Pietro Aretino, my lord and best companion', saying that although he would try to advance the cause of his friend everyone at Asti was preoccupied by making a start for France, 'full of animosity'. He added a postscript: 'One more thing. The Duke of Marche goes on the right side of His Majesty, who will be Governor in Italy of the S.ta. [*de le S.ta*] Or so they say.'

This postscript[9] is a puzzle. There was no such person as a Duke of Marche and the meaning of the abbreviation 'le S.ta' is further obscured by the article, which is a feminine plural, and the 'S.ta', possibly Santa or Holy, which is singular. Since the original letter is missing – it is known only from a collection of letters written to Aretino that was printed later – it is impossible to say whether Titian writing in haste accidentally wrote Marche for another name or whether the clerk who transcribed the letter for the press misread his scrawled handwriting. But Santa what? Santa Chiesa, Holy Church? One possibility[10] is that Marche should have been Mantua and, if 'S.ta'

was an abbreviation of the Santa Chiesa, the Duke of Mantua was on the right side of the emperor because the pope was about to announce that he intended to summon a General Council of the Holy Church to take place in Mantua. While it sat the emperor would be secular governor of the Church in Italy, rather than in Germany as he and the Protestants had requested. It may not be a coincidence that Paul announced the General Council on 1 June, the day after Titian had passed on the gossip about it to Aretino.[11]

The emperor struck out from Asti on 22 June at the head of a contingent of 50,000 men under Ferrante Gonzaga and the Duke of Alba aiming for Provence, where they planned a counter-offensive against Francis I's invasion of Savoy and Turin. It was a campaign that soon turned into a nightmare for both sides. The imperial invaders, exhausted by a French scorched-earth policy and decimated by dysentery, retreated after failing to take Marseilles. It was Charles's first significant military defeat, and it lost him the better part of a good army and left him more deeply in debt than ever. But Francis was equally damaged. With Provence in ruins and the rest of his country bled by war taxes he had neither the money nor the strength to press on with his conquest of Milan.

Before embarking for Spain from Genoa Charles granted Aretino, in return for his silence about his affair with his wife's sister, the beautiful Beatrice, Duchess of Savoy, a pension of 200 gold scudi to be drawn on the treasury of Milan. He also promised Titian a canonicate for Pomponio at the church of Santa Maria della Scala in Milan.[12] There was one last piece of urgent business to be concluded before the emperor and his court set sail for Spain. The problem of Federico Gonzaga's investiture as Marquis of Montferrat had to be resolved quickly because without a ruler who was solidly faithful to the empire the citizens of Casale might open their gates to France. Federico produced more bribes, a gold vase for Cobos, drawings by Giulio Romano for the vice chancellor of Aragon. But he needn't have bothered. Charles had in fact made up his mind to ensure the stability of Casale by ratifying the investiture, and on 25 November Federico Gonzaga entered Casale as Duke of Mantua and Marquis of Montferrat.

Pomponio's canonicate did not fall vacant until 1540. Titian – despite repeated requests, demands, interventions by his powerful friends, assurances and requests from the emperor himself[13] – never received permission from the exchequer of Naples to export the duty-free grain, which would have increased in value in the years he tried to obtain it.[14] It was not the last time he would be financially disappointed by the Habsburg bureaucracy in Italy, which was not always well controlled by the emperor, or later by his son Philip, both of whom were chronically short of funds and extracted what they could from their wealthy Italian dominions. Local officials in Naples and Milan had nothing to gain from paying a painter in Venice with pensions or other privileges, and the Neapolitan nobility were free to do as they pleased with their own land. But it seems to have been Habsburg practice to offer such rewards in the knowledge that not all would be honoured. Aretino, who was a more dangerous character than Titian, did receive his pension but by no means on a regular basis.

Once the Marquisate of Montferrat was ensured, Federico lost interest in imperial politics, even to the extent of resisting the papal–imperial plan to host the General Council of the Church in Mantua, which in any case never took place because the Protestants refused to confer on Italian soil. For the remaining years of his life the Duke of Mantua and Marquis of Montferrat devoted his energies to the administration of his dominions and to commissioning works of art for his personal gratification and the glorification of his dynasty. His most ambitious project was a new suite of rooms designed by Giulio Romano in the ducal palace including a Chamber of the Caesars for which he asked Titian to paint three-quarter-length portraits of the twelve Roman Emperors as described by the ancient Roman historian Suetonius. Titian was the only foreign artist with whom Giulio, who was jealous of his position as Federico's court artist, willingly collaborated, and it was probably during a visit to his house that Titian painted his portrait holding a plan for a centralized church (Mantua, Casa di Mantegna). The commission for the Emperors was the largest and most unusual order Titian had ever received from Federico, and he

prepared for it by studying the Gonzaga collection, one of the largest in Italy, of Roman portrait busts and medals. He was already familiar with the Bembo collection of antiquities in Padua, and had often incorporated antique motifs in his paintings. But this more purposeful archaeological investigation would provide the greatest portraitist of the Renaissance with a new and deeper appreciation of Roman portraiture and the uses he could make of it.

Federico had discussed the project with Titian when they were together in Asti, but the first portrait, of Augustus, was not dispatched until 26 March of the following year, 1537. Federico wrote to 'Messer Ticiano my dearest friend' that the room would be ready in May and that it would give him supreme satisfaction if Titian would let him have the Emperors as soon as possible. He also advised Benedetto Agnello that he wished to reward Titian with the gift of a coat. Titian, however, was not to be fobbed off so easily. A more appropriate reward, as he saw it, would be relief from the twenty-five ducats that he was required to pay annually out of the income from Pomponio's benefice of Medole. On 6 April one of his amanuenses addressed his last surviving letter to Federico Gonzaga, 'My Most Illustrious and Excellent Lord, and most faithful patron', in which he thanks the duke for his letters and the coat, but reminds him that he has not yet reacted to one of the pictures he has sent and will finish the others when he has heard that the first is satisfactory. In the meantime he hopes that Federico would be so kind as to free the benefice from the pension payable on it, which 'apart from the loss of the money I pay out each year, causes me no little bother and disturbance from the people who are driving me crazy, from whose hands only Your Excellency can liberate me'.

Federico replied four days later that the portrait of Augustus was very satisfactory although the measurements were not quite right, and that he had the matter of freeing the benefice from the pension close to his heart and would entrust it to his brother Cardinal Ercole who was just then on his way to Mantua from Rome. In June Titian accepted an invitation to visit Mantua for the baptism of Federico's second child Isabella when he would have the opportunity to take

measurements in the Chamber of the Caesars and discuss with Ercole the question of the pension on the income from Medole.[15] It was a useful visit – the spaces Giulio Romano had allocated for the Emperors turned out to be longer than his prototype portrait of Augustus – and it might have been an enjoyable one since the guest list included among many important dignitaries his old acquaintance Pietro Bembo and the polymath humanist and patron of the arts Daniele Barbaro (whom he would portray a decade later). But although he had been invited to stay in Mantua for several weeks Doge Gritti's representative in Mantua for the occasion of the baptism conveyed a message so alarming that he cut his visit short and returned to Venice as soon as he decently could after the conclusion of the festivities.

On 23 June 1537, just a few days after Titian's arrival in Mantua, the Council of Ten had issued the decree that Titian had been dreading.

Since December 1516 Titian has been in possession of a broker's patent, with a salary varying from 118 to 120 ducats a year, on condition that he shall paint the canvas of the land fight on the side of the Hall of the Great Council looking out on the Grand Canal. Since that time he has held his patent and drawn his salary without performing his promise. It is proper that this state of things should cease, and accordingly Titian is called upon to refund all that he has received for the time in which he has done no work.[16]

Now at last, twenty-four years after he had beseeched the Council to allow him to paint the battle scene, Titian knew he must actually produce it, which he did a little more than a year later.

Nevertheless, although the completion of the battle scene was his most urgent priority, Titian was sufficiently reassured by his discussions at Mantua with Cardinal Ercole about freeing Pomponio's benefice to deliver three more Emperors by October. But by August of the following year, when the matter of the claim on the benefice was still not resolved, Titian had produced no further Emperors. Federico now tried a strategy that he was sure would induce Titian to carry on

with the project. On 5 August he offered through Agnello to pay the pension himself, but only when all the Emperors were delivered. On 10 August Agnello reported that Titian had finished his painting for the Great Council Hall and could now turn his attention to the Emperors.[17] But Federico Gonzaga and the painter he called his dearest friend had reached a stalemate. Titian would not finish the remaining Emperors until Federico relieved him of the obligation to pay the annuity and of the endless pestering of the claimants whose demands he said were making it impossible for him to work. Federico would not oblige him until he had received the remaining Emperors.

In the winter of 1538–9 an unusually high flood of the Po caused extensive damage to Giulio Romano's new suite of rooms, and repairs were delayed by continuing heavy rain. Isabella d'Este, who was concerned about her son's failing health, had persuaded him to spend a holiday with her in Venice in the autumn. They had a good time, but on the journey back to Mantua in bad weather she was seized with gastric pains. She remained bed-ridden but mentally alert and hungry for news of her adored grandchildren and of events in which she could no longer take part until she died on 13 February 1539. After the funeral Federico spent April and May with his family at Casale. Titian seems to have put off acting on an invitation to Mantua in July, but in November obliged Federico by sending him some paintbrushes from Venice. We have no further news of the Emperors until 4 January 1540 when Benedetto Agnello's secretary sent an invoice to Gian Giacomo Calandra for a half a barrel of finest Malvasia wine and the cases for the paintings of Emperors which Titian had had constructed for their transport. He would ship them later that day in the ducal gondola. He also noted that he had given a gold chain and clothing to Aretino, who had expressed his gratitude and hoped that the gifts would mark the resumption of Federico's generosity. In February Titian went to Milan to collect Pomponio's benefice on Santa Maria della Scala, which had fallen vacant, from Alfonso d'Avolos, who was then governor of the city. He travelled from Milan to Mantua in April. We know this from a letter written from Venice to Francisco de los Cobos by Diego Hurtado de Mendoza, Lope de Soria's successor as

imperial ambassador to the Republic.[18] The letter does not mention the Emperors, but we can allow ourselves to hope that the purpose of Titian's visit was to finish and install the full set.

Although Giulio Romano's final design had allowed for only eleven Emperors,[19] they must have looked magnificent in their elaborate stucco frames between niches containing bronze statuettes of the Emperors, each with a fresco illustrating a scene from his life below. After his relatively weak prototype portrait of Augustus, Titian's imagination had been increasingly fired by the Roman busts and medals he studied in the Gonzaga collection. He took the features from those antique examples but made them look as though they had sat for him in person – he dressed Claudius, indeed, in the cuirass left on loan in his studio by Guidobaldo della Rovere when he was painting his portrait in armour. As he worked on the series he used all his skills as a portraitist to vary the poses, which became more effortlessly forceful, each Emperor grasping his baton of command at a different angle that seems to give a clue to his character. The armoured warrior rulers of ancient Rome, with whom all Renaissance princes wished to be associated, had sprung to life in Federico Gonzaga's Cabinet of the Caesars. Federico's critical vocabulary had always been limited to the clichés of his day – 'very beautiful', 'very perfect', 'so natural that no one, not nature itself, could have done better', and so on. Although we don't know what if anything he said about his Emperors, we can assume that when he saw them in place his heart beat faster than his descriptive abilities might suggest.

Although Federico had been unwell for some time, his death on 28 June,[20] at his favourite villa Marmirola, was unexpected. He had been conducting a long correspondence in Latin with a distant German relative about an offer he had made to present him with portraits by Titian of himself and Margherita, which Titian may have begun during his Mantuan visit in April. Aretino, who had made up his differences with Federico just in time, sent the widowed Duchess Margherita a copy of his recently published *Life of St Catherine* with a letter advising her that just as 'the illustrious qualities of such a great duke and splendid marquis have left the world with an eternal example of generosity'

she should 'convert her sadness into a joy like that of the earth when lit up by the sun'. In his will Federico left a horse each to Titian and Giulio Romano – Titian's was called Zoia. And in October Margherita and Ercole, who were acting as joint regents for Federico's seven-year-old son and heir Francesco III, ordered their treasurer Gian Giacomo Calandra to issue a decree liberating Pomponio's benefice on Medole from the annual payment of twenty-five ducats, according to the wishes of the late Federico Gonzaga who had expressed a desire to reward Titian in this way for 'the images of the most serene and modern Emperors'. That settlement, however, marked the end of his working relationship with the Gonzagas. Although they remained on cordial terms, Federico's limitless appetite for art and luxury had exhausted the treasury to such an extent that his widow and brother were obliged to institute a regime of austerity. There would be no more letters to Benedetto Agnello and Titian requesting precious objects, exotic animals, edible delicacies or paintings.

Titian would never have another patron who took such a close personal interest in his financial welfare and the promotion of his career. Federico's reiterated protestations of friendship had been to a large extent proprietorial. He had enjoyed Titian's engaging personality and the fruits of his genius but also recognized their diplomatic value. Although it would be anachronistic to assume that he considered Titian his social equal, he had, unlike his uncle Alfonso d'Este, accepted that his independent-minded favourite painter would never be entirely at his beck and call. While the two men jousted in their correspondence about Titian's delays and rewards, Federico never resorted to threats, and as a result rarely had to wait long for his paintings or for Titian's visits. Without Federico Gonzaga, Titian would probably not have met Charles V, whose high regard for his 'first painter' was the key to an international success unmatched by any other artist of the time. Without him he would not have enjoyed the opportunity to immerse himself in the Gonzaga relics of the ancient Roman world.

In his own lifetime and for the next two centuries the Emperors were the most admired of Titian's paintings for the Gonzagas. Dolce

wrote that they were 'of such perfection that an infinitude of people' came to Mantua with the sole purpose of seeing them, 'imagining that they were seeing the real Caesars and not pictures of them'. Vasari singled them out for mention with only two other of Titian's Mantuan paintings (a portrait of Federico and one of his brother Ercole). In 1628 they were sold with the rest of the Gonzaga paintings to Charles I of England, who displayed them in St James's Palace. On the dispersal of the royal collection during the Commonwealth they were given to Spain, where they were destroyed in 1734 by a fire in the Alcázar in Madrid.

The Roman Emperors were among the most copied of Titian's works, with no fewer than seven complete sets recorded in his lifetime. Aegidius Sadler made a set of engravings of them in the 1590s, but to judge from other extant reproductions Ippolito Andreasi's pen-and-ink copies are more accurate. Visitors to the ducal palace today can at least get an impression of the appearance of Federico's Chamber of the Caesars, which has been restored as far as possible and hung with painted reproductions. But no copy conveys the qualities that inspired Titian's contemporaries to glimpse as through a window those valorous ancient warrior rulers reborn in the guise of their own Renaissance Caesars. For Titian the discipline of a task that required him to work within pre-set dimensions from archaeological models stimulated his virtuosity and deepened his visual culture in ways that lent a new stature to his portraits of contemporaries. The most obvious surviving example – and the work that gives the best impression of how the original Emperors might have looked – is the *Portrait of Francesco Maria della Rovere* in armour holding his baton of command. But we can see how deeply imbued Titian was with Roman portraiture in a number of other works painted during and after the four years he spent researching and painting the Emperors. One of them is the portrait he painted of Aretino in 1537 or 1538, not of course in armour but posed like an emperor, an emperor of letters.

SIX

The Writers' Venice

There are four people lodging here ... We have one bed between
the two of us, and each has his own (O beautiful secret!)
chamberpot, because the privies are common to all ... at night, in
the manner of a cruel doctor, an army of huge bedbugs ... and a
mob of fat fleas, test my pulse and bleed me; above my head, in an
old loft, I think there is a college of mice and a consistory of
cobwebs ... No sooner is it daybreak than the boats, barge and
gondolas appear in a stinking, fetid, vile canal, with people
shouting and braying with coarse and disjointed voices,
competing with each other, one with Brenta water, another
onions and fresh garlic and mouldy melons, rotten grapes, stale
fish and green kindling wood, enough to drive crazy everyone
of sound mind.

ANTON FRANCESCO DONI, FROM A LETTER
TO A FRIEND DESCRIBING HIS LODGINGS IN
VENICE, 1550[1]

When Titian painted, in just three days, the friend he called the brig-
and chief of letters gazing thoughtfully into the distance with one of
the heavy gold chains he had extracted from his patrons resting on his
fur lapels (New York, Frick Collection) Aretino was powerbroker to
the world. The first volume of his collected letters, dedicated to the
Duke of Urbino and published by Marcolini in January 1538, sold
out. In the next five years it went through ten editions (including

numerous pirated editions) and was followed by five more volumes. Titian's portrait was the prototype for the woodcut frontispiece of the second, enlarged edition printed in September 1538. The published letters turned Aretino into an international literary celebrity. Entertaining, absurd, preposterous, pompous, obsequious, self-serving, shrewd, some are wise, and some, when he wrote from the heart about bereavement, love or art, are deeply moving. They were the closest texts the Renaissance had to newspapers, and we can read them as biased editorials on the times in which they were written, although there is a caveat. For a prolific writer with a maimed right hand and disorderly habits of filing, the editing process was extremely laborious. As he confessed to Vasari when asking him to return a letter describing Charles V's entry into Florence in 1536, 'I shall be careful to place it with the more than two hundred letters I am printing, but they would be more than two thousand if I had all those I have written without keeping copies of the originals.' He had also neglected in many cases to make a note of the dates on which those he had kept were written. In a last-minute attempt to impose some kind of chronological order he simply dated those at the end of the volume, some of which must have been written earlier, to November and December 1537.

In the May after the first publication of his letters two of Aretino's enemies brought against him a charge of blasphemy and sodomy (*per bestemmiatore e rompitore de tondi*). But a decade after crossing the lagoon with a dubious reputation and the remains of a tip from Federico Gonzaga to speed him on his way, Aretino had manipulated for himself a position in Venice that guaranteed immunity from punishments for behaviour that sent less useful men to the gallows or into permanent exile. While the heat was on he retreated to a villa on the Brenta, but returned to Venice at the end of June when Benedetto Agnello reported that the charges had been dismissed on the intervention of the Duke of Urbino – with, we can assume, the compliance of Aretino's most powerful protector, Doge Andrea Gritti. Since the charges against Aretino are absent from the otherwise well-preserved government records it seems that his case was not brought to trial.

Meanwhile, Charles V's victory at Tunis followed by Francis I's unholy alliance with the Turks had suggested that it was time to reconsider his political allegiance. Without breaking with Francis he began to court the emperor with adulation that 'soon passed', as Burckhardt put it, 'into the most ludicrous worship'.

> Because your majesty is more like a God than any man there ever was ... I make bold to celebrate the Faith, the Religion, the Piety, the Good Fortune, the Courtesy, the Goodness, the Prudence and the Worth of Your Majesty in this my letter. If the paper on which it was written lived and breathed, it would turn up its nose at even the most glorious sheets of paper of the olden days, and that because it was not merely read, but touched by that true friend of Christ, Charles the August, before whose merits the entire universe should bow ... For there is not room enough in the whole empyrean for your winged fame.[2]

After the disastrous campaign in Provence and Charles's promise of a pension, he wrote again praising what had in fact been an ignominious retreat as a wise manoeuvre and eulogizing the 'superhuman courage' with which 'the great Charles overcoming impossible difficulties had flown into the enemy camp where no soldier had dared to attack him'. He urged Caesar to follow his 'victory' in Provence by joining Venice in raising a fleet against the Turks. Finally he offered grudging thanks for the pension, 'which has partly relieved the weight of my poverty' – it would do for the moment, that is, but was not enough to cover his expenses or the price of his loyalty.

As a journalist in the service of the Venetian government, Aretino's self-appointed job was not only to manipulate the great rulers of Europe but also to extract from them the largest possible rewards for himself. But even his love of art, which he understood better than any of his contemporaries and wrote about with a sinuous rhetoric that aimed to equal or outdo the works he described, was not entirely untainted by self-interest and greed. He pestered Michelangelo for a drawing: 'two marks of charcoal on a sheet' would give him 'greater pleasure than any number of chains from a prince'. Michelangelo sent

sketches by an inferior artist after his own drawings for some sculptures. Aretino continued to pester him with flattering requests for 'one of those marvels which are continually given birth to by the divinity which your genius makes pregnant'. Not long after he had received the disappointing drawings, Aretino addressed to Michelangelo a long letter sharing his vision of how he should paint his *Last Judgement* for the Sistine Chapel, to which Michelangelo replied that he was sorry, because Aretino was 'the only model of knowledge in the world', that he could not avail himself of the treasures of his imagination because he had already finished part of his painting but that he hoped Aretino would publish the advice he had given. Aretino offered to come to Rome to see the painting. Michelangelo replied that he must not break his vow of never revisiting Rome merely on account of his picture. But Aretino was not one to be brushed off by irony.

Having seen an engraving of the finished *Last Judgement* he addressed to Michelangelo and the world a long letter expressing his shock and horror as a baptized Christian at the exposed genitals of the naked figures in the highest temple of God, comparing the *Last Judgement* to a fresco in a brothel, suggesting that Michelangelo should restore his good name by covering the indecent parts. Aretino's opinion, which was repeated later in Dolce's fictitious dialogue *L'Aretino*, and was shared by many others, was based less on morality – he was after all a published pornographer – than on the Renaissance theory of decorum: what was appropriate in a brothel or for the private amusement of an artist was an outrage in a temple of God. But he had a selfish motive as well. Aretino was after nothing less than a cardinal's hat,[3] and although the very idea may seem to us the acme of absurdity, as indeed it did to some of his contemporaries, he had his supporters. Clement VII had suggested that he might have the makings of a cardinal if he learned how to behave himself, which he did not do to the satisfaction of that pope.

The substance of his denunciation of the *Last Judgement*, although the wording was more colourful, echoed the charges being made by Cardinal Gianpietro Caraffa and his fellow Theatine censors in Rome,

who were conducting their 'figleaf' campaign against what they regarded as the intolerable obscenity of Michelangelo's naked figures.[4] Gianpietro Caraffa, formerly Bishop of Chieti – and later pope as Paul IV – was so famous for his rigid and intransigent reformist Catholicism that Aretino, who loathed him and everything he stood for, used his ecclesiastical title as a synonym for bigotry – *chietino, chietismo*. The Scourge had in the past lampooned him[5] but had briefly changed his tune when Caraffa moved to Venice in 1536 as a papal agent with a brief to suppress all discussion and writing about Lutheranism. When Caraffa was made a cardinal the following year, Aretino had written a letter of congratulation at the end of which he compared himself to Saul who had been converted by Our Redeemer in order to sound the bell of His name, suggesting that he might be considered as 'a minister of His temple', a cardinal.

Two years after that gentle hint had failed, he found another opportunity when his friend Bembo became a cardinal. If Bembo, who was after all a writer and a womanizer like himself, was worthy of a cardinalate why not Aretino? This time he wrote directly to Paul III. He congratulated him on Bembo's appointment, assured him that he had been shown the path of virtue by the charismatic Sienese preacher Bernardino Ochino who had delivered an enthralling sermon in his parish church, and threw himself at the feet of the pope. His satire of the papal court, *I Ragionamenti delle Corti* (*The Dialogues about Courts*), a fictional dialogue about the courts of this world and those in heaven in which he had not spared Caraffa or his old enemy Gianmatteo Giberti, now Bishop of Verona, had been published the previous year. Now he begged pardon for the foolishness of his anticlerical writings, hoping that his repentance would be rewarded rather than punished.

Meanwhile, following the charges against him of blasphemy and sodomy, Aretino set about restoring his reputation and demonstrating his suitability for a career in the Church by putting together a selection of letters written to him by notable members of the European establishment up to 1538. The *Letters Written to Aretino*, 405 of them, were published by Marcolini in 1542 with a dedication to Innocenzo

del Monte, an illegitimate boy who was the adoptive nephew, monkey keeper and, so it was rumoured, lover of Cardinal Giovanni Maria Ciocchi del Monte. It was in Aretino's interests to cultivate the del Monte family, who were leading aristocrats in his native Arezzo. It may be that his uncanny ability to predict the future told him that they would soon be even better placed to help him don his red hat. And so it happened that in 1550 Giovanni Maria, on his election as Pope Julius III, legitimized the seventeen-year-old Innocenzo and made him a cardinal.

Letters written to, rather than from, a famous person were unusual in the period, and these were the first to be published during the lifetime of a recipient. They are actually not so much 'to' as about the paragon of all virtues who is addressed by his correspondents as divine or most divine, magnificent or most magnificent or magnificent and most learned, or our most beloved and honoured; or in the case of the first letter, from his deceased best friend Giovanni de' Medici, as the Stupendous Pietro Aretino a True Friend and Miracle of Nature. There is no way of knowing if the letters were doctored by Aretino or Marcolini because the originals have disappeared. It is perhaps more likely that only the most praising examples were selected. Nevertheless, the final letter in the collection, from Anton Francesco Doni, which proclaims that Aretino's goodness has reached such a peak that it could climb no higher, is dated 1538, ten years before the two men actually met.

Aretino had also turned out a stream of religious writings beginning with paraphrases of the Bible, which had been recently translated by his friend Antonio Brucioli. His devotional works were immensely popular, reprinted many times, and although not great literature, and certainly not as profound as the religious writings of Michelangelo or Vittoria Colonna, perhaps not as cynical as some of Aretino's critics have suggested. He may have been a bad man, but he was a good old-fashioned Catholic who detested Martin Luther for his pedantry as well as for his heretical beliefs, just as much as he loathed and despised Cardinal Caraffa.

The earliest of his religious books, a paraphrase of *The Seven Penitential Psalms* and *The Humanity of Christ*, had coincided with two volumes of satirical pornography, *I Ragionamenti* (*The Dialogues*) published in 1534 and 1536. In Rome, during the Sack of the Holy City in 1527, two ageing courtesans, Nanna and Antonia, reminisce about their lascivious adventures and teach Nanna's little daughter Pippa the tricks of their trade. In one of the dialogues, set on the feast day of Mary Magdalen, they describe the instructive pornographic frescos on walls of a convent-brothel, one of which illustrates the life of St Nafissa, who for the love of God has slept with absolutely everybody – police spies, card sharps, priests, footmen 'and all such deserving people'. St Nafissa was a joke that ran through the rest of Aretino's writings and even found its way into one of his letters to the Duke of Urbino.

The *Ragionamenti* have been accurately described as 'probably the frankest pornography in Italian literature'.[6] Translated immediately into French, they were to be the model of obscene works for the next two centuries, and were all the more deliciously shocking at a time when very little pornography was written in Italy. But although Aretino's descriptions of every possible variation on the sexual act, not excluding masturbation in public and orgies involving chain buggery, are as explicit as the genre can get, they are never about the exploitation of women. On the contrary, the women take as much pleasure in the fun as the men, and usually outwit them. Pornography might seem a perverse way of pursuing a cardinalate, but as usual Aretino had an ulterior motive. Andrea Gritti's Venetian government was trying to reform its convents, which were rightly regarded as brothels, while the papacy remained indifferent to the corruption in Roman religious houses of ill repute. By placing his story in Rome during the most humiliating invasion it had ever experienced and pretending to disapprove of the acts he described (it was necessary for superior minds to know evil in order to defeat it), he set up Venice, home of honourable and pure courtesans like Angela Zaffetta, as a morally superior example to a Holy City in need of reform.

The *Ragionamenti* could have been published only in Venice, where the official requirement that all books should receive a privilege to publish was not enforced in practice until much later in the Counter-Reformation. From the middle of the 1530s the unparalleled freedom of expression in the lagoon and the example of Aretino's immense success attracted vernacular writers and publishers to Venice from elsewhere in Italy. Known to historians of literature as the *poligrafi*,[7] or polygraphs – jacks of all literary trades willing and able to turn their hands to editing or translating as well as writing their own works – they were most of them ten or twenty years younger than Aretino, angry young men who came, as he had, from relatively humble backgrounds. Some had been monks and had the classical languages that Aretino lacked, which made them useful as his secretaries. Most were followers of Erasmus and like so many Erasmian humanists deplored the abusive behaviour of the clergy and papacy. But they went further. The most articulate of the polygraphs overturned all Renaissance values. Whereas humanists stressed the importance of community life and civic responsibility, they praised solitary life in the country where men could find peace and forget vain ambitions. They were not the only Italians to regard grammar and humanist learning as irrelevant to the modern world, and their rejection of academic scholarship in favour of learning from the book of nature anticipated similar views expressed later in the century by Bacon and by Montaigne, who gave fifteenth-century Italian humanism as the cause of the peninsula's downfall.[8]

What the most conscientious of them had in common was anger. Bitterly disillusioned by the times in which they lived, they demanded redistribution of wealth, denouncing the injustices of a society in which the rich and powerful avoided the taxes they levied on the starving poor. Although none of them matched the energy, range, wit or speed of Aretino's high-flying pen, they had one quality he lacked. They had social consciences, which made them less self-serving than their role model. While Aretino flattered the rulers who paid him best, they lashed out at Charles V and all the greedy tyrannical Italian dukes, princes and counts whose gross appetites and lack of reasoning

power made the possibility of political or religious reform impossible. Their ideas were, as they knew, so far ahead of their times that no ruler could take them seriously. But the popularity of their works, which continued to sell in numerous editions into the seventeenth century, indicates that their readers shared their proto-revolutionary views.

The centres of intellectual discussion in Venice were the publishing houses, especially those set up in the mid-1530s by the Piedmontese Gabriel Giolito de Ferrari and Francesco Marcolini of Forlì, who operated the most commercially successful of the vernacular presses. Marcolini was also an architect and a great friend of Titian, Sansovino and Aretino, whose letters he published. Venetian and foreign writers and bibliophiles, literary patricians and businessmen congregated in his printing shop to exchange ideas. Among the Venetians there were Lodovico Dolce, the productive editor, translator and writer whose treatise on the theory of art included the first biography of Titian; Francesco Sansovino, whose father the famous architect Jacopo had paid for his study of law in Padua and was a friend of Titian's son Pomponio; Sperone Speroni, who wrote dialogues about language, love, women, usury and the active life; and Lorenzo Venier, author of *The Thirty-One of Angela Zaffetta* and *The Wandering Whore*, of whom Aretino said that for sheer malice Venier was four days ahead of him.

The three most prominent foreign-born polygraphs were Ortensio Lando, Anton Francesco Doni and Niccolò Franco. Lando, a former monk who described his temperament as full of anger, ambitious, impatient, haughty, frenzied and inconstant, was one of the few among these men who enjoyed an uninterrupted friendship with Aretino. He had studied medicine in Bologna, and after his arrival in Venice in the late 1540s translated writings by Martin Luther and Thomas Moore. Doni, a Florentine and also formerly a monk, was the most original and imaginative of the polygraphs. He specialized in reportage, picking up anecdotes and gossip in the Piazza, and published a large collection of his letters as well as seventeen books, including a treatise on painting and sculpture. His heretical beliefs,

anticlassicism and irritable temper alienated potential patrons, and he lived from hand to mouth working as an editor in Giolito's shop and occasionally as secretary to Aretino, with whom he later had a flaming row. Franco had come to Venice from Benevento in 1536 with an introduction to Titian. He lived in Aretino's house for a year before turning against his protectors. On meeting Titian in the street one day he pocketed his hat so he would not have to greet him, then wrote a sonnet castigating his portrait of Aretino for immortalizing 'In the space of one tiny picture/All the infamy of our estate'. Aretino accused Franco of plagiarism; Franco charged Aretino with jealousy, and continued his verbal assaults – why did Venice bother to cleanse its canals when it did not disinfect the house of Aretino, a veritable Cloaca Maxima; and so on – until he was driven from Venice by one of Aretino's young protégés who stabbed him. In 1570 he was sent to the gallows for lampooning the pope.

Titian was distantly acquainted with the polygraphs, who praised him in the conventional terms of their day, usually in the same breath as Michelangelo, almost as a matter of routine.[9] The prestige of artists had grown in the first decades of the sixteenth century to the point where educated people were supposed to know the names of the most famous of them and if they were writers to mention them as evidence of their wide culture. But there is no indication that many of the critics, not even Dolce who had probably never seen a work by Michelangelo or Raphael, understood anything about the techniques of painting or knew where individual pictures were located. Doni and Vasari, both well-travelled Florentines, were the first writers on art after Michiel in the 1520s to describe specific paintings and advise their readers where they could be found. Nevertheless, while practising artists, then as now, learned not from writers but from other artists, such critical theory as there was about art was borrowed from classical literary rhetoric. The old tag *ut pictura poesis*, poetry resembles painting,[10] which was frequently invoked directly or indirectly – Sperone Speroni wrote that poems give voice to paintings and paintings give flesh and bones to poems – is both patently untrue and tells us nothing much about either art. Titian portrayed many men of

letters – Speroni among them, as well as the learned imperial ambassador to Venice Diego Hurtado de Mendoza, the patrician polymath Daniele Barbaro, the Florentine historian and humanist Benedetto Varchi, Pietro Bembo the greatest Venetian writer of his day and, of course, his friend Aretino. Nevertheless, although it is tempting to speculate about his relationships with the writers and publishers who made Venice in the 1530s, 1540s and 1550s the Italian centre of vernacular literature,[11] there is no indication in what we know about Titian's day-to-day life in Venice that he spent much of his time reading or discussing literary texts. If he listened with respect to Aretino, it was because his friend, thanks to his close friendships with a great many artists working in all media, was unique in his understanding of how a work of art is actually made, of what is difficult and therefore especially praiseworthy. No other writer on art would have been capable of exploding, as Aretino did in one of his letters to Sansovino, the conventional literary dialectic about the relative merits of painting and sculpture:

> This is a controversy that has been fought out, not only more times than there is marble and are pigments in the world, but even than there are crazy thoughts among those who carve stone and paint ... This kind of dispute is like trying to decide whether divine providence or human ignorance controls the fortunes of our life.[12]

While Aretino rarely disappoints when writing about art, even he was unable to lift the veil that shrouds Titian's love life. His own sexuality, however, was as complicated and public as Titian's was apparently monogamous and certainly private. His first child, a daughter by one of his mistresses, Caterina Cataneo, was born as he was preparing the first edition of his published letters. He named the baby Adria after the Adriatic Sea and appointed Fra Sebastiano del Piombo – who had been required to take religious orders when appointed keeper of the seal (lead, *piombo*) for the Curia in 1531 – her godfather. He wrote to Sebastiano after her birth that he had like all expectant fathers hoped for a boy, but since it had pleased God that it should be a girl he had

discovered the truth that girls – 'apart from concerns about their chastity, which must be carefully guarded' – are the greater consolation. He must have had Titian's problems with Pomponio in his mind when he wrote:

> a boy at the age of twelve or thirteen begins to break free of the paternal reins and runs away from school, refuses to obey and makes those who begot him weak with unhappiness. And what is worse is the rudeness, the threats with which he assails his mother and father day and night, which they fear will be followed by denunciations and punishments from the law and from God. But a daughter is a couch upon which those who brought her into the world can take their repose in their declining years …

He concluded the letter with one of his tributes to Venice:

> … Adria is her name and she is well named because she was born by divine grace in the lap of these waves. And I am proud of it because this place is the garden of nature as I well know who have lived here for ten years with more contentment than I would have had woes had I stayed in Rome …

He adored his little girl from the moment he first set eyes on her. He was 'overcome by the tenderness that welled in my heart', and he prayed to God that:

> He grant only that I live long enough to see her married. In the meantime I must submit to being her plaything, for what are we fathers but our children's clowns … Nor is there any pleasure in the world that could equal the delight this brings us … Every childish tear they shed, every cry they give, every sigh that escapes their lips, disturbs our very souls. Not a leaf drops nor a piece of down floats through the air that does not seem a leaden weight that might fall on their heads and crush them …

He supervised every detail of her care and upbringing, showed her off at his dinner parties, and before she could walk began soliciting his wealthy friends and patrons for contributions to her dowry. Adria's mother Caterina Cataneo, who came from a good Venetian family, had entered his service as an 'Aretine' soon after his arrival in Venice and helped him to set up his house on the Grand Canal and entertain there. If we can judge from two portraits of her, one attributed to Titian and one to Tintoretto,[13] she was auburn haired, Junoesque if not quite obese, with a face suggestive of a tough character. She was already thirty-six when she gave birth to Adria in 1537, and a year or two afterwards Aretino found her a husband, Bartolo Sandelli, a wealthy minor nobleman more than ten years her junior by whom she had a son. Although Aretino, out of respect for her reputation and Sandelli's wealth and social position, tried to persuade her to return to her husband, she clung to him, complaining piteously about her husband's chronic unfaithfulness. And so her position in Aretino's house and bed was scarcely changed by the marriage. She continued to organize his parties and act as his hostess, and was recognized and treated by his circle of friends as his partner.

Aretino, feeling his age in his forties – he complained that he was writhing like Laocoön from the pain of gout and syphilis and that he could no longer write at his former speed – was experiencing a range of new emotions, from the joyous astonishment and inevitable anxieties of parental love to obsessive heterosexual passion. It was only now as his beard was going grey that he was able to write to his friend Luigi Anichini, a Ferrarese engraver of gems, that:

Love is a wicked beast and a man who runs at its tail can't be a poet or artist and compose verses or carve gems. I say that it's a monstrous and intemperate appetite that is nourished by strange fancies and longings, and when it seizes a man's heart it also invades and captures for itself his mind and soul and senses. A person in love, therefore, is like one of those raging bulls, urged on by the *assillo*, as in my country we call the spur given by ticks, flies and wasps to horses and asses ...

At the time of Adria's birth he was also emotionally involved with Perina Riccia, the sickly wife of a merchant and twenty-nine years his junior, for whom his feelings were a heady mixture of paternal and erotic. He nursed her through tuberculosis, supported her and her husband, befriended her mother, and suffered terribly when she ran off with one of his assistants, a man closer to her own age. Perina's defection seems to have been his first lesson in the truism that 'Those who truly love cannot cease to do so whenever they wish':

> Though love betrays us, we must endure its perfidies. The soul deprived of the presence and attention of what it loves is like a land devastated by the cruel violence of its enemies and only capable ... of weeping and wailing, hoping by its tears and prayers to be granted, if not mercy, at least compassion ...

His soulmate during this time was Angela Serena, a Sienese noblewoman and minor poet who had nothing in common with Caterina or Perina apart from being married to a dissolute husband, Giannantonio Serena, who if Aretino is to be believed was a bisexual adulterer. Aretino wrote to him in praise of marriage, inviting him to admire with him Angela's 'tresses, scattered over her shoulders and around her temples and neck, shining almost like spun topaz with the subtlety of art, curling around her ears and above her forehead like bees in a meadow; and crystal is not as clear as the limbs of her inviolable chastity, a miraculous treasure in these shameless times ...'. In his *Poems in Honour of Angela Serena*, published by Marcolini in 1537 and dedicated to the empress Isabella, he emphasized Angela's chastity again and again, and it does seem that her appeal lay mainly in her intellect – they read each other's work, discussed philosophy and religion. She died young in 1540 when Aretino's obsession with Perina was at its height. In a long letter to Lope de Soria he wrote about his feelings for both: 'to the one who is still living and to the one who has died I have not failed in any of those things which befit anyone who loves with his whole heart ...'. Although the sad news about Angela had 'widowed my sense of

sight', he had run to Perina's bed, giving no thought to the danger that he might catch her illness.

> Instead I kissed her sunken eyes, her ghastly cheeks, and her sour mouth ... I suppose the fact that her beauty had vanished should have ended once and for all my avid affection for her. Instead, it increased it so greatly that the bowels of the most loving of fathers did not ever so fill with sorrow and pity, as mine did because of her great affliction ...[14]

Perina lived until 1545. Two years after her death – when, after the birth of Austria, her second child by Aretino, Caterina Sandella had settled in as the permanent partner of his old age – Aretino wrote to Daniele Barbaro that when Perina died, 'I died too ... I will live the living death of her illness for ever.'

If the habit of wearing his heart on his sleeve is one of the more engaging sides of Aretino's character, another is his loyalty to his friends and his concern for their children. He tried, unsuccessfully, to pump some energy into the lazy and wayward Pomponio; and acted as Francesco Sansovino's mentor, sent him money when he was in difficulties, scolded him when he disobeyed his father. And he never lost the opportunity to promote the interests of their fathers.

In the first volume of his letters he addressed an open letter dated 20 November 1537 to Jacopo Sansovino, whose transformation of the Piazza San Marco was only just under way and was already subject to endless problems and delays. Andrea Gritti, who was the architect's chief protector, had to contend with an 'anti-Roman' faction in the government, which favoured traditional Gothic architecture over Sansovino's Venetianized High Renaissance style. Some of the shops, inns, brothels, market stalls and all the other businesses that cluttered the Piazza were valuable sources of income for the procurators who owned and leased them. Others, kept by stallholders, such as those who had the hereditary right to sell grain for the pigeons, were privately owned and would have to be moved or their owners compensated. Clearing the Piazza meant prolonged negotiations with the various magistracies and the private owners. It was part of

Sansovino's job to convince the procurators that his improvements would increase the value of their property and rents, and this was something he did with remarkable diplomatic skill. Vasari noted his talent as a businessman and said he was constantly thinking of ways to improve the fortunes of the procuracy. But, although his salary as chief architect to the procurators was more than that of the director of the arsenal and he was given a generous working budget, he was sometimes discouraged by the difficulties and delays and seems to have considered accepting an invitation to return to Rome and work for the papal court.

In his letter Aretino warns him against leaving 'Venetian senators for courtier prelates ... a greeting from these noble Venetian sleeves is worth more than a gift from those ignoble mitres'. He reminds him of the fine apartments he has been given in the Procuratie Vecchie in the Piazza, 'which shows in what esteem the talented are held by this Republic, which marvels at all that you create daily with your hands and intellect'. He goes on to list some of the buildings that have astonished, overwhelmed and aroused the unstinting admiration of all who behold them. In fact they had only just been commissioned and in most cases their foundations not yet laid. Many were still unfinished by the time of Aretino's death in 1556, and some not until after the death of Sansovino in 1570. Nevertheless, Aretino, who must have seen Sansovino's drawings, used his imagination and power of description to encourage his friend by envisaging the final appearance of his unrealized building projects. He singles out for praise the 'Corinthian structure' of the Scuola della Misericordia;[15] the 'rustication and Doric order' of the new mint;[16] the 'carved Doric order with the Ionic above, together with appropriate decoration' of the library of St Mark;[17] the loggetta at the base of San Marco's bell tower, 'with its combination of different stones and marbles ... the form of which is to be composed of all the beauties of architecture';[18] 'the proud roofs of the new palace of the Corner family' on the Grand Canal at San Maurizio;[19] and the church of San Francesco della Vigna.[20]

Andrea Gritti, who lived in the campo of San Francisco della Vigna and was a patron of the church, took a special interest in the

reconstruction of the old Gothic building, and reserved tombs for himself and his closest political counsellors in its presbytery. But soon after he had laid the foundation stone on 15 August 1534 a dispute arose about the proportions of Sansovino's plan. Gritti commissioned Francesco Giorgi, a Franciscan monk, to write a memorandum about the model, in which he opined that, according to the Pythagorean model, the number three was the first real number, and its square and cube contained the consonances of the universe, as Plato and Aristotle, who never went beyond the number twenty-seven in their analysis of the world, had demonstrated. The number three was also sacred as the symbol of the Trinity. What mattered more, however, was not the actual numbers but their ratios, which Giorgio expressed in musical terms. He advised that the proportion of width to length of the nave should be 9:27, which represent an octave and a fifth.[21] Three men were consulted about Giorgio's memorandum: the architect Sebastiano Serlio, who was in Venice at the time preparing his treatise on architecture; Fortunio Spira, a humanist who is now forgotten but was greatly admired by, among others, Francesco Sansovino and Aretino; and Titian. The choice of Titian and his approval of the memorandum raises the intriguing questions of how much he understood about Neoplatonic theories of proportion and musical intervals and whether, consciously or unconsciously, he applied them to the geometry of his paintings.

Aretino meanwhile turned his attention to devising ways of promoting Titian, whose reputation was suffering from his failure to produce a major public painting since the St Peter Martyr. The wild but talented medallist and sculptor Leone Leoni, a fellow Aretine and possibly a relative, was in Venice at the time under Aretino's protection, so he was in a position to order from him the medal portrait of Titian that is the earliest secure image of him we have. He is shown in profile, as Roman emperors were on antique medals, and in one version Aretino's portrait is on the other side. At the same time the Secretary of the World thought up a plan that would serve the double purpose of advancing Titian's friendship with the emperor while producing the chance of a nice income. In 1536 Titian had finished a

very large altarpiece of the Annunciation for the nuns of the church of Santa Maria degli Angeli on Murano. When they baulked at his asking fee of 500 ducats Aretino suggested that Titian send it instead as a diplomatic gift to the empress Isabella. Titian took his advice and added the emperor's insignia 'PLVS VLTRA' scrolled between the angels at the top corners of the painting. Charles, just as they had hoped, rewarded him with the promise of a pension of 100 scudi per annum to be paid from the treasury of Milan.[22] Isabella's Annunciation disappeared during the Napoleonic wars. But the fine engraving by Jacopo Caraglio made in 1537, probably under Titian's supervision before it was dispatched to Spain, suggests that it was an unprecedented treatment of a subject that had previously been depicted as a moment of quiet, private joy. This Annunciation was as dramatic and almost as large as the Frari *Assunta* in which God the Father bursts out of the mysterious blackness of heaven to receive the Virgin Mary. Now at the moment of her Immaculate Conception the heavens open, inspiring awe and terror as the dove of the Holy Spirit descends upon her through supernatural rays of light. The nuns of Santa Maria degli Angeli, who may have found the painting too theatrical for their tastes as well as too expensive, commissioned the more obliging Pordenone to paint something more peaceful for their altar.

Titian's interpretation of the Annunciation closely paralleled Aretino's ecstatic, highly charged description of the event in his *Humanity of Christ* published in 1535, and both may have been inspired by the vision of Ezekiel in the Old Testament in which Ezekiel is so overwhelmed by terror that he falls on his face.[23] Aretino echoed his earlier account in a letter to Titian dated November 1537 that colours in Caraglio's black and white engraving with his account of the dazzling 'refulgent light shed by the rays of Paradise', the rainbow over the landscape at dawn, 'the heavenly majesty' of the countenance of Gabriel, whose 'cheeks tremble under the flesh-tints of milk and blood which your colouring has rendered so true to Nature'.

·I say nothing of the Virgin herself ... because you have painted her in such a fashion and so marvellously that our eyes, dazzled in the light

of her gaze ... cannot bear to look at her. In the same way, because of its strange brilliance, we cannot praise enough the scene you are painting in the Palace of St Mark to honour our nobles and to reprove those who cannot deny your genius and mine and so put you in the first rank as a mere painter of portraits and me there as a slanderer, as though your works and mine could not be seen by the whole world.[24]

In this last sentence Aretino is rebutting claims that his friend, now well into his forties, has sold his artistic soul to the 'mere' art of portraiture, an easier and more profitable but less respected genre than the religious and mythological paintings with which he had made his name in the 1520s. The Annunciation was his first large public altarpiece since the St Peter Martyr. In the intervening years he had produced some forty portraits and a few small religious paintings for private patrons. But the 'scene' Aretino said he was painting in the palace of San Marco was one of the largest and most important public works of his career. It was The Battle of Spoleto, one of the cycle of history paintings for the Great Council Hall, which Titian had managed to put off since 1513 when as a young man seeking recognition in Venice he had persuaded the Council of Ten to let him paint 'not so much from the desire for profit as to acquire some little bit of fame ... to put into that task all my intellect and spirit for as long as I live'.

SEVEN

An Old Battle and a New War

Something at once courtly and homely, a great intimacy or
naïveté of perception which enchants us in the work of Gentile
Bellini, or in the pictures by Carpaccio, and Titian's frescoes at
Padua, recurs again in the 'Presentation', perhaps for the last time
in Venetian art.

CHARLES RICKETTS, *TITIAN*, 1900

Titian cannot have been surprised by the decision of the Council of
Ten to revoke his brokerage on the German exchange house and order
him to refund the annual payment of more than 100 ducats that he
had been receiving while they waited for the battle scene for the Great
Council Hall.[1] Twenty-four years had passed since he had offered 'to
make this work with such speed and excellence that you will be very
happy with it'. He was not the only holder of a *sanseria*[2] to abuse the
system, but he had done so in an unusually high-handed way, and he
must have been aware of the increasingly loud grumbles in govern-
ment circles that he had been working for foreigners while living on
the brokerage, which, unlike the emperor's annuity, had been paid
regularly by the state since he had completed Giovanni Bellini's
Humiliation of Frederick Barbarossa in 1523. So far he had got away
with his cavalier behaviour because there was no painter in Venice
who could match his genius or his social skills. Titian, as Vasari put it,
'had rivals in Venice, but none of much talent, none that he did not
crush by his excellence and his knowledge of the world in converse

with gentlemen'. But now the Friulian painter Giovanni Antonio Pordenone had returned to Venice, and in the November after its demand that Titian should repay the government the Council of Ten, with the backing of Andrea Gritti, offered Pordenone the canvas next to the space reserved for Titian's Battle. Although he had more experience with painting large frescos than working with oil on canvas Pordenone was a master of the exaggerated, violent foreshortening with images bursting through the picture plane that was in vogue at the time.[3] He was decorating ceilings in the ducal palace and had impressed the Council of Ten as an artist who was more reliable and in their view probably talented enough to continue the cycle of history paintings in the Great Council Hall in which Titian had apparently lost interest.

Doge Gritti, enfeebled by old age and occupying an increasingly lonely stance in government, was no longer in a position to continue protecting Titian from what would have been a serious financial setback as well as the humiliation of being replaced by Pordenone as the government's most favoured painter. Venice, for the first time since the peace of 1503, was slowly coming to terms with the inevitability of another all-out war against the Turks, who began to confiscate Venetian estates and merchandise in the Levant. In September 1537 the Senate voted for war, but against the advice of the doge. And still the Venetians hesitated. Suleiman's hand was immeasurably strengthened by his alliance with Francis I, which had been formalized the previous year, while the Republic was as yet without allies. Aretino now stepped in and on 18 September addressed to the French king one of the most important and widely circulated political letters of his career. He advised Francis to break his alliance with the Turks and join the pope, the emperor Charles V and the 'religious, most excellent and magnanimous Venetians' in their crusade against the great monster whose arrogance had enslaved his friendship. The world, Aretino proclaimed, was asking what was in the most excellent heart of the French king: Was it hatred for others or was it the love he owed to God? If it was hatred what was the meaning of his title 'Most Christian King'? If it was love the Holy League would not merely

accept him but would enfold him in its arms. 'You, you must clear the mind of the purest and most noble king there ever was. Where, Francis, is the valorous prudence, which has enriched you with so many triumphs? It is still with you. Listen therefore to the supplications of the Church and the will of your own people. Here is Paul who calls you, here is Charles who accepts you, here is [St] Mark who exhorts you to proceed with all speed – you will be praised for haste and will regret delay – resolving that any consideration regarding your worldly arrangements with men is a wrong that you do to Christ.'

Aretino, as so often, was anticipating events: Venice had not yet gone to war and the league with the pope and emperor was not formulated until the following year. The letter, however, succeeded in damaging the reputation of the French king among his own people as well as throughout the rest of Europe. It won the unstinting praise of Alfonso d'Avalos, of the Spanish ambassador in Venice Lope de Soria, and of Gasparo Contarini. The Constable of France, the Duke of Montmorency, responded with an offer from Francis to double the emperor's pension of 200 crowns if Aretino would write about the emperor and the French king 'more accurately'. Since Charles's latest payment was overdue, and it was in the interests of the government of St Mark that he should maintain his pressure on Francis, he did not refuse.

On 1 May 1538 the Secretary of the World wrote to Francis again. Paul III, who had maintained his position of neutrality in the struggle between Francis and Charles, was planning a conference at Nice where he hoped to enable an alliance of all Christian states against the Turks by engineering reconciliation between the Most Christian King and the Holy Roman Emperor. Given their mutual hatred and continuing dispute over possession of Milan, it would not be easy. But Francis, who was bankrupt and aware that Charles had the upper hand in Milan, was already half inclined to give in to the pope's exhortations. Aretino's letter was an attempt to tip the balance of his indecision in the pope's favour, but he used flattery rather than condemnation and offered the king a lesson in statecraft that for cynicism and grasp of realpolitik could not have been bettered by Machiavelli.

Francis, he wrote, was too sensible, valorous, generous and open-hearted for his own good. If he would only temper the sweetness of his most excellent being with keen attention to the realities of modern statecraft he would have grasped the first step towards wisdom, which was to use 'deceit and pretence almost as though guided by military tactics'. He had already proved the goodness of which he was the very personification by failing to conquer Italy when Charles's entire army and navy were away fighting in Tunis. And who but Francis, through his alliance with the Turks, had brought the infidels among Christians? 'The interest of him who reigns has nothing to do with the finer points of law, he knows nothing of formalities, he does not give in to illusory honesty, and once he becomes the lord of his government everything that is forbidden is allowed and every reproof is praise.'

The implication was that there was nothing to prevent him from doing what was in his best interests, which was to restore his damaged reputation by abandoning his formal alliance with the Turks and joining forces with the pope and the emperor. The Congress of Nice lasted from 15 May to 20 June. Since Paul was unable to persuade Francis and Charles to meet there in person, he appointed three cardinals to represent each of them, and Francis was finally persuaded to sign a ten-year truce. In December of the following year Aretino asked Giuseppe Porta Salviati to send a portrait of himself to Francis[4] with a letter in which he said that even Titian, 'the life of the brush and colour of nature, who has represented my face, cannot show my heart, because if that had been possible, in the ardent centre of it you would have seen the image of Your Highness'. The Treaty of Nice did not last, and no joint action against the Turks was undertaken.

We don't know when Titian started the battle scene for the Great Council Hall – he may have done some work on the canvas over the years – but we do know that he had finished by August 1538, only a little more than a year after the threatening decree from the Council of Ten. And we can see how he planned it from a marvellously vigorous preparatory drawing (Paris, Louvre, Cabinet des Dessins)[5] in black crayon and white chalk on blue paper from which one can

surmise that he owed the basic arrangement of his composition to Leonardo da Vinci's cartoons for his *Battle of Anghiari*. There also exist a number of drawings for the horses and riders.[6] These sketches for the battle, of which there are more than for any of Titian's other paintings, were presumably for the use of one or more assistants, without whom he could not have finished such a large and complex work in time to avert financial disaster, especially as it was one of the most elaborate and at nearly six metres high perhaps the largest he ever painted. All the other artists who had so far worked on this scale for the Great Council Hall had used assistants, and in this case the overall composition was more important than the quality of the brushwork in a very large painting that would be impossible to see in detail when it was placed high on a wall between two south-facing windows.

Like the other two great Renaissance battle scenes by Leonardo da Vinci and Michelangelo for the Great Council Hall in Florence, Titian's is lost. But we have some idea of how the completed work looked before it was destroyed in the fire of 1577 from an engraving of it by Giulio Fontana, from the survival of one of a number of painted copies and from contemporary descriptions. The writers Anton Doni, Lodovico Dolce and Vasari singled it out as one of the principal attractions of Venice. El Greco, who knew Titian's work well and may have been in his workshop in 1570, thought it his supreme masterpiece. Vasari described it as 'a fury of fighting soldiers while a terrible rain falls from heaven, which work, taken entirely from life, is held to be the best of the histories in the room and the most beautiful'. But Vasari, or the assistants who helped him with his biography of Titian, was confused about its subject. It was not a viewpoint that could possibly have been taken from life even if the artist had been present at the battle, and its subject was supposed to be the Battle of Spoleto, which according to legend had taken place in the twelfth century. Perhaps Titian later confessed to Vasari that he had based the setting on a place near Pieve di Cadore that he had known well since childhood and on accounts he had heard from relatives who had taken part in the Battle of Cadore in which the victorious Venetians

had been commanded by Bartolomeo d'Alviano. But Vasari wrote that it represented the rout of Ghiara d'Adda (now Gera d'Adda), a battle that d'Alviano had actually lost in 1499.

Dolce in a brief reference just called it a battle. Ridolfi, who was born many years after it was destroyed, knew the Fontana print but must also have seen one of the painted copies when he described it as 'the armed encounter at Cadore between the imperial troops and the Venetians' in which 'he imagined the natural site of his hometown with the castle situated above on a high mountain where the flash from a lightning bolt in the form of an arrow is suspended.[7]

Francesco Sansovino, whose father Jacopo was one of Titian's closest friends, recognized that the battle scene was intended to represent the episode in the cycle of history paintings in which the emperor Federick Barbarossa destroyed Spoleto in 1155:

> With surprising industry and art Titian represented the Battle of Spoleto in Umbria, where – conspicuous above all others – a captain, awake on a sudden to the noise of a fight, was armed by a page. On the front of his breastplate there shone with incredible reality the lights and reflections of arms and the clothes of the page. There was a horse of extreme beauty and a young girl rising from the depth of a ditch to its banks, in whose face the utmost terror was depicted. And beneath this piece there was no inscription.[8]

It is this missing inscription, which had clearly identified the subject of the ruined fresco, that has given rise to continuing speculations that Titian transposed the legendary medieval battle to the setting of a Venetian victory in order to please Doge Andrea Gritti, who hoped that the scene would remind those who caught the reference to the freezing day and night in March 1508 when the Venetian cavalry had destroyed the invading forces of Charles V's grandfather the emperor Maximilian of Habsburg. If so, it seems an oddly impolitic reference at a time when the Venetian government was in need of Charles's support against the Turks; and we can be reasonably certain that although Titian imagined the battle as having taken place in his

native territory the subject he was asked to paint was the Battle of Spoleto.[9]

It would be going too far to suggest that Titian's battle was a Renaissance *Guernica*, but representations of the horror and confusion of real battles, which claim innocent victims as well as armed warriors, were unusual in Renaissance Italy; and it was doubtless for that reason that Dolce singled out only one of the 'extremely notable features': the young woman, also mentioned by Ridolfi and Sansovino, 'who has fallen into a ditch and is climbing out: she uses the bank for support with a stretch of the leg which is highly natural, and the leg gives the impression not of painting, but of actual flesh'. But Titian must also have taken particular pleasure in painting the suits of armour. His researches for Federico Gonzaga's Emperors, which he had not yet completed, were on his mind. He had also made close studies of the cuirasses loaned to him by Francesco Maria and Guidobaldo della Rovere. And as he sketched the model for the battle scene, the pose of his Emperor Claudius wearing Guidobaldo's cuirass stood in for the commander in the bottom-right corner the line of whose outstretched right arm is continued by the cannon that points to the horseman on the bridge.[10]

Titian's *sanseria* was reinstated in August 1539; and although he never produced another history painting for the palace he retained it for the rest of his life, despite two later attempts to revoke it.[11] The Council of Ten was from now on more cautious about granting *sanserie* to artists,[12] but it may be that Titian struck a deal with the government that allowed him to fulfil his obligation by continuing to paint some of the ducal portraits that hung above the history paintings.[13]

Although the loss of Titian's only history painting leaves a gaping hole in our appreciation of his output in the second half of the 1530s, another very large but entirely different kind of painting that he must have finished around the same time is still to be seen in the Accademia Gallery, in the former *albergo* or meeting room of the Scuola Grande della Carità.[14] A competition for a 'story of Our Lady as she was presented in the temple', which was to be one of a cycle of

canvases illustrating the life of the Virgin, had originally been won in 1504 by a minor painter who died soon afterwards. The board of the Scuola, in true Venetian fashion, waited another thirty years before it became sufficiently embarrassed by the superior standard of decorations in the other Scuole Grandi to invite Titian to paint the *Presentation of the Virgin in the Temple* – the apocryphal story is told in Jacobus de Voragine's *Golden Legend*. He received the commission on 29 August 1534 and was planning it at least by the following February when the officers of the Scuola decided to adapt the windows to the left of the wall 'in order to give light to the painting going on in the room'.

For Titian the job presented a number of challenges, one of which was the sheer size of the painting, which would stretch seven and a half metres along the entire length of one of the long walls of the room and have to make allowance for an existing entrance door. He would have to find a way of reconciling the by now retardataire narrative tableaux painted for Venetian Scuole around the turn of the century by Gentile Bellini and Carpaccio (a genre which Titian had himself rendered obsolete with his frescos in the Paduan Scuole di San Antonio more than two decades earlier) with the artistic requirements of the 1530s for more complex, sophisticated and livelier paintings. Whereas the older generation of 'eyewitness' painters had shown the members of the Scuole processing through a literal representation of Venice – chimney pots, bridges, buildings and all – Titian's *Presentation* is a capriccio, a fantasy incorporating real and imaginary visual elements from a wide variety of sources, so that as Burckhardt put it,[15] 'The real subject is nearly overlaid by the crowd of accessory motives, which are indeed represented with astonishing freshness and beauty.'

What is most immediately striking about the *Presentation* is the unusual weight Titian gave to its architectural setting, which suggests that he discussed it with his architect friends Jacopo Sansovino and Sebastiano Serlio. He borrowed a number of his motifs from treatments of the same subject by Cima da Conegliano and Carpaccio; and from Jacopo Bellini, whose sketchbooks he had studied as a young

apprentice in the studios of Jacopo's sons Gentile and Giovanni. Just as Jacopo had alluded to the doge's palace in his paintings of Solomon's temple, the patterned pink and white bricks of the wall of the building on the right of Titian's *Presentation* allude to the analogy between the ancient and modern temples of wisdom and justice. Jacopo's versions of the same subject had also used the porch of pillars on Solomon's temple described in I Kings 7: 6 and the same vantage point for the steps seen from the side on which the little girl ascends to meet the high priests of the temple. Titian, like Jacopo, incorporated an obelisk, a symbolic representation of the sun's rays according to Pliny's *Natural History*, which in the Renaissance had come to stand also for Christian light. Titian's obelisk may refer to the Christ Pantocrator in the central roundel of the ceiling of the room who holds an open book displaying the words *Ego sum lux mundi*, I am the light of the world. An obelisk in any case was a standard feature of stage sets and was often used in paintings of the Presentation of the Virgin.[16] Below it, on the far left, a woman holding a baby receives alms from a member of the confraternity, whose primary purpose was to provide for the poor.

Lit from the left, the actors, among them such incidental characters as a turbaned Turk, a Roman centurion, a little boy baiting a dog with a biscuit, contemporary Venetians leaning out of windows or from balconies, move and gesture towards the ascending *piccola Maria*, as Venetians affectionately call her, 'sparkling like a sapphire in her nimbus of pale gold'[17] against one of Titian's most breathtaking landscape backdrops, where an escarpment very like the one with which he had 'signed' his fresco of the *Miracle of the Jealous Husband* in Padua and the craggy blue peaks of what looks like Monte Tre Pietre or Monte Pizzocco as seen from Sedico on the road that runs along the Piave from Venice to Cadore rise into billowing white clouds. This was not the last time he would evoke his native landscape, but it was the last time he would paint it in such specific focus. Directly beneath the twinned mountains Mary's parents, Joachim and Anna in antique dress, lead a procession of the chief officers of the Scuola and other members of the board wearing their flat black caps and official robes, each one an individualized portrait. Vasari, when he wrote that Titian

had included 'all kinds of heads depicted from life', set the competition to identify them. Ridolfi wanted the man in the red robe to be Titian's friend Andrea de' Franceschi, the serving grand chancellor of Venice at the time, whose portrait he had painted twice in the early 1530s. De' Franceschi was a member but not an official of the Scuola, and Titian's portraits of him do not resemble this man, whose red robe and black stole suggest that he was the chief executive. Later writers have thought they saw Bembo in the high priest, as well as Aretino, Titian and his daughter Lavinia in other characters.

But who are the three ornamental ladies at the foot of the steps? Titian took them virtually unchanged from Raphael's cartoon for *Paul Preaching at Athens*,[18] which was in the collection of Cardinal Grimani. And who is the old hag, one of the most discussed of the 'portraits', sitting with her chickens and basket of eggs by the side of the steps? Erwin Panofsky, who famously called her the 'horrid egg woman',[19] thought she represented unconverted Judaism. Others maintain that she is nothing more than a deliberate quotation of the similar figure who appears in Cima's *Presentation* and Carpaccio's *Reception of the English Ambassadors*. As with so many Renaissance paintings there will always be a tension between commentators who search for iconographic meaning and those who believe that in Titian subject and meaning is subordinated to sensuousness of colour and pictorial design.[20]

And there has always been a division of opinion between those who feel affection and admiration for Titian's *Presentation of the Virgin* and those who see it as a banal return to an outmoded tradition of narrative painting – or worse. For the English Romantic John Ruskin it was:

> To me simply the most stupid and uninteresting picture ever painted by Titian. The colour of the landscape is as false as a piece of common blue tapestry, and the 'celebrated' old woman with the basket of eggs is as dismally ugly and vulgar a filling of a spare corner as was ever daubed on a side scene in a hurry at Drury Lane.

But for Hippolyte Taine, the French champion of naturalism, it was, unlike the works of Florentine painters who created a detached, abstract, idealized world, 'more spontaneous and happier' because 'Titian loves our world, he understands it, he lives within it, and he reproduces it embellishing without recasting or suppressing it'.[21]

The officials of the Scuola, who seem to have been singularly uninterested in art, evidently did not care much for it. Perhaps they were put off by the brushwork, which is looser and more expressive than anything seen in previous narrative paintings for the Scuole Grandi. At their annual meeting on 6 March 1538, when Titian's painting must have been all but finished,[22] they recorded their decision to commission the next picture in the cycle from Pordenone. They asked him for an Assumption of the Virgin, but it was noted that Pordenone had come to the Scuola and explained that that late episode in her life did not follow on from the subject painted by 'the most excellent master Titian' and a vertical picture was the wrong shape for the space allocated to it. He proposed instead a Marriage of the Virgin, but in December he left for Ferrara and died there early in the new year of violent stomach pains and diarrhoea.[23] The board of the Scuola Grande della Carità remained so indifferent to the masterpiece that is now one of the star paintings in the Accademia Gallery that in 1572 they cut a new door into the left side of the painting, thus chopping off the legs of their predecessors.

Titian's *St John the Almsgiver*[24] (Venice, Church of San Giovanni Elemosinario), another of his rare public paintings of the 1530s, is much less visited because its quality was for a long time obscured by destructive treatments in the nineteenth and twentieth centuries and the church was closed for many years before a restoration in 1989–90 removed overpaintings and layers of yellow varnish. Now that the church is open, those who take the trouble to find it behind the market stalls that spill out from the Rialto can judge for themselves whether they agree with Ridolfi that 'he showed in the saint's face and in his grey hair the idea of a perfect man standing and giving alms to a poor man, exchanging in the bank of heaven golden coins

for gems of glory'; or with Antonio Zanetti[25] that it was as remarkable for its massive definition of parts and its brushstrokes 'of determined conclusiveness'; or with Crowe and Cavalcaselle,[26] who saw it in 'dim and dusty' light after some restorers had done their worst and squared off the arched top, that it was nevertheless 'one of the finest works of the master's middle time'; or with Johannes Wilde:[27] 'The saint's appearance is imposing and calm. The colours do not disturb this calm: plum-red, the blue of ripe figs, and a gold-green have been extended on broad planes and are shown in innumerable tone values.'

From what Vasari has to tell us the altarpiece seems to have played a part in Pordenone's brief and doomed attempt to gain supremacy over Titian in Venice. In his 'Life of Titian' Vasari wrote that Titian, after his return from Bologna,

> found that a number of gentlemen who had taken Pordenone into their favour (giving high praise to the works executed by him on the ceiling of the Sala de' Pregadi and elsewhere) had won for him the commission to paint a little altarpiece in the church of San Giovanni Elemosinario [*Sts Catherine, Sebastian and Rocco Shown the Way by an Angel* in the chapel to the right of the high altar]. This was so that he should do something in competition with Titian, who shortly before had painted for the same place a picture showing St John the Almsgiver in the robes of a bishop. However, for all the diligence with which he worked, Pordenone's altarpiece fell far short of Titian's work.

Vasari, who thought that Titian had gone to Bologna in 1530, was thus placing the picture at shortly after that date. In his 'Life of Pordenone' in the first (1550) edition of his *Lives* he said it had been painted in Pordenone's lifetime, that is before 1539. If he was correct, which of course he often was not, Titian could have painted *St John the Almsgiver* while he was working on the *Presentation of the Virgin* or soon after he finished it. Some scholars,[28] citing the thick overlapping brushstrokes and subdued colours lit by flashes of light that characterized Titian's later style, have preferred to place it in the

middle or late 1540s. But the protean Titian, who was able to change his style to suit his subject or the taste of a patron, has a way of fooling those who try to date his paintings by their style alone. The earlier date, furthermore, is supported by the likelihood that the painting was commissioned by Andrea Gritti, who had ordered that the church should be rebuilt after a fire in 1513 and who as its patron had the right to appoint its curates.

Andrea Gritti was eighty-four when he died on 28 December 1538 apparently from eating too many grilled eels on Christmas Eve. Titian had probably begun his portrait of him for the frieze above the cycle of history paintings in the Great Council Hall soon after losing his state brokerage. But Gritti never saw the portrait, which was not finished until 1540 when Titian received the customary fee for a ducal portrait of twenty-five ducats; and we know it only from replicas and variants.[29] The best record we have of his forceful personality (Washington, DC, National Gallery of Art)[30] was probably an unofficial commission for his family, and since it is lit from the right, which is unusual for right-handed artists, intended for a specific place. It is all the more imposing because the canvas has not been relined and the detail of the brushwork survives.[31] Gritti had supervised all the arrangements for his funeral. Bernardo Navagero, brother of Andrea Navagero who had died in 1529, delivered the oration at the formal ceremony in Santi Giovanni e Paolo, but the doge chose to be buried in San Francesco della Vigna, his parish church, which he had had rebuilt by Jacopo Sansovino, and where his tomb can be seen today to the left of the main altar. Although few can have disagreed with Benedetto Agnello that he had been 'a wise doge for these troubled times', Gritti's last years had not been happy or politically successful. His robust constitution was worn down by a lifetime of unstinting expenditure of energy on behalf of the Republic. In 1530 he had suffered a bout of melancholy after a bad fall that left him temporarily unable to walk. The death of his son Luigi in 1534 had nearly broken his spirit. He recovered well enough to refuse advice that he should renounce the excessive pleasures of the table to which he had been addicted all his life. But it cannot have escaped his sense

of irony that the government of the Venice Jacopo Sansovino was transforming into a New Rome was in trouble.

Gritti's lifelong Francophilia had been compromised by the alliance of Francis I with the heathen Turks and his policy of neutrality shattered by the Senate's decision to go to war at sea against the Turks. Although Francis had agreed to a ten-year truce with Venice and the papacy in the May before Gritti died, in September Suleiman's most feared admiral and corsair, Khair ed-Din, known as Barbarossa, defeated Venice and the papacy in a naval battle off Preveza in the Gulf of Arta which marked the start of a war that would end with Venice worse off than when it began. With Charles V persuaded by his sister Mary, regent of the Netherlands, to limit his objectives and his Genoese mercenary commander Andrea Doria less interested in victory than in maintaining his fleet intact, Venice found itself bearing the brunt of a hopeless and unfocused war.

Pietro Lando was seventy-seven when he succeeded Andrea Gritti on 19 January 1539 after a hard-fought electoral battle against the seventy-year-old procurator Francesco Donà. The new doge was said to be still a handsome man when Titian painted a votive portrait of him for the Collegio three years later, but that picture was destroyed in the fire of 1574. Lando had studied humanities and philosophy as a young man, but had begun practising as an advocate when he was eighteen in order to support his family, which was neither rich nor one of the oldest of the patrician clans. He proved himself an able bureaucrat in a succession of government posts and a distinguished captain general at sea before his election to the procuracy, the antechamber of the doges, in 1535. He assumed with his doge's hat what was in many ways a poisoned chalice. The government of the Most Serene Republic was going soft and becoming ever more open to corruption. The price of grain was inflated by severe shortages. Petty rulers who had once been happy to trade on favourable terms were now in the hands of the papacy, the emperor and the Turks, all of whom drove harder bargains. There was flooding on the mainland. The plagues that had formerly controlled the size of the population had ceased for the time being, but the city was infected with a

breakdown of morale. The state was insolvent, the rich too lazy and pampered to think of embarking on the war galleys, the poor struggling to ward off starvation.

As the Turkish war ground on, Lando's government took the decision to offer the sultan, if absolutely necessary, up to 300,000 ducats for a truce that would give Venice ownership of Nauplia and Malvasia. Although the decision was of course highly classified, French spies managed to penetrate the secretariats of the Senate and the Council of Ten. A certain Agostino Abondio, an employee of the French ambassador in Venice, bribed two brothers, Constantino and Nicolò Cavazza, secretaries to the Council of Ten and the Senate respectively, to leak information about the concessions the Venetians were prepared to make, which the French ambassador passed on immediately to Constantinople. The plot was not uncovered until 1542, when the lover of Abondio's wife found incriminating evidence that pointed also to a number of corrupt Venetian patricians. So when it came to negotiating a peace treaty in 1540 Venetian diplomats were in the dark about the reasons for the sultan's adamant refusal to bargain, and on 2 October Venice, in addition to agreeing to pay the enormous sum of 300,000 ducats in instalments, was also obliged to sign away the fortresses of Nauplia and Malvasia, the last Venetian trading posts in the Peloponnesus, as well as islands in the Aegean that it had previously held.

But Lando, who presided over the sorry end of a war that had not been of his making, turned out to be a capable leader. In the six years of his reign the machinery of government was reformed and strengthened with the creation of new offices and magistracies, one of which was specifically created to prevent further leaks of state secrets. Nor were the terms of the truce entirely unfavourable to Venice. Suleiman was diverted in the coming years by wars in Persia, and although the Ottoman officials required Venetian trading galleys to gain official licences to enter and leave Turkish waters, Venice retained the right to continue sending merchant fleets to Alexandria, Beirut and Tripoli. By April 1541, when relations with the Turks were stable enough for the Republic to turn its attention towards the restitution of Venetian

prisoners, Aretino addressed one of his most grovelling letters, sent with a silver portrait medal of himself, to none other than 'Khair ed-Din Barbarossa King of Algiers'. Barbarossa was not a king. He was Suleiman's viceroy of Algiers. Aretino flattered him with his praise of the 'famous king, worthy pasha, unconquered captain and egregious man' and the valour and wisdom that maintained the favour of 'his tremendous and benign majesty Suleiman, mightiest of emperors', advising him that Christian pens, despite their different religion, had described his triumphant adventures in books that would preserve him from being forgotten; and so why not, 'when the fortunes of war give to you as prisoner some poor Frank or other, treat him with clemency, remembering the obligation that your lofty greatness has to those whose pens have given you immortality'? The outrageous flattery was successful. Barbarossa replied with a letter addressed to 'The first among Christian writers Pietro Aretino' in which he observed that the portrait of his magnificent visage had impressed the grand vizier, and that he, Barbarossa, wanted to meet 'the writer with the face of a soldier'.

When in late October 1541 Charles V launched a delayed and ill-advised attack on Barbarossa's Algiers – funded in large part by the treasuries of Naples and Sicily – Venice wisely did not take part. The emperor was forced to retreat after only a week during which the imperial fleet was battered by a violent storm. Aretino, with his eye on his imperial pension, wrote to the emperor praising the resourcefulness and fortitude he had shown in the face of a battle that had been won by the weather, describing – as he had done before in relation to the failure of the imperial army in Provence – what had actually been a humiliating defeat as a victory, 'Whereby the supreme and sacred name of the great Charles has become a marvel which will hold the world in continuing admiration'. The world maybe, but not the Republic of Venice, which had learned the lesson that Andrea Gritti had failed to impart: it was not strong enough to fight the Turks alone and it could not count on allies. Its policy of peace was justified only a year later after the defeat at Algiers when an attempt by Ferdinand of Austria to reconquer part of Hungary proved another disaster for

the Habsburgs. So it was that for the next thirty years of Titian's life the Most Serene Republic of Venice remained at peace, and as a French historian writing in the nineteenth century put it, the history of the Venetians flowed on 'without being marked by any events worthy of the attention of posterity'.[32]

Titian in his Fifties

Certainly your brush has kept its miracles for the
ripeness of your old age.

ARETINO TO TITIAN, JULY 1542

If Titian and Michelangelo were one body, or if the *disegno* of
Michelangelo were joined with the *colore* of Titian, you could call
him the god of painting, exactly like real gods, and whoever holds
a different opinion is a stinking heretic.

PAOLO PINO, *DIALOGO DI PITTURA*, 1548

When Titian reached the then venerable age of fifty, his career was at
a low ebb. In the 1520s he had juggled commissions from Alfonso
d'Este, Altobello Averoldi, Broccado Malchiostro, Alvise Gozzi, Jacopo
Pesaro and Federico Gonzaga. The Death of St Peter Martyr,
completed in 1530, was universally regarded then and until it was
consumed by fire in the nineteenth century as his supreme master-
piece; and for the rest of that decade continuing demands from
Federico Gonzaga, Francesco Maria della Rovere, the Scuola della
Carità, the ducal palace and not least the emperor and his entourage
had stretched him and his workshop to the limit. But by 1540 four of
his most appreciative and powerful patrons were dead: Alfonso d'Este
in 1534, Francesco Maria della Rovere and Andrea Gritti in 1538,
Federico Gonzaga in 1540. His battle scene for the Great Council Hall

and *Presentation of the Virgin* for the Scuola della Carità had proved that he could paint difficult subjects with many figures on a very large scale. Nevertheless, the most lucrative commissions that came his way were for portraits.

Meanwhile there was trouble at home. Titian's second marriage and the birth of his daughter Lavinia were blows to the adolescent Pomponio. Insecure at the best of times as the motherless child of a famous father, Pomponio had more reason than most teenagers to wonder who he was and where he stood in the world. Although his lack of vocation for the priesthood cannot have been unusual at a time when 3 per cent of the male population of Europe were in the Church in one capacity or another, he must have felt, as he approached manhood, that his father had as good as disinherited him. And he may have been right. Although Titian's ostensible motive for choosing the priesthood for the boy was to spare him the hardships and uncertainties of an artist's life, he may also have disliked the idea of interference from anyone, least of all his elder son, with his own evolving creativity. As a priest Pomponio was excluded from the studio, the centre of Titian's life and thoughts, where the younger Orazio would take the place as his father's chief assistant and heir that would normally be given to the first-born. Pomponio could never marry, could never continue the Vecellio line with legitimate children, and if he had had children (which he never did) could not have passed on property to them. Nevertheless, when the boy threw aside his studies for the priesthood and fled from Biri Grande to Cadore, Titian cared enough to turn for help to Aretino, who obliged him by writing to 'Pomponio, my little monsignor':

Your father Titian has just brought me the greetings you sent, and they pleased me hardly less than the two grouse that came with them, which I was supposed to present to another gentleman in his name but instead gave to myself. And now that you have seen how generous I am allow me to pay you back 'a thousand, thousand times, singing all night long' as the saying goes; and asking that you give the leanest of them to your pretty little brother Orazio since he has forgotten to tell

me how goes his latest fancy for spending, as soon as he can, this world and the next. Your thrift is a better way of getting worldly goods and since you are to be a priest I don't believe you will ever have to depart from the order of Melchizedek.[1]

And so, he continues, he wishes the boy good health, but has 'worse to say':

It is time to return to your studies, and since as far as I know there are no schools in the country, the city must be the fur coat that keeps you warm this winter. Come away, and with the twelve years that you have try some snacks of Hebrew, Latin and Greek. I want us to drive all the learned doctors in this world to despair just as the fine things your papa does drive mad all the painters in Italy. That's all. Keep warm and in good appetite.[2]

But the Aretino whose mighty pen could persuade the most powerful rulers in the world to do his bidding could not lure Pomponio back to his studies for long. Several years later Titian, in the postscript to a letter to his first cousin Toma Tito Vecellio, a notary in Cadore, wrote, 'About Pomponio I say nothing because I know that he is putting on weight and is a great one for hunting birds with falcons. Soon the cold will drive him away from Cadore.'

The body of the letter to Toma Tito, which Titian wrote from Venice on 23 September 1539, was about a more immediately urgent family matter. His sister Dorotea, now getting on for fifty and still living in Cadore, had recently been widowed. She relied for her living on the dowry, worth in excess of 700 lire (110 ducats), which had been provided by their grandfather Conte on her marriage to Matteo Soldani in 1508. But the notarized affidavit confirming Dorotea's dowry had been lost during the Cambrai war in a raid on Cadore by the emperor Maximilian. There was a claim against the estate of her late husband, and without proof of her legal right to the dowry it could be regarded as part of his estate. Although there can be no doubt that Titian was concerned for the financial security of his sister,

it was also in his own interest that she should retain her dowry. If her right to it could not be proved, he would have to repay the money raised against it, and it would have fallen upon him and the rest of the family to support Dorotea in her old age. Titian requested Toma Tito to ask for the help of his father Antonio, also a notary, and of Dorotea's brother-in-law, Ser Tomaso, and to read to Dorotea a letter he was writing to her on the same day with instructions about how to proceed. She must appoint as her agent an attorney by the name of Alexandro Ziliol, giving him the power to act for her in all respects, then have the legal document he has drawn up sent to Titian. Meanwhile she should try to remember the names of some of the witnesses to the dowry agreement, have them questioned by the Venetian representative in Cadore and see that the deposition is sent to the judges dealing with dowries in Venice. 'Do all these things as quickly as possible, because time is of the essence, since I am being pressed by our adversary to give him the money that we raised, so do not be wanting for diligence and prompness, and be well.'

On 16 October three men who had been present at Dorotea's marriage testified before a judge appointed by the Council of Cadore that the value of her dowry had been something between 700 and 800 lire. And since we hear nothing more about the matter it can be assumed that Titian's legal action was successful.

On a visit to Cadore the following September Titian used his power as a count palatine for the first time to appoint another first cousin, Vincenzo Vecellio, as notary. (Two years later, Vincenzo sold Titian and Francesco two sawmills at Ansogne, near Pieve, for the bargain price of thirteen ducats.) But Titian's close relationships with his family had less benign consequences for his two sons. He had forced Pomponio into a career in the Church to which the boy, as Titian himself later agreed, 'was not much inclined'. His more biddable younger son Orazio put off deciding on a career until he took up his brushes at sixteen and began to work in a simplified version of his father's style. But he was as lazy in his own way as Pomponio, and Titian had other uses for him. Although Orazio would marry in 1547, he remained under his father's thumb all his life, sometimes assisting him in the

studio but more often as his factotum, a role that would become more onerous after the death of Titian's brother Francesco in 1559.

In the early 1540s Titian was embroiled in a prolonged and bitter dispute about his *Pentecost* (Venice, Church of Santa Maria della Salute). This was an old commission for the high altar of the Augustinian church of Santo Spirito in Isola (for which he had painted his *St Mark Enthroned* many years earlier), which had recently been rebuilt by Sansovino. There were problems with the commission from the beginning. As long ago as 1529 Titian had painted the subject one way, tried another a few years later and then put it aside. That there was no contract for the painting is not surprising since none survives for so many of his Venetian altarpieces. When he failed to deliver it several years after the original commission, the patrons of the church discontinued their annual payments of the grain and wine that had been intended to defray the final fee, which was to have been decided by experts when the altarpiece was finished. In the intervening years Titian worked on it from time to time. But it was not until Vasari, in Venice in the winter of 1541–2 to design the stage sets for Aretino's new Carnival comedy *La Talenta*, was offered the job of decorating the ceiling of Santo Spirito that he began to work on the commission in earnest. Vasari had turned down the request to paint the ceiling, but it may have been the whiff of competition that impelled Titian at long last to get on with his altarpiece.

We know what happened when he finally delivered the painting from the surviving records of a legal action he took against the canons of Santo Spirito not long afterwards. One of the witnesses who testified during the case said he had seen a painted sketch of the altarpiece in Titian's studio in 1538; another had actually seen Titian working on it. Meanwhile the prior of the church had offered 400 ducats for it. Titian had insisted on 500, and two patricians, Antonio Dandolo and Girolamo Cornaro, agreed to settle the matter. The *Pentecost* was still unfinished when it was installed in the church in a marble frame in 1541. Titian had himself rowed out to the church to work on it over the next several years, but had still not completed it when the paint began to blister. He then had it removed to his house for repairs. And

there it remained. The original turned out to be so damaged by blistering and mould that he painted the new version, probably with studio help using the first version as a guide, that can be seen in Santa Maria della Salute today.[3]

The judge appointed to hear Titian's case was the auditor of the papal legate in Venice, Giovanni della Casa, who was to play a significant role in Titian's later career, and who, after the canons of the church objected to the pope that della Casa was biased in Titian's favour, acted jointly with the vicar of the patriarch Girolamo Querini. The question to be decided was whether, as Titian claimed, the painting had deteriorated because the canons had failed to take adequate precautions against the damp, or whether, as the canons insisted – with some justice considering that Titian had worked on the painting in situ – the cause was the artist's bad workmanship. Unfortunately we do not know the outcome, but it must have been resolved by 1546 when Titian began work on the three ceiling paintings for the same church that Vasari had refused.

In the meantime Titian and Francesco, who were expanding the timber business and investing in property on the mainland, acquired some land near Vittorio Veneto, as it is known today, halfway between Venice and Cadore. Orazio had scarcely reached the age of sixteen when Titian employed him, on 24 December 1539, to pay twenty-five ducats to the relevant body in Venice for exemption from local taxes on ten fields he had purchased on a low hill, the Col di Manza, near the castle of Roganzuolo, six kilometres south of Ceneda (which is now joined with Serravalle as Vittorio Veneto). It was from these Cenedese Hills that Titian stopping as a boy on his journey from Cadore to Venice had had his first sight of the Venetian plain stretching down to the lagoon with the bell tower of San Marco just visible in the distance. Now, some four decades later, the countryside through which he made the same journey had been developed with villas and farms as more and more Venetians invested in property and agriculture on the terraferma as an alternative to trade with the Levant. Today the view from Castello Roganzuolo is obscured by the smoke from factories that have long since disfigured the beauty of the plain.

But the place where Titian would spend holidays for the rest of his life has retained some of its magic. There are no signposts to Castello Roganzuolo and when you ask for directions some people say they have never heard of it. But once you have made your way through the modern suburbs around Vittorio Veneto you will finally come upon a little hamlet where stands of cypresses, olive trees and vineyards run right up to the terrace of the now forlorn little church of San Fior Sopra. The Via Tiziano passes villas, a few of them old but mostly run down or heavily restored, any one or none of which might have been the one Titian built there in the late 1540s.

At the end of October 1542 Titian accepted a commission from the Venetian representative in Serravalle to paint an altarpiece for the cathedral (the *Virgin and Child in Glory with Sts Andrew and Peter*, still in situ over the high altar), and sent a drawing for it on the back of a letter to 'The Magnificent and Most Illustrious Signor Podestà of Serravalle':

> I greatly wish to serve Your Magnificence and this Honourable Community in the matter of the promised altarpiece, the sketch for which is well advanced. If you do not fail to support me, you will know from the result the affection and love that I bear you. And because the space for the altarpiece is too big, I would like to make a gilded border half a foot wide to go all around it, as it is here below. Please write and tell me what you think.

According to the contract signed on 13 November Titian was to receive 250 ducats for the painting. The idea of acquiring property in the area may well have come from Francesco, who had connections there going back as far as 1526 when he was paid for decorating a banner for the cathedral of Ceneda.[4] Francesco, who travelled frequently on the mainland, painting altarpieces, investing in real estate and supervising the timber business, would have needed a base there more than Titian; and although the investment was probably a joint venture, it is Francesco who is recorded in 1547 as the owner of ten fields, on which there was a house roofed with pantiles and a barn for storing hay, as

well as of other neighbouring properties. He may have camped out in the house while supervising construction of the new villa, which began in 1547. In the following year Titian and his studio painted a triptych of the *Virgin and Child with Sts Peter and Paul* for the parish church of San Fior Sopra (Vittorio Veneto, Museo Diocesani di Arte Sacra, now very ruined) in return for which the citizens of Ceneda gave him the building materials, their transport to the site, local labour, the loan of equipment to till his land, and seeds. By 1550 Francesco had continued to expand the Vecellio real estate portfolio with the purchase of another twelve fields, four of them near Conegliano. But six years later, by which time Francesco was immersed in the local politics of Cadore, the title deeds were returned to Titian, who was planning to pass his properties on to Orazio. It was also in 1547 that Titian finished the altarpiece for Serravalle, with considerable assistance from his studio. The authorities, however, were reluctant to pay the full fee, not as one might expect because Titian's hand is barely discernible in it, but, so they insisted, because the final touches had not been made with the quantity and quality of the colours they had specified. The dispute rumbled on. Francesco took over the negotiations, with the help in the last stages of the procurator Celso Sanfior, and the full amount was finally handed over in February 1553.

In the years around 1540 Titian was primarily occupied with portraiture. He had of course painted portraits all his life, but never perhaps at quite the rate he did in this period when his genius for conferring immortality on his sitters by making them, so his contemporaries said, seem to live and breathe was at peak demand. Many of the portraits from this period are of foreigners, perhaps because times were hard in Venice and fewer Venetians could afford his prices. They are now so scattered that it would take a trip nearly round the world to grasp how prodigious his output was during these years. Many have disappeared. One of the most regrettable losses is the portrait he painted in 1540 or 1541 of Don Diego Hurtado de Mendoza, who was only in his mid-thirties when he succeeded Lope de Soria as imperial ambassador in Venice in 1539. Scion of the old Castilian aristocracy

and a younger son of the patrician governor of Granada, Mendoza was also one of the outstanding intellects in Charles V's diplomatic corps. He had studied Arabic, Latin and Greek as well as civil and canon law in Granada and Salamanca before entering Charles's service in 1532; and had been imperial ambassador in England during Henry VIII's divorce proceedings before coming to Venice, where he was closely involved in negotiations for the General Council of the Church that would begin sitting at Trent in 1545 and where he would act as the Spanish representative. In Venice, the city he found the most intellectually stimulating of all his postings, he collected Greek manuscripts, one of which would later inspire Titian's *Rape of Europa* painted for the King of Spain Philip II,[5] and started writing a novel,[6] which would be a source for Titian's *Venus and Adonis*, also for Philip.

Mendoza enjoyed himself in Venice. He took a summer house with a pleasant garden on Murano, and fell obsessively in love with a Jewish woman, whom he described in a letter to his friend Francisco de los Cobos as the most beautiful and most intelligent Jewess he had ever seen in his life, 'a woman who has a head'. Cobos, whose own love affair with Cornelia Malaspina would have inclined him to be sympathetic, supplied him with gifts from Spain for the Jewess, and joked about setting a date for his circumcision. Mendoza had Titian paint her portrait and requested a sonnet about it from Aretino, who was not, however, permitted to see the portrait, which Mendoza kept wrapped in silk like a reliquary. The ever ingenious Aretino, whose pen was never stalled by such minor obstacles, responded with typical artifice:[7]

Furtively, Titian and Love
Taking up their brushes and squares,
Created two examples of a beautiful woman,
And dedicated them to Mendoza, excellent Lord.
…
And while that effigy and this image
He inwardly reveals to himself and outwardly conceals from others,
And in so doing desires more, appearing to desire less …[8]

Aretino, who relied on Mendoza to help keep his imperial pension flowing and was forever praising his youth, elegant mind, knowledge and quick wits, also wrote a sonnet about Titian's portrait of him.[9]

According to Vasari, the portrait of Mendoza was the first of Titian's two earliest full-length portraits and therefore a landmark in his stylistic development.[10]

Vasari was himself in Venice at the time Titian painted another full-length portrait, of Cristoforo Madruzzo (São Paulo, Museu de Arte), a nobleman and successful career ecclesiastic from Trent who was in Venice from mid-February to mid-March of 1542. But although Vasari probably heard about Titian's second full-length portrait, he may not have seen it because Madruzzo does not, as he claimed, wear the red robe of a cardinal, a position to which he was not raised until the following year. He dressed for his portrait, walking towards us on a red carpet 'like a minister busy with the cares of state',[11] in the black robe and hat of the prince-bishop of Trent, a position he had held since 1539. It was Madruzzo, who had the respect of both the emperor and the pope and became one of the most powerful men in Europe, who would finally resolve their long-standing quarrel about whether the nineteenth Ecumenical Council of the Catholic Church should take place on Italian or imperial soil by persuading Paul III to accept Trent, a free city of the Holy Roman Empire but geographically close to Italy, as the venue. At Trent he would act as host and chair of the first sitting of the Council and be rewarded by the emperor in 1546 with an annual pension of 2,000 ducats. Two inscriptions on his portrait giving the date 1552, one on the clock and one at the upper right, have caused some scholars to prefer that date. But both are much later additions, certainly not by Titian, and may refer to the clock, a valuable object but so clumsily painted that it could not possibly be by Titian, rather than to the portrait.[12]

When Jacob Burckhardt[13] wrote that no Florentine could paint Florentine intellectuals as well as Titian, he gave as an example Titian's fine portrait of Benedetto Varchi holding a leather-bound book (Vienna, Kunsthistorisches Museum).[14] Varchi, the leading central Italian intellectual to follow Machiavelli, was in Venice between 1536

and 1540 acting as tutor to the children of the Strozzi, the immensely wealthy Florentine banking family who had taken refuge in the lagoon city after their failed attempt to unseat the Medici, which had been mounted with the aid of France. In Venice the Strozzi moved in French circles, but were expelled in 1542 when they were implicated in the leaking of state secrets to the French ambassador. Before their departure Titian immortalized the curly-haired Clarissa (Berlin, Staatliche Museen), the first-born child of Roberto Strozzi, with what is one of the most enchanting portraits of a toddler ever painted as well as one of Titian's most masterly studies of arrested motion. The little girl, as we see from the inscription on the tablet on the wall above her, was two years old at the time Titian caught her animated figure and set it against the intersection of a dark wall and a wooded landscape. The gold pendant hanging from her belt is swinging, her liveliness echoed by the frolicking putti of the relief carving under the table.[15] Titian, who understood children and dogs, seems to have captured her attention by pretending that his real subject is her little spaniel, which she solemnly holds in place grasping a biscuit – it looks like a *corna di gazzella* or gazelle's horn – in her right hand as a promised reward for his obedience. The portrait was finished by July 1542 when Aretino wrote to Titian:

> I have seen, dear old friend, your portrait of the little girl of Roberto Strozzi, that grave and excellent gentleman. And since you seek my opinion, I say to you that if I were a painter I would despair; although it would be necessary for my vision to have divine knowledge in order to understand why I should despair. Certainly your brush has kept its miracles for the maturity of your old age. Whereby I, who am not blind to such genius, solemnly swear in all conscience that it is not possible to believe, let alone to do, such a thing; thus it deserves to be placed before all the paintings there have ever been or ever will be. So that nature must swear that such a likeness is not feigned if art asserts that it is not alive. I would praise the puppy that she strokes, if it were enough to exclaim on the liveliness that animates it. And I conclude with the wonder with which this painting takes the words from my mouth.

An unusual double portrait (Northumberland, Alnwick Castle) is of George d'Armagnac, Bishop of Rodez, one of the French ambassadors in Venice in 1536–9, who had Titian portray him with his secretary Guillaume Philandrier. Although Philandrier was a scholar and pupil of Serlio, Titian emphasizes his social inferiority by placing him below and behind the ambassador gazing up adoringly at his master, whose enormous padded shoulders and impassive expression are bows to the French style of portraiture.[16] Nothing, however, is known about the circumstances in which Titian painted the portrait of Count Antonio Porcia e Brugnera (Milan, Pinacoteca di Brera) who came from an old feudal family in the Friuli, except that it looks as though it was painted around the same time as his portraits of the Duke and Duchess of Urbino. But a more intriguing unsolved mystery surrounds one of the most compelling of Titian's portraits, the so-called *Young Englishman* (Florence, Galleria Palatina), although there has been no shortage of theories about the identity of this handsome, possibly psychotic young man whose blue eyes seem to out-stare the enquiring gaze of the painter. One idea has been that he is Guidobaldo della Rovere, an earlier portrait of whom Titian was repairing or repainting in 1545. It was listed as a portrait of Aretino in an inventory of the della Rovere collection in the seventeenth century, but looks nothing at all like any of Titian's surviving portraits of him. A plausible hypothesis[17] is that he might be Count Agostino Lando,[18] to whom Aretino wrote in November 1539 praising his generosity, thanking him effusively for a gift of anchovies from Piacenza and referring to the portrait Titian was painting of him. If Lando was not psychotic he was capable of violence. Eight years later he took part in the murder of Pier Luigi Farnese, the only son of Paul III, who had given Pier Luigi the Landi's ancestral domains of Piacenza and Parma.

The Vendramin family, whose group portrait (London, National Gallery) Titian began in the early 1540s,[19] were heirs to a large fortune made in the fourteenth century by their ancestor Andrea Vendramin, an industrialist who manufactured soap and a merchant dealing in oil and other commodities, who was received into the Venetian patriciate in 1381 for services to the Republic in the war against Genoa. Andrea's

grandson, also Andrea, had been doge in the years 1476–8. One of Andrea's great-nephews was Gabriele Vendramin, who played host to the artists and intellectuals of his day and whose large and famous collection of paintings and antiquities included Giorgione's *Tempesta*. Gabriele was a good friend of Titian, who witnessed codicils to his wills and supplied him with paintings, including a portrait of himself drawing with a sculpture of Venus behind him.[20] That painting is lost, but a delightful survival from the collection, one that was widely accepted as autograph only after a cleaning in 2009, is the *Triumph of Love* (Oxford, Ashmolean Museum),[21] in which Cupid armed with bow and arrows prances on a tamed lion which appears to be leaping out of the picture against a luminous fantasy landscape of the lagoon with Titian's signature mountain in the distance. The theme of love conquering all (in this case even the lion of St Mark) was frequently depicted in engravings, medals and bronzes. Titian's, which may have been derived from a similar figure in a bronze group in the Vendramin collection, was originally rectangular and intended as the cover of a more valuable painting, perhaps a portrait of a desirable aristocratic woman, in which case Cupid would have acted as a gloss on her beauty as well as concealing it in the interests of discretion. Although such covers were commonplace in the Renaissance, very few have survived, probably because they were considered of secondary importance.[22] This example may have been saved for posterity by its charm.

It was probably Gabriele, an admirer of Titian's *Pesaro Madonna* in the Frari, who asked Titian to undertake the group portrait of his brother and nephews that was later described in an inventory of the contents of his palace, which still stands in the campiello of Santa Fosca,[23] as 'a large picture in which there are depicted the miraculous cross with Andrea Vendramin with seven sons and Gabriele Vendramin with its gilded frame made by the hand of Titian'. (Gabriele, who had married in 1538, had seven daughters, but it would not have been considered appropriate to include women.) The miraculous cross, a silver-gilt and rock-crystal reliquary in which splinters of the True Cross were preserved, had been received in 1369 on behalf of the Scuola di San Giovanni Evangelista by Andrea

Vendramin, who was then its chief official. This reliquary – it is the one carried by the members of the Scuola in Gentile Bellini's *Procession in San Marco* – was responsible for several miracles including the one depicted in Gentile's *Miracle of the Cross at Ponte San Lorenzo* for the same cycle. It had also safeguarded the Vendramins' commercial interests, and Gabriele, who had adopted the children of his brother Andrea at around the time he gave Titian the commission, was concerned that they and their descendants should never forget that their welfare depended on this precious and protective object of veneration.

Gabriele's brother Andrea, the balding man in the red fur-lined robe, presents the cross to his four oldest children, while the three younger ones sitting on the steps below the altar take more interest in the little puppy – which seems to be out of the same litter as Clarissa Strozzi's pet – held in place by the youngest child. The question that remains is the identity of the old man with the grey beard who looks out at us while grasping the altar in a proprietorial way. Before the discovery that Gabriele, who was born in 1484, was in fact three years younger than Andrea, it was not unreasonably supposed that the old man, as stated in the inventory, must be Gabriele. But since the central figure is far too grizzled to be a man of only fifty-six, one can speculate that he asked Titian to exaggerate his age in order to suggest the posthumous presence of the Vendramin patriarch Andrea in commemoration of the original receiver of the True Cross and founder of the family fortune and its patrician status.

Titian worked on the painting sporadically for a few years before putting it aside; and by the time he returned to it in the mid-1550s Gabriele, Andrea and Andrea's eldest son Lunardo (the bearded young man on the left) were all dead.[24] After making a start on a major reworking during which he moved Lunardo's profile further to the left, he allowed a member of his studio to squeeze in the three clumsily painted boys – it must have been the same assistant who painted the youngest man in the mysterious *Allegory of Prudence* (London, National Gallery) – who would have been given more space if the canvas had been widened as he intended. But the *Vendramin Family*, although its

spatial composition is distorted on the left side, is otherwise entirely autograph and therefore interesting as the only surviving example after the *Presentation of the Virgin* of a large, complex picture containing many figures begun by Titian in the late 1530s to early 1540s.[25]

After the death of the wayward Cardinal Ippolito de' Medici, both Titian and Aretino were on the lookout for another well-placed friend in the Roman curia who was in a position to advance their interests there. Aretino wanted a cardinalate, Titian a papal benefice for Pomponio. The ideal contact emerged when Titian's old acquaintance Pietro Bembo, whose invitation to Rome he had refused twenty-six years previously, was among the cardinals appointed by Paul III in March 1539. (Another was Ippolito d'Este, the son of Alfonso d'Este and Bembo's former mistress Lucrezia Borgia, a coincidence that apparently amused the pope.)[26] Before Bembo left Venice for Rome in October Titian painted his portrait (Washington, DC, National Gallery of Art) with the grey beard he had started growing four years earlier – in order, so he wrote to Benedetto Varchi, to look more like an antique sage – wearing his cardinal's hat and scarlet cape, which looks as though it has been taken out of its box and unfolded for the first time. Bembo's gaunt but lively face – high forehead, hollowed cheeks, penetrating eyes, sharply aquiline nose – looks to his right while the eloquent fingers of his right hand point in the opposite direction. As a connoisseur of painting he would have appreciated the elegance of his portrait and have understood the difficulty of achieving his subtly twisting pose.

In May of the following year Bembo wrote from Rome to Girolamo Querini asking him to convey his thanks to M. Tiziano for the gift of his second portrait for which he had intended to pay as was only proper. But 'now that he in his courtesy wishes that I should remain in his debt so it shall be, and one day I will do something else for him'. The return favour Titian may have had in mind when he refused payment, something that he rarely sacrificed, was Bembo's assistance in engineering a papal benefice for Pomponio. The benefice in question was attached to San Pietro in Colle, an imposing castle that stood across the valley from the property he was in the process of buying for

his holiday villa on the Col di Manza. The abbey itself had been suppressed in the previous century, but still provided a very handsome income from the extensive lands it had owned. Possessing this living for Pomponio was to become an obsession that Titian would pursue relentlessly over the coming years.

Two portraits of military men – Gabriele Tadino, Charles V's artillery commander, 1538 (Winterthur, Bühler Collection) and Vincenzo Cappello, 1540 (Washington, DC, National Gallery of Art), five times supreme commander of the Venetian navy – are of questionable authenticity.[27] But the *Allocution of Alfonso d'Avalos* (Madrid, Prado), before it was damaged by a fire in the Madrid Alcázar and subsequently repainted so extensively that virtually nothing of Titian remains of it, was so impressive that it deceived generations to come about the true character of d'Avalos[28] and of the event it purportedly records. Alfonso d'Avalos, Marquis of Pescara and Vasto, whom Charles V had appointed military governor of Milan in 1538, commissioned the painting when he was in Venice in January 1539. He had been sent there by Charles to attend the celebrations surrounding the installation as doge of Pietro Lando, and to try to persuade the Venetians to join a crusade against the Turks in alliance with Charles and Francis I. He was given a grand reception but failed to accomplish his mission. Early in the following year when Titian was in Milan they agreed that the portrait would show him addressing his troops from a podium with his nine-year-old son Francesco Ferrante standing by his side as helmet bearer. There were a number of Italian precedents for the depiction of the ancient Roman ceremony known as an *adlocutio*, and the subject must have interested Titian at a time when he was absorbed by the Roman portrait busts and medals he was using as models for Federico Gonzaga's Roman Emperors.

Because he was still working on the Emperors at the time of the commission he did not make an immediate start on the *Allocution*. Aretino, however, kept d'Avalos in touch with its progress. In November 1540 he wrote explaining that the delay was due to Titian having been detained at Mantua and praising the painting that he said

he had seen the previous day: the reflections from the plates of armour flashing like lightning which would blind if not dazzle the eyes of those who beheld it; d'Avalos's son wearing armour similar to that worn by Roman heroes on antique arches, looking like Phoebus by the side of Mars. When the picture was not ready a month later, Aretino sent d'Avalos a large painted sketch of it in an attempt to mollify his mounting impatience. But even then the armour Aretino had described was not yet painted. Titian wanted to encase d'Avalos in the most up-to-date suit, the one in which he had portrayed him ten years earlier being by then out of fashion. In February 1541 Aretino wrote to Girolamo Martinengo, a Brescian nobleman and army captain through whom he sometimes obtained knives, weapons and armour for his friends from the famous manufacturers in Brescia, suggesting that Titian would immortalize him with a portrait in exchange for 'a breastplate with a matching light helmet and arm pieces in today's style but pure white'.

Titian may or may not have been aware that his *Allocution* was a piece of dishonest propaganda. The event to which it referred had taken place in 1537 when d'Avalos's Spanish troops in Lombardy had mutinied. Far from rallying them with his eloquence, he had hesitated before taking action and when the insurrection got out of hand he had managed to quell it by offering his son as hostage, a courageous gesture that was lost on the people of Milan from whom he had raised the necessary money. He was in any case a disastrous governor, whose repressive measures had included persecuting Augustinian friars whom he suspected of heresy. Nevertheless, when Titian's painting reached Milan in time for a visit by Charles V on 22 August 1541 it caused a sensation with the crowds d'Avalos invited to admire it. Francesco Marcolini, who had seen it there, wrote to Aretino praising the painting in which 'your more than brother Tiziano has painted a lifelike portrait of Alfonso Davolos del Vasto Marchese who addresses his army in the action and form of Julius Caesar … which the entire population of Milan saw as a Divine and most distinguished simulacrum'. Titian rewarded Aretino for his help by portraying him as one of the halberdiers, and d'Avalos was sufficiently satisfied by the

success of the painting to reward Titian with a lifetime pension of fifty ducats a year.

The painting did not, however, succeed in appeasing the emperor, who was aware of d'Avalos's unpopularity in Milan and of the inglorious circumstances of the episode it was supposed to record. D'Avalos was further discredited in the emperor's eyes when the French defeated his army in 1544, and he died in disgrace two years later. Nevertheless, Titian's *Allocution* worked its magic on his posthumous reputation. For the rest of the century many people were persuaded by Titian's skill and use of classical imagery that this Roman general in shining armour represented personal sacrifice and the fidelity of armies to the emperor's commanders.

The main business of Titian's visit to Milan in early 1540, when he had discussed plans for the *Allocution*, was to receive Pomponio's canonicate of the church of Santa Maria della Scala, promised by the emperor and now vacant, which was handed over by d'Avalos. It may have been d'Avalos who persuaded him while he was in Milan to accept a commission from the Confraternity of the Holy Crown for an altarpiece for its chapel in the Dominican church of Santa Maria delle Grazie in which one of the thorns from Christ's crown of thorns was preserved. Titian did not contest the fee for the *Crowning with Thorns* (Paris, Louvre) although it was only 200 scudi, less than half the payment he had asked from the nuns of the church of Santa Maria degli Angeli for his Annunciation and was demanding from the canons of Santo Spirito for the *Pentecost*. The panel was relatively small and there were probably other considerations that persuaded him to paint for quite a modest fee his only major altarpiece of the period for a church outside Venice. He may have wished to commemorate Pomponio's benefice by establishing his artistic presence in Milan. Perhaps he liked the idea of seeing his work compared with Leonardo's *Last Supper* in the refectory of the same church, where it had already begun to deteriorate because Leonardo had used oil instead of fresco on plaster.

And yet there is something unconvincing about the *Crowning with Thorns*, which suggests that Titian was not yet comfortable

with the Catholic Reformation emphasis on the redemption of mankind through Christ's suffering, which was no longer compatible with the religious pastoral idylls that had been favoured by Neoplatonic humanists in his youth. Unable to engage his emotions with the subject, he built the picture with images that were fresh in his mind's eye. The heavily rusticated wall in the background recalls Giulio Romano's architecture in Mantua,[29] while the two Herculean brutes who press the crown into His skull are quotations from Giulio's frescos of giants in the Palazzo Tè. The pose of the man in chain mail with his back to us is the same figure in reverse as the halberdier in the *Allocution*, and the bust in the arch of the Roman emperor Tiberius, who ruled at the time of the Crucifixion, is taken from his Emperor Nero for Federico Gonzaga. Although the triangular halo around Christ's head formed by the sticks of His torturers is a clever device, His flaccid figure looks more like a model posing than a Redeemer suffering intolerable pain. Christ's toes are unnaturally relaxed while His plump legs twist in one direction and His upper body the other in a way that was presumably intended to refer to the *Laocoön* – a source that had become something of a cliché by then.[30]

The *Crowning with Thorns* has been taken as evidence that the ageing Titian was undergoing a 'Mannerist crisis' caused by a need to come to terms with the styles of the young breakaway Tintoretto, of Michelangelo, the only living artist whose reputation rivalled his own, and of the Tuscan Mannerists Vasari and Francesco Salviati, both of whom were in close touch with Aretino when they came to Venice on short working visits in the late 1530s and early 1540s. Although crisis is perhaps too strong a word – Titian, after all, had been absorbing ideas from Michelangelo and other central Italian artists since the beginning of his career while retaining his own distinctly Venetian painterly style – it is true that in the next two decades, as his patrons became more aware of the latest artistic trends outside Venice, his artistic relationship with Michelangelo became more intense, his figures more monumental, but his brushwork looser as though in defiance of the Tuscan preference for high finish.

His depiction of Christ's agony and the barbarous brutality of those who torture Him is certainly disturbing – some critics have gone so far as to dismiss the painting as merely histrionic – in a way that none of his religious paintings had been up to that point. The subject, however, was not his choice. It was dictated by the Confraternity for whose chapel it was destined. Titian was always sensitive to the wishes of his patrons and was able to adapt his style to their chosen subjects. It was not until later in life that his palette and his religious subjects would darken as though in sympathy with the tortures undergone by Christ and the Catholic saints who had died at the hands of brutal heretics in order to redeem mankind from its fall from grace.

The days when pastoral and religious texts were often conflated by humanists, when the Virgilian Arcadia was identified with the Garden of Eden, and Titian had painted his charming Madonnas and saints dressed as fine ladies picnicking in the mountain pastures of the Veneto, were over. Times had changed since a sophisticated young Venetian elite, recently liberated from the seafaring duties that had preoccupied their parents and steeped in the pastoral literature published by the Venetian presses, had enjoyed Titian's identification of the Christian story with the pagan Golden Age. The earliest of his Giorgionesque idylls had been painted during the Cambrai war, the greatest external threat that the Republic of Venice had ever faced. The battle now was of an altogether different order: it was for the very souls of all Catholics; and if few of them understood the finer points of the higher theological dialectic no one, neither Titian nor his wealthy patrons, would be able to escape the new religious uneasiness.

Titian returned to Venice from Milan in February when he received the first instalment of three payments[31] for the *Crowning of Thorns*. In April Aretino negotiated on his behalf with a maker of musical instruments, Alessandro Trasontino, known as 'dagli Organi', for a harpsichord, 'one of those machines', as Aretino described it in his letter to Trasontino, 'which makes the soul a prey to ecstasy'. Titian, wrote Aretino, would pay for the instrument with a portrait of Trasontino

which would be one of those examples of his work so true to living nature that it would fill people with wonder. The harpsichord had been installed in Biri Grande when Titian gave a supper party on 1 August.

The guests were Aretino, Sansovino and two other Tuscans, Francesco Priscianese, a Latin grammarian, and Giacomo Nardi, an historian and playwright, both Florentine republicans living in exile. It is the only occasion on which Titian is reported to have dined in literary company, and at the beginning of the evening a conversation about art was interrupted by the arrival of a letter deploring the behaviour of an unnamed grammarian who had spoiled a similar occasion in Rome with 'the bitterness of grammatical questions'. Nevertheless Priscianese was so struck by Titian's hospitality that he wrote a letter about it to two friends. Later he appended it to his magnum opus, which was being printed in Venice at the time.

On 1 August I was invited to celebrate the kind of Bacchanal which, I know not why, is called *ferrare agosto*,[32] so that for most of the evening I argued about it in a delightful garden belonging to Missier Titiano Vecellio, the excellent Venetian painter (as everyone knows), a person truly suited to spice every feast with his pleasantries. There were gathered together with the said Missier Titiano (because birds of a feather flock together) some of the most rare intellects that are found today in this city ... so that I was the fourth amongst so much wisdom. Here, before the tables were set out, because the sun despite the shade was still making his heat much felt, we spent the time looking at the lifelike figures in the excellent pictures which fill the house and in discussing the real beauty and charm of the garden, which everyone marvelled at with singular pleasure. The house is situated at the far end of Venice by the edge of the sea, and from it one sees the pretty little island of Murano and other lovely places. As soon as the sun set, this part of the sea teemed with gondolas adorned with beautiful women and resounded with the varied harmony of voice and musical instruments which accompanied our delightful supper until midnight.[33]

Titian at this time had crossed the threshold into what the Venetian census classified as old age. If he had died then he would still be marked out by posterity as one of the supreme masters of European painting. What neither he nor his guests could possibly have known on that idyllic evening in Biri Grande was that Titian in his fifties was at the mid-point of his career, and that the most extraordinary work was still to come.

PART IV

1543–1562

In the last three decades of his long career, Titian did not paint man as if he were as free from care and as fitted to his environment as a lark on an April morning. Rather did he represent man as acting on his environment and suffering from its reactions … Yet Titian became neither soured nor a pessimist. Many of his late portraits are even more energetic than those of his early maturity.

BERNARD BERENSON, *ITALIAN PAINTERS OF THE RENAISSANCE*, 1938

ONE

Aretino Plays Pontius Pilate

Why do you continue to torture Him when there is no cause? Do
you not hear that the earth and the sky cry out at the wrong that
your wickedness does Him? Ah put off every injury and calm your
souls which are moved by lack of reason …
Take Him away and crucify Him then, but I should not consent to
the death of a man who has done no wrong.

PONTIUS PILATE IN PIETRO ARETINO'S *THE
HUMANITY OF CHRIST*, 1535

Daily life was good for Titian in his early fifties. There were some days
when he locked himself away from the world in the studio on the top
floor of the house in Biri Grande, painting up a storm, turning from
one work to another as the mood took him. But Titian – unlike the
solitary, spiritually tortured Michelangelo, who considered socializing
a waste of time that weakened the powers of serious artists – was a
man who could balance an intense and complex inner life with an
appetite for society. When he put down his brushes and changed from
his paint-splattered work clothes into the silks, satins and furs that
befitted his status as a wealthy gentleman, he was ready for the
company of family and friends. The house in Biri Grande had enough
rooms to accommodate Pomponio, Orazio, his little daughter Lavinia,
a few servants and any of the numerous Vecellio relatives when they
were in Venice. Having sown his wild oats in his youth he now (much
to Aretino's despairing incredulity) preferred a peaceful,

427

monogamous relationship with a domesticated wife who looked after his household – and who kept such a low profile that we know nothing about her. Pomponio was always a worry, but whatever his problems he could forget them for a while when relaxing with old friends and new acquaintances, dining with Aretino and Sansovino at Casa Aretino on the Grand Canal or entertaining at Biri Grande where his guests whiled away hot summer evenings sitting under the trees, catching the breeze from the lagoon, admiring the pictures on his walls, making music, dining on rare delicacies.

When he made his way through the city he saw a Venice – 'this Venice of his', as an imperial ambassador had put it when Titian refused one of the emperor's several invitations to his court in Spain – that was different in many ways from the city he had first known four decades previously as an awestruck boy from the mountains. He could remember the days when the outskirts had been occupied by monasteries, gardens, orchards and sheds for drying dyed textiles. Now the suburbs were being developed – his own house had been built as recently as 1527 – to accommodate an expanding population; and the waters of the northern lagoon, which had once bordered his garden, were receding. New palaces of gleaming Istrian stone in the High Renaissance classical style were replacing brick or painted façades pierced by lacy Gothic windows. The Piazza San Marco, the centre of government and hub of the Venetian Empire, was a building site while his friend Jacopo Sansovino planned the most ambitious architectural transformation of any Renaissance city. After decades of war, Venice was at peace with the rest of Europe and would remain at peace with the Ottoman Empire until the last years of Titian's life. Peace, however unsatisfactory the terms, was always beneficial to an economy based on trade. When people put tags on Italian cities – Florence 'the Fair', Bologna 'the Studious', and so on – Venice was once again 'the Rich'.

The capital city of the Most Serene Republic was more famous than ever for its spectacular public processions, its carnivals, markets, music and theatrical entertainments, often with architectural stage sets designed by Sebastiano Serlio, a member of Titian's inner circle

whose treatise on the classical style, *The General Rules of Architecture* (the fourth volume of which was published in Venice in 1537), was spreading the language of Italian Renaissance architecture across Europe. Venice would remain the courtesan city par excellence until well after the Counter-Reformation, despite the usual occasional attempts by the authorities to crack down on prostitution and on courtesans whose style mimicked noble ladies. The government continued to issue sumptuary laws. One proclaimed in 1543 forbade prostitutes to wear, 'nor have on any part of her person, gold, silver or silk, nor wear necklaces, pearl or jewelled or plain rings ... and the use of all jewels is forbidden them, both out of doors and in their houses'. Nevertheless, some forty years later Montaigne would admire the luxurious apartments and dress of the courtesans he met in Venice, and by the seventeenth century the word 'Venice' over a door in other European cities was a euphemism for brothel.

Venice was still set apart from all other cities by the beauty and singularity of its location in the middle of a lagoon; by its polyglot population of merchants, fortune seekers and refugees; by its independence from foreign rule; and by the stability of its unique oligarchic government. Governed as a republic by a closed class of patricians who inherited their right and obligation to rule, Venice nevertheless remained famous for the degree of tolerance and freedom of expression so eloquently celebrated by Titian's dearest friend, 'other self' and publicist, the journalist, author and international powerbroker Pietro Aretino. From the safety of his house on the Grand Canal, Aretino continued to address his thundering, manipulative letters to everyone of consequence in the Renaissance world. The first volume of his letters published in 1537 had made him an international celebrity. The second volume appeared in 1542, dedicated to 'the magnanimous and most supremely excellent' Henry VIII, King of England, who responded by promising him a reward of 300 scudi.[1]

Titian's Venice was at the centre of the intensifying debate about the need to reform the Catholic Church in the face of the Protestant challenge. In 1536 the Farnese pope Paul III had chosen the Venetian nobleman, diplomat and historian Cardinal Gasparo Contarini, who

as a younger man had undergone a spiritual crisis anticipating Martin Luther's vision of justification by faith and abiding love of Christ, to preside over a committee of eminent prelates charged with investigating malpractices in the Church and proposing solutions. Their report, *Concilium de emendenda ecclesia*, published in 1537, exposed gross abuses and made recommendations about how to stamp them out. The Catholic Reformation, however, was split into two factions. The austere Theatine order, whose founding members had taken refuge in Venice from the Sack of Rome in 1527, were uncompromising theological reactionaries dedicated to rooting out as heresy anything that smacked of Protestantism. Paolo Giovio was one of many humanists who recognized the deficits of the obsessively high-minded Theatines, 'who with strange appetites want tart sugar and who want to bind the elements of this ancient machine [the Catholic Church], and put them in a sack and reduce them to make them more beautiful and do not see that the wish to reduce them down to the primary materials would be to bring the machine itself to destruction'.[2] Cardinal Gianpietro Caraffa, the zealous bigot who would become pope as Paul IV in 1555, was the leader and most powerful spokesman of the order.

The more progressive Spirituali, also known as Italian Evangelists, were with very few exceptions loyal Catholics but occupied a middle ground that recognized the importance of such Protestant beliefs as personal religious renewal, justification in the eyes of God by faith, and guidance by the Scriptures. Their inner circle included the pious widow and poet Vittoria Colonna, whose bleak religious sonnets were admired by Michelangelo; the English cardinal Reginald Pole, who was Colonna's spiritual adviser; the beautiful widow Giulia Gonzaga; Gianmatteo Giberti, Bishop of Verona; and the Sienese friar Bernardino Ochino, vicar general of the Capuchin order. Cardinal Contarini was their leader, and the pope, Paul III, was at first inclined to favour his liberal approach to reform, which was in tune with the policy favoured by Charles V, over Caraffa's belligerent intolerance.

When, in 1541, the emperor convened a colloquy of Catholic and Protestant theologians chaired by Contarini at Ratisbon (modern

Regensburg), Paul's hopes for a compromise seemed justified as the Catholic delegates came close to accepting the Protestant doctrine of justification by faith. The Protestants, however, refused to agree with the Catholic position on transubstantiation, and the negotiations broke down. After Contarini's failure to achieve a compromise, and his death in 1542, the pope, fearing that the Erasmian approach to compromise favoured by Contarini and Charles V might go too far towards appeasing the Protestant reformers, decided to give Caraffa his head. In July 1542 the reign of terror began when the Roman Inquisition, the first in Italy since the Middle Ages, was revived, and Caraffa became the most eager of six cardinals appointed 'to suppress and uproot', as he put it, 'permitting no trace [of heresy] to remain'.

One of the first and most prominent targets of the Inquisition was the Sienese Franciscan Bernardo Ochino, the most brilliant and charismatic preacher of the day, whose sermons, voicing the concerns of his fellow Spirituali, were especially popular in a Venice that had always been distrustful of papal interference and inclined towards anticlericalism. Pietro Bembo, who persuaded Vittoria Colonna to invite Ochino to deliver the Lenten sermon of 1539 in the Venetian church of Santi Apostoli, afterwards described to her the deeply emotional response of the crowds that packed the church: Ochino is 'adored in this city, nor is there a man or woman who does not praise him to the skies'. Aretino was overwhelmed[3] by his intellect, grace, deep sincerity, profound knowledge, elegant language and magisterial presence. The Venetians, he proclaimed, could not have been more eager to hear him if he had been John the Baptist. The friar, whom he described as 'the trumpet and bell of the word of God', had opened his own heart and mind 'as though he had stood before Jesus Christ' and shown him, so he claimed in a letter to the pope (in which he was angling for a cardinalate for himself), the errors of his ways. Santi Apostoli was, as it happened, Aretino's parish church, and after Ochino had delivered a second sermon there in 1542 he wrote to the parish priest thanking him for giving his pulpit to a preacher whose 'apostolic voice and Catholic words made kings good and the just perfect'.

A few days later Ochino was summoned to Rome to appear before the Inquisition. Disguised in lay clothes and with Giberti and Ercole Gonzaga acting as his cover, he escaped across the Alps to Protestant Germany and went on to join Calvin in Geneva. The apostate Ochino wrote to a Venetian patrician that he would have taken refuge in Venice – 'my Venice' as he always called it – and knew he would have been welcomed there but had wanted to suffer alone and quickly rather than bring suffering on others by delaying the inevitable. He went on: '… God knows how much I want to see Christ [by which he now meant the Christ of the Protestants] reign in my Venice … Christ has begun to penetrate into Italy; but I want Him to enter in glory and openly, and I believe that Venice will be the gateway …'[4]

Ochino's belief that Venice would be the gateway of Protestantism into Italy was by no means far fetched. Protestant or quasi-Protestant academies continued to flourish in the lagoon where some of the young patricians held philo-Protestant views despite the disapproval of their elders. Concern with inner personal conversion and profound love of God was more widely and deeply felt in Counter-Reformation Venice than in any other Italian city. And it was in Venice that the intense, ecstatic, elaborated retellings of the biblical stories and lives of saints that poured from the fluent pen of Pietro Aretino in the late 1530s and 1540s made their greatest impact. Embellished with visual metaphors and added incidents, written in a racy demotic that was deliberately more accessible than the high-flown rhetoric of his letters, they were bestsellers frequently reprinted.

Titian took the cue for his large, stormy *Ecce Homo* (Vienna, Kunsthistorisches Museum) from Aretino's *Humanity of Christ*, first published in 1535, in which the writer had added his own anecdotes to the episode from John 19: 2–3 and portrayed Pontius Pilate – the Roman governor of Judaea who reluctantly authorized the Crucifixion of Christ with the words 'Behold the Man. I find no fault in him' – as just and peaceable because he had after all done his best to save Christ. Titian, who finished his painting in 1543, gave the story an added dimension of contemporary relevance with references to events that

affected Venice in the years while he was working on it. He cast Aretino as Pontius Pilate, the wise man who could see both sides of a problem but could not impose his judgement of Christ as innocent on the baying mob. He dressed him in shimmering pale-blue satin as he presents the bleeding, broken King of the Jews to a multitude of onlookers. From the steps of a Roman palace that might have been designed by Sebastiano Serlio, Aretino/Pilate directs the other players: some biblical figures in modern dress, some portraits of contemporaries, each relating in one way or another to the self-styled repository of the world's secrets and chief propagandist for a Venice that called itself the City of Christ and the New Rome.

The *Ecce Homo* was commissioned by Giovanni d'Anna, an immensely wealthy merchant of Flemish extraction and friend of Titian and Aretino, for the piano nobile of his family palace at San Benedetto. Giovanni's father Martin van Haanan had Italianized the family name to d'Anna after settling in Venice in 1529 when he had the palace frescoed by Pordenone. Martin's father had been ennobled by the Habsburgs in recognition of his financial contributions to their wars against the Ottoman Turks, and his son Giovanni remained close to the inner circle of the Habsburg court, which was chronically short of funds. The prominent two-headed Habsburg eagle on the shield held by the Roman soldier with his back to us at the bottom of the steps proclaims the patron's imperial connection, as does Titian's signature, 'TITIANVS EQVES CES F' (Titian Caesar's Knight made this), the first of only seven extant paintings to refer to the knighthood that had been conferred upon him by Charles V.

It is one of the largest[5] and most spatially complex paintings that Titian produced in this period. Since he was in any case a slow worker who made changes to his paintings as he went along[6] it is likely that he had started it some years before 1543, the date that appears beneath his signature on the scroll propped against the steps. He may have set to work on it in the late 1530s, shortly after completing the *Presentation of the Virgin*, which is organized on similar lines with a classical architectural setting as well as hints of the open brushwork that vibrates on the surface of the *Ecce Homo*. It is not impossible that Giovanni

d'Anna's commission was inspired by Bernardino Ochino's first Lenten sermon in Venice, which had so greatly impressed Aretino and which d'Anna is likely also to have attended. If so, the lean figure in black carrying a wayfarer's staff could be the friar in the simple dress that indicated his humility, conducting an 'impossible dialogue' across centuries about the significance of Christ's sacrifice with the fat, goitered high priest Caiaphas, the real villain of the story, represented here as a rich contemporary Jew overdressed in an opulent purple robe and ermine shawl.[7]

The two dynamic horsemen at the opposite end of the composition are the Turkish sultan Suleiman the Magnificent and Alfonso d'Avalos. At the end of 1539 Charles V had sent d'Avalos to Venice to try to persuade the doge to continue fighting the unsuccessful war against the Ottoman Turks, who were threatening to invade Italy at that time. Titian cast him here as an ideal of the Christian soldier who directs the attention of the turbaned infidel across the gesticulating crowd to the episode of the Passion of Christ. Titian's other portraits of Suleiman, whose image he painted often for various patrons from coins, medals and verbal descriptions, are lost to us. In this, the only one to survive, he gives him a surprisingly individualized face. The old enemy of the Venetian Republic and scourge of the Habsburg Empire on land and sea was by no means without his admirers, among them Paolo Giovio, who had observed in a commentary on the Turks dedicated to Charles V:

> Your Majesty should know that he is resolute and minutely informed on the affairs of Christianity and that he keeps his mind and forces in instant readiness for more wars. He has marvellous intuition. Not only is he adorned with many virtues, he lacks the salient vices of cruelty, avarice, and treachery … Above all, he is religious and liberal, and with these two qualities one flies to heaven.[8]

The only women in the painting stand apart from the action. A ray of light shines on the white dress of the slender, blonde, older girl who catches our eye as though inviting us to share her feminine

perspective on the cruelty and violence of a world dominated by men. Titian's model for this representative of purity and common sense may have been Cecilia Alessandrini, possibly the daughter of a sister of his first wife and thus the first cousin of Pomponio and Orazio. The plump little girl in black who leans against her, apparently bored and restless because she is too young to understand the significance of what is happening, could be Aretino's daughter, Adria, who was born in 1537. But a more likely candidate is Titian's own daughter, Lavinia, by his second wife, who would have been about the right age; moreover, this little girl looks remarkably like Titian's *Portrait of Lavinia as a Matron* (Dresden, Gemäldegalerie) painted after she had married and borne several children.[9]

By the time the *Ecce Homo* was installed in the Palazzo d'Anna in 1543 its contemporary references would have assumed a more ambiguous significance. But if the altered circumstances affected the d'Anna family's appreciation of Titian's great painting there is no sign of it. Giovanni d'Anna must have been pleased with it because he commissioned Titian to paint a Christ at Golgotha as a pendant, as well as a Virgin and Child and two portraits of himself. (All these are lost.) The family continued to value the *Ecce Homo* so highly that they refused an offer of 800 ducats for it from the French king Henry III when he passed through Venice in 1574, and it remained in the palace until 1621 when it was acquired by the English envoy in Venice for the Duke of Buckingham. Carlo Ridolfi, who must have seen it before it was taken to England, was the first writer to recognize Aretino as Pontius Pilate and Suleiman as the turbaned horseman; and it was Ridolfi who set off attempts by subsequent writers to identify the other characters. Some have explained the crowd of onlookers as members of the d'Anna family, some the slender figure in black as the patron Giovanni d'Anna or Titian. But it was not until 1992 that an Italian scholar[10] published the most revealing and plausible analysis so far of the painting in the context of the times.

If Giovanni d'Anna's *Ecce Homo* was not the only work in progress in Titian's studio in the early 1540s, there was less steady work at that time than there had been in the previous two decades. It may have

crossed the painter's mind to reconsider the invitations from Charles V to join the imperial court. That thought, however, was put to one side when Aretino suggested another equally exalted source of patronage, one furthermore that offered the possibility of a lucrative benefice for Pomponio, which, in addition to those he had already obtained from Federico Gonzaga and Charles V, could bring in a very handsome living indeed for his son. Aretino had leaked Titian's willingness to work for the Farnese pope Paul III and his family in a letter dated July 1539 to his friend the sculptor and medallist Leone Leoni: 'It is clear that my old friend did not want to go to Spain, even when the emperor asked our everlasting government for him; but he would like to leave the memory of his art with portraits of the princes of the most celebrated house of Farnese …' He added that it would be good for Titian to see at last the Roman antiquities and the work of Michelangelo first hand. Paul III was an enlightened patron of the arts; and his eldest grandson Cardinal Alessandro Farnese, who supported Bembo and Vasari and was responsible for Michelangelo's completion of the Palazzo Farnese, the most imposing Roman palace built in the sixteenth century, was on his way to becoming one of the greatest Italian patrons and collectors of that century. But the Farnese, although aware of Titian's unsurpassed fame as a court portraitist and of course impressed by the high favour in which he was held by the emperor, had so far held back from approaching him. Aware that Titian had turned down several opportunities to visit Rome, they may not have wished to risk rejection. Alessandro, in any case, had never been to Venice or seen a painting by Titian.

It was not until the summer of 1542 that the opportunity arose for Titian to paint one of the Farnese family without so much as crossing the Venetian lagoon. In August 1541 the eleven-year-old Ranuccio Farnese, Alessandro's younger brother and the second youngest of the pope's four grandsons, had come to pursue his studies in Padua accompanied by a private tutor, the humanist Gian Francesco Leoni. Ranuccio was also put in the care of two Venetian patricians, Marco Grimani, Patriarch of Aquileia, and Andrea Corner, Bishop of Brescia (later cardinal). Ranuccio's mother Girolama Orsini pined for her

absent son, and Alessandro, perhaps as a way of comforting their mother while also testing Titian's skill, requested a portrait of the boy through the intercession of the Bishop of Brescia. Titian made a start on the *Portrait of Ranuccio Farnese* (Washington, DC, National Gallery of Art) in the summer of 1542. The boy is dressed as a knight of Malta because he was in Venice to attend a congregation at the church of San Giovanni di Malta where he had been prior since the age of four.

The painting, one of the most beguiling and sensitive of all Titian's portraits, was ready by 22 September when Gian Francesco Leoni wrote from Padua to Alessandro Farnese that the Bishop of Brescia would bring it with him to Rome. He stressed, as evidence of Titian's genius, that he had painted it 'partly in the presence and partly in the absence of the Lord Prior'. He also reported that Titian might be persuaded to come to Rome, 'having as he does a son who is studying here, whom he has destined for the Church and who has already received benefices', and assured the cardinal that 'Titian, apart from his talent, seemed to all of us tractable, gentle and easy to deal with, which is a thing worthy of consideration in respect of such exceptional men as he is.'

Leoni's account of Titian as easy to deal with was doubtless intended to contrast him with the difficult, the *terribile*, Michelangelo. His aside that Titian had painted Ranuccio's portrait partly in his presence and partly in his absence was meant as high praise. As we have seen, Renaissance patrons admired the ability to achieve a likeness in the absence of a sitter, and were prepared to enter into a game of pretending that generalized features of people Titian had never or only briefly met were perfect likenesses. In this case, however, we are left in no doubt about the veracity of Ranuccio's highly individualized face. The beautifully subtle composition of the boy's uniform as a Knight of Malta may well have been done in the boy's absence, but the charming, earnest face must have been sketched from the life. It is the face of a studious, shy child conscious of the obligation to assume grown-up responsibilities. Although it is obvious that Titian took special pains with this introductory commission from the Farnese,

there is more to the portrait than its originality and technical mastery. Titian had an intuitive sympathy for children and it looks as though his heart went out to the privileged, malleable, scholarly Ranuccio, whose engaging personality and lack of personal ambition may have reminded him of his own son Pomponio. He could not, however, have predicted that four years after he completed the portrait Ranuccio would meekly accept the cardinal's hat thrust upon his young head by his grandfather (against the wishes of the jealous Alessandro) when he would have preferred to be left alone with his books.

Gian Francesco Leoni, who was no mean diplomat and had spent time with Titian in Venice, struck exactly the right chord with the painter by suggesting the possibility of a papal benefice for Pomponio. Although it seems not to have occurred to the Farnese to pay for Ranuccio's portrait, the prospect of this benefice for his son was more than enough to satisfy Titian for the time being. The one he had in mind was the imposing abbey of San Pietro in Colle, which benefice, unfortunately, was in the keeping of a certain Giulio Antonio Sertorio, Archbishop of Santa Severina, a diocese in Calabria, and Abbot of Nonantola, an abbey in his native province of Modena where he had the protection of the Duke of Ferrara. Although the pope in theory had the power to transfer the benefice to Pomponio it would not be easy to unseat the powerful and well-connected Sertorio. Nevertheless, the very thought of having his son endowed with such a valuable benefice[11] was irresistible. It would determine his actions in the next few years and lead to some of the greatest paintings of his career.

The Last Great Pope of the Renaissance

Enormously charming, [Paul III] was also enormously intelligent
… Yet there was plenty about him to worry earnest men. The first
Roman nobleman to be elected pope since Martin V, he was
emphatically a product of old corruption.

EAMON DUFFY, *SAINTS AND SINNERS*, 2006

On 10 April 1543 Pietro Aretino wrote to Duke Cosmo I de' Medici
to report that the pope had sent for Titian. It seemed that the fine
portrait of Ranuccio Farnese and the possibility – mentioned by
Ranuccio's tutor in his letter of recommendation to Alessandro
Farnese – that Titian could be lured to Rome in return for Pomponio's
benefice had caught the attention of Paul III. Titian was in Ferrara by
22 April, in time for the ceremonial entry of the pontiff. He followed
the papal party on to Bologna, and stayed in its train as the guest of
Alessandro Farnese for the next three months. For a man who enjoyed
an otherwise unusually balanced temperament for an artist of genius,
Titian's ambition to obtain rich ecclesiastical livings for his son had
turned into an obsession, one that, judging from a sketch for a differ-
ent version that has been detected by radiography beneath the *Portrait
of Paul III* (Naples, Capodimonte), he recognized in the pope, who
was notorious for his nepotism.[1] Titian in any case cannot have been
unaware of Paul's reputation for unscrupulous manipulation of his
power. He was the subject of countless pasquinades accusing him of
everything from rape and incest to homicide. His enemies compared

him to the Antichrist; and Aretino, before changing tune when he decided to beg him for a cardinalate, had once gone so far as to describe him as worse than Nero. In Titian's first sketch of him the pontiff's forehead is deeply furrowed, the sunken eyes cast down; the long nose resembles the beak of a bird of prey.

But by the time Titian reached Bologna he had come to to realize that to portray the pope as an evil vulture was hardly the best way to obtain the papal benefice for Pomponio. And so he transformed his first impulse into the greatest and most penetrating portrait of papal power before Velázquez's *Portrait of Innocent X* – which owes a great deal to Titian's example. The hair, beard and the long, bony, mani-cured hand that stretches over the papal purse look at first glance as though they might have been painted with tempera: some of the hairs of the beard and eyebrows were done with individual strokes of a fine brush. But the crimson papal gown and bulky winter cape are modelled out of colour, glazes and scumbles, in one place with the butt end of the artist's brush, with breathtaking freedom and assur-ance. We can almost hear the colour of the voice, softly insinuating and tinged with irony, of a great man who knew that his worldly goals for his family were in conflict with his ambition to reform the abusive practices that riddled the Holy Roman Church. Vasari in a letter to a friend[2] was probably referring to this portrait when he wrote that many passers-by who saw it drying in the sun on a terrace thought it was the living pope and raised their hats to it. This was a conventional trope referring to Pliny's stories about the illusionist power of painted images. But Aretino (who between hurling insults at Paul had also called him the Roman lion) was not overstating his case when he described the portrait as a 'miracle'.

Born into an old noble family with close papal connections, the young Alessandro Farnese had received a fine humanist education in Florence, in the ambience of Lorenzo the Magnificent, and at the University of Pisa. He won his cardinal's hat along with the appella-tion 'Cardinal Fregnese' (Cardinal Cunt) in 1495 by procuring his beautiful sister Giulia for the Borgia pope Alexander VI. After ascend-ing the papal throne in 1534 at the age of sixty-six, he

retained a lifelong love of the arts and literature, and was responsible for reviving the urban and artistic glory of Rome, which had lain desolate since the Sack of 1527. His commissions included Michelangelo's *Last Judgement* in the Sistine Chapel and the appointment of the same artist to rebuild St Peter's.[3] A true Epicurean in the ancient Roman style – Benvenuto Cellini described his habit of gorging himself and then vomiting – he brought the city back to life with carnivals, bullfights and horse races in the streets.

As a cardinal Paul had fathered at least four bastard children by his mistress Silvia Ruffini, a well-born widow.[4] Although it was by no means unusual for cardinals to sire children, Paul's flagrant nepotism, which was loudly condemned by Luther and Calvin, was beginning also to worry Catholic reformers. Paul had wasted no time in positioning his son Pier Luigi and his five grandsons, like pawns in a chess game, to secure his dynastic ambitions for his family and their continuing power in the Church after his death. Pier Luigi had four sons by his virtuous and devoted wife Gerolama Orsini: Alessandro, Ottavio, Ranuccio and Orazio. Immediately after his election Paul made cardinals of Alessandro, who was then fourteen, and of the sixteen-year-old Guido Asciano Sforza di Santa Fiora, his grandson by his daughter Costanza. Ranuccio reluctantly donned his cardinal's hat after he had reached the age of fifteen in 1545. Ottavio and Orazio were to marry in order to ensure the perpetuation of the Farnese dynasty. In 1538 Paul had chosen Charles V's natural daughter Margaret for Ottavio.[5] Nine years later he would marry Orazio to Diana, the daughter of the new king of France, Henry II. The three cardinal grandsons were instructed that if Orazio and Ottavio should die without issue they should renounce the Church in order to marry and continue the Farnese line. Alessandro, who would have been only too eager to marry the daughter of an emperor or king and rule a duchy of his own, deeply resented having been forced into the Church – he was said to have turned pale with jealousy at Ottavio's wedding. Although his grandfather made him vice chancellor of the Holy Roman Church and rewarded him handsomely for the sacrifice of his primogeniture with some thirty bishoprics including the most

lucrative in Christendom, Alessandro would not commit himself to the Church until he finally took major orders in 1564. Meanwhile he consoled himself with womanizing, using his vast wealth to collect works of art, bestowing his patronage on writers and artists, and throwing lavish parties at which he liked to show off his talent for energetic dancing.

Despite his flagrant nepotism, Paul was a genuine and indeed courageous advocate of Church reform. He could not, however, agree with Charles V about either the agenda or the venue of an Ecumenical Council. Paul insisted that the talks should be limited to matters of doctrine rather than disciplinary reform of abuses (of which he was himself guilty), which he maintained was the prerogative of the Curia, and wanted them held in Italy. Charles, always hoping for reconciliation with his Protestant subjects, proposed that the Council should be hosted in Germany and should focus on reform of Church abuses rather than on confirmation of Catholic dogma, which would further inflame Protestant resentment. Eventually they agreed to call the meeting at the small town of Trent.

When Titian first saw him at Bologna, Paul III, now in his seventy-fifth year, had braved the winter weather to travel from Rome to northern Italy where a preliminary Council had been called at Trent. A General Council could not take place without peace between the two Catholic monarchs, the Holy Roman Emperor Charles V and Francis I, King of France, who between them ruled virtually the whole of continental Europe, and who loathed one another as ever on a personal, visceral as well as political level and had been continually and uselessly at war for two decades. Paul had succeeded in remaining on good terms with them both, and the first objective of his journey to northern Italy was to find a way of making peace between them.

Although the emperor was as eager to meet the pope as the pope was to meet the emperor, they had different agendas. Charles hoped to gain Paul's support against the French, who in the summer of 1542 had launched simultaneous offensives on Luxemburg in the northern empire and Perpignan in the south. In February of that year Charles had contracted a secret alliance against the French with Henry VIII of

England, but Francis's shocking alliance with the Turks left Italy vulnerable to attack, especially now that the Venetians had made peace with the Turks. On another front Charles, aware that the balance of power in Germany was shifting to the Protestants, was looking for the support of the pope if it should prove necessary to take military action against them. His voyage to Italy was, however, delayed by business in Spain, and it was not till 24 May 1543 that Pier Luigi Farnese was dispatched to Genoa to greet the emperor and issue a formal invitation to an interview with the pope. Titian waited with the Farnese court in Bologna for another month while the papal and imperial aides argued about the venue for the meeting. The emperor proposed Mantua or Parma. The pope, alarmed by the sizeable army that accompanied the emperor and knowing that Mantua was an imperial fief and that Charles had a residual claim to Parma, suggested Busseto, a small town in papal territory between Fidenza and Cremona which Paolo Giovio later described as 'a fetid hole where sleep was banned' – presumably by the mosquitoes that plague that part of Italy even today.

The negotiations at Busseto finally took place between 21 and 26 June, and went badly from the start despite the presence of fourteen imperialist cardinals and the best efforts of Nicolas Perrenot de Granvelle, the lawyer from Franche-Comté who was Charles's first minister and chancellor. Charles, who was suffering from one of his attacks of gout, was dismayed when Paul not only refused to withdraw his friendship from the French king but pretended to doubt reports that the French and Turkish fleets were acting together. Paul, furthermore, responded to Charles's urgent pleas that a full Council of the Church be held at Trent by postponing a definite decision. What interested the pope first and foremost was the Duchy of Milan, the most important prize in the conflict between Charles and Francis, which he hoped to acquire for his own family by settling it on his grandson Ottavio Farnese and Ottavio's wife, Charles's natural daughter Margaret. Charles set a price of two million ducats for transferring Milan to Ottavio and Margaret; the papal advisers refused the exorbitant demand but offered to meet him halfway with the

appointment of more imperialist cardinals. But if Charles was briefly tempted to give up Milan he chose instead to take the advice of Don Diego Mendoza, his ambassador in Venice at the time, who warned him in a heated memorandum to 'keep what you have ... Milan is a fit inheritance for your only son and rightful heir [Philip]. It is contrary to sense and reason to bestow it on a natural daughter ... If your conscience pricks you for Milan, why not give up Spain as well? ... Milan is the gateway to Italy. Let it but once fall into the hands of the French and all your friends in the peninsula will desert you.'[6] The conference ended with cordial assurances of friendship on both sides. The emperor, however, noted that the pope 'was very much concerned for the advancement of his house, and that his relations were extremely grasping'.[7]

Although the short conference at Busseto was not a political success, it was a landmark in Titian's career. For those few days he found himself in the same place at the same time as the two mightiest rulers in Christendom, both of them now his patrons. He had finished the portrait of Paul III; and although he received no payment for it, apart from two scudi and twenty soldi on 22 May for the transport of the picture to Rome, he had reason to believe that it would be rewarded with the benefice for Pomponio. It was also at Busseto that the emperor entrusted him with one of the most touching commissions in the history of patronage. Charles was still grieving for his wife Isabella of Portugal, who had died four years earlier at only thirty-five after a miscarriage. He remained in mourning, his black clothes increasingly shabby, for the rest of his life and refused to remarry even for political or dynastic advantage. Because Isabella had died young and unexpectedly, and Charles had never quite given up the hope that Titian would be persuaded to portray her sooner or later, he was alarmed to discover that he had no portrait of her. The only one he could find had been painted from life years earlier for Margaret of Austria and was in the possession of Mary of Hungary. He borrowed it from Mary, but although when he saw it he did not consider it a true likeness he had it brought to Busseto to give Titian a starting point for

his own portrait. Titian took it with him when he returned to Venice, where Aretino described it as 'very similar to her true appearance but by a trivial brush'. A year or two later Titian sent the emperor his portrait of the dead empress as a young woman dressed in black with flowers on her lap and the imperial crown behind her. The original, now known from copies and an engraving by Pieter de Jode, was destroyed by fire in the palace of El Pardo in 1604, but another post-humous portrait of her, which Titian painted several years later, survives (Madrid, Prado).[8]

After the unsuccessful conference at Busseto the emperor and his court moved north towards Trent, the Brenner Pass and Germany, having persuaded the eminent Flemish anatomist Andreas Vesalius, whose public dissection of human bodies at the University of Padua had attracted crowds, to join the court as his personal physician and treat the battle wounds of his commanders.[9] Guidobaldo della Rovere, Duke of Urbino and commander of the Venetian army, was one of the dignitaries appointed by the Venetian government to accompany the imperial party through Venetian territory; and it was Guidobaldo who invited his good friend Pietro Aretino to join the party of escorts. Aretino received a less than enthusiastic welcome in Verona, where he wrote to Titian pretending that he had surprised a mutual friend, himself and no doubt Titian as well by absenting himself from Venice – 'our terrestrial paradise' – at the persuasion of His Excellency Guidobaldo.

But then something happened, if we can believe Aretino's account of it in a long letter to a friend,[10] that was to be the apogee of his political and diplomatic career and the most gratifying fulfilment of his deep need for attention. The four Venetian ambassadors who were waiting in Verona for the delayed arrival of the emperor made a great fuss of the famous writer, treating him 'with the continuous kindness due to a friend, instead of issuing commands to me as if I were their servant'. They invited him to go with them 'to meet the Caesarian monarch'. As they caught sight of the black double-headed eagle on the crimson banners of the Habsburg court, the slight figure of Charles V, 'the illustrious master of Christendom', came forward and

invited Aretino with a nod to ride on his right hand. The next morning, the emperor did him the honour of greeting him informally with a modest smile, or, as Aretino put it, 'he greeted me without greeting me'. They talked about the revolts in Flanders, the strength of France and Barbarossa's raids, and despite all these problems Caesar 'still did not abstain from acknowledging with every possible sign of pleasure my devotions toward his deity'. Now one of the imperial courtiers came forward, pressed gold into Aretino's hand and informed him that as soon as Caesar had heard mass he would command him 'with a gesture of his hand and a nod of his head to become one of his followers'.

If it was true – which it may not be – that the emperor really invited Aretino to accompany him to Germany, it was not an invitation that the Scourge of Princes, who had so often expressed a hatred of princely courts and vowed never to leave Venice, could accept: 'The reason that I did not follow him was that it did not please God that I should.' Nevertheless, so Aretino would have us believe, after he had slipped away to Venice without bidding Caesar a final farewell, Charles summoned the Venetian ambassadors, 'and said to these grave and respectable men: "O honoured friends, surely it will not irk you to tell your government that I will be very grateful to them if they treat the person of Aretino with the respect due to someone who is very dear to me"'. As the emperor prepared to cross the Alps, Aretino returned to Venice 'amid such an applause of visits, praises, and embraces, that I must needs now live happily who have won immortal and perpetual fame'.

Titian remained in Bologna at least until 8 July when the papal treasury paid him fifty scudi to cover the expenses of his return to Venice. It may have been during his three months with the papal entourage, or it may have been later, that he painted in what appears to be great haste for the pope's grandson Cardinal Guido Asciano Sforza di Santa Fiora[11] a second *Portrait of Paul III* (Naples,' Capodimonte), this one smaller and with Paul wearing the papal cap or *camauro*. There are numerous copies of the two portraits,[12] some with and some without the *camauro*. All were painted by other hands,

but the high quality of most testifies to the impact Titian's originals made on lesser artists.

Paul III, although aware that the Venetian master had immortalized him in a way that his portraits of Charles V and Francis I had not done for the other two most powerful European rulers, did not deign to pay Titian in cash. Instead he proposed a reward that another artist, one with a less independent spirit, would have been only too happy to accept. He tried to lure him to Rome with the offer of the papal seal, the *piombo*. Twelve years earlier Clement VII had given the *piombo* to Titian's old Venetian-born friend Sebastiano Luciani, who is best known today as Sebastiano del Piombo. The office of the *piombatore* was supposedly for life and provided the handsome income of more than 800 scudi out of which Sebastiano had agreed to pay a yearly pension[13] to Giovanni da Udine, a decorative painter and master of stuccowork who had been one of Raphael's principal assistants. Avaricious though Titian may have been, there were some lengths to which he would not go, not even for a very handsome income. Depriving two fellow artists of their livings and being trapped in Rome for life were two of them, as Aretino, who wrote him a letter of congratulation for his largeness of soul in turning down the offer, knew better than anyone.

The two friends, as they gossiped over their dinners, may have laughed at the very idea of Titian in the service of the papal court – the writer who despised all courts and had made a particular point of satirizing the papal court[14] and the painter who had consistently refused to leave Venice for long, not even at the behest of the emperor. They may not, however, have been fully aware that by refusing Sebastiano's *piombo* Titian was sacrificing the interest of Alessandro Farnese, who although still young was already a master broker of papal benefices and might have found a way to help with Pomponio's benefice on San Pietro in Colle if he had been able to lure Titian to Rome as painter to the papal family. Nevertheless, Aretino was not wrong about Titian's sense of honour in this matter. Titian changed his mind a few years later and proposed himself for the office of the *piombatore*, but by that time Sebastiano was dead.

As far as Titian was concerned the Farnese had bought him with the prospect of the benefice of San Pietro in Colle for Pomponio. It was a living that would raise the status, as well as the income, of the entire Vecellio family, and it was to that end that he had taken great pains with the portraits of Ranuccio and of Paul III, masterpieces for which he had received no payment. He had not, however, grasped just how well connected the incumbent Archbishop Giulio Sertorio was or how set on retaining the benefice for himself. Cardinal Farnese fulfilled a promise to write to Sertorio requesting him to relinquish the benefice. But before he received a reply he was suddenly struck by the first signs of a fever and made a hasty retreat from Bologna, leaving it to his secretary Bernardino Maffei, later an archbishop and cardinal, to communicate the unwelcome news of his departure to Titian. When Maffei softened the blow by pretending that Sertorio had agreed to cede the benefice, Titian reacted with a letter to the cardinal, dictated to his nephew Giovanni Alessandrini[15] soon after his return to Venice on 26 July, in which he expressed his joy, relief and willingness to compensate His Most Reverend and Illustrious Highness with his goodwill and his works.

> So I will await the letter of possession, just as Maffei has promised me, in the hope that the bull will be expedited in good time. I desire this possession not so much for my own sake, because I know that it cannot now fail to be mine, as for the satisfaction of the many of my lords and patrons who, because of the good they wish me, are waiting impatiently for the letter so they can rejoice with me from the depths of their hearts and because some of them intend to keep me company when I go to take possession of the Abbey.

When Titian had received no reply by the following March he and Alessandrini, with rhetorical flourishes probably suggested by Aretino, wrote again, this time to Maffei.

> The fame of the great Alexander resounds in the ears of the world, excluding all other conversation or praise, so that I, who adore him,

hear such words of praise like a return of youth and will be no less rejuvenated when I hear that the pope in his immeasurable kindness and sainted clemency has fulfilled his promise of the benefice …

The benefice, he maintained, was the minimum recompense he deserved for the works he had executed for the Farnese; and yet, in addition to having received nothing for his portraits, he had had to suffer embarrassment in Venice where everyone believed that he had secured the benefice. He concluded with a pitiful postscript asking Maffei to let him know the thoughts of the Most Reverend Cardinal Alessandro about the letter he had written to him some time before. When this request, like the others, was greeted with silence Titian might have concluded that Aretino had been right to warn him of the false promises of the 'priestly rabble' in Rome.

Nothing, however, could distract him from the question of Pomponio's papal benefice, which had become a matter as much of pride as of avariciousness. He paid a visit to Ranuccio Farnese, who agreed to write to his brother Cardinal Alessandro on his behalf. He wrote to Michelangelo asking him, as a brother-in-craft, to favour his suit in Rome. Aretino, as ever his most loyal champion, poured out a stream of letters: to Michelangelo; to Carlo Gualteruzzi, a friend of Pietro Bembo who was also secretary to Ottavio Farnese, asserting that the benefice would dry the sweat from the virtuous forehead of the painter who had expended so much trouble and genius on his portraits of the Farnese, and suggesting an approach to Bembo who might use his influence with Michelangelo; and to Ottavio Farnese himself. In May 1544, when such interventions seemed to be falling on deaf ears, Aretino addressed to Titian a prose poem in the form of a letter, which of all the many letters he wrote to and about Titian is perhaps the most beautiful and heartfelt testimony of their shared sensibility. He did not publish the letter until 1546, but it is not impossible that before its publication he had it delivered directly or indirectly to the Farnese who in 1544 were so stubbornly refusing to give Titian his due.[16] Aretino, who was suffering from a fever, leaned on his windowsill and turned his eyes to heaven, 'which, from the

moment when God made it, was never adorned with such painted loveliness of lights and shadows':

> The whole region of the air was what those who envy you, because they are unable to be you, would fain express. To begin with, the buildings of Venice, though of solid stone, seemed made of some ethereal substance. Then the sky was full of variety – here clear and ardent, there dulled and overclouded. What marvellous clouds there were! Masses of them in the centre of the scene hung above the house-roofs, while the immediate part was formed of a grey tint inclining to dark. I gazed astonished at the varied colours they displayed. The nearer masses burned with flames of sunset; the more remote blushed with a blaze of crimson less afire. Oh, how splendidly did Nature's pencil treat and dispose that airy landscape, keeping the sky apart from the palaces, just as Titian does! On one side the heavens showed a greenish-blue, on another a bluish-green, invented verily by the caprice of Nature, who is mistress of the greatest masters. With her lights and her darks, there she was harmonising, toning, and bringing out into relief, just as she wished. Seeing which, I who know that your pencil is the spirit of her inmost soul, cried aloud thrice or four times, 'Oh, Titian! Where are you now?'[17]

THREE

A Miracle of Nature

As heaven is the paradise of the soul, so God has transfused into
Titian's colours the paradise of our bodies.

'TULLIA D'ARAGONE' IN SPERONE SPERONI'S
DIALOGUE ON LOVE, 1537

Titian must have been pleased that his son Pomponio, now a young man
in his early twenties, had buckled down to the study of law at the
University of Padua, and had grown out of his adolescent sulks well
enough to have learned the three sacred languages, Latin, Greek and
Hebrew, that were a requirement for the priesthood, and which Titian
regretted never having had the opportunity to study himself. We can read
something of Pomponio's lack of self-confidence and anxiety to please
from two letters that he wrote from Padua in May 1544 to his relative
Toma Tito Vecellio, who was living temporarily in Venice at the time.
Toma Tito had evidently written Pomponio an avuncular letter inviting
him to show off his learning in a humorous way by giving his opinion
about a legal matter. Pomponio's replies, which he signed 'Pomponius
Vecellius', were supposed to be a parody of legal pedantry and are full of
quotes from a Latin textbook. He is trying to be witty, but claims failure
of inspiration and lack of learning – 'I have little expertise in one profes-
sion and much less in the other' – and swears he would 'rather be Aretino
than half a Cicero'. He sends his love to Titian and everybody at home.
When, a month later, he took minor orders Titian had reason to believe
that his boy had accepted the career he had chosen for him.

By September 1545, however, it had become obvious that Pomponio had no intention of fulfilling the requirement of residence in return for the benefice of Santa Maria della Scala. Titian gave Giovanni Alessandrini power of attorney to exchange that living with another, but continued his relentless pursuit of the living of San Pietro in Colle, which carried greater prestige as well as a higher income. In this Titian found an ally in Giovanni della Casa, a Tuscan prelate, best known for his obscene poetry and courtly dialogues about language and manners,[1] who arrived in Venice in August as papal nuncio. Della Casa was Alessandro Farnese's principal courtier, and Titian, who may have met him previously through their mutual friend Pietro Bembo, wasted no time before paying him a visit, charming him with his pleasant manners and the gift of a copy of his portrait of Paul III,[2] so that when the new nuncio called on him at Biri Grande he was already predisposed to help the Venetian master. One of the paintings he saw in Titian's studio gave him an idea. It was a painting of a luscious reclining nude, probably the copy of the *Venus of Urbino*[3] that Titian had promised ten years before to paint for Cardinal Jean de Lorraine, who had never collected it.

On 20 September della Casa wrote to Cardinal Farnese that Titian had 'corrupted' him with the gift of a portrait of the pope in such a way that he had agreed to act as his representative in reminding him that Giulio Sertorio should receive compensation for the living of San Pietro in Colle, so that Titian could have it, 'which would be the very culmination of his happiness, and he is ready to portray the Illustrious House of Your Most Reverend Lord right down to the cats'. He went on to request a sketch of the 'sister-in-law' – a euphemism for Alessandro's mistress, a courtesan by the name of Angela – so that Titian could enlarge it and he, della Casa, write a sonnet about it. Titian, he continued, had almost finished a nude that would put the devil on the back of the principal censor of the Church. The Venus [of Urbino], 'which Your Most Reverend Lord saw in the chambers of the Duke of Urbino, is a Theatine nun compared to this one, and he wants to give her the features of the above-mentioned sister-in-law, provided that the benefice is his'.[4]

While della Casa was in Venice he was closely acquainted with Elisabetta Querini Massolo, a Venetian noblewoman, niece of the Venetian patriarch Girolamo Querini and a prominent figure in the literary circles he frequented. She was about fifty and had been married to Lorenzo Massolo for thirty years when the legate commissioned Titian to paint her portrait, which both della Casa and Aretino praised with sonnets celebrating the beauty he had captured. The portrait cannot be identified, but copies (one is in Rome, Galleria Borghese), suggest that she was far from beautiful by that time. Her attractiveness probably lay in a lively and cultivated mind – Bembo regarded her as the muse of his old age. It was probably at her suggestion that Lorenzo, later in the 1540s, would commission from Titian the dark, turbulent *Martyrdom of St Lawrence* for the family tomb in the church of Santa Maria de' Crociferi.[5] Titian did not get around to painting it until after Lorenzo's death in 1557, when he had become intensely interested in the treatment of light, of which this painting was a landmark in his artistic development.

Although Titian was not often to be found at the Venetian literary academies, print shops and private salons where books and ideas were discussed he was the portraitist of choice for those *letterati* who could afford his prices. One of these was the Paduan-born Sperone Speroni, who in a will of 1569 wrote that Titian had painted his portrait in 1544 (the weak *Portrait of a Man Holding a Book* in the Treviso Museo Civico could be a studio copy, although it looks nothing like other portraits of Speroni). Speroni was a philosopher and dramatist best known for his fictional dialogues in which such themes as rhetoric, the use of the vernacular as preferable to Latin, the status of women and the nature of love are discussed by people of different backgrounds and perspectives.[6] Although the names of his speakers were borrowed from well-known contemporaries, Speroni explained in an *Apology on the Dialogues* that he had used poetic licence, as one would do in portraits or plays, and had not intended to voice the real opinions of real people. In the *Dialogue on Love*, which was read aloud at one of Aretino's literary soirées in 1537, he has Tullia d'Aragona, the famous philosopher-courtesan, contrast love, which she defines as an

image of God created by nature, with painted portraits which show nothing but the outer semblance of a living man. 'But', cries the poet Bernardo Tasso,[7] 'you are unjust to Titian.' 'No,' replies Tullia, 'I hold Titian to be not a painter – his creations are not art – but his works to be miracles, and I think that his pigments must be composed of that wonderful herb which made Glaucus a god when he partook of it; since his portraits make upon me the impression of something divine, and as heaven is the paradise of the soul, so God has transfused into Titian's colours the paradise of our bodies.'

Speroni's collected dialogues, published by the Manutius Press[8] in 1542, were edited by Daniele Barbaro, the Venetian nobleman and polymath whom Titian portrayed twice, in 1544–5, both times wearing black and holding a book. One (Ottawa, National Gallery of Canada) was commissioned by Paolo Giovio for his gallery in Como of portraits of famous men and women; the other, which is almost identical (Madrid, Prado), possibly kept in Titian's studio as a record. Barbaro was a philosopher, mathematician, scientist and patron of the arts with a special interest in architecture, which he regarded as a union of science and art and therefore superior to both. He was only thirty-one when Titian portrayed him, with an impressive career ahead of him. Together with his brother Marcantonio, he would commission Palladio's Villa Barbaro at Maser and work with Paolo Veronese on the programme for the interior frescos, which are among the liveliest and most enjoyable of all illusionist paintings. But he never abandoned his scholarly pursuits, which included a translation of Vitruvius (1556) and a later edition (1567) in Latin with illustrations by Palladio and a commentary containing his famous definition of perfection as 'that which lacks nothing and to which nothing can be added'. In Titian's portraits of him we see the sombre man who disliked ostentation and gave an instruction in his will that he be buried in a common grave in San Francesco della Vigna. But for Veronese, who also portrayed him twice but many years later, after he had taken up appointments as Patriarch of Aquileia, as Venetian ambassador to the court of Elizabeth I of England and as representative of Venice at the Council of Trent, he dressed once in the ermine

stole of a high-ranking Venetian patrician (Florence, Galleria Palatina) and again as a high dignitary of the Church in a silver cape and pleated robe with his treatise on architectural perspective and his commentary on Vitruvius on the table beside him (Amsterdam, Rijksmuseum).

Barbaro, della Casa and Bembo, like Castiglione before them, were humanists and men of the Church who believed in the perfectibility of humankind through close study of the classical texts, which were, however, seen as supplementary rather than contradictory to faith in God as the source of all wisdom. Aretino, by contrast, was a talented but ultimately self-seeking journalist who styled himself the scourge not only of princes but also of 'pedants' who bored the world with the classical learning that he was proud to confess he lacked. But the portrait of himself that Aretino commissioned from Titian in 1545 (Florence, Galleria Palatina) as a gift for Cosimo de' Medici, Duke of Florence, out-dazzles Titian's portrayals of worthier subjects. Titian painted at least four portraits of his friend. This is one of the two survivals; and, as Aretino's publisher Marcolini said, it is far finer than the earlier portrait now in the Frick Collection that had been used in 1538 as the prototype for the frontispiece of the second printing of Aretino's collected letters. Aretino's initial reaction was not far short of ecstatic. In a letter to Paolo Giovio written in April 1545 when the portrait was probably still in progress he maintained that 'such a terrifying marvel' had never before been seen, that his portrait was nothing less than 'a miracle sprung from the brush of such a wonderful spirit'.

The Divine Aretino, who looks inordinately pleased with himself, does not hold a book or any other attribute that indicates his profession as a writer. The gold chain of honour around his neck, one of a large collection that he had amassed over the years, testifies to his celebrity and success in extracting valuable gifts from wealthy patrons. He had just turned fifty-three, but, as he boasted to Cosimo de' Medici a year later, remained remarkably youthful for that great age, apart from the strands of grey in his beard, which he had noticed a few years earlier.[9] (He started dyeing it at some time after Titian indicated them in his portrait, but had abandoned the practice by 1548.) His gaze is

directed to his left at what was to be a pendant portrait of Cosimo's father, the mercenary commander Giovanni de' Medici whom he had also commissioned Titian to portray from a death mask. Giovanni dalle Bande Nere, who died in Mantua of a battle wound in the winter of 1526, had been Aretino's closest friend before he met Titian. Although the unlikely bond between the dashing, aristocratic soldier and the fearless, self-made writer had been wholly genuine, Aretino now saw it as an opportunity to remind Cosimo of his own quasi-aristocratic status by association while at the same time making an audacious attempt to introduce an example of the Venetian painterly style to Florence, where Cosimo's court painter was Agnolo Bronzino, Mannerist painter of inhumanly elegant, minutely detailed and polished portraits.

In Titian's portrait of his friend, Aretino's bulky body, the maimed right hand concealed behind his back, strains against the edges of the canvas as though too big and restless to be contained. From the highlights rapidly scribbled across the red satin coat and brown doublet, from the naked brushmarks stabbed on the right lapel, and the left hand stuffed into a thick glove as though he couldn't be bothered with the difficult task of painting a realistic hand, one might guess that Titian executed the whole of Aretino's costume at high speed, or that he left it unfinished. And knowing, as we do, that he reused a canvas on which he had previously painted a discarded portrait of a different, younger man, it would be reasonable to conclude that Titian tossed off the composition in an inspired afternoon. But did he? Why would he, who normally worked so slowly, take such little care with a likeness of his dearest friend that was intended to capture the attention of one of the most powerful lords in Italy? In fact the brushmarks that appear so spontaneous were applied over carefully prepared ground and were intended to produce an optical illusion. Look closely and they make an exciting but apparently random pattern. Stand back and you see a realistic impression of light playing on red satin.[10]

It is hard to believe that Aretino, who was so interested in the techniques of painting and enjoyed watching Titian at work, did not put

his two cents' worth into the painting of his portrait. Nevertheless, when he dispatched it to Cosimo in October 1545 he wrote two letters, one to Titian and one to Cosimo, which contain the only negative comments he is known to have made in writing about the artist whom he routinely praised as a miracle of nature, the very spirit, indeed, of nature's inmost soul. To Titian he wrote that the portrait of himself was 'more of a sketch than a finished work of art' and that he was angry because he had neglected to portray Giovanni dalle Bande Nere from the death mask he loaned him for that purpose. To Cosimo he maintained that Titian was interested only in work that brought large rewards and apologized for his failure to portray the duke's immortal father, who had been as much his boon companion as his servant and whom he had obeyed in the saddle and the stalls. But he would shortly send a portrait by another artist 'of that unruffled and energetic man that will perhaps be as true to life as anything that might have come from the hand of the aforesaid painter'. As for Titian's portrait of himself:

> Truly it breathes, its pulses beat, and it is animated with the same spirit with which I am in actual life, and if only I had counted out more crowns to him the clothes I wore would likewise have been as shining and soft, yet firm to the touch as are actual satin, velvet and brocade.

Aretino was looking at his portrait through the eyes of the Florentine duke, who preferred the high finish of Bronzino. Although he clearly knew very well that Titian's portrait was a masterpiece, he was anticipating the duke's reaction to a degree of painterly freedom that might strike him as strange or even shocking.

He felt on safer ground about the reception in Florence of the portrait of Giovanni dalle Bande Nere in profile (Florence, Uffizi), which he commissioned from Gian Paolo Pace when Titian was too busy with other commitments to take it on. When Pace's portrait was finished by November Aretino wrote to the artist that he had 'transfixed living colour' into Giovanni's death mask, 'an effigy dully transfixed in the amber of death', and that it gave him immense satisfaction

'to restore the immortal father to his fortunate son'. Unfortunately, however, a ducal aide who was a champion of Bronzino concealed Titian's portrait of Aretino from Cosimo; and when the duke finally acknowledged it in April of 1546 his reply was civil enough but made it clear that he knew how to beat Aretino at his own game. He used the very bond between them that Aretino had tried to secure with the portraits – and with the dedication to Cosimo of the third volume of his letters – as an excuse for a very small payment for them: 'Between us there is no need to behave as one does with foreigners or those with whom one has little other business.' Aretino had to make do with the satisfaction of knowing that his portrait by Titian was hung in the Medici private gallery side by side with Pace's of his other dearest friend. And they remained together for two centuries until the Pace was sent across the Arno to the Uffizi Gallery.

In September 1544, when Giovanni della Casa wrote to Alessandro Farnese on Titian's behalf, Charles V and Francis I signed a peace treaty at Crépy-en-Laonnais according to which Francis promised to help fight the Turks and to support reform of the Church and a meeting of its General Council. Alessandro, who had been acting as itinerant papal legate to the courts of the emperor and the French king charged with making the peace between them upon which his grandfather's ambitions for a General Council depended, had reason to believe he had succeeded. Three months later Titian felt confident enough of gaining Alessandro's ear to urge his interest in his lawsuit against the canons of Santo Spirito over the ruined *Pentecost*. But still he heard nothing further from the cardinal about Pomponio's benefice on San Pietro in Colle or the visit della Casa had promised he would make to Rome.

The treaty held good for only one year. At its core was Francis's claim to Milan for his second son the Duke of Orleans on condition that Orleans would marry either Charles's daughter Mary or his brother Ferdinand's daughter Anne. The death of the Duke of Orleans in September 1545 broke Francis's heart, but came as a relief to Charles, who retained control of Milan. 'This death came just in time,'

he wrote in his memoirs five years later. 'And, being a natural one, it could be said that God had sent it to accomplish his secret designs.' Fortunately for the prospects of the General Council that would meet at Trent in three months' time, neither Charles nor Francis was keen to restart an expensive war that was distracting them both from other more urgent objectives. Most of the Farnese were in Rome with enough leisure to sit for the portraits Titian had promised to paint of them all, including their cats.

But it was not the Farnese who invited Titian to Rome. It was the Venetian patriarch Girolamo Querini who advised the painter that the time was ripe to make the journey to the Holy City in pursuit of Pomponio's papal benefice. Querini persuaded Guidobaldo della Rovere – who had hoped to attract Titian to his own court at Pesaro for an extended visit – to come in person to Venice to fetch Titian and Orazio. The ducal suite took father and son by way of Ferrara to Pesaro, where, as Aretino wrote thanking Guidobaldo on Titian's behalf, the painter was plied with 'caresses, honours, presents and the hospitality of a palace which he was bidden to treat as his own'. Reluctant though Guidobaldo was to let the artist go, he provided him with an escort that carried him safely and as comfortably as possible through the Papal States.

On 10 October Pietro Bembo wrote from Rome to Girolamo Querini, 'Your Titian, or rather our Titian, is here.' He went on:

> And he tells me that he is under great obligation to you for having been the main cause of his coming hither, and encouraging him by the kindest words to make the trip, of which he is more contented than he can say. He has already seen so many fine antiques that he is filled with wonder, and glad that he came.

Immediately after his arrival Titian wrote enthusiastically and often to Aretino: he was astounded by his first sight of Rome and wished he had come twenty years earlier: the pope had greeted him in the friendliest of ways; Bembo had wept with joy when he conveyed Aretino's greetings. Aretino replied[11] that he could hardly wait for

Titian's return so that he could hear his friend's thoughts about the art he had seen in Rome:

> about the skill of the ancients in carving marble, and whether in his art Buonarrotti was greater or less than they, and whether Raphael does not come up to him or surpasses him in painting ... Do keep in mind the accomplishments of every painter, and especially those of our friend, Fra Sebastiano ... and compare in your own mind the status of our gossip Messer Jacopo [Sansovino], with those carved by men who, since they compete with him without justification, are rightly criticized. Come back here, too, as well informed about the court and all the doing of the courtiers as you are of the masterworks of paint-brush and chisel, but pay special attention to the works of Perin del Vaga for he has remarkable genius.

But although Titian could hardly have failed to be interested in the artistic splendours he was seeing for the first time, Aretino was aware that the real grail of his pilgrimage to the Holy City was the benefice for Pomponio. And about this Aretino issued, as he had done in the past, a warning:

> It is a characteristic of the house of Farnese to abound in a great plenty of kindly deeds, for it is well known that they are the mother of those hopes provided by nature for the enjoyment of mankind – mankind which is ordinarily fed upon promises which are only certain in their great uncertainty.

FOUR

Rome

Do not trust the Pope, who neither honours his word nor has the
general interests of Christianity at heart.

FROM CHARLES V'S INSTRUCTIONS TO HIS
SON PHILIP, 1548

With a single glance the great Venetian master revealed in this
painting what Italians at that time thought of politics: it was as
though he had summarized with a few magisterial brush strokes
some of the most famous chapters of Machiavelli's *Prince* without
ever having read them.

ROBERTO ZAPPERI, *TIZIANO, PAOLO III E I SUOI
NIPOTI*, 1990

Titian and Orazio were given lodgings and a studio in the Vatican's
Villa Belvedere where they could communicate easily with the Farnese
family, who, as Titian could hardly fail to notice, were getting on very
badly.[1] Alessandro, his principal contact in Rome, was colossally
wealthy, a powerful fixer and consummate patron of art and litera-
ture, but also deeply dissatisfied with his lot in life and bitterly jealous
of his three younger brothers. Ottavio and Margaret had been blessed
with twin sons, named Carlo and Alessandro after their respective
grandfathers, born on the very day after the investiture of Ottavio's
father Pier Luigi as Duke of Piacenza and Parma. The pope's youngest

grandson, Orazio, was being groomed at the court of Francis I while Paul negotiated his marriage to Diana, the natural daughter of the dauphin, the future Henry II. Three days after the opening of the Council of Trent on 11 December 1545 he added to the list of Alessandro's grievances by investing Ranuccio with a cardinalate. Alessandro had tried hard to block his younger brother's nomination. Paul's explanation that an additional Farnese cardinal would insure against Alessandro's premature death was hardly a comfort.

The underdrawings for Titian's *Portrait of Cardinal Alessandro Farnese* (Naples, Capodimonte)[2] suggest that the painter might have taken as much trouble to conceal his first gut feelings about his subject as he had with the earlier *Portrait of Paul III*. Alessandro's features as originally sketched are coarser, the right arm pushes towards the edge of the canvas with its elbow more pronounced. But in the finished work the twenty-five-year-old cardinal's dark, apparently candid eyes set in a handsome oval face gaze straight out at the viewer. The red, sensuous lower lip hovers between a pout and a smile. His pose is more elegant, the watered silk of his red cape superbly realized. The glove held lightly in his left hand indicates that he is a gentleman about town as well as a dignitary of the Church – a daring challenge to the Counter-Reformation ideal that prelates should behave like poor honest priests.

There can be little doubt that the lascivious Alessandro was delighted by the copy of a reclining nude, on to which Titian had promised della Casa that he would attach the head of the cardinal's courtesan mistress Angela, as well as by the enlarged portrait of Angela in the demure guise of a young Venetian patrician (Naples, Capodimonte).[3] At a time when Petrarchan poets separated the kind of women with whom a man has carnal relations from the nobler creature who can only be desired from afar, Titian had already exploited the arousing paradox that the same woman can in fact be (as we would put it) a lady in the drawing room and a whore in bed when he had put clothes on the original *Venus of Urbino* for the portrait acquired by Francesco Maria della Rovere that we know as *La Bella*. But this time there was a problem. Behaviour that had been

more or less acceptable when Paul, as a young cardinal, had himself kept a mistress and sired children by her was now, as the Nineteenth Ecumenical Council of the Church began its first sitting at Trent, an embarrassment. Gossip about the relentless womanizing of the *gran cardinale* was flying up and down the corridors of the Vatican. It had reached the ears of some of the older cardinals that the pope intended to make Alessandro his successor to the papal throne. That, some said, would at least stop him from skirt chasing.

Titian's naked and clothed Angela would not of course have been on public display. They were to hang in Alessandro's private chambers where they would be covered by curtains; but they could not be hidden altogether from servants and prying courtiers, and it would not be long before the pope heard about them. It was necessary therefore to take evasive action. Alessandro asked Titian, who had succeeded all too well in producing a recognizable likeness of the notorious Angela from the miniature sent to him in Venice, to reorganize her features in both paintings to those of an anonymous young woman.[4] But the more ingenious solution was to clothe the naked girl in the decency of a classical myth, to which Paul, who was at that time having his own apartments in Castel Sant'Angelo decorated with erotic frescos of the myth of Cupid and Psyche, could hardly object.

Ovid's story of Danaë was an ideal disguise. Danaë was the daughter of the king of Argos, who, to safeguard himself from a prophecy that he would be killed by his daughter's son, locked her in a bronze tower where no man could reach her. But Jupiter penetrated the tower and impregnated her with a shower of golden rain. (In the end their son, Perseus, did in fact accidentally kill his grandfather.) It may have been Alessandro who ordered the transformation of the naked courtesan into *Danaë* (Naples, Capodimonte), or it may have been a collaborative idea. Either way, it was Titian who made it happen with his magical brushes and genius for turning a good story into a great painting.

On his numerous visits to Mantua, he had often had occasion to admire Correggio's *Danaë* (Rome, Galleria Borghese) commissioned in the early 1530s by his old patron Federico Gonzaga. But if the

memory of Correggio's glorious version of the story was one of his starting points, the challenge of transforming the body of his *Venus of Urbino*, a Venetian courtesan inviting sex in a contemporary domestic setting, into a mythological woman engaging in the act of love with a Greek god inspired a masterpiece of modelling, chiaroscuro and high drama. The curtain that divided the composition of the *Venus of Urbino* in half is swept aside to reveal a dark grey plinth and the shaft of a pillar which rises through a shower not of golden rain but of coins, intended, perhaps, to suggest the seductive power of money. He replaced the little dog and two maidservants in his copy of the *Venus of Urbino* with a plump cupid – a boy rather than a baby and reminiscent of antique statues that Titian could have seen in the Grimani collection in Venice and in the Vatican collection in Rome – who gives a backward look as he departs from the scene on Jupiter's orders while the god's golden sperm descends between Danaë's open legs. Although her face is partly cast in shadow, Danaë is evidently enjoying herself as she gazes rapturously at the invasive shower of gold. Her body, propped up a little higher than her predecessor's on white sheets, bolster and pillows, is more robustly Michelangelesque, apparently inspired by a sketch of Michelangelo's sculpture of *Night* in the Medici tombs in Florence[5] and by the same artist's *Leda*.[6]

The *Danaë* was probably finished by the second half of November 1545 when Vasari, who had been summoned to Rome by the Farnese to fresco a room in the Cancelleria,[7] acted as Titian's guide. Vasari, who by his own account brought Michelangelo to Titian's studio, described the reaction of the greatest central Italian artist in one of the most frequently cited passages of his 'Life of Titian'.

Then one day Michelangelo and Vasari went along to visit Titian in the Belvedere, where they saw a picture he had finished of a nude woman, representing Danaë, who had in her lap Jove transformed into a rain of gold; and naturally, as one would do with the artist present, they praised it warmly. After they had left they started to discuss Titian's method and Buonarroti commended it highly, saying that his colour-

ing and his style pleased him very much but that it was a shame that in Venice they did not learn to draw well from the beginning and that those painters did not pursue their studies with more method. For the truth was, he went on, that if Titian had been assisted by art and design as much as he was by nature, and especially in reproducing living subjects, then no one could achieve more or work better, for he had a fine spirit and a lively and entrancing style. To be sure, what Michelangelo said was nothing but the truth ...[8]

Vasari, whose 'Life of Titian' was not published until two decades after that meeting, was using Michelangelo to record his own theory that art in its most mature phase, of which Michelangelo was in his view the highest representative, supersedes nature; and that Venetian spontaneity and use of colour and shaded outlines to imitate reality was, for all its charm, less noble than the Florentine method based on the discipline of drawing. But if, as seems unlikely, Vasari's famous anecdote about the encounter of the two artists was based on a real conversation, it may be that Michelangelo was annoyed, or even repelled, to see Titian's womanly version of two of his own mannish figures in the act of heterosexual sex.

Although Michelangelo was too lofty a figure to be threatened by the presence in Rome of the Venetian master, other lesser artists, including perhaps Vasari himself, feared that they could lose commissions to the foreign painter who was for the time being a favourite of the Farnese. In his biography of Perino del Vaga (the Tuscan artist Aretino had asked Titian to study while in Rome), Vasari wrote that Perino, who was very worried about competition from Titian, shared the general hostility in Rome to Venetian masters. The convivial Sebastiano del Piombo, as he had been known for over a decade, had no reason to resent Titian's presence. He and Titian were friends from the old days in Venice, and Titian had demonstrated his continuing loyalty by turning down his office of the *piombatore*. Sebastiano had, however, been marginalized in Rome since the Sack had cast its long shadow over the last years of his patron Clement VII. He had a reputation for laziness and vanity (he had once described himself in a

letter to Aretino as the most beautiful friar in Rome), and what with one thing and another had never received one of the major decorative commissions that were the hallmarks of success in the Holy City. Dolce, in his *L'Aretino*, was referring to the supporting role in which Michelangelo cast Sebastiano during his artistic battle with Raphael when he had his fictional Aretino dismiss him as 'the lance of Michelangelo',[9] and went on to tell the story of a visit Titian and Sebastiano had paid to the Vatican Stanze to admire Raphael's frescos.

Lutheran soldiers occupying the Vatican during the Sack had damaged parts of Raphael's work, and after the troops had left Pope Clement had commissioned Sebastiano to restore some of the heads.

> Now when Titian came to be in Rome, and was passing through these rooms one day in Sebastiano's company, he concentrated his thoughts and his eyes on a study of the Raphael frescoes, which he had never seen before; and when he reached the part where Sebastiano had restored the heads, he asked the latter who the presumptuous and ignorant fellow was who had put daubs on these faces – in ignorance, of course, that Sebastiano had re-worked them, and seeing only the unbecoming contrast between the other heads and these.[10]

If Dolce's anecdote is true Titian may have regretted an unintentional insult that would have been especially distressing at a time when Sebastiano's reputation was at a low ebb.

But Titian was more concerned at the time about another friend. News had reached him from Venice about a disaster that had struck Jacopo Sansovino just as his library of St Mark, on which no expense had been spared, was nearing completion. On the night of 18–19 December the vault of the first bay of the great hall of the library collapsed silently and without warning. Immediately afterwards Sansovino was arrested and thrown into jail. It took four days for letters from Venice to reach Rome, but as soon as Titian heard the news he rallied to Sansovino's defence, as did Bembo, Hurtado de Mendoza and Aretino. It was a stroke of good luck that Francesco

Donà, a friend of the Triumvirate – Titian had begun a portrait of him shortly before leaving for Rome when he was still a senator – had been elected doge only weeks before the calamitous event. Thanks to powerful supporters, including some members of the Council of Ten, the architect was released. Sansovino, in a letter to Bembo, put the blame on the severe winter weather, on the vibrations from artillery salutes fired that night from a galley on the Grand Canal, and on unskilled workmen who had removed the props from the vault too soon, although he admitted privately that his insistence on introducing vaults instead of the flat timber ceilings that were normally used in Venice because they were more flexible was part of the problem. His reputation suffered in the short term, and his salary was not restored for more than two years. It seemed, as Aretino later wrote to Titian, 'a strange and cruel trick of fate that the very building which was to have been the temple of our brother's glory should have become the cemetery of his good name'.

Aretino meanwhile had resumed his pursuit of a cardinal's hat, a prize that he was as blindly determined to obtain as Titian was to have the benefice of San Pietro for Pomponio. Early in the New Year the Scourge rejoiced when he received a letter from a friend in Rome[11] who was a valet in Pier Luigi Farnese's bedchamber. While his attendants were putting him to bed Pier Luigi had told them about a conversation he had had with his father the pope. 'Holy father,' the Duke of Piacenza had said,

> you make cardinals of men who are poor and of low station for no other reason than that they have served our family faithfully, a thing that is certainly well done and laudable. But if such persons have seemed to you fit for such high promotion, what would you not gain by bestowing a similar advancement on Pietro Aretino? He may be poor and baseborn, but he is on good terms with every prince in the world. If he should receive this dignity he would render you immortal.

But the pope was evidently unimpressed by his son's intervention, and when by the spring Aretino realized he had failed once again he circulated an obnoxious sonnet, in which he listed all the old denunciations of Paul, true and false. He called the pope an old coxcomb, vindictive, iniquitous, seditious, an ugly lecher, born of incest, guilty of incestuous relations with his daughter Costanza and thus both grandfather and father to her sons. The latter charges were entirely untrue. Paul was the legitimate son of Pier Luigi Farnese the Elder and Giovanella Caetani. Although he adored Costanza, he had certainly not taken her to bed, and Aretino's outrageous charge was particularly painful coming as it did less than a year after her death.

Titian must have been aware of his friend's latest attack on the pope, or at least of the opinions it expressed, while he was working on his *Portrait of Paul III with his Grandsons Alessandro and Ottavio Farnese* (Naples, Capodimonte). But it would be a mistake to deduce from its apparent atmosphere of evil intrigue that the painting was intended as a criticism of the Farnese family or, as some have guessed, of the pope's nepotism. It would not have been in Titian's interests to reveal a negative judgement about the behaviour or characters of patrons upon whom Pomponio's benefice, the reason he was in Rome, depended. And nepotism, as Titian was well aware, was traditional papal practice, openly celebrated in previous paintings by other artists that were intended to promote dynastic succession.[12] Titian's artistic starting point was the copy by Andrea del Sarto of Raphael's *Portrait of Leo X and his Cousins*, which he would have seen in Federico Gonzaga's collection. But while the Raphael and its all but identical copy are superb paintings it is Titian's less resolved sketch of members of the Farnese family that draws us into a family drama so intense and complex that one can't help wondering what Verdi would have made of it.

The large canvas delivered to Titian's studio in the Belvedere was to hang in a public room in the Palazzo Farnese where ambassadors were received and where it would advertise the prestige of the family and convey a political message directed specifically at Charles V. The message was that Alessandro should succeed his grandfather as pope

and Ottavio follow his father Pier Luigi as Duke of Parma and Piacenza, the latter requiring the permission of the emperor. The members of the family who do not appear in the painting are as significant as those who do. It would have been inappropriate to include Pier Luigi in a picture of state because the promotion of a son was one of the few restrictions on the practice of nepotism, and because the emperor was still refusing to recognize Pier Luigi as Duke of Parma and Piacenza. The presence of Orazio, who was secretly destined to marry the granddaughter of Charles's arch-enemy the King of France, was also out of the question. Alessandro, the most finished figure in the painting, stands on the pope's right apparently detached from the drama while Ottavio hovers in profile on the left in an ungainly attitude that would end with the ritual abasement on all fours kissing the papal shoe that protrudes from Paul's robe. So Ottavio, eventual heir to Parma and Piacenza, is – like his father-in-law the emperor, who is also required to kiss the papal foot when they meet – ultimately subject to the authority of the pope. Paul gives Ottavio, whom he knows to be deeply resentful at having been forced to sacrifice for the time being his right to Parma and Piacenza, a quick, irritable glance.

Titian received his first instructions for this painting early in December 1545, three months after Pier Luigi's investiture as duke of a secularized Parma and Piacenza had enraged Charles V and sown in the disappointed Ottavio the seeds of rebellion against the pope. Titian continued to work on the painting until he returned to Venice at the end of May, and the many laborious pentimenti, which are particularly numerous beneath the seated pope, are evidence of how hard he tried to please his patrons and resolve the considerable spatial problems of portraying in one painting three figures: one three-quarter length, one seated, one standing at an angle while bowing. Alessandro, whose portrait was originally further to the left, close to the edge of the canvas, may have asked Titian to shift it forward and closer to the papal throne, which he grasps to indicate his forthcoming succession (the two heads side by side can be seen in an X-ray). This displacement made it necessary to move and

repaint the table on which the pope's unfinished right hand rests, and on which Titian erased an inkstand and added the hourglass that was presumably meant to remind imperial visitors that it was only a matter of time before Alessandro would be pope and Ottavio Duke of Parma and Piacenza. When it was decided to portray Ottavio in profile, he slightly softened the ugly curve of his nose, but if he had finished the painting he would surely have succeeded in making him look less oleaginous.

As it is, what we see is a work still in progress, and the unease that we may feel when standing before it could reflect circumstances that Titian sensed without being entirely aware of the tragedy that was unfolding as he laboured on the most challenging of his Roman commissions, and his first triple portrait since the *Concert* of more than three decades earlier. The pope at seventy-seven had aged noticeably. He was reputed to have said that the behaviour of his grandsons would be the death of him, and some of his cardinals were giving him three or four years to live. Titian, now well into his fifties, was old enough to empathize with Paul's struggle for survival. He must also, as a father determined to dictate the future of his own ungrateful son, have understood the pope's feelings about heirs who were dissatisfied with all the wealth and power he had lavished on them. But looking again at the painting in the light of Titian's expectations for Pomponio's benefice, which was still hanging in the air, one can't help speculating that his own anxiety might be one of the elements in the dramatic tension that we feel, whether or not we know its background, when we look at this unfinished masterpiece.

Titian painted other pictures during his Roman stay, one of them a lost Ecce Homo mentioned by Vasari that was apparently not to the taste of the pope. Another was a copy of Raphael's *Portrait of Pope Julius II* (the Raphael is in the London National Gallery, Titian's copy in the Florence Galleria Palatina), which was on public display in the church of Santa Maria del Popolo. But the only other surviving painting that has been attributed to Titian on circumstantial evidence[13] is the damaged portrait of Pietro Bembo (Naples, Capodimonte), who was then seventy-six with less than a year to live. Although Bembo,

who had rejoiced at Titian's arrival, was in Rome throughout his visit, the portrait, even allowing for its poor condition, is so unworthy of Titian's brush that we can guess that, in order to concentrate fully on the Farnese pictures, he may have left this task to Orazio.[14] In one of the inventories of the Farnese collection the portrait is attributed to Titian or an assistant, and since the only assistant Titian brought with him to Rome was Orazio, it could have been Titian's son who had the honour to paint the last portrait of the greatest Venetian writer of his time.

When the benefice of San Pietro in Colle was not forthcoming by 24 March 1546, the pope assigned to Pomponio the parish church of Sant'Andrea at Favaro Veneto in the diocese of Treviso, which made Pomponio a simple parish priest rather than the abbot of a great monastic foundation.[15] The document mentions an annual income of twenty-four ducats, a pittance compared to the benefice of the abbey of San Pietro, although the living from Sant'Andrea di Favaro was later raised considerably. The Farnese assured Titian that this was only an interim reward while they continued to negotiate with Giulio Sertorio about San Pietro. Nevertheless, their interest in the triple portrait diminished as its political significance began to unravel after Alfonso d'Avalos, Charles V's unpopular and disgraced governor of Milan, died from the complications of a battle wound on 31 March.

Paul, whose request that Ottavio and Margaret should govern Milan had come to nothing during his meeting with Charles at Busseto, now hoped that the emperor would be prepared to allow Milan, the imperial power base in Italy, to be governed by his Farnese son-in-law. Charles, however, was determined to take his revenge on the pope for his dynastic scheming. Even before the death of Alfonso d'Avalos he had installed his son Prince Philip as Duke of Milan and promised the post of governor to Ferrante Gonzaga, who shared the emperor's loathing of the Farnese, and who was likely sooner or later to remove Pier Luigi from Piacenza and Parma. The old fox Paul III had fallen into a trap set by the Habsburg eagle. On 10 September 1547 Pier Luigi was assassinated by a gang of disaffected noblemen of

Piacenza, including Agostino Landi, possibly the subject of Titian's portrait known as *The Young Englishman*. The murder was incited by an agent of Ferrante Gonzaga, who immediately seized Piacenza before Ottavio could succeed his father there as planned. Ottavio, reluctantly at first, or so he made out, accepted Parma from the emperor, who feared that it might otherwise fall to the French.[16]

If Paul – after the loss of Piacenza, his failure to see Ottavio and Margaret governing Milan, and Ottavio's betrayal – lost interest in Titian's triple portrait, Titian had his own reason for leaving the painting unfinished. On 19 March he was made a citizen of Rome in a ceremony that took place on the Campidoglio, the hub of the ancient Roman Empire, which had been redesigned by Michelangelo, who had also designed the base for the gilded bronze equestrian statue of the Roman emperor Marcus Aurelius. Although the setting could hardly have been more magnificent, the conferral of citizenship was not really a special honour. The ceremonies took place every month, and foreigners had to pay for the privilege. On the day Titian took part twelve other people, including the pope's singer but otherwise obscure, were also granted citizenship.[17] The main purpose was to make money for the city, and since the only advantages of Roman citizenship were certain tax concessions and permission to buy property, Titian's motive was probably to demonstrate to the Farnese that he might consider moving permanently to Rome in exchange for Pomponio's benefice if invited back in order to finish the triple portrait.

On 24 May the Archbishop Giulio Sertorio wrote to Alessandro Farnese that, although he personally would be happy to accept compensation for the benefice of San Pietro in Colle, the Duke of Ferrara and Cardinal Salviati wanted it for some of their friends and he could not let go of it without their consent. The news did not entirely dampen Titian's hopes as he and Orazio prepared for their return journey to Venice. On 25 May he was given a tax exemption for the export of some plaster casts and fragments of antique marbles presented to him by the Farnese. By mid-June he was in Florence. Ten years earlier he had turned down an invitation from Vasari to join

him in the Medici city. Now he was hoping for a commission from Duke Cosimo de' Medici, who received him at his villa Poggio a Caiano but, ever loyal to his favourite Bronzino, refused to sit for the Venetian painter. On his return to Venice Titian sent Guidobaldo della Rovere, a great-nephew of Julius II, the copy he had made of the Raphael portrait of Julius.

Although Vasari later claimed[18] that the Farnese had been very satisfied with Titian's triple portrait, the truth is that Alessandro, although he kept in touch with Titian, did not call upon him to finish it or even bother to have it framed. When Paul III died at the end of 1549 and was succeeded not by Alessandro but by the del Monte pope Julius III, the message the painting had been intended to convey was a dead letter. It was presumably somewhere in the Palazzo Farnese when Van Dyck sketched it during a visit to Rome in the winter of 1622–3; but no one else seems to have recognized its merit until 1653 when it was given a frame and a fringed silk cover of the kind made only for the most important paintings. The *Portrait of Paul III and his Grandsons* was eventually brought to Naples by Charles of Bourbon, who had inherited it from his mother Elizabeth Farnese. Crowe and Cavalcaselle, who saw it there in the late nineteenth century, were the first in a long line of critics to praise it in writing. During the Second World War it was stolen by German troops and stored in a cave near Salzburg where it was discovered after the war and restored to the Italian government.

A Matter of Religion

If we fail to intervene now all the Estates of Germany would be in
danger of breaking with the faith. I have decided to embark on a
war against Hesse and Saxony as transgressors of the peace against
the Duke of Brunswick and his territory, although this pretext will
not long disguise the fact that it is a matter of religion.

CHARLES V IN A LETTER TO HIS SISTER MARY OF
HUNGARY, 1546

Soon after his return from Rome Titian painted his self-portrait
(Berlin, Staatliche Museen)[1] as a gentleman about town dressed in silk
and fur with a gold chain of honour around his neck. He did not
include a brush or palette or any other reference to his profession. His
forehead is high and broad, nose powerfully arched, mouth, framed
by a greying moustache and beard, turned down at the corners. The
eyes, a little watery at his age but alert, look away as though summon-
ing a muse that has temporarily disobeyed its master. The confronta-
tional pose of the upper body with its broad shoulders emphasized by
the fur shawl may not have been deliberate since this part of the
portrait is unfinished. As he left it the fingers of his large right hand
seem to be drumming impatiently on the table in front of him while
the right hand rests on his knee, fingers pointing inwards in an atti-
tude that causes the elbow to protrude aggressively beyond the edge
of the painting. The black cap may serve the purpose of concealing
his baldness or allude to Renaissance portraits of famous intellectuals

– Aristotle and St Jerome were among thinkers depicted wearing a similar cap – or both. It is in any case a trademark that appears again in Titian's subsequent self-portraits as well as in portraits of him by other artists, and in the finely modelled lead medal portrait made around the same time by the Sienese medallist Pastorino de' Pastorini, in which Titian's face is shown in profile as in antique Roman medal portraits and the inscription identifies him as a knight, 'EQVES', of Caesar. If we knew nothing else about Titian's personality we might guess from the Berlin self-portrait that we are looking at a wealthy, socially distinguished man in his early fifties, in vigorous good health for his years, who knows his own worth but is not vain (unlike his friends Aretino, Sansovino and Sebastiano del Piombo), and who will put all his formidable energies into getting his way whatever the task in hand, whether it is confronting a difficult painting or getting the best possible result from a business deal, a patron or a lazy son.

Titian, or possibly Orazio, used the self-portrait as the sketch for a reduced version of the head, now lost,[2] which had been commissioned by Paolo Giovio, perhaps when the two met in Rome, for his gallery of famous men in Como. The only portrait of a major Venetian artist represented in Giovio's private gallery, it reached Como in May 1549 with a consignment of other portraits including one of Michelangelo. It is possible that Titian started the Berlin sketch as a pendant to his earlier portrait of Aretino now in the Pitti's Galleria Palatina in Florence, which is roughly the same size. He probably kept it in his studio for the rest of his life, for reference or as a memoir for his children.

Titian's house was full of family in these years.[3] His second wife and their daughter Lavinia, now approaching puberty, were there to welcome him back from Rome. Francesco commuted to and from Cadore where he continued the family tradition of holding offices in the local government and managing the Vecellio timber business, as well as painting altarpieces in and around Cadore and Belluno. Giovanni Alessandrini, a notary who was a first cousin of Pomponio and Orazio – his father Pietro Alessandrini had probably been married to a sister of Titian's first wife Cecilia – was living near by or

perhaps in Titian's house with his two sisters, Cecilia and Lucia (the name of Titian's mother). Giovanni, to whom Titian had entrusted power of attorney before departing for Rome, wrote letters for Titian, made fair copies for Aretino and later moved to Pieve di Cadore where he continued to conduct business on Titian's behalf. Titian's sister Orsa is not recorded as living at Biri Grande until 1549 but may well have been in residence there for many years before that.[4]

There were problems with the boys. Orazio married in 1547 when he was in his early twenties. We know this only from a letter that Aretino wrote to him in April of that year congratulating him for having invited a courtesan named Lucrezia to his wedding. Aretino did not mention the bride's name, and like so many of the women in Titian's clan she left no other trace of her identity. Marriage did not immediately persuade Orazio to settle down. Always a spendthrift, he tagged along with Pomponio and Francesco Sansovino in wild and wasteful ways for a few more years. He had a low threshold of boredom, and had inherited his father's taste for luxury but not his commitment to his art. He took up his brush when required to do so, but preferred dabbling in dubious business ventures and experimenting with alchemy, which had the effect, as Ridolfi put it, of sending his father's gold up in smoke. Francesco Sansovino eventually became a successful writer. Orazio had some talent as a painter, especially of portraits, and might have developed it under different circumstances. But Titian, while pouring into Orazio all the care, affection and forgiveness he denied Pomponio, had determined that his second son would become his irreplaceable factotum. It was a role that would become more onerous with the passage of time as Titian became increasingly reliant on him to negotiate his business deals and run his enlarged studio as it filled the growing demand for replicas of the master's originals.

Titian must have been embarrassed when Pomponio refused, on the grounds that the damp climate disagreed with him, to take up the residence as parish priest at Favaro given by the Farnese. Poor Pomponio. Abandoned by his mother's death at a sensitive age in his childhood, displaced in his father's heart by a stepmother, a half-sister

and his own younger brother, destined at birth for a career not of his own choosing – how could he ever have found the confidence to take on the role of a wealthy and socially prominent man of the Church? How hard he must have found it to be confronted time and again by that down-turned mouth, that averted gaze and those drumming fingers. Like many weak and aimless people he played the rebel while yearning for affection. But this father, this famous artist who charmed the high and mighty, whose brush could discover the essential humanity of his sitters and tap into the dramatic wellsprings of ancient tragedies, was incapable of averting the deteriorating relationship with his son that was to be the greatest tragedy of his own personal life.

Aretino was always ready to give sympathetic advice to Titian and Sansovino about their difficult sons. He told them that they must not despair, that they must remember that they too were once young, and did his best to make peace between the artist fathers and the ungrateful sons they had sent to college to learn classical languages that would equip them to avoid the uncertainty of an artist's career. Aretino thanked God for giving him a daughter, the biddable and affectionate Adria, who turned nine in 1546, prompting him to begin thinking seriously about the dowry he had been soliciting from powerful friends since her birth. Adria's mother, Caterina Sandella, had been his mistress and hostess at Casa Aretino for nearly twenty years when he wrote to her in January 1546 declaring his immeasurable love for her as 'more than a father' but trying to persuade her for the sake of her own reputation and his to return to the adulterous husband he had found for her soon after the birth of Adria. He would, he assured her in a published letter, continue to provide her with the magnificent dresses and rich necklaces that made other women incapable of hiding their jealousy. If the letter was intended to demonstrate that he was prepared to sacrifice love for honour he changed his mind a few months later when Caterina discovered that she was pregnant by him once again. A second daughter, whom he named Austria in honour of the Habsburg Empire, was born in 1547. As far as we know the robust Caterina, who was forty-six at the time of Austria's birth and who lived to be ninety, stayed with Aretino for the rest of his life.

It was in 1546 that Sansovino began his commemoration of the Triumvirate of Taste with the bronze portrait heads of Titian, Aretino, himself and others including his son Francesco in the guise of prophets, that were eventually installed on the frame of the sacristy door in the basilica of San Marco.[5] Although Sansovino's reputation was still shadowed by the collapse of part of his library of St Mark he was entrusted with the rebuilding, financed by the government, of the Corner palace at San Maurizio – the old palace had burned to the ground in 1532 but its replacement had been delayed by complicated family disputes – which his son Francesco would rate as the most memorable in Venice and Vasari would say was reputed to be the finest in Italy.

Sansovino could rely on the patronage of the new doge, Francesco Donà. Titian now revised the portrait he had painted of Donà as a senator, giving him full ducal regalia with a view of the Piazza in the background that includes Sansovino's library. (The portrait is lost. The best of several copies is in a private collection in Scotland at Mount Stuart, Isle of Bute.)[6] Donà was seventy-seven when elected, with a long career as a prominent senator and administrator behind him. Unlike Andrea Gritti he had no military experience; nor did he allow his personal politics, which were Francophile, anti-imperial and anticlerical, to sway his policy of maintaining Venetian neutrality in the Habsburg–Valois struggles. After three ducal reigns that had seen disastrous wars, he was welcomed in Venice as the herald of a period of peace, and by a group of young patrician philo-Protestants who saw him as an advocate of liberal Church reform in the tradition of Gasparo Contarini and the other Italian Evangelists. Although he appeased the Roman Inquisition by establishing a new magistracy against heresy, he retained the jurisprudential independence of Venetian courts. But he did not give way to the young hotheads in his government who supported the campaign of the Protestant Schmalkaldic League in Germany in the name of restoring Italian independence from imperial rule. Before he died eight years after his election his many admirers had reason to believe him when he wrote that he had revived the ideal of Venice as defender of peace and justice.

Although there was never a period in his life when Titian did not paint portraits, with increasing fame and demands on his time he became more selective about the status of his sitters, and there are fewer portraits after the mid-1540s than from earlier periods. One is the *Portrait of Titian's Special Friend* (San Francisco, M. H. De Young Memorial Museum), so called after a letter in the subject's hand that reads 'special friend of Tiziano Vecellio'. Because he holds the letter in his left hand (*mano sinistra*) – and because Vasari refers to a portrait by Titian of a friend of his called Sinistri – it is likely that the subject is a member of the Sinistri family, several of whom were Titian's friends. The portrait was copied much later, perhaps as a student exercise, in the mysterious *Triple Portrait of Titian and Friends* (Hampton Court, Royal Collection), a pastiche in which the grand chancellor Andrea de' Franceschi, as Titian had portrayed him in the early 1530s, is in the middle with Titian as in the Berlin self-portrait on his right and the 'Special Friend' on de' Franceschi's left.

Although Titian, as Aretino once wrote, could throw off portraits 'as quickly as another could scratch the ornament on a chest', for larger, time-consuming pictures with many figures he relied more and more on assistants to execute the work under his supervision. He used assistants for two sets of illusionist ceiling paintings, one for the new boardroom of the Scuola Grande di San Giovanni Evangelista, the other for the Augustinian church of Santo Spirito in Isola.[7] The commission for ceiling paintings for the new boardroom of the Scuola di San Giovanni Evangelista probably dates from about 1544 when Titian was called upon in April of that year for advice about whether some existing paintings in the old boardroom should be cut down to provide access to the new building. The centrepiece of his ceiling, the *Vision of St John on Patmos* (Washington, DC, National Gallery of Art), is more confident than the Santo Spirito ceiling, and numerous pentimenti beneath the final outline of the figures suggest that Titian played a direct part in its planning. The St John was directly inspired by Correggio's figure of the same saint in the dome of the cathedral of Parma, although Titian modified Correggio's

illusionism. The canvas was set in an elaborately carved and gilded framework with a surrounding of smaller paintings of different sizes and shapes (all but one, which is lost, are in Venice, Accademia): cherubs, grotesque masks and rectangular canvases of the symbols of the Four Evangelists, two flanked by reclining nudes, two by cavorting putti. The ceiling was dismantled during the Napoleonic era and in 1818 the central canvas was sold as a ruin to a dealer in Turin. It subsequently disappeared before surfacing on the art market in the 1950s when it was acquired by the Kress Foundation.[8]

Venetian ceilings, which were normally flat, because vaults and domes are liable to crack when buildings move on their foundations of wooden piles, were traditionally decorated with carved and gilded wood and coffering, sometimes set with small paintings that had no illusionist effect. Titian, however, was familiar from his many visits to Mantua with Giulio Romano's frescos of giants on the vaulted ceilings of the Palazzo Tè. He had admired Correggio's frescos in the dome of the cathedral of Parma when he first saw them in 1529 and had had the opportunity to study them again more recently while in that city with the entourage of Paul III. Now, after the overwhelming experience of studying Michelangelo's Sistine ceiling in Rome, he was ready for the challenge of adapting the perspective of heroic, twisting figures to be seen at a distance from below (*di sotto in sù*) to the more oblique arrangement suitable for the flat surfaces of Venetian ceilings.

The Santo Spirito commission (the painting is now in the sacristy of the church of Santa Maria della Salute) had been transferred to Titian some time after Vasari, who had more experience than he with illusionist ceiling paintings, turned down the job. The three Old Testament stories may have been chosen by an Augustinian hermit preacher, Agostino Museo, who had been acquitted of a charge of heresy and was under the protection of Cardinal Marino Grimani and Giovanni Grimani, Patriarch of Aquileia. It has been suggested[9] that the stories allude to St Augustine's vision of the predestination of Christ and of the elect members of the Church through free will, faith and mercy, in which case *Cain and Abel* would represent predestination and free will (however tragic the outcome), *Abraham's Sacrifice*

of Isaac justification by faith, and *David and Goliath* mercy (David is shown praying to God after he has killed Goliath). The figures, which are twice life-size, form a zigzag pattern, perhaps suggested by the similar design of the Sistine ceiling, which gives the three paintings a dramatic unity. It was a daunting task, and Titian, whose detailed drawing for the *Sacrifice of Isaac* (Paris, École des Beaux-Arts), probably for the benefit of an assistant, survives,[10] must have supervised the execution of the entire project, including the eight flanking roundels of the *Four Evangelists* and *Four Fathers of the Church*. Although the foreshortening doesn't entirely work in the *Cain and Abel*, the Santo Spirito ceiling paintings, although deprived of their original architectural setting and of Sansovino's carved and gilded framework, fascinated Van Dyck and Rubens.

But Titian had not relied exclusively on Venetian patronage since his earliest years and he had no intention of doing so now that he was the only European artist who had had the honour of portraying both the reigning emperor and pope, patrons who could provide him with the maximum prestige as well, he hoped, as a stable income. The most prominent foreign patrons of his youth – the Dukes of Ferrara, Mantua and Urbino – were related to one another by blood or marriage and were prepared to share him. Their duchies were within easy reach of Venice, and he had been able to work for them, up to a point, on his own terms, in his own studio and in his own good time. To work concurrently for the pope in Rome and the emperor in Germany would be another matter. Sooner or later he would have to make a choice. Meanwhile he hedged his bets for as long as he could.

Shortly before setting off for Rome he had sent Charles his posthumous portraits of the empress Isabella with a note saying that he would have brought them himself had he not been prevented by old age from undertaking such a long journey. He sent a stronger hint while working for the Farnese in Rome where, just as he was starting work on the *Portrait of Paul III and his Grandsons*, he hired a professional scribe to compose and pen a very fine-looking letter to the

emperor informing His Majesty in suitable language that he, Titian, had painted a Venus for him, which he hoped, the Good Lord permitting, to present to him in person. He was now studying the marvellous ancient stones of Rome so that his art might become worthy of portraying the victories over the infidels in the East that God was preparing for His Majesty. Finally he took the opportunity of kissing the emperor's most indomitable hand with all the affection and reverence in his heart to remind him that he had not yet received the permission to export the Neapolitan grain promised so many years before nor the annual pension of 100 scudi payable on the treasury of Milan promised as a reward for the Annunciation he had presented to the empress Isabella.

Titian was aware that he could not, for the time being, expect a summons from the emperor, who was making preparations for war against the Protestant Schmalkaldic League in Germany. And so, on 18 June 1546, only a few days after his return from Rome, he turned to Alessandro Farnese offering his services in exchange for Pomponio's benefice. He received no reply, but Farnese, on his way south from Germany where he had been acting for the pope in the formation of a papal–imperial league against the Protestants, put in a surprise appearance in Venice in late November when he visited Titian's studio and ordered some paintings he saw there to be finished and sent to him in Rome.[11]

In June of 1547 Titian wrote again to the cardinal to say that one painting was finished. This time he begged His Lordship 'to prepare to employ me and give me commands'. Sebastiano del Piombo having recently died, Titian was now ready to obey these commands, 'even though your Lordship should impose on me for the third time the acceptance of the cowl of the late Fra Sebastiano'. Two weeks later Giovanni della Casa wrote to Farnese to say that Titian had been informed that the seals of the *piombo* were reserved for him. 'It seems to me', della Casa continued, 'that Titian is more inclined to accept the place now than he was on former occasions, and that it would be very desirable that Your Lordship should acquire such an ornament as he is for the court of His Holiness'.

The truth was that Titian was standing undecided at a crossroads. If the Farnese had been able to be more positive about the benefice, if they had not finally lost patience and given the office of the *piombo* to the sculptor Giovanni della Porta, he might have been tempted to take the path to Rome. But it had become increasingly obvious to everyone that the emperor, at forty-seven, was strong, while his enemy Paul III, now seventy-nine and showing it, was weak. Charles was in control of Milan, and Milan, the main prize in his wars with Francis I, meant control of northern Italy. (A few years later Charles wrote to his son Philip that Milan had 'tormented him more than all the rest put together'.) Charles's status, furthermore, was immeasurably enhanced by two coincidental deaths – Henry VIII died in January 1547, followed by Francis I on 31 March – which left him as the only one of the three powerful monarchs who had been shaking the world.

Titian's future was to be indirectly affected by another decisive death, that of Martin Luther, one of the great defining figures of the age, who departed this world on 18 February 1546 while the Council of Trent was sitting. Luther almost to the end of his life had maintained that peace was more important to him than justice and kept a restraining hand on his protector John Frederick of Saxony, the most respected of the Lutheran princes and one of the founders, with his cousin Philip, Landgrave of Hesse, of the militant Protestant Schmalkaldic League. Charles, distracted for too long by his struggles against Francis I, had failed to appreciate the strength of the new religion in his German Empire. He had never mastered the German language ('one speaks German to one's stable boys') and had not set foot in the empire during the nine years between 1532 and the fruitless Diet of Ratisbon in 1541. But in April 1546, after the death of Luther and in the light of the growing aggression of his followers, he was persuaded by Paul III to sign a treaty of alliance against the Protestants at another Diet at Ratisbon, this one equally inconclusive because the Protestants refused to attend in person. There he took advantage of his unaccustomed leisure to have an affair with a girl called Barbara Blomberg. Their son, the future Don John of Austria, who would command the Christian fleet at the naval battle of Lepanto in 1571, was born on 24 February 1547.

With the League now on the attack, Charles had the financial and military backing of the pope with an immediate advance against the pope's promise of 500,000 ducats from the Fuggers of Augsburg. He also had, thanks to a diplomatic coup secured by his chancellor Nicolas Perrenot de Granvelle, an all-important alliance with the nominally Protestant Maurice, Duke of Saxony, who, although married to the daughter of Philip of Hesse, had long been suspicious of John Frederick. Maurice agreed to help defeat the League by invading Saxony in return for a promise that he would replace John Frederick as elector in the event of an imperial victory. Paul III withdrew his troops from the imperial army in January 1547 in protest against the emperor's attack on Parma. But the Protestant League, weakened by divided command and shortage of funds, was losing the initiative. Charles took the advice of the Duke of Alba, a distinguished Spanish diplomat, brilliant military strategist and commander of his Spanish divisions, to postpone war until the enemy's problems had taken their toll.

By April 1547 the time had come to march against John Frederick. Always the least yielding of the Lutheran princes, he had been outlawed by the emperor for his continuing occupation of Brunswick, and he was now rattling his sword at Ferdinand's Kingdom of Bohemia. After a long journey during which Charles was so ill that he had to be carried in a litter, the imperial army reached the Elbe River in the small hours of Sunday 24 April, a misty morning that was, as it happened, the feast day of St George, patron saint of Christian soldiers. The elector's army was sighted on the far side of the river in the village of Mühlberg where John Frederick believed himself to be safe because as far as he knew the river at that point could not be forded. Charles, mounted on a black charger, pain and exhaustion forgotten, urged his troops forward. Some waded across the river carrying their guns above their heads; some of Alba's Spaniards stripped naked and swam with knives between their teeth. Then Alba discovered that there was in fact a ford. John Frederick was at church still unaware of the danger when the imperial troops charged across the ford. While the elector and his troops fled in confusion the

imperialists, Charles now riding in the vanguard accompanied by Maurice, with Ferdinand and his son, the Archduke Maximilian, in the second line, gave chase. By midday the mist had been burned off by a blazing sun, and the figure of John Frederick was easily sighted. He was immensely fat, encased in black armour and riding the stallion he favoured because it was strong enough to bear his great weight. After a short battle in a wood near Mühlberg, he was taken prisoner, bleeding from a wound on his cheek, and handed over to Alba. 'Do you now acknowledge me as Roman Emperor?' Charles demanded. To which the elector replied, 'I am today but an unfortunate prisoner, and I beg Your Imperial Majesty to treat me as a born prince.' 'That', Charles insisted, 'I cannot do.' John Frederick, however, remained popular with the Protestant citizens of Augsburg, who, according to a report sent to Venice by the two Venetian ambassadors, had greeted him with nothing less than reverence on his arrival in the city after his defeat, dragged along on a cart with a guard of 150 Spanish soldiers.

A Spanish historian who witnessed the battle and its aftermath[12] found a parallel between the crossing of the Elbe and Julius Caesar's crossing of the Rubicon and recounted that Charles 'attributed this great victory to God, as something granted by His hand; and thus he spoke Caesar's three words, changing the third as befitting a Christian prince: "I came, I saw, and God conquered"'. Charles regarded the routing of the Protestants as the most glorious day of his life. He was never more himself than when in the thick of battle, and by defeating the League he believed he had subdued every subversive element in Europe, even down to the Venetian philo-Protestants who resented Habsburg domination in the rest of northern Italy. Mühlberg was followed by the even more significant capture of Wittenberg – the stronghold of Protestant opposition where Martin Luther had launched the Reformation – as well as by the capture and imprisonment of Philip of Hesse. On 14 May the leader of the Venetian clique that had supported the League was executed in the Piazza, while others were exiled.

On 1 August the emperor convened an Imperial Diet at Augsburg where he hoped to fulfil his lifelong goal and God-given duty of

reconstructing a universal Catholic monarchy by floating a programme of reform that would be acceptable to both Catholic and Protestant princes. His first idea, a league of all the imperial states with its own parliamentary, administrative and judicial institutions, was quickly defeated by the Catholics, who perceived it as an attempt to dilute their powers. And after the flush of adrenaline that had carried him to victory on the battlefield, Charles paid the price in ill health. He developed a fever, and his gout, asthma and haemorrhoids returned with a vengeance. His chronic depression was aggravated by insomnia – he had not slept for more than four consecutive hours at a time since 1540 – and now by enforced immobility and the restricted diet recommended by his doctors. He withdrew from company, taking his meals alone. Each morning he communicated in secret about official business with Nicolas Perrenot de Granvelle, who was acting as president of his Council, by means of letters carried by a valet who could not read or write.

It was in this dark and pensive mood that Charles instructed Diego Hurtado de Mendoza, in a short letter written on 21 October, to invite Titian to come to Augsburg to repair the nose of his portrait of Isabella with an offer to pay his travel expenses. On 29 October Mendoza replied that Titian would leave soon for Augsburg and that he would be given 100 scudi for his expenses. Titian hesitated, unable to make up his mind, and disinclined to make the arduous journey across the Alps just as winter was closing in. Another possible explanation, one that must remain in the realm of speculation because Titian's private life at this time is a mystery, is that he was delayed by the death of his second wife or the imminent birth of his fourth child Emilia, the result of an affair, possibly with a housekeeper. Aretino urged him to make an early start for Augsburg, and, at last, on 24 December Titian wrote as tactfully as possible to Cardinal Farnese that he had decided to accept the emperor's summons but hoped that he would not withdraw his favour in respect of the benefice of Colle. He sent this letter by way of Guidobaldo della Rovere, who after the death of Julia Varano had married Cardinal Farnese's sister Vittoria (with what some thought indecent haste). Guidobaldo forwarded

Titian's message to Farnese with a note begging him 'to be convinced that the matter in question is quite as much desired by me as it is by him'.

The emperor had not, of course, asked the ageing Titian to make the journey across the Alps only to repair the damaged nose of his portrait of Isabella. He would be required to portray the members of the Habsburg dynasty present at the Diet, as well as their principal courtiers and prisoners. Since no one painter could have fulfilled so many commissions in a relatively short time he brought with him seven assistants, described by Ridolfi as 'a party of gallant youths'. We can be sure that Orazio was one of them and fairly sure that Cesare Vecellio, his first cousin once removed,[13] was another. The others cannot be identified because the documents relating to Titian's visit to Augsburg were destroyed during the Second World War.

Two canvases for Charles were packed with extra care for loading on and off the mules that would carry them across the Alps. One was the Venus that he had painted on his own initiative in Venice in 1545 – Mendoza had described it as his finest work – and which he had promised Charles in his letter from Rome. Since the original for Charles is lost we can only speculate that Titian kept a drawing or painting of it in his studio as the prototype for at least six derivatives painted for different clients over the next fifteen years or so. Titian's other gift for Charles survives. It is an *Ecce Homo* (Madrid, Prado), his only painting on slate,[14] in which the beautiful, youthful figure of Christ accepting his humiliation and pain is divorced from the episode in the story of Christ's Passion that Titian had narrated so dramatically for Giovanni d'Anna. This *Ecce Homo*, an exemplary Counter-Reformation image, was intended to promote private devotion, and its gravity and restraint suggest that Titian, whatever his own religious leanings, understood the profound and personal relationship with his God that motivated the emperor's commitment to Catholic reform.

On the Christmas morning before his departure Titian sent Aretino a copy of the *Ecce Homo* he had painted for Charles (possibly the one in the Chantilly Musée Condé, which differs from the original in that

Christ holds in his right hand the reed with which he has been beaten), for which he received effusive thanks. And on 6 January 1548 Titian was at Ceneda, perhaps sleeping in his newly built villa, where he met Count Girolamo della Torre. Della Torre took the opportunity to write a letter of recommendation to Cardinal Madruzzo, who had arrived at Augsburg from Rome on the previous day, in which he described Titian 'as the first man in Christendom … who is coming at the emperor's bidding to work for His Majesty', and begging Madruzzo to help Titian in any way he can 'because in so doing you will be doing a favour to me'. What was this favour? Madruzzo, whom Titian had portrayed in Venice years earlier, was one of the most powerful prelates of his day and therefore an ideal person to approach about Pomponio's benefice of Colle.

The rest of the journey seems to have been uneventful, although it must have been hard. As the convoy of horses, mules and carriages struggled through the snowy passes towards Germany Titian, who had by no means given up hope that the Farnese would sooner or later honour their promise to give Pomponio the greatly desired papal benefice, could not have guessed that by accepting the emperor's invitation he had severed his relationship with the Farnese and that by the end of his life he and his studio would have produced no fewer than 150 paintings for the Habsburgs, seventy of them in the next six years.

SIX

Augsburg

And it is told of Titian that while he was painting the portrait [of
Charles V on Horseback], he dropped a brush, which the emperor
picked up, and bowing low, Titian declared: 'Sire, one of your
servants does not deserve such an honour.' To this Charles replied:
'Titian deserves to be served by Caesar.'

CARLO RIDOLFI, *LE MARAVIGLIE DELL'ARTE*, 1648

Augsburg, founded by the Roman emperor Octavian Augustus and
situated at the junction of two tributaries of the Danube on the trade
route between Venice and Antwerp, was sixteenth-century Germany's
largest city and headquarters of its most important banker merchants,
of whom the Fugger family were the wealthiest. The Fuggers had
made a fortune from lending to the Habsburgs since the reign of
Charles V's grandfather Maximilian I. It was from the Fuggers that
Charles had borrowed more than half of the bribes that won him his
election as Holy Roman Emperor, but which also set him on the road
to the bankruptcy and financial mismanagement that would last until
the end of the Habsburg era. The Fuggers had originally secured their
loans against anticipated revenues from the copper and silver mines
in Castile and the Tyrol. But in the 1540s, as the extravagant Habsburg
borrowings increased – not only Charles's, but also those of his
brother Ferdinand, King of the Romans, and their sister Mary of
Hungary, regent of the Netherlands – the bankers themselves had to
resort to borrowing in order to lend on the required scale, while the

Habsburgs, who never succeeded in balancing income with expenditure, delayed repayment of principal sums indefinitely. The Fuggers continued to profit from the Habsburg business by charging enormous interest rates, levying penalties for late payments, imposing brokerage fees, manipulating exchange rates and accepting such favours as imperial land sold to them at special prices. But they were seeing their profit margins reduced, and Anton Fugger, who had inherited the bank from his uncle Jacob, 'the Rich',[1] was beginning to tire of his close relationship with the imperial family. The Fuggers, who were keen patrons of Venetian art – Paris Bordone and Gian Paolo Pace had come to Augsburg to paint their portraits – also kept a palace in Venice where they traditionally sent their sons to complete their education and their experience of the business world. Aretino, needless to say, made a point of getting to know Anton Fugger's two sons and of trying to extract money from them.

Titian must have been struck by the clean, broad streets lined with steeply gabled houses, by the enormous size of the churches, and by the cold: Augsburg is one of the chilliest cities in southern Germany. It was an orderly city, certainly by comparison to Venice, but perhaps too orderly. Did he, coming from a Venice that styled itself the home of liberty, notice that the Protestant guilds had been suppressed, and the privileges formerly due in an imperial free city revoked? In any case he received a warm welcome in the Fugger palace, a complex of houses and courtyards that was home to the Habsburgs when the court was in Augsburg. The assistants were housed separately, while the emperor saw to it that Titian was given rooms overlooking the wine market that were close to his own so that they could meet and talk without being seen and where he could work on paintings that did not require assistance. Ridolfi's story about Charles V bowing to pick up Titian's paintbrush may have been an invention, but the documented comments of Titian's contemporaries leave no doubt about the warm friendship and mutual respect that developed at Augsburg between the painter and the most powerful ruler in the world. Gian Giacomo Leonardi, Guidobaldo della Rovere's agent in Venice, wrote that he had heard from a man who had just come from

Augsburg – but wished to remain anonymous – that the emperor distracted himself from his illness with his collection of clocks and paintings by Titian; and that Titian, so they said, was entirely at ease with His Majesty and much favoured by him and by the whole of the court. Leonardi would leave it to Guidobaldo to judge for himself whether such a thing could be true or not.[2] It was indeed the official truth, as testified by the Venetian ambassadors at Augsburg, Alvise Mocenigo and Francesco Badoer, who confirmed that Titian was 'greatly cherished by the emperor and highly regarded and appreciated by all the lords of this court'.

Titian described the emperor's affectionate greeting in a letter to Aretino, but was too absorbed by work to write again immediately. By April 1548 when the Scourge had heard nothing further from his 'no less brother than friend', he penned an indignant letter saying that it seemed, although it surely could not be true, that the favours of His Majesty had so inflated Titian's ego that he no longer deigned to notice his friends. 'You know', he wrote threateningly, 'that I could make even the emperor a laughing stock if he should make a jest of me.' This fit of jealous pique was quickly forgotten, however, when he heard news that the emperor had promised when the time came to pay the dowry of his little daughter Austria, to which he responded by telling Titian exactly how he should paint a portrait of the emperor on horseback trampling on the Protestants in commemoration of the victory at Mühlberg.

The court, in festive mood after the great battle, was crowded with members of the Habsburg family, their ministers, diplomats and military commanders. Ferdinand came with the eldest of his nine children, Anna, and his eleven-year-old son and heir Maximilian of Austria. Nicolas Perrenot de Granvelle, the emperor's chancellor and most trusted adviser since the death of Mercurio de Gattinara, was present with his wife Nicole Bonvalot and their brilliant son Antoine, Bishop of Arras. At thirty-one Antoine was a highly accomplished young politician destined to become a cardinal and Charles's chief minister after the death of his father. Prominent among the Spanish contingent were Fernando Álvarez de Toledo, third Duke of Alba, the

hero of Mühlberg; and Francisco de Vargas y Mexia, an ecclesiastical writer who was Charles's attorney general, one of his representatives at the first sitting of the Council of Trent and a future imperial ambassador to Venice. Titian spent time with Bernardo Tasso, father of the later more famous poet Torquato; and with Tasso's patron, the imperial commander Ferrante Sanseverino, Prince of Salerno, who was sufficiently impressed by the painter to promise him a pension – a gesture that he quickly forgot although Titian did not. The men brought their ladies, and the gregarious Ferdinand was only too happy to host the numerous balls and dinners, at which the emperor rarely made an appearance, or, when he did, defied his doctors' orders by eating enormously before retiring to a corner where he listened attentively to his courtiers without commenting on what he heard.

Titian would have noticed how much Charles's health had deteriorated since he had last seen him at Busseto in 1543. Thinner and paler than ever, his red hair faded to a mousey brown streaked with grey, his frail figure was described as that of a ghost, a mummy, a man more dead than alive. Charles was comforted by the *Ecce Homo* Titian had brought with him: it is one of the paintings he would take to Spain to aid his meditations on his retirement. But Titian, seeing him so troubled and aged, may not have been altogether surprised when the emperor, who had never liked mythological paintings unless they had historical, religious or moral themes, later passed his reclining Venus on to an associate. The complex question of the succession, which Charles had been pondering for most of his reign, was now in the forefront of his thoughts as he prepared for his abdication in favour of Philip. He spent many hours at Augsburg composing, with the help of Nicolas Perrenot de Granvelle, a political testament for his son's guidance. Although he had frequently changed his mind about which members of the dynasty would rule the Netherlands, Milan and the German Empire, even in a moment of euphoria contemplating a dynastic alliance with the French Valois, he had never wavered on one point: his son Philip would rule Spain. He had made Philip his regent there in 1543, and in 1546 had invested him with the Duchy of Milan, the key to Spanish rule in Italy.

Titian's programme at Augsburg was part of a recording process, prompted by the emperor's intimations of mortality, that would continue two years later when Charles began dictating his memoirs to a secretary on a trip down the Rhine. His favourite painter was to produce, necessarily with considerable help from the assistants he had brought with him, a gallery of portraits in which the Habsburg dynasty would process, followed by their most senior counsellors, diplomats and commanders, to be trailed, eventually, by the Protestant prisoners as tokens of the victory at Mühlberg. Mary of Hungary, who was more knowledgeable about painting than either of her brothers, and who over the next decade would assemble the largest contemporary collection of paintings by Titian, may have been partly responsible for the idea. We can imagine her, from what we know of her forceful if charmless personality, organizing the sittings, lining up the relatives, some in twos or threes, Ferdinand and his two elder children one at a time, for their chance to enter the studio where the master would sketch their features, perhaps indicate their poses, and leave the costume and other details to his assistants. Alas, the originals of the portraits commissioned by Mary were lost to fires after being transferred to Spain, and we know about them only from some copies and an inventory of her collection that was compiled after her death in 1558. He portrayed Mary in 'everyday dress',[3] Ferdinand in armour,[4] Maurice of Saxony in armour, the Duke of Alba in cuirass and scarf (known from an engraving after a copy by Rubens). A portrait of the princely prisoner John Frederick of Saxony bulging out of his inelegant black armour with the wound on his cheek that he had suffered at Mühlberg survives (Madrid, Prado).[5]

Among the other rare survivals of Mary's commissions are the *Tityus* and *Sisyphus* (Madrid, Prado), large, strenuously muscular male nudes which were, with two others (Tantalus and Ixion, which were lost to a fire in the Madrid Alcázar in 1734), intended as part of an allegorical programme to be displayed in the newly built Grande Salle of her château at Binche, which she was transforming at vast expense into one of the most magnificent Renaissance palaces in northern Europe. The stories of the Damned Men in Hades, as told

by Ovid and Virgil,[6] illustrate the eternal punishment that awaits those who anger the gods. Educated guests who saw them at Binche, hung high between the windows of the Grande Salle, would have interpreted them as antique morality tales intended to parallel the terrible punishments deserved by Protestants who dared to defy the sacred authority of their legitimate ruler, the Holy Roman Emperor, God's imperial representative on earth. Like the ceiling paintings for Santo Spirito and San Giovanni Evangelista, their monumental conception was probably informed by Titian's study in Rome of Michelangelo's Sistine ceiling and *Last Judgement*. The two survivals are hard to read through the damage by fire and the restorations they have suffered. But from their lack of emotional engagement we can guess that their execution was left mostly to the studio, probably after Titian's return to Venice.

Some of the courtiers at Augsburg commissioned their own portraits from Titian. The surviving portrait of Nicolas Perrenot de Granvelle (Besançon, Musée du Temps) at sixty-eight with a long, forked grey beard seems to have been painted in haste and may be partly or entirely a studio copy of an original. It was destined, along with a now lost portrait of Granvelle's wife, Nicole Bonvalot, for the family palace at Besançon where the Granvelles, who were connoisseurs of painting, assembled a large collection of works of art including several others by Titian. The portrait of Nicolas's son Antoine Perrenot de Granvelle (Kansas City, Nelson-Atkins Museum of Art) is more finished and more impressive. It is, however, a reminder that Titian was more than capable of ignoring the true character of subjects it was in his interest to flatter. The oval face, straight nose and courteously enquiring expression of the elegant young Bishop of Arras, his half-smile, lively eyes and raised eyebrows, give a misleading impression of the man – and of his girth: both he and his father were often described as stout. Far from descending from a long noble lineage, as one might imagine from the polished figure we see in the portrait, his father had risen from relatively humble origins. Antoine, who was to become the dominating imperial statesman of the second half of the century, was a gifted

intellectual and patron of the arts who spoke seven languages. But he lacked the art of making himself popular, and would prove capable of great cruelty in his application of the Inquisition, and of ruthless manipulation of his superiors in the cause of imperial realpolitik. Nor was either Granvelle above taking 'presents' for services rendered. Antoine received 14,000 ducats in benefices; and the Granvelles *père et fils* were reputed to have accumulated property worth one million ducats.

Antoine Perrenot de Granvelle and Titian became great friends. They dined together when they found themselves in the same city at the same time, and Granvelle went out of his way to use his influence at court to help Titian retrieve the payments and pensions that were chronically delayed. In Titian's portrait he holds a book with a Venetian leather binding: he had recently ordered a consignment of such books from Venice. The beautifully painted domed table clock, probably made in Augsburg or Nuremberg, is one of seven similar clocks to appear in Titian's portraits of around this time.[7] It may have been a gift from the emperor or reflect a fashion set by Charles's mania for clocks: his courtiers frequently commented that he spent hours during his pain-filled days and sleepless nights checking, adjusting and setting his clocks. Clocks in sixteenth-century portraits served, not just as reminders of the passage of time and the inevitability of death, but as metaphorical attributes of the sitters. In the case of Granvelle the clock probably referred to his other profession as Bishop of Arras. Contemporary iconographers[8] recommended that clocks should be included in likenesses of prelates to signify that men of the Church are the clocks that regulate the world, like the bell towers on church buildings. Some authorities believe that the *Portrait of Antoine Perrenot* was painted by an assistant. It is hard to judge because both Granvelle portraits were dispatched to Brussels in damp weather before the varnish had completely dried and needed extensive repainting. The portrait of Antoine, furthermore, was later cut down, then at a later date enlarged. Nevertheless, it is the finest and most memorable of the many portraits of him, and made an impact on Anthonis Mor who must have seen it in Brussels when, later in

1548, he painted his own *Portrait of Antonio de Perrenot Granvelle* wearing the same arrangement of rings.

It goes without saying that the emperor had first call on Titian's time. Once again he ordered a *Portrait of the Dead Isabella* (Madrid, Prado), this time dressed as Charles remembered her in the fashion of the 1530s.[9] She sits next to a window – 'like a High Renaissance Madonna', as one scholar has put it[10] – no longer interested in the book she holds in her left hand, but still young and delicately beautiful despite the ghostly pallor of her complexion and her abstracted gaze. It is easy to understand why the emperor was pleased with the portrait, of which Aretino wrote that Titian had revived Isabella 'with the breath of his colours so that one of her is possessed by God and the other by Charles'. It was among Charles's most cherished possessions. He kept it with him at all times, took it with him to Spain after his abdication in 1556 and asked to see it as he was dying.

Titian used the portrait of Isabella in black commissioned at Busseto as the basis of a double portrait of the emperor sitting by her side at a table. (The double portrait is known only from a copy by Rubens in the Madrid Collection of the Dukes of Alba.) In this case the clock displayed on the table would have been, as well as a reflection of the emperor's interest in clocks, a metaphor for the ruler who sets and guides his subject people.[11] That portrait of Charles, dressed entirely in mourning, his black coat adorned only by the badge of the Order of the Golden Fleece, was the model for the *Portrait of Charles V Seated* (Munich, Alte Pinakothek), painted by an assistant probably for the Fuggers.[12] Although the stick propped against his chair indicates the sad reality of his physical condition, Titian also painted Charles standing in armour holding the baton of command – this portrait was destroyed by the fire of 1734 but is known from a number of copies and variants, one of which is in the monastery of the Escorial – as well as another, now vanished without trace, for Antoine Perrenot de Granvelle.

The Council of Trent, where the Catholic majority had so far failed to find common ground with the Protestants, had recessed in June

1547, three months after Paul III had moved it to Bologna in order to escape what he regarded as the balefully conciliatory influence of the emperor. Charles, still innocent of any real understanding of the spiritual force of Lutheranism, of the political and social developments that had taken place in Germany while he was directing his attention to the struggle with Francis I, or of the stubborn resistance to conciliation on the part of the Catholic princes there, continued to believe that doctrinal compromise with the Protestants was possible. Guessing correctly that it would be some time before the Council of Trent resumed, he took advantage of the hiatus to preside at Augsburg over an Interim, at which a committee of Catholic and Protestant theologians tried to work out a compromise that would be his last attempt to achieve reconciliation. The Interim of Augsburg, as passed by the Catholic majority at the Diet in June 1548, did make some concessions to the Protestants: clerical marriage, justification by faith, the need for reform of Catholic abuses, and the right to the Lutheran Eucharist, in which the bread and wine are symbolic of Christ's body and blood rather than as in the Catholic rite constituting substantial and real presence. But the compromises proved to be too little, too late. Although Paul III reluctantly accepted its provisions just before he died in 1549, the emperor's prisoner John Frederick of Saxony coldly refused the pleas of both Granvelles for his agreement. Some Protestants were appeased, but the Augsburg Interim was largely ignored by both sides. While it was being formulated, however, the Habsburgs maintained high hopes for its success.

Under these circumstances a triumphalist image of the military victory at Mühlberg – such as the bronze sculpture of *Fury in Chains at the Foot of the Emperor* delivered by Leone Leoni in 1549 – would have been counter-productive. Aretino's over-excited letter to Titian describing his vision of a portrait of Charles V at Mühlberg accompanied by the figures of Religion and Fame, riding a horse that tramples the defeated Protestants beneath its hooves, was no longer appropriate. Although the *Portrait of Charles V on Horseback* (Madrid, Prado), which Titian began in April, is routinely described as a commemoration of the Battle of Mühlberg, it is at least as much

about the image of himself that the emperor wished to project at that time as about that single episode in his life. He wears the same armour, made for him in 1545 by Desiderius Colman of Augsburg, as he had worn at Mühlberg,[13] and carries the same spear.[14] He canters sublimely on his magnificent black charger across a landscape unscarred by battle, beneath a blazing sky that Titian might almost have recalled from Aretino's description of the sun setting over the Grand Canal.

Titian executed this masterpiece entirely without assistance. The equestrian statue of Marcus Aurelius, which he had recently seen on the Capitol in Rome, was fresh in his mind's eye. But since the statue had not yet been identified it may be an apt coincidence that Marcus Aurelius was the Roman emperor upon whom Charles's Spanish confessor had advised him to model himself. This is Charles as Christian warrior, the *miles christianus* of the medieval tales of chivalric honour and of crusades against the Ottoman infidel that had enthralled him as a child. His sash, the plume of his helmet and his horse's caparison are the colour of his birthplace, Burgundy, the duchy once ruled by his father Philip the Handsome, where as a young man Charles had expressed a desire to be buried, and to which he advised his son Philip never to give up his ancestral claim. While Titian was painting them he ran short of red lake and sent urgently to Aretino for a courier to bring him from Venice half a pound of the pigment, 'the kind that so blazes and is so brilliant with the true colour of cochineal that even the crimson of velvet and silk would seem less than splendid in comparison with it'.[15]

But it is the emperor's face, painted with a sympathy and tenderness that are rare even in Titian's portraits, that haunts the mind's eye: masterful, thoughtful, weary, earnest, certain of his purpose but unsure of his ability to achieve it in the time left to him. Seen side by side with Titian's portrait painted five years earlier of the wily and cynical Paul III we see more at a glance about the characters of the two representatives of God on earth who, for better or worse and for different motives, shaped the destiny of Christendom, than from a hundred pages of written history.[16] Titian's *Portrait of Charles V on Horseback* was his only monumental state portrait and the first of all

painted equestrian portraits on this scale. Its impact would reverber-
ate in the mounted portraits painted by Rubens and Velázquez for
Charles's great-grandson Philip IV and on down the centuries until
the last victorious general climbed down from the last warhorse. It
has never been surpassed, and we can be grateful that having passed
into the hands of Mary of Hungary and hung with the rest of her
collection in the Madrid Alcázar it was rescued from the fire there in
1734 by being cut out of its frame.

The court had begun to disperse in March 1548, when Mary of
Hungary departed, followed in April by Maximilian of Austria who
returned to Madrid taking with him his portrait by Titian, which he
described as 'much cherished by the emperor and well received and
appreciated by all the lords of this court'. The dynastic portraits were
completed by June, when Titian also finished a portrait of Ferdinand
as a gift intended to promote the Vecellio timber interests in Austria.
The emperor had invited him to travel on with the royal party to
Brussels when it left the city, but Titian, anxious to put his workshop
at home in order and pleading that he had been away from Venice
longer than he had expected, sent his excuses by way of Antoine
Perrenot de Granvelle. He continued to work on the equestrian
portrait after the emperor's departure on 13 August. As he wrote to
Granvelle on 1 September, it had taken him longer than he had antici-
pated. Although technical investigation suggests that the horse was
painted last and without changes, the numerous pentimenti that can
be detected beneath the mounted figure of the emperor are evidence
of the difficulties he had in getting the angle of his head and the pos-
ition of the horse and rider on the canvas exactly as he wanted.

When it was completed to his satisfaction in early September, the
picture was set out in a garden of the Fugger palace for the varnish to
dry when an accident occurred. A gust of wind blew it over on to a
stake, which gashed the image of the horse. Titian entrusted the repair
to the German painter and printmaker Christoph Amberger. (It may
be that his assistants were otherwise occupied with lucrative work for
the Fuggers and that this is when one of them painted the *Portrait of
Charles V Seated* now in Munich.) Amberger, born in Nuremberg in

1505, was a favourite of the Fuggers, and among his many portraits was a fine but realistically unflattering portrait of Charles V. It is possible that as a young man he had worked in Titian's studio as an apprentice, and in the 1560s his son Emanuel would become the most valued member of Titian's inner circle of assistants. Nevertheless, as Amberger reported on 16 September, Titian had insisted that the repair should be executed in his presence.

Money was never far from Titian's mind, and with the court gone and the city quiet, his thoughts turned to the pension on Milan promised him by the emperor in 1541. He had heard from home, probably from Francesco, that the pension, although doubled by the emperor in July, had not actually been paid. Charles had given explicit instructions that Titian should receive it in October 1547 when he was expecting to see him in Augsburg. In June 1548 he had written from Augsburg to Ferrante Gonzaga, his governor in Milan, that Titian must be paid what he was owed because he had travelled from Venice on the understanding that the money would be made available in Venice to support his wife and family.[17] There is a marginal note on this letter in Ferrante's hand that the money would be paid on his orders. It was not, however, forthcoming by 1 September when Titian wrote from Augsburg to Antoine Perrenot de Granvelle that he had heard from home that the money had not arrived. The fault actually lay not with the emperor, who was evidently anxious that his favourite painter should be rewarded, nor with Ferrante Gonzaga, but with the overstretched treasury of Milan and a bureaucracy that required such privileges to be registered with the minister in charge of legal affairs and countersigned by officers many of whom were reluctant to waste their restricted funds on foreigners like Titian. Despite the efforts of Titian, Granvelle, Ferrante Gonzaga and the emperor himself, the pension did not begin to be paid retrospectively, and even then only in small amounts, until 1549, although it is interesting if not altogether surprising to note that the pension on Milan of the more dangerous Aretino was honoured.

Titian's letter to Granvelle of 1 September is one of the few we have written in his own hand and in his own clumsy Italian, presumably

because he could not find a secretary in Augsburg to compose it for him. It was the beginning of an extended correspondence between the two men in the course of which Titian relied on Granvelle's 'infinite goodwill' to solicit his help with a litany of problems in recovering delayed payments that had been promised by the emperor and others. In the postscript to this letter he lists the pictures he has painted for the emperor: 'First the Christ which His Majesty took away with him, and then the Venus, the empress alone, and then the one of his majesty and the empress, and then that big one of his Caesarean majesty on horseback, which altogether makes six pieces.'

On 16 September Titian and his itinerant workshop took the old Roman road, the Via Claudia Augusta, stopping at Füssen where he stayed in the Bishop's Castle as the guest of the cardinal-bishop Otto Truchsess von Waldburg, one of the leading participants in the Council of Trent and a collector and patron of the arts. Cardinal Truchsess, in a letter of recommendation to the Tyrolese governor written on 1 October, described Titian as 'a very famous man and excellent in art, as well as religious, respectable and honest'. On 4 October Titian was in Innsbruck where he spent the next seventeen days making a start on portraits, to be completed in Venice, of seven of Ferdinand's daughters, which Ridolfi described as 'what seems almost to be a paradise full of terrestrial goddesses': four single figures, and one group portrait of the three youngest, as well as a portrait of the young Archduke Ferdinand. All the portraits Titian painted at Augsburg and Innsbruck of Ferdinand and his immediate family have vanished, including replicas made for Mary of Hungary and others, leaving us with nothing to see from Titian's stopover in Innsbruck, apart from one business letter addressed to Ferdinand in which he complains that his right to fell timber had been challenged by Ferdinand's bureaucrats contrary to His Majesty's orders and that he needs the wood not for merchandise but for himself and his buildings.

One of his portraits of the children, that of the Archduchess Catherine, who was then fifteen, misfired badly. The girl was evidently not very pretty and Titian, unusually, seems to have made no attempt

to flatter her. A replica sent to Francesco Gonzaga, Federico's son and successor as Duke of Mantua, who was betrothed to Catherine, was preceded by a mild caveat from one of Ferdinand's courtiers, who wrote to a friend at the Mantuan court that the painting was very natural, but the face was somewhat more severe than in life. There was some confusion about who was supposed to pay for the portrait, and when Titian had received nothing for it by June 1549 he asked his old acquaintance Benedetto Agnello, the Mantuan ambassador in Venice, if it had actually reached the patrons. When Agnello answered in the affirmative, Titian, so Agnello reported, sighed, saying that he could not believe that His Excellency did not intend to send him a present appropriate to his greatness and to the merits of the work itself; and if nothing were forthcoming he would be forced to say even worse things than Aretino.[18] When Agnello met Catherine some months later on her arrival in Italy, he wrote immediately to the duke's mother, Margherita Paleologo, that he had found her very happy and cheerful, 'besides which she is beautiful, and Titian can go hang himself, for the portrait that he has painted resembles Her Serenity as much as a wolf does an ass'.[19] The sources are silent about the outcome of this unpleasant squabble.

After ten months in the service of the Habsburgs in Germany Titian's homecoming was bound to cause a stir in Venice, where the Senate required a formal report. One sour note was struck by the papal legate, Giovanni della Casa, who pretended to be mildly shocked by Titian's intimacy with the emperor, perhaps because he was irritated by the painter's defection from the Farnese to the Habsburgs. 'Messer Titian', he wrote to Alessandro Farnese,

> has spent a long time with His Imperial Majesty painting his portrait, and seems to have had plenty of opportunities to talk with him, while he was painting and so on. In short, he reports that His Majesty is in good health, but exceptionally anxious and melancholy, and that when the court left for Flanders Monsignor d'Arras told him, on behalf of His Majesty, that he ought to go too; but after he had excused himself on the grounds that he had spent too long away from home, and had

asked permission to return to Venice, Monsignor d'Arras said that he could go, because in any case His Majesty would see him again next summer in Italy, and this would be equally satisfactory. Since Your Reverence knows the gentlemen of this court you will be able to judge whether it is customary to tell people like Messer Titian what His Majesty does or does not intend to do.[20]

Titian, Aretino and their large circle of friends gathered over their dinners to hang upon every word that Titian uttered about every detail of everything he had seen and heard from and about the emperor and his court.

Little did the gossips know that these were to be among the last times they would meet at Casa Aretino. Within eighteen months, while Titian was once again in Augsburg, Aretino would be evicted from the cramped apartment in the little house opposite the Rialto fish market that had been his home, and a second home to Titian and Sansovino, for twenty-two years. In all that time he had managed to pay not a penny in rent to his patrician landlords, the brothers Domenico and Jacopo Bollani, for the accommodation that all Venice knew as the Casa Aretino. The favourable arrangement, which may well have suited the Bollani when they were young, ambitious men looking for Aretino's support in the advancement of their careers, was now if anything an embarrassment. Domenico, who had been a successful ambassador to England, was on his way to being made a bishop and a staunch ecclesiastical reformer at the Council of Trent. Jacopo, now a senator and recently married, may have wanted to live in the house with his bride.

On handing over the keys in January 1551, Aretino wrote Domenico a letter, which was of course intended for publication, condemning his lack of respect towards a person who had been received favourably by the emperor himself but adding that he was avenging his landlord's discourtesy with the courtesy of telling him how much he had enjoyed the house. Aretino's new home was on the upper residential floor of a palace on the Riva del Carbon a little way up the Grand Canal. It still stands, its Gothic façade now badly mutilated, at the centre of two other houses, one of them a twentieth-century replacement for the

original, which were then owned by the Dandolo family. The apartment, as well as being located at a better address and in a larger, older and more distinguished palace than the former Casa Aretino, had twice as many rooms, higher ceilings and a larger *portego* for entertaining. The annual rent of sixty ducats rising to sixty-five a year was twice the nominal asking price, but the bills were picked up by Cosimo de' Medici.[21]

Titian could hardly have failed to notice that while he was in Germany a Venetian painter half his age had bounded into the artistic limelight with an astonishing painting for the Scuola Grande di San Marco. In Jacopo Tintoretto's *Miracle of St Mark Freeing a Slave* St Mark, the patron saint of Venice, dives from the heavens like Superman into a throng of Turkish heathens to rescue a man who has been condemned to martyrdom for worshipping the saint's relics. This thunderbolt of a masterpiece, with its energy, ostentatious foreshortening and entirely new treatment of deep pictorial space, was at least as innovative, and as controversial, as Titian's *Assunta* had been when it was unveiled thirty years earlier over the high altar of the Frari. It may have given Titian pause for thought if he knew that Tintoretto had been born in that same year, and that he had been about the same age as Tintoretto now was when he painted the altarpiece that had launched his own career. But Titian, who frequently quoted passages from other artists, might have been mildly flattered to see that the younger painter had used his own gesticulating disciples from the *Assunta* as a source for his crowd of witnesses to the miracle of St Mark.

Jacopo Robusti, known as Tintoretto because he was the son of a silk dyer, a *tintore*, was not unknown to Titian. If we can believe Carlo Ridolfi, whose *Life of Tintoretto* of 1642 is the only source we have for his early life, he had served for ten days in Titian's workshop before Titian expelled him out of jealousy. While it is true that Titian was not a nurturer of young talent, it is likely that he had been not so much jealous of Tintoretto as irritated by him. The young man was everything Titian was not: impulsive, uncouth, tactless, inarticulate, badly

dressed, lacking in respect for his elders and betters, not especially interested in money or honours. One of Tintoretto's friends compared him in a letter to a peppercorn capable of overpowering ten bunches of poppies;[22] The poet Marco Boschini described him as *spiritoso*, too clever by half. It is an indication of his brusque treatment even of members of his family who were not working in his studio that when his brother asked him, among other questions, if their mother had died, Tintoretto replied in a letter consisting of one sentence: 'To all your questions the answer is NO.' Ridolfi spun a tale about Tintoretto, which is almost as famous as his story of Charles V picking up Titian's paintbrush, no less unlikely but representative of a general truth. His story goes that one day Tintoretto appeared at Aretino's house with a pistol in his hand, saying, 'I'm going to take your measure!' He then announced that he was going to measure the critic in pistol lengths before painting his portrait.[23] The same writer also mentioned a back-handed compliment paid to Titian by Tintoretto, who said that the older master sometimes produced works that could never be improved or more easily understood even though other artists might have designed them better still. Nevertheless, Tintoretto later acquired several paintings by Titian, and, again according to Ridolfi, once tried to pass off one of his portraits as a Titian.

Different though they were as personalities and artists, there is no evidence of outright conflict between Titian and Tintoretto, who worked exclusively for Venetian patrons and posed no threat to Titian's international prestige; neither did Veronese, who was in his early twenties when he made his debut in Venice in 1551–2 with the altarpiece, still in the church of San Francesco della Vigna, of the *Holy Family with Sts John the Baptist, Anthony Abbot and Catherine*, which pays homage to Titian's *Pesaro Madonna* in the Frari. Much, perhaps too much, has been made of the rivalrous relationship of the three greatest Venetian painters of the second half of the sixteenth century. But it is true that three geniuses working in the same small city at the same time – dining in the same taverns, walking the same streets, listening to the same gossip – could hardly have failed to keep a jealous eye on one another's work.

Titian's two younger 'rivals', both of whom set up flourishing family practices in Venice, could be said to represent the two sides of the Venetian temperament: the lonely, sometimes agonized search for truth and meaning versus the love of material luxury that suited a society ruled by proudly money-minded merchant-patricians. Tintoretto's paintings seem to reveal a tortured soul, hectic, impulsive, defiant, brash, restless, too hasty for his own good – a poet whose dramatic use of linear perspective, exaggerated foreshortenings, violent lighting and elongated figures in frantic motion owe something to central Italian Mannerism. Titian may well have admired Tintoretto's work, but he would never be interested in the deep space, swooping diagonals and exaggerations that characterized the younger artist's paintings from the start. Veronese, by contrast, was controlled, elegant, superficial, coldly materialistic, a master of illusionism and of the voluptuous treatment of beautiful skin, hair, jewels and fashionable clothes painted in striking combinations of crystalline pastels. Both were fast workers and more interested in effect than in the humanity of their subjects. Neither achieved Titian's balanced combination of dramatic force and deep feeling.

Nevertheless, Aretino, who was the first to recognize Tintoretto's exceptional genius, took care to praise him only when Titian was away from Venice. In 1545 he commissioned from him the two paintings for the ceiling of his bedroom, both associated with music and the first of Tintoretto's works that can be dated with certainty. One of these, of *Apollo and Marsyas*, may survive (Hartford, Connecticut, Wadsworth Atheneum).[24] The other, the story of Argus and Mercury, is lost. Aretino thanked him with a long letter, written while Titian was in Rome, expressing admiration for his ability to work both fast and well. In April 1548, when Titian was in Augsburg, he wrote to Jacopo Sansovino that Tintoretto was nearing the finishing line in the race for artistic supremacy. But in a letter written at the same time he warned his protégé that his *Miracle of St Mark Freeing a Slave* was 'more true to life than finished', and that he should try to temper speed of execution with patience.[25] After January 1549, we hear no more about Tintoretto from Aretino, who may have decided that his

friendship with Titian was more important than encouraging the young firebrand, although several years later he did commission from Tintoretto a portrait of Caterina Sandella, his long-standing mistress and the mother of his daughters.[26]

Jacopo del Ponte, known as Bassano from the town where he was born in 1510 and where he continued to work for the whole of his life, and Andrea Meldolla, called Schiavone, 'the Slav', after his birthplace in Dalmatia, were both about twenty years younger than Titian, who exercised a strong influence on their youthful work. But by the 1550s Bassano had developed his own style, and the large, robust, crowded religious and genre scenes he pioneered were as influential in their time as the paintings of Tintoretto and Veronese. But it was Titian – the unchallenged master of what Aretino called 'the sense of things', who rarely, as he grew older, let virtuosity stand in the way of his probing reifications in paint of a vision so deeply personal and original that no other artist could borrow from it – who stood head and shoulders above the others, marvellous artists though they were.

Meanwhile, in November and December 1548 after his return to Venice, Titian, with the help of his nephew and resident amanuensis Giovanni Alessandrini, continued his correspondence with Granvelle. The tone of Granvelle's letters, which are addressed to 'Titiano' or 'Ticiano', and offer sound practical advice about how he should go about obtaining the pensions and payments due to him, is relaxed, confidential and sometimes humorous. On 4 November he sends his infinite thanks for the arrival of the three portraits commissioned at Augsburg of himself, his father Nicolas Perrenot de Granvelle and the emperor. He jokes that his father, who is the eldest of the three, might not, on account of his age, have endured such a long journey but has in fact arrived in excellent shape. He hopes Titian has not forgotten an Ecce Homo he had promised to send. He wants it to differ from the version he has left with him: 'Above all I would like it to have the beautiful, sweet and delicate face that I know you know how to do. I would also like the background to be dark brown as is the custom. The stole I would like to be purple rather than blue; the tunic can stay red as in the other one.' But a month later he seems to have realized

that it was a solecism to tell the master of *colorito* how to choose his colours and writes that he made the suggestions only as a matter of comparison and would always rely on Titian's judgement.

On 17 December, Titian interrupts a letter to Granvelle about the usual subject of his unpaid pensions to make an announcement: 'And now, my unique patron, having been invited by our most serene lord the Prince of Spain, I am obliged to leave Venice for Milan the day after tomorrow in order to make a first bow to his highness and to obey his command, which I cannot fail to do having been summoned with the greatest urgency'.

The Prince and the Painter

Now lies the earth all Danaë to the stars
And all thy heart lies open unto me.

ALFRED LORD TENNYSON, *THE PRINCESS*, 1847

At some point after writing his political testament for Philip, Charles V made up his mind that his son would succeed him as ruler of the Netherlands, the group of seventeen semi-autonomous low-lying provinces which he had inherited or acquired, and which were governed by his sister Mary of Hungary. The Netherlands, apart from its allegiance to the emperor, was neither politically nor culturally united. Most of the greater nobles were Burgundian by origin but often married into German families. The harsh measures taken by the Habsburgs to put down rebellions had not been entirely forgotten, and the political situation remained potentially explosive. In the northern provinces religious liberals, in the tradition of their greatest citizen Erasmus of Rotterdam, tolerated Protestant worship, even for a time allowing the Anabaptists, the most radical of all heretical sects, to set up independent communities. At Augsburg Charles V had persuaded the Diet that the Netherlands would henceforth form a single 'Burgundian Circle', outside the jurisdiction of the imperial parliament but entitled to its protection in exchange for troops and money at twice the rate required of a German elector or three times in case of war with the Turks. It would prove to be one of the most short-sighted decisions of his entire reign when after his death the

Netherlands, and Milan, would become military outposts of Philip's Kingdom of Spain.

In September 1548 Charles disposed of the rival candidate to rule the Netherlands, Ferdinand's adolescent son Maximilian, by ordering his marriage to his own daughter Maria. Maximilian and Maria, who were married at Madrid in September, were then dispatched to take over the regency of Spain so that Philip could join his father at Brussels for an extended tour of his future domains. Philip left Valladolid on 2 October for what his courtiers described as his *felicissimo viaje*, his most happy voyage. The royal party sailed a month later in fifty-eight galleys commanded by the eighty-two-year-old Genoese admiral Andrea Doria, whose private fleet had been the mainstay of the emperor's Spanish navy for the past twenty years. Two weeks later they were in Genoa, where they remained for sixteen days of feasting and celebrations as Doria's guests before departing for Milan on 11 December in cold and snowy weather. If Philip looked forward to inspecting the duchy with which Charles had invested him two years earlier, he was also so eager to be portrayed by his father's friend and favourite painter that he sent his urgent summons to Titian even before the royal party arrived in Milan on 19 December.

Since the death of Philip of Spain in 1598 most English-speaking historians have portrayed him as a paradigm of evil: mediocre, pedantic, suspicious, licentious, small minded, cruel, brutal and misguided suppressor of Protestant 'heretics' in Flanders, and of course perpetrator of the failed attempt by the Spanish Armada in 1588 to overthrow Elizabeth I of England. But when Titian met Philip in Milan the prince was only twenty-one, with the grounds for his posthumous reputation far in the future. As effective King of Spain since the age of sixteen, when his father had left him in charge there in 1543, he had got used to taking decisions on his own account, appending to his signature the words 'Yo el Principe' (I, the prince). In that same year Charles had married him to his cousin Princess Maria of Portugal, who was six months younger than Philip. The union of Philip and Maria, both of them descended from Charles's grandmother Joanna the Mad, proved to be one of the emperor's most destructive

consanguineous marital arrangements. Maria died two years after the marriage giving birth to Don Carlos, who, as the product of three generations of inbreeding between the Spanish and Portuguese royal families, had four great-grandparents instead of the usual eight. Even as a toddler he began showing signs of the mental instability that would manifest itself in fits of irrational paranoia, murderous rages and physical assaults. It must be said in Philip's favour that he did what he could to involve his son in matters of state until he was finally forced to arrest him for violent behaviour and treasonable contacts with the rebels in Flanders.[1]

Philip's own childhood had been lonely even by the standard of the future rulers of his day. Charles V had rejoiced at the birth of his firstborn, who would prove to be his only legitimate son, and although he was rarely in Spain while his heir was growing up, he took great pains to supervise from abroad matters concerning his health and education. Philip worshipped his absent father, but the formative influence in his early childhood was his beautiful, gentle mother Isabella and her Portuguese retinue. Isabella's untimely death when Philip was twelve must have affected him all the more through his father's grief: Charles retired to a convent for seven weeks and ordered Philip to wear mourning for the next two years. The boy turned for affection to his two sisters, Maria and Juana, to his Portuguese governess and to his guardian and tutor, Juan de Zúñiga, grand commander of Castile, who encouraged the earnestness and piety that were to be so much a part of his adult character.

His father's letters of instruction, written for Philip's guidance during his regency, were intended to form the style of his eventual rule: he must 'keep God always in mind', 'accept good advice at all times', 'never allow heresies to enter your realms', 'support the Holy Inquisition'. He should be faithful to his wife but abstain as far as possible from enjoyable or prolonged sexual relations with her 'because besides being harmful both to bodily growth and strength, often it impairs the capacity to have children and can kill'. In this matter, however, Philip would follow his father's example as a serial adulterer rather than heed his advice. And despite the instruction that

in order to communicate with the many peoples over whom he would rule it was essential to learn Latin and reasonable French, Philip was never at ease in Latin or French, and his lack of fluency in foreign languages was a handicap that would affect his comprehension and judgement of foreign affairs later in his life. Nor, although he greatly admired his father's military prowess and showed some skill in the tourneys, war games and hunts that were intended to train him up as a soldier, did he ever share Charles's zeal for the heat of battle or for leading his armies in person.

He was haughtier and even more of an introvert than Charles, although he could relax in the company of women and was energetic and flirtatious at the court festivities that were part of the royal routine. Although no scholar, he grew up surrounded by books, took an interest in science, music and particularly architecture. As he grew older he would develop a taste for painting that was keener and better informed than that of the other members of his family and more adventurously eclectic than that of any of his contemporaries. He bought paintings by Bosch as well as Titian, although he rejected El Greco; and by the end of his life he had amassed a collection of over a thousand pictures in addition to the 500 mostly Flemish works he had inherited. At the time of his first meeting with Titian, however, he was most familiar with the Flemish paintings in the Spanish royal collection, although the beginnings of a taste for Italian mythological paintings might have been sparked by Correggio's *Loves of Jupiter*, originally commissioned by Federico Gonzaga, which Charles had given to Philip. As a child Philip had seen Titian's explosive Annunciation for Isabella, which arrived in Spain when he was ten. But it was the (now lost) portrait of Charles V, the father he adored but rarely saw in person, painted in armour by Titian in 1533 when Philip was only four, that captured his attention and filled his dreams.

Philip must have had this portrait or an enlarged copy in mind when he invited Titian to Milan to paint the portrait of himself (Madrid, Prado), which is also in armour,[2] of the same dimensions, and which he hung next to the portrait of his father in his chambers.[3] Titian probably intended the high finish and attention to detail of this

magnificent portrait – the first in a line of Spanish court portraits that would make an indelible impression on Velázquez and Van Dyck – to accord with Philip's familiarity with the Flemish style. It would be a mistake, however, to condemn with knowledge of hindsight the character we may think we see behind the thick red lips, the sparse little beard that barely conceals the jutting Habsburg jaw, the cold, sidelong stare of the hooded eyes, because this portrait is in fact one of Titian's most considered exercises in idealization. Philip, who was in reality an ungainly figure of medium height and a reluctant warrior, was transformed by Titian into a proud military leader, at ease in his superbly painted damascened parade armour with one hand resting on his sword, the other on his plumed helmet. The light emanating from the left splashes on his polished breastplate and describes an aura around the prince's head. Behind him the stone shaft of a pillar (perhaps a reference to Charles V's personal emblem of the pillars of Hercules) bisects his helmet and gauntlet to form a right angle with the burgundy plush cover of the rectangular table in one of Titian's strongest compositions. Aretino, who saw the portrait when Titian was finishing it in Venice, rightly described it in a sonnet addressed to the prince[4] as having 'the handsome bearing of royal majesty'.

On 7 January 1549 Philip resumed his journey towards Brussels, where he was to join his father for a tour of the Netherlands, his retinue accompanied by the sculptor Leone Leoni who was to make a portrait medal of Antoine Perrenot de Granvelle. Titian, who travelled with the royal party as far as Verona, may have noticed Philip's undisguised appreciation of beautiful women. On 29 January, at Trent, where Philip's party was greeted by the German and Spanish cardinals who had defied the pope's orders to move the Council to Bologna, the prince gave orders that Titian should be paid 1,000 gold scudi for 'certain portraits which he is making at my command'. Two of them were versions of the portrait of Philip for Antoine Perrenot de Granvelle and Mary of Hungary. Philip's portrait was sent to him at Brussels on 9 July, when Mendoza reported that the other two versions were nearly ready, although not as good as the original done in Milan. In fact, Titian's studio was now so crowded with

commissions for the Habsburgs that he put these portraits to one side while finishing the *Tityus* and *Sisyphus* for Mary of Hungary. They reached her palace at Binche in June,[5] in good time to be hung in the Grande Salle for her reception in late August for the emperor and Prince Philip, who particularly admired Roger van der Weyden's *Descent from the Cross*, which hung in the chapel and which he later acquired for the Escorial.

July is a hot, humid, mosquito-ridden month in Venice, and the July of 1549 was unusually unpleasant. Titian would probably have escaped to Cadore or to his villa in the hills above Ceneda had he not, as he wrote to Granvelle early in the month, been working full stretch for the court despite the 'strange heats', which 'barely let us live'. Although the portrait of Philip for Granvelle was finished by the 29th, Titian did not send it to him until the following year, and work on the version for Mary seems to have been suspended altogether for the time being. Then he fell ill, and remained indisposed for the rest of the summer.[6] Although we don't know the nature of the illness it would not be surprising if the sexagenarian Titian had succumbed, in the suffocating heat of a Venetian high summer, to the combined pressures of an exceptionally heavy workload, of the energy he put into chasing his creditors and not least of his deteriorating relationship with Pomponio, who had given up all pretence of a vocation for the priesthood and was devoting himself to a life of self-indulgence at his father's expense.

Pomponio, as Aretino wrote to the no longer so young wastrel in September 1550, was causing his father 'such distress of mind that it made me weep to see him':

> It is all because that really great man wanted you to change your way of life. Your goings on, indeed, make me think of a low comedy. The audience does not judge it on the basis of how long they have to listen to it, but on whether it is well acted and well staged ... It is not right that the money amassed by the paintbrushes, the skill, the labour, and the long journeys of Titian should be thrown away in riotous living ...

As your godfather I pray fervently that you will go back to the way of living that I long for and desire to see in you ... If you do this, you will find your way home into your father's heart again.

The correspondence about Pomponio's riotous and wasteful behaviour continued over the next three years, with Titian swearing he would have nothing to do with his son, Aretino offering to intervene, Pomponio apologizing but then carrying on as before. Pomponio complained to Aretino that his father was unreasonably severe. Aretino took Titian's side, saying that it was a son's duty to obey, but recommended clemency to Titian. As Aretino wrote to another friend in January 1553 about the behaviour of Pomponio and Francesco Sansovino, 'The children of those two who are so well known to the world will learn that the glory and fame of their fathers is a heavy burden to their sons who live dissolutely.'

We can guess what it was that the two young unmarried men, whose identities had been hijacked by their successful fathers, might have been up to. Pomponio, having reached the age when his patrician contemporaries were obliged to wear the toga and take their place in the Great Council of government, and his less privileged friends to earn their living, was a reluctant priest with no responsibilities and nothing to show for himself except a famous father and the church benefices his father took endless trouble to obtain for him. Like his friend Francesco Sansovino, who was for a while his companion in what Aretino called 'lewd doings', Pomponio wanted to be a writer; but unlike Francesco, who did later become a successful writer, he had neither the willpower nor the talent to pursue any particular goal. Pomponio, furthermore, was a priest whether he liked it or not. Although the two young men lived in a culture where it was taken for granted that the majority of men, until tamed by marriage, would misbehave, priests were at the very least expected to be discreet about unacceptable behaviour. So even Aretino would have recognized that whatever the two of them were up to – presumably prancing about town in expensive finery, getting drunk, running up debts in the shops, brothels and taverns – was particularly reprehensible in the

case of a priest. He wrote to Titian and Jacopo Sansovino that they had every right to deny their sons 'not merely luxuries, but bread, and that forthwith … But', he went on, 'if it should come to pass that we oldsters were willing to remember what we did at the same age, we would forgive young people their faults and laugh at them, getting back 100 per cent what we spent by enjoying their amusements and their pleasures.'

Titian, unfortunately, could not bring himself to forgive. On 6 July 1549 he asked Granvelle to obtain the emperor's signature on a *placet* transferring the living of Santa Maria della Scala, where his son was not able to fulfil the obligation of residence, to another beneficiary, a certain Pietro de Randa, who would pay Pomponio a pension of eighty scudi. Four years later Titian would take control of the two other benefices he had acquired for Pomponio, that of Medole, obtained from Federico Gonzaga in 1531, and that of Sant'Andrea di Favaro, granted by Pope Paul III in 1546. On 26 April 1554, without consulting Pomponio, he wrote to Cardinal Ercole Gonzaga that Pomponio 'does not seem to be as much inclined to be a churchman as I would like', and asked the cardinal for permission to transfer the benefice of Medole to a relative whom he did not name.[7] The sweetener was an altarpiece painted by his studio of *Christ Appearing to the Virgin* for the church of Santa Maria in Medole, where it is still in situ. Father and son were already communicating about the benefices through lawyers on 29 October 1554 when Titian issued a warrant of attorney empowering him to claim all incomes past, present and future from the benefice of Sant'Andrea di Favaro, which he would dispose of as he pleased. Pomponio must make a solemn promise never to interfere with the power or make any claim whatsoever on the benefice.

However much time and effort Titian had put into obtaining the livings for Pomponio, and however disinclined Pomponio was to live at Medole, let alone Favaro – where the climate, so he frequently complained, was bad for his health – the father had no right under ecclesiastical law to appropriate benefices that had been granted to his son. It seems that Pomponio may in fact have retained the Medole

benefice at least until 1566 when he is known to have transferred it himself to a priest named Agostino Agnelli in return for an annual pension of 168 ducats rising to 200 in the next three years. But Titian's arrogant and illegal actions, not least his attempt to dispose of Medole without so much as informing Pomponio of his intentions, had planted seeds of a poisonous mutual resentment that would eventually destroy their relationship.

Granvelle meanwhile was doing his best to unlock the many sources of income that had been promised to Titian over the years but had never materialized. Titian's pension on the treasury of Milan was still not forthcoming. The Prince of Salerno, who in a rash moment had offered a pension at Augsburg, had conveniently forgotten about it. The heirs of the late Alfonso d'Avalos were unwilling to come up with the pension of fifty ducats with which d'Avalos had rewarded Titian for his *Allocution* in 1541. And, by no means the least of Titian's grievances, the authorities in Naples continued to withhold the 300 cartloads of grain for export duty-free which as long ago as 1535 Charles V, flushed by his victory at Tunis, had ordered the then viceroy to provide. But for now Granvelle was able to offer more explanations than solutions for the delayed payments. He informed Titian that the Milan pension could not be paid because the authenticated documents had not yet been produced, because a secretary in Milan had made a mistake, because Charles V was too ill to sign the document, and so on. Titian engaged the help of his nephew Giovanni Alessandrini, who got nowhere with the d'Avalos pension or the Prince of Salerno's. When Titian sent Alessandrini to Naples he did think he might be making some progress with the grain. But, so he grumbled to Granvelle, it was no longer worth what it had been. Alessandrini's negotiations in any case came to nothing.

Titian was hardly a poor man. He had recently received 1,000 gold scudi from Philip, and by the early 1550s he could expect, at least on paper, an annual income from the Habsburgs alone of at least 500 ducats, about twice that of the most senior Venetian government officials and ten times the salary of a skilled workman in the arsenal; and this was in addition to payments for paintings for other patrons, his

sanseria, Pomponio's benefices, profits from the family timber and
real estate businesses, and windfalls such as an annual pension of
forty ducats for life given him by Bembo's son Torquato in 1552
(which Torquato stopped paying in the 1570s). His insistent dunning
letters – sometimes threatening, sometimes pathetically pleading
poverty or old age – may seem surprising coming from that most
poetic and temperamentally balanced of great artists. Indeed, his
interest in the minutiae of his finances has no parallel in the period,
which is why, four years after his death, Jacopo Bassano chose to
portray Titian as the grasping moneychanger in his *Purification of the
Temple* (1580). Nevertheless, the explanation for his obsession with
money – his pensions, as he put it himself, were 'his passions'[8] – is not
as simple as mere personal greed on the part of a self-made man who
had spent his early childhood in a household in the mountains where
every penny and stick of firewood had to be counted. Unlike the rich
and famous artists of our own day, he had no gallery to manage his
business affairs, and even Aretino, whose powers of persuasion were
beginning to fail him, would not have recommended taking legal
action against the likes of the Habsburgs. So Titian fought for what
was after all his due in the only way he could – through highborn or
well-connected men like Granvelle, trading gifts of paintings for their
favours. He knew his worth and wanted to demonstrate it by living,
dressing and behaving like an aristocrat; and he also wanted to be in
a position to pass on, like an aristocrat, his wealth and status to his
family, which now included, as well as a new baby daughter, two sons
who were running through his money and a daughter, Lavinia, who
had reached puberty and would soon need a substantial dowry if she
were to marry into the nobility.

Lavinia's dowry was on his mind when, somewhat recovered from
his illness on 8 September 1549 he sent a portrait of the emperor to
Ferrante Gonzaga in Milan with a letter thanking him for the infor-
mation, received through an intermediary, that the pension on Milan
would be paid on presentation of the authentic documents: '... I am
all the more thankful and obliged for this kindness as nothing could
be more opportune than the receipt of these moneys, because, having

a marriageable daughter, I ventured to betroth her on the faith of your Excellency's performance.' It was not strictly true that he had betrothed Lavinia, for whom he did not find a suitable husband for another six years. But he was already determined that she should marry into a family of good social standing, perhaps minor nobility, and was aware that entrée would require raising a dowry for her that was well beyond the means of other artists. Unfortunately, neither the portrait nor Titian's hint that he needed the pension specifically for his daughter's dowry succeeded in softening Ferrante's heart. A few months later that 'honoured and invincible hand', which Titian had begged to kiss in his letter, sent Titian's file to the Senate of Milan with a request that the statute of limitations should not apply to his claim for the pension.

Venice at this time was undergoing a threat to the religious tolerance, freedom of expression and traditional independence from Rome that the Most Serene Republic, alone among all other Italian states, had maintained throughout its history. The papal legate Giovanni della Casa – courtier, poet, pornographer and expert on etiquette – had introduced the Roman Inquisition and the Index of Prohibited Books to Venice, and was pressing the government to allow book burnings and the execution of heretics. As the shadows gathered over the home of liberty Aretino alerted Titian, his 'dear fraternal friend', to the plight of their confessor, a Franciscan friar who was in prison on bread and water charged with Lutheranism because, wanting to appear more learned than he was, he had gone around saying that the holy confession of sins was not divinely established; he had, furthermore, persuaded a girl, whom he knew 'to be more inclined to the flesh than to the spirit', to marry rather than enter a convent. Aretino, who also wrote on the friar's behalf to the general of the Franciscan order, asked Titian to put in a good word for the friar with della Casa, whose portrait he was about to paint before the legate returned to Rome. Titian would have had time during the sittings to plead that the friar had made nothing more than an innocent blunder. It is also just possible that Titian, who rarely portrayed humble men unable to afford his fees, demonstrated his affection for his confessor

by painting the *Portrait of a Monk* (Melbourne, National Gallery of Victoria).[9]

The early spring of 1550 brought a personal loss and a professional slight. Titian's sister Orsa died in March. We know nothing for certain about Orsa apart from two letters to Titian from Aretino, one of the previous year advising Titian that he had found a young servant girl for her and Lavinia. But Aretino's heartfelt letter of condolence, which describes Orsa as 'not just a sister, but a daughter, mother and companion ... worthy of honour and reverence', suggests that she had indeed occupied a valued place in Titian's heart and household. The bereavement coincided with an insult. The first bound copies of Vasari's *Lives of the Most Excellent Italian Architects, Painters and Sculptors since Cimabue* appeared in March. Vasari devoted this first edition of his *Lives* to deceased artists, with the single exception among painters of the seventy-five-year-old Michelangelo, the most venerated Tuscan artist, whose work he knew very well, who was now approaching the end of his career and whom, as a Tuscan himself, he could hardly have ignored. Vasari was not, however, well acquainted with the work of Venetian artists, and although he could have gathered information about Titian when they met at Rome he had not yet thought of writing his *Lives* at that time.

Titian was nevertheless offended. Vasari's *Lives* was the first book about the history of art since Pliny's *Natural History* and the first to popularize the idea that art was reborn in central Italy shortly after 1300. The exclusion of Titian from that monumental and important work[10] prompted Lodovico Dolce to write his own biography of Titian, which took the form of an imagined dialogue between a fictional Aretino and a Tuscan by the name of Giovanni Francesco Fabrini. Dolce has 'Fabrini' caricature Vasari's unstinting praise of Michelangelo; 'Aretino', while admitting that Michelangelo is a magnificent painter, champions Raphael as a more universal artist and Titian as the master of *colorito* as well as very able in *disegno* and *invenzione*. It was several years, however, before Dolce began to plan his work, which was unlike anything he had ever written and was not finally published until 1557.

Titian's own immediate riposte to Vasari's encomium of Michelangelo as the master of *disegno* was to commission an advertisement of himself, a woodcut that could be printed and circulated in multiples, in the act of drawing. Some years earlier he had painted for his patron Gabriele Vendramin, a collector of drawings, self-portraits and antiquities, a tondo portrait of himself, with a statue of Venus behind him, drawing on a tablet.[11] Until that time it had been considered indecorous to discuss, much less show, the act of artistic creation. This was the first time an Italian artist had portrayed himself using his hands, and it was this image that he asked Giovanni Britto, a woodcutter of German origin with whom he had collaborated since the 1530s, to reproduce in a square rather than the original round format and without the Venus. Britto hounded Aretino to publicize the woodcut with a sonnet. Aretino, who was evidently not impressed by Britto or his work, obliged in July with the sonnet, which was however preceded by an irritable letter berating the German for pestering him two or three times a day in a heatwave that would have undone the disciples of Caraffa (*i chietini*) let alone a poet. The first verse of the sonnet –

> This is Titian, the wonder of the world,
> Because he transforms nature into art,
> Where we see in all his figures,
> *Disegno* and *colore* in flesh and bone.

– was followed by a list, in reverse chronological order, of some of Titian's most recent portraits: of Philip, Ferdinand and his daughters, and Paul III. Aretino did not mention that Britto had failed to reverse the image on his block, with the result that in the printed impressions Titian appears to be drawing with his left hand, a mistake that probably caused him to withdraw the prints from circulation and would explain why there are only four extant examples.

But Titian had more pressing concerns. On 3 July, as Charles V was calling another Diet at Augsburg, Prince Philip wrote from Ulm to

Juan Hurtado de Mendoza, who had recently replaced his brother Diego as Spanish ambassador in Venice, asking him to invite Titian to Augsburg and to request him to bring with him a painting, the subject of which he did not specify. This painting might have referred to the unfinished portrait of Philip destined for his aunt Mary of Hungary that Titian had put aside during his illness. Alternatively, it might have been the *Danaë* (Madrid, Prado), a variant of Alessandro Farnese's *Danaë* now in Naples. Although the date of Philip's *Danaë* is highly controversial,[12] it is possible that he began it shortly after his meeting with Philip at Milan. He may have discussed it with the prince, perhaps while talking about their mutual admiration for Correggio and about the different techniques of the tight Flemish and free-handed Venetian styles. It is equally possible that he painted it for the prince on his own initiative – just as he had the nude for Cardinal Farnese that became the first *Danaë* and the Venus he had brought to Charles V on his first visit to Augsburg – in order to demonstrate his versatility, introduce the prince to the Venetian painterly style and perhaps not least appeal to his well-known lust.

Philip's *Danaë*, the most sensuous of all Titian's female nudes, is a work intended for a young, sexually active man in his physical prime. It transmits a dark erotic charge that makes all previous reclining nudes – including the *Venus of Urbino* and the Farnese version that della Casa had said would put the devil on the back of the Vatican censor – look innocent by comparison. If the *Venus of Urbino* is about flirtation and the Farnese *Danaë* about the moment of penetration, the *Danaë* Titian painted for Philip is about the climax of passion. The girl's delicate young body, painted in a very diluted oil floated on the surface of the canvas, is raised a little higher on her pillows as though straining towards her lover. The smooth sheets of the Farnese *Danaë* are now a mass of crumpled satin indicated by short, thick stabbings of impasto. The boy Cupid has been replaced by an ugly old hag, the keeper of the keys to Danaë's prison, who sits with her back to us on the end of the blood-red bed-hanging that flows behind the girl's body, straining forward to catch Jupiter's golden sperm in her apron. Her pose and her dark wrinkled skin contrast with the pale,

smooth young body of the girl who lies legs open on the bed enjoying the god's lovemaking. Is the old woman – she is an add-on to the original myth – attempting to prevent insemination? Or is she trying to catch some of the gold, and some of the pleasure? Titian, or a member of his studio, seems to have traced Danaë's body from a cartoon taken from a record in the studio of the Farnese version. The figural composition thus established, he allowed his brushes to work in the visible strokes that anticipate his work of a decade later.

Titian was supposed to leave Venice for Augsburg in August, but it was already September when Philip asked Juan Hurtado de Mendoza to make sure that he came as soon as possible. He finally arrived, late as usual, on 4 November, having brought with him some of the portraits commissioned on the previous visit. The celebratory mood that had followed the victory at Mühlberg had turned sour. Charles V was burdened with more problems than ever before in his reign. The victory at Mühlberg and the Augsburg Interim drawn up at the previous Diet had succeeded only in stiffening the Protestants' resolve. Now the new French king Henry II, having signed a truce with Scotland and England, was trying to engineer a new Habsburg–Turkish war in order to distract the Habsburgs on the eastern front while he prepared to revive the Habsburg–Valois struggle in Europe. But Charles, his body racked with the pain of multiple illnesses, his mind focused on abdication if death did not come first, was obsessed by the matter that had always been a priority: that of the Habsburg dynastic succession. At the end of Philip's extended tour of the seventeen provinces on 2 April, Charles had proclaimed his son heir to the Netherlands. The good burghers had not and never would warm to the haughty, ungainly, dourly pious Catholic prince who spoke neither French nor Dutch. But Philip in his father's eyes could do no wrong.

Now, at Augsburg, Charles reached a far more controversial decision. He was minded to decide that Philip, rather than Ferdinand's son Maximilian, would succeed Ferdinand as King of the Romans. The title would then pass to Maximilian, assuming that Philip predeceased him, but Philip, not Maximilian, would be first in line for the

imperial succession. Ferdinand was outraged by what he rightly regarded as a betrayal of the original agreement that the imperial crown would descend through his branch of the family. Titian must have heard the shouting matches between the brothers that echoed through the Fugger palace. Charles summoned Mary of Hungary, who adored him and would always comply with his wishes. Ferdinand sent for Maximilian, who on arrival ostentatiously avoided the company of Philip. The shouting gave way to silence as the two sides resorted to communicating by letters carried by servants. It is possible that Nicolas Perrenot de Granvelle, the adviser with whom Charles had formed his closest rapport over twenty years, would have found an acceptable compromise, but Perrenot had fallen ill the previous year, and although he managed to attend the Diet at Charles's bidding he was close to death. When it came in August, people close to the emperor said that with the loss of the elder Granvelle, the counsellor Charles had called his 'bed of rest', the emperor lost his own soul.

Although it was Philip who had issued the invitation to Augsburg, Titian spent more time there with Charles. The great theorist of Lutheranism, Philipp Melanchthon, writing from Wittenberg to a friend and fellow theologian, Joachim Camerarius, thought it worthy of note that Titian had frequent access to the emperor and was well informed about the state of his health, which was not good. Although Titian, who had his own aches and pains, may well have been interested in talk about illness, their conversations were by no means limited to the emperor's health. Titian may have confided in Charles about his problems with his children because before the painter left Augsburg the emperor granted Pomponio naturalization as a citizen of Spain, which allowed him to hold benefices in Spain to the value of 500 scudi. As the freezing winter settled on Augsburg and the two men warmed their bones before blazing fires, Charles asked for two paintings, the only ones he had ever requested from Titian that were not portraits and the last that Titian would paint for him. One was a *Grieving Madonna* (Madrid, Prado; two versions) to be a pendant to the *Ecce Homo* that Titian had brought with him on his previous visit to Augsburg. The other commission at Augsburg, for which Charles

gave precise instructions, was in anticipation of his abdication in favour of Philip, when he planned to take the painting with him to the Spanish monastery Philip had found for his retirement in Estramadura. Known as the *Adoration of the Trinity* or *La Gloria* (Madrid, Prado) – Charles on his death bed would call it a Last Judgement – it is an exceptionally complex painting with many figures including, on our right, portraits of the imperial family, from which Ferdinand and Maximilian are, however, notable for their absence. The imperial ambassador in Venice, Francisco de Vargas, as Titian wrote to Charles V when he delivered the painting to him three years later, had asked to be portrayed as the figure at the emperor's feet, but 'if it should please Your Majesty, any painter can, with a couple of strokes, convert it into any other person'. Titian took special pains with this painting, and by the time he sent it three years later along with the *Grieving Madonna*, Charles was in the process of finalizing arrangements for his long-awaited abdication.

The election on 7 February 1550 of Aretino's compatriot Giovanmaria del Monte as Pope Julius III had revived his hopes that the cardinal's hat he had been seeking for more than a decade would at last be his. Julius was not an impressive man intellectually or physically, and his pontificate was remarkable for nothing more than continuing the unstoppable momentum of the Reformation. He stank of the onions for which he had a passion and which were delivered to him in the Vatican by the cartload, and was so uncommonly ugly that an envoy of Cosimo de' Medici wrote to his secretary that neither Giorgio Vasari nor anyone else could paint the pope's portrait because his nose was so large and hooked, and he had thought of sending for Titian to do it. Even the Romans, who were not easily shocked, were appalled when he promoted his monkey keeper, a teenaged boy he had picked up on the streets, to the cardinalate. So why not Pietro Aretino? Julius was a native of Arezzo, and Aretino knew the del Monte family well enough to have stood godfather, together with Titian and Sansovino, to the child of one of his relatives. He bombarded the new pope with flattering sonnets and letters, and was rewarded with 1,000 crowns, a post as honourable chief magistrate of

Arezzo and a knighthood of St Peter that carried an annual salary of eighty crowns. The fourth volume of his letters, which was ready for publication, was followed immediately by a fifth rushed through the press and dedicated to Julius's brother Baldovino del Monte. He received encouraging letters from acquaintances in Rome, some of whom might not have had his best interests in mind. But Daniele Barbaro, writing from London in November, assured him that this time his cardinalate was as good as a certainty.

The timing of Titian's second visit to Augsburg seemed to favour Aretino's chances. Julius was planning to reconvene the Council of Trent and wanted the emperor's support. Although Charles was concerned about the effect on the Protestants of a new sitting at Trent, he was, for the time being at least, the pope's ally, having persuaded him to help to remove Ottavio Farnese from Parma. Titian agreed to carry his friend's supplications to Charles and promised to present them to him as soon as the occasion arose, which it did within days of his arrival. On 11 November he wrote to Signor Pietro, Honoured Gossip, describing Charles's reaction.

After the usual courtesies and examination of the pictures I had brought, he asked for news of you and whether I had letters from you to deliver. To the last question I answered affirmatively, and then presented the letter you gave me. Having read it, the emperor repeated its contents so as to be heard by His Highness his son, the Duke of Alba, Don Luigi Davila, and the rest of the gentlemen of the chamber. But since I was mentioned in the letter he asked me what it was I required of him. To which I replied that at Venice, Rome, and in all Italy the public assumed that His Holiness was well minded to make you, etc. At this Caesar's face showed signs of rejoicing, saying that this would greatly please him and could not fail to please you.

And so, dear brother, I have done for you the service we should all do for true friends such as yourself; and if I can assist you in any other way you need only command me.

He added that the Duke of Alba was continually expressing his love and support for the Divine Aretino, and that Granvelle would be writing to him shortly.

This letter, one of only two from Titian that Aretino included in his collections of letters written to him and very likely edited down to focus on the parts that concerned him, appeared in the second volume of *Letters Written to Aretino*, published in 1551 by Marcolini, who described the contents in his dedication as examples of the multitude Aretino received 'day after day from Knights, Lords, from Counts, Marquises, Dukes, Princes and every kind of grand gentleman and lady'. The scandal that had prompted Aretino to cleanse his reputation with the earlier edition of letters written to him published in 1542 had by now been forgotten. This volume, in which the correspondents were evidently chosen as witnesses or guarantors of Aretino's many virtues – political, religious, charitable – was more directly intended to proclaim him as an ideal candidate for a cardinalate. Nothing, however, came of it for the time being, although he did not altogether give up hope.

Although Titian always missed Venice and his old friends when he was abroad, he found plenty of convivial company in Augsburg. He renewed his friendship with the brilliant, amusing younger Granvelle, whose wit and sense of irony were not wasted on him, and Granvelle continued to help him with his difficulties in obtaining moneys promised by the Habsburgs and ordered a Mary Magdalen, a suitable subject for a bishop at a time when the penitent Magdalen had become an exemplar of the dictate of the reconvened Council of Trent that salvation came from penance, not, as the Protestants believed, from faith alone. Granvelle's Magdalen is lost but may have been the prototype for a number of others painted by Titian and his studio in the 1560s in which the reformed whore, her long auburn hair falling over her bare shoulders and between her full breasts, her eyes raised and red with weeping, is given the Tridentine attributes of a skull and a prayer book.

When the temperamental sculptor Leone Leoni of Arezzo, an old friend of Pietro Aretino, arrived in January, summoned by Granvelle

to make a medal for the emperor of the late empress Isabella taken from a portrait by Titian, the two artists and Granvelle dined merrily together. But Titian's most interesting encounter must have been with Lucas Cranach of Wittenberg, the friend of Martin Luther and court painter to the electors of Saxony, who with his studio had turned·out no fewer than sixty pairs of portraits of John Frederick of Saxony and his wife Sibilla. Cranach, who had painted Charles V as a boy of eight, was permitted to visit John Frederick who was still under house arrest in roomy quarters across a bridge from the Fugger palace where the German princes at the Diet held court. Titian's second *Portrait of John Frederick of Saxony* (Vienna, Kunsthistorisches Museum)[13] in which the elector seems apprehensive, the wound sustained at Mühlberg now healed into a scar, his tonsured head forming the apex of the enormous pyramidal body outlined against a plain background, looks like a bow to the style of the German painter, whose portraits he would have seen in the Fugger collection. This time the elector's clumsy armour is replaced by the fur pelisse suitable to his rank. Perhaps Titian discussed his new portrait of him when he sat to Cranach for his own portrait. And what would we not give to have some account of the conversation between the friend of Luther and the friend of Charles V, and to see what Cranach made of Titian in his portrait, one of the many regrettable losses in the unwritten catalogue of Renaissance paintings that have vanished without trace.

Philip, for all that he revered the father who was grooming him for power at Augsburg, must have been counting the days until the conclusion of the Diet would permit him to sail home to Spain. He was uneasy in the presence of Protestants, whom he knew he had to tolerate but privately regarded as loathsome heretics. He was alienated from his uncle Ferdinand and his cousin Maximilian who regarded him as a usurper of their rights. He could not express himself in any language except his native Spanish, and was even unable to cheer himself up by drinking wine, which made him sick. But he was not disappointed by his second encounter with Titian. In February 1551 he paid him 200 ducats plus thirty for colours for a second portrait, for which he chose to wear a *sayo*, a waisted Spanish coat lined with

white wolf-skin. Judging from the three extant versions of this portrait,[14] in which Philip's face does not change, he looked paler, older and perhaps a little sadder than in the portrait in armour that Titian had painted less than two years earlier in Milan. Philip sent this portrait to Mary of Hungary on 16 May along with some others including her version of the portrait in armour, which Titian had evidently finished in haste, or perhaps left to an assistant, as the prince remarked in the accompanying letter: 'You can see very well the haste with which he has painted my armour, and if there had been more time I would have had him work on it again. The other [presumably the portrait of Philip wearing the *sayo*] has been slightly damaged by the varnish, but not in the face; and it can be repaired there, and the fault is not mine but Titian's.'

But while Philip quibbled he was also more than generous. In addition to other payments, he paid 1,000 ducats for works so far completed or requested and promised an annual pension of 200 scudi to be paid for life from the Spanish treasury by the Habsburg bank in Genoa.[15] Something extraordinary had happened between the gloomy young prince and the ageing painter. The prince may have been baffled and perhaps slightly shocked by the overt sensuality of his *Danaë*. If so, he was also intrigued by it. In the course of their conversations, necessarily conducted through an interpreter, Titian agreed to provide about ten paintings over the next decade or so. Five were to be taken from stories told by Ovid in his popular *Metamorphoses*, of which Philip possessed a Spanish translation as well as two editions in the original Latin. Titian must have read the *Metamorphoses* in one of the many sixteenth-century translations, probably Dolce's paraphrase published in 1553. But he was not bound by Ovid's versions. The ancient tales had been often retold,[16] and Titian, who never needed more than the germ of a story to arouse his painter's imagination, sometimes even took hints from the crude erotic woodcuts and engravings from classical mythology that were circulated by the presses for the delectation of the wider public. The other works for Philip were to be religious paintings, which he would paint in the sombre key suitable for a pious proponent of the Catholic

Reformation. There was no contract for these paintings to come.[17] We can, however, be sure that unlike his father, who enjoyed Titian's company but valued his talent primarily as a vehicle for promoting his own image, Philip, a sophisticated connoisseur of painting, recognized in Titian an artist of genius possessed of independent spirit, who if left to his own devices could produce paintings that would satisfy Philip's more highly developed aesthetic taste.

Titian – or Dolce, who may have written his first letters to Philip – called his mythological works for Philip *poesie*, or poems, a word in literary currency at the time to describe paintings taken from classical poets and to indicate that painting could have a similar effect on the intellect and senses as poetry. After Philip's *Danaë*, which is smaller than the others and which he did not consider part of the group, he would deliver five more: *Venus and Adonis* (Madrid, Prado), *Perseus and Andromeda* (London, Wallace Collection), *Diana and Actaeon* and its pair *Diana and Callisto* (shown together on a rotating basis in the London National Gallery and Edinburgh, National Gallery of Scotland)[18] and the *Rape of Europa* (Boston, Isabella Stewart Gardner Museum).[19] Although not originally commissioned as a series or for a particular room – Philip, who did not yet have a permanent residence, may have intended them for his bedroom in one his many country palaces – they are all of roughly similar dimensions, loosely linked by narrative and thematic threads taken from the *Metamorphoses*, and Titian seems to have envisaged a notional room in which they would hang in pairs. In each of his mute poems Titian would display his unique talent for painting female nudes in motion and from different angles. But his poems, which are today among his most famous and admired paintings, are first and foremost about erotic passion (or in the case of the Diana pictures about its negation), which for better or worse changes us and determines our destiny. And just as Ovid edited the much older and more detailed Greek myths in order to dramatize that underlying theme, so Titian took liberties with Ovid to convey, in a way that would be rivalled only by Shakespeare, the many manifestations of the most primitive and overwhelming of human emotions: the sadness of anticipated

loss, the suspense, danger, cruelty and unfairness, and the sheer, anarchic fun. It was in these paintings that Titian, to paraphrase Marco Boschini, showed himself to be the dispenser of all emotions and the plenipotentiary of the senses.[20]

After they departed from Augsburg in May, Philip for Spain and Titian for Venice, they never met again, although they communicated frequently by letter, Philip dictating to his secretaries in Spanish, Titian to his in Italian. Unlike Alfonso d'Este, for whom the young Titian had painted his exuberant Bacchanals for the ducal *camerino d'alabastro*, Philip usually left it to Titian to choose the subjects of his paintings, and never insisted on literal adherence to Ovid, or complained when Titian changed his mind about paintings he had promised, or even when he sent paintings executed with workshop assistance. Although Titian in the first instance took care to accommodate Philip's reservations about the painterly style of the *Danaë*, it was not long before the prince accepted the artist's innovative way of laying on paint as though it were light, which Vasari, writing about the *poesie* in his 'Life of Titian', described as 'executed with bold, sweeping strokes, and in patches of colour, with the result that they can hardly be viewed from close up, but appear perfect at a distance'. From now on Titian would, with only a few exceptions, reserve his best works for Philip, supplying him with original paintings while most other patrons had to make do with studio versions. Philip, the most generous, liberating and sensitive patron of Titian's entire career, gave him the security of a court artist without the obligation to spend time at a court or even to leave his studio in Biri Grande. That independence, which was unprecedented in the history of patronage, released in Titian a new wellspring of creativity.

EIGHT

Venus and Adonis

With this he breaketh from the sweet embrace
Of those fair arms which bound him to her breast
And homeward through the dark laund runs apace;
Leaves Love upon her back, deeply distressed.
Look how a bright star shooteth from the sky,
So glides he in the night from Venus' eye.

SHAKESPEARE, *VENUS AND ADONIS*, 1593

Philip had to wait two years for the first of the *poesie* Titian had promised him at Augsburg. In the meantime Titian sent him two pictures from stock in the studio. One was a *St Margaret and the Dragon* (Madrid, Escorial), based on a Raphael then in a Venetian collection, and a suitable subject for Philip because St Margaret was a saint especially venerated by the Habsburgs. The other was almost certainly the painting now known as the *Pardo Venus* (Paris, Louvre) because it was once in the palace of El Pardo where it was described in an inventory as 'Jupiter and Antiope', the story mentioned in passing by Ovid in which Jupiter, aroused by Cupid's arrows, assumes the form of a satyr and steals up on the sleeping nymph Antiope. It is Titian's largest mythological painting, but in his correspondence with Philip he referred to it simply as 'the landscape'. Orazio, writing to Philip many years later, identified it more precisely as 'the nude woman with the landscape and the satyr'.[1]

These two offerings, both of which are now in poor condition, were carried to Spain in the summer of 1552 in the baggage of the Bishop of Segovia having been dispatched by the new imperial ambassador in Venice, Francisco de Vargas, who had taken over from Juan Hurtado de Mendoza in early May. It was one of Vargas's first tasks to write to Philip about the paintings, and he would remain Titian's principal contact with the Habsburgs for the next seven years. The portrait Titian painted of him, which was praised by Aretino in generalized clichés, has not survived, although Titian had done the ambassador the honour of accepting his request to include him in Charles's *Adoration of the Trinity*. It is through Vargas that we have one of Titian's rare explanations of his artistic philosophy. The ambassador, who apparently claimed to have seen Titian painting with a brush that was as big as a birch broom, asked him why he did not paint in the more refined manner of his great contemporaries, to which Titian is said to have replied:

> Sir, I am not confident of achieving the delicacy and beauty of the brushwork of Michelangelo, Raphael, Correggio and Parmigianino; and if I did, I would be judged with them, or else considered to be an imitator. But ambition, which is as natural in my art as in any other, urges me to choose a new path to make myself famous, much as the others acquired their own fame from the way they followed.[2]

The *St Margaret* and *Pardo Venus* were followed to Spain in October 1552 by a Queen of Persia, probably a painting of a pretty girl in oriental costume, which may have been related to the so-called Sultana series of pretty women painted by or in collaboration with the workshop. In one of the studio versions, *Sultana Rossa* (Sarasota, John and Mable Ringling Museum of Art), the woman wears an oriental hat. In another, the *Girl with an Apple* (Washington, DC, National Gallery of Art), the same girl, clutching an apple presumably to signify her sexual availability, wears a loose green robe. Philip seems never to have received his version, or if he did he never acknowledged it.

Philip did however make him a gift of 500 scudi, which prompted Titian to send a now lost self-portrait holding a small portrait of the prince[3] with a letter composed by Dolce dated March 1553:

> I have had the letter from Your Highness of 12 December, which is so gracious and generous that although old I am restored to youth. In such a way has Your Highness wrought a miracle in me ... And so nothing can issue from my mouth or my heart but the great Philip my lord, and in testimony of this while I am putting in order the *poesie* I am sending to Your Highness yourself ...

On the back of Titian's letter Philip noted 'Answer Titian':

> Well beloved and Faithful,
> ... We received your letter and the portrait that accompanied it; it is as though from your own hand and for which, as well as for the trouble you have taken, we give you many thanks, together with assurance of our goodwill in respect of your offer.

Nevertheless, the emperor and Mary of Hungary continued to claim more of his painting time than Philip. Mary had ordered more family portraits as well as two other pictures, a lost Psyche Presented to Venus, and a *Noli me tangere*, of which only the head and shoulders of Christ survive (Madrid, Prado). One autograph masterpiece for Mary does, however, survive intact. It is another *St Margaret and the Dragon* (Madrid, Prado), probably painted at some time before her death in 1558[4] and far more exciting than what is left of Philip's version. In the distance, across a shallow lagoon, a city has been set alight by the dragon.[5] The green-blue sky is filled with smoke, which balances the escarpment that looms over the action in the foreground. The dragon, still belching fire, sprawls across the base of the painting clutching the right thigh of the terrified and dishevelled young saint, who, her figure lit up by the flames that would consume her, but cool in her scanty lime-green dress, vanquishes the force of evil by brandishing a tiny crucifix. Mary, as Titian knew, took a more sophis-

ticated delight in the aesthetics of painting than her brother Charles, whose *Trinity* he was required to compose to the emperor's instructions, and her *St Margaret* is one of Titian's spectacular evocations of fire, an anticipation of the freely suggestive way of laying on paint that we see more often in his later work.

The *Trinity* was under way by the end of May 1553 when Charles, who had heard a rumour circulating in Brussels that Titian was dead, wrote to Vargas asking for confirmation that the story, as he suspected, was untrue. Titian wrote to reassure him, and so, on 30 June, did Vargas.

> Titian is alive and well, and not a little pleased to know that Your Majesty was inquiring for him. He took me to see the 'Trinity', which he promised to finish towards the end of September. It seems to me a fine work. Equally so a Christ appearing to the Magdalen in the garden for the Most Serene Queen Mary. The other picture he says will be a 'grieving Madonna', companion to the 'Ecce Homo' already in possession of Your Majesty, which he has not done because the size was not given, but which he will execute so soon as the particulars are sent to him.[6]

Another priority for Titian after three prolonged absences abroad was to re-establish his presence in Venice. He was one of several artists who joined the Accademia Pellegrina (The Wanderers' Academy), which had been founded in 1549 by Anton Francesco Doni and other *letterati* with financial aid from the Venetian nobility for the education of their sons. Before leaving for his second visit to Augsburg he had taken the precaution of asking to be reinstated as a member of the Scuola di San Rocco, where as far as we know he had not attended a meeting since 1528 and had not paid his membership dues for eighteen years. He was at a meeting there in March 1552, was elected to the advisory board in June, and in September 1553 he offered to paint a large canvas for the *albergo*. Nothing came of this suggestion, which Titian would doubtless have left to assistants and may have made simply to spur the board on to doing something about the

long-delayed interior decorations of the building. The board in any case were not unanimously in favour of committing themselves to the expense. Titian did not press the matter, and the wall in the *albergo* was filled twelve years later by Tintoretto's astounding *Crucifixion*.

There was also the matter of the *sanseria*. The broker's patent that paid an annual 100 ducats had quite properly been withdrawn during Titian's absences on the grounds that he was too busy working abroad for foreigners to fulfil the requirement of supplying paintings for the ducal palace. The *sanseria* was reinstated in October 1552, no doubt after some networking in high places by Titian and his friends; and Titian was called upon to paint official portraits of two more doges for the palace. Marcantonio Trevisan was a compromise candidate who had succeeded Francesco Donà in June of that year. Aretino praised Titian's portrait of him and of Vargas in a letter written in November 1553, which tells us nothing about the painting itself:

> Divine in charm was Raphael;
> And Michelangelo, more divine than human,
> In design stupendous; and Titian
> Has the sense of things in his brush.

The Mantuan ambassador Benedetto Agnello described Trevisan as 'better at reciting the rosary than governing states'. Agnello also claimed that Trevisan wore a hair shirt and spent much of his time in office trying to save nuns from prurient thoughts, which he believed would be aroused by paintings of naked flesh or even of copulating chickens, cats or dogs. He died of apoplexy a year after his election. Agnello welcomed the election in June 1554 of Trevisan's successor, Francesco Venier, a younger, wiser and more sophisticated man, although also given to frugal personal habits, who proved to be an excellent administrator during the two years before illness overcame him.

The official portraits of Marcantonio Trevisan and Francesco Venier were destroyed in the fire in the Great Council Hall in 1577. Fortunately, however, Venier commissioned another portrait of

himself (Madrid, Museo Thyssen-Bornemisza),[7] whether for another government building or for his own residence we do not know. It is one of the most moving of the portraits Titian painted at this period and seems to bear out Benedetto Agnello's judgement of the doge's character. At sixty-six and within a year of his death, Venier looks old and frail beyond his years, his long, noble face flushed with red patches that suggest high fever, his emaciated body weighed down by the gold damascened robe of state, which Titian contrasts with a red satin curtain (painted in the same loose style as Aretino's robe in the portrait of 1545) on his left. The gesture of his outstretched hand with palm facing down is that of a Roman emperor demonstrating authority and good conscience, perhaps derived from the statue of Marcus Aurelius, which both Titian and Venier, as ambassador to the Holy See in 1545, had had the opportunity to admire in Rome. The red curtain is balanced by an opening on Venier's right through which Titian painted a fire, seen from across a lagoon. A little boat, its sail powered by a high wind, speeds towards Venice. Venice was at peace at the time, Venier was a pacific doge and there had been no recent major conflagration. What Titian meant to convey by this fire is therefore difficult to ascertain. It may have been inspired by the flames issuing from the glass foundries on Murano, which were a mainstay of the Venetian economy, and which Titian could see from his house. He may have used the view simply to give energy to the image of a doge who although old and ill was still actively in charge and capable of controlling any threats to the Republic.

The portrait of Francesco Venier was Titian's last but one portrayal of a doge and one of the few portraits, apart from those of the Habsburgs and their courtiers, that he had painted since the late 1540s. Having been dismissed in his forties by some as a 'mere' portraitist, Titian had become a reluctant one, although he made exceptions. The *Man with a Clock*, or the *Knight of Malta* as it is sometimes known from the white cross stitched on to the gentleman's elegant clothing (Madrid, Prado), is one his most striking portraits, for the immediacy of the man's pose and expression and the superb evocation of black and white fabric. Nothing is known about the

identity of the sitter, except that he was clearly of high social standing and that Titian took pains with his portrait, raising the left arm, which originally hung by the man's side, and adding the clock the knight touches with his left hand. Another magnificent portrait of this period is of the papal legate in Venice, Luca Beccadelli (Florence, Uffizi), a Bolognese humanist and Bishop of Ravello, who had succeeded Giovanni della Casa as papal nuncio in 1550, and two years later sat for Titian seated in his black bishop's cape. Titian identified him, signed the portrait 'Titianus Vecelius faciebat Venetijs' and dated it 1552 in the long inscription on the letter Beccadelli holds in his hands where he has made a wonderful still life of the contrasting textures of the paper and the pleated white silk of the bishop's robe.[8] But on the whole Titian seems to have been content to let Tintoretto take over as portraitist of the Venetian nobility. Tintoretto was fast, extremely ambitious and cheap: he charged only twenty ducats apiece for his portraits, many of which are very dull. He was also ready and willing to fulfil the big public commissions for which Titian's commitments to the Habsburgs left him neither time nor energy.

King Edward VI of England died on 6 July 1553, and after the nine-day reign of the unfortunate Lady Jane Grey, Mary Tudor, the only surviving child of Henry VIII and Charles V's Spanish aunt Catherine of Aragon, was proclaimed Queen of England. Mary, whose mission it was to restore the Catholic faith in England, offered her hand in marriage to Charles. Since the recent Diet at Augsburg he had suffered a series of humiliating political and military defeats. At the Council of Trent, which had been reconvened by Julius III in 1551, the pope and ·his legates had resisted his conciliarist position towards the Protestants, which would never again be revived. He was estranged from Ferdinand over the matter of the succession. Worst of all, the French king Henry II had revived the Habsburg–Valois conflict, invaded the Netherlands and occupied the three bishoprics of Metz, Toul and Verdun, which were states of the Holy Roman Empire. A failed attempt to retake Metz on New Year's Day 1553 had had disastrous consequences for the emperor's treasury and for his physical and psychological health,

which were described in alarming detail by a Netherlandish councillor: his arthritis had 'spread to all the limbs, joints and nerves of his body' and was worsened by cold weather; he was so severely affected by catarrh that 'when he has it he cannot speak, and when he speaks he cannot be heard or scarcely understood by his attendants'; 'his haemorrhoids have swollen and hurt him so much that they cannot be put back in without great pain and tears'; and instead of being gracious and affable 'as he used to be', he had become sad and pensive, 'and often weeps for long periods and with such copious shedding of tears as if he were a child'. He refused to see ambassadors or even his own councillors or to sign papers, and spent his days and sleepless nights adjusting his large collection of clocks and reading the psalms of David.

Nevertheless, the prospect of a marriage that would unite England and the Spanish empire under a single Catholic monarchy against the French could not be ignored. Charles refused Mary's offer of her hand in marriage, but proposed Philip in his stead; and Philip, although not personally enthusiastic, had no choice but to agree that it was his duty to obey his father's command. Mary was eleven years his senior and no beauty, as can be seen from the portrait of her that he commissioned from Anthonis Mor (Madrid, Prado), which accords with descriptions of her appearance by members of the Spanish court when they reached England as unattractive, wrinkled, 'very short-sighted', her voice 'rough and loud like a man's'; 'very white and fair-haired; she has no eyebrows; she is a saint; she dresses very badly'. But neither Mary nor Philip had any illusions that it would be a love match, although a son and heir to the English throne, which would perpetuate the Catholic alliance, was of course highly desirable.

Philip was committed but put off the wedding for as long as possible. He withdrew from his plan to marry Maria of Portugal, but continued a serious affair with one of his ladies in waiting throughout the negotiations for the marriage to Mary Tudor, which were conducted on Charles's behalf by Granvelle and Simon Renard, his ambassador in England. Mary also hesitated. Many of her councillors were strongly opposed to the match on political or religious grounds,

or because they did not want to see England embroiled in the perpetual continental wars. The English people hated foreigners, especially Spaniards. And she was troubled by rumours about Philip's womanizing. Nevertheless, she was a determined woman with a mind of her own, and by the end of October 1553 she had made her decision. On the 29th she gave Renard her solemn assurance before the Sacrament that she would marry Philip.

She asked Granvelle to provide a portrait of her future husband; and on 13 November, the day after Charles had dispatched a party of councillors to draw up the marriage treaty, Granvelle wrote to Renard from Brussels that he hoped Mary of Hungary would soon send Mary Tudor a portrait of Philip by Titian that was in her possession: it was already old and showed Philip in a less good colour than he had in reality, and the queen should bear it in mind that he was now more mature and his beard had thickened. Six days later Mary of Hungary herself wrote anxiously to Renard that the portrait had been done three years earlier when it was judged very lifelike. It was, however, somewhat damaged by the passage of time and the journey from Augsburg, and should be seen in the appropriate light and from a distance, 'like all the paintings of the said Titian, which cannot be recognized from close by'. Mary of Hungary was doubtless concerned that Mary Tudor, who was not familiar with contemporary Italian painting, would judge Titian's portrait by the standards of Holbein or Anthonis Mor or another of the northern artists who worked at the English and Habsburg courts. But we have a more precise and more favourable description of the portrait in a letter from Charles's secretary Francisco de Eraso to the prince on 21 November.

> It appears that the portrait of Your Highness painted by Titian, the one in the *sayo* lined with white wolf-skin, which is very good and like you, has been sent in secret to the Most Serene Queen of England. I am sure it would please her greatly if she had not already declared her wishes.[9]

Philip, however, continued to put off the journey to England, and when his Castilian entourage, sailing in seventy large vessels followed

by an escort of thirty armed ships, finally reached the Isle of Wight he did not immediately disembark. The day before the wedding, which was celebrated at Winchester on 25 July 1554, Charles renounced Milan in Philip's favour and created him King of Naples and Sicily.

On 10 September, less than two months after the marriage, Titian dispatched his first *poesia*, *Venus and Adonis*, to London with a letter to the new king, which was written by a secretary or literary friend with Titian's approval. It refers to the *paragone* or comparison of the merits of painting with those of sculpture, which was still debated in literary circles.

> My spirit now rejoices with Your Majesty because of the new kingdom which God has bestowed upon you and my congratulations are accompanied by the painting of Venus and Adonis, which you will view with those approving eyes that are already accustomed to look at the works of your servant Titian; and, because in the Danaë which I have already sent Your Majesty one sees everything from the front, I wanted in this other *poesia* to vary it and to show you the opposite side, so that the chamber where they have to hang will be more attractive. I will be sending you immediately the *poesia* of Perseus and Andromeda, which will have a different viewpoint, and likewise Medea and Jason, and besides these I hope with God's help to send you a most devout work which I have had in hand these past ten years, wherein I hope that Your Serene Highness will see all the power of art that your servant Titian knows how to employ in painting.[10]

On 16 October Francisco de Vargas wrote to Granvelle that Titian's *Venus and Adonis* was an estimable work but 'excessively lascivious'. Philip, however, acknowledging receipt of the painting in a letter to Vargas dated 6 December, found only one flaw.

> The picture of Adonis that Titian has completed has arrived here and truly it seems to me to be as perfect as you told me; but it is disfigured by a crease running across the middle in such a way that it now needs an extensive restoration. Concerning the other pictures that the painter

541

is making for me, I desire that you take renewed care; and it would be most advisable if from now on you did not send them to me before informing me that they are finished and receiving my orders concerning their shipment.

The crease about which Philip complained is a join in the canvas, which may have been stretched when the rolled canvas was accidentally squeezed flat in transport. It is visible to this day in the Madrid painting.

In the story of Venus and Adonis, as told by Ovid in the tenth book of his *Metamorphoses*, Venus fell in love with Adonis when Cupid while kissing her accidentally grazed her with one of his arrows and she noticed a resemblance between the young and beautiful man and her son. She liked to go hunting with her lover, but warned him not to pursue the fiercer prey, such as wild boars. But one morning, when Venus had gone off in her sky-borne chariot, Adonis could not resist the lure of the hunt. Ignoring her advice he speared a wild boar, but the beast turned on him and gored his thigh. Venus heard his cries from her chariot, but by the time she reached his side he was dying. She scattered his blood to the wind and the flowers we call windflowers or wood anemones grew from the places where it fell to the ground.

Titian improved upon Ovid with the invention of a new episode in the story. In his painting the naked Venus clings desperately to her lover, who is dressed and ready for the hunt, the fateful spear held high in one hand while his baying dogs tug at the other. Cupid, who has unwittingly brought the lovers together, sleeps in the shade of a tree on which he has hung up his bow and quiver. Although there was a great deal of literary interest in the story at the time, no written account has been discovered that would entirely explain Titian's departure from Ovid's story, although his revision of it may have been prompted by Hurtado de Mendoza's *Fable of Adonis, Hippomenes and Atalanta*,[11] which was published in Venice in 1553, and in which Mendoza does describe a final embrace, but with the lovers both seated on the ground. The pose of Venus is instead modelled on a visual source, so obviously as to be closer to an outright quotation

than any of Titian's other large figures. It is a first-century BC Roman marble relief known at the time as the *Bed of Polyclitus* because the original was attributed to that ancient Greek sculptor. Titian would have seen Giulio Romano's adoption of the same figure in his fresco of *Bacchus and Ariadne* in the Palazzo Tè in Mantua, as well as a version of the relief in Rome and the use made of it by Raphael's workshop for the figure of Hebe in the fresco of the *Banquet of the Gods* in Agostino Chigi's Roman villa (now the Villa Farnesina). Both Bembo and Granvelle owned copies, and it is possible that one or another of Titian's learned friends suggested that it would be fitting for the modern Apelles to pay homage to the great ancient sculptor.

Although the telltale seam in the Prado version leaves little doubt that this was the painting sent to Philip, it was not Titian's only version of the subject.[12] There exist at least four other versions of the Madrid painting,[13] all very similar to one another, as well as several copies, some later, all probably workshop replicas, as well as numerous engravings. There are also several versions of a slightly different composition, known as the 'Farnese type'[14] from the one Ridolfi claimed – mistakenly as all critics now agree – that Titian had painted for Ottavio Farnese as a pendant to Alessandro's *Danaë*.

The erotic appeal of Titian's *Venus and Adonis* and the poignancy of the scene he invented, as well as the theme of hunting, ensured that it became one of his most popular and immediately influential works, and the myth became the one that was most frequently painted by European artists. At a time when both Catholic and Protestant clerics were dedicated to repressing lust outside marriage, which was regarded as the second most terrible sin after avarice, crude engravings of erotic images in the guise of vulgarized classical myths were widely available on both sides of the Alps. Among the most popular with the educated and moneyed elite were the many copies and derivatives of Titian's *Venus and Adonis* for Philip. Shakespeare, who may well have been alerted to the story by its international popularity with artists, also departs from Ovid by devoting a large part of his bestselling poem *Venus and Adonis* to the goddess's futile attempt to detain her lover. But, although the possibility that he had seen an engraving

of Titian's painting cannot be discounted, his Adonis is repelled by Venus' advances and leaves her not in the morning to go hunting but at night to join his friends at dawn.

Philip's first *poesia* also benefited from a remarkable piece of publicity written by Lodovico Dolce, no doubt with Titian at his elbow, and published in 1555 in a collection of Dolce's letters. It is a descriptive eulogy of the picture, which is longer and more detailed even than any praise ever heaped on Titian by Aretino. It was addressed to a patrician, Alessandro Contarini, as a return favour for Contarini's verbal account of a painting by Raphael, the painter to whom Dolce would compare Titian in his *L'Aretino*, published two years later. First Dolce described the figure of Adonis as being:

> of a height appropriate to a lad of sixteen or eighteen, well proportioned, handsome and graceful in every one of his parts, with a pleasing tint to his flesh in which extreme delicacy and the presence of royal blood are conveyed. And one sees that in the facial expression this unique master has aimed to convey a certain handsome beauty which would have its share of femininity, yet not be remote from virility ... an amalgam which is hard to achieve and agreeable and was (if we are to believe Pliny) supremely prized by Apelles ... He turns his face towards Venus with lively and smiling eyes ... and one has the impression that with wanton and amorous endearments he is comforting Venus into not being afraid.

Moving on to Venus:

> [She] has her back turnèd ... to display art in double measure. For in the turn of her face towards Adonis, as she exerts herself with both arms to hold him back and is half-seated on a firm cloth of *pavonazzo*[15] she everywhere evinces certain feelings which are sweet and vital and such that they are not seen except in her. With her, too, there is a marvellous piece of dexterity on the part of this divine spirit, in that one recognizes in the hindmost parts here the distension of the flesh caused by sitting ... I swear to you, my Lord, that there is no man so

544

sharp of sight and discernment that he does not believe when he sees her that she is alive; and no one so chilled by age or so hard in his makeup that he does not feel himself growing warm and tender, and the whole of his blood stirring in his veins. And no wonder; for if a marble statue could, with the shafts of its beauty, penetrate to the marrow of a young man so that he left his stain there, then what should this figure do which is made of flesh, which is beauty itself, which seems to breathe?

The marble statue to which Dolce refers was the *Cnidian Venus*, Praxitiles' most famous statue, the back view of which so inflamed the lust of a young admirer that he left a stain on her thigh. The story was considered the ultimate accolade of the power of an erotic work of art to arouse.

When he dispatched the painting to London after the marriage of Philip and Mary Tudor, Titian cannot have known how uncannily analogous a picture of a man tearing himself from the embrace of a woman was to the situation in which the royal couple found themselves. Although they did not share a common language – Mary spoke to Philip in French, which he just about understood; she had learned enough Spanish from her mother to follow his conversation – Mary was celebrating the first of what would be two false pregnancies and had fallen a bit in love with her consort. While he carried on adulterous affairs – one of his lovers seems to have borne him a daughter – Mary comforted herself with the observation that if she did not have a chaste king 'at least he was free from the love of any other woman'. Philip was always at his best with women. He was the first man to have taken Mary to bed and was never less than considerate to her. She also desperately needed his support in her determined persecution and burnings of Protestants, a policy which, as Charles V had warned her, was turning her people against her.

But Charles also needed Philip by his side. The French war dragged on – in 1554 French troops raided and destroyed Mary of Hungary's palatial château at Binche. Charles, who was now far too ill and depressed to take to the saddle, was eager to make final arrangements

for his abdication, for which he had been waiting for some years until his son was in a position to replace him. He sent continual messages from Brussels begging Philip to come to him. Philip waited until Mary's second pregnancy turned out, like the first, to be a prolonged attack of wind before making arrangements to cross the Channel to Brussels. When he took his leave of her at Greenwich on 29 August 1555 she was seen fighting back her tears. Then standing at a window in her apartments overlooking the Thames, she sobbed uncontrollably until Philip's barge was out of sight. She would not see him again for another two years.

On 10 September 1554, the day Titian sent Philip's *Venus and Adonis* to London, he wrote to Granvelle.

> I know that His Caesarean Majesty is now in considerable difficulties because of the war, but I have another art as well as that of painting, which is to predict the future, and I hope that my paintings of the Holy Trinity and the Grieving Madonna, which I am sending to His Caesarean Majesty, will find him in peace and glorious victory so that he can enjoy my paintings with a light heart. And Your Most Reverent Lord, having requested your devout Magdalen, which I am sending as my intercessor, will find this a good opportunity to see that my pensions on Milan, which have never been paid either in whole or in part, come in aid of my necessity, since those of Signor Aretino are brought perfumed even to his house.

He would, furthermore, be grateful to Granvelle, his Most Reverend and Illustrious Lord, whose good will he knows will not fail him, to relieve his distress by obtaining, as well as the pension on Milan, the trade agreement to export grain from Naples, and the naturalization in Spain for Pomponio worth a pension of up to 500 scudi.

On the same day, Titian wrote directly to Charles V reminding him, without preliminaries, that he had been granted a pension on Milan worth 200 scudi, the privilege of exporting grain from the Kingdom of Naples duty free, which had cost him hundreds of scudi in

maintaining an agent there, and the naturalization for his son in Spain carrying a pension of 500 scudi. It had been his ill fortune to obtain nothing from these grants, and he would now like to have a word with his Most Caesarean Majesty in the hope that the most liberal soul of the greatest Christian emperor there ever was would not allow his orders to be disregarded by his ministers.

> I should consider such a benefit as an act of charity because I find myself in some financial difficulties having been ill and having married a daughter. I have appealed to the Queen of heaven that she should intercede on my behalf with Your Caesarean Majesty with a record of her image [the *Grieving Madonna*], which now comes before you with that semblance of grieving which expresses the quality of my troubles. I also send your painting of The Trinity, and, had it not been for the tribulations I have undergone, I should have finished it earlier, although in my desire to satisfy your C.M. I have not spared myself the pains of striking out two or three times the work of many days to bring it to perfection and satisfy myself, whereby more time was wasted than I usually take to do such things …

Granvelle's Mary Magdalen, along with the *Grieving Madonna* and the *Trinity* for Charles, were dispatched in the same crate to Brussels a month later. Granvelle's Magdalen is lost. The *Grieving Madonna*, her hands tightly clasped as she meditates on the suffering of her Son, is as moving in its restraint as the *Ecce Homo* for which it was intended as a pendant. But soon after its arrival Charles, who had failed to give Titian the correct measurements for it, asked for another, this one with the Virgin's hands parted in stupefaction, for which he provided a Flemish painting as a model, and he specified that Titian's new version should be painted on marble, an extremely unusual, delicate and costly support. It was a strange request and the resulting picture, in which the Madonna's grief is emphasized by tears, demonstrates the limitations of Charles's understanding of Titian's more under-stated way of conveying deep emotion. Both versions, which are now in the Madrid Prado, were in Charles's possession at his death.

The numerous pentimenti that have been detected beneath the surface of the *Trinity* are evidence that this extraordinary and exceptionally complex work had indeed cost Titian much trouble and hard labour. Charles may have conceived the design from a type of German painting or relief carving in which the patron and his family are shown in prayer before the Holy Trinity or some other representative image of Christian faith. Titian's composition, however, seems to have been suggested by Lorenzo Lotto's altarpiece of *St Nicholas in Glory* painted in 1529 and still in the Venetian church of Santa Maria del Carmine. Charles and Isabella, dressed in shrouds, the imperial crown cast to one side, gaze upwards in pleading adoration at the Holy Trinity, which is surrounded by a host of angels at the apex of the painting. Behind and below them are their children Philip and Juana, and Charles's sisters Leonora and Mary of Hungary, all of them guided by angels. On the opposite side of the canvas the Virgin Mother walks towards the Holy Trinity shrouded in the same ultramarine as Christ and God the Father and followed by the other principal intercessor, St John the Baptist. The Madonna looks down on a group of large, muscular Michelangelo-like figures tumbling in different positions across the foreground. Moses hands a Tablet to a turbaned man holding up a scroll on which Titian has placed his signature, 'TITIANVS P'. The man has been variously identified as St John the Evangelist leaning back on his attribute the eagle, or as the Old Testament prophet Ezekiel. Noah lifts up his ark with the dove of peace perched on it at the exact centre of the painting directly below the dove of the Holy Ghost. The woman dressed in green with her back to us could be Mary Magdalen or a sybil. King David, robed in royal blue, clutches his harp. The portrait of himself requested by Francisco de Vargas is probably the bearded man just below the imperial family. Tiny figures in the strip of earthly landscape across the bottom of the picture witness the miraculous vision.

The quality of the painting is uneven, and the composition looks at first sight like an awkward jumble of unrelated figures, although it is largely redeemed by Titian's incomparable use of light and shade. The golden rays of light that emanate from the heavenly host of angels

penetrate a dark cloud to shine on the figures suspended below against an azure sky that reflects the blue robes of God the Father, Christ and Mary, while earthly landscape at the bottom of the painting is cast in shadow. Titian usually referred to this work as the Trinity or the Paradise. The iconographical sources have never been satisfactorily identified, although one scholar[16] has maintained that the painting corresponds to St Augustine's vision of the blessed as described in his *City of God*.[17] Nevertheless, we can be certain that it is primarily significant as a representation of the personal vision of Charles V, who in his will called it the 'Last Judgement'. It is about his hopes, for himself and his family, for eternal salvation. It is a vision that Titian may have shared, or wished to be seen to share, when he squeezed his profile – grizzled, naked apart from a toga-like shroud, without the cap that normally covered his balding head – into the right edge of the painting next to Vargas and just below the imperial family.

NINE

The Passing of the Leviathans

I laughed at the dream I dreamed last night while sleeping.
Resting in my bed with my eyes shut, I saw a devil and an angel
side by side. They said to me that, when it pleased God, my soul
would go to the other world post-haste, and that it would spend
one month in Hell, and another month in Heaven.
'How so? I asked.
They answered that the praises given by me to great lords who did
not deserve them condemned me to the abyss as a liar, but that
the rebukes with which I had buried them alive, won me Heaven
and its joy.

PIETRO ARETINO, DECEMBER 1554[1]

Titian had been thinking about a suitable husband for Lavinia for at least six years before he married her to Cornelio Sarcinelli of Serravalle, having put together a dowry of 1,500 gold ducats in cash, jewels and a pearl necklace, to be paid in instalments. His nephew and amanuensis Giovanni Alessandrini, who was now practising as a notary in Cadore where he also looked after the business interests of Titian and Francesco, witnessed the marriage contract on 20 March 1555. Lavinia's dowry was less than a third of the value of the average patrician dowry at the time, but by the standards of contemporary artists, who tended to marry their daughters to fellow artists in the interest of perpetuating the family practice,[2] it was an enormous sum. Titian, who was at the time renegotiating his lease on Biri Grande, was

feeling the pinch when, shortly after the signing of the marriage contract, the Council of Cadore sent his favourite cousin Toma Tito Vecellio to Venice to request a loan of 250 ducats to cover debts incurred in the purchase of salt and grain. On 1 April Titian granted the Council 200 ducats, which was in addition to 200 outstanding from a previous loan. Toma Tito, acting for the Council, agreed that it would pay an annual interest of thirty-two ducats, or 8 per cent, on the 400 ducats until the entire amount was repaid voluntarily or Titian asked for it.

Lavinia's dowry provided her with the means to climb the social ladder. Cornelio Sarcinelli was a well-off gentleman farmer belonging to the minor nobility of Serravalle where his handsome house still stands in the old town overlooking the Piazza Grande. Titian may not, however, have bargained for the provincial snobbery of a son-in-law who, although happy enough to accept Lavinia and her dowry, was more conscious of Titian's social inferiority than impressed by his genius or his friendship with the great men of the world. Sarcinelli turned out to be an unscrupulous, grasping boor, and, judging from his behaviour after Titian's death, slightly unhinged. After the marriage was celebrated on 19 June 1555, relations between Titian and Sarcinelli were superficially cordial but distant. It seems that Lavinia was rarely if ever allowed to visit home and that Titian did not even attend the baptisms of his grandchildren: Hersilia, Helena, Giacomo, Orazio and Bernardo.[3]

The *Portrait of Lavinia as a Matron*,[4] for which she posed at some point after her marriage, may show the effect of repeated pregnancies; or it could be, since she was already plump as a little girl when she posed for Titian's *Ecce Homo* in the early 1540s, that she was naturally a buxom figure and that this was a wedding portrait. She wears the string of pearls and jewels that were probably part of her dowry and fashionable identical bracelets like the ones that Titian placed on the wrists of his reclining Venuses to suggest that they were women of the upper classes. Nothing more is known about the rest of her life except that she was still alive in 1573 and dead by 1577, when she would have been in her early forties, and that her husband outlived her.

Although Orazio, to whom Titian gave power of attorney to pay over the final instalment of the dowry in 1558, continued to do business with Cornelio Sarcinelli, Titian seems not to have been in contact with him after that date. He must, however, have seen Lavinia on his frequent visits to the area where he owned property and where two of his nieces were also living in Serravalle. In 1551 Giovanni Alessandrini had given Cecilia, the elder of his two sisters, in marriage to Celso di San Fior of Serravalle with a dowry of 400 ducats. San Fior, a nephew of the syndic of that town and Titian's business agent there, would play an important part in his later life. For Lucia, the younger sister, Alessandrini provided a dowry of 250 ducats on her marriage in 1555 to Giuseppe Zuccato, also of Serravalle. Since Zuccato was not a particularly common surname, it is reasonable to suppose that Giuseppe may have been a relative of Titian's friends the mosaicists Francesco and Valerio Zuccato. Titian's relationship with Pomponio meanwhile was almost but not quite at breaking point after his attempts to take over management of the church livings at Sant'Andrea di Favaro and Medole.

It was a distressing time for Aretino. The early 1550s were a period when a less resilient man might have complained that Fortune had turned against him – and a wiser one questioned his own judgement. Poor Adria, a beauty like Aretino's mother Tita, was only thirteen when he found a husband for her, one Diotalivi Rota, who was sixteen years her elder and a man of property in Urbino. Rota insisted on a dowry of 1,000 ducats, which Aretino, who had been begging for contributions to her dowry since her birth, raised from some of his wealthy friends including Cosimo de' Medici, who, knowing Aretino's way with money, gave his donation directly to Rota's father. The couple were married in June 1550 and were given a grand reception by Aretino's friend Guidobaldo della Rovere, Duke of Urbino. But it was soon clear that Rota and his family were fortune hunters whose only interest in the pretty little Adria was to extract more money from her famous father. They repeatedly locked her up in her bedroom, kept her on starvation rations, appropriated the jewellery and clothing that were part of her dowry and taunted her about her il-

legitimacy. Aretino wrote that Titian, to whom he poured out the story, was reduced by it to anguish. The girl was taken under the protection of the Duchess of Urbino, but by the time Aretino managed to persuade Guidobaldo to allow her to come home permanently it was too late. Her heart was broken, and so was Aretino's when she died in 1554, largely through his own fault.

His hopes for a cardinalate, however, had not been altogether extinguished by the failure of Titian's intervention with Charles V at Augsburg. He had continued to drop hints here and there that he might or might not accept the red hat, and in January 1553 he commissioned a medal from the sculptor Alessandro Vittoria with instructions to cast 'several in bronze and silver, because people in Rome and elsewhere want them right away'. The portrait side of the medal is inscribed 'DIVUS PETRVS ARETINVS'. On the reverse, after an invention of his own, the Divus is seated on a throne wearing a capacious toga before a group of bowing princes; the inscription reads 'I PRINCIPI TRIBVTATI DAI POPOLI IL SERVO LORO TRIBVTANO' (The Princes who receive tribute from their people pay tribute to their servant). When in February Guidobaldo della Rovere was created captain general of the Church and invited him to travel with him to Rome, Aretino broke his vow never to leave Venice. 'You should know', he wrote in a letter to Guidobaldo in March begging for fifty ducats on top of his pension to pay for the necessary wardrobe,

> that the treasures of San Marco and the strength of Hercules would not have been enough to move my feet from here for even a single day, and that by persuading me to come to Rome, you have been able to accomplish something that neither Emperor nor Pope nor Duke of Florence has been able to do.

Set out he did, at the end of May, to kiss the feet of Pope Julius III, who received him with 'fraternal tenderness'. And during that sweltering Roman summer not a word was said about the cardinalate, not by Julius nor by Aretino. The Divus left Rome in August, and after

stopping off at Urbino was home in Venice later that month only to learn that the pope's brother Baldovino del Monte, to whom he had dedicated the latest collection of his letters, had decided to stop paying him a pension.

At last the Divine Aretino – Scourge of Princes, Secretary of the World, Prophet of Truth and Fifth Evangelist – had to admit defeat. The red hat he had worn in his hopes and dreams would never be his. His books were out of tune with the dictates of the Council of Trent, his rhetoric was getting stale, his critics outnumbered his admirers. But for a man who loved life as much as Aretino there were compensations. The sixth volume of his letters, which would be published posthumously, records many moments of pleasure. The delight of his old age, as he wrote from the heart to Benedetto Agnello, was little Austria,

> who continually wants me to buy her golden bands for her head, silken slippers for her feet and dresses of every colour for her back … It is nothing to marvel at, then, that every time she wants to have me put my arms around her neck, kiss her, fondle her locks, seat her upon my knee, embrace her, and yield to her whims in every matter I do yield to her … It seems to me that to do this, is to do something pious, devoted, and real …

And so he went on for a few more years: loving from his heart, rejuvenating himself with bouts of whoring, sharing his gifts of food with Titian and Sansovino and one or two pretty Aretines, unleashing the fury of his pen 'upon the unrighteous' to less and less effect.

But then, three years years after the insult to his pride in Rome, he found himself engaged in a stormy literary row with the renegade priest Anton Francesco Doni, the most talented and prolific of the other writers in Venice. Aretino had openly recognized Doni's talent since the mid-1540s, and Doni was indebted to his example. But when Doni, down on his luck, asked Aretino for a letter of recommendation to the Duke of Urbino, in whose duchy he hoped to settle, Aretino refused the favour. Doni, who was well known for his temper,

responded with an explosive denunciation of the Divine Aretino in the form of a book of letters, *Il Teremoto* (The Earthquake), which was published on 1 March 1556 with the subtitle 'The Earthquake of Doni the Florentine, with the Ruin of a Great Colossus, the Bestial Anti-Christ of our Age'. *Il Teremoto* was the most colourful and brilliant work of defamatory writing of the sixteenth century, and more than worthy of its subject, at whom Doni hurled insult after slanderous insult, some for the attention of the Dukes of Urbino and Tuscany, the doge of Venice and the emperor. Those written directly to Aretino bore poisonous dedications such as 'To that disgraceful scoundrel, source and spring of every rascally deed, Pietro Aretino, stinking organ of devilish lies'; 'To his Divine Hogheadedness, formerly Messer Pier of Arezzo, a Divine Wine-jug'; 'To Aretino, the tiltyard dummy of all worthless rascals, gilded without but wooden within'. Doni also invented completely unjustified rumours, such as that Aretino was sleeping with the wife of his friend and publisher Francesco Marcolini. In the last book he predicted that Aretino would die within the year.

And so it happened that on 21 October, a Wednesday, Aretino was dining with some friends when someone in the party cracked a joke. Roaring with laughter he leaned back in his chair, which keeled over under the weight of his enormous bulk as his face turned from livid to grey. The death certificate gave the cause of death as apoplexy, but the story went round that he had died, appropriately, of laughter. Although the death was also officially described as instantaneous, another anecdote had him live long enough to receive extreme unction and utter his last blasphemy: 'Now I am oiled keep me from the rats.' The funeral was held in the sacristy of the church of San Luca. Some said that the magnificent gold chain with vermilion tongues given him by Francis I was sold to defray the funeral expenses; others that it was broken up on his instructions and distributed to the poor. It was the kind of antithesis that Aretino would have appreciated.

Not everyone was sorry to see the last of the Divine Aretino. Three days after his death the Florentine ambassador in Venice reported to Cosimo de' Medici that 'The mortal Pietro Aretino on Wednesday at

the third hour of the night was carried off into the next world by a stroke of apoplexy without any decent man being sorry to lose him.' And one of Ferrante Gonzaga's creatures, a certain Antonio Pola, who had taken care to flatter the Scourge when he was alive, echoed the ambassador's sentiment in November in a letter to his master: 'On reaching Venice I found that that buffoon had given up his soul to Satan, whose death I think will not displease many, and particularly not those who are from henceforth relieved from paying tribute to the brute.' Aretino's tombstone in San Luca has long since disappeared, but the memorial for which he is best remembered is the *Dialogue on Painting*, which Lodovico Dolce rushed into print ten months after his death with the title *L'Aretino*. Dolce, although a prolific writer, translator and editor, had never written anything like this before. As we have seen, he had begun the work seven years earlier as a riposte to Vasari's first edition of *The Lives of the Artists*, which had excluded Titian. Now the demise of Aretino gave him an additional purpose. *L'Aretino* is a celebration of the critical powers of the writer who had loved and understood the art of painting better than any of his literary contemporaries, and to whose fictional persona Dolce gave the honour of relating the first biography of Titian.

From Titian himself not so much as a word has survived about the loss of the more than brother and dearest gossip who had helped to launch his international career, ghosted many of his best letters and ridden on his coat tails for three decades. We might have heard something about Titian's feelings from Benedetto Agnello, the Mantuan ambassador who had recorded his sadness at the loss of his first wife Cecilia in 1530. But Agnello, who had been reporting news from Venice to the Gonzagas for some twenty-five years, had predeceased Aretino to the grave by seven months, thus depriving posterity of the candid and intimate observations of another cynical, independent-minded and sharp-witted insider. Aretino, although he had been increasingly conscious of the shadow of death in his later years, had never stopped to predict what Titian's future would be like without his Divine, irreplaceable self. If he had written his own obituary would he have included, along with the inevitable eulogies of his own

greatness, a paragraph or two about what his death would mean to Titian? He knew, although he might not have confessed it, that Titian's worldwide reputation had long since outdistanced, and would soon all but obliterate, his own. He would never, however, be replaced as the alter ego of the painter who walked at one with nature.

After Aretino's death Titian, now approaching seventy, became more and more dependent on Orazio, who ran the studio, acted as his business manager and wrote some of his letters for him. For his most important official letters Titian turned to Giovanni Maria Verdizotti, a Venetian writer, draughtsman, printmaker and later man of the cloth who was thirty-one when Aretino died. Verdizotti, who came from an upper-middle-class family, had a reputation for precocious brilliance: it was said that at the age of sixteen he had translated the first book of Ovid's *Metamorphoses*. But although gifted with the classical education that Aretino had pretended to despise, he lacked the rhetorical flair and independent judgement of his predecessor. Some of the letters he wrote on Titian's behalf read as though translated from Latin into Italian; and unlike Aretino he followed instructions from Titian or Orazio about their content.

Aretino's death coincided with a shift in religious attitudes and in the power structure of Europe that left no place for a man of his particular ambitions and talents. Although he might have boasted that he had exited the world in the nick of time, he did have the misfortune to live just long enough to see the election in June 1555 as Pope Paul IV of his *bête noire* Gian Pietro Caraffa, the former Bishop of Chieti and a founder of the Theatine order. In the good old days Aretino had not hesitated to revile Caraffa, 'that parasite of penitence'. And so it proved that Paul IV became the most destructive and hated pope of the sixteenth century.

The new pope, who was seventy-nine when he ascended the papal throne, had devoted his entire life to implementing strict Church reform. As soon as he was elected he decided that the English cardinal Reginald Pole was a Lutheran and set about imprisoning other members of the moderate Spirituali. No matter was too large or

small to escape his vigilance. He suspended the Council of Trent indefinitely. Roman Jews were herded into ghettos, forced to sell their property to Christians and to wear yellow hats. He let it be known that he preferred the male members of the Sistine choir to be celibate; and it was he who employed Daniele da Volterra to paint loincloths over the exposed genitals in Michelangelo's *Last Judgement*, an act of artistic vandalism in response to which Michelangelo commented that it would be better for His Holiness to attend to the more difficult task of reforming the world since 'Reforming a painting is easily done.' Under Paul IV the creativity and search for the truth that we think of as hallmarks of the Italian Renaissance were temporarily replaced by suppression, blind orthodoxy and fear of innovation; but only for as long as he lived. Paul's death four years after his election was greeted in Rome with jubilation. Mobs rampaged through the streets toppling statues of the late unlamented pope and smashing open the cells in which prisoners of the inquisition had been incarcerated. He was succeeded by the moderate, conventionally religious Pius IV, an affable man and able bureaucrat, who immediately pardoned those who had participated in the riots and went on to revive the Council of Trent and see it through its final sitting.

The Pauline Index of Prohibited Books, the most comprehensive up to that time, was at least as irrational as all previous and subsequent attempts at totalitarian censorship. Anton Francesco Doni got off quite lightly, while the nearly 600 other banned authors included Machiavelli, Erasmus, Aretino's friend Antonio Brucioli for his translation of the Bible, and the obscene poems of Titian's friend Giovanni della Casa, the former papal legate who had compiled the first Venetian Index of Prohibited Books. The posthumous Aretino was thus in good company when his description of the Annunciation in *The Humanity of Christ* was singled out in a petition to ban the rest of his religious writings. How he would have revelled in the ironic inconsistencies of the Index. No attempt was made to suppress Jacopo Caraglio's engraving of Titian's painting of the *Annunciation* that had been sent to the empress Isabella although it had been directly

inspired by his own banned account. And while his religious works were Indexed, his pornographic and anticlerical writings were ignored. Venice resisted the Index and the Inquisition for a few more years, but religious and state censorship gradually took hold, and the age of the subversive *poligrafi* was over by the end of the decade. The Venetian presses continued to whirr, but from now on they turned out orthodox religious works.

Titian, unaffected by the repressive strictures, continued to turn his brushes simultaneously to pagan myths intended to arouse the senses and flatter erudition and to deeply pious images of the sufferings of Christ and the saints as required by the dictates of the Counter-Reformation and his own deepening faith, adapting not only his style and chromatic range but apparently his emotional engagement to what we might think of as inimical genres. He kept his *Venus with a Mirror and Two Cupids* of around 1555 (Washington, DC, National Gallery of Art) in his studio for the rest of his life, probably to serve as the prototype for commissioned versions, of which there were several. He had every reason to anticipate the popularity of this stunning tour de force, a more sophisticated and 'modern' departure from the Venuses with Mirrors that he and Giovanni Bellini had painted early in the century, and more glamorous and compositionally interesting than contemporary paintings of naked women with mirrors by Tintoretto and Veronese, which look vulgar or contrived by comparison. It refers to the *paragone* between painting and sculpture with wit, sensuality and a complex but compelling design. Venus adopts the pudica pose, covering a breast and lower abdomen with her hands as in classical statues, although he must have taken her sweet, shy, vulnerable facial expression from a living model, whose torso is modelled against a dark background. You can count the pearls that dress her golden hair, but reproductions cannot do justice to the thick, open application of paint elsewhere in the painting, notably Venus' reflection in the mirror, which anticipates the style of his later works. Titian painted her over an abandoned double portrait of a man and woman, which he turned on its side, and from which he reused the fur-lined red velvet robe trimmed with silver-gilt embroidery that

Venus clutches around her hips in such a way that the fur outlines the pudenda it is meant to conceal.[5] The two cupids are posed to emphasize her tall, upright stature: one has to stretch to place the laurel wreath on her head; the other, balancing precariously on the striped coverlet of her couch, struggles to hold up the heavy rectangular mirror at an oblique angle so that we see in her blurred reflection only part of her shoulder and face with one black eye that could be admiring herself or could be directed at the viewer.

The moving *Penitent St Jerome* (Milan, Brera), painted around the same time or a few years later, was originally an altarpiece in the now demolished Venetian parish church of Santa Maria Nuova.[6] It is one of the least seen of Titian's greatest paintings because it cannot be loaned to exhibitions by reason of its large size and its panel support.[7] St Jerome, the ascetic intellectual, retired to the Syrian desert with his books and his faithful lion to do penance for the sexual hallucinations that plagued him, with, according to his own description, 'only the scorpions and wild beasts for company'. Titian placed him on the dark and gloomy slope of a wooded hillside in the Veneto, realized with thick impastos of primary colours and brownish glazes. St Jerome, naked apart from a white loincloth and a red drape twisted around his hips, reaches intently towards a small crucifix, clutching in each hand stones with which to purify his soul by beating his breast. A lizard slinks towards Titian's signature on the rock upon which the saint kneels. Two skinny tree trunks appear to tiptoe towards him like wild beasts, their heads blocking out all but tiny patches of the azure sky that once, long ago, filled the background of Titian's youthful religious pictures. A skull, bone and hourglass on the rock behind the saint signify the transience of life, but we see from the sand, which has only just begun to flow, that there is time enough for repentance. The two books are closed while the saint focuses all his attention on the Word that was God and 'was made flesh, and dwelt among us'.[8]

Nothing was known about the circumstances of its commission until the early twenty-first century when documentary evidence was discovered[9] that the patron was a merchant from Cologne by the name of Enrico. More usually known as Rigo Helman, his name

appears as 'Elman R' in the blurred inscription on the book propped up and facing us. In 1556 Rigo Helman, wishing as a foreigner to establish his piety and the presence of himself and his large family in Venice, obtained the right to erect a family altar in the first space on the right aisle of Santa Maria Nuova, and after one of his sons, whose name was Jerome, died prematurely the decision was taken to dedicate the altar to the boy's name saint. Although a well-established member of the German merchant community for twenty years, Helman might not have been wealthy or important enough to approach the great Titian for an altarpiece, let alone one that was entirely autograph, but he had a connection that would have been persuasive. He was happily married to and had eight children by Chiara d'Anna, the much loved sister of Titian's friend and patron, the vastly wealthy Giovanni d'Anna. Helman's story nevertheless has a sad ending. In 1561 he was, probably unjustly, accused of fraud and fled the lagoon never to return.

Titian would later send versions of both these subjects to Philip,[10] but for the time being he was more concerned to continue with the *poesie* promised at Augsburg. In March 1556, eighteen months after dispatching *Venus and Adonis*, he completed a group of paintings for the king that included a *poesia* taken from Ovid's story of Perseus and Andromeda at the end of Book IV of the *Metamorphoses*, as well as a 'most devout work' (probably the *Crucifixion* now in the Madrid Escorial).[11] In May Philip instructed Vargas to send the pictures to him at Brussels and to make sure they were packed carefully so as to avoid the damage done to his *Venus and Adonis*. They were in good condition when they reached Philip in September.

Perseus, the son of Danaë and Jupiter, was flying on his winged sandals – a gift from Mercury – over the realm of Ethiopia when he noticed the maiden Andromeda chained to a jagged rockface by the god of that land as a punishment for her mother's boasts about her own surpassing beauty.

Unconscious desire was kindled within him.
Dumbly amazed and entranced by the beautiful vision before him,
He almost omitted to move his wings as he hovered in the air.
Then once he'd alighted, he said to the maiden, 'Shame on such fetters!'
…
When out of the sea there resounded
a sinister roar and, advancing across the expanse of ocean,
breasting the surge of the waves, there emerged a menacing monster.

Perseus engages in a tremendous battle with the monster. When he flies up into the sky on his sandals the monster attacks his shadow on the water. Perseus swoops down wounding the beast with his curved sword, but the monster spews a mixture of seawater and blood that drenches his sandals and weighs them down so that Perseus, not daring to attempt flight, stands on a rock for support and delivers the kill from there, plunging his weapon again and again through the monster's vitals. Andromeda's parents are of course delighted and the hero is immediately married to the beautiful woman he has rescued from certain death.

When he started work on this painting Titian found himself undecided about which episode in the battle would be most effective. In one of the versions that can be detected beneath the finished painting he followed Ovid by placing Perseus standing on the ground with his back to us on the left side of the canvas and Andromeda, with both arms raised above her head, chained to her rock on the other side. His final solution is in wretched condition, thanks to having spent twenty years hanging in Sir Richard Wallace's bathroom in the mid-nineteenth century when the attribution to Titian had been lost. Nevertheless, it remains a great painting. The overall tone is low and the chromatic range all the more exciting for that. The figures move in a fictional space – the writhing monster almost seems to turn that space inside out – that defies the laws of perspective. His final decision to have Perseus flying down from the sky in an attitude that reverses the pose of the chained Andromeda was doubtless influenced by Tintoretto's swooping figures. It didn't interest Titian that in real

space Perseus' shield would be too close to the monster's mouth or that his sword would have missed its target; nor should it interest us because neither the story nor Titian's interpretation of it is about reality.

Philip's *Crucifixion* was revealed by a cleaning in the 1970s to be a deeply moving and beautiful devotional work in which the dead Christ, high on his cross against a stormy dawn sky and receding landscape, is alone, while his murderers, their job done, ride triumphantly towards the city in the distance. If this is indeed 'the most devout work which I have had on my hands already for ten years' that he had mentioned in his letter to Philip of September 1554, he must have completed it originally for another patron, possibly Cardinal Alessandro Farnese for whom he had painted pictures of unspecified subjects in the second half of the 1540s which were never delivered.

There is no simple explanation for the care he took with a variant of Philip's *Crucifixion* (Ancona, Church of San Domenico) for a less important patron except that he had always liked to start from a given – a landscape, an architectural setting, a painting by another artist, and now increasingly as he grew older from his own previous works. The Ancona *Crucifixion* was commissioned in the same year, while Philip's version was still fresh in his mind, by a wealthy Venetian merchant, Pietro Cornovi della Vecchia, who had recently moved to Ancona. Eight years after della Vecchia's painting was installed over the high altar of the Dominican church in Ancona on 22 July 1558 Titian told Vasari, who cannot have seen the original, that he had painted it in his later style, that is, 'with patches of colour'. The technique of rendering form through colour had now become as important to him as new inventions. In the Ancona version, which is half again the size of Philip's *Crucifixion*, the hill town and landscape have been replaced by fire, which Titian imagined following the earthquake that occurred, according to St Matthew's account, and rent the veil of the temple in twain after Christ yielded up the ghost. The fire that has destroyed the old religion describes a halo around the bowed figure of Christ's Mother as its smoke rises into the dramatically striated sky – 'there was darkness over all the land' – where the wood of Christ's

cross merges with the heavens as though He were already with God. St Dominic, titular saint of the church and altar, clutches the foot of the cross while St John the Evangelist, his arms flung out in grief, gazes up at the dead Christ.

When Philip received his most recent paintings from Titian in September 1556 he was ruler of the most extensive monarchy in the world. In the course of the previous year his father had relinquished in his favour sovereignty of the Netherlands, Spain, its American possessions and most of Italy. Philip's domain did not, however, embrace the Holy Roman Empire, which Charles V had decided after all to give to his brother Ferdinand and Ferdinand's heirs (although the German electors did not accept this decision for another two years). Philip II of Spain, as he now was, had said his last goodbyes to the father he adored in August; and Charles, having abdicated all his titles, was now sailing to Spain in a small fleet of Flemish, English and Spanish ships with a reduced household in the charge of Don Luis Méndez de Quijada, who had served him for three decades, and his two sisters Mary of Hungary and Eleanor of France.

Charles had been pondering his succession since his fortieth birthday, and had decided that Spain would be his last resting place as early as 1544 when he had asked Philip to find him a retirement home in the country he had first known as an awkward and unwelcome king of sixteen and which was now closest to his heart: Spanish, he had once said, was the language one speaks to one's God. Abdication in favour of Philip had been in the forefront of his mind since as early as 1550. And in the years that followed he had struggled with increasing exhaustion, bodily ill health, mental depression, disillusionment and an overwhelming recognition that his imperial programme had failed. He had hoped for peace, but his reign had been marked by continual wars. In Italy he was once again at war with a pope and a French king who was also threatening the Netherlands. His authority in Germany had collapsed after the Battle of Metz in 1553. His plans for a dynastic alliance with England and the Netherlands against France had been dashed when Mary Tudor proved to be barren.

But the timing of his final decision to abdicate was precipitated more than any other factor by a peace treaty between the German Lutherans and Catholics negotiated by Ferdinand and signed at Augsburg by Charles, only at his brother's behest, on 25 September 1555. The Peace of Augsburg allowed local rulers in Germany to determine the religion of their subjects with the formula *cuius regio, eius religio* (whose realm, his religion). It was an historic turning point, which brought religious peace to Germany for the next sixty years. But the recognition of Lutheranism as an independent power in the Holy Roman Empire, one that could not be suppressed either by compromise or by force of arms, brought an end to Charles's vision of himself as the secular ruler of a universal Christendom: Titian's portrait of him as a Christian soldier fighting triumphantly for that goal after the Battle of Mühlberg was not among the paintings that he brought with him to contemplate in his retirement.

A month after the signing of the Peace of Augsburg, Charles renounced sovereignty of the Order of the Golden Fleece. In a ceremony in the great hall of the castle of Brussels, where his coming of age had been declared forty years earlier, he delivered a speech summarizing his life at the end of which, white with exhaustion, he asked Philip to kneel before him and announced his desire to cede his own lands to his son, and the empire to his brother Ferdinand. The hall was silent except for the sound of suppressed sobs. The English envoy observed that there was 'not one man in the whole assemblie that poured not oute abundantly teares'. Philip, after a few words in halting French, asked Antoine Perrenot de Granvelle to deliver his address. Mary of Hungary indicated that she would resign as governor of the Netherlands and follow her brother to Spain. At the end of the ceremony Charles formally invested his son as sovereign of the Netherlands.

The remaining acts of abdication took place on 16 January 1556, when Charles transferred to Philip sovereignty of Castile, Aragon, Sicily and the Indies, and 5 February when he gave Philip the province of Franche-Comté. He had hoped to see Ferdinand once again before his departure, but when this proved impossible he sent him a letter on

12 September, just before embarking for Spain, in which he gave him the imperial crown. The decision to split the empire – one about which he had misgivings, which he would later regret and which greatly disappointed Philip although he had the good sense not to contest it – was to have long-lasting consequences. The Spanish Habsburgs, Charles's direct descendants, would rule Spain, the Netherlands, Milan, the Kingdom of Naples and the New World until 1700. They were to be outlasted by the Austrian branch descended from Ferdinand which continued to rule the old imperial heartlands of Germany, Austria, most of modern Czechoslovakia and part of Hungary until 1918. At the time the abdication and division of the empire with Ferdinand was, of all the actions Charles had taken in his life, the one that most impressed his contemporaries as the humble and self-sacrificing behaviour of a true Christian ruler.

Philip had located a suitable site for his father's retirement at Yuste, in the foothills of the Sierra de Gredos in the Estramadura, where a comfortable villa adjoining a monastery dedicated to St Jerome was still under construction when Charles arrived in Spain. When he settled there in February 1557 he took with him the *Ecce Homo* Titian had brought with him on his first visit to Augsburg; and he had Titian's posthumous portrait of Isabella hung in his bedroom, while the *Adoration of the Trinity* was placed over the high altar of the church. He spent his days praying, reading, sitting in the sun overlooking the beautiful valley of the Vera, devouring enormous meals in defiance of his doctors' orders. At first he refused to see visitors apart from his sisters. Gradually he got back in touch with events in the world, although he rebuffed Philip's request to come to his aid as he faced his first battle with the French since his father's abdication.

The Duke of Alba, acting on Philip's instructions, had invaded the papal territories and forced a peace settlement on Paul IV and Henry II. Charles had objected on the grounds that this would have the effect of strengthening the papal alliance with the French. And so it happened in January 1557 that the French broke a truce by attacking Italy and the Netherlands. Philip, acting from Brussels as commander in chief, took charge of co-ordinating troops – about half were

German, some were Netherlanders, with only a small contingent of Spanish and, at the last minute, of English soldiers – and masterminding strategy. A brilliant tactician but a reluctant warrior, the king put his young cousin Emanuele Filiberto, Duke of Savoy and regent of the Netherlands since Mary's retirement, in active command of his forces. But it was Philip who took the decision to attack Saint-Quentin, in Picardy on the direct route from Brussels to Paris, where the French had taken a stand. The battle waged there on 10 August 1558, the feast day of St Lawrence, ended in a decisive victory for the Duke of Savoy, who lost only 500 or so men while the French dead were reckoned at more than 5,000 and thousands more were taken as prisoners. Charles, although delighted by news of the victory, did register his disappointment that Savoy had not pressed on to Paris and that Philip had failed to command his troops in person.

Nevertheless, although the victory was not complete and the French retaliated by seizing Calais, the last of England's possessions in France, the Battle of Saint-Quentin can be seen in retrospect as the most significant battle of the sixteenth century. It marked the end of Paul IV's aggressive foreign policy and the beginning of the end of French expansionist ambitions – less, however, on account of the battle itself than because both sides of the Habsburg–Valois struggle were exhausted and bankrupt. In the previous year Philip had been forced by the massive debts inherited from his father to issue a decree of bankruptcy. He suspended payments from his treasury in Castile, and embarked on negotiations with his creditors, above all with the Fugger bank, about rescheduling repayments. Charles had warned him as early as 1543 that when he succeeded him in Spain 'your treasury will be in such a state that it will give you a lot of trouble'. But neither Philip nor the imperial bankers knew just how deeply in debt the emperor was: the full extent of the problem had been kept secret even from his Financial Council. Throughout his reign Charles had almost never succeeded in balancing income against expenditure; and as time went on his debts were compounded by rising interest rates. Proceeds from American bullion were fully mortgaged; and when it began to arrive in increasing amounts its value was eroded by the

inflation it caused, while private importers who failed to register imported specie reduced the king's official share of one-fifth. In March 1557 when it was discovered that 90 per cent of a shipment unloaded at Seville had been smuggled with the connivance of bribed officials, Charles wrote from Yuste that had he still been ruler he would have seized the corrupt officials and tortured them until they disgorged.

In May 1558 the imperial title was formally transferred to Ferdinand, and from then on Charles signed his letters simply 'Carlos'. In August he contracted a heavy cold and fever, which his doctors attributed to overindulgence in venison and anchovies. It was complicated by an attack of gout that tortured every bone and muscle in his body. He took to his bed and began to prepare for death, still haunted by the spectre of Lutheranism, the iceberg on which his empire had finally foundered. When he heard that Lutheran cells had been uncovered in Seville and Valladolid he advised Philip and Juana in the strongest terms of which he was capable to take action against them. The future Don John of Austria, born eleven years earlier from his affair with Barbara Blomberg at Ratisbon, was not yet openly recognized as Charles's son, but was living close by in the care of the master of the household, Don Luis Méndez de Quijada and his childless wife Magdalena. It was one of Charles's last pleasures to watch his fair-haired little boy scurrying about as a page. He wrote a codicil in his will ensuring the boy's future and leaving a legacy to his mother.

Bartolomé Caranza, Archbishop of Toledo,[12] arrived in time to hear his last confession and deliver extreme unction, and to place in Charles's hand the little crucifix that had comforted Isabella at the moment of her death. A witness[13] described one of his last days at Yuste:

> The very day that this happened between the emperor and his confessor – I don't know what drove him or what he felt – he went out and summoned his treasurer, and when he came, told him to bring the portrait of the empress, his wife, and spent some time looking at it. He then asked for the painting of the Last Judgement. Here the space was

larger and the meditation longer, so long that Mathisio, the doctor, came to advise him to suspend the powers of the soul, which govern the operations of the body. Trembling, he turned to the doctor and said: I don't feel well; this was the last day of August at four o'clock in the afternoon …

Charles V died, his eyes fixed on Titian's painting of the *Adoration of the Trinity*, his Last Judgement as he saw it, on 21 September, four months short of his fifty-ninth birthday. 'Thus', wrote Luis Méndez de Quijada, 'ended the greatest gentleman there ever was.'

The Diana Poems

No crime was committed. Why punish a man
for a pure mistake? …

OVID, *METAMORPHOSES*, BOOK II

The news of his father's death reached Philip on 1 November 1558 at Arras, where he was engaged in peace talks with the French. Eighteen days later, on his way to Brussels to arrange the funeral ceremonies, he heard that his wife Mary Tudor had died during a flu epidemic in England. Before the month was over she was followed to the grave by his aunt Mary of Hungary. Philip retired to mourn in the monastery of Grunendal, and from there, on Christmas Day, he dictated a letter addressed to the Duke of Sessa, whom he had appointed as his governor and commander-in-chief in Milan, instructing him to pay Titian the arrears of the pensions assigned to him in 1541 and 1548 by Charles V. The letter was written out by Philip's chief secretary Gonzalo Pérez, who had served Charles V in that office and was a patron of Titian in his own right.[1] Philip appended a note in his own hand.

> You already know the joy I shall experience in having this matter taken care of, because it concerns Titian, and I therefore urgently charge you with the task of having him paid immediately, in a way that there will be no further need for turning to me again or for having me issue the order yet again.[2]

In the new year the Duke of Sessa invited Titian to come to Milan to collect the accrued value of the pensions,[3] which amounted by this time to the very substantial sum of 2,200 scudi.[4] Titian, who was feeling slightly unwell and wanted to conserve his energies for the paintings he was preparing for the new King of Spain, sent Orazio to Milan as his representative. Orazio took rooms in the Falcon Inn and wrote to his father on 19 March 1559, Palm Sunday, that all was going well: he hoped the funds would be handed over after Easter. He planned to go on to Genoa, if he could obtain a letter of recommendation from the Duke of Sessa to His Majesty's ambassador there, to collect 2,000 scudi of the Spanish pension Philip had promised Titian at Augsburg. Unfortunately, Orazio's visit to Genoa proved fruitless because the treasurer did not have the means to pay that amount. The 2,000 scudi owing from the treasury of Milan was, however, paid in cash to Orazio in April and was followed by a further payment of 200 in May.

Orazio did not return immediately to Venice. He had business of his own in Milan, where he sold forty paintings to the Duke of Sessa, who also sat to him for a full-length portrait (all of these are apparently lost). So Leone Leoni, medallist and court sculptor to the Habsburgs and master of the mint in Milan, invited him to be his guest and sent an escort of riders to accompany him to the palace where he lived in considerable style. Leoni was a wilfully violent man who had had a turbulent youth, but by the time Orazio arrived as his guest in Milan he was fifty and well established as an artist. He had good reason to be grateful to Titian, of whom he had made a medal portrait and with whom he was on friendly terms. The two artists had renewed their friendship over a pleasant dinner together with Granvelle at Augsburg, and Titian had played a part in promoting Leoni's interests with the Habsburgs.

Orazio stayed on in Milan to supervise the framing of his canvases for the Duke of Sessa, and wrote to his father, evidently in great haste, that he had obtained four ducats from the Duke and was about to depart again for Genoa to try to arrange payment of the 2,000 scudi promised by Philip at Augsburg.[5] Titian, aware that the full amount owing from Milan had been paid, replied on 17 June:

571

Orazio, your delay in writing to me has worried me. You write that you have had 4 ducats:[6] so it is in your letter. That wouldn't cover the cost of sending a letter to Milan; or perhaps in your joy you made an error with your pen, with which you wanted to say two thousand, but said four ducats instead. It's enough that you think things will go well.

I have written to His Majesty that the treasurer of Genoa has no means to pay me. I hope that His Majesty will make that provision. From what you write it is your intention to go to Genoa. If you think that will bear fruit you will do well with the favour of His Excellency. It might however be better if you consider yourself rather than me. Now if you do go take care that you don't ride in the heat; if you could go in two days, go in four.[7]

By then Orazio, planning to prolong his stay Milan while he supervised the framing of his canvases for the Duke of Sessa, had decided that he had overstayed his welcome at the Palazzo Leoni and returned to his lodgings at the Falcon. He may in fact have experienced the violent temper that his host, despite his age and success, had not learned to control. He was nevertheless unprepared for what happened when, on 14 June, he went to collect his belongings with a servant to help carry his paintings and even later was not sure of Leoni's motive in what was nothing less than an attempt to assassinate him. While he was packing, a cloak was thrown over his head and Leoni and his servants attacked him again and again with daggers and swords. Orazio fell senseless to the floor and would have perished had it not been for his servant who unsheathed his sword while shouting as loudly as he could. The servant received three wounds before neighbours heard the commotion and helped the two victims to escape on to the street. Orazio was carried to the Falcon where the Duke of Sessa's barber was summoned to attend to his wounds. The assault, so Orazio told the magistrate the next day, had been motivated by Leoni's jealousy of the favour shown him by the present duke.[8] In subsequent submissions he insisted that Leoni had wanted to rob him of the 2,200 scudi that he knew to be in his possession.

Titian was unaware of the attack when on 19 June he wrote to 'The Most Potent Catholic King' that he had finished and would be sending two more *poesie*, 'the one of Diana at the fountain surprised by Actaeon [*Diana and Actaeon*] and the other of Callisto pregnant by Jove and stripped at the fountain at the command of Diana by her nymphs [*Diana and Callisto*]'. He added that he had made a start on 'Christ in the Orchard' (the *Agony in the Garden*) and on two more *poesie*, 'one of Europa on top of the bull [the *Rape of Europa*] and the other of Actaeon torn to pieces by his hounds [the *Death of Actaeon*]'.[9] The letter concludes with one of his appeals for payment of the pensions due from Philip's agents at Genoa.

Philip replied from Ghent on 13 July, addressing Titian as 'our most beloved', that the paintings should be handed over to García Hernández, his representative in Venice – Philip had sent Vargas to Rome as Spanish ambassador to the Holy See – who would dispatch them to Genoa for embarkation to Spain. He was very particular about the arrangements because Titian's Entombment of Christ had been lost two years previously on the way from Venice to Flanders. Titian must pack the new paintings with his own hands to avoid damage. Philip would also be pleased if Titian would make haste to complete the *Agony in the Garden* as well as the two mythological paintings, and would be delighted if he would execute another Christ dead in the Sepulchre (the *Entombment of Christ*, Madrid, Prado) to replace the one that had been lost. He added that he was displeased that his order to pay the outstanding amount had not been obeyed and would write again to ensure that this time there would be no oversight.

It was several weeks before Orazio wrote to his father about the attack, and when Titian heard about it he was distraught. On 12 July he wrote a very long letter to Philip (which crossed with Philip's to him about the paintings) relating the attempted assassination in detail, and describing Leoni, for whom he, Titian, had done so many favours, as moved by the devil, an enemy of God, a well-known criminal, knave and scoundrel whose son (Pomponio Leoni, who was employed by the court in Spain) had been exiled from Spain as a

Lutheran. The letter, although probably polished by Verdizotti – who may have added touches, suitable for a pious king at the height of the Counter-Reformation, about Lutheranism and the devil – has the straightforward, no-nonsense ring of Titian's own style. It begins, as was Titian's wont when his emotions were involved, by condemning Leone's wickedness without preliminaries, and concludes with a plea that Philip should see that justice is done to that 'most villainous man in the world' and with a profession of love for Orazio:

> If Orazio had been killed I swear to you with all my faith that from the pain of it I, who have placed all my life and my hope in his wellbeing in this my impotent old age, would have been deprived of spirit and consequently of the ability to serve my most potent Catholic King, in whose service I consider myself to be happy and most fortunate.

Without Orazio by his side to manage his business affairs and his studio, the septuagenarian Titian knew he might not have found the strength to continue to supervise the workshop and produce masterpieces for Philip that required his undisturbed concentration. The troublesome young spendthrift, now a married middle-aged man, had grown into a very different character from his weak if ingratiating brother Pomponio. He shared his father's entrepreneurial flair and knew how to drive a hard bargain; and as more of his autonomous paintings are discovered the posthumous view of him as a lazy, indifferent painter has had to be revised. If he was untouched by Titian's genius, he was admired in his lifetime as an adept portraitist, although only one portrait that bears his signature has come to light.[10] Signed 'HORATIVS TITIANI FILIVS/FACIEBAT' it is an accomplished *Portrait of a Man* of about 1560–5, which is typical of his father's manner: the lively face challenging the spectator, the body in three-quarter length slightly rotated and at ease.

Of Orazio himself we have one certain image, in a wax medallion framed in seed pearls that portrays Titian holding a small portrait of a bearded man who is identified by an inscription as his son.[11] The central head in the *Allegory of Prudence*,[12] which seems to have

been originally envisaged as an independent portrait that was only later incorporated into the *Allegory*, is also usually taken to be a portrait of Orazio, although the nose, hairline and colour of the beard do not quite match those of the medallion portrait. But if it is Orazio, who is portrayed in the *Allegory* with his eyes brimming with tears, it is tempting to speculate that Titian portrayed him after the assassination attempt, perhaps with the idea of sending the portrait to Philip.

Orazio continued to live in fear of his life for several years, but his repeated requests to the Council of Ten for a permit to carry arms or to be given an armed bodyguard were turned down. Titian, tenacious as ever, continued to plead with Philip that the scoundrel Leoni should be brought to justice, repeating in subsequent letters that Orazio's death would have been followed by his own, reminding the king of Leoni's past crimes and insisting that there were dozens of other Italian sculptors who could have served the emperor just as well. But Philip, probably for lack of time and perhaps out of respect for his late father's patronage of Leoni, was unmoved by the appeals; and the villain remained Caesarean sculptor and master of the mint in Milan until shortly before his death in 1590.

Titian was still polishing and adding to the two Diana pictures and the *Entombment* on 3 August 1559 when Hernández informed Philip that they would be ready in twenty days 'because they are large and involve much work, and he wants to do some little things to them which no one else would think necessary'. The 'little things' were not completed to the master's satisfaction until 22 September, when, with Verdizotti's help, Titian wrote to Philip apologizing for the delay: 'I send Your Majesty the pictures of Adonis, Callisto and Our Saviour in the sepulchre in place of the one that was lost on the way and I rejoice that this second [*Entombment*], besides being larger, has succeeded better than the first and is more worthy of acceptance by Your Majesty.' He goes on to say that he considers himself so flattered to serve the king that he does not envy 'the famous Apelles, who was so dear to Alexander the Great ... because the authority of your kindly judge-

ment … makes me equal to Apelles, and perhaps his superior in the opinion of men'.

> And so, in order to show my gratitude in every way I can think of, I send, besides the other pictures, the portrait of her who is absolute patroness of my soul, and that is her who is dressed in yellow, who, though in truth only painted, is the dearest and most precious thing I could send away … and so enough as to paintings.

The letter now turned to the attempt on his son's life:

> I wrote some days ago to Your Majesty in reference to the assassination of my son Orazio, at Milan, by Leone Aretino, and of the mortal wounds which he received, praying for the deserved punishment of the offender after the custom of Your Majesty's justice. Process was issued in due form against him, and great effort was made after his recovery by my son to hasten the trial, and for this he was forced to spend much of the money obtained by Your Majesty's bounty at Milan, but the wretch is so clever and so favoured on account of the name which he bears of Sculptor to Your Majesty, and my son is so much a stranger at Milan, that the case has been subjected to delays, and will probably end in smoke, to the great detriment of justice, and the more so because my son has come home, and there is no one at Milan who can counteract the cunning ways of this wicked man. I therefore most humbly pray that Your Majesty will deign to give orders to the senate to hasten the judgement and exercise justice in a manner suitable to so great an offence, showing that Your Majesty holds me to be one of your servants. My son Orazio above named (I had almost forgotten) sends with mine a small picture of Christ on the Cross, painted by himself. Will Your Majesty deign to accept it as a small testimony of his great desire to imitate his father in serving you? And with all the inclination of the heart, I and he recommend ourselves, and I kiss your Royal and Catholic hand.

Although Titian had frequently been dubbed the Apelles of his age, this seems to have been the first time he had made the comparison himself. He may have been referring to a painting by Apelles of Diana and her Nymphs, one of only two large compositions by the artist mentioned by the ancient sources, which 'in the opinion of men' he had outdone with his own Diana paintings for Philip. Orazio's small *Crucifixion with Angels* (Madrid, Escorial) is indeed very small, and not in good condition. It is, however, more expertly painted than his other surviving religious pictures, and we can guess that Titian in his desire to promote his son with the king may have had a hand in it. The portrait of the girl in yellow 'the absolute patroness of his soul' and 'the dearest and most precious thing he could send away', must have been of his natural daughter Emilia, who would have been in her early teens at the time.[13] That portrait is known only from a copy by Rubens. But two years later Titian sent another very similar *Portrait of Emilia with a Fan* (Dresden, Gemäldegalerie) to Alfonso II d'Este with a letter saying that the girl was 'his most beloved object' and that he could not send Alfonso 'anything dearer'.[14] The pretty and vivacious young Emilia, illegitimate though she was, was evidently a delight of Titian in his old age. There is no clue to her mother's identity: she may have been a housekeeper acting also as a resident model like Titian's first wife Cecilia. Whoever she was, Titian had kept her a secret, even from Aretino. Emilia lived with Titian in Biri Grande until her marriage in 1568; and when she was perhaps twenty she posed for two paintings of dancing girls, one bare armed as Salome in a brick-red dress holding up the head of John the Baptist on a silver salver (Madrid, Prado), and again in the same dress but with her arms covered and the grisly head replaced by an arrangement of fruit (Berlin, Staatliche Museen). Her pose and features were to be templates for a number of workshop paintings of girls holding up different objects.

The *Entombment of Christ,* now in the Prado, which Titian sent to Philip with the two Diana pictures, was his third treatment of the subject after his early Giorgionesque *Entombment* in the Louvre and the version for Philip that had gone astray in 1557. It is the best

preserved of his religious pictures for the king (despite having been stolen from the Escorial by Napoleon's army) and perhaps the most moving in its expression of human grief. Titian's signature, 'TITIANVS VECELLIVS OPVS AEQVES CAES.' (The work of Titian Vecellio Knight of Caesar), is incised on a stone slab propped against the corner of Christ's tomb, which Joseph of Arimathea, according to the Gospels, had prepared for himself, and on which Titian painted fictive relief carvings of Cain and Abel and the Sacrifice of Isaac, the Old Testament story that prefigures God's sacrifice of His Son. The clean white sheet that will serve as Christ's shroud is draped over the near side of the sarcophagus. The arrangement of the figures follows Aretino's description of the event in *The Humanity of Christ*, as does the position of the Virgin's hands holding the inert arm of her dead Son, which is not mentioned in the Gospel accounts. The aged Nicodemus bears the head of His body and Joseph His feet as they lower the slack figure of the Saviour into the tomb.[15] Some may see Titian's features in the toothless, grey-bearded face of Nicodemus, the Pharisee who sought Christ's teaching by night and to whom Christ compared the spirit of God to the wind that 'bloweth where it listeth, and thou hearest the sound thereof, but canst not tell whence it cometh, and whither it goeth'.[16] Joseph has his shoulders and head turned away from us in counterpoint to the body of Christ. The light falls on his belted red tunic, the only bright colour in the painting apart from the undiluted ultramarine of the Virgin's cloak, and focuses on the bald spot on the back of his head as though to emphasize his vulnerable humanity. Titian's pentimenti are most numerous beneath the beautiful, ethereal figure of Mary Magdalen, whose outflung arm seems to echo through the scene like a cry while her virginal white gown floats into the leaden grey of the wind-blown clouds.

The Diana poems that accompanied the *Entombment* to Spain are quite unlike any treatments of the stories before or since, and their play of colours comes as a surprise after Titian's preference over the previous decades for more sombre earth tones. The explanation for their raised tonality could be his admiration for the younger

arch-colourist Paolo Veronese. In 1556, when Titian was planning the pictures, Veronese had completed his luminous paintings in the church of San Sebastiano in Venice. In the same year Titian and Sansovino chose him as one of seven painters to take part in a competition by decorating the compartmented ceiling of Sansovino's library of St Mark. Since the other six painters were relatively undistinguished, and Tintoretto was excluded, it was a foregone conclusion that Veronese would win the prize for the best, a gold chain, for his *Allegory of Music*.

But if Veronese was the inspiration for Titian's brighter tonality his chromatic range is in no way comparable to the younger master's sharp, vivid, arbitrarily decorative colour schemes. Titian blended and wove together crimson, scarlet, rose; ochres, golds and browns; blue greens and green blues; and all the varied tints of youthful flesh as though revealed by light. It is as though the curtains in a darkened room had been thrown open on a sunny afternoon, so that the King of Spain, whose enlightened patronage had emboldened the old painter to take new risks, could see what no mere mortal was permitted to see: the naked bodies of the virgin goddess Diana and her attendant nymphs transported from Ovid's Gargáphië to a glade in the Veneto. There are many artists working today who would agree with Lucian Freud that the Diana poems are 'quite simply the most beautiful pictures in the world'.[17]

The tale of Diana and Actaeon, as recounted by Ovid in Book III of the *Metamorphoses*, was put into a nutshell by Boccaccio:

Actaeon was a hunter. One day, tired from the chase, he had gone up into the valley of Gargafia, probably to quench his thirst, for there was a fresh and clear spring in the valley, and it happened that he beheld Diana in the spring, who was naked and washing herself. Diana, discovering this, took it ill, and she took some water in her hands and splashed it in Actaeon's face, saying: 'Go, and say what you have seen, if you can.' And Actaeon was immediately changed into a stag, and when his hounds saw him he was killed immediately and gashed with their teeth and eaten up.[18]

The fable was so popular that it was frequently illustrated by artists and referred to by writers as a trope for the magnificent injustice that might lie in wait for their own unwitting protagonists. It is Titian's version, however, that most people today associate with the story. What is striking at first sight of the painting is the tension he created between Actaeon, the hapless young hunter, and the outraged moon goddess, sister of the sun god Apollo, whose virginity has been compromised by his seeing her naked body. Actaeon's penetration of the goddess's private space is trumpeted by her red robe, which Titian flung as an afterthought against the azure sky over a line at the entrance to the grotto. She rears back, snatching up a cloth to conceal, not her sex as a mortal woman might react, but the crescent moon of divinity in her hair. 'She stood with her front turned sideways and looked at the rash intruder over her shoulder': so much taller than her attendants, as Ovid told it, that the tallest barely reached to her navel and could not have concealed her neck and shoulders. Titian took immense trouble with the figure of Diana, first painting her realistic-ally from the side, and only at the end deciding on the anatomically impossible pose – a deliberate solecism that was unprecedented in European painting – that shows the breast in profile as well as nearly the whole of the back. Her averted head, too small for her body, gives a snake-like venom to her pose. The silence is deepened by the yapping of the lapdog at her feet.

Between the two protagonists Diana's nymphs, also naked as they warm themselves in the sun after their bath, lounge, stand, crouch or bend around a stone basin that sags under the weight of its antiquity into the stream. Titian created a deep space by showing the scene at a slight diagonal, which is counterbalanced by the stream that flows diagonally in the other direction through the picture, with each of the eight figures occupying a separate plane. Colours, textures and shapes, of flesh, fabric, sky, trees, water and stone, are magicked by Titian's chromatic alchemy into what seems from a distance like an enchanted three-dimensional reality. Everywhere you look in this glorious painting you see his colours dancing to subtle patterns that are never arbitrary. The purple plush on which Diana sits answers

her rose-red robe. The ochre of Actaeon's tunic and the orange of his boot cuffs modulate into the stripes of the dress that slips from the shoulders of Diana's African slave, whose ebony skin highlights the pearly white of the goddess's flesh while her right arm merges with the lighter brown bark of one of those trees painted by Titian that seems to sum up the beauty and strangeness of all trees. The skull of a stag's head on the rusticated stone pillar foretells the tragic fate that awaits Actaeon.

The stream runs on to another part of the glade where Titian set the poem of *Diana and Callisto*. Ovid had made no connection between the two fables: 'Diana and Callisto' comes in Book II of the *Metamorphoses*, 'Diana and Actaeon' in Book III. Titian was the first, but not the last, artist to put them together. Callisto was, like Actaeon, an innocent victim of pure chance; like him she had committed no crime. Jove, spotting her at rest in a glade, had assumed the form of Diana in order to win her trust before raping and impregnating her. Eight months later Diana and her companions stopped to bathe in a stream. When Callisto refused to undress the other nymphs stripped off her tunic revealing her swollen belly, and the outraged Diana banished her for ever from her presence. When Callisto gave birth to Jove's son, Arcas, Juno, incensed with jealousy, destroyed the girl's beauty by turning her into a bear. But Jove took pity on his mistress and son. He transported them through space and gave them places in the heavens as the neighbouring constellations of Ursa Major and Ursa Minor, the big and little bear.

Titian stops the narrative at the moment when Diana, seeing that Callisto's virginity has been defiled, cries, '"Be gone! This sacred spring must not be polluted!"/And so her favourite was sternly commanded to leave her presence.' On the banded stone pillar, inset with fictive carvings that foretell the transformation of Actaeon into a stag, a putto empties the water from an urn in an act of purification. It is the end of the day's hunting, and the setting sun has turned the clouds to amber. A bow and quiver lie discarded on the ground; one of the dogs rests by the stream. But a spaniel prowls among the girls clustered round Diana still bearing their weapons ready to defend her

against intruders. Since no man is present, Diana's naked body is seen from the front, in counterpoise to the Michelangelesque girl seated on the ground next to her with her back to us. The goddess of chastity points at the exposed belly of Callisto with one extended arm, curling the other around the shoulders of a woman richly dressed in pink, her hair adorned with pearls.

The two paintings are framed, as though by curtains, by the red robe that Titian added at the last minute to *Diana and Actaeon* and by the gold cloth he flung into the branches of the tree in the far corner of *Diana and Callisto*. If Titian made a start on the *Death of Actaeon*, the painting of 'Actaeon torn to pieces by his hounds' that he had promised Philip, he put it aside for the time being. Towards the end of his life he returned to it, but he left it unfinished and never sent it to Spain. Everyone knew how the story ended, and at the time he painted the Diana poems he was perhaps not in the mood for the sombre tonality that would have been appropriate.

In October, soon after this latest batch of pictures had been sent to Spain, García Hernández, who had spent a good deal of time at Biri Grande urging Titian on and discussing arrangements for packing and dispatch about which Philip was so very particular, wrote to the king about 'a large picture with the three Magi' that he had seen in the studio. The *Adoration of the Magi* (Madrid, Escorial), a subject more in Jacopo Bassano's repertoire than in Titian's, had been commissioned three years previously by Cardinal Ippolito d'Este as a gift for the French king Henry II, whose emblematic lilies and the falcon of his mistress Diane de Poitiers are on the saddle and bridle of the white horse in the foreground. The painting is ruined by fire and inept restoration, but one can just make out how beautiful it was when Hernández persuaded Titian to present it instead to Philip. Since Henry had died at the end of June, the cardinal was no longer in urgent need of it, and he had to wait five years before Titian sent him a copy (Milan, Pinacoteca Ambrosiana) in the autumn of 1564 in a gilded frame decorated with lilies and falcons. Those symbols, which would have conferred importance by association on any owner, were

retained not only in Philip's painting but also in the several later copies made in Titian's studio or by local painters in Spain.

But it was Philip's reaction to the Diana pictures that most concerned Titian. With these innovative tone poems Titian had gambled on the king's ever more sophisticated appreciation of his way of painting. But when months passed without so much as an acknowledgement from Spain he became increasingly apprehensive about the king's reaction. He waited for a letter or even a word from someone close to Philip until 24 March 1560 when, no longer able contain his impatience, he wrote to the king that it was 'many days' since he had sent His Majesty the pictures he had ordered. 'And not having heard anything at all, I am inclined to wonder either whether Your Majesty has received them, or whether they have not pleased you, in which case I would exert myself to redo them in such a way that would satisfy Your Majesty.' The rest of the letter is about Leoni's attempt on Orazio's life and the need to bring him to justice.

A month later, on 22 April, he wrote again, this time in more direct language.

> It is seven months ago today that I sent Your Majesty the Pictures that were ordered by you and not having had any advice about their reception I would be singularly grateful to hear if they have pleased, and if they have not pleased the perfect judgement of Your Majesty I will labour to remake them again, to correct past errors and when they have pleased I will be able to put more heart into finishing the fable of Jove with Europa [the *Rape of Europa*] and the story of Christ in the Orchard [the *Agony in the Garden*], in order to make something that will not prove entirely unworthy of such a great King.

He goes on to inform the king that the warrants issued for the payment of his recompense in Genoa have had no effect:

> from which it seems that he who knows how to vanquish the most powerful and haughty enemies with his most indomitable valour [a reference to Philip's victory at Saint-Quentin] is not obeyed by his

ministers in such a way that I do not see how I can hope ever to obtain those moneys kindly assigned to me. Nevertheless I humbly beseech Your Royal Majesty to overcome their obstinate insolence …

Finally, prompted, Titian says, by his devotion, he underlines his close relationship with Philip's father the emperor by suggesting that His Majesty might consider ordering:

that the glorious and immortal victories of Caesar should be painted as a memorial to posterity, and of these I should be the first to paint one, as a sign of gratitude for the many benefits I have received from their Caesarean and Catholic Majesties. So I should esteem it a favour of Your Majesty if you would deign to let me know the light and shape of the rooms where these pictures are to hang.

He received no reply to this letter. Philip never took up his offer to paint the victories of Charles V; and another year passed before he heard, even then at second hand, that the Diana poems and the *Entombment* had pleased the king.

While he was painting these latest masterpieces for Philip, Titian had a young muse in his studio. Irene di Spilimbergo, a gifted poet and musician, admired also for her embroidery, was not yet twenty when Titian took her on as a pupil. She was the daughter of Giulia da Ponte and the granddaughter of Paolo da Ponte, both close friends since his early years in Venice: according to Vasari, Titian had portrayed both of them and Giulia had stood as godmother to one of his sons. After Giulia had married Irene's father, Adriano di Spilimbergo, a member of a distinguished Friulian family, Titian must have called on them from time to time in their castle, which is not far from Pieve di Cadore. Adriano died when Irene was still in her teens, and she and her sister Emilia were taken to Venice to be educated by their grandfather Paolo. It was Paolo who persuaded Titian, usually a reluctant teacher, to introduce her to the art of painting after she had been inspired by the self-portrait of the Cremonese painter Sofonisba Anguissola (Milan, Brera), a woman of high birth like herself. It was

said that Irene learned by copying Titian's paintings, and with such success that those who saw her works were amazed and envious. Daniele Barbaro and the powerful patrician and author Nicolò Zen, both of whom sat to Titian, are among those recorded as admiring her work. Had she lived a little longer and left paintings for posterity to judge she might be hailed today as one of the very few talented women of her times, and for centuries more to come, who were permitted let alone encouraged to take up the messy business of painting in oils.

Irene was only twenty when she died in December 1559. In the previous year Gian Paolo Pace had sketched a portrait of her, which Paolo da Ponte judged to be a very inferior piece of work. So, soon after her death, he persuaded Titian to finish the portrait, which he said that Titian, working from memory, did so much better than he could have desired that it was as though she was actually present, and for which he charged only six ducats. It seems that da Ponte was blinded by Titian's generosity and reputation, because the *Portrait of Irene di Spilimbergo* and its pendant portrait of her sister Emilia (both Washington, DC, National Gallery of Art), look as though they were largely entrusted to the workshop. The compositions, sharply divided by a dark pillar in one case and by a curtain in the other, with a landscape background behind Irene and a seascape behind Emilia, are typical of Titian; but the doll-like features and flaccid gestures of the girls cannot have been painted by Titian even on a bad day.

It is not altogether surprising that Titian did not actually take the trouble to make a convincing record of Irene's appearance. Portraiture had interested him less and less since the early 1550s when he had turned his attention to the more challenging work for Philip of Spain. His posthumous votive *Portrait of Doge Antonio Grimani* (Venice, Doge's Palace, Sala delle Quattro Porte) – Grimani had died thirty-two years earlier – was ordered by the Council of Ten in 1555 for a payment of 171 ducats. It was his last portrait of a doge and the only one to survive a fire in 1574, possibly because it was still unfinished in Titian's studio at the time.[19] It was a relief when, in the year he was supposed to begin the Grimani portrait, the obligation to provide

portraits of doges was transferred to Tintoretto. Titian was also, on the whole, content to leave privately commissioned portraits to the studio or younger artists. When he made exceptions, however, we can guess that he charged a good deal more than the six ducats he had been paid by Paolo da Ponte. And some of his late portraits are of the highest quality. In the *Portrait of Fabrizio Salvaresio* (Vienna, Kunsthistorisches Museum) the sitter is identified by the cartouche on the wall behind him as aged fifty when Titian portrayed him in 1558. The Salvaresio family were wealthy merchants trading in velvet, silk, grain and slaves, and were in charge of Venetian mercantile activities outside the Republic. They made a fortune from supplying Venice with Turkish wheat at a time when the expanding population increased demand; and it is possible that the timing of Titian's portrait is in some way related to a contract in which Salvaresio is recorded as providing wheat to the Serenissima in 1558 and again in 1559. Titian portrayed him as an amiably self-confident extrovert wearing a fur-lined jacket, the fingers of his right hand hooked informally around his striped sash. The magnificent table clock behind him, which would refer to his age and prosperity, is painted in white lead glazed with yellow. The little black page who offers him flowers may be a real portrait of one of Salvaresio's retinue of servants.

The subject of the *Portrait of a Man with a Palm* (Dresden, Gemäldegalerie), however, remains a mystery. The inscription is not autograph but there is no reason to doubt the information, which gives the date as 1561 and the age of the sitter as forty-six. One theory is that the palm held by the man identifies him as the painter Antonio Palma, a nephew of Palma Vecchio and father of Palma Giovane. Antonio may have worked for a time in Titian's studio and would have been around the right age. Another proposal[20] is that the box of colours on the windowsill may identify the portrait of a Venetian *vendecolore* from whom Titian and Orazio chose pigments sent to Spain at the request of Philip II. The problem with both suggestions is that the man is dressed expensively in a black toga and stole with silk-lined sleeves, the costume, that is, of a wealthy gentleman or aristocrat rather than a minor painter or merchant of pigments, and that

the painting is one of only seven that Titian signed 'AEQVES CAESARIS', Knight of Caesar.

Titian must have missed Irene's feminine presence in the house. It would have been some compensation for the absence of Orsa, who had recently died, and of Lavinia and the Alessandrini girls, all three now married and living in Serravalle. But then, within a month of her death, came a far greater personal loss. Francesco, the brother of whom it was said that to give a gift to Titian's brother was to give it also to Titian, died at the end of the year. In January 1560 the brothers' first cousin Vincenzo Vecellio delivered Francesco's funeral oration in Latin. He stressed Francesco's service to the community of Cadore, and described him as an ideal humanist: 'an admirable man in every respect, wise, honest, pious', generous to the poor, a convivial and loyal friend who never failed to share his wisdom and learning with others. The orator devoted only a few lines to Francesco's prolific career as a painter, which he claimed, incorrectly, he had given up early in life when he recognized Titian's superior talent.

Francesco is portrayed with a long white beard as St Andrew[21] in the *Madonna and Child Worshipped by Titian with Sts Titian and Andrew* (Pieve di Cadore, Santa Maria Nascente),[22] painted not long after his death for the family chapel in the parish church of Cadore. Titian in his black cap is behind St Titian gazing at the Madonna nursing her child. His early biographers said he had painted it because he wanted to leave something of himself in his birthplace. He must also have wished it to express his devotion to Francesco and to his own patron saint, whose feast day he remembered in a note written in his own hand on New Year's Day 1561 to his first cousin the notary Toma Tito Vecellio, the relative in Cadore to whom he was closest after Francesco, saying that since he is not able to be in Cadore for Christmas he is sending some sweets with his love, and will follow with twelve lire for charity on the feast day of St Titian (16 January).

Francesco's death placed the burden of managing Titian's affairs in Cadore and the properties elsewhere on the mainland squarely on the shoulders of Orazio; and Orazio's energies seem to have been released by the opportunity to exercise his entrepreneurial talents on behalf of

his father. In the course of the next fifteen years Orazio engaged in numerous business ventures (some of them on his own account, and some dubious). He supplied the Duke of Urbino, whose agent complained about his hard bargaining, with timber (1562–4), invested in a wine business (1565), supplied Murano with the wood to rebuild a bridge (1568) and part financed the design and construction of a machine to grind wheat (1573). At the same time he was required to supervise the studio while acting on his father's behalf in the increasingly complex and acrimonious matter of Pomponio's benefices, as well as the ongoing problem of the timber yard at San Francesco della Vigna, which was, with the sawmills near Pieve, a linchpin in their timber business.

The timber yard belonged technically to the commune of Cadore, but the Vecellio relatives, who were strongly represented on the council, had long since, albeit unofficially, reserved them for Titian's use as a quid pro quo for loans. Orazio was charged with the troublesome problem of retrieving the most recent loans, which had been requested to cover a shortage of funds to buy food and amounted to 1,300 ducats. These loans had been made as leverage to persuade the council to apply to the Council of Ten for planning permission to fence off the timber yard and erect buildings there to protect his imported wood. This was not the first time Titian had tried the same tactic, and when, as previously, it didn't have the desired result, probably because the expense of the improvements was considered too great, he wrote to the Magnifica Comunità di Cadore – two of the surviving letters are in his own hand – requesting repayment of the debt with interest, insisting that his own need for the money was now greater than theirs 'for many and many reasons which I need not spell out to you'.

Titian turned to Vecello Vecellio, the son of Tiziano di Andrea Vecellio, to whom he had directed a similar appeal as long ago as 1534. Orazio was dispatched to Cadore bearing gifts for Vecello, including a copy of Titian's *Venus and Adonis*, which Titian described as 'a little picture of Adonis, which is very beautiful'. Orazio also wrote to Vecello under Titian's signature on 20 April 1561 asking that the loans be repaid and that ambassadors from Cadore should be sent to Venice to

seek planning permission for the improvements from the Ten. We don't know if or how the Council of Ten responded to the petition, or if it was ever issued, only that the improvements to the timber yard seem not to have taken place. Nevertheless a letter Titian sent to Vecello in August 1561 may provide a clue to the identity of one of his rare late portraits. In this letter Titian wrote that he had prepared comfortable rooms in his house for Vecello and Toma Tito, who had evidently been chosen to act as ambassadors to the Council of Ten, and that they should come to Venice soon so as to submit their petition before a new Ten were elected on 1 October. It sounds as though Titian may have had one or more well-wishers on the acting Council, and it is not impossible that one of them was Nicolò Zen, the prominent patrician. It was in any case around this time that Zen sat to Titian for his magnificent portrait (Dorset, Kingston Lacy, Bankes Collection) wearing the scarlet sash and fur-lined sleeves of a high-ranking member of government. If only we could make out the not quite legible letter on the desk in front of him it might be possible to confirm or deny the hypothesis.

For all Titian's close attention to local matters of business, the Kingston Lacy portrait shows us a painter still at the top of his form in his early seventies. He was a vigorous survivor, but time was running out. He had to make choices and had already decided to devote the rest of his artistic life, with only a few exceptions, to serving the King of Spain, who understood his art better than any other patron.

The Rape of Europa

In the contrary wind her lovely golden hair plays over her breasts;
her garment waves in the wind and blows behind her, one hand
grasps his back, the other his horn.
She gathers in her bare feet as if fearing lest the sea wash over her;
in such a pose of fear and grief, she seems to call in vain to her
dear companions; they, left behind among the flowers and leaves,
each mournfully cry for Europa. 'Europa,' the shore resounds.
'Europa, come back.' The bull swims on, and now and then kisses
her feet.

ANGELO POLIZIANO, LATE 1470S[1]

On 3 April 1559, when Orazio was in Milan and Titian was working
on his Diana poems for Philip II, high-ranking representatives of
Spain, France and England met for talks in a dilapidated bishop's
château at Cateau-Cambrésis on the outskirts of Cambrai and
concluded the peace treaty that was to prove a watershed in the early
modern history of western Europe. Although the fate of Italy was the
main issue on the agenda, no Italian state was represented; nor was
Ferdinand's increasingly marginalized Holy Roman Empire. England,
ruled by Mary Tudor's twenty-six-year-old half-sister, the Protestant
Elizabeth I, accepted the reconquest of Calais by the French, who also
kept the fortress-bishoprics Metz, Toul and Verdun in the Rhineland
in return for ceding Piedmont-Savoy back to its duke, Emanuel
Philibert, who had led the victory at Saint-Quentin. The most

significant outcome of the settlement was the confirmation of Spanish control over Milan, Naples, Sicily and Sardinia, and indirectly over Siena and its territories, which became a fiefdom of ducal Florence. Cateau-Cambrésis brought to a close the Wars of Italy that had begun in 1494 with the invasion of the peninsula by the French king Charles VIII. The long-standing contest between France and the Habsburgs was laid to rest for the remainder of the century, not so much because of the terms of the treaty – treaties, after all, were routinely broken – but because both sides were bankrupt and preoccupied with their own more pressing domestic problems.

The treaty was further sealed by two events, one a dynastic calculation in the Habsburg tradition, the other totally unexpected. On 22 June Philip was married by proxy to Elizabeth de Valois, the eldest daughter of Henry II and Catherine de' Medici, who had originally been intended for Philip's son Don Carlos. A magnificent wedding was celebrated in Paris, in the cathedral of Notre Dame, with the Duke of Alba standing in for the king, and was followed by festivities at the French court. Eight days after his daughter's wedding Henry took part in a celebratory jousting tournament during which a young Scots Guard accidentally penetrated his visor with his lance and pierced his right eye. Henry was only forty when he died of the wound on 10 July to be succeeded by his fifteen-year-old son Francis II, husband of Mary Stuart, Queen of Scotland. Francis survived for barely a year. His brother Charles being only ten when he followed him to the throne, it was left to the Queen Mother Catherine de' Medici to preside uncertainly over a France that was soon plunged into factional chaos and religious wars between Huguenots (French Calvinists) and Catholics.

Religious tendencies across Europe were becoming more rigorous and uncompromising. Ideological calls for action surged from Calvin's Geneva into countries where government was weakest: Scotland, France, the Netherlands, the Rhineland (where antagonisms between Calvinists and Lutherans were sharper than those between Lutherans and Catholics), Hungary, and Bohemia. In Counter-Reformation Rome the old humanist liberals were dying out or taking

a harder stance against Protestant heresy. The final session of the Council of Trent, which opened in January 1562, was dominated by new men: Carlo Borromeo, nephew and right-hand man of Pope Pius IV; the austere Dominican Michele Gislieri, son of a shepherd and later to be elected pope as Pius V (both Borromeo and Pius V were subsequently canonized); and Gabriele Paleotti, whose diary of the proceedings of the Council remains one of its most informative accounts. When the Council rose for the last time in December 1563 after approving an array of decrees – about, among other matters, the condemnation of heresy, definitions of disputed doctrines, recognition of the absolute rule of the pope, the organization and behaviour of the clergy, and the importance of simplified and decorous religious art as fundamental to the teaching and dissemination of Catholic orthodoxy – any lingering dreams about Charles V's always unrealistic aspirations for a universal Christendom embracing reformed Catholics and Protestants were quashed for ever. The Catholic doctrine of redemption from Original Sin through devotion to Christ's sufferings in the Passion was triumphantly proclaimed, while the Protestant belief that salvation was obtainable through faith alone was totally rejected. It took many years to implement the reforms, but no further general council took place until 1869; and there was to be no comparable review of Catholic teaching and procedures until the Second Vatican Council initiated by Pope John XXIII in the twentieth century.

Venice, which had always cherished its independence from Holy Rome, remained relatively unaffected by the conclusions reached at Trent. And for utopian intellectuals who yearned for the pan-European unity and peace provided by sanitized ideas about the ancient Roman and Carolingian empires (both of which had been plagued by continual wars) Venice remained the social and political model. Determined to stay out of power politics but armed for defence, the Venetian oligarchy continued in practice and propaganda to sustain its mythic status as guardian of the republican values of harmonious government, liberty, peace and justice. The patrician humanist Bernardo Navagero, ambassador to Rome during the

negotiations at Cateau-Cambrésis, summed up Venetian foreign policy in his reports to the Senate: 'It is better, in my view, to treat all enemy rulers as potential friends, and friends as potential enemies ... I have also noted that it is wise to overestimate the enemy's strength and to underestimate that of oneself and one's allies ... I have become convinced, Most Serene Prince, that wars are always to be avoided for the disadvantages they bring.'[2] The last three paintings of the cycle in the Great Council Hall celebrating the foundation myth, according to which a twelfth-century doge made peace between a pope and an emperor, were completed in the early 1560s by Tintoretto, Veronese and Titian's son Orazio. In 1566 Jacopo Sansovino's enormous statues of Mars and Neptune, personifying wealth and dominance of the sea, were placed at the head of the great staircase to the doge's palace.

Philip had not yet heard news of the recent death of Henry II when he wrote to Titian on 13 July 1559 requesting that the Diana *poesie* and the *Entombment* be sent to Genoa for embarkation to Spain, where he planned to return shortly. He delayed his departure out of respect for his deceased father-in-law, but after attending the funeral ceremonies and winding up last-minute business with the States General of the Netherlands he sailed in August. He left his thirty-nine-year-old half-sister Margaret of Parma, natural daughter of Charles V and estranged wife of Ottavio Farnese, as regent of the Netherlands with Antoine Perrenot de Granvelle as the prime minister of the council of state. Philip was in Castile when Titian's pictures, dispatched by García Hernández with a consignment of Venetian glass, arrived in October. By that time, however, he was overwhelmed by a deluge of problems, many of them unforeseen, and while attending to the paperwork that had piled up on his desk may have put off unpacking Titian's paintings until he had the leisure to enjoy them.

During his four years in the Netherlands Philip had relied exclusively on money imported or expected from Spain, the only European country with direct access to American silver, and had found it increasingly difficult to extract funds for his wars, let alone to pay Titian, from his Italian dominions. After declaring bankruptcy in

1557 he had realized that the only way to manage his finances was to be close to the source of his wealth. But on his return there he found the Spanish treasury in desperate straits, far worse, as he informed Granvelle, than the situation in Brussels: 'I confess that I never thought it could be like this ... Apart from nearly all my revenues being sold or mortgaged, I owe very large sums of money and have need of very much more for the maintenance of my realms.' The flow of American bullion had increased during Charles's reign (and would triple during Philip's), but prices in Spain had doubled, and debts to financiers and other creditors were consuming two-thirds of ordinary income despite punitive taxation imposed on the populace of Spain. Many of the poor were already starving when their misery was increased by the failure of harvests, always unreliable in Castile, in 1559 and again in 1561. The regency government had tried to resolve the desperate financial problems by fiscal expedients – selling munici-pal offices and alienating Crown lands and jurisdiction – that had weakened royal authority.

Control of the government, which Philip had left in the hands of his sister the Infanta Juana, was in disarray after the nobles had taken advantage of his absence to jostle for power. It was also deemed neces-sary to deal with the nests of Protestant heretics discovered in Seville and Valladolid during the last year of his father's life. In October 1559 Philip presided in the main square of Valladolid over one of the *autos da fé* for which his reign would be notorious, although it should be said in his defence that he never witnessed the burnings, which took place on the outskirts of cities. The arrival of Elizabeth de Valois in December was a welcome relief in an otherwise dire period of his reign. His new queen was not quite fourteen, bright eyed, vivacious and with an appealing personality, although 'not greatly beautiful' in the judgement of the Venetian ambassador. Philip at any rate was delighted by her. The attraction was mutual, and Elizabeth, an amateur painter, shared Philip's interest in art. After their marriage was formalized at Guadalajara at the end of January 1560, he carried on a long-standing affair with his lover, Eufrasia de Guzmán, a lady in waiting to Juana. But when Eufrasia became pregnant four years later

he married her off to a nobleman and gradually became accustomed to the deeper peace of the marital bed.

The worst of the problems facing the king, then and over the coming years, was the threat posed by the Ottoman Empire of Suleiman the Magnificent, whose Muslim allies in Tripoli and Algiers, commanded by the pirate-general Dragut, were preying on Christian shipping in the western Mediterranean. Before leaving Brussels Philip had, unwisely as it turned out, given his approval to a siege of Tripoli by a huge Spanish–Italian expeditionary force commanded by Gian Andrea Doria, who had succeeded his uncle as head of Spain's Mediterranean fleet. In July 1560, while Titian was waiting impatiently for Philip's reaction to his paintings, Dragut's navy sank half the Christian fleet and captured more than 10,000 men, who were paraded through the streets of Constantinople. It was the most calamitous military defeat in the history of Spain, and it brought home to the humbled Philip the need to give his full attention to a kingdom that was vulnerable not only to bankruptcy, heresy and rebellion but also to the Turks.

Under the circumstances it is not surprising that he did not reply immediately to Titian's letters of March and April 1560 pressing for a reaction to *Diana and Actaeon*, *Diana and Callisto* and the *Entombment*, for the punishment of Leone Leoni and for payment of the outstanding 2,000 scudi from Genoa, or that he ignored Titian's suggestion that the victories of Charles V should be immortalized in a series of paintings of which he would execute the first. When he did hear, from a friend who was a Venetian diplomat in Spain, that his masterpieces had met with His Majesty's approval it was enough to embolden him to write to the king on 2 April thanking him in advance for the outstanding 2,000 scudi 'of which payment was ordered three years since in Genoa', claiming that in anticipation of the promised funds he had bought 'some possessions for the support of myself and my children, which, to my great distress, I have been obliged to sell'.

As an intercessor in the case, I have prepared a picture in which the Magdalen appears before you with tears and as a suppliant in favour

of your most devoted servant.[3] But before sending this I wait to be informed by Your Majesty to whom it shall be consigned, that it may not be lost like the Entombment; and in the meantime I shall get ready the Christ in the Garden and the *poesia* of Europa, and pray for the happiness which your Royal Crown deserves.

Philip, apparently surprised that his orders to pay Titian had not been obeyed, appended a marginal note to this letter: 'It seems to me that this matter has already been arranged, and that a written order was sent to pay and settle what is here stated.' But it was not until high summer that 2,000 ducats were sent to Titian in Venice. Titian thanked the Most Potent Catholic King on 17 August for the money, which 'frees me from some embarrassment', but pointed out that because the Genoese had paid him by banker's order rather than in gold he had received 200 less than the original promise. He was sure His Majesty would make up the difference and awaited his instructions about the delivery of the St Mary Magdalen, promised long before,

and which I have completed in such a manner that, if ever Your Majesty was pleased with any work of mine, Your Majesty will be pleased with this … Meanwhile I shall proceed with the Christ in the Orchard [the *Agony in the Garden*], the Europa [the *Rape of Europa*], and the other paintings that I have already designed to make for Your Majesty …

When a précis of this letter was laid on Philip's desk on 22 October, he appended in his own hand numbered instructions that: 1. The 200 scudi should be sent from Spain, 'which will be least inconvenient'; 2. The Magdalen should be forwarded by Hernández by a safe conveyance with some more of the Venetian glass as previously purchased; 3. Titian should be told to hasten the completion of the other pictures, which should also go by safe conveyance and be dispatched with similar care from Genoa. On the same day Philip, 'by the grace of God King of Spain, etc.', wrote by way of Hernández to Titian 'our beloved' that he was certain from what Titian had said that the Magdalen would be quite perfect and he looked forward to having it very soon

and in such a way that it was not damaged. Hernández should also send the other pictures of Christ in the Garden and the *poesia* of Europa, and the others when they were finished.

Hernández reported to Philip on 20 November that his letter had given Titian considerable pleasure. Although he had said he had finished the Magdalen, he was in truth still working on it, but good judges of art were saying it was the best thing he had done.

> He is labouring on the other pictures slowly as is natural to a man who is past eighty, but he says they shall be completed by February next ... I have pressed him to keep his word and not to miss so good an opportunity. Your Majesty will be pleased to order the payment of 400 scudi, which are due for two years' pension to Titian, who being old is somewhat covetous.

Titian cannot have been more than seventy-three at this time. Although he may not have known or remembered exactly how old he was, it is unlikely that he really thought he was 'past eighty', as he had apparently told Hernández or as the envoy had assumed from Titian's claim six years earlier, when he was at most sixty-seven, to be eighty-five. He had been exaggerating his age for many years as an excuse for prevarication, as a bargaining chip and as evidence of an achievement that commanded respectful obedience, especially in an artist whose brush could still work miracles. But now that old age really had caught up with him the sense of entitlement that had always characterized his insistent demands to be paid what he had been promised was reinforced by claims of neediness that were either unspecified or greatly exaggerated. Titian may have felt, as many old people do, poorer than he actually was. But his reiterated claims of financial distress were often invented. There is, for example, no evidence that when he wrote to Philip on 2 April begging for the unpaid 2,000 scudi he had bought or sold 'possessions purchased on behalf of myself and my children', unless he was referring to property near Serravalle purchased by Orazio as an investment in 1560 for 100 ducats and leased back to the vendor.

On 1 December 1561 Titian wrote Philip a letter to accompany the weeping St Mary Magdalen that he had promised the previous April and which he hoped His Majesty would deign to accept and enjoy and which his Catholic eyes would see from the expression of her face towards God as an example of his own devotion towards the king. Meanwhile, he wrote, he was bringing the other pictures to completion. Twelve days later Hernández entrusted the painting to the Marquis of Pescara for dispatch to Spain. But it was not the same Magdalen that the secretary had described as considered by good judges of art to be the best thing Titian had done. That Magdalen, so Vasari tells us, had been snapped up by the Venetian patrician and connoisseur Silvio Badoer, an admirer of Titian who owned and probably commissioned the version of his *Danaë* now in the St Petersburg Hermitage. Badoer, seeing Philip's Magdalen on Titian's easel, had offered 100 scudi for it, a price Titian had found too good to refuse especially since he knew that the studio could easily run up another. Although neither Badoer's nor Philip's Magdalens can be identified we can assume that they looked like extant versions (including those in the St Petersburg Hermitage, the Los Angeles Getty and the Naples Capodimonte) in which the reformed saint wears a striped Jewish shawl and, despite her red eyes, supplicating expression and prayer book, has not, for all her suffering and fasting in the desert, lost her voluptuous sexuality or the gleaming auburn hair that flows provocatively over her bare shoulders and lightly veiled breasts. The paradox struck a young Florentine nobleman who recorded a visit he had paid to Titian's studio at around the time he was working on the Magdalen sold to Badoer and the one sent to Philip.

> There I met Titian, almost immobilised by age who, despite the fact that he was appreciated for painting from the life, showed me a very attractive Magdalen in the desert. Also I remember now that I told him she was too attractive, so fresh and dewy, for such penitence. Having understood that I meant that she should be gaunt through fasting, he answered laughing that he had painted her on the first day she had

entered, before she began fasting, in order to be able to paint her as a penitent indeed, but also as lovely as he could, and that she certainly was.[4]

Philip's Magdalen was a replica of the one he sold to Badoer, probably mostly by his own hand: at this time he generally reserved his autograph work for Philip. There is, however, a painting in Venice that is as beautiful as anything he sent to the king, and which visitors to the city too often miss. It is a hexagonal painting, once aptly described as 'a bouquet of pure colours',[5] which can still be seen today on the ceiling of the vestibule to the Biblioteca Marciana, where it is set in an elaborate illusionist architectural framework, itself a tour de force, completed in 1560 by Cristoforo and Stefano Rosa, Brescian specialists in *quadratura* painting. The figure of *Wisdom*, as she is usually identified,[6] is seen in profile reclining gracefully on a pillow of billowing blue-grey clouds. She is dressed in a rose-red skirt, a gold shawl, with her legs covered by an olive-green drape. A scroll rests on her left palm while her right arm stretches out to receive a folio – perhaps it is one of the Greek manuscripts given to the Republic a century earlier and which had only recently found a home in Sansovino's library – from a winged putto representing the inspiration of literature on art. Titian created this wonderfully seamless composition by using the minimum of foreshortening necessary for a ceiling painting and the mosaic-like technique of applying colours that he had absorbed from the Zuccati brothers and brought to perfection in Philip's *poesie*.

He created the *Wisdom*, his only autograph ceiling painting, as a gesture of his long-standing friendship with Jacopo Sansovino, the architect of the library, but also because he wanted his work to be compared favourably with those of the most renowned of the younger Venetian painters whom he and Sansovino had chosen several years earlier to decorate the ceiling of the library. But Titian had reserved the vestibule ceiling for himself, and we need not doubt that he intended to demonstrate that even at his advanced age he could make something that was beyond the reach of Veronese, much though he admired and had learned from his use of colour. And so he did, with

a painterly tenderness and fluency of design that makes Veronese's virtuoso *Allegory of Music* in the library look effortful and contrived by comparison.

The *Wisdom* had been installed in the Rosa brothers' frame on the ceiling of the vestibule by 26 April 1562 when Titian wrote to Philip that he had, at last and with the help of divine providence, brought to completion the *Agony in the Garden* and the *Rape of Europa*, which, he confessed, had been long since ordered by His Catholic Majesty. He sent another *Agony in the Garden* to Philip about a year later, and scholars are divided about which is which. Both are night scenes depicting the imminent capture of Christ, but taken from different Gospel accounts. In one version (Madrid, Prado), one of the soldiers carries a lantern as mentioned in John 18: 3. In the other (Madrid, Escorial) an angel appears before the praying Christ as in Luke 22: 43. Whichever he sent to Philip in April 1562 it was the first night Titian painted for the king, who eventually sent both versions to the Escorial where they were allowed to moulder over the centuries, and are by now so ruined by neglect and destructive restoration that it is difficult to judge the qualities that Titian thought made them the equal of the *Rape of Europa*, the last, and now best preserved, of the *poesie* he painted for Philip.

Europa was the daughter of Agenor, king of the Levantine city of Tyre. One day Jupiter, who had been lusting after her from Olympus, could resist her charms no longer. He took the form of a handsome white bull and swam ashore while she was playing on the beach with her handmaidens. Jupiter joined their games, persuaded her to mount him, then gradually edged away from the shore. Europa was attracted to the bull but not quite ready when he plunged into the sea and carried her with the speed of wind across the water from Asia to Crete. There he assumed the form of a man and impregnated her, and their descendants become known as the Europeans.

The story could hardly have been more suitable for a king who, with his family, ruled most of continental Europe. It had been told by Ovid in the *Metamorphoses* and the *Fasti*, and often retold and represented by artists,[7] although none, not even Rembrandt in the next

century, ever gave the story the dynamism of Titian's version. Veronese's charming but static later versions, one in the Anti-Collegio of the doge's palace, depict the scene on the shore with the bull lying down and licking one of Europa's feet. Dürer, in a sketch of around 1495, shows Europa astride the bull as he gallops through reeds towards the open sea. But what painter but Titian would have risked the more challenging image of the bull breasting the sparkling waves, with the surprised Europa on his back, legs open, under one of those Venetian sun-streaked evening skies that Aretino had described all those years before in homage to Titian's unique ability to translate the effects of nature into paint. Everything is in motion. Two flying cupids are buffeted by the wind as they try to keep up with the couple; a third, riding on a dolphin behind the bull, directs his gaze between Europa's legs. The handmaidens left behind wave from the shore as the glowing clouds race towards the darkness of night.

Titian took his interpretation of the fable less from Ovid's account than from a description of a classical painting at the beginning of the romance of *Leucippe and Clitophon* by the Alexandrian writer Achilles Tatius. His friend the scholarly Diego Hurtado de Mendoza, during his term as Spanish ambassador in Venice in the 1540s, had acquired the manuscript, which would have been accessible to Titian in a translation by Lodovico Dolce. The story was popular in Spain, but Titian never mentioned his source in his correspondence with Philip, who may or may not have read it. Tatius described Europa balancing precariously on the bull's back, clad in a veil of lawn 'from her breast to her privy parts', her scarf swelling against the force of the wind like a sail. But it was Titian who turned her face so that her ecstatic expression is half concealed by the shadow of her raised right arm. It was Titian who painted the beguiling head of the bull whose horn she clutches with her other hand as he looks out at us with an eye that is about to wink an invitation to give in to our passions wherever they may lead us. And it is Titian who varied the textures, so that figures in the foreground rendered in impasto appear solidly three dimensional against the landscape background so thinly painted that you can see the weave of the canvas; and the mountains, just as Shelley would see

them when he gazed at the Euganean Hills, are made transparent by the vaporous sun.

The apparently effortless fluency of design and the springtime palette of the *Rape of Europa*, and of the Marciana *Wisdom*, are enough to reassure us that, old, frail and needy though Titian may have claimed to be when dealing with matters of business, his heart lifted when he went into his studio and took up his brushes to reveal an inner life that was still bursting with painterly creativity and fresh ideas. With the *Rape of Europa* and the *Agony in the Garden* he had fulfilled the terms of the agreement he had concluded with Philip at Augsburg in 1551. Nevertheless, he promised to proceed with a *Madonna and Child* (Munich, Alte Pinakothek) which Philip had apparently requested, and which he hoped would please the king no less than his other paintings. We don't know when he sent it but Philip must indeed have been pleased by this ravishing piece. The elongated figure of the seated Madonna, reminiscent of Mannerist sculptures by Sansovino and Michelangelo, glances down with amused tenderness at her restless baby boy as He struggles to slip off her lap. Dressed in pink and smoky blue, she is set against one of those dark backdrops with which Titian still liked to bisect his pictures and which opens up on our right to a fiery sunset over a distant city.

Meanwhile, on 26 April 1562, in a letter to Philip that accompanied the *Agony in the Garden* and the *Rape of Europa* to Spain, Titian wrote that these pictures 'put the seal on all that Your Majesty was pleased to order, and that I was bound to deliver':

> Though nothing now remains of what Your Catholic Majesty required, and I had determined to take a rest for those years of my old age which it may please the Majesty of God to grant me; still, having dedicated such knowledge as I possess to Your Majesty's service, when I hear – as I hope to do – that my pains have met with the approval of Your Majesty's judgment, I shall devote all that is left of my life to doing reverence to your Catholic Majesty with new pictures, taking care that my pencil shall bring them to that satisfactory state which I desire and the grandeur of so exalted a King demands.[8]

PART V

1562–1576

The difference between the old Titian ... and the young Titian, painter of the 'Assumption' and of the 'Bacchus and Ariadne', is the difference between the Shakespeare of the *Midsummer-Night's Dream* and the Shakespeare of the *Tempest*. Titian and Shakespeare begin and end so much in the same way by no mere accident. They were both products of the Renaissance, they underwent similar changes, and each was the highest and completest expression of his own age.

BERNARD BERENSON, *ITALIAN PAINTERS OF THE RENAISSANCE*, 1938

ONE

A Factory of Images

Although many have been with Titian to learn, the number of
those whom one could truly call his disciples is not large; so that
he has not taught much, but has imparted more or less to each
one according to what they have known how to take from his own
paintings.

GIORGIO VASARI, 'LIFE OF TITIAN', 1568

When Titian painted his self-portrait (Madrid, Prado) in 1562[1] he was
the most famous person in the proudest and most admired city in
Europe and was universally recognized as the greatest artist of his
time apart from the octogenarian Michelangelo, who had only two
years more to live. Titian emerges, like his earliest sitters, from a shad-
owy background, his features strongly lit. He looks less distinguished
in Veronese's portrait of him dressed in red playing the viol da gamba
in the huge *Marriage at Cana* (Paris, Louvre), painted in the same year
for Palladio's new dining hall in the monastery of San Giorgio
Maggiore. But if Titian flattered himself up to a point, he did not
disguise his years. Mottled skin sags from the bones of his long face,
the nose more prominent than ever against sunken cheeks, down-
turned mouth collapsed as though no longer supported by teeth. He
wears discreetly expensive blacks, which no painter could imitate as
convincingly as Titian and which define his status as a wealthy gentle-
man. The textured blacks of his doublet and fur pelisse are relieved by
a white linen collar and gold chain of honour around his neck. The

paintbrush in his unfinished right hand seems to be there as an emblem rather than a tool of the profession that has brought him fame and fortune. The near-profile view of his face is unusual in painted portraits of the period, and to paint a self-portrait from that angle would have involved taking the trouble to set up an arrangement of mirrors. Titian may have chosen it because the profile portrait was a standard format on classical coins and was for that reason associated with nobility and immortality.

Since there seems to have been no commission for this self-portrait we can guess that Titian painted it for his own satisfaction, perhaps as an epilogue to a career that might be terminated by death at any minute. Although he may not have known exactly how old he was, he had begun referring to himself as old and frail as early as 1548 when he was approaching sixty. Now into his seventies he had been spared the many illnesses for which doctors had no cure: malaria, typhus, dysentery, plague, severe influenza, gout, the septicaemia that was the inevitable consequence of a burst appendix or the gangrene that infested open wounds. He had outlived many of his patrons, relatives and friends, Aretino, Charles V and his siblings Orsa and Francesco among them. So what we see in this last of his self-portraits is a survivor, at a time when old age was regarded as an achievement, in a Venice ruled by old men. Stiffened by his years, but with more work ahead, he is as determined as ever to maintain himself, his children and the headquarters in Biri Grande where he received distinguished guests, notaries and lawyers in the style suitable to his quasi-aristocratic status. Ridolfi recounts that Titian:

> kept in his home an honourable retinue of servants and dressed ostentatiously as a great knight; in his travels to the courts of princes, he always acted generously, and it is said that when he unexpectedly invited Granvelle and Pacecco [another cardinal] ... to dine with him, he threw a purse at his servants and said: 'Prepare dinner, for I have the entire world in my house,' and he kept them with him long enough to retouch their portraits.

As a younger man Titian had been known, unusually for an artist of rare genius, as pleasant and easy to deal with (although those who knew him well were aware of his stubborn nature).[2] Now he was more often described as sly, grasping, unreasonable and dishonest. Ridolfi, who was writing in the next century partly from hearsay, maintained[3] that Titian hid his autograph paintings from his assistants, but when he discovered that they had made copies of them without his authorization he worked them up for sale. But Ridolfi also records his 'resplendent greatness of spirit'. Titian's surviving letters, which are almost exclusively about money, may well give us a distorted idea of his character, but it does seem from the comments made about him by others that, with fame and old age, the sense of entitlement and canny head for the details of business that had characterized his dealings with patrons from early on were turning into a degree of avariciousness that was unusual among Renaissance artists. In 1561 Philip's ambassador in Venice had referred to Titian merely as 'somewhat covetous'. Three years later, when Titian and Orazio were supplying his long-standing and friendly patron Guidobaldo II, Duke of Urbino, with timber, the duke's agent in Venice, Giovanni Francesco Agatone, began complaining about Titian's cupidity. 'He does nothing other than demand money,' he wrote in 1564. And two years later, 'as I have written before, when it comes to money, [Titian] is the most obstinate man'. And in 1567, 'there is no more obstinate man in Venice than Tiziano Vecellio. And his son, certainly in terms of avarice, is in no way inferior to his father.'

Fifteen-sixty-two, the year of the last self-portrait we have of him, also saw the first publication of Titian's *impresa*, one of the devices printed in the period to honour great men with a motto, short poem and metaphorical illustration. Titian's *impresa* appeared in an engraved anthology of such devices with verses by Lodovico Dolce.[4] It bears the motto 'NATVRA POTENTIOR ARS' (Art is more powerful than nature), and a doggerel verse by Dolce, which concludes with the lines 'But TITIAN, thanks to great fortune,/has defeated art, genius and nature'. The theme of Titian as godlike creator of a new nature was by then a commonplace, a stale trope for a quality of his

paintings that is difficult to define even with today's more sophisticated critical vocabulary. We would probably settle for Truth, the complex, ambiguous truth that we recognize only in the work of the greatest artists. The text is illustrated by the apparently incongruous image of a she-bear and cub, which would have made sense to educated contemporaries as a metaphor for artistic creativity inspired by ancient biographies of Virgil in which the poet was routinely described as gradually licking his works into shape just as a mother bear gives shape to her formless offspring. Dolce may also have chosen it to emphasize Titian's *sprezzatura*, the contemporary word for the time and labour that goes into apparently effortless achievements.

Another event of 1562 that concerned Titian was the commissioning of the last remaining pictures of the Alexandrine cycle in the Great Council Hall, which were given to Veronese, Tintoretto and Orazio Vecellio, each of whom was to be paid 100 ducats.[5] Titian, out of respect for his standing and his age, had been relieved of official duties in the ducal palace but was permitted to continue drawing his *sanseria*, the brokerage on the Salt Office worth 100 ducats per annum, for life. Since Orazio, whose subject was the Battle of the Forces of the Emperor Barbarossa and the Roman Barons near Castel Sant'Angelo, was not in the same league as Veronese and Tintoretto it is likely that Titian had used his influence to obtain for him the highly prestigious job and stood over his shoulder while he executed it. Vasari reported that 'some people said' that Orazio had help from Titian. But from Titian's stunning drawing of a *Horse and Rider* (Munich, Staatliche Graphische Sammlung),[6] made for Orazio's guidance in black chalk on squared blue paper, it looks more as though the old master was not just helping but trying to pump something of his own genius and vitality into the son who would one day take his place at the head of the studio.

Relations with Pomponio were for the time being on an even keel after years of effort on the part of the Church authorities to settle the differences between father and son over the benefices of Medole and Sant'Andrea di Favaro, which Titian had acquired for Pomponio but tried to appropriate. In August 1563 an agreement was drawn up and

signed by the papal legate in Venice according to which Pomponio's ownership of the benefices was acknowledged but which gave Titian power of attorney to manage, use and profit from them in return for the very handsome monthly payment to his son of twenty-five ducats. Soon afterwards, on 18 October, Pomponio took major orders, which entailed a sacred vow never to renounce the priesthood and the obligation to officiate at mass and care for souls. Four decades earlier Titian, rejoicing at the arrival of a healthy firstborn boy, may have allowed himself to dream that the baby in his mother's arms would one day wear the red hat. By now, however, it was enough that Pomponio had at least committed himself to the priesthood. What Titian may not have noticed was that Pomponio, well rewarded though he was by their agreement, continued to resent his father's condescension, and perhaps all the more now that he was a fully qualified priest.

Overbearing, shortsighted and selfish though he could be as a father, Titian was unfailingly loyal to his friends. He had done everything he could to help Jacopo Sansovino when the vault of his library of St Mark had collapsed in 1546 and to promote Aretino's embarrassing bids for a cardinal's hat. In 1563 Titian's close friends the mosaicists Francesco and Valerio Zuccato found themselves in trouble. A rival mosaicist, one Vincenzo Bianchini, with whom the Zuccati brothers had been engaged in a long-standing feud, denounced them for using paper and paint to cover a mistake in the representation of some towers in a mosaic of the Vision of St John the Evangelist at Patmos. The Byzantine art of mosaic was still taken very seriously in High Renaissance Venice, and the work in question occupied a prominent position in the great vault of the loggia where the four gilded Roman horses were displayed. The mosaic was completely remade in the late nineteenth century, but the minutes of the investigation of the Zuccati's original survive intact, giving us one of the rare opportunities to hear Titian's voice reported verbatim.

On 22 May a procurator, who was unwell and unable to climb up to the loggia to see the mosaic for himself, came to the basilica accompanied by a group of artists including Titian, Jacopo Sansovino,

Andrea Schiavone, Jacopo Tintoretto and Paolo Veronese. Titian, on account of his seniority, was the chief witness: 'I say to you that as regards the art of mosaic I see nothing better, by which I mean all the works in the church which were made in past times and which are exposed to view, nor do I recognize any defects in them. But because I do not have much experience in the art of mosaic, I do not want to involve myself in talking about what I do not know ...' This was disingenuous. Titian's studio had been designing mosaics for the Zuccati for more than three decades. Asked if he had any vested interest in their work he made no attempt to conceal his friendship with the brothers: 'I have been friendly with the Zuccati for very many years and Master Francesco stood as godfather when I had my little girl [a daughter by his first wife Cecilia] baptized, who died ... It is true that they said to me, "Look what calumny this is!" and so I said to them that justice would not be wanting, as they had done no wrong, and I eat and drink with Master Valerio for the sake of good company.' When the procurator put it to him, 'Are the mosaics well or badly executed?', he replied, 'About that I leave the decision to these young painters.' The painters were unanimous in their opinion that the papering was a trivial matter that did not compromise the beauty of the mosaic. Nevertheless, the Zuccati were found guilty. Francesco was given the opportunity to restore his reputation. Valerio, who, Titian admitted, had spent his days at his boutique at Santi Filippo e Giacomo cutting the gold tiles over which the paper and paint would be applied, was forbidden by the procurator in charge of the investigation to continue practising as a mosaicist.

Ridolfi tells us that Titian painted two portraits of Francesco Zuccato, one with a self-portrait. A painting formerly at Cobham Hall in Kent, in which a heavily bearded man looks with keen interest over the shoulder of a version of the Berlin self-portrait, is sometimes said to be a studio or posthumous copy of the painting mentioned by Ridolfi but has never been taken seriously by scholars. In the other, according to Ridolfi, Titian portrayed Francesco as Simon of Cyrene helping Christ to carry the cross to Golgotha. There are two versions of Titian's late *Christ Carrying the Cross* (St Petersburg, Hermitage

and Madrid, Prado), both usually dated 1565–70, both painted over abandoned compositions, as was Titian's wont in these years. In these paintings Titian applied his mature sense of tragedy to the subject he had painted for the church of San Rocco at the start of his career. Now, more than five decades later, he brought the face of the exhausted Christ to the front of the picture where He gazes at us with tearful bloodshot eyes while shouldering the burden of the cross painted at a steep diagonal. Although we can't be certain that the figure of Simon of Cyrene is the portrait of Francesco Zuccato mentioned by Ridolfi, his noble, well-characterized head and the ring he wears on his thumb do indicate that it is a portrait of someone.

Titian took Valerio Zuccato under his wing and may have employed him as an apprentice painter. (At any rate Valerio witnessed various documents for him in Venice or Pieve di Cadore.) The workshop in Biri Grande was now run as a highly efficient business turning out the copies, variants and paraphrases of Titian's originals that had become status objects in their own right, especially if Titian added the few convincing strokes of his own that were known in Venice, according to Marco Boschini, as 'the icing on the cake'. The quality of the surviving studio works varies greatly depending on how much work Titian put into them. Sometimes he would make a brush drawing to be finished by an assistant; or he would paint or repaint certain passages, which shine out from otherwise dull studio replicas. The master had gathered round him a stable team of assistants, of whom the most important in the coming years would be Emanuel Amberger, the son of Christoph Amberger who had repaired the *Portrait of Charles V on Horseback* in Augsburg. Although Emanuel is first documented as being in the workshop in 1565 he may have arrived several years earlier, perhaps after the death of his father in 1562 when he was in his early thirties and therefore a mature painter. In the coming years he would stay on as the most valued member of the studio, living in Biri Grande as part of the family. Titian's young cousin Marco Vecellio, the son of Toma Tito, may have come for a while as an apprentice in the late 1550s. After joining the core team in 1565 at the age of twenty

he was given the unenviable task of collecting payments, and his career as an independent painter did not take off until after Titian's death. Girolamo Dente, having combined four decades of service to Titian with a career as an autonomous painter on the mainland, seems to have been in the process of freeing himself from the master's shadow while still relying on the valuable connection for commissions.

It had become common practice in the workshop to keep *ricordi* – sketches on squared paper, small oil versions, perhaps cartoons – of original works that could be copied, with variations and perhaps a few finishing strokes of his own, to meet the demands of the market.[7] Titian or one of his assistants would copy or trace the main outlines of the template on to a new canvas in chalk or charcoal, and these could then be developed into multiple versions with some alterations added at the final stage. Titian signed some of them, or his assistants signed themselves as his alumni, or forged his signature. Works largely or partly executed by the studio come on to the market even today, and fetch good prices, although not of course as high as originals.

The clearest example of how the system worked is provided by the Reclining Venus series, which was derived from the original Titian had taken on his first visit to Augsburg as a gift for Charles V and executed over the following fifteen years or so.[8] All the Venuses lie on a couch in a villa in the Veneto in front of a window overlooking a formal garden or mountain landscape. Opinion is divided about whether the lost original looked more like the *Venus and Cupid with a Partridge* in the Florence Uffizi[9] or like the *Venus and Organist* in the Madrid Prado.[10] The Uffizi version is the only one of the group that does not include a musician. In all the others an organist or lutanist serenades the naked woman, no doubt with one of the sexually explicit madrigals of the time, while gazing back at her with evident lust. Cupid is present in all but the Madrid *Venus and Organist*, which was painted, possibly as a marriage picture, for a Paduan lawyer, who would have been familiar with the Venetian tradition of pretty girls portrayed without the classical alibi of a Cupid.[11] The three organists, who from the direction of their gazes appear to be in the early stages

of seduction, have different faces. The identical young lutanists, in what are probably the last two paintings in the series, apparently celebrate the aftermath of love as they look up at Venus being crowned by Cupid. Titian's favourite breed of spaniel, familiar from the *Venus of Urbino* and other pictures, reappears in some. All of the girls wear identical gold bracelets, one on each wrist, a fashion that persists today with well-born women from the Veneto and Friuli.

From the 1560s on the paintings that emerged from Biri Grande are – with the notable exceptions of those sent to Philip II of Spain – difficult to date, and their quality varies, usually depending on the degree of Titian's involvement. There are fewer large, complex narratives, more replicas and variants, and more variants and paraphrases of earlier subjects. The master was slowing down. Although there had always been days when he simply did not feel up to painting, they came more often now. In the 1550s a Florentine physician, Filippo Capponi,[12] who was curious about the temperaments and working habits of artists, had interviewed the musician Adriano Willaert, Michelangelo the sculptor and Titian the painter. Titian had confessed that on some days he enjoyed painting but on others he did not. He could not explain the cause of these variations in the will to work but he wished he could be freed of the difficulty, which on bad days was beyond his control.[13] Capponi was ahead of his times in advocating the idea that health is influenced by behaviour and diet rather than by the stars. Other contemporaries would have diagnosed Titian's problem days as symptoms of the conjunction of certain planets. Nevertheless, it was impossible to avoid the conclusion that by the 1560s Titian was simply getting old. In 1564 he had to retreat temporarily from his long-standing and doggedly repeated claim on the Neapolitan corn granted to him by Charles V, because he had absent-mindedly lost the receipt. More often now he combed through his store of paintings begun and discarded over the years, finished them or gave them to his studio to finish, or reused the canvases as supports for new paintings.

There is a division of opinion about the degree of Titian's participation in the *Annunciation* (Venice, Church of San Salvatore), the last

of his several treatments of the subject and still in situ in Jacopo Sansovino's stone frame over the altar for which it was commissioned in May 1559 by Antonio Cornovi della Vecchia, who ordered a painting by Titian of 'the Incarnation of our Lord'. Some connoisseurs admire the San Salvatore *Annunciation* as a magnificent example of the late style; others cite what they see as inept drawing and murky colours as evidence that it must be largely a studio work.[14] Vasari, who interviewed Titian in 1566 soon after it was finished, reported that Titian himself did not much care for it or for the *Transfiguration of Christ*, which was probably ordered separately by the Augustinian canons of the church as a weekday cover for a medieval silver-gilt reredos and is still over the high altar although in very bad condition. Both, in Vasari's opinion, 'have some good aspects', but 'in fact fall short of the perfection of his other pictures'.

A third painting for San Salvatore, a Crucifixion, was ordered from Titian at the same time by the Flemish merchant Giovanni d'Anna for his family altar directly across the nave from that of the Cornovi. Both the d'Annas and the Cornovi had made large fortunes in the textile trade, and Titian had a personal connection with them both through the Scuola di San Rocco of which all three were members. In 1558 he had delivered his superb Ancona *Crucifixion* to Antonio's first cousin Pietro Cornovi della Vecchia. He was godfather to Giovanni d'Anna's son, and had painted the *Ecce Homo* and other pictures for the family palace. Titian was thus the obvious choice for both, and the interior of San Salvatore, which, after a major reconstruction completed by Jacopo Sansovino in the 1530s, was (and is) one of the most impressive in the city, was the ideal place for two wealthy *cittadini* merchants, who would have spent a lot of time at the nearby German warehouse and were aware that showing off their piety and patronage was a way of confirming their status in the city and perhaps even gaining admittance to the patriciate. Sadly the d'Anna family fell on hard times after Giovanni's death; construction of the altar was suspended, and Titian's Crucifixion, which may or may not have been finished,[15] disappeared.[16]

Given the prestige of the church and Titian's personal connection with Cornovi it seems unlikely that he would have given this

Annunciation entirely to assistants. It could be that its muddy tonality and some clumsy passages such as the angel flying on his stomach at the top of the picture, are due to an intrusive restoration mentioned by Ridolfi. It may have been that same restorer who overpainted Titian's original signature 'FACIEBAT', a trope that he had used many years earlier for the Averoldi polyptych in Brescia, with the words 'FECIT FECIT'. Ridolfi attributed the repetition to Titian's intention to force the patron, who, so he said, failed to appreciate the altarpiece, to acknowledge his scarce understanding of the art of painting. For the next three and a half centuries it was interpreted as an assertion of the master's awareness of his miraculous creativity even in his old age – 'I made it. I made it' – and was the single most famous aspect of the painting, until a technical examination in the late twentieth century revealed Titian's more conventional original signature, 'I was making it'.

The unusual iconography of the San Salvatore *Annunciation* may have been inspired by Aretino's *Life of the Virgin Mary* in which Mary 'drank with her mouth of the desire and grace of all the splendour that burned in her womb without burning'. The inscription in the bottom-right corner of the picture, 'IGNIS ARDENS NON COMBVRENS' (The fire that burns but does not consume), refers to the burning bush that was not consumed by its flames from which God called out to Moses, an episode that prefigures the Incarnation of Christ and which is illustrated on the step above the inscription by the burning leaves in the crystal vase that signifies the ancient Christian dogma that Mary's virginity remained intact during and after the birth of Christ. A burly angel Gabriel, his profile slightly turned away from the viewer, stomps towards Mary arms crossed and without proffering the usual lily. The crossed arms are normally given to the Virgin, and X-rays show that the angel annunciate was originally painted with arms outstretched and palms down. But Gabriel's crossed arms, far from indicating humility, have the reverse effect of making him look all the more aggressive, while Mary, her face borrowed from one of Jacopo Bassano's peasant Madonnas, opens her arms in an attitude that seems more like apprehension or even

self-defence than joyful amazement at what this hulking messenger is about to do to her. It is, as one art historian[17] has put it, as though Titian 'is showing us that we do not fully grasp the message of the announcing angel until we recognise, as Mary manifestly does, that it involves, amongst other things, a fierce assault on a woman's body'. The aggressive masculinity of Gabriel and the feminine receptivity of Mary are further emphasized by the angels that swarm around the dove of the Holy Spirit, little naked boys above the angel annunciate and older clothed girls above Mary.

It has been proposed that the painting carries a hidden message about heterodox religious opinions supposedly harboured by Titian and other heretical Venetians who doubted the central Catholic dogma of the Virgin Birth.[18] The hypothesis seems unlikely given that the San Salvatore *Annunciation* was one of a small selection of his paintings that Titian later chose to have engraved for mass circulation and that he was on excellent terms with high-ranking prelates of the Church with whom he often dined. It is true that one of his tenants, a writer from Brescia by the name of Andrea di Ugoni, had had problems with the Inquisition from the mid-1540s. But when in 1565 he was summoned again he confessed to heretical beliefs but recanted, and was permitted to return to Titian's house, which would not have been allowed if there had been the slightest doubt about Titian's own orthodox faith.

Although the question of studio participation in the San Salvatore *Annunciation* may never be resolved, it should be borne in mind that Titian's contemporaries did not always make the same distinction between studio and autograph paintings that began to concern collectors in the seventeenth century. One case in point is the little *St Nicholas of Bari* (Venice, Church of San Sebastiano) in which the saint accompanied by a figure holding his bishop's crown appears to be addressing an imaginary audience in the stall of a cathedral choir. It was delivered to the patron, a lawyer Niccolò Crasso – for whom Titian had painted a portrait and a version of his *Venus with a Mirror* (St Petersburg, Hermitage) – by 1563 when Crasso dedicated the altar to his name saint. Crowe and Cavalcaselle, writing as early as 1877,

recognized it as an admirable studio work probably largely by Orazio and other assistants, and it is possible that Crasso also accepted that his altarpiece was not entirely autograph. Titian could be cavalier even with commissions from potentially useful men. Later in the 1560s Cardinal Michele Bonelli, an influential member of the Curia, ordered a painting of St Catherine of Alexandria. Although Cardinal Bonelli was well placed to help him exchange Pomponio's living at Sant'Andrea di Favaro for the richer living of San Pietro in Colle, it seems that Titian or an assistant merely adapted the figure of the Virgin in an abandoned Annunciation that had been in the studio for some time. Nevertheless, when the cardinal received his *St Catherine of Alexandria* (Boston, Museum of Fine Arts) in 1568 he professed himself delighted with the clumsy result.

Not all clients were as easily satisfied. When in 1564 the town councillors of Brescia ordered three ceiling paintings for the council hall of the communal palace, Titian went to Brescia where he signed a contract according to which he was paid an advance of 150 ducats, the final price to be determined by a commission after the completion of the work. The canvases were to represent an Allegory of Brescia, Ceres and Bacchus, and the Forge of Vulcan, the latter a reference to Brescia as a centre of the manufacture of arms and weapons, and it was stipulated that they should be entirely by Titian's own hand. Titian failed, however, to anticipate that a committee of provincial town councillors might be less forgiving than individual patrons like Crasso and Bonelli. When Orazio delivered the paintings in the winter of 1568 the councillors, certain they were the work of assistants, refused to pay more than 1,000 ducats for them. Orazio refused the payment, and Titian continued to insist that he had fulfilled the terms of the contract. He appealed to the Bishop of Brescia, to his friend Cristoforo Rosa, the Brescian painter of illusionist frames; he sent Orazio and his young relative Marco Vecellio to negotiate with the councillors. In the end he backed down from a threat to take the matter to arbitration, which suggests that the councillors may have been correct in their suspicions. There is no way of telling because the paintings went up in flames in 1575; and the only evidence we have of their appearance

is an engraving by Cornelis Cort of *The Forge of Vulcan* and a sheet of drawings by Rubens after preparatory drawings for the Allegory of Brescia.

Titian certainly did not regard the Brescia paintings as a priority. At the time of the commission he was at work on two paintings for Philip; and in the autumn of 1565, shortly after he had acknowledged his final instructions from the town councillors of Brescia, he travelled home to Pieve di Cadore to discuss a commission there. Leaving Orazio behind to mind the studio and explain the delays to the Brescia paintings – it was too hot, it was too cold, the varnish wouldn't dry – he took with him Emanuel Amberger and Valerio Zuccato, who were joined by Marco Vecellio. Titian and the assistants were in his house in Pieve on 1 October to witness his creation, by right of his power as knight palatine, of Fausto Vecellio as a notary. The purpose of the visit was to inspect and measure the chancel of the parish church of Santa Maria Nascente which was to be entirely decorated with frescos on a Marian theme executed by the assistants to designs that would be made by Titian after he returned to Venice with the measurements. The project was completed in 1567 after Titian agreed to drop his price from 500 to 200 ducats, which was financed by public subscription, the first instalment being paid in lieu of cash with fifty cartloads of timber.[19]

Titian in the meantime had not neglected his unsolicited promise to devote the remaining years of his life to providing the King of Spain with paintings. Although the *Rape of Europa* marks the end of his brief Indian summer, he would send eight more paintings to Spain. Although they are almost the only works to leave his studio in the last years of his life that we can be certain he considered to be finished, these last paintings for Philip were largely ignored by art historians and by the public until the early twenty-first century when some were shown in public exhibitions.[20] Before that Spain was by and large off the map for art historians, who were more drawn to Italy, the fountainhead of Renaissance art. Most of the late paintings for Philip were in any case locked away in the Escorial where they were difficult to access. Although some are in bad condition they look, on the whole,

more finished or less apparently experimental than the pictures he did not send to Philip and for that reason are treated by some scholars as touchstones in the debate about Titian's stylistic intentions in the last years of his life.

Titian's correspondence with Philip and Philip's about Titian to his ministers in Italy and Spain are well preserved. In the aftermath of Cateau-Cambrésis and the beginning of a steady flow of silver from the Americas, the king was in a position to pay Titian on a more regular basis than previously, and when payments were delayed it was not for lack of effort on Philip's part to speed on his reluctant officials. Under those circumstances Titian's continual demands for money, and his habit of withholding paintings Philip had never requested in the first place until the next payment arrived, his pleas of poverty and exaggerated old age may seem to us, as they did to some of his contemporaries, to be indications of encroaching senility. If so, Philip, the desk-bound bureaucrat who maintained that he ruled half the world with two inches of paper, never suggested that Titian was unreasonable. Overworked though he was, his passion for art never dimmed, and he would continue as he had begun to encourage Titian and to do everything in his power to support his claims.

TWO

The Spider King

God has turned into a Spaniard.

SIXTEENTH-CENTURY ITALIAN SAYING ABOUT
PHILIP II OF SPAIN

After his return from Flanders in the summer of 1559 Philip II never again set foot outside Spain. From now on he spent his days at one or another of his desks in Castile, the centre of the Iberian peninsula – like a spider, so it was said, motionless at the centre of its web – toiling over mountains of documents: issuing or annotating hundreds of reports each day, studying maps, calculating numbers and troop movements, transferring bullion and bills of exchange. *Le roi paper-assier* had been recalled to his kingdom by American silver, and as more bullion flowed faster from his mines in Mexico, Peru and the Caribbean the axis of financial and economic power in Europe shifted westward away from the Mediterranean towards the Atlantic with Spain at its hub. It was from Spain that the 'Catholic King' played the primary role in calling the last session of the Council of Trent. When it rose in December 1563 Philip's Spain was established as the spearhead of the Counter-Reformation. Protestants who suffered from his brutal enforcement of orthodox Catholicism called him the demon of the south, but for his Spanish subjects he was their Solomon, their Prudent King – two views of this complex ruler that persist to this day.

He was a well-informed, dogged and in many ways a talented bureaucrat, who had been well trained to take over the enormous

empire passed on to him by a father he revered and desperately tried to emulate. But Philip had a weaker character than Charles, and his health suffered under the stress of his responsibilities, as well as an unhealthy diet after his return to Spain: in 1563 he had his first attack of the gout that had plagued his father. His blinkered piety, obsession with detail, inability to speak foreign languages, indecisiveness and failure to travel to his foreign dominions left him too often unable to see the wood for the trees. He preferred soft slippery words in his ear to strong decisive advice, and thus fell victim to factionalism at his court, which had hardened during the revolt of the *comuneros* in the first years of Charles's reign and would flare up again over his own policy of repressing heretics in the Netherlands.

Philip ascended the throne of Spain in a Europe that was fundamentally changed by the abdication of his father. Charles V had presided over an unwieldy, outmoded empire, which, after his abdication and decision to partition his inheritance between Philip and his brother Ferdinand I, served no purpose. Without the unifying force of one all-powerful personality European governments in the second half of the century focused inwards and exercised more control over their subjects, a cause for discontent and factionalism in the upper classes, as well as among the over-taxed poor, whose numbers increased disproportionately as populations swelled in the peace that followed Cateau-Cambrésis. Expanded government activity required the support of enlarged civil services, but since few could afford to pay their officers living wages, corrupt practices – from fees for favours to outright bribes and the sale of offices – were tacitly accepted. With domestic problems taking precedence over foreign relations, the age of ambassadors began drawing gradually to a close as high-ranking diplomats were replaced by lesser men employed to gather information or to spy rather than to negotiate. Inflation soared, fuelled by the inflow of American bullion and the Habsburg habit of living on credit; and as usual it was the unemployed poor who suffered most from the price revolution. The widespread appeal of militant Calvinism threatened all weak governments, but most disastrously from Philip's point of view those of France, his monolithic and

powerful neighbour, and of the Netherlands, an important market for Spanish commodities, which would come to rival Venice as a centre of diamond cutting and publishing, and whose port of Antwerp was beginning to replace Venice as the most active in Europe.

Philip's struggle to control a scattered empire that was calculated by contemporaries to be twenty times the size of the ancient Roman Empire was compounded by the problem of distance. The Habsburgs had perfected a courier and postal system that was unprecedented for speed and efficiency, but it was never fast enough to keep up with events: messages between Castile and Brussels took at least three weeks, and eight months or more to and from Peru. Nor was it perfectly reliable, as Titian had learned when his first Entombment for Philip went astray. The peace settlement at Cateau-Cambrésis had an added benefit of allowing Philip's envoys and troops to travel through France, a country that had been closed to Charles V during his perpetual wars with the Valois kings. But the French were still openly in alliance with the Turks, who continued to threaten Spanish Sicily and Spain itself from their satellite bases in North Africa. The behaviour of Philip's mother-in-law the Queen Mother Catherine de' Medici, furthermore, was cause for grave concern. Catherine, determined to retain power until her son the future Charles IX was old enough to rule, oscillated in her support between Catholics and Huguenots, and refused Philip's offer of troops to crack down on the Huguenot heretics. Explaining her conciliatory position in a letter to Rome, she wrote, 'It is impossible to reduce either by arms or by law those who are separated from the Roman Church, so great is their number.' In March 1562, three months after she had in fact issued an edict of toleration of the Huguenots, religious tension in France erupted into war when a Huguenot congregation at Vassy was massacred by Catholics. It was the first civil war France had known for a century, and the first of eight religious wars that would be fought there throughout the rest of Philip's reign.

Philip was obsessed by the spread of Calvinism, which he saw as an international conspiracy, and as the financial position of the Crown improved he set his sights on the Netherlands, a hotbed of heresy and

rebellion, which as far as he was concerned were one and the same. Although Charles had always wanted religious reform in the Netherlands he knew it would have to be incremental. He had also understood the value of stroking egos, and had a genuine bond with the Burgundian high aristocracy through his childhood in Ghent and the Order of the Golden Fleece. Philip had no such sympathies. He had always been suspicious of what was to him an alien culture and his feelings were returned in full measure. Margaret of Parma, illegitimate daughter of the late emperor and also born in the Netherlands, would have made a good governor in normal times. Described by contemporaries as of masculine appearance, she was a woman of considerable abilities although lacking the sensitive political antennae of her aunt Mary of Hungary, and she did what she could to persuade Philip that his repressive measures were doing more harm than good. But the appointment of Antoine Perrenot de Granvelle as prime minister of her Council of State proved a disaster. The aristocracy, led by the Prince of Orange, richest of the Netherlands magnates and a favourite of the late emperor, were insulted by the power invested in a foreign commoner who seemed the personification of royal absolutism. They appealed to Philip for his removal, stirred up popular feeling against him, refused to attend meetings of the Council of State as long as he presided. In 1564 Philip reluctantly 'authorized' Cardinal Granvelle 'to visit his mother in Burgundy'. But the king continued to seek his advice about the Netherlands and a year later sent him to Rome to look after Spanish interests there.

The situation in the Netherlands worsened after Granvelle's removal when a financial crisis left Margaret in a difficult position. She was unable to pay her officials or troops, and her authority deteriorated, opening the way to Calvinist preachers who spread in increasing numbers into the northern provinces from their base in the south. They were particularly successful in areas where there was high unemployment but also made converts among members of the minor nobility, who deplored the Spanish persecution and burnings of their fellow citizens and sympathized with calls for independence from Spain. Philip instructed Margaret to enforce edicts against

heretics and the Netherlands Inquisition. In April 1566 a league of minor noblemen, who called their movement the Compromise because many of them were Catholics, rode to Brussels to present a petition against the government's religious policy. But they were a minority and for the time being succeeded only in earning themselves the nickname of 'beggars'. The real revolution started with the lower classes in the towns where the wages of unskilled workers had not kept up with inflation. There was famine in Antwerp, where the cathedral was devastated by the rebels. The Calvinists were making thousands of converts. Rioting rebels broke into churches, smashing pictures, statues and altars. Margaret managed to calm the situation by promising to abolish the Inquisition. The Prince of Orange, who was compromised in the eyes of both Catholics and Calvinists by his attempts to pursue a moderate policy, fled to Germany and began raising an army. The majority of the high nobility, however, including Orange's friends the Counts Egmont and Hoorn, took new oaths of loyalty to the king.

Granvelle, the Duke of Alba and the new pope Pius V advised Philip to persist with his hard line, but also urgently recommended that he visit Brussels in person. Philip dithered: he was suffering from severe headaches; his wife Elizabeth de Valois was pregnant and ill. He determined to go, he promised to go, but there was always a reason not to. In the summer of 1566 he decided to send his best general, the Duke of Alba, hero of Charles V's victory at Mühlberg, to reassert Spanish authority in the Netherlands. Margaret objected, and there were serious doubts in Madrid about the wisdom of committing military resources so far from the main enemy, the Turk. But Philip, lulled into a sense of false security by the death in that year of Suleiman the Magnificent and the succession to the sultanate of Suleiman's debauched son Selim II, persisted. 'I neither intend nor desire to be the ruler of heretics,' he wrote to his ambassador in Rome. 'If things cannot be remedied as I wish without recourse to arms, I am determined to go to war.' The Iron Duke arrived in Brussels on 22 August 1567 at the head of an army of Spanish soldiers and effectively took over from Margaret, who resigned in protest against his brutal

measures. Alba set up a new court, the Council of Troubles, which over the next several years tried and condemned some 12,000 rebels. He was soon known as 'the butcher of Flanders' and his Council of Troubles as the Council of Blood. Egmont and Hoorn, guilty only by previous association with the Prince of Orange, who was sponsoring periodic raids from Germany, were arrested. Philip waived their privilege as Knights of the Golden Fleece to be tried by their peers; and in June 1568 they were executed in the Grand Place of Brussels. The executions of Philip's brother knights, men who had, moreover, been instrumental in planning the victory of Saint-Quentin, sent shockwaves throughout Europe.

Philip meanwhile had returned to a kingdom that he recognized as a cultural backwater, and was determined to create a civilized royal court that would be a centre of humanist learning and compete with the great palaces and gardens he had seen in Italy, England, southern Germany and the Netherlands. Previous Castilian rulers had held an itinerant court that moved from one major city to another. Philip broke that tradition in 1561 when he moved to Madrid with Elizabeth de Valois and let it be known that Madrid would be his capital city and the permanent seat of his court. It was a surprising choice for the most powerful monarch in Europe. Charles V had recommended Toledo, the residence of the archbishop primate; Valladolid or Burgos, which were legal and commercial centres, would have been acceptable alternatives. Madrid, by contrast, was nothing more than a dusty, squalid village of some 12,000 residents huddled around its medieval fortress, the Alcázar, in the inhospitable climate of the dry Castilian tableland. The reasons for his choice of Madrid, which seemed puzzling at the time, remain obscure. It was geographically at the heart of the Iberian peninsula with his favourite royal palaces and hunting lodges within easy distance, but it was far from the ports that received American bullion. The main attraction may have been the very insignificance of Madrid, as well as its proximity to forests and granite quarries, which allowed him to indulge his addiction to building. Although he transformed the Alcázar into an imposing Italianate palace, which spelled the end of Mudéjar architecture in Spain, he

never devised a proper town plan for his capital, which was developed haphazardly as and when needed to accommodate a rapidly expanding population.

Instead he indulged his passion for gardens, building and forest conservation at the ring of palaces around Madrid – Valsaín, Aranjuez, El Pardo, Toledo – which comprised an area of royal residences without equal in Europe. But Philip's grandest project, and still the best place to understand his dour personality, love of splendour and ideals as defender in chief of the Counter-Reformation, is the great grim granite monastery and palace that he built from scratch on a slope of the windswept Sierra Guadarrama near the small town of Escorial forty-three kilometres north-west of Madrid. He dedicated the Escorial to the Spanish-born St Lawrence on whose feast day, 10 August, his armies at Saint-Quentin had won his only military victory; and he instructed his architect Joan Bautista de Toledo, who had been trained in Rome, to adopt a plan roughly in the shape of the gridiron upon which St Lawrence was roasted alive. Even before the foundation stone was laid in 1562 he defied his father's explicit wishes that his remains and Titian's *Adoration of the Trinity* should remain in perpetuity at Yuste by transporting them to the Escorial where he intended to found the mausoleum that would be the pantheon of the Spanish Habsburgs. In the decades before the complex was finished in 1595 Philip supervised every detail of its construction and interior arrangements, searching the world for rare books and original codices for a library that was intended to establish Spain as a centre of humanist learning, covering its walls with paintings and frescos. Titian was by no means the only foreign artist who received his favour. Philip was an enthusiastic collector of Bosch; the Fleming Anthonis Mor became his court painter around 1560 and was succeeded in that role by his Spanish pupil Alonso Sánchez Coello. A host of lesser-known Flemish and Italian painters were summoned to Spain. Philip's Spanish subjects called the Escorial the eighth wonder of the world.

This then was Philip's situation when Titian sent his next paintings to Spain. One was a *Last Supper* (Madrid, Escorial), which Titian,

writing on 28 July 1563, announced would be ready for delivery in a few days. It was a painting, he wrote, upon which he had been working for six years and was 'perhaps one of the most laborious and important that I ever did for Your Majesty'; and might he beg His Majesty most humbly to console him about the Neapolitan corn 'which was granted to me so long ago by the glorious memory of Caesar', likewise for the promised pension from Pomponio's naturalization in Spain, and would His Majesty deign to write to the Duke of Sessa about the pension due from the chamber of Milan, 'of which I have not had a quatrino for more than four years'? On 6 December, having heard nothing from the king, he wrote again begging for 'a sign if not a letter' from His Majesty, which 'would add ten years to my life and be an incitement to send with a more joyful heart the Last Supper of which I wrote on previous occasions'.

Three months later, on 8 March 1564, Philip acknowledged receipt of Titian's letters in a packet addressed to García Hernández, to whom he wrote that he would be glad to receive the *Last Supper* (Madrid, Escorial) now that it was finished. He also enclosed a letter to Titian with copies of his orders made that day to the governor of Milan and to the viceroy of Naples to settle his claims over the pension and the grant to export corn from Naples. In the same post came a letter to Titian from Antonio Pérez, the illegitimate son of Gonzalo who was bedridden with gout. The younger Pérez at twenty-four was dapper, vain, greedy, ambitious and, as it would transpire, a corrupt courtier, who had studied at Padua and Venice and was already beginning to take charge of Italian affairs. Philip distrusted him at first, and split Gonzalo's job between Antonio and another courtier. Although the king's instinct would prove correct years later when it was discovered that Antonio was selling state secrets, after his father's death in 1566 he became Philip's most powerful secretary, wielding considerable and in the end baleful influence on the king while making himself a rich man.[1] Pérez assured Titian that when the *Supper* arrived he would see to it that the king sent a suitable acknowledgement. But when Hernández replied to Philip on 16 April 1564 he had to report that the *Last Supper* was not finished after all, and that Titian was prepared to drop his

claim on the Naples corn because he was an old man and could not find or remember the relevant documents. Titian promised that the *Supper* would be ready in May. May came and went, and on 11 June it transpired that it would not be completed for another three months.

The pattern was all too familiar: Titian proposing a subject, Philip expressing enthusiasm, Titian obsequious but withholding the painting until he was certain of receiving overdue payments, Philip's officials reluctant to release the funds. The rhythm of their relationship skipped a beat on 31 August when Philip, who in the previous year had laid the cornerstone of the monastery at the Escorial, requested a specific subject for the first time since his arrangement with Titian at Augsburg. In a short minute to Hernández the king enquired whether Titian was still disposed to work because he would like him to paint a picture of the *señor sant lorenço*. Hernández, who seems to have regarded Titian with a mixture of admiration and exasperation, replied briefly that the painter was well able to work 'since in order to get money he has gone from here to Brescia'. On the same day, 8 October, he wrote a longer and more interesting letter to Antonio Pérez in which he informed him that, although 'the painting of Christ at the Supper' was finished, Titian was claiming that it was not, 'which I suspect is due to his covetousness and avarice, which make him keep it back, and may continue to do so, till the King's dispatch arrives ordering the payment to be made'. Hernández would, however, still try to obtain it and make him begin the *St Lawrence*:

> For though he is old he works and can still work, and if there were but money forthcoming we should get more out of him than we would expect from his age; seeing that for the sake of earning he went from hence to Brescia to look at the place in which he has to set certain pictures just ordered of him ... and if Your Magnificence should like some little things from the master's hand it would be a fitting and easy opportunity ...

Titian, who was accustomed to trading pictures for favours, would have understood, and may have been behind, the suggestion that

'some little things' might engage the secretary's interest in pursuing the matter of his pension, which had still not been paid by the new governor of Milan Don Gabriel de la Cueva. *Venus Blindfolding Cupid* (Rome, Galleria Borghese) looks as though it was painted around this time; and since a picture of the same subject is mentioned in 1585 as belonging to Antonio Pérez, it is not impossible that it was painted for him.[2] Although in bad condition it has the hallmarks of a largely autograph work: the broken brushwork, the sensuous textures of hair, flesh and skin, the palpability of the cupid at Venus' back nestling in her blonde curls, the subtle colouristic harmony and rosy glow cast by evening light over the mountains of Cadore, as well as the major pentimenti associated with his method of working on autograph paintings.

The composition was modelled on the *Allegory of Marriage* of three decades earlier, and the features of Venus – black eyes, blonde hair pulled back off her face, straight-bridged nose and small, full mouth – are similar to his Reclining Venuses. His original idea, which has been detected by X-ray, was for a portrait of a lady in court dress wearing a tilted hat with feathers accompanied by the two cupids, as in the Rome picture, but three rather than the two female figures we see today.[3] The presence of two cupids has invited a number of allegorical interpretations according to which they are Venus' twin sons Anteros and Eros. Anteros represented either Platonic 'higher' or divine love, or love reciprocated, Eros earthly, irresponsible love. So the higher or reciprocated love watches over his mother's shoulder as she blindfolds Eros to prevent him from doing harm.

Hernández continued his letter to Pérez with a suggestion.

In a monastery of this city there is a picture of St Lawrence done by Titian many years ago … The friars have told me that they would give it for 200 scudi, and it could be copied by Girolamo Titiano, a relative or pupil who has been in Titian's house more than thirty years, and is considered the next best after him; and if His Majesty should like these they could be had more quickly. I beg Your Magnificence to advise me as to this …

He was referring to the *Martyrdom of St Lawrence* (Venice, Church of Santa Maria dei Gesuiti)[4] which had been commissioned by Lorenzo Massolo and his wife Elisabetta Querini, for the family tomb in the church of Santa Maria dei Crociferi,[5] in the late 1540s but remained unfinished after Lorenzo Massolo's death in 1557, when Elisabetta instructed the executors of his will to see that it was brought to completion as soon as possible. We don't know for certain if she saw it in situ before she died in 1559 because there is no documented mention of it before Hernández's letter to Pérez. Titian's source was the account of the martyrdom of St Lawrence in *The Golden Legend* in which the Roman emperor Decius commands the saint, 'Sacrifice to the gods or thou shalt pass the night in torments,' and Lawrence answers: 'My night hath no darkness. All things shine with light.' Those lines prompted Titian to explore the chromatic qualities of the different sources of light – the firelight under St Lawrence, the torches held up by his executioners, the Holy Spirit that breaks through the clouds in a bolt of lightning – so that you see, as his anonymous biographer put it, 'not only the figures of the bodies but the very air of the dark night illustrated by light'. He employed a visual vocabulary enriched by first-hand knowledge of the works of Michelangelo, Raphael and other central Italian artists and of the antique buildings he had seen in Rome. The giant Corinthian colonnade that runs diagonally across the left side of the picture may refer to the Temple of Hadrian in the Campus Martius in Rome: there was no building like it in Venice until Palladio's façade of the church of San Francesco della Vigna was completed in 1564. The torso of the figure of St Lawrence is taken from a Hellenistic statue, the *Dying Gaul*, that was then in the Grimani collection in the doge's palace, but with his left arm stretched towards the lightning that will transform the saint's physical body – according to a dictum of the Council of Trent – into spirit. The executioner prods the torso with his long fork in response to the saint's stoically ironic request: 'See, I am done enough on this side. Turn me over and cook the other. Now you can test the work of your god Vulcan.'

It was his first night scene and the most authentically Roman of his paintings so far. But the monks of the Crociferi, who were

prepared to sell their *St Lawrence* for the derisory sum of 200 ducats, cannot have thought very highly of it. Nevertheless, if Hernández and Girolamo Dente had reason to believe that Titian would accept the idea of sending it and a copy by Dente to Philip he changed his mind on his return from Brescia when Titian insisted that he would paint a new version himself, and, so Hernández informed the king, would not remove his hands from it until it was finished. Hernández also reported to Philip that Titian was in excellent form but that this was the time, if ever, to get 'other things' from him because according to some people who knew him Titian was about ninety years old, though he didn't show it, and would do anything for money. Philip, who was given a précis of Hernández's latest letters about the *Last Supper*, the pensions, Dente's offer of a copy of the *St Lawrence* and Titian's decision to paint a new one, wrote his usual laconic notes in the margin.

> Orders have been sent to Milan to make the payment; and as to matters here, I don't know how they stand.
>
> The picture should be bought from Titian's relative for 50 ducats. Titian's should not be taken unless it differs from the first, for then there would be two instead of one.

The *Last Supper* was finally dispatched later in October. It was probably a variation of a now lost Last Supper he had done a decade earlier for the refectory of the monastery of Santi Giovanni e Paolo;[6] and it cannot have been originally intended for Philip because he had not mentioned it to him until 1563 when he said he had been working on it for six years, the years in which he had reserved his best autograph paintings for the king. Indeed, technical investigation has shown that it was executed with considerable studio assistance. Even so the *Last Supper* that arrived at the Escorial may have been as fine a painting as Titian and Hernández had claimed. Unfortunately, however, it was too large for the wall in the refectory for which it was intended, and an immediate decision was taken to cut it down on all four sides. The painter Juan Fernandez Navarrete, known as 'the Titian of Spain',

protested, but Navarrette, who was deaf and dumb, failed to prevent the amputation. And that was just the beginning of the destruction of Titian's *Last Supper*, which was subsequently repainted so often that original surface colours were buried alive, leaving only the rhythmic grouping of the figures, especially of the Apostles on the right of Christ, as evidence of the master's contribution.

While his most recent offering to Philip was being mutilated in Spain, Titian in Venice had the outline composition of his first *Martyrdom of St Lawrence* for the Massolo transferred on to a fresh canvas of similar size but slightly different dimensions and with a squared rather than an arched top. He must have known how important the subject was for Philip, given that he had never before requested a specific subject; and Philip's *St Lawrence*, which he executed without assistance, was the most significant project under way in the studio and one of the most expressive of all his paintings. It is unlikely that the variations Titian made on the earlier version were intended to comply with Philip's order that his *St Lawrence* should differ from the first, which the king had never seen and never would. This was not the first time that the opportunity to reconsider a previous painting would inspire in Titian an even greater, more deeply considered treatment of the same subject.

He cancelled the stagey Roman portico and replaced it with the arch of an atrium in which the action is enclosed. It is less theatrical than the Gesuiti painting but more intensely dramatic and more crowded. Titian, who had never been interested in exploring deep space, pushed the scene more insistently forward to the front of the painting. Expecting that the picture would be seen in flickering candlelight, he used his own interior lighting: the flames that roast the saint and the flickering torches that flank the pagan altar sending sparks into the darkness explore the textures of flesh, stone and metal. The brushwork is very loose, the paint apparently applied at speed as though the old painter could scarcely keep up with his ideas. There are new elements: a Roman soldier directing the martyrdom on horseback, a spaniel looking the other way, a barefoot boy in green with his hands manacled – is he another innocent prisoner? Two baby

angels (quoted from his most famous work, the St Peter Martyr of 1530) tread the smoke-filled air at the top of the painting waiting to crown the spirit of the saint when it is released from his tormented body. Did Titian dream the nightmare he painted in the background outside the atrium arch? A pale sickle moon emerging from wind-swept clouds casts its eerie light on – what? Is it an escarpment? the ruin of a fountain? Is the indistinct stick-like figure carrying some kind of weapon and running towards the martyrdom another Roman soldier or a Christian seeking his own salvation? Perhaps he is attempting to rescue the innocent boy in green? Is it the spectre of approaching death?

The *Martyrdom of St Lawrence* (Madrid, Escorial, Old Church) was ready for dispatch to Spain on 2 December 1567, when Titian addressed a mean-minded letter to the king blaming its late delivery on 'the delays, indisposition and death' of García Hernández: not a word of commiseration about the envoy, who had been his intermediary with the king for years and had been responsible for advising Philip that Titian was not too old to take on the new *St Lawrence*. Titian went on to say that he had heard that His Majesty wished to have paintings of scenes from the life of St Lawrence, and if he would inform him of the size and lighting of each piece the saint's life could be illustrated in eight or ten pictures, which he would do with the assistance of Orazio and 'another clever assistant', presumably Emanuel Amberger. But this series, like the one of the emperor's military victories that he had offered previously, was never realized. The letter concludes with the usual complaints about the overdue pensions from Spain and Milan, as well as a renewed request for the claim on Naples, about which he had lost the relevant documents, to be settled. This was followed by further apologies for the delay in sending the *St Lawrence* 'through the fault of Your Majesty's ministers', and a douceur: 'I may add that I send with that picture a Naked Venus, which I finished after the St Lawrence was completed.' This was a variant on the Washington DC *Venus with a Mirror and Two Cupids* of about a decade earlier, which Titian had kept in his studio. Philip's Venus is lost but is known from a copy by Rubens.

Philip had intended his *St Lawrence* for the high altar of the basilica, which was to be the centrepiece and raison d'être of the Escorial but for which he had not yet settled on a plan. The painting was placed temporarily over the high altar of the Escorial Old Church, but turned out to be the wrong size for the basilica altar as finally designed. And so it remains to this day in the Old Church, a small oblong room on the first floor of the monastery, where it covers the whole altar wall up to the ceiling. Despite considerable damage, the vibrancy of the brushwork with which Titian has modelled his figures against the dark background has not been lost. And when, after centuries of its being locked away from the gaze of all but the most persistent or well-connected visitors, it was shown for the first time at a public exhibition at the Prado in 2003, it prompted a reassessment of Titian's capacity to paint in his old age.

Although the *Martyrdom of St Lawrence* was the largest and most ambitious work of Titian's later years, it was by no means his only preoccupation in the three years it took to complete. Nor was he above using a subject especially dear to Philip's heart to twist the king's arm with regard to overdue payments by stalling and pleading poverty. On 18 July 1565, in the summer after he had agreed to paint the *St Lawrence* himself, he wrote to Philip complaining that the treasury of Milan had had the effrontery to pay some of his pension in the form of a warrant for rice, which had put him at a loss of more than 100 ducats, so would His Majesty make good 'the loss I have sustained so that, having no other salary, I may be able to live in the service of Your Majesty with that small sum which the glorious memory of Caesar Your Majesty's Sire and Your Majesty's self conceded to me'. He would await the effect of Philip's infinite kindness, meanwhile proceeding with the 'picture of the Blessed Lawrence'.

Philip would not have known or cared that Titian was an extremely wealthy man who, far from having no salary, could count on his *sanseria*, the annual brokerage fee on the Fondaco dei Tedeschi, for life (although the tax exemption worth about eighteen to twenty ducats per annum was cancelled in 1566), never mind high fees for paintings,

as well as the proceeds from the timber and real estate businesses managed by Orazio. We know something about the extent of his holdings in real estate from a tax return on landed property that all Venetians were required to present to the tax authorities, the Ten Savi alle Decime, the Magistrates of the Tithes, which Orazio wrote out in the summer of 1566.[7] He declared the house at Biri Grande for which he was paying a rent of sixty ducats annually to Madonna Bianca Polani for the piano nobile, studio and garden, in addition to which he paid her thirty-two ducats for two mezzanine flats which he subleased to tenants (he took care to say they were not prostitutes) who paid fourteen and sixteen ducats respectively, thereby incurring a loss of two ducats. The house at Cadore in which Francesco had lived produced nothing more than a load of hay from an adjoining meadow. Two sawmills at Ansogne (which he and Francesco had bought from Vincenzo Vecellio in 1542 for the knock-down price of thirteen ducats), were let for twenty-four ducats each but involved expenses for embanking the River Piave. There was a house in Conegliano, and various fields, meadows and cottages, some of them rented out, in the territory around Cadore and Serravalle including the ten fields, cottage and villa on the Col di Manza. He gave his income from property as about 101 ducats. The return, which has been described as 'a masterpiece of fiscal evasion',[8] makes no mention of the timber yard at San Francesco della Vigna, which belonged technically to the community of Cadore, or of another one on the Zattere, which seems to have belonged to Orazio.[9] Although he was not required to declare other sources of income, let alone the profits Orazio was making from the timber business, he gave the impression that the 101 ducats represented his entire wealth, a sum so small, he claimed, that he found difficulty in maintaining his family.

If Titian in his late seventies had become more close-handed than ever about money, his capacity to switch the beam of his creative intelligence from one to another of the unrelated artistic projects in his studio at the same time was scarcely diminished. In the winter of 1565–6, while working on the final stages of Philip's *Martyrdom of St Lawrence*, he invited the Flemish master engraver Cornelis Cort to live

in his house in order to begin, under his close supervision, a process of recording with copperplate engravings a selection of his works from the previous fifteen years. Titian, who had designed his own original woodcuts as a young man, understood the art and the commercial value of printmaking. He licensed engravings of his works before and after his collaboration with Cort, and it is thanks only to printed versions of some of his most important earlier paintings that are now lost that we know what they looked like and that Ridolfi was able to describe paintings he had never seen because they had long since been sent away from Italy.

But of the thirty or so engravings made after his works those Cornelis Cort made in 1565–6 and on a return visit to Venice in 1571–2 are in a class of their own. Cort, who was thirty when he was summoned to Biri Grande from Antwerp, was a genius in his medium. Although he had the advantage of working closely with Titian, it is the artistry with which he employed his burins that reproduces in black and white the fluttering lines of Titian's brushstrokes and gives a sensation of colour with a masterly use of light and shade. Titian chose five paintings and one drawing for Cort: the recently completed San Salvatore *Annunciation*, Charles V's *Trinity*, Mary of Hungary's *Tityus*, Philip II's *Diana and Callisto* and its studio variation, a Mary Magdalen, and *Ruggiero and Angelica*, an episode from Ariosto's *Orlando Furioso* of which he had made a superb drawing (Bayonne, Musée Bonnat) some ten years earlier. The selection was based on several considerations. They were subjects likely to appeal to a wide public; three of them paid homage to the patronage of the Habsburgs; and the set intentionally demonstrated the diversity of his creative range: sacred and mythological subjects, landscapes with figures, the monumental *Trinity*, and a half-figure of the ever-popular Weeping Magdalen.

Cort's *Annunciation* is the most faithful to the painting apart from the way the image, which was not reversed on the copperplate, appears on impressions in mirror image. This must have been deliberate because Cort was not an artist who would have made that kind of blunder, and the impressions of *Ruggiero and Angelica* and *Diana and*

Callisto are also reversed. Was it an experiment that allowed Titian to see how his inventions looked in reverse order? He often reversed later versions of earlier subjects, as with the *Entombment*, the *Tribute Money* for Philip of Spain, and the *Death of Actaeon* in which Diana, who was positioned on the spectator's right in Philip's *Diana and Actaeon* and *Diana and Callisto* presides over the tragic denouement of the story from our left. If the *Annunciation* was their first project, most of the engravings that followed were reinterpretations rather than copies of the originals, the compositions were simplified and some details changed to make them more accessible, to work better in black and white or perhaps to satisfy Titian's restless habit of making changes. The engraving of *St Jerome* is a new variation on a favourite theme in which the saint seated on a rock is absorbed in reading against a wild mountain landscape.

The most ambitious of the six engravings, and the one that carried most prestige, was taken from the *Trinity*, which, although the painting had been sent to Charles V more than ten years previously, is close enough to suggest that it must have been based on a prototype drawing or painted model that had been kept in the studio. Cort made numerous small changes to the lighting and to the gestures and costume of the figures, not least to the profile of Titian on the right edge of the picture, which is much more explicitly recognizable than in the painting. Whereas in Charles's original he had portrayed himself as a bareheaded and half-naked supplicant, in the engraving he wears the more dignified turban and cloak suitable to his status. There is a reduced painted version of the *Trinity* in the London National Gallery, but its relationship, if any, to Cort's engraving is problematic. Although superficially very similar to the original picture in the Prado, it was painted over a cruder version that has been detected by X-ray and parts of which can be seen with the naked eye where the top layer of paint has worn away revealing different colours – Mary Magdalen's dress, for example, was pink; the robes of Christ and David were partly red – that would not have been used as base colours for the Magdalen's green dress or the blue robes worn by Christ and David. A plausible theory about the evolution of the

London painting[10] is that it was first taken from Cort's engraving by an inferior and unidentifiable artist who did not have access to the original in Spain. At some time not later than the eighteenth century, the picture came to Spain (where it is in fact first recorded) where a painter, probably a clever forger who was in a position to see the original, corrected the colours and all but a few of Cort's changes, perhaps with a view to convincing a dealer that his version was the model that had been kept in Titian's studio.

On 4 January 1567 the inquisitor Valerio Faenzi, who was responsible for vetting the content of religious works seeking publication in the territory of the Venetian Republic, authorized Cort's engraving of 'the most saintly Trinity by the excellent master Ticiano, in which there are many figures from the Old Testament' as 'a work that deserves to be seen to the honour of God and worthy of every privilege'. On 22 January the three *capi* of the Council of Ten granted a privilege to publish, which was followed on 4 February by a copyright authorized by the Senate. It entailed strict fines for plagiarists – plagiarism was a not uncommon practice in the Veneto – to be valid for the next fifteen years. This was unusual. A copyright, which gave the holder the right to all proceeds from sales, would normally have been granted to the engraver. But it may be that Cort, whose name had not appeared on the first impressions, was content with the prize of having his name along with Titian's on subsequent states of the engravings.

Titian supervised the international distribution of the prints, sending first impressions of the *Trinity* to his most illustrious patrons, among them Philip II, Margaret of Parma and Cardinal Alessandro Farnese. He used a dealer in art and antiques, Niccolò Stoppio, to dispatch the complete set to the Flemish humanist Dominique Lampsonius, secretary to the Prince-Bishop of Liège and responsible for recommending Cort to Titian in the first place. On 3 March 1567, soon after Cort had left for Rome taking with him an impression of the *Trinity*, Lampsonius wrote to Titian praising all six but especially the *St Jerome Reading in the Desert*. The hand of Cort, he wrote, was bolder and more rapid than that of any other engraver who had

reproduced Titian's compositions and gave grace to the wildness of his landscapes,

> among which that desolate and lonely little landscape with St Jerome is unique in the world and which I can imagine with the greatest pleasure how it would have been coloured by the most felicitous hand of your Lordship in such a way that the figure of St Jerome would have been large as life, just as I persuade myself that Your Lordship has made it. And in fact Your Lordship has by a long way stolen the reputation for landscape from our Flemish landscape painters (because you Italians are the winners as regards figures) in that aspect of painting in which we thought to hold the field.

Titian was close to eighty when he sent the *Martyrdom of St Lawrence* to Spain, and on some days, when the Venetian winter crept into his bones or the humidity of high summer caused the brushes to slip in his arthritic fingers, he felt even older. Although he knew he had long since been immortalized by his paintings, he wanted the studio to continue operating after his death. Unlike Tintoretto, Veronese and the Bassano, who ran family practices in the Venetian tradition, Titian had only one child who was competent to succeed him. He had done his best to promote Orazio's paintings with the Venetian government and with Philip of Spain. Now the time had come to reward the son who had served him so faithfully and would continue to do so until they were parted by death. In April 1567 he applied to the Council of Ten to transfer his *sanseria* to Orazio, 'the image of myself'. It was an unusual request, one that would have required the government to pay Orazio, who was still only in his early forties, for many years to come; and it was turned down, although by only one vote. A few months later he applied again, this time suggesting a reduced time limit of twenty-five years for the payments. This too failed. He tried again. This time he admitted to what he thought might be the stumbling block. Yes, he had worked for many foreign patrons. Nevertheless, he had refused all invitations to join their courts on a permanent basis and had served the Republic faithfully throughout his life. The

granting of his petition would therefore be an example to other artists to live virtuously and faithfully in order to perpetuate the glory of the Republic, in the service of which 'Orazio my son desires above everything to live and to die in your good graces'. In April 1569 the Ten voted that the *sanseria* would be paid to Orazio for a period of fifteen years.

The process of passing on to his younger son the wealth that Titian had all his life gone to such lengths to enhance and protect continued into the 1570s. A plan to transfer his pension on Milan to Orazio, which Titian had first mooted in a letter to Granvelle in 1548, was ratified by Philip in July 1571 and confirmed by the Senate of Milan in June of the following year. By 1573 most of the real estate acquired over the years by Titian and Francesco, including the villa on the Col di Manza and the fields near Ceneda, were registered in the name of Orazio. Orazio went to Brescia once more in 1570 to negotiate with the town councillors about the ceiling paintings. But three years later Titian sent his young relative Marco Vecellio there instead. Orazio never again left Venice or his father's side where, as well as running the businesses and the studio, he collaborated more often on the commissioned paintings.

The Biographer, the Art Dealer and the King's Annus Horribilis

It is true that his method of painting in these late works is very different from the way he worked as a young man. For the early works are executed with a certain finesse and an incredible diligence, so that they can be seen from close to as well as from a distance; while these last pictures are executed with broad and bold strokes and smudges, so that from near by nothing can be seen whereas from a distance they appear perfect. This method of painting has caused many artists, who have wished to imitate him and thus display their skill, to produce clumsy pictures.

GIORGIO VASARI, 'LIFE OF TITIAN', 1568

Giorgio Vasari's 'Life of Titian', published in 1568 in the second edition of his *Lives of the Most Excellent Painters, Sculptors and Architects*, is an essential source for all subsequent biographies of Titian. But the story of how it came to be written is not straightforward; nor, although anyone who writes about Titian cannot avoid referring to 'Vasari', was the 'Life' composed entirely by Vasari.[1] When in the early 1560s Vasari decided to include Titian in a second edition of his *Lives* he knew very little about his subject's life and works, apart from those he had seen in Venice and Rome. And at the time he visited Titian's studio in 1566, the two men had met only twice before: in 1541–2 when Vasari had spent thirteen months in Venice and again in Rome in 1546 when he had acted as Titian's guide to the Holy City. He therefore delegated the task of gathering information

to his friend and fellow Tuscan Cosimo Bartoli, who was the Florentine ambassador in Venice; and shortly after Bartoli had taken up his post there in 1563 he wrote to Vasari promising a list of paintings by the Venetian master. But Titian, who was still offended by his exclusion from the first edition, proved uncooperative. Bartoli, unable or unwilling to force himself on the venerable master, turned instead for information to Titian's amanuensis Giovanni Maria Verdizotti. By the time Vasari visited Titian's studio in May 1566 the 'Life' had already been drafted by more than one hand, as one might suspect from internal evidence and the different styles in which it is written, sometimes in the first person as though by Vasari, but sometimes referring to Vasari in the third person as in 'When Vasari was in Venice … Titian introduced to him his talented young friend Giovanni Maria Verdizotti.'

Vasari, who spent only five days in Venice, from 21 to 25 May, was further handicapped by the absence of most of Titian's greatest paintings, which had been sent to their foreign patrons, some as far back as the 1520s. Although he had been travelling for the book in northern Italy, he is vague about the Este Bacchanals in Ferrara (he fails to mention *Bacchus and Ariadne* and conflates the *Worship of Venus* with the *Andrians*), the great Gonzaga collection in Mantua and the della Rovere paintings in Pesaro, presumably because he did not gain access to the ducal palaces. Verdizotti was in a position to fill him in about the Habsburg pictures and may have been responsible for the famous passage about the blotchy style of Philip II's *poesie*. He had been working for Titian since the death of Aretino in 1556, and since he was treated as a member of the household may also have provided details of the early life, which are remarkably accurate. But the chronology of the rest of the biography is muddled partly by lack of information (it seems that the authors failed to consult Aretino's letters or Dolce's *L'Aretino*), partly by a decision to organize the biography thematically rather than chronologically, and partly because it would have been impossible to discuss Titian's entire life's work up to 1566 in the few pages Vasari allocated to his 'Life'. He confesses as much when he interrupts a section about the portraits to comment, 'But

what a waste of time this is! For there has been hardly a single lord of great name, or prince or great lady who has not been portrayed by Titian, a painter of extraordinary talent in this branch of art,' then covers his omissions: 'As well as the works I mentioned earlier he did many others at various times.'

The 'Life of Titian' as put together by Cosimo Bartoli and Giovanni Maria Verdizotti was ready for the typesetters in 1564 or 1565, before Vasari interviewed Titian in Venice. As it happened, work on the last section of the book was suspended during his preparations for the ceremonial entry into Florence of the Archduchess Joanna of Austria, the consort of Cosimo de' Medici's heir Francesco. This is fortunate because Vasari was able to extract some valuable information from Titian that we might not otherwise have had. Titian, for example, persuaded him that he, rather than Giorgione, as Vasari had stated in the first edition, had painted the *Christ Carrying the Cross* for the church of San Rocco: 'This image (which many people have attributed to Giorgione) is today held in the greatest veneration in Venice, where it has received in alms more crowns than Titian and Giorgione ever earned in all their lives.' In the studio Vasari saw, among other paintings, some of which cannot be traced, the *Self-Portrait of Titian*, which we can date to 1562 because Titian told Vasari that he had finished it four years earlier. We also know from Vasari that the *Martyrdom of St Lawrence* for Philip, the Crucifixion for Giovanni d'Anna's altar in the church of San Salvatore, the votive *Portrait of Doge Antonio Grimani* and the three ceiling paintings for Brescia were all still in the studio 'sketched in and begun'.

When printing of the *Lives* resumed early in 1568 it was done in such great haste that errors inevitably went unnoticed. A portrait of Titian accompanies the 'Life of Alfonso Lombardi' and Titian's 'Life' is illustrated with a portrait of another man. There is also an inconsistency, probably a typographical error, that continues to cause confusion about the thorny question of Titian's date of birth. In the first sentence of the 'Life' Vasari recounts that Titian was born in Cadore in the year 1480. At the end, however, he gives Titian's present age at the time of his visit to the studio in 1566 as seventy-six, that is,

born in 1490, a date that accords approximately with the views of most scholars today.

After Vasari had returned to Tuscany in the autumn of 1566 a group of Venetian artists applied jointly for membership of the Florentine Accademia del Disegno, which had been founded three years earlier by Cosimo de' Medici acting on Vasari's advice (it still exists with the purpose of safeguarding Italian art). The applicants were Titian, Andrea Palladio, Giuseppe Salviati, the sculptor Danese Cattaneo, Battista Zelotti and Tintoretto. The council of the Accademia noted that the artists were all known to Vasari and answered their letter immediately, having waived whatever reservations they may have had about the Venetian style to vote unanimously to enrol them as members.

Vasari, who had found Titian 'in his studio, despite his great age, busy about his painting, with his brushes in his hand', was not alone in his opinion that it would have been better if Titian had given up painting when his powers began to fail. It was also in 1566 that the Venetian agent of the friendly Guidobaldo II, Duke of Urbino, felt it necessary to reassure the duke that a Christ and a Madonna were by Titian's hand. Guidobaldo was in fact delighted by the Madonna when he received it the following year. But in 1568, in a letter addressed to Max Fugger on 29 February, Niccolò Stoppio, a gossipmonger and dealer in art and antiquities, reported to Max Fugger that:

> Everyone says he no longer sees what he is doing, and his hand trembles so much that he cannot bring anything to completion, but leaves this to his pupils. He has a German in his house, Emanuel ... who is excellent and does many things for him which he then finishes with two strokes of his brush and sells as his own work.

Stoppio, who was Flemish by birth but had been resident in Venice since the early 1540s, was one of a flock of predatory scholar-dealers who swarmed over northern Italy in the second half of the century searching for the rich pickings in collections of art and antiquities assembled by a previous generation, whose heirs were more

interested, as he wrote to Max Fugger in 1567, in 'play and betting and women'. Their principal clients were German: the Fugger bankers, the Habsburg Holy Roman emperors and the dukes of Bavaria. Their targets included the Venetian palaces of the Vendramin, Cornaro, Grimani and Venier families and of Andrea Odoni – who was portrayed with his antique sculptures by Lorenzo Lotto in 1532 – as well as Pietro Bembo's collection in Padua, and Giulio Romano's in Mantua. The Vendramin collection was temporarily protected by Gabriel Vendramin's will, which stipulated that it should be kept together in the palace, but Bembo's son Torquato, despite his father's similar request, began disposing of the best pieces in the 1560s and had sold most of the collection by the early 1580s.

Titian was occasionally asked for his opinion about works of art for sale, and Stoppio, for a while, nurtured a friendly relationship with him to add authority to his own eye. In a letter to Hans Jacob Fugger written on 14 December 1567 he claimed, as evidence that he was 'not as slow witted as some people thought', that he had been in Titian's studio fifteen years earlier when the master had taken his advice about two changes to his *Venus and Adonis*. Whether this was true or not, Titian used Stoppio for his own purposes. It was Stoppio who had arranged delivery of Cornelis Cort's engravings to Liège. And in August of 1567 the dealer wrote to Albrecht V, Duke of Bavaria, about a silver-gilt casket set with crystals that was for sale in Titian's house. It belonged to Carlo della Serpa, a friend of Titian and a former high chamberlain to Pope Julius II. Serpa had turned down an offer from the Venetian government of 1,200 crowns and entrusted the casket to Titian with instructions to sell, but only for cash, to the highest bidder. Albrecht was keen. His agent in Venice, David Ott, beat down Titian's asking price from 1,000 golden crowns to 1,000 ducats, but the duke set the condition that although he would pay for transport of the fragile object it must be sent at Titian's risk. There followed heated arguments between Orazio and Ott and Orazio and Serpa about the means of delivery to Munich. Stoppio wrote that Serpa and Titian's son 'chaffered so long that neither of them could speak. It is hard to deal with such curious people.' In November it was agreed in the

presence of two witnesses that Ott would take the risk of transport and either pay the 1,000 ducats and send the casket or return it six weeks hence. It is possible, since a silver-gilt casket was mentioned in an inventory of Titian's possessions after his death, that it was never delivered to Albrecht V.[2]

The casket was a trivial matter compared to Titian's ambitious plan to sell to the emperor Maximilian II, whom he had already provided with an Allegory of Religion, a group of studio paintings, which he intended to pass off as his own. We know what they were from a letter sent to the emperor by the imperial ambassador in Venice, Veit von Dornberg, written on 28 November 1568 in which he mentions that Titian could provide paintings of Diana and Endymion, Actaeon at the fountain, the death of Actaeon, the pregnancy of Callisto, Adonis killed by a boar, Andromeda freed by Perseus, and Europa on the bull. The ambassador said he was passing on information received directly from Titian and that the list was in the hand of Orazio, who sent an identical menu to Maximilian's brother-in-law Albrecht V of Bavaria. Three of the subjects sound as though they were copies of Philip's *poesie*, but the only surviving paintings that might have been on the list are the *Death of Actaeon* (London, National Gallery), possibly the painting he had promised Philip in 1559 but never finished or sent to Spain, and the simplified variant of *Diana and Callisto* (Vienna, Kunsthistorisches Museum), on the back of which an outline design of Philip's *Diana and Callisto* can still be seen where it was traced from a studio record on to a new canvas. (Since the technique of that variant bears some resemblance to Girolamo Dente's autonomous paintings, he has been proposed as the most likely painter.)

Dente, if it was he, made a number of changes to the original, which had the effect of taming as well as simplifying it. Callisto's swollen belly is now lightly veiled, and the naked, triumphant nymph who betrayed her by ripping off her clothes is clothed and half kneeling. The nymph at Diana's feet has disappeared, and the goddess's hunting hounds have been replaced by a lapdog. In place of the pillar with fictive relief carvings of Actaeon's punishment there is a meaningless fountain with a statue of the goddess. The modifications cancelled the

sense of tension that is so remarkable in the original, but the most striking difference at first sight is the treatment of the girls' flesh, which is rendered in a smooth pedantic manner that bears no resemblance to the broken brushwork and shadowy tonality of Titian's original. The variant of *Diana and Callisto* had probably been in the studio for some years waiting for a suitable buyer. Titian kept the *Death of Actaeon* in his studio and continued to work on it for the rest of his life. There is no trace of the other pictures on the list, which may never have been executed after the emperor replied to Dornberg that he thought Titian was too old to paint.

Titian engaged Jacopo Strada, adviser to the imperial court and the most successful dealer of the day, to help him clinch the sale; and in lieu of a commission painted Strada's portrait. He had all but given up portraiture by this time, and this is the last of his surviving portraits and one of the few that are even documented from his later years. But if there is a painting that confounds the rumours that Titian could no longer see or paint it is this vigorous, intensely observed *Portrait of Jacopo Strada* (Vienna, Kunsthistorisches Museum). Jacopo Strada was a painter, architect, goldsmith and numismatist, as well as a dealer. Born in Mantua around 1515, he had trained there as a goldsmith in Giulio Romano's workshop. Later, in Rome, where he was employed by Pope Julius III, he bought up the entire contents of Perino del Vaga's studio. His career as a dealer took off in Nuremberg where he became acquainted with Hans Jacob Fugger; and he went on to serve three successive Habsburg emperors, Ferdinand I, Maximilian II and Rudolf II. By the late 1560s he was wealthy enough to build himself a magnificent palace/museum in Vienna, and was designing for Albrecht of Bavaria an antiquarium in Munich – the earliest part of the residence is still the most splendid palace north of the Alps – for which he acquired the Roman sculptures that are to be seen there today. When he sat for Titian in Venice in 1568 he was attempting, unsuccessfully as it turned out, to buy up the Vendramin collection for Albrecht of Bavaria.[3]

Niccolò Stoppio, beside himself with jealousy of Strada's partnership with Titian, and apparently unaware of Strada's close

relationship with the Fuggers, directed venomous letters about the two of them to Max Fugger. In the letter of 29 February 1568 in which he had reported Titian's failing eyesight and trembling hand, he described Strada and Titian as 'like two gluttons at the same dish':

Strada is having him paint his portrait, but Titian will take another year over it, and if in the meantime Strada does not do as he wants it will never be finished. Titian has already demanded a sable lining for a cloak, either as a gift or for cash, and in order to get it he wants to send something to the emperor. Strada encourages his hopes so that he can get the portrait out of him; but he is wasting his time. You will be amused to hear that the other day, when a gentleman who is a great friend of mine as well as an intimate of Titian asked him what he thought of Strada, Titian at once replied: 'Strada is one of the most pompous idiots you will ever find. He doesn't know anything beyond the fact that one needs to be lucky and to understand how to get on with people, as Strada has done in Germany, where he shoots them every line you can imagine, and they, being open by nature, don't see the duplicity of this fine fellow.' These were Titian's own words.[4]

A restoration and scientific examination of the *Portrait of Jacopo Strada* in 1996[5] revealed, beneath layers of discoloured varnish, the full force of a composition that is one of the most dynamic and original of Titian's works, and beneath it the many changes he made until he got it exactly as he wanted. Although one starting point was Lotto's *Portrait of Andrea Odoni*, in which the sitter is also surrounded by objects from his collection, the wealthier and more powerful Jacopo Strada is lavishly dressed with a gold chain of honour wrapped not once but four times around his neck and from which a medallion portrait of Maximilian II in profile is suspended at the exact centre of the painting. The dealer looms into the light from the confined space of his den of treasures looking intently to his left as though anticipating a reaction to the precious objects Titian has painted as attributes of his many interests: the gold and silver coins on the table in front of him, the books on the shelf above, the antique torso and the statuette

of Venus that he clutches in his right hand pressing against her naked figure with three fingers in a way that suggests erotic possessiveness. Strada's leaning torso paralleled by the tilted statuette of Venus and the line of his fur cloak, are in opposition to the direction of his red satin sleeves and the glinting hilts of his sword and dagger, the unstable play of diagonals held in place by the vertical and horizontal lines of the stepped space behind him. The wonderfully painted fur cloak that seems to be slipping from his shoulders, which was one of Titian's final additions, could be the one he had promised Titian as payment for the portrait. Another last-minute change was the letter addressed to the 'Magnifico Titiano' on the table, which was painted over a second arrangement of coins. The cartouche on the wall, which interrupts the geometry of the composition, is not by Titian but may have been added by Strada or on his orders shortly after the portrait was finished. The inscription on it identifies him as a Roman citizen, imperial antiquarian (he was using the title before he actually got it from Maximilian in 1574) and minister of war (this was mere wishful thinking). If Stoppio's poisonous letter about Titian's low opinion of Strada had any substance Titian would scarcely have revealed it to such a valuable client, and, although some may see Strada in Titian's portrayal as sinister and malign there is no other evidence that the dealer and the painter were on anything but good terms.[6]

Strada bought nearly one hundred paintings in Venice, some described as modern, some as *modernissimo*. He sold some of them on to the Fuggers and Maximilian, but acquired many other works by Titian as well as by the Bassano, Francesco Salviati and Veronese[7] for his own palace in Vienna. The dealer brought with him to Venice his eighteen-year-old son Ottavio, a numismatist, antiquarian and scholar like his father, and commissioned Tintoretto, if it was Tintoretto, to paint Ottavio's portrait as a pendant to Titian's of himself. Tintoretto, who four years earlier had begun work on the cycle of paintings in the Scuola di San Rocco, which were to be the major achievement of his career, had always been an uneven portraitist. But the *Portrait of Ottavio Strada* is such an eccentric mess that it deserves a place at the top of the list of the silliest paintings of the

Italian Renaissance, although we might see it differently if there is any substance to a proposal of one of Tintoretto's biographers[8] that it was actually painted by his thirteen-year-old daughter Marietta.

Titian was making his final adjustments to the *Portrait of Jacopo Strada* at the end of 1568 when he sent the less impressive *Tribute Money* (London, National Gallery) to Philip of Spain. It was a rare subject, which he had painted once before, in 1516 for the door of the cabinet in which the Duke of Ferrara, his first foreign patron, had kept his collection of coins. The admiration that painting had attracted would explain the inscription, in Philip's version, on the gold coin held out by the Pharisee which is identified as Ferrarese. In his letter to Philip of 26 October 1568 Titian claimed that he had just finished the picture of 'Our Lord and the Pharisee showing the coin'. In fact, it looks more characteristic of his work in the early 1540s, and the variety of handling across the picture and numerous radical revisions, especially to Christ's head and drapery, suggest that it may have been begun around the same time as Giovanni d'Anna's *Ecce Homo*, to which it bears a stylistic resemblance. In the same letter he took the opportunity to beg the king to alleviate his great want by ordering the settlement of the concession to export corn duty free from Naples granted to him by Charles V as long ago as 1535. Philip, overwhelmed though he was by paperwork and a gathering cloud of problems, responded to Titian's plea on 17 March of the following year with a letter to the viceroy of Naples, the Duke of Alcalá, asking him to make a single payment to Titian of 1,000 ducats in compensation for all his failed attempts to activate the grant.

Philip's *Tribute Money* hung in the sacristy of the Escorial monastery until 1809 when Joseph Bonaparte, recently created King of Spain, presented it, along with five other paintings plundered from the Escorial, to the collector Marshal Nicolas-Jean de Dieu Soult, one of Napoleon's most talented commanders. Opinions were less than enthusiastic, however, after the London National Gallery bought it from the Soult collection in 1852 for £2,604. Although the painting contains passages of great refinement it is less polished, intimate and adept than Alfonso d'Este's original, and the explicit gestures of the

two figures are not accurately resolved where Christ's forearm protrudes over the arm of the Pharisee. Crowe and Cavalcaselle dismissed the painting as 'a treatment far more crude and unsatisfactory than we can concede to even Palma Giovane in his bad days'. Berenson, in his *Lists* of 1957, was one of many who attributed it to Titian's workshop. It is now accepted by the National Gallery as by Titian's hand, if not up to his highest standards. But academic judgements do not necessarily affect the spark a painting can light in the imaginations of spectators who are not professional connoisseurs. During its time in Spain it was regarded as a marvel, even as a definitive likeness of the serenely powerful features of Christ. In the nineteenth century, not long after the National Gallery had acquired the picture, George Eliot, in her great novel *Daniel Deronda*, described Mordecai, the scholarly old Jew wandering 'in the National Gallery in search of paintings which might feed his hopefulness with grave and noble types of the human form'. She found it for him when she came to the meeting between Mordecai and her eponymous hero (whose features, 'healthy grave sensitive', she likened to those of Titian's *Man with a Glove* in the Louvre). 'I wish', she wrote, 'that I could perpetuate those two faces, as Titian's "Tribute Money" has perpetuated two types presenting another sort of contrast.'

Fifteen-sixty-eight was a year that Philip would remember as one of the most difficult of his life. An uprising by the Moriscos of Andalusia in protest against laws that prohibited native customs and obliged them to convert to Christianity was all the more worrying at a time when the Muslims across the Straits of Gibraltar were on the offensive. It took longer than it should have to crush because the Duke of Alba's crack troops were engaged in the Netherlands, and was put down only in 1570 under the command of Don John of Austria. Huguenot Breton seamen who were blocking Spanish shipping in the Gulf of Gascony managed to cut Spain's maritime communications with Flanders. The king saw heresy wherever he looked and overreacted when he learned that Huguenots, who were in fact harmless, were crossing the frontier with France to and from Catalonia. Even

the transatlantic domains, which had previously been safe, were threatened. There were problems in Peru and Mexico, and English privateers, like Sir John Hawkins, were raiding the Spanish Caribbean.

One personal tragedy followed another. The behaviour of Don Carlos, Philip's crippled and mentally unstable son by his first wife Maria of Portugal, had become ever more bizarre and unpredictable. The young man had developed an unhealthy attachment to his step-mother Elizabeth de Valois, whom he showered with jewels. He was monstrously and gratuitously cruel to animals and servants. Above all he harboured a deep hatred for his father and high ambitions for himself, which may have led him into making sympathetic overtures to the rebels in the Netherlands. When Alba was appointed to quell the rebellion there, Don Carlos protested that it was he who should lead the army. He threatened to kill both Alba and his father and pleaded for the support of the grandees and of Philip's half-brother Don John of Austria, who informed Philip of the plot. In January 1568 the king felt obliged to imprison his only son and heir. Rumours more sinister than the truth flew about Europe (and continued to do so two centuries later when Schiller's play *Don Carlos* transformed its eponymous hero into a republican martyr whose passion for Elizabeth de Valois was requited). After successive failed attempts at suicide, the prince died in prison on 24 July 1568 at the age of twenty-three. The court was in mourning for Don Carlos when Philip's much-loved wife Elizabeth de Valois, who had never fully recovered from the birth of a daughter, Catherine, in the previous year and was pregnant again, fell ill. Philip was by her bedside when she died on 3 October after the stillbirth of another daughter. She was twenty-two.

Philip had never been popular outside Spain, and the coincidence of the two deaths with his cruel policies in the Netherlands suggested foul play even to respectable historians of the day. There was not a major European country that did not express disgust and outrage at Alba's Council of Blood and the executions of Egmont and Hoorn. The disapproval was particularly strong in Germany, which had always had close links with the Netherlands, and where Protestants and Catholics alike were alienated. Philip, isolated even from his

German relatives, began to consider a more merciful programme in the Netherlands, and in 1570 turned to the time-honoured Habsburg solution of a dynastic marriage. He settled on his niece, the emperor Maximilian II's daughter Anna of Austria. It turned out that a marriage that had been calculated to pacify the Austrian branch of the family had the added benefit of bringing Philip unprecedented personal happiness. Anna, who was twenty-two years younger than her ageing husband, had been born in Spain during her father's regency there and was the only one of his wives with whom he could converse in Spanish. Petite, blonde and blue-eyed, she was a completely different kind of person from Elizabeth de Valois. Philip fell immediately and lastingly in love with her, and in December of the following year she gave him a son and heir, whose birth was later to be commemorated by Titian in one of the last paintings he sent to the king.

FOUR

Wars

White founts falling in the Courts of the sun,
And the Soldan of Byzantium is smiling as they run;
There is laughter like the fountains in that face of all men feared,
It stirs the forest darkness, the darkness of his beard,
It curls the blood-red crescent, the crescent of his lips;
For the inmost sea of all the earth is shaken with his ships.
They have dared the white republics up the capes of Italy,
They have dashed the Adriatic round the Lion of the Sea,
And the Pope has cast his arms abroad for agony and loss,
And called the kings of Christendom for swords about the Cross.

G. K. CHESTERTON, 'LEPANTO', 1915

One morning in December 1567 the Reverend Pomponio Vecellio
woke up in a rage, went to his desk and threw down a hysterical letter
to Titian, charging him with ruining his life in general and with tax
evasion in particular. The bitterness between father and son had a
long, sad history; and if the contract agreed by both parties four years
earlier had brought peace between them for a while it had not lasted.
According to that agreement, which had been witnessed by the papal
legate in Venice, Pomponio retained ownership of the benefices of
Medole, which Titian had laboriously acquired for him in 1531
through Federico Gonzaga, and of Sant'Andrea di Favaro, granted by
Paul III in 1546. Titian was given the power to manage the benefices
and receive the income from them in return for providing Pomponio

with a monthly allowance of twenty-five ducats. In 1562 Orazio, acting on behalf of his father and his brother, had sublet Sant'Andrea di Favaro, where Pomponio had always maintained that the climate was bad for his health, to another Venetian priest for a period of three years. A year later Orazio negotiated the pensioning off of Medole for 168 ducats a year rising to 200.

Unfortunately there were underlying emotional tensions between Titian and his elder son that could not be resolved by law or by Orazio. Titian, who expected unconditional obedience from his children, regarded himself as owner of the benefices, if not strictly in ecclesiastical law then by right of his status as *paterfamilias*, of the efforts he had put into securing them for Pomponio, and of the respect due to him in what he called his 'last old age'. Pomponio, now a grown man in his forties and a fully fledged priest, resented the role of remittance man; nor would it be altogether surprising if he was jealous of his father's closer attachment to the younger brother to whom Titian was in the process of passing on a substantial proportion of his income and property.

Living in the toxic climate of Sant'Andrea di Favaro, as he had done without Titian's permission since the three-year sublet came to an end, did nothing to improve Pomponio's state of mind when he wrote his garbled letter and delivered it at the gate of a public notary in Piazza San Marco, where its receipt was registered on 16 December 1567. The thrust of the letter was that Titian had failed to pay taxes on the income from the benefices with the result that bailiffs had seized from Pomponio a cask of wine and eight loads of wheat, which were necessary for his sustenance. 'I sent word to you immediately, but you paid no heed, and seeing that you have made me give up everything, and my affairs and reputation are falling into total ruin, thanks to you, I have informed the legal magistrates so that you cannot at any time protest that you did not know.' Unfortunately, venting his spleen on paper did nothing to cool Pomponio's ire. The two men never spoke again. But six months after that first sally Pomponio fired off another anguished letter, this time accusing Titian of withholding the monthly payments of twenty-five ducats as stipulated by the irrevocable power

of attorney granted in 1563. He had taken up residence at Sant'Andrea di Favaro, as he was obliged to do, so he said, by the decrees of the holy Council of Trent, and was suffering from the bad air there and from the sequestration of his wine and wheat. He was, furthermore, worn out by visits from Titian's agents, all of which had reduced him to such a state that he was almost embarrassed to appear in the company of other men. So would Titian kindly make the payments and hold off his agents, 'since I have always been that honourable son that you know, and so that I will continue to live as such'. He sent his best wishes formally, in Latin, adding that the letter would be registered with a public notary at the canonical offices in Venice, as indeed it was on 22 June 1568.

This time it was Titian who lost his temper. So far he had left the management of the benefices to Orazio, as he did all practical problems, which included most recently a dispute arising from damage to a Vecellio sawmill in Ansogne near Pieve caused by a flood in a neighbouring sawmill. But he was irritated by Pomponio's self-righteous claim to be abiding by the decrees of the Council of Trent, which he knew to be a half-truth since the requirement that priests must live in the parishes from which they derived livings had not yet come into force in Italy. (Nor for that matter was the celibacy of priests, another Tridentine decree, yet taken very seriously as we can infer from the fact that later that year, in September, Titian used his power as a knight palatine to confer legitimacy on the natural sons of a curate practising in Cadore.) But whatever the rights and wrongs of the matter, where Pomponio was concerned Titian's self-control was liable to tip over into tempestuous anger: he was not after all the first or last of those who reserve their worst behaviour for the closest members of their families.

Four days after receiving Pomponio's second letter he hastened through the streets of Venice, seething with fury and faster than was wise for a man of his age, to the office of a scribe, where he relieved his feelings with an instruction to take down 'word for word' his reply to 'messer priest Pomponio', in which he castigated his son for contravening the terms of the irrevocable mandate by pensioning off his

benefices without his father's consent and insisted that by doing so
Pomponio had contravened the terms of the irrevocable power and
was therefore no longer entitled to the stipulated allowance of twenty-
five ducats a month. Having begun with a promise to reply to
Pomponio briefly 'because it is the role of a father to conceal the
misery and disgrace of a son so disobedient', he found himself unable
to control his rage, so that it was not easy, even for a professional
scribe, to make sense of the incoherent outpouring of words, which
forced the poor man to write so fast that some of them are illegible.
But it was not until he finally drew breath that he allowed himself, for
the first time in their relationship, to express the real source of his
pain:

> Not to mention that it gives me all the greater pain and distress to
> think of the trouble, sacrifices and sweat I have suffered in order to
> acquire for you these honourable benefices, setting you on the path to
> make yourself grand and rich, and Your Reverence did not want that,
> but nor do you want to agree to live on your own in your own way.

But Pomponio, who had studied law and classical languages at Padua
and was more literate than his father, believed he had the upper hand.
His sarcastic reply, recorded by a notary on 1 July, was intended as
much to hurt as to win the argument.

> Magnificent signor father, since as a layman you have no authority to
> order me about and I do not consent to it, I will say in reply that if I
> were to blame the person who replied to my letter a few days ago and
> if I were certain that he had glanced through the content of your quit-
> tance of ownership of my benefices with an irrevocable power of attor-
> ney, and if I were not certain that this excellent person was not making
> a fool of you I would deem him a great ignoramus since you must have
> told him the truth about having at one time paid me month after
> month the twenty-five ducats, beginning with the month of your
> quittance.

He went on to remind Titian that the power of attorney had in fact never been legally annulled, that he had renounced the benefice of Medole because he was not permitted to act as priest in two parishes, and, furthermore, that Titian had known about it because he had himself negotiated the terms with the abbot of Medole, and Orazio, who had stood in for Titian, was one of many witnesses.

As for his residence at Sant'Andrea di Favaro:

> at the time of your quittance it was not obligatory, but since the reforms of the holy Council of Trent the whole town of Favaro and all of Mestre can bear witness that I have obeyed the holy decrees to my great suffering and in danger of death working in this poisonous climate and with great expense. But since, as they say, every day has its night and I being by now more old than young, I am resolved that I am no longer able to toil as I have in the past, whereby I once again declare to you that in whatever way I suffer, as much from the residence as from every other matter relating to this irrevocable power of attorney, that it will be and understood to be to your detriment and ruin if it pleases you to revoke the quittance and power of attorney and if you don't from now on pay out the twenty-five ducats a month that you are obliged to pay me and without prejudice to the overdue debts enforced by that power.[1]

And yet, although his relationship with Pomponio would never recover, Titian could not give up the habit of trying to acquire income for his elder son, and it was with his Spanish pension in mind that he revived his connection with the still powerful Cardinal Alessandro Farnese and plied him with gifts: a first impression of Cort's engraving of the *Trinity* sent in December 1567; and in May of 1568 a *Penitent Magdalen* (Naples, Capodimonte). Farnese accepted the gifts but did nothing to help with the pension.

Titian also had the welfare of another child to consider. Emilia,[2] the love child of his dotage, the precious little girl he had once described to the King of Spain as 'the absolute patroness of my soul', had reached marriageable age. In June 1568, while Titian was smarting from

Pomponio's latest insulting letter, a contract was drawn up that provided Emilia with a dowry of 750 ducats on her marriage to Andrea Dossena, a grain merchant. They were married later that year in Titian's house, perhaps in the presence of Emilia's mother, about whom, however, nothing is known.[3] The dowry was half the amount he had provided for his legitimate daughter Lavinia, and unlike the family of Lavinia's husband Cornelio Sarcinelli, who were landed gentry in Serravalle, the Dossena, although by no means penniless, were ordinary working people. The young couple started their married life under the roof of Andrea's father Giovanni but soon moved into their own rented house near the church of San Pantalon. Nothing is known about Titian's connection with the Dossena or why he chose Andrea for Emilia, except that his social standing probably seemed about right for a natural daughter. At least we can allow ourselves to imagine that it was a happy marriage – they were still together when Emilia died in 1582 – and that Titian enjoyed the three grandchildren they gave him: Alcide, Zanetto and Vecellia,[4] who, unlike Lavinia's children, who were brought up in Serravalle, lived close by in Venice.

The end of the decade was a miserable time for Venice. In 1569–70 a bad harvest that affected most of Italy brought a devastating famine to the lagoon city where the pressure of population, which had grown by more than 50 per cent, from about 110,000 in 1509 to approximately 175,000, was aggravated by the inflow of starving peasants from the mainland. A chronicler,[5] writing about 'the worst shortage of bread and flour ever seen within the memories even of ancient men', described the riots, the people crushed to death in crowds pushing and shoving around bakeries that turned out to be empty, the theft of bread by some arsenal workers, the plight of impoverished immigrants who 'hammered on the doors in the town for two months on end; and such poverty and wretchedness were truly pitiful sights … Throughout Venice one heard talk of nothing but this terrible famine, and in truth it struck the greatest imaginable terror into the hearts of men.' At the same time there was an eruption of 'spotted

fever' (measles-like spots are characteristic of typhus), which failed to see off enough people to relieve the shortage of bread. The unpopular doge Pietro Loredan served as scapegoat for the famine, and when he died, aged eighty-eight, in May 1570 the people rejoiced and for days afterwards little boys ran through the streets singing:

> Long live our saint and lords of noble birth;
> Dead is the Doge who brought upon us dearth!

> Let bells ring out, for Loredan's dead,
> Who fed us tickets with our bread!

As though famine and contagious disease were not enough the most destructive fire the city had seen for more than half a century broke out in the arsenal at midnight on 13 September 1569. The stores of gunpowder blew up, the walls and towers collapsed, and the surrounding neighbourhood burned down, stopping just short of the church of San Francesco della Vigna and Titian's timber yards on the shore of the lagoon. It was rumoured that the fire was the work of foreign saboteurs, the Jews as always being prime suspects. The Most Serene Republic of Venice was nevertheless sustained, as always through good times and bad, by the image of itself as a peaceful, well-run and harmonious community endowed with a God-given ability to overcome all natural disasters. Contemporary accounts of the fire turned it into a triumph, giving detailed encomiums of the largest, most efficient and wealthiest of all naval shipyards, and describing the catastrophe as a magnificent spectacle worthy of the very marvel it consumed: all Venice ran to watch (we can imagine Titian who had always been fascinated by fire joining the crowd of spectators); all the world spoke of it. And it is true, as the chroniclers maintained, that thanks to the superlative leadership of the Council of Ten, and the readiness of the people of Venice to respond to the challenge, the fire was quickly put out, and in a few months the arsenal was rebuilt and returned to its former splendour and productivity.

Unfortunately the Myth of Venice could not protect the Republic from its nemesis: the Turk. The Turkish sultan Selim II, successor to his father, the formidable Suleiman the Magnificent, may have been a drunkard – hence his nickname Selim 'the Sot' – but he was proving to be a more bellicose ruler than Christian Europe had bargained for. He devoted the first two years of his reign to continuing his father's campaigns in Hungary. But after concluding a truce with Maximilian II in 1568 he set his sights on the fertile island of Cyprus, which Venice had owned since 1479. Cyprus, the easternmost possession of the Venetian maritime empire, was not well governed by its colonial overlords who had aroused resentment in the local populace; and since it was 2,400 kilometres from the lagoon but fewer than eighty from Selim's own southern shores the wonder is that the Turks had not seized it earlier. Nevertheless, although it was widely believed that the loss of the Venetian fleet in the arsenal fire would be an incentive for Selim to attack Cyprus, the Venetian government hesitated to take action even as news reached the Rialto that the Turks were intriguing with disaffected local inhabitants and taking soundings in the Cypriot cities of Nicosia and Famagusta. Venetian prosperity depended on peace with the Ottoman Empire, and the policy of keeping that peace by means of diplomacy and the maintenance of an invincible defensive fleet had worked well since 1540. Neutral, independent Venice was not merely dedicated to peace on its own behalf. According to the foundation myth, images of which lined the walls of the Great Council Hall, it was the historic role of the Republic to act as peacemaker between the other great powers. As recently as 1567 Titian had been deputed to arrange a meeting in Venice between Philip II's representative García Hernández and the Turkish ambassador Alban Bey.

Nevertheless, military preparations on both sides were under way when Selim made a formal demand for Cyprus in March 1570. He was turned down by the Senate, which sent dispatches throughout the maritime empire declaring that a state of open war existed with the Turks. Now, however, Venice paid the price of the isolationist policy it had maintained for thirty years. Admired though it was throughout

Europe for its internal political stability, the Republic had no natural allies, and appeals for help from other Christian states were rejected, with the sole exceptions of Pius V and Philip of Spain who made only token contributions. The pope agreed to equip a small squadron of vessels on condition that Venice provided the hulls. Philip, who was rightly suspicious of the Venetian tendency to make peace with Islam, sent a fleet of fifty ships under the command of Gian Andrea Doria, with secret instructions to let the Venetians, who produced the largest fleet, do most of the fighting.

The opening of the War of Cyprus was a shambles. The Venetian fleet waited in vain at Zara for the Spaniards, who simply stayed in Sicily until the pope urged Philip to send Doria his sailing orders. News of unopposed Turkish landings in Cyprus reached the Venetians on 9 August, but it was not until 1 September that the papal and Spanish fleets finally joined the Venetians at Crete. They were still off Rhodes on 9 September, when, after a prolonged siege of the Cypriot capital Nicosia the Turks breached the thin medieval walls, beheaded the incompetent Venetian Lieutenant Nicolò Dandolo and went on to enjoy a week of massacres, gratuitous impalings and quarterings, rapes of both sexes, desecration of churches and looting.

The Turkish fleet sailed on to Famagusta, the principal port, which was better defended by its Venetian fortifications and by the commander Astorre Baglioni and Captain Marcantonio Bragadin. The Turkish siege of Famagusta began on 17 September and continued throughout the winter. A relief force of 1,500 men with arms and munitions managed to get through the Turkish blockade in January 1571, but food supplies began to run out in April. Meanwhile the Turks were closing in with siege towers from which they were able to bombard the town from above the walls. Although the Venetian–Spanish relief expedition on which the Christians had been counting failed to materialize, they fought back bravely even while powder was running short and after all the horses, donkeys and cats had been eaten and two-thirds of the defenders killed or wounded in successive bombardments. Finally, on 1 August, the Venetian generals took the decision to surrender Famagusta to the Turks.

The peace terms offered by the Turks were surprisingly generous, and the document setting them out was delivered to Baglioni and Bragadin with a covering letter personally signed by the Turkish commander Lala Mustafa Pasha complimenting them on their magnificent defence of the city. Four days after the surrender Bragadin sent word to Mustafa proposing to call on him in order to present the keys of Famagusta. Mustafa smiled pleasantly as he greeted Bragadin, Baglioni, other senior officers and a party of Italian, Greek and Albanian soldiers. Then, without warning, he began shouting accusations at the Christians. He whipped out a knife and cut off Bragadin's right ear, ordering an attendant to dispose of the other ear and his nose while he commanded his guards to execute the rest of the delegation. The decapitated heads were later said to have numbered 350. But the atrocity that was to ring down through Venetian history was reserved for Marcantonio Bragadin, whose ghastly fate still makes Venetian schoolchildren shudder. After two weeks in prison by which time he was seriously ill from his festering wounds, he was dragged round the city walls, tied to a chair and hoisted to the yardarm of the Turkish flagship so that the sailors could hurl taunts at him, then taken to the main square and flayed alive. Death came to his rescue when the executioner reached his waist, but it was not enough for his torturers. His head was cut off, his body quartered; his skin, sewn together and stuffed with straw and cotton, was paraded through the streets mounted on a cow. Nine years later a Venetian who had survived the siege of Famagusta managed to steal the skin from the arsenal of Constantinople and return it to Bragadin's sons. Its remains, a few shreds of browned skin, were discovered in 1961 during a restoration of the hero's monument in Santi Giovanni e Paolo, where they are kept to this day.[6] We will never know what was in Titian's mind when he chose the *Flaying of Marsyas* as one of his last mythological subjects. We can be sure, however, that there was not a man, woman or child in Venice who was not haunted by the story of the flaying of Marcantonio Bragadin and that Titian cannot have been an exception.

Pius and Philip were by now sufficiently alarmed by Turkish supremacy in the eastern Mediterranean to opt for a formal alliance

with Venice. The zealous ascetic Pius had looked for an excuse to form a crusading Christian alliance against the crescent of Islam since his election in 1566. Philip now came to see the Venetians as a front line of defence against the Turks, who were poised to attack Spain from the central Mediterranean and the Barbary Coast; and with the Netherlands apparently under control he could afford the cost of joining the crusade. This time it was Venice, which had the most to lose but was ever hopeful of a settlement that would reopen the Levant to its mercantile galleys, that held back – until Turkish landings along the coast of Dalmatia threatened invasion of the Friuli and the Lido. The anti-Turkish Holy League, brokered from Rome over many months by Cardinal Granvelle, was signed by all three parties on 20 May 1571.

The allied Christian fleets assembled at Messina in August. Sebastiano Venier, in charge of the Venetian fleet, was in his early seventies, twice the age of the papal commander Marcantonio Colonna. The dashing Don John of Austria, the illegitimate son of Charles V born twenty-six years earlier at Ratisbon after the emperor's affair with the burgher's daughter Barbara Blomberg, assumed overall control. The pope himself designed the fighting banner, an image of Christ Crucified and the emblems of the three allies emblazoned on an azure background, which was presented to Don John at Messina by Cardinal Granvelle with the words 'Take, O illustrious Prince, the insignia of the Word Made Flesh. Take the living symbol of the holy Faith whose defender you will be in this enterprise. He gives you glorious victory over the impious enemy, and by your hand shall his pride be laid in the dust.'

On 16 September the fleets headed for Corfu where they received information that the Turks were in the Gulf of Lepanto (modern Naupactus on the Gulf of Patras). The two massive formations sighted one another there at dawn on the morning of 7 October, a brilliantly sunny day: contemporary descriptions of the ensuing battle dwell on the flashing helmets, armour and weapons. The Turks had something like 230 vessels and over 50,000 men, the Christians some 200 galleys and about 40,000 men. The opposing fleets were otherwise

comparably crewed and used similar tactics: rowing into formation, firing, closing to board infantry. It was the superior firepower of the Venetian galleasses and artillery, the more protective armour worn by the allies, and not least the discipline and fighting spirit instilled in their men by Sebastiano Venier and Don John of Austria that gave the Christians the advantage that culminated at the end of the day in the near annihilation of the Turkish fleet. Estimates of the respective losses vary, but approximations indicate that the Turks lost at least three times as many galleys and men as the Venetians. Fifteen thousand Christian galley slaves, furthermore, were set free and the plunder taken from the Turkish vessels was beyond the most optimistic dreams of the victors.

Almost immediately after the news reached Venice twelve days later cheering crowds assembled in the Piazza San Marco and a *Te Deum* was sung in the basilica. Of all the public celebrations so far enacted in Venice this was the most elaborate and prolonged demonstration of patriotic fervour. People danced in the streets, complete strangers embraced. For days the city, lit up by torches and fireworks, resounded with music by Andrea Gabrieli.[7] The drapers' guild organized another three-day spectacular that transformed the Rialto Bridge and surrounding streets with displays of tapestries and of paintings by Bellini, Pordenone, Titian and other Venetian artists, all lit by lanterns. The rejoicing carried on through the carnival of 1572 with a masquerade procession led by the figure of Victory trampling on a bleeding serpent. The Venetian historian Paolo Paruta, in a funeral oration for the dead delivered in the basilica of San Marco, described the Battle of Lepanto as 'the most beautiful and most joyful day that this city, in all her history, has ever seen'. The jubilation was no less explosive in Rome, where the pope designated 7 October as the feast day of the Holy Rosary; or in Spain, where Philip II's treasury had contributed the lion's share of the cost of the battle and the rhetoric proclaimed that the kingdom had fulfilled its destiny as God's champion against the infidel. Many years later Miguel de Cervantes, who had fought with the Spaniards and sustained a wound that permanently maimed his left hand, remembered it as 'the greatest occasion

that past or present ages have witnessed or that the future can hope to witness'.[8]

But if Lepanto was the greatest naval victory since ancient times it was also the least decisive. Venice's allies began bickering within months and soon regretted their military investment in a part of the Mediterranean where the Most Serene Republic would reap the major benefit. The Venetians, who recognized that one battle, however glorious, had not won the war, advocated mounting another attack before the Turkish fleet had time to recover and rearm. Aware that they could not win a war against the Turks without support, they maintained the hope that Philip could be persuaded to join them in another campaign against the Turks. Of all his closest advisers the one most capable of turning the king was his secretary, the Italophile and connoisseur of painting Antonio Pérez, who had played a significant role in negotiating the alliance. So when in November 1571 Pérez, at a meeting with Leonardo Donà, the Venetian ambassador in Madrid, expressed a desire to possess a signed painting by Titian, Donà lost no time in communicating the request to the Council of Ten, which took an immediate decision to present Pérez with two of the most beautiful pictures in Titian's studio, one a religious subject, the other 'some beautiful story'.

The latter cannot be identified. The religious painting was a variant (Madrid, Prado) of the *Entombment of Christ* that Titian had sent to Philip in 1559. There exist a number of studio variants of Philip's masterpiece,[9] of which a record of the outline composition had been transferred on to a new canvas. The one now in Madrid, which is signed 'TITIANVS. F.' and looks as though the master may have touched it up with his own brush to make it more presentable, is of higher quality than the others and the most likely to have been the one chosen for Pérez. Christ's face, which is tranquil in the original, is distorted in the copy by His suffering, and the anatomy of His body is weaker. The relief carvings on the tomb have been replaced by a smooth marble surface; and Joseph of Arimathea's red silk robe changed into a curious spotted affair (a suggestion from Valerio Zuccato or Cesare Vecellio, both experts in the latest fashions?), and

a building that looks like Castel Sant'Angelo added to the background.

But Philip, who was sliding towards his second bankruptcy, was beyond the reach of Venetian diplomacy. The king was overwhelmed by other problems, including a crisis of stability in Peru. Charles IX of France was intriguing against him on several fronts, not least in the Netherlands where he supported the rebellion. As the cost of that war soared out of control, Alba, whose bloodletting was proving counter-productive, requested new supplies: 'It is not the Turks who are troubling Christendom but the heretics, and these are already within our gates.' Philip turned the duke down: 'I shall never have enough money to satisfy your needs.' A revolt in 1572 incited by the Prince of Orange, who had organized a military and diplomatic offensive, was the undoing of 'the butcher of Flanders'. His counter-offensive failed and Philip accepted his request for recall.[10]

Pius V, now a sick man, did his best to spur Spain into action. But, although the victory at Lepanto remained a major propaganda weapon of the Counter-Reformation opposition to heretical faiths, the death on 1 May 1572 of the pope who had been its champion extinguished the fighting spirit of the holy crusade. Venice was alone, and on 7 March 1573 representatives of the Republican government agreed peace terms with the Ottoman Empire in Constantinople. The principal clause of the treaty ceded Cyprus to the Turks, who retained control of the island for just over three centuries.

It is a great irony of Venetian history that one of the most celebrated of all naval victories marked the beginning of the long, slow decline of the Republic as a military and mercantile power. The maritime empire continued to shrink while other trading nations, especially the English, Dutch and Portuguese, sailed round the Cape, more effectively than the Portuguese had done at the end of the previous century, to the lucrative markets in India and the Far East. Shipbuilding in the arsenal gradually ceased to be a major Venetian industry. Other ports – Marseilles, Ragusa and Livorno – developed an interest in eastern trade while Seville continued to enjoy a monopoly on the Spanish bullion from the Americas. But, even as the wealth and power

of the Republic diminished, the Myth of Venice lived on, refreshed by the propagandistic value of Lepanto. On 8 November 1571, a month after the victory, the Great Council issued a declaration that 'if ever a noted action of bygone times deserved to be represented and kept alive in the minds of the people, none was more entitled to such a distinction than the victory of the Holy League over the Turkish armada'. Several years after the Peace of Constantinople Veronese's painting of *Doge Sebastiano Venier Offering Thanks to Christ for the Victory of Lepanto* was placed over the tribune of the Sala del Collegio, and his splendid representation of *Venice Enthroned with Justice and Peace* installed on the ceiling of the same room.[11]

The three *capi* of the Council of Ten had previously chosen Titian to commemorate the battle with Giuseppe Salviati as his assistant. But Titian, who also received a commission from Philip of Spain for an allegorical celebration of the victory and of the birth of his son, the Infante Don Ferdinand, on 4 December, prevaricated; and Tintoretto seized the opportunity with an enormous painting (now lost) of the battle for the hall of the library of the doge's palace, for which he was rewarded in 1574 with a *sanseria* for life. Titian meanwhile was in no hurry either to fulfil Philip's order, which was the first in their long relationship that was accompanied by precise instructions, and was all the more disinclined to tackle it before he received a reaction to an erotic history painting that he had sent to the king on 1 August 1571, on the very eve of the great battle. The subject was the *Rape of Lucretia*, which he had described to Philip three years earlier as 'a subject of larger compass and greater artifice than I have undertaken for years'.

FIVE

'In This my Old Age'

Titian, perhaps the most famous Painter, and certainly amongst
the most famous, sometimes painted with such fine and diligent
brushwork that it seems almost as though he wanted us to count
the hairs; and sometimes it pleased him better to represent a
coarser style with few and very rough strokes. Intelligent
spectators of such a diverse manner will recognise in the one
feminine charm, in the other masculine strength; the former will
receive praise, the latter admiration; you might feel sweetly
inclined towards the delicate style, and by the rough violently
raped.

VIRGILIO MALVEZZI, *CONSIDERATIONI CON*
OCCASIONE D'ALCUNI LUOGHI DELLE VITE
D'ALCIBIADE E DI CORIOLANO, VOL. 2, 1648

Sextus Tarquinius, the hot-blooded son of the Etruscan king
Tarquinius Superbus, was inflamed with desire for Lucretia, the virtu-
ous wife of Lucius Tarquinius Collatinus, who was his friend and
distant relative. Lucretia was famed for her chastity and her beauty,
but it was her chastity that most excited Sextus Tarquinius. One day
he presented himself at the house of Collatinus. He was welcomed as
an honoured guest, but when Collatinus boasted about Lucretia's
unassailable purity, Sextus Tarquinius could restrain himself no
longer. When night fell, and Lucretia retired to the nuptial bedcham-
ber, Sextus Tarquinius followed her, drew his sword and threatened

that if she did not give in to him he would kill her and one of the slave boys guarding her room, and would claim afterwards that he had surprised them in bed together. Lucretia had no choice, but the next morning she summoned her husband and the royal court, told them of her disgrace and, refusing all sympathy and pardons, plunged a dagger into her breast. The scandal forced Tarquinius Superbus to flee with his children, thus marking the end of the Etruscan dynasty and the foundation of the Roman Republic in 510 BC.

The story was first recounted by Livy in his *History of Rome*, and was often retold by, among others, Ovid,[1] Dante,[2] who placed her in a section of the Inferno reserved for virtuous pagans, Boccaccio[3] and Chaucer,[4] all of whom praised Lucretia's exemplary virtue and honour. But by the time Titian came to paint the subject Renaissance writers had adopted a more cynical view of Lucretia's resistance to what St Augustine[5] had called 'the fatal pleasure'. A late fourteenth-century interpretation of the story,[6] which Titian might have known from an adaptation published in 1544,[7] proposed that Lucretia's suicide had been motivated by guilt and the danger that she might again succumb to adulterous temptations. In Machiavelli's satirical play *Mandragola* Lucretia takes pleasure in her enforced adultery. Aretino, waxing polemical in a letter to a poet, maintained that shame was a better subject for a poem than honour,[8] and put it to his correspondent: 'What do you make of Lucretia? Was she not mad to listen to the promptings of honour? It would have been better if she had had her fun with him, and lived.'

While other Italian painters preferred to depict Lucretia's suicide, Titian, taking his model from northern European engravings,[9] chose the more challenging scene of her rape, perhaps as a way of demonstrating to himself and to Philip that he could still, despite his advanced years, do something as exciting as his *Rape of Europa*. Philip's *Rape of Lucretia* (Cambridge, Fitzwilliam Museum),[10] however, does not in fact quite come off. The twist of Tarquin's body, although it may have been an intentional attempt at *contraposto*, is unconvincing, as is the relationship of Lucretia's right leg and foot. Nevertheless, it was doubtless the best Titian could do at the time in

the polished style to which the king was accustomed. Although he made very few changes, apart from raising the position of the stabbing arm, the particles of dirt that have been detected between the layers of paint are evidence that he spent time on the painting. And he must have been satisfied with the composition because when Cornelis Cort paid a return visit to Venice in 1571 he made two engravings of it, one of which reverses the image, that are unusually faithful to Titian's original design.

Although not comparable with the greatest of his *poesie*, the *Rape of Lucretia* is nevertheless a remarkable achievement for an artist in his eighties and may well have had the desired effect of titillating a ruler who could associate with a villain of royal blood but must rein in his own darker instincts, except as a voyeur of Titian's erotic paintings (like the little slave boy who watches the rape from behind a curtain?). Titian's Lucretia, her blonde hair beautifully coiffed, her skin and ample body soft as a ripe peach, is naked but for her pearls, earrings, fashionable identical bracelets and a translucent veil bunched between her legs that does not quite conceal her dark pubic hair. As though to draw attention to both her elegance and her nakedness Titian placed his signature 'TITIANVS F' on the little pink slipper she had dropped next to the bed. Tarquin by contrast remains fully clothed, and for his royal attire Titian used a brilliant and expensive palette.[11] One of his bright vermilion stockings has slipped down his leg, a sign of uncivilized brutishness. His reddish-purple breeches, finished with red lake made from kermes, the most costly of red dyestuffs, are underpainted with white lead, which shows through as highlights. The meticulously individualized gold threads of his embroidered waistcoat may have been beyond the capacity of an artist whose eyesight was failing, but if they were executed by an assistant he was highly skilled. There is, however, no reason to doubt Titian's hand in the blackish-brown painted underdrawing[12] that established the composition, or in such painterly passages as the cascade of sheets, which are slightly blued by the addition of azurite, and the shot-silk effect of the valence achieved by exposing some of the pinkish-brown underpainting.

Many art historians, possibly affected by feminist sensibilities, maintain that the tear-streaked face of Lucretia represents the very epitome of terror and was intended to invite compassion, an emotional response that, according to Aristotle, was one of the defining characteristics of tragedy. It is indeed one of the most brutal of Titian's secular paintings. Nevertheless, it is worth considering whether Titian, who was no stranger to ambiguity and the vagaries of human nature, might have been aware of contemporary interpretations of the story and, after a lifetime of observing faces, knew that expressions signifying terror and ecstasy are all but identical. It is not impossible that he wanted the king for whom he had painted his Ovidian erotic tragedies to imagine that this beautiful woman, having noticed that a handsome young prince is strongly attracted to her and retires to bed naked except for her jewellery, might have mixed feelings when he bursts into her room. Would he have left her jewellery on and her hair immaculately bound – unlike the loosened hair that signified rape in classical literature – only to indicate, as is frequently said, that she maintained decorum throughout her ordeal?

Scholars are divided about how much of a hand Titian had in the two other versions of the *Rape of Lucretia*. In a cruder variation (Bordeaux, Musée des Beaux-Arts), which is more explicit but less violent, Tarquin stabs from below (as in the cancelled passage of the one sent to Philip) rather than above, aiming his curved dagger at Lucretia's pudenda, while she turns her face away from him and towards us so that we see her scream. But the third rape (Vienna, Akademie der Bildenden Künste),[13] which, even if we accept it as unfinished, is so entirely different from the other two that some scholars believe it might represent a different subject or have been executed by another hand. It is painted as though in a fury with a rich autumnal palette and varying surface texture, the paint thin in some places and in others nine layers deep. There is no doubt here about the artist's sympathy for the innocence of the fragile, helpless victim, who wears no jewellery and is dressed in a demure white dress indicated by visible and rapidly executed sweeps of the brush. As she pushes her left hand defensively against Tarquin's chest, the forward

thrust of his body throws her off balance. X-rays have shown up a previous draft in which the figures are smaller and further apart and indicate that Titian, if it was he, moved the position of Tarquin's hand and dagger three times.

Palma Giovane, a great-nephew of Palma Vecchio, joined Titian's workshop around 1570 when he was in his mid-twenties and Titian at least eighty. Titian granted Palma the unusual privilege of watching him at his easels, and long after Titian's death, when Palma was himself an old man, he remembered what he had seen and described it to Marco Boschini, who published it in 1674. It is the most vivid and revealing description of a great painter at work in the literature of art.

> He laid in his pictures with a mass of colour which served as a groundwork for what he wanted to express. I myself have seen such vigorous underpainting in plain red earth [terra rossa, probably Venetian red] for the half-tones, or in white lead. With the same brush dipped in red, black, or yellow he worked up the light parts and in four strokes he could create a remarkably fine figure ... Then he turned the picture to the wall and left it for months without looking at it, until he returned to it and stared critically at it, as if it were a mortal enemy ... If he found something which displeased him he went to work like a surgeon ... Thus, by repeated revisions he brought his pictures to a high state of perfection and while one was drying he worked on another. This quintessence of a composition he then covered with many layers of living flesh ... He never painted a figure alla prima, and used to say that he who improvises can never make a perfect line of poetry. The final touches he softened occasionally modulating the highest lights into the half-tones and local colours with his finger; sometimes he used his finger to dab a dark patch in a corner as an accent, or to heighten the surface with a bit of red like a drop of blood. He finished his figures like this and in the last stages he used his fingers more than his brush.[14]

Palma might have seen Titian at work on Philip's *Rape of Lucretia*, or even have assisted him with it. But the driven, complex working procedure he described – which tallies, at least up to a point, with the results of modern scientific investigations – helps to elucidate the style of the very different paintings Titian did not send to Philip in the last years of his life, either because they were unfinished[15] or because he considered them inappropriate for the royal patron who, although he had responded positively to the open brushwork developed in the 1550s and 1560s, would not have understood the more subjective and experimental paintings from his last years, which are characterized by a disintegration of forms as though Titian's visible, agitated strokes and stabs were consuming with paint the azure mountains, the peaceful pastures and the youthful flesh and gorgeous attire of the beautiful sacred and profane men and women that he had once brought to life with his godlike brushes.

The painting Boschini had in mind when he quoted Palma Giovane was the *Crowning with Thorns* (Munich, Alte Pinakothek), which he described as 'a marvel worthy of a place in an academy to show students all the secrets of art, and teach them not to degrade but to improve nature'.[16] We know that Titian never finished this painting, which evidence suggests may have been commissioned by Paolo d'Anna for his father Giovanni's altar in the church of San Salvatore,[17] because four years after Titian's death Pomponio, who was in the process of clearing the studio, wrote to Paolo asking if he wanted the clothes to be finished by Titian's pupils. It seems that this never happened. Eventually Tintoretto bought it, after hearing about it from a fellow member of the Scuola di San Rocco; and when Boschini saw it in the house of Tintoretto's son it was still unfinished.

In the passage from the Gospel of St John, immediately before Pilate presented Christ to the Jews, 'the soldiers platted a crown of thorns, and put it on his head, and they put on him a purple robe, And said, Hail, King of the Jews! And they smote him with their hands'.[18] Titian's late depiction of the episode is a recasting of the very similar composition he had painted in the early 1540s for the church of Santa Maria delle Grazie in Milan. He had executed that slick,

assured, histrionic painting with half an eye on central Italian Mannerism and to fulfil the requirements of ecclesiastical patrons for an image of Christ's suffering, which does not seem to have moved him greatly at the time. He must have kept a record of that altarpiece; and now, some thirty years later, he treated the same subject on a canvas of the same size and to a similar design. Although the exaggerated poses of Christ's tormentors are all but identical to those in the earlier version, the sombre lighting and looser application of paint transformed the plump, awkwardly posed Christ in the Louvre painting into the Man whose body and face express patient acceptance of the suffering He must undergo as the Saviour of Mankind. In this, his last and most profoundly moving representation of Christ, we can believe that Titian as he prepared to meet his God had found the deeper faith that had eluded him in his earlier years; and that the emotion we feel is his own, personal response to the Passion, rather than to the requirements of the post-Tridentine Counter-Reformation.

The most striking difference between the two paintings is that in the later work he brought the scene closer to the front of the picture plane, as he had done in his second *Martyrdom of St Lawrence*, and set it at night lit by the smoky flames of a candelabra, which casts a phantasmagorical play of light over the scene. On the waist of the brute on our left, on Christ's chest, robe and left ankle the 'trails of red, almost like drops of blood' that Palma Giovane tells us Titian used to revitalize 'some superficial sentiment' act like rhetorical asides that raise the temperature of our emotional response to the suffering of Christ. The fully clothed figure with his back to us, whom Titian in the Louvre version had depicted as a soldier in chain mail, is all the more sinister for being dressed as a dandified young man with a jolly red feather in his cap, as though he was just any uncaring member of the baying crowd enjoying the spectacle. The dirty white of Christ's robe would have been purple if the painting had been finished.

Titian had always been able to vary his style to suit the requirements of his patrons, and for all his physical disabilities continued to do so right up to the year before his death. For Philip he painted the

Rape of Lucretia and the later *Penitent St Jerome*[19] (Madrid, Escorial) in the meticulous 'feminine' style with which he had imitated nature in his youth while at the same time experimenting with the rough 'masculine' way of laying on paint that Palma Giovane described to Boschini. The looser, more painterly style had come about very gradually, almost inevitably. As early as the 1540s Aretino had noticed that Titian was using his brushes in a new way, and complained to Cosimo de' Medici that the portrait of himself now in Florence was excessively sketchy, at least by Florentine standards. Vasari/Verdizotti had described the *poesie* of the 1550s and early 1560s favourably as 'painted with broad and bold strokes and blotches'. But the Florentine Vasari, who dismissed more recent paintings as inferior, evidently could not understand the even more open style – or the eccentric practice of applying his colours in scumbles often with his fingers – that Titian was employing at the time of his visit in 1566.

The subject of the haunting *Boy with Dogs*[20] (Rotterdam, Museum Boijmans Van Beuningen) is unprecedented and mysterious. Like many painters Titian was fascinated by dogs, but had previously used them as accessories while these are full, individualized portraits, which transmit his affection as well as his delight in the visceral appeal of their faces, the warmth of their bodies and textures of their fur. He had used the blond Labrador before in a *Portrait of a Soldier* (Kassel, Staatliche Kunstsammlungen),[21] but the black spaniel nursing her puppies from a belly lit up like a hearth is new. And since none of the art historians who are uncomfortable without allegorical explanations has come up with one for this painting there is no harm in speculating that the dogs were family pets also used for hunting in the country, that the little boy gathering grapes in his pink tunic (whether or not he is also a reference to Bacchus) was one of Titian's youngest grandchildren, and that the nursing spaniel refers to his birth. The lighting of the painting is uneven, perhaps because it was trimmed on all sides at some point in its history; and the finish varies from the fully three-dimensional dogs and left leg of the boy to the blasted landscape, which seems to anticipate the technique of the *Flaying of Marsyas*, in which the boy appears again as a satyr.

The tender *Virgin and Child* (London, National Gallery), the last extant version of the many Titian had painted since the beginning of his career, is by contrast all of a piece, and all the more touching for being gently out of focus.[22] The pose of the Virgin seems to repeat in reverse the similar figure in the family altarpiece in the church of Pieve di Cadore,[23] while that of the Child, His little cheek puffed up and ruddy from the effort of suckling, is based on a drawing by Michelangelo. Like so many of Titian's late paintings, this *Virgin and Child* was more or less ignored in the eighteenth century and for most of the nineteenth, before Claude Phillips, in his monograph of 1898, praised 'its almost monochromatic harmony of embrowned silver'; and the director of the London National Gallery[24] on its acquisition in 1924 extolled it as 'lit as it were from within by murky and fitful fires'.

But there were also failures. Titian had frequently depicted the Ecce Homo, the episode from the passage in the Gospel of St John in which Pontius Pilate shows Christ to the Jews with the words 'Behold the man!' But his last two treatments of the episode (Madrid, Prado[25] and St Louis Art Museum) are disappointing, certainly by comparison with the magnificent theatrical production he had painted for Giovanni d'Anna in 1543 and the moving close-up of Christ alone that he had brought to Augsburg in 1548 for the private worship of Charles V. In this much later version in the Prado[26] the figure of Christ holding the reed, which was taken from an engraving made by Luca Bertelli in 1564, itself based on a version sent to Philip II, is impressive. The rest of the composition, which he expanded to include three other figures, was not improved by Titian's numerous changes, which can still be seen with the naked eye – the executioner shown from behind was originally in profile; the reed pointed the other way; the window was originally circular and without the grille – while the uneven quality of the painting seems to betray the contribution of more than one hand. The St Louis version, which may be the later of the two, has been described by one authority[27] as 'a magnificent example of an unfinished painting by Titian'. The decorative elements, notably Pontius Pilate's brocade tunic, are almost certainly by an

anonymous assistant – possibly the one who painted the embroidered tunic worn by Philip II's Tarquin – or added after Titian's death. But although the composition is improved by the absence of the executioner and the grilled window in the upper right-hand corner, which was replaced by smoke and flames emerging from a torch, it could be that he grew impatient with attempts to say something new about the subject and simply gave up on it.

On 1 August 1571, on the eve of the Battle of Lepanto, Titian wrote to Philip II asking for his reaction to the *Rape of Lucretia*, which had been delivered to the Venetian ambassador in Spain.

> The calamities of the present times, in which everyone is suffering from the continuance of war, force me to this step, and oblige me at the same time to be favoured with some kind of proof of Your Majesty's grace, as well as with some assistance from Spain or elsewhere, since I have not been able for years past to obtain any payment, either from the Naples grant, or from my ordinary pensions. The state of my affairs is such that I do not know how to live in this my old age, devoted as it is entirely to the service of your Catholic Majesty, and to no other. Not having for eighteen years past received a *quatrino* for the paintings which I delivered from time to time, and of which I forward a list by this opportunity to the Secretary Pérez, I feel assured that Your Majesty's infinite clemency will cause a careful consideration to be made of the services of an old servant of ninety-five by extending to him some evidence of munificence and liberality …[28]

This letter, apart perhaps from Titian's claim to be ninety-five, was not unreasonable. Titian considered that the pensions on Milan and Spain, which were indeed often in arrears, were in reward for his work for Charles V and for Philip at the time of his second trip to Augsburg in 1550. He expected that the king would make some kind of ex-gratia payments for the pictures he sent subsequently, and the list he mentioned, which is lost, was presumably related to them. Philip, although he had given up answering Titian's begging letters directly,

was by no means indifferent to his claims. In 1569, as already noted, he had instructed the then viceroy of Naples, the Duke of Alcalá, to make a single payment of 1,000 ducats in compensation for Titian's numerous failed attempts to activate Charles V's promise, made as long ago as 1535, to grant his favourite painter the right to export corn from the Kingdom of Naples free of duty. But it was Philip's appointment in 1571 of Titian's old friend and dining companion Cardinal Antoine Perrenot de Granvelle as viceroy of Naples that finally resolved the Naples problem. Granvelle, after befriending Titian at Augsburg in 1548, had gone out of his way to advise him about the recovery of his various delayed pensions and the Naples grant. Now, as Philip's representative in Naples, he was in a position to take direct action on Titian's behalf. On 29 October 1571 he informed the newly appointed Spanish ambassador in Venice, Diego Guzmán de Silva, that he had instructed the Neapolitan treasury to pay Titian 500 ducats and the rest shortly. When nothing happened Philip, perhaps in response to Titian's letter about the *Rape of Lucretia*, wrote to Granvelle on 25 April 1572 instructing him to see that the grant was finally honoured.

In 1570 Titian was required, as a condition of drawing his Spanish pensions, to produce an annual certificate testifying that he was still alive. Jacopo Sansovino died in the same year at the age of ninety-one, and two years later he was followed by Francesco Zuccato. Girolamo Dente, Titian's most faithful assistant since the days in the old studio in the Ca' del Duca and a witness to his marriage to Cecilia, had gone off to pursue his own career on the back of Titian's immense prestige. The loss of close friends and colleagues is one of the penalties of survival into extreme old age. For some people, however, a sharpened memory for the distant past may be some compensation. Although Titian was not a sentimental man, we can imagine him summoning up the details of particular minutes or hours in the studio of Francesco's father Sebastiano where as a boy of ten he had taken his first lessons in painting. Flashing forward by nearly three decades came the arrival in Venice of Aretino and Jacopo Sansovino, the two

men who quickly became his best friends. Their glory days as Doge Andrea Gritti's Triumvirate of Taste followed – their mutual support in good times and bad, the friendly arguments, the laughter, dinners and exchanges of letters.

But if Titian missed his friends he was not solitary. There was always the extended family to console and bother him: four adult children, possibly as many as nine grandchildren, and at least five nephews and nieces. We see some of them in the *Madonna of Mercy* (Florence, Galleria Palatina), which was commissioned in May 1573 by Titian's faithful patron, Guidobaldo della Rovere, 'to put in one of

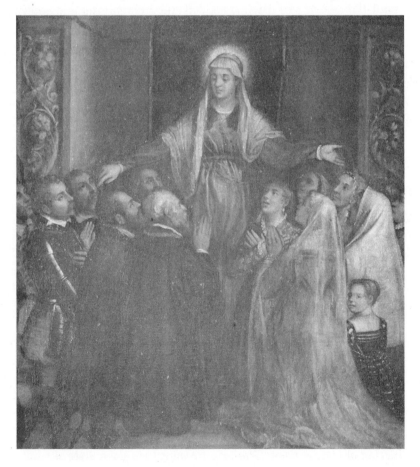

Madonna of Mercy

our little chapels' in Pesaro. Images of the Madonna sheltering her people with outstretched arms had been popular since the late Middle Ages and can still be seen in relief carving on buildings in Venice. Since Guidobaldo did not specify identities for the people, Titian represented them as members of his family with the men kneeling on her right and the female relatives on her left. Titian, bareheaded and wearing his gold chain of honour, is just in front of Orazio, who is dressed in an identical black cloak. We don't know who the other four men are, but they could be sons-in-law, nephews, cousins or grown-up grandchildren. The woman with her arms crossed looks very much like Titian's portrait of Lavinia painted after her marriage and now in Dresden. Two of the women who seem to be wearing shrouds might be dead relatives: Titian's first wife Cecilia? His second wife? His sister Orsa? The little girl looking out at us is surely one of his youngest grandchildren by Emilia, who might be one of the other women. Livia Balbi, who had come to live with Titian after separating from her husband Gaspare, is also a candidate for one of the women.[29]

When Guidobaldo requested this painting he wrote to his agent Giovanni Francesco Agatone that 'since we believe that the signor Titiano no longer works with his own hand, we desire nevertheless that he will take care to have it diligently executed by one of his [*uno di quei suoi*]'. 'Titian', for Guidobaldo as for many other patrons, had come to mean 'Titian's workshop', supervised by the master and authenticated by a few strokes of his brush. In the case of Guidobaldo's commission, however, Titian replied through Agatone first that he wanted to do it with his own hand, and again that he had sketched it and was still resolved to paint it himself. Perhaps the process of sketching the composition took him back to the family groups he had painted in his prime for Jacopo Pesaro and Gabriele Vendramin, and he realized that he no longer had the patience or the steady hand required to execute so many portraits in one painting. We can't be certain which one of 'his' completed the picture. It could have been his young relative Marco Vecellio, who later completed Titian's votive *Portrait of Doge Antonio Grimani*, the somewhat naive style of which is akin to that of the *Madonna of Mercy*.

Nevertheless, if Titian in his eighties used his assistants more than ever he would not put down his brushes until he was close to death. When the eyes of a painter begin to fail, the hand, guided by knowledge gained through long experience, may take over; and if the hand trembles it is still the hand of an artist, in Titian's case an artist with one of the greatest and most original minds of all. The subjective, expressive paintings from the last five or six years of his life that were not intended for Philip of Spain – notably the *Crowning with Thorns*, the *Death of Actaeon*, *Nymph and Shepherd*, the *Flaying of Marsyas* and the *Pietà* – are often compared to the late works of Beethoven, Verdi, Shakespeare or Rembrandt (who was consciously following Titian and who refused to commit himself on the question whether a painting was 'finished' or not), or are admired anachronistically through the filter of twentieth-century Expressionism.[30] They strike a particular chord with modern sensibilities, especially with working painters whose style may bear no resemblance to Titian's but who see them as the apotheosis of his career. Younger contemporary artists like Tintoretto appreciated what he was doing. But patrons, on the whole, did not understand them, or put their 'blotchy' style down to old age. The rough, apparently unfinished style did not come into fashion with mainstream collectors until the next century, so it must have been Boschini writing in the late seventeenth century, rather than Palma Giovane a century earlier, who thought that Titian's late paintings were unfinished and all the more sought after for that reason.[31]

We will never know whether Titian considered all of his most radical latest paintings to be 'finished' or not, or to what extent they were affected by his well-documented failing vision (perhaps cataracts or macular degeneration) and trembling hand. Nor, failing surviving documentary evidence about them – and because of Titian's ability to work contemporaneously in different styles, and his habit of applying himself sporadically to paintings, as the mood took him, or to let one layer dry before applying the next – can they be put into chronological order. The most that can be said is that some of them must have been on his easels by the time he was painting Philip's relatively

conventional *Rape of Lucretia*, of which the technique and finish is similar to, if not as successful as, the *poesie* of the 1550s and early 1560s. And this raises the never to be resolved question of whether he hoped to work up the more roughly painted canvases to a similar degree of finish; or whether, despite or because of his physical limitations, he was searching for something so new, and so deeply private, that he would never have let them out of the studio where Ridolfi said he hid them away from view, and where they remained at the time of his death.

Another Way of Using Colour

The event is gloomy and this monotony seems to be appropriate.
The hounds by which the transformed Actaeon is torn to death
are expressive symbols; they are ghosts rather than creatures
known in nature. One can say that Titian has here discovered yet
another way of using colour.

JOHANNES WILDE ON THE *DEATH OF ACTAEON*, IN
VENETIAN ART FROM BELLINI TO TITIAN, 1974

Even by Titian's usual standards the *Death of Actaeon* had a remark-
ably prolonged gestation. He had mentioned a painting of 'Actaeon
torn to pieces by his own hounds' in the letter to Philip II of 19 July
1559 in which he announced the completion of *Diana and Actaeon*
and *Diana and Callisto* and added that he had already begun the *Rape
of Europa*.[1] He kept Philip informed about his progress on the *Rape of
Europa*, which was delivered to Spain in 1562, but the 'Actaeon torn
to pieces by his own hounds' never appears again in his correspond-
ence with the king, and the subject is not mentioned again until
November 1568 when the imperial ambassador in Venice offered the
emperor Maximilian II a selection of pictures by Titian which
included a Death of Actaeon. That picture, like the others on the list,
would have been a studio copy.[2] The original, however, almost
certainly remained in Titian's studio until the end of his life, and by
that time it looked nothing like any of the paintings he had ever sent
to Philip. It may be, judging from the numerous changes he made

even at the planning stage, that he had set himself a task that he could not at that time complete to his own satisfaction, or that the grim episode of Actaeon's death may not, in the happier days of the 1550s, have suited his mood or what he knew would please the king.

At the end of Ovid's story of Diana and Actaeon the virgin goddess of the moon, naked and unable to reach her bow and arrows, splashes water in the face of the unwitting intruder and challenges him to tell the world what he has seen – 'if tell he can'. As Actaeon flees he senses a change in himself but does not realize the full horror of what has happened to him until he stops at a stream to drink and sees from his reflection in the water that he is being transformed into a stag. He tries to speak but cannot, whereupon he is set upon and killed by his hounds. In his *Diana and Actaeon* Titian had anticipated Actaeon's gruesome punishment by placing the skeleton of a stag's head on a rusticated pier and Diana's quiver hanging from a tree high above her. It would be logical to assume that he intended his painting of Actaeon's death, which in Ovid follows immediately after Diana's curse, as a sequel to that painting. Titian had, however, decided to pair *Diana and Actaeon* with the unrelated story from the *Metamorphoses* of *Diana and Callisto*. And, apart from the stream that runs through all three pictures, the composition of the *Death of Actaeon* does not relate to his previous two Diana poems, in both of which the goddess is naked on our right with her nymphs striking different poses. In the *Death of Actaeon* she is alone on our left and clothed, in a rose-red tunic with one breast bared and her wrists adorned with matching bracelets, hunting down the stag that was Actaeon who is chased by his pack of hounds in the middle distance.

As the years passed the most protean of Renaissance painters seems to have discovered – like Actaeon, who found himself running faster than usual before he understood why – that something new was happening each time he confronted his easel, so that, as Francis Bacon remarked in 1972,[3] the painting looks as though he was using 'the light to work into the paint, so that the images are never absolutely definite and yet they are the suggestion of a tremendously tragic act'. The preparations[4] are conventional: a thin gypsum ground, rough

preliminary drawings made with a brush and lead white, and a dark translucent primer. But, although Titian had always tended to change his mind as he went along, this time he seems to have been even less satisfied than usual with his first ideas. The thinly painted figure of Diana, the dominant and most defined part of the painting, once had wind-blown hair and a flying scarf; her left arm was raised higher and her right arm hung by her side, slightly bent. The landscape also evolved over time: the tree in the foreground on our right was once in the distance; Actaeon was further to our left.

Last seen in *Diana and Actaeon* as a handsome young hunter, Actaeon's metamorphosis is not yet complete: he already has the head of a stag, but as he rears back on his hind legs, his pose reversing that of Diana, his arms and torso are those of a man still human enough to understand his fate. The dog that slips between Diana's legs could be the shadow of a dog. But the hounds that are already attacking their prey, as they 'emerge from a flurry of energetic brushwork visible in X-ray',[5] are real hounds, executed with a broad brush and the help of the artist's fingers. In the brief interval that follows Diana's curse, the high summer of the previous Diana poems has turned to late autumn. The sky is a stormy grey tinged with the acid yellow he used for the foliage, which is painted with dry, broken stabs of the brush. Instead of adopting the traditional practice of applying translucent glazes over opaque colours, Titian let his yellow paint overlap in random order with a red-brown glaze. Perhaps his brush slipped once or twice and he decided he liked the effect? The mesmerizing bush in the foreground, however, is without a glaze, so that we can admire the extraordinarily vigorous and charismatic brushwork of a painter well into his eighties.

Titian had always taken liberties with Ovid's stories, but never as radically as in the *Death of Actaeon*. In Ovid's account Diana was not present at Actaeon's death, nor was it necessary that she should be since she had already pronounced his doom only minutes before he left her in her grotto naked and unable to reach her quiver. This woman is clothed, with a quiver slung over a shoulder and holding up a bow from which she seems just to have fired an arrow, although the

bow has no visible string and the arrow would have shot over Actaeon's head – perhaps Titian was pleased by the pattern formed by the intersection of her arm holding the curved bow with the straight trunk of the tree across the river. Nor does she wear her attribute, the crescent moon, in her hair. So is she Diana? or might she be, as has been argued by one scholar,[6] a personification of Diana's vengeance?

The ongoing debate about whether or not Titian considered the painting to be finished will never be resolved, if only because it is difficult to distinguish the numerous abrasions and paint losses – especially along all the edges and the vertical seam of the centre of the canvas – from passages that were either unfinished or deliberately left vague. It was regarded as unfinished when first sold in the seventeenth century;[7] and it may be that Titian, with no patron to consider, was so fascinated by the new way of using colour that was evolving as he worked that he was prevented only by death from making further changes.[8]

The subdued surface tone, the variation of painterly definition and the more open and apparently freer brushwork of the paintings from the 1570s have led to numerous theories about the aesthetic intentions of the octogenarian Titian and how much they were determined by his physical limitations. Some of them were contradicted, in the case of one exemplary late masterpiece, by a conservator who spent five years in the first decade of the twenty-first century examining and restoring his last secular poem *Nymph and Shepherd* (Vienna, Kunsthistorisches Museum).[9] She found no signs of the haphazard, accidental or spontaneous work that might indicate a confused approach or an unfinished state; but saw that, on the contrary, Titian's technique was even more elaborate and sophisticated than the procedures described by Palma Giovane, and was 'developed to achieve a specific artistic effect'. The painting, which had previously been regarded as ruined beyond the possibility of recovery, was found to be in reasonably good condition apart from numerous small paint losses, filled in over time by dirt and discoloured varnish, 'which visually spanned the painting like a black net'. The surface had been further darkened by excessive previous cleanings, which had rubbed away the

paint surface down to the brown or grey-brown underpainting Titian had used beneath brighter colours. As with the *Rape of Lucretia*, but unlike so many of Titian's earlier paintings, he followed the overall design established by his fluid preparatory sketches; even the scarcely detectable man sheering sheep in the distance was part of the original design.

The contours and position of the nymph, whose naked body reclines across the centre of the picture with her back to us, nestling into the pelt of a dead leopard – its head peers out at us from beneath her legs – were unchanged, although at a later stage he threw her into relief by modelling the outline of her body with dark glazes; nor was the figure of the shepherd altered apart from the shape of his head. Their lovemaking takes place in a blasted landscape, in which there seems to be a vaguely indicated castle in the distance and a shattered tree, as in the *Three Ages of Man* painted some sixty years earlier, but this time with a goat gnawing at one of its branches. The agitated mood of the background looks sketchy or unfinished, but must have been deliberate because it was retained throughout the successive painting campaigns, and the apparently spontaneous two strokes of red indicating the last rays of a setting sun that seem to set the sky on fire were made with thick multiple brushstrokes of lead white followed by the red, which was applied before the white had fully dried. One of the most surprising revelations of the investigation was the myriad of brilliant colours – emerald green, for example, for the foliage – that Titian had used before suppressing them with dark glazes. The underlying layers of the flesh of the nymph, a figure that is unique in Titian's late works, are also composed of a variety of bright colours that would have given its original glazed surface a shimmering opalescent glow. Titian, who had always been especially famous for his depiction of living flesh, realized hers in a different technique from the rest of the painting, with no visible brushstrokes or use of his fingers.

There have been the usual attempts to find a subject for the painting – Diana and Endymion, Paris and Oenone, and Bacchus and Ariadne have all been proposed. But all that can be said with reasonable certainty is that Titian's starting point for the nymph seems to

have been an engraving by Giulio Campagnola of a lost painting perhaps by Giorgione. Since nothing is known about the patron, if there was one, of *Nymph and Shepherd* we can only imagine that Titian took such immense trouble to finish a depiction of sensuous experience because that subject, despite his more ambiguous feelings about it in his old age, had not lost its importance for him. The nymph and shepherd are young, as they were in the *Three Ages of Man*, but the old painter's perspective on their youthful lovemaking has changed. In the earlier painting it was the shepherd who was naked and the clothed woman seducing him with her pipes. Their young flesh glowed in the fresh mountain air against an untroubled azure horizon while the broken tree and the old bearded man holding a skull in each hand served as warnings about the inevitable transience of such beauty and exquisite pleasure. Sixty years later Titian's girl is naked and it is the clothed shepherd who calls the tune with his pipe. The prophetic old man, has disappeared from our view. But we can imagine him there in his studio standing, or perhaps sitting now, in front of his easel, painting his wintry poem about the pleasures of the flesh from the other end of life's telescope.

When the London National Gallery acquired the *Death of Actaeon* in 1972[10] the director,[11] who was less than enthusiastic about it, commented that Titian 'had become pessimistic, perhaps rightly'. There were certainly more reasons to be pessimistic in the 1570s than there had been in the 1550s when he had delighted Philip with his erotic poems. No one living in the lagoon city was immune to what Titian in his letters to Spain called the calamitous times: the famine, the disease, the horrific flaying by the Turks of Marcantonio Bragadin, the loss of Cyprus despite the glorious victory at Lepanto. The great fire in the arsenal of 1569 was followed in 1571 by another, which consumed Titian's Last Supper in the refectory of Santi Giovanni e Paolo, caused by some drunken Germans who accidentally blew up a store of weapons beneath the monastery; and another in May 1574 when three rooms in the doge's palace, the Sala delle Quattro Porte, the Anti-Collegio and the Collegio itself, were gutted,[12] and another

in 1575 in the communal palace of Brescia, which destroyed the three ceiling paintings that had been the cause of Titian's prolonged dispute with the councillors.

Nevertheless, the dark and violent subject matter of Titian's paintings from the 1570s reflects a change in outlook so profound that it surely transcended the calamities of the times. Most Venetians in any case – or those who could afford to indulge voluptuous appetites – continued to enjoy the finer things of life. Two years after the conclusion of the Council of Trent a catalogue of courtesans was freely circulated complete with prices and the names of pimps. Decrees by the Senate forbidding the wearing of pearls and excessive consumption at banquets were ignored, as they always had been. Veronese's popular paintings of make-believe neo-Roman dinner parties[13] continued to reflect the fantasy world of a self-important patriciate whose government was corrupted, whose fortunes were being eroded by inflation and the decline in maritime trade, but who did at least enjoy a degree of freedom, one that was unique in Catholic Europe, from the repressive dictates of the post-Tridentine Counter-Reformation.

The Inquisition operated with a light hand in Venice, where it was under the control of the state. The only occasion on which it challenged an artist concerned the feast Veronese had painted for the monks of Santi Giovanni e Paolo as a replacement of Titian's Last Supper. Even then the Inquisitors seem to have been motivated more by a grievance against the prior of the monastery than by a wish to impose Tridentine definitions of the purpose of art by illustrating the suffering of Christ and the saints as a means to salvation. Veronese named as his subject, probably picking it out of a hat, the banquet at which the Pharisee Simon entertained Christ in his house, where Mary Magdalen sought Him out and washed His feet with her tears and dried it with her hair. Unfortunately Veronese had absentmindedly neglected to include the Magdalen in his feast. The Inquisitors ordered the prior to demand that the painter replace the large dog in the foreground with a figure of the saint. Having failed to do so Veronese was summoned by the Inquisitors on 18 July 1573 when

they informed him that they further objected to the presence of a clown holding a parrot, as well as 'drunkards, German halberdiers, dwarfs, and other lewd things'. Veronese coolly admitted that 'if in a painting there is space left over, I fill it with figures from my imagination ... My commission was to make this picture beautiful according to my judgement, and it seemed to me that it was big and capable of holding many figures.' He was ordered to correct the painting within three months at his own expense. But the painter, evidently undaunted by the demands of the Holy Office of the Inquisition, got round the problem by changing the title of his painting to the *Feast in the House of Levi*, which is described in the Gospel of St Luke as a great feast in which 'there was a great company of publicans and of others that sat down' with Christ and the Apostles.[14]

While the younger virtuoso continued to produce his gorgeous tributes to an idealized Venice – and Tintoretto to reflect his agonized spirituality in his magnificent fresco cycle for the Scuola di San Rocco[15] – Titian was engaged by very different projects. While working on the *Allegory of Lepanto* that Philip had ordered after the great victory and a *St Jerome* that he would send with it in September 1575, he continued to explore the new way of painting that he knew would be unacceptable to the king as, indeed, to most paying patrons. The earlier more accessible works were still sought after, and the workshop continued to turn out copies and variants. But his assistants could not follow him to the place where his painterly imagination was taking him. Weakened by age, jealous of his painting time, he leaned more than ever before on Orazio to collaborate in the studio as well as to perform practical tasks, such as the selection and purchase for over 130 ducats from a Venetian *vendecolore* of an array of colours requested by Phillip II in May 1572 for the decoration of the Escorial, where work was beginning on the King's House.

Personal and family problems weighed more heavily in the extreme old age that he unfailingly cited as a reason for having his way. When in the winter of 1572 there was trouble in Cadore involving his relatives who served on the council Titian sprang ardently to the defence of his nephew, his sister Dorotea's son Odorico Soldano, a notary and

prefectural chancellor of the communal government of Cadore. Odorico was at the centre of a heated row that had split the Vecellio clan. He had aroused the resentment of the other notaries in the communal government, and when the *centuria*, or administrative district, of Domegge wished to elect him as their official representative the council insisted that such an appointment would be incompatible with his office as chancellor. Led by Vecello Vecellio and his son Tiziano, the council decided to send to Venice four orators and twenty representatives of the *centurie* to put the case against Odorico to the doge. On 26 December Titian reacted with a furious letter to the Magnifica Comunità di Cadore. The council, he wrote, was putting itself in danger of losing the good faith of the Most Serene Republic, and its behaviour was judged very bad indeed by all intelligent people. 'This, I say with great passion from my heart because each one of you knows how many benefits I have extended to you … whether sought after or not.' He went on:

> … I love my dear homeland and try always to honour it to favour you. But I would never have believed that I would receive in recompense for those loving and good deeds a persecution like that you are making against the person of the Chancellor, knowing that he is my nephew the son of one of my sisters and a person in his own right of valour and repute, and a good son of your dear country, which I cannot fail, nor will I ever fail to favour with all my power in matters of honesty and justice … It saddens me however that although my nephew has wanted to give every kind of satisfaction to your envoys they, having no inclination to make peace, have not wished to listen. And so I exhort you in the name of that true love that I have borne and bear for the Magnifica Comunità that each one of you will put lovingly aside petty interests and private hatreds, and direct your attention to peace, quiet and the public good.

Unfortunately, the gravitas and past generosity of Cadore's most famous citizen were not persuasive. The dispute raged on, as petty provincial quarrels do. Odorico Soldano was condemned by the

council in May 1573 but appealed with the support of three of the *centurie*. He also managed to have the accounts of the council examined by an external judge, the *podestà* of Treviso, to the evident embarrassment of the Vecellio. After further manoeuvres the matter was finally settled in 1574. Soldano remained chancellor and was appointed official of one of the *centurie*. But Titian was sufficiently disgusted by the behaviour of his relatives to question a lifelong assumption that he would be buried in his birthplace, near his parents and his brother Francesco.

The continuing row with Pomponio over the management of the church benefices was another festering wound, one that he knew would never be healed. Although the two never met again after their exchange of angry letters in 1568 the dispute dragged on and on. In 1573 they were once again engaged in litigation, with Pomponio claiming as before that his father was mismanaging the benefices and Titian denying the charge. Then in September of the same year Titian was further insulted by a tax demand on properties he had transferred to Orazio. He appealed, successfully, with a querulous letter to the Serenissma insisting that he, an old man who could no longer work or earn, had been 'unjustly condemned' to pay taxes.

Titian's great age and physical infirmities were the subject of increasing comment in these years. Guidobaldo della Rovere, who had come to believe that Titian 'no longer works with his own hand', was not alone in thinking that he was too old and enfeebled to do more than participate in the paintings that came out of his workshop. Even Philip II was not sure that his favourite painter would be up to the *Allegory of Lepanto*, which he had ordered after the victory. When ordering the painting he let it be known, as he had a few years earlier about his *Martyrdom of St Lawrence*, that if Titian couldn't do it he would find someone else. In 1573–4 Prospero Visconti, a painter who acted as agent to the Duke of Bavaria, William V, proposed the acquisition of a 'Judith or Herodias' painted by the 'disciples' and 'corrected' by Titian. And when the English poet Sir Philip Sidney was in Venice in 1574 he chose Veronese to paint his portrait (lost) rather than Titian, who would doubtless have been his first choice a decade earlier.

But if some were put off by rumours of Titian's failing health and of the strange new paintings that looked to conventional eyes like mere blotches, Titian was still the most famous painter in Europe, and the people who came to Venice to marvel, as Ridolfi would have it, at its beauty, wealth and good government, 'also came to see Titian, unique among painters, just as Venice is unique in the universe'. One of these visitors was no less a personage than Henry III, the elected King of Poland, who stopped in Venice for ten days in July 1574 on his way from Poland to assume the throne of France after the death of his brother Charles IX. The Serenissma, which was trying to establish closer ties with France, received Henry with the most elaborate and magnificent spectacles ever mounted in the lagoon city. A triumphal arch, fifteen metres wide, designed by Palladio and painted by Veronese and Tintoretto with scenes of Henry's achievements, was erected for the occasion in Piazza San Marco. There were masques, music and banquets at which napkins, plates and even the tables were made of sugar. Each of the 200 Scuole decorated a boat. A wooden float on the Grand Canal let off explosions of flames and fireworks that Francesco Sansovino likened to an eruption of Mount Etna. Henry, who conducted a liaison with the poet and courtesan Veronica Franco, also, according to Ridolfi, made a point of paying a visit to Titian's studio where the master regaled the king with an account of all the great rulers he had served and offered to make a present to him of all the pictures of which he asked the price. It was also said that Henry made an offer to Paolo d'Anna of 800 scudi for the great *Ecce Homo* that Titian had painted for Paolo's father Giovanni, and that Paolo turned it down.

Although the story about Henry's visit to the studio and Titian's uncharacteristic offer to make a gift of paintings to the king may well be one of Ridolfi's inventions, Titian still had important patrons, and his international prestige was such, and his core of assistants so highly skilled, that anything bearing the imprimatur of the greatest living painter was still valued. And Titian was still confident enough of his abilities and the products of his studio to claim valuable rewards.[16] In

1572 he supplied the Duke of Alba, whose portrait he had painted at Augsburg and who was now Philip II's governor of the Netherlands, with two paintings, a copy of the *Penitent Magdalen*, of which he had kept the template (St Petersburg, Hermitage) in his studio, and, appropriately for a professional soldier, a Bellona, goddess of war (lost). His fee was to be a set of tapestry wall hangings, the *spalliere* hung over furniture, which, as he wrote to the duke on 31 October 1573 reminding him of his promise, were 'so dear to me that it could not be more so if you had given me two thousand scudi, because scudi you spend and these serve in the house for ever, and after I have enjoyed them they will be left to my descendants as a testimony of my grateful service to a prince as great as Your Most Illustrious Excellency'. The tapestries, he wrote tactfully, seemed to have gone astray, but when they reached him he would inform the duke in Spain and would send a devotional picture for him along with the next lot of paintings for His Most Catholic Majesty.

Titian would have heard from the Spanish ambassador in Venice, Diego Guzmán de Silva, that Alba was about to be relieved of his post and was preparing to return to Spain. The duke's campaign to bring the heretical Netherlanders to heel – his Council of Blood, the threatening presence of Spanish troops, the hated tax known as the Tenth Penny, the never to be forgotten execution of Counts Egmont and Hoorn – had had disastrous consequences for the reputation and finances of Spain. In the six years of Alba's rule the Netherlands had become the biggest single drain on the Spanish treasury, the debt alone consuming two-thirds of available income. After the failure of a siege of Haarlem led by Alba's son Fadrique, which was repelled when the citizens threatened to wash away the Spaniards by opening the dykes, the Iron Duke, now a sick and weary man, admitted defeat and offered his resignation. When Titian wrote to him about the wall hangings Alba was eagerly waiting for the arrival of his replacement, Luis de Requesens, so that he could be relieved of his post and return to Spain.

Even Cardinal Granvelle, who had himself advocated a tough line and continued to express his admiration for Alba as a person, let it be

known that he believed the Netherlands had been ruined under his governance. But it was not only that failure that would be Alba's undoing. The Castilian aristocracy had long been split into two rival factions, each linked by ties of family and clientage, which were jostling for power through influence on their indecisive king. Alba was the leader of the hawks, who continued to lobby for a hard line in the Netherlands. Those who opposed him and his policy were led by Ruy Gómez de Silva, Prince of Eboli, whom Philip on his accession had appointed a councillor of state. When the Prince of Eboli died soon after Alba's retirement and return to Spain, Philip's secretary Antonio Pérez stepped into his shoes and was joined three years later by Eboli's widow, Doña Aña de Mendoza, a volatile and ambitious intriguer at court whose celebrated beauty was all the more fascinating for the black patch she wore to cover a lost eye. The Ebolist manipulation of Philip brought about a U-turn in Spanish policy in the Netherlands. Luis de Requesens, a member of a distinguished Catalonian family, was sent there as governor charged with negotiating a settlement with the rebels. Philip was persuaded to exile Alba to his estates in Portugal. After the duke's disgrace we hear nothing more about Titian's wall hangings.

Antonio Pérez, despite his support for a policy of conciliation in the Netherlands, was a nastier piece of work than the Iron Duke. It was later discovered that he had been selling state secrets, and that he and the Princess of Eboli had conspired in the murder of an enemy who had discovered incriminating evidence against him. But that was after Titian's death. In the 1570s Pérez was still the most powerful influence on the king, and Titian continued to seek his favour by sending him paintings while reminding him of the moneys he had not yet received from the king, including the pension from Milan, which the Spanish ambassador in Venice Guzmán de Silva had assured him was forthcoming, as well as payment for the pictures sent to His Catholic Majesty in recent years. In a letter to Pérez of 22 December 1574 he prays 'that your courteous wishes might have effect, as, being in want of money in these calamitous times, this will probably be the greatest favour that I can hope to obtain from Your Lordship ...'.

He enclosed with this letter a 'Memorial to His Catholic Majesty by Titian and his son Orazio' with a list of the paintings for which he had not been paid:

> First, that the pension in Milan of my son Orazio may be put in balance, in order that he may without trouble, fatigue, or interest enjoy the favour done him by His Majesty.
>
> Item, the pictures sent to His Majesty at diverse times in the last twenty-five years are these, but only in part, and it is desired that Signor Alons [Alonso Sánchez Coello], painter to His Majesty, should add to the list such pieces as have been forgotten here:
>
> > Venus and Adonis
> > Calisto pregnant by Jove
> > Actaeon arriving unexpectedly at the bath
> > Andromeda tied to a rock
> > Europa carried away by the bull
> > The Jews tempting Christ with the coin
> > Christ in the tomb
> > The Saint Mary Magdalen
> > The Three magi of the east
> > Venus with cupid holding a mirror
> > The supper of Our Lord
> > The martyrdom of St Lawrence
> > with many others that I do not remember, etc.

Philip, who was deeply in debt and sliding rapidly towards a second bankruptcy,[17] would never find the money to reward Titian for those masterpieces. He had, however, been demanding that his officials must pay the overdue pensions from Spain and Milan, and had indeed already ordered his governor in Milan, Antonio de Guzmán y Zúñiga, third Marquis of Ayamonte, to pay the arrears of the pension and see to it that it was paid regularly henceforth:

I have been informed that 600 ducats from the pension he receives from us are owing to Master Titian, painter living in Venice, and that as he is a person towards whom we are well disposed for the skill he possesses as an artist, and since he has served and continues to serve us I charge you to give order that he is to be paid whatever may be owing from the said pension and that this payment should be continued whenever necessary.

Payment of the pension on the chamber of Milan – granted to Titian by Charles V many years earlier, doubled when they met at Augsburg and now transferred to Orazio – had often been stalled by previous governors, whose treasury was chronically overstretched and whose officials saw no reason to divert scarce resources to some foreign painter. Ayamonte and Guzmán de Silva, however, had particular motives of their own to withhold the pension for the time being. Ayamonte, for political reasons, urgently wanted to acquire paintings by Titian at the lowest possible price; and he and de Silva had agreed that the pension should be used as an inducement to get work out of the ageing painter. So Ayamonte replied to Philip that he would be delighted to pay Titian but had more pressing financial obligations regarding the king's business in Milan. Privately he complained to de Silva that the king was putting Titian's interests ahead of those of his own governor. He made sure nevertheless that de Silva, a fellow nobleman and crony, was paid promptly and assured him of his continuing service, for which, he joked, the ambassador should pay him 'though I do not paint as well as Titian'.

The Marquis of Ayamonte was forty-nine when he took up his post as governor of Milan in September 1573, replacing Luis de Requesens, who had been sent to govern the Netherlands. There was at that time a power struggle between the Church and Spanish civil authorities in Italy, which was particularly acute in Milan where the archbishop was the saintly, extremely able Carlo Borromeo. Borromeo, one of the most influential voices at the Council of Trent, had returned to his native Milan in 1565 as its archbishop with a mission to create a new mood of popular devotion that would unite the city in a passionate

search for salvation. He practised the ascetic life he preached, living within the sumptuous surroundings of the archbishop's palace in only two small, sparsely furnished rooms with pictures of scenes from the Passion of Christ on the walls. He disapproved of the Spanish regime, continually interfered with its business, and after a clash with Requesens had excommunicated him and the president of the secretariat of the Milan Senate. Requesens had retaliated by occupying a fortress belonging to the archbishopric. The excommunication was quickly rescinded by order of the Holy See. But the tension in Milan was palpable when Ayamonte took over as governor. Unlike Requesens, who prided himself on being independent of the factionalism that split Philip's Council of State, Ayamonte was affiliated with the pacifist Pérez–Ebolist faction, which had stolen the ear of the king. It was therefore all the more important to retain Philip's trust by finding ways of coping with and even discrediting Borromeo. He decided to use subtler means than his predecessor; and it was part of his strategy to bolster his authority and demonstrate his piety by acquiring religious pictures by the hand of the great Titian, who had been befriended by the emperor Charles V, and was the favourite of the Spanish king, as well as of the king's secretary and leader of the Ebolist faction Antonio Pérez.

On 1 October 1573, two weeks after he took up his appointment, and six days before his first interview with Carlo Borromeo, Ayamonte wrote to Guzmán de Silva, also an Ebolist through his family connection with the Prince of Eboli, that he would like to possess an unfinished image of 'Our Lady and her Son' – it is tempting to speculate that it might have been the late *Virgin Suckling the Infant Christ* now in the London National Gallery – that the two men had seen in Titian's studio the previous July, and would de Silva negotiate a price for it. Busy though he was with his new official responsibilities he continued to nag the ambassador about delivery of the painting: please ensure that he obtained it; it must be dry before the packing, which should be done with care. When it arrived in November it was in fact slightly damaged where the paint had not completely dried. Ayamonte advised de Silva not to tell Titian, but please would he find out the

price, because the devotion the picture aroused in him would be moderated if it were to prove too expensive. By 30 December, however, he had changed his mind about the price. The image was very fine, although he confessed that he 'would have to be better' to dare to stay in front of it; and Titian should be well rewarded so as to give him the opportunity of acquiring further paintings by his hand. But for all his fussing Ayamonte had failed to notice that his painting was not the one he had seen in Titian's studio. It was a copy by Orazio, to whom in February 1574 de Silva ordered that a credit of twenty scudi should be made on account for a painting by his hand of Our Lady and her Son as sent to the Marquis of Ayamonte.

Ayamonte was an unusual patron in being neither a connoisseur nor a collector. He was primarily concerned with the condition of the paintings he received from Titian, in their prices and in the effect they would have on his standing in Milan. He left the bargaining and aesthetic judgements to Guzmán de Silva, who was to be the last in a long line of ambassadors in Venice charged with cajoling the ever dilatory Titian into producing paintings for their impatient clients. Unlike most diplomats, however, de Silva was interested in painting – at one point in their correspondence he mentioned his discovery of a painter called Bassano – and was willing to express his opinions. Although Titian and de Silva disagreed about the quality of Titian's most recent paintings, and Titian seems to have hidden from de Silva the earlier ones that the ambassador preferred, the master respected him well enough to give him free access to the workshop, and to paint his portrait (lost) in 1574 at a time when he had virtually given up portraiture.

Until de Silva's death in 1577 he and Ayamonte, who died in office three years later, were in frequent touch about official business and current events (sensitive information was relayed in code). But between 1 October 1573 and 1 December 1575, nine months before Titian's death, a third of their official correspondence and half of their private letters were also or exclusively about Titian.[18] Although de Silva did not name or precisely describe the pictures he saw in the studio his accounts of his meetings with the aged painter cast a light,

albeit a flickering light, on Titian in the last two years of his life, the time when he was working on his last pictures for Philip II and on the more radical paintings – de Silva may have seen in progress the *Death of Actaeon*, *Nymph and Shepherd*, the *Flaying of Marsyas* and the *Pietà* – that looked to de Silva, who had never seen anything like them, to be incomprehensible blotches, which he put down to the master's age and failing powers. This was the standard reaction of contemporaries who were not themselves painters. And to do justice to de Silva's connoisseurship we should remember that it was not until the twentieth century that the general preference for Titian's earlier paintings would begin to give way to our present appreciation of the last dark, expressive, freehanded style.

By November 1574 the use of the Milan pension as a bribe seems to have had the desired effect because Titian was working on a panel or canvas, which, so the governor understood from de Silva, the painter was making anew; he could only hope that it would ever be finished. It was in fact ready for dispatch in December when Ayamonte told de Silva that, even though it had not yet arrived, he would trust his judgement and do what he could to release at least some of the pension. He did not in fact sign the mandate until 12 February of the next year (and even then his officials dragged their heels), perhaps because when the painting arrived in January he was annoyed to find that it had been done on an old and torn canvas, with a patch on Christ's face near the ear where a nail had been clumsily inserted during the packing. Nevertheless, Ayamonte wrote, since Titian 'is so old that one must suspect he is dying' he would be grateful if de Silva would see if Titian had other examples of the subject and price them. De Silva replied that the canvas was indeed old 'for the painting is old as well, if it has not been renewed. Thus Your Excellency should appreciate it all the more, as it belongs to those he created when he still painted everything in his own hand, while he hardly still does that today.'

By 27 January 1575 the governor had had another idea. He would like a picture of the dead Christ on his winding-sheet (an Entombment) with the Madonna standing (as was consistent with

Spanish preference) and looking at Him with a suitable expression. On 5 February de Silva reiterated his opinion that the older pictures were better than the new ones, despite Titian's insistence that he valued his new paintings just as highly. 'As for Titian's painting I have nothing else to say than what I have already written, namely that his earlier paintings were good ... the new ones are not, even though he likes them as much as his earlier ones.' And on 24 February:

> Like Your Grace, I fear that Titian is of more advanced age than can be of advantage to good painting; his trembling hand may not affect the atmosphere and spirit of his paintings, but it does affect the application of paint and other things that can be executed only with a steady hand. I fear that it will prove difficult for him to start it and even more difficult for him to finish it.

On 3 March de Silva wrote that although Titian was too old to do anything but daubs his assistants gave life to what they could finish, especially Orazio, 'who works well, if only he were to devote as much time to painting as he does to other sources of profit, which he must think are more advantageous uses of his father's money and his own industry'. Ayamonte replied seven days later.

> I am convinced, as Your Grace says, that those pictures that he paints now or will still paint will not be worth very much, as the imagination is incapable of producing more than the merit of the work, but instead of those he painted earlier, he would rather take one of the recent ones into the other world with him, as great craftsmen almost always become strange with age.

Nevertheless, it seems that de Silva was beginning to recognize that there was something about the products of Titian's trembling hand that he could not quite define. On 17 March Ayamonte agreed with him that 'a blotch by Titian is better than anything done by another painter'. And two days later de Silva replied that although the works Titian was doing now were not to his taste, 'nonetheless they are his,

because although the bodies are not all there, the souls will be, and this is what gives them life'. It seems from this letter that Titian had decided to do something surprisingly ambitious for the governor. It was 'a design of Our Lady with her Son on the ground', a Pietà that is, which Titian would send in three or four days. When Ayamonte had seen the outline sketch and the measurements of it, he wrote to de Silva on 27 April that it was big, but:

> since the master is so old it will be better that way, because he can no longer work as well as he could on small pieces; although where there is the Mother and the Son little is needed to achieve any effect. Nonetheless the Magdalen will be good, since she is such a great example of the effect that God has on sinners and such a great teacher of how those who have sinned ought to behave; and so it will be good that the picture comes with the Mother and with the Son.

But Ayamonte was to be disappointed. Titian had never intended to let him have the large Pietà with the Magdalen. He had used the offer as a way of forcing the governor's hand over the still unpaid Milan pension, and by the time that manoeuvre had proved successful he had another destination in mind for the painting, which neither Ayamonte nor de Silva ever mentioned again.[19]

The Plague and the Pity

All I have produced before the age of seventy is not worth taking
into account. At seventy-three I have learned a little about the real
structure of nature, of animals, plants, trees, birds, fishes and
insects. In consequence when I am eighty, I shall have made still
more progress. At ninety I shall penetrate the mystery of things; at
a hundred I shall certainly have reached a marvellous stage; and
when I am a hundred and ten, everything I do, be it a dot or a
line, will be alive. I beg those who live as long as I to see if I do not
keep my word. Written at the age of seventy-five by me, once
Hokusai, today Gwakio Rojin, the old man mad about drawing.

HOKUSAI, PREFACE TO *ONE HUNDRED VIEWS OF*
MOUNT FUJI, 1834–5

All his life Titian had assumed he would be buried where he was born,
close to his family in Pieve di Cadore, the tiny mountain village that
he continued to think of as his homeland. His bones would rest in the
parish church of Pieve, Santa Maria Nascente, where he had been
baptised and had attended mass as a small child, and where his assis-
tants had decorated the choir with frescos to his design. His *Madonna
and Child Worshipped by Titian*, through the intercession of his patron
St Titian, with St Andrew portrayed as his brother Francesco, can still
be seen in the rebuilt church. But after the drawn-out dispute over the
prevarications of the Magnifica Comunità and his Vecellio relatives
over the timber yards at San Francesco della Vigna and the repayment

of his generous loans, followed by the petty vendetta against his nephew Odorico Soldano, he changed his plan. At some time after 1572 he decided that his last resting place would be in the Venetian church of Santa Maria Gloriosa dei Frari, where the triumphant *Assunta* that had launched his fame dominates the interior from the high altar, and the asymmetrical painting of the Pesaro family that set a new style for altarpieces still greets us as we walk down the left aisle.

He struck a deal with the guardian and the friars of the church for burial rights in the chapel of the Crucifix and donated a painting by his hand of the Pietà – a representation of the seated Virgin cradling her dead Son on her lap – to be placed over his tomb. The friars accepted the painting, but refused to replace the sacred image of the Crucifix and hung Titian's painting over another altar. Titian, enraged by the insult, sought the intervention of the papal nuncio, who issued a decree on 1 March 1575 instructing the church authorities to return the painted image of the Pietà to the artist 'so that he can dispose of it as he wishes'.[1] Titian then changed his mind once again, and returned to his original plan to be buried in Pieve di Cadore. Over the next year and a half he enlarged the picture he had recovered from the ungrateful friars, until it fitted the space over the high altar of the parish church of his home town.

Meanwhile there was unfinished work for Philip of Spain, who was expecting the three paintings Titian had promised him. They were ready by 24 September 1575 when Diego Guzmán de Silva informed the king that he was about to send 'the Victory over the Turks, a St Jerome, and the Religion', as well as a copy by Geronimo Sánchez, who had recently been in Venice, of Titian's Death of St Peter Martyr, 'one of the best things Titian ever made'.

Philip had requested the *Allegory of Lepanto* (Madrid, Prado) in 1571 as a joint celebration of the victory at Lepanto and the birth soon afterwards of his son Prince Ferdinand by Anna of Austria. He had specified a subject for Titian only once before when asking for his *Martyrdom of St Lawrence*, but this was the first time he also gave explicit instructions for how it should look. He sent portraits of himself and the newborn prince, which was reasonable enough

considering that Titian had not met Philip for twenty years and had never seen the baby. What Titian must have found more dispiriting was that for the first and only time in their relationship Philip, who had his doubts about whether the aged painter would be able to achieve the desired result without direction, also provided a design for the picture. It was by his court painter Alonso Sánchez Coello, a competent artist but hardly in Titian's league. The monarch offers the Infante Don Ferdinand to heaven through the mediation of a swooping angel, boldly foreshortened in the manner of Tintoretto, who proffers the palm of victory and a banner bearing the words 'MAIORA TIBI' (Greater triumphs await you). On our right a colonnade runs down the side of a terrace that opens on to the sea, where the battle raging in the distance is the most convincing part of the painting.[2] A shackled Turk with his turban and the spoils of war are in the left foreground. Although Titian signed the painting with his imperial title 'TICIANVS VECELLIVS EQVES CAESARIS FECIT', something that he rarely did, it is far from an inspired work and, apart possibly from the battle scene, looks as though he left it mostly to the studio to follow Coello's design. It should however be noted that the composition worked better before it was enlarged in 1625 to match the dimensions of Titian's *Charles V on Horseback*,[3] and that it attracted admiration in the sixteenth and early seventeenth centuries. Guidobaldo della Rovere, who saw it in Titian's studio in May 1573, and Antonio Pérez were only the first of a number of patrons to order replicas or variants.

Since Philip did not request *Religion Succoured by Spain* (Madrid, Prado), it may be that Titian assumed from his eagerness to have the Lepanto painting that the king would welcome another allegorical celebration of Spain's role as defender of the true faith against the Turkish heretic. He had never been interested in pictorial allegory and made the self-appointed task easier for himself by adapting a studio replica of a mythological painting sent to Maximilian II at some time after 1566. Maximilian's painting is lost but is known from an engraving by Giulio Fontana and a description by Vasari who saw it in the studio and said the picture had been begun for Alfonso I d'Este many

years earlier but left unfinished. Vasari described that painting as of a young nude kneeling before Minerva with a seascape where Neptune rides on his chariot. Titian transformed Minerva into a personification of Spain, armed as Pallas Athena and holding a shield with the arms of Philip II. He replaced Neptune's crown with a Turkish turban, and made the kneeling woman an allegory of Religion by the addition of a cross and chalice on the rock behind her, so that the serpents winding around the tree trunk at her back, which would originally have been seen as threatening the purity of the young woman, would be read as the false heretical religions of Protestantism and Islam. It was a neat trick, but the result is even less compelling than the *Allegory of Lepanto*.

If the allegories for Philip are devoid of the animating soul that Guzmán de Silva recognized in Titian's late paintings, the *Penitent St Jerome* (Madrid, Escorial) that sailed with them to Spain is another matter altogether. Until 2003, when it was shown at the London National Gallery and Prado exhibitions, it was hidden away in the Escorial and was, with the Cambridge *Rape of Lucretia*, one of Titian's least-known paintings. Since then some critics, baffled by the remarkable quality and high finish of some passages, have explained it as in part an earlier work, begun before the master's eyesight had started to fail, perhaps as a variation of the same subject from the late 1550s now in the Milan Brera. This *St Jerome*, however, is not really comparable to the Brera picture.[4] Its dimensions are different – wider and shorter – as is its design, which he based on a well-known woodcut made by Dürer in 1512; and it is a more tranquil, optimistic and colourful vision of the story of the penitent saint who went into the desert to make peace with himself and his God, a painting that must have given comfort and aesthetic pleasure to the monks praying in the chapel in the Escorial where it was placed.

St Jerome's elderly but lithe and muscular body, the carmine robe around his loins and the open book he holds to aid his meditations are illuminated by an opening in the rocky glade through which we see a brilliant blue sky, a distant mountain frosted by snow and a heavenly ray of light, confirmation that God has heard his prayers,

which beams towards the tiny portable Crucifix the saint has brought with him into the desert. The spooky nighttime setting of the Brera picture has given way to full daylight; the creeping lizard, the skull and the bones have disappeared. A crystal-clear stream bubbling in the right foreground is rendered with masterly strokes of white lead, as are the highlights on St Jerome's robe and on the beautiful still life of two closed books, an hourglass and scattered papers on the rock behind his kneeling figure. These meticulously polished passages contrast with the rough treatment of the rocky glade, which is rendered in a subdued palette: ochre, greys, browns and dark greens, enlivened here and there by those 'strokes of red like drops of blood' that Palma Giovane described.

The Escorial *St Jerome* is a painting that poses unanswerable questions about Titian's aesthetic intentions and physical capabilities in the last years of his life. Ayamonte's comment, made only eight months before the picture was dispatched to Spain, that Titian was so old that one must assume he was dying does suggest that the polished passages had been executed years earlier. Or was he still capable of working with precision – eyeglasses after all had been available for centuries – as he may have been in the Cambridge *Rape of Lucretia*? The superb quality of the highlights on the saint, his attributes and the bubbling stream would seem to rule out the contribution of the studio. As for the much sketchier setting, which is typical of the late paintings that some critics regard as unfinished, it may have been the best he could do, but it is unlikely that he would have insulted Philip with a work that he, Titian, regarded as unfinished.

The Marquis of Ayamonte, writing from Milan on 1 December 1575 in the last of his preserved letters about Titian to Diego Guzmán de Silva, urged the ambassador not to forget about Titian's work because of the salutary influence upon him of one of his paintings, which 'forces me to perform the duties of my office through the good effect of a few moments of looking at it'. He also asked for a precise report of the contagious disease that was rumoured to be spreading in Venice. He does not, however, enlarge on one abruptly ominous

sentence: 'Fear and mistrust are threatening us from every corner of the world.'

The Venetian authorities had been monitoring the progress of a plague, probably an Ebola-like virus, which had killed 200,000 people in Moscow and its environs in 1570, and had been raging in Constantinople before it travelled to Trent, Schio and Bassano. Nevertheless, the first cases to strike Venice in the summer of 1575 took the government almost by surprise. Every generation since the tenth century had suffered at least one plague; but some, like the most recent epidemic in 1556, had been relatively mild, and it was hoped that isolating the first victim, a visitor from Trent, and his Venetian hosts would contain the disease. A major outbreak at this time would spell disaster for the Serenissima: the Turks had been rearming after Spain withdrew from the alliance that had won the Battle of Lepanto; and Philip II, who was aiming to strengthen his position in Italy, made no secret of his antipathy for the Most Serene Republic. As the disease spread, Venetian ambassadors were instructed to give reassuring reports and to underestimate the fatalities while the health office, the Provveditori alla Sanità, took the usual sensible precautions. Infected individuals and those living with them were sequestered in their houses or sent to quarantine stations established in the previous century on islands in the lagoon: to the old hospital, the Lazzaretto Vecchio near the Lido, for treatment; to the Lazzaretto Novo, between Murano and Mazzorbo, for a period of quarantine. But there was no stopping the current of panic that ran through the population. As always in times of catastrophe there was a surge of religious fervour and collective guilt. Processions of supplicants carrying images of the Redeemer and the Blessed Virgin wound through the streets chanting litanies and prayers of penitence. Quacks set up stalls hoping to make their fortunes by selling remedies. Charitable donations to the poor increased. More miracles occurred than usual. But the Holy Office sensibly banned as superstitious printed flyers that promised protection or cure to those who followed particular programmes of recitations, invocations to Christ and Mary and multiple makings of the sign of the cross.

Although plague was easily diagnosed from the boils, or buboes, on the necks and armpits of its victims, and it was obvious that it was transmitted by human contact, the disease was not fully understood by sixteenth-century Venetians, who thought it was caused by a poisonous miasma or by swallowing rotten food or polluted water. The superstitious blamed the disease on vampires. Because the majority of victims were the poor who subsisted on unhealthy or inadequate diets in overcrowded and insanitary conditions some doctors concluded that the epidemic was a kind of famine fever, which could be controlled by poor relief or by transferring the inhabitants of slums to settlements on the islands or mainland. Within the limits of current medical knowledge, however, the Serenissima responded to the crisis with its usual efficiency and good sense, although it was forced to take what our modern politicians like to call 'tough decisions', such as putting out of work everyone – from charlatans and strolling players to schoolmasters – whose jobs depended on gathering crowds. More problematic was the general belief that the infection was carried by merchandise, especially textiles, whose manufacture and trade were fundamental to Venetian prosperity and to the employment of workers, not least of Jews who dealt in second-hand furnishings and whose loans were often a last resort for the poor. The government was thus in a no-win situation. Banning industry and trade would depress the economy, reduce the wealth of merchants and manufacturers (many of them members of the governing class) and inflate the numbers of the starving poor by creating mass unemployment. Failure to do so could result in hundreds of thousands of deaths across the Veneto. Representatives from Verona, on which a blockade had been imposed after a severe outbreak of plague in September, were successful in persuading the Senate that such preventive measures were more harmful than the plague itself.

Titian, relieved of his obligations to Philip and probably immune to plague after so many exposures to it, continued painting in his airy studio in Biri Grande. His depiction of St Sebastian (St Petersburg, Hermitage), the convert soldier tortured by a hail of arrows and associated with plague because his wounds were thought to resemble the

buboes, was probably commissioned during the onset of the infection. At the beginning of his career Titian had painted a heroic St Sebastian in his altarpiece, *St Mark Enthroned*, ordered by the monks of the church of Santo Spirito during the epidemic of 1510–12 that had killed Giorgione. In 1520 another *St Sebastian*, a panel for Altobello Averoldi's Resurrection polyptych in Brescia, had caused a sensation when it was shown separately in Venice. The youthful Titian had intended that writhing figure, inspired by the then recently discovered Hellenistic statue of *Laocoön and his Sons*, to show off his skill by rivalling Michelangelo. Now he wanted to convey the martyr's quiet agony, his acceptance of God's will and the chaos that seems to be encroaching around him. The twist of St Sebastian's body repeats the subtler pose of another Hellenistic statue, the *Apollo Belvedere*. He stands alone against a black tree and livid sky streaked with angry red – the colours of plague. His face, half in shadow, is raised to heaven. A trickle of blood from an arrow piercing his torso runs down his body and loincloth smearing his right leg. Titian began with a half-length figure to which he added strips of canvas below and to the right to accommodate the legs, the very sketchy landscape and the blurred beginnings of what would have been the former soldier's discarded cuirass if he had finished the picture.

Then, with the arrival of winter, the plague lifted. Titian did not mention it when, on Christmas Day, he wrote a begging letter to Philip, in which he referred to another of his 'memorials', this one compiled by Sánchez Coello, of the pictures 'sent at various times by command of Your Majesty' for which he had not been paid. The conclusion of the letter echoes the pessimism expressed by the governor of Milan only twenty-five days earlier: 'There is so much ill fortune in the world now that I feel great want of the power and royal liberality of a holy prince of the world, such as Your Catholic Majesty, whom I pray that God may keep for a long time.'

When he wrote again to Philip on 27 February 1576, there was once again no reference to the plague. It is a long, rambling letter in which he hopes to 'recall myself to your royal memory', as though imagining that the king had forgotten his existence. He reminded him that it was

twenty years since His Majesty had paid him for the many pictures he had sent, that his father Charles V had numbered him among his 'familiar, nay, most faithful servants' by honouring him with the title of *cavaliere*, and that 'it may be known that the services done by me during many years to the most serene House of Austria have met with grateful return, thus causing me, with more joyful heart than hitherto, to spend what remains of my days in the service of Your Majesty'.[5]

This was to be Titian's last letter to the most powerful monarch in the world, who was, however, bankrupt and without the power to repay his creditors, let alone persuade his ministers to compensate a foreign painter for pictures that meant considerably less to them than managing their slender budgets and drawing their own salaries. At least the Milan pension, which had so often been in arrears, was paid in full by 1575, and Titian seems to have got almost all that he was owed on the Spanish pension by the end of 1574 and to have received the balance in 1575 or 1576. He was thus rewarded for the work he had done for Charles V and Philip II before and during his trip to Augsburg in 1551. But for the masterpieces, some of them the greatest of the Italian Renaissance, that were sent to Philip after 1551 he would never receive, as he had so often complained, so much as a *quatrino*.

At least he was free to paint as he liked without the constraint of pleasing the king. For his last mythological work, the harrowing *Flaying of Marsyas* (Kroměříž, Archbishop's Palace), Titian chose the horrific story, as recounted by Ovid in Book VI of the *Metamorphoses*, of the Phrygian satyr Marsyas, who challenged Apollo to a musical contest, pitting his shrill pan pipes against the heavenly music of the sun god's lyre, and was punished for his hubris by being flayed alive.

'Don't rip me away from myself!' he entreated;
'I'm sorry!' he shouted between his shrieks, 'Don't flay me for piping!'
In spite of his cries, the skin was peeled from his flesh, and his body
was turned into one great wound; the blood was pouring all over him,
muscles were fully exposed, his uncovered veins convulsively
quivered; the palpitating intestines could well be counted,
and so could the organs glistening through the wall of his chest.

The piper was mourned by the rustic fauns who watch over the
 woodlands,
his brother satyrs, the nymphs and Olympus, the pupil he loved,
by all who tended their flocks or herds on the Lycian mountains.
Their tears dropped down and saturated the fertile earth,
who absorbed them deep in her veins and discharged them back to the
 air
in the form of a spring. This found its way to the sea through a channel,
which took the name of the Marsyas, clearest of Phrygian rivers.[6]

The story was often confused or deliberately conflated, as in Titian's
painting, with that of another musical contest, the one between
Apollo and Pan from Book XI of the *Metamorphoses* in which the
foolish King Midas, the only judge to prefer the barbarous strains of
Pan's rustic pipes to the courtly music of Apollo's lyre, has his insensi-
tive ears turned by Apollo into those of an ass.

Since classical antiquity there had been numerous illustrations of
the story of Marsyas. The figure of the flayed satyr had been engraved
on gemstones, carved on sarcophagus reliefs or as freestanding stat-
ues, woven into tapestries and depicted in paintings. His gruesome
punishment had taken on a variety of extended meanings: the victory
of the arts that appeal to superior intellects, exemplified by Apollo's
lyre, over coarser arts like the satyr's pipes that merely excite the
senses; Marsyas as the crucified Christ and Apollo the risen Christ; the
ascent of man from baseness and confusion to the realm of universal
harmony; the escape of the soul from its earthbound body. Dante,
placing himself under the protection of Apollo at the beginning of the
Paradiso, beseeches the god: 'Enter my breast, and breathe there as you
did when you tore Marsyas from the sheath of his limbs.' Titian would
have known, among other representations, the woodcut of Apollo
and Marsyas in a 1497 paraphrase of the *Metamorphoses*; Tintoretto's
painting in Aretino's house; the fresco on a ceiling of Raphael's Stanze
della Segnatura in the Vatican; Perino del Vaga's decorations of Castel
Sant'Angelo where Apollo flays Marsyas in the centre of the vaulting
of the Sala di Apollo. He may also have been inspired by Michelangelo's

self-portrait as the flayed skin of St Bartholomew in the Sistine Chapel *Last Judgement*. But when it came to planning his own painting he took his cue from an awkward sketch for a now damaged fresco in the Palazzo Tè in Mantua, which had been executed some fifty years earlier by his old friend Giulio Romano for their mutual patron Federico Gonzaga.

In Giulio's drawing (Paris, Louvre, Cabinet des Dessins) Marsyas is seen sideways, hanging upside down with his goat's legs tied to the branches of a tree. Titian revolved the satyr's upended body to face us and narrowed the composition, so that we are directly confronted by the terrifying sight of the tormented Marsyas strung up like a butchered animal, hairy legs secured to the tree by jolly pink bows.[7] There is no distant horizon or window of blue sky through which we can escape the brutal, slow torture we are forced to witness on this stormy summer night. The angry sky is visible in small patches of white impasto through the pulsating foliage of the forest that closes in on the scene. The air in this claustrophobic space is difficult to breathe. On our left Apollo – crowned, just as Ovid described him in Book XI, 'with a wreath of Parnassian bay on his golden hair', and wearing 'his mantle of Tyrian purple' – kneels on the ground, completely absorbed by the task of stripping away the flesh of the goat-man who has dared to challenge with his primitive pop music the classical harmonies associated, especially in Venice, with orderly civic virtue. The god of harmony probes the area of skin close to Marsyas' heart but delicately, holding as though it were a painter's brush a knife that resembles the scalpels surgeons used to lance the boils of plague victims. His face is in shadow, his expression childlike and intensely curious as he inflicts his brutal punishment, like a child pulling off the wings of a fly, seeking perhaps to penetrate the source of his victim's pristine, human fallibility. The god has left the cruder task of skinning the satyr's hairy haunches to a Scythian assistant. Marsyas' offending pipes are hung high from a tree branch next to an ethereal figure in a rose tunic who accompanies the scene on the lira da braccio.[8] On the ground beneath the satyr's head a little pet dog – it is the Papillon spaniel we have seen peacefully curled up on beds

or chairs in so many previous paintings – is lapping up the pool of blood that drips from the skinned body.

The rectangle of dark paint to the right of Marsyas' waist could be the river that Ovid tells us sprang from the earth that was saturated with the tears of his fellow woodland creatures. One of them, another satyr, has emerged from the wind-tossed forest with a pail brimming with – is it the martyr's blood or is it water to sluice his body? The child from Titian's *Boy with Dogs* stares at us from the bottom-right corner restraining his black and white spaniel from attacking Marsyas head first. But this child has satyr's legs. Fifty years earlier Titian had placed a prancing baby satyr at the centre of his *Bacchus and Ariadne*, apparently inviting us to enjoy the gory Dionysian revels. Now the child is crying, his face turned towards us in helpless appeal.[9] King Midas, most famous for the granting of his foolish wish that everything he touched be turned to gold, sits between the two satyrs, lost in thought. He has Titian's features, and it seems he has not yet made a judgement about the punishment he is witnessing. What is he thinking? Why did he choose this terrifying subject – the only life-sized painting of the skinned Marsyas in Renaissance art? What meaning did the story have for him?

The shocking news of the flaying of Marcantonio Bragadin at Famagusta in August 1571, and of the slaughtering and torturing by Philip's armies in the Netherlands, must have affected Titian as it did everyone in Venice. But as the painting evolved it became something much more ambiguous, so subjective that he could not have put into words a range of conflicting emotions that could – and can – only be expressed in paint. It is barely conceivable that Titian, who had spent his life courting and flattering the European establishment, who could convey aristocratic status better than any other artist, would have empathized with the lowly, half-human being who had challenged the accepted hierarchical order of art and society. And yet the suffering Marsyas, whose broad peasant's features resemble those of Titian's last *St Sebastian*, his eyes expressing brave, bewildered acceptance, whose mouth seems to be smiling unless we turn ourselves upside down, must be intended to arouse our sympathy. Did Titian, like the

immortal, omnipotent Apollo, half envy this primitive creature who was capable of a kind of suffering – and of a kind of original creativity – that no god would ever know? Did he want to discover what lay beneath the living flesh that his contemporaries said he painted not with pigments but as though with real, trembling skin? Was he, as his own aged flesh thinned and decayed, sitting in judgement, in the guise of the foolish, greedy Midas, on his own hubris and love of gold, he who was famous for rivalling God's creations, who, as it was said, was loved by the world but hated by jealous nature? Was it the studio, as some authorities believe, who finished certain details – the bucket, the teeth of the little dog that laps up the satyr's blood, Apollo's wreath, Midas' crown? Or did Titian use them to highlight the terror by standing out against the smoky, flickering brushwork of the claustrophobic setting of his horrific scene?

If the *Death of Actaeon* (to which Titian may have returned after completing his last pictures for Philip) is a pessimistic painting, in the *Flaying of Marsyas* he seems to give vent to rage, or to something that feels almost like demonic elation, as though there was an element of the wild satyr in the creative genius of this suave gentleman who knew so well how to flatter his social superiors and had scarcely ever written a letter that was not about money, as though he knew he was breaking the mould of High Renaissance decorum in anticipation of the course his art would take centuries after his death. Although his signature on the painting may indicate that it was done for a patron, it is difficult to imagine let alone identify any contemporary collector who would have been capable of following him into a far distant future where this painting from his old age would be in tune with the artistic sensibilities of the twentieth and twenty-first centuries, when he would be recognized as the ur-father of modern painting. And still it retains the power to shock us – we in the West who are used to the images of violence and suffering that flash at us on a daily basis from our newspapers and television sets and from the work of modern artists, we who, whatever our religious faith or lack of faith, have been brought up in a world dominated by a Christian story that is about extreme cruelty. Titian and his Catholic contemporaries, who knew more at

first hand about pain and violence than most of us who live today in the developed world, worshipped in churches the walls and altars of which were covered with paintings, frescos and sculptures of the agonies suffered by Christ and the martyred saints, which must, through their very familiarity and orthodoxy, have inured them to the appalling suffering they described.

Had Titian, meditating on the Christian story in what he knew were his final years, 'found a subject through which, consciously or unconsciously, he can articulate something of the meaning embedded in the cruelty of the Crucifixion'? This is the view of a psychoanalyst[10] who has made a close study of the *Flaying of Marsyas* as a way of investigating a hypothesis about non-verbalized thought, 'that what goes on in our unconscious minds is not just proto thinking, as is usually assumed, but thinking that can be highly evolved and complex'. By portraying himself as the meditating Midas, she suggests, Titian is inviting us to understand that what we see is 'the content of his mind. This is Titian's final testament. We are looking at thinking.'

> in Marsyas the stylistic features common to this period of Titian's work are maintained with particular intensity and reveal, not only Titian's strenuous physical involvement with the making of this work, but a fusing of idea and form of the highest order. The manner appears so fresh, so spontaneous, that we seem to be in the presence of a highly complex whole which has just erupted entire onto the canvas, much as thoughts appear in our minds.

The *Flaying of Marsyas* was probably in Titian's studio at his death, but can be traced back only as far as the early seventeenth century when it was in the Arundel collection.[11] In 1673 the painting was acquired at a lottery by the Bishop of Olmütz, and hung in the archiepiscopal palace at Kroměříž, now in the Czech Republic, where it remains to this day at one end of a large and beautiful room lit by windows overlooking the palace gardens. The painting was all but forgotten until the early twentieth century when it was authenticated by scholars (with some exceptions, notably Erwin Panofsky who

rejected it sight unseen on the grounds that the subject was too repellent to have been painted by Titian). Shown for the first time in western Europe in 1983 at the London Royal Academy's Genius of Venice exhibition it was greeted with astonished admiration. The American painter Frank Stella found it impossible to focus on the painting except in snatches: 'The idea of studying a painting of such cruelty became embarrassing.'[12] Since then the *Flaying of Marsyas* has become the most discussed, revered and loathed of all Titian's paintings. The novelist Iris Murdoch considered it the greatest painting in the Western canon; Tom Phillips copied it as the background of his portrait of her. Leon Kossoff, Frank Auerbach and R. B. Kitaj are only some of the modern painters who have drawn from it. Frank Stella is one of several who have read it as a warning about the difficulties and perils of a life devoted to artistic creation.

> This picture forces us to take it personally, to identify it as a personal statement by Titian, first about himself, second about anyone, including ourselves, who would hope to succeed him as an artist. This painting is more accurate about showing the personal costs inherent in the mechanics of painting than it is profound about describing the human condition in sixteenth-century Italy. By stripping away a surface created by the artist's gifted touch Titian reveals the blood-filled sinew and bone of pictorial technique, showing us how difficult it is for the artist to nurture and manipulate the body of his creation without mutilating it.[13]

By February 1576, a total of 3,696 plague deaths, about 2 per cent of the Venetian population, were recorded as having occurred since the previous August (the Provveditori alla Sanità kept precise records), but the majority of cases were in the slums and the crowded ghetto where Jews were confined. Those Venetians who, like Titian, could afford spacious and airy accommodation had been largely spared. The bans on crowds, manufacturing and trade were lifted. But with the onset of spring and an unusually early and hot summer the fatalities rose. On 16 June the doge, Alvise Mocenigo, presided over a

debate in the Great Council Hall at which two learned physicians from Padua, Girolamo Mercuriale and Girolamo Capodivacca, asserted that the infection was not plague but a famine fever that affected only the undernourished poor. The Serenissima had only a few days to rejoice before, suddenly, the contagion spread like wildfire into the houses of rich and poor alike, throughout the city, its mainland domains and beyond.

A cloud of black smoke from burning bodies hung over Venice until the stench became so great that a cemetery was established near the Lido where the corpses were piled into deep pits, in rows between layers of lime. The dead were shrouded and carried away by the *picegamorti*, corpse bearers, who had to be recruited from the prisons and mainland villages because few law-abiding Venetians, however poor, were prepared to risk their lives even with a promised reward of 100 ducats when the plague ended. Not all corpse bearers resisted the temptation to loot the houses of the dead, and some were said to be necrophiliacs; nor were they fastidious about distinguishing the dead from the dying, some of whom were buried alive in the lime pits. Doctors, circulating the city in gondolas followed by barbers and Jesuit priests, took pulses, lanced boils, applied leeches, and spread the contagion by marking the doors of contaminated houses with the infected blood of their patients. Some of the sick were sequestered in their houses along with anyone who had been in contact with them; others were stripped naked, their clothes and bedding burned, before they were taken to one of the *lazzaretti*.

No one was permitted to enter condemned houses except priests and public officials. Transport of the victims was slowed when the decision was taken to drain the canals of infected water. Still, a veritable armada of boats plied the lagoon carrying the sick, the well who had been in close contact with them, and the dead, all to dreadful destinations. A survivor writing many years later[14] recalled the hospital island, the Lazzaretto Vecchio, as like hell itself. The stench was unendurable, the groans and sighs ceaseless. Some 7,000–8,000 patients slept three to a bed: 'We should not be surprised if scarcely one in ten survived, and if hundreds died every day upon those beds,

719

stinking and blackened with smoke as they were.' The Lazzaretto Novo, the quarantine island, which was also crowded beyond capacity, 'seemed a mere Purgatory, where unfortunate people, in a poor state, suffered and lamented the death of their relatives, their own wretched plight and the break-up of their homes'. The cost of feeding and caring for so many people sent the public debt soaring to a record 5,714,439 ducats; and before the plague finally subsided in 1577 it had claimed 46,721 Venetians, nearly a quarter of the population. Wealthy patricians and civil servants fled to their comfortable houses on the mainland. Attendance at the Great Council fell to only thirty, and many ministries were paralysed. The Marquis of Ayamonte escaped from Milan while the saintly Carlo Borromeo, who attributed the outbreak of plague to the lavish celebrations of a visit by Don John of Austria, stayed behind and laboured tirelessly to comfort the bodies and souls of the sick.

Titian did not retreat to the villa in the Cenedese Hills. It was too hot; it may be that he was too frail to face the journey, or considered that it would be unseemly for a man of his age to flee the inevitability of death. It may be that a few of the most loyal servants and assistants stayed with him. But it was Orazio he needed most, however vulnerable the young man might be to plague. We can imagine the aged master stooped, toothless, deaf and half blind shuffling through the stifling empty rooms, shouting irritably, fearfully for Orazio. At least it was less hot in the north-facing studio where the occasional breeze from the lagoon cooled his brow as he worked. There was so much to do. We can guess that he turned, as he always had, from one easel to another, squinting at the paintings through his magnifying glasses, hesitating before adding new strokes. But with one exception we can only guess what they were: the Munich *Crowning with Thorns*? the London *Death of Actaeon*? the St Petersburg *St Sebastian*? the Kroměříž *Flaying of Marsyas*? The only work that we know with certainty that Titian painted in the last months of his life is the *Pietà* (Venice, Accademia), which he intended for his birthplace in Cadore. It is a commemoration of his artistic life, a dialogue with the paintings, sculptures and architecture that had nourished his genius, a final

declaration of the capacity of paint to represent and improve upon stone sculpture, and a testament of his devotion to Christ and His mother Mary. The *Pietà* he had recovered from the Frari was painted on two strips of canvas of unequal size over a discarded Entombment.[15] When it was back in the studio, Titian had Orazio add five more pieces of a different weave – two on either side, one for the entire upper section, a long strip at the bottom and a small piece at the bottom right – until its dimensions fitted exactly the high altar of the parish church of Pieve di Cadore.

The Madonna and her dead Son answer in reverse Michelangelo's early sculpture of the *Pietà* in the basilica of St Peter's in Rome. They are set in an enormous aedicule, its painted stone seemingly more alive than their figures, which is framed by pillars of rusticated blocks in the classical architectural style introduced to Venice by Jacopo Sansovino and Sebastiano Serlio. Six of the seven lamps of the apocalypse (the seventh is nearly hidden on the keystone) burn on the raked cornice of the pediment, over which spill the figleaves of the Fall of Man. The tripartite keystone of the pediment, symbol of the Holy Trinity, the cornerstone of Christ's Church, rests on a shimmering golden semi-dome encasing the pelican that was associated with Christ's Resurrection because the pelican was thought to revive its young with blood plucked from its breast. With this by then archaic mosaic semi-dome Titian looked back to his earliest recollections of Venice: to the Byzantine domes and vaults he had seen with the eyes of an impressionable young boy from the mountains; to his long friendship with Francesco and Valerio Zuccati, the leading mosaicists in the city; to the neo-Byzantine semi-domes painted by his greatest master and founder of the Venetian Renaissance, Giovanni Bellini, whom Titian had supplanted with his more daring and dynamic works, but to whom he now expressed his gratitude and respect.

The aedicule is flanked by stone statues, both adaptations of statues in Rome by Michelangelo,[16] which recall predictions of Christ's coming from the pagan past. On our left is Moses, who prefigured Christ, holding the Tablet of the Ten Commandments and the rod with which he struck water from the rock. On our right is the

Hellespontine Sybil, who predicted the crucifixion of the messiah, wears a crown of thorns and carries a cross that is taller than herself. They stand on bases carved with snarling lions, references perhaps to the lion of St Mark, but more likely in this context to devouring death, as in the *Salva me* psalm – 'Save me from the mouth of the lion' – recited in masses for the dead. The Madonna directs her stoical, self-less gaze at St Jerome the intercessor in his crimson toga who kneels on Christ's right side gently holding His hand.[17] But the true living protagonist is Mary Magdalen whose figure, taken from a relief of Aphrodite grieving for the dead Adonis on a sarcophagus in the ducal palace in Mantua, rushes at us out of the picture plane like a Maenad, mantle swirling, shouting her impassioned message that Christ, who will choose her to be the sole witness of His Resurrection, has redeemed mankind from Adam's original sin with His suffering. Propped against the lion socle on the right and so small that they are easily missed is a shield with Titian's coat of arms bearing the Habsburg eagle, and a tablet with portraits of himself and Orazio kneeling in prayer before a celestial vision of the Pietà.

Titian died on 27 August 1576. Orazio was by his bedside when the parish priest of San Canciano gave him extreme unction. A doctor from the Provveditori alla Sanità examined the body and found no symptoms of plague: the death certificate, which is lodged in the records of Titian's parish church of San Canciano, gives the cause of death as fever and his age as 103. With the plague at its height it was not possible to honour Titian's wish that his body should be trans-ported for burial to Pieve di Cadore. Ridolfi ends his biography of Titian with an account of a long and elaborate funeral ceremony in Venice – it was intended to rival Vasari's description of Michelangelo's funeral in Florence – which he says never took place but was written up by one of the Venetian painters who wished to honour Titian. He was carried instead through the silent, plague-ridden city to the Frari where a modest funeral was celebrated by a canon of San Marco, two subcanons, twenty-one other people and perhaps a choir, before he was interred in the chapel of the Crucifixion.[18] The cost of the funeral

was thirty-eight lire and sixteen soldi. A week or so later Orazio, who may already have been ill, was visited by the plague doctors, who had him taken to the hell of the Lazzaretto Vecchio. He never returned. Had he lived Orazio would doubtless have ensured that the *Pietà* was taken to Pieve. But his death was followed by an acrimonious dispute about Titian's estate between the surviving next of kin who were less sensitive to Titian's wishes; and so the picture, which was part of that estate, remained in Venice.

Titian left no will, perhaps because he had decided to entrust the dispersal of his estate to Orazio, his sole heir, who also died intestate. There is no surviving record of a ceremony or oration in Pieve di Cadore, or of a report of Titian's death by an ambassador or the papal nuncio in Venice at the time. But we do have, in the *Pietà*, Titian's autobiographical epitaph to himself. Looking at it in the Accademia Gallery in Venice, where it hangs opposite Tintoretto's first master-piece, the *Miracle of the Slave*, and reflecting on the *paragone* – the comparison between the merits of painting, sculpture and writing that exercised Titian and his contemporaries – we may decide for ourselves whether this painting expresses emotion better than words or stone could do. At some point after Titian's death Palma Giovane took possession of the *Pietà*. He retouched it here and there and added the flying angel carrying an Easter candle, and an inscription, which reads 'QVOD TITIANVS INCHOATVM RELIQVIT PALMA REVERENTER ABSOLVIT DEOQ. DICAVIT OPVS' (What Titian left unfinished Palma reverently set free, dedicating the work to God). It is a reference to a then well-known passage from Cicero,[19] who, writing about a Venus left unfinished at the death of Apelles, used the verb *absolvit*, he discharges or sets free, rather than *perfecit*, he finishes, to indicate that no other artist would be capable of completing a work by that greatest of masters.

Titian's Legacy

The argument that the finest artists have not been affected by changing tastes can be reduced in the last analysis to the proposition that for no extended periods since their lifetimes have Raphael, Titian, and Rubens not been considered great painters by the most influential sections of articulate opinion.

FRANCIS HASKELL, *REDISCOVERIES IN ART*, 1976

It is no exaggeration to say that Titian's late style brought about a fundamental change in the course of the history of painting.

ERNST VAN DE WETERING, 'REMBRANDT'S MANNER: TECHNIQUE IN THE SERVICE OF ILLUSION', 1991[1]

When the plague finally lifted, the Venetian Senate took the decision to erect on the Giudecca a church designed by Andrea Palladio and dedicated to Christ the Most Holy Redeemer as a demonstration of the gratitude of the Most Serene Republic and of its power to survive even the worst disasters. It was determined that there would be an annual procession across a bridge of pontoons from the Zattere to the church where a mass would be said with prayers of thanksgiving for the mercy of the Lord God. The church was consecrated in 1592; and the procession, which takes place on the third Sunday in July with a display of fireworks on the previous evening, remains a major event in the Venetian calendar. The rejoicing was muted on 10 December

1577 when a raging fire in the doge's palace destroyed the Great Council Hall and all of the canvases in it including Titian's Battle of Spoleto. But the hall was soon rebuilt and the pictures replaced with glorifications of Venice by Veronese, Leandro Bassano, Federico Zuccari and others, and the colossal *Paradiso*, said to be the largest oil painting ever made, by Tintoretto and his son Domenico. Such displays of resilience could not, however, delay the slow decline of the Most Serene Republic of Venice as a great imperial and trading power.

Meanwhile it fell to Pomponio to sort out his father's estate, most of which was invested in landed property.[2] This he did in the years after Titian's death, sometimes acting with the weakness and naivety that one would expect from a man who had never been capable of managing his own affairs, but also with a degree of good humour, fairness and generosity to his friends and relatives that may come as a surprise after what we know of his confrontational attitude to an authoritarian father whom he had never been able to please. Now he had his chance to show that he could behave properly, and he did so to the best of his ability in difficult circumstances. Pomponio had his faults, but the avariciousness for which his father and brother had been so well known was not one of them.

The first we hear of him after the deaths of Titian and Orazio is on 22 September 1576 when he gave an art dealer, Francesco Brachieri, who had been in touch with Titian, power of attorney to withdraw thirty ducats from Orazio's account in the Tiepolo and Pisani bank.[3] Five days later he applied to the *giudici del proprio*, the judges that dealt with inheritance and property, to be recognized as Orazio's sole heir. The application, which was not contested, was granted on 23 October. Meanwhile, anxious to be away from the family house that held so many unhappy memories, he persuaded Celso di San Fior, who had acted for many years as Titian's agent in Serravalle, to live in the Biri Grande house and look after the estate. Celso moved in early in October and stayed until the end of March of the following year.

Pomponio's troubles started on 15 February 1577 when Cornelio Sarcinelli, the grasping husband of Titian's daughter Lavinia, issued a court order requiring Celso di San Fior to produce within ten days a

letter of intention written, so Sarcinelli insisted, by Titian stating that on the death of Orazio without legitimate descendants the entire estate should pass to his sons by Lavinia. Lavinia was dead or dying, perhaps of the plague, which may explain why Sarcinelli had waited six months after Orazio's death to make his bid. Both Celso and Pomponio denied any knowledge of such a letter, which is in fact unlikely to have existed. There is no reason why Titian, if he had made a will, would have failed to make some provision for other members of his family, not least his natural daughter Emilia, whom he had described in a letter to Philip II as 'the absolute patroness of my soul'. Sarcinelli then put a judicial seal on the house, which Celso or Pomponio had to have removed by court order. Nevertheless, on 26 March Pomponio, in the interests of restoring harmony within the family, co-signed a notarized agreement with Sarcinelli giving his children the properties in and around Serravalle, about thirty fields and some buildings, which constituted the greater part of Titian's wealth, while Pomponio retained the land and buildings in and around Pieve di Cadore. Copies of the agreement were obtained by Gian Domenico Dossena, the brother of Emilia's husband Andrea, and by Gaspare Balbi and his wife Livia, all of whom presumably believed they had a stake in the inheritance.

On 18 April Sarcinelli moved into Biri Grande at the request of Pomponio, who seems to have underestimated the ruthless character of his brother-in-law. Sarcinelli was still living in the house on 24 July when a proclamation was issued by the criminal court that Titian and Orazio had left 'many goods of very great value, credits, writings, accounts, instruments, notes of many debtors, leases and receipts, and objects of gold, silver and gems, and other furniture and innumerable paintings of no small value', a great quantity of which had been 'taken away, usurped, robbed and concealed' by unknown persons, against the interests of Pomponio and Sarcinelli. It is often assumed either that Pomponio had helped himself to the items or that the house was looted at some time after Titian's death. The presumed looting is, however, unlikely since the house was probably never left empty, and if there had been a robbery it would not have taken nearly a year after

Titian's death before the loss of the items was noticed and reported. There was, furthermore, no reason for Pomponio to steal what was his by right as sole heir. The finger of suspicion points more plausibly at Sarcinelli, especially given his subsequent behaviour and his personal interest as a claimant in the documents, which would have had no value for a casual thief. But for the time being he had Pomponio's trust and persuaded him that they should go together to the court to proclaim that the house had been robbed.

By September Sarcinelli, not content with more than half the landed property, had resorted to more aggressive behaviour, which caused Pomponio to obtain an injunction on the 16th preventing him from offending, injuring or molesting himself, his sister Emilia's husband Andrea Dossena or Andrea's brothers, or Celso di San Fior. Pomponio failed, however, to have Sarcinelli expelled from the house. Then, on 19 October, Sarcinelli's lawyers persuaded a Venetian magistracy that Titian's letter of intention did exist and that the entire inheritance should therefore pass to his children. Pomponio had the case overturned on appeal, but Sarcinelli was not a man to give up. He continued to defy Pomponio's attempts to have him removed from Biri Grande with the argument that by inviting him to stay there Pomponio had in effect conceded to him the house and its contents; and on 10 April 1578, in a renewed petition that Titian's entire estate should pass to his children, he described Pomponio as a man who 'is controlled by others, and his will serves someone who with different devices directs it as he pleases'. Although there may have been more than an element of truth in this observation, Pomponio's wish to share the estate with other legitimate claimants seems to have been motivated as much by conscientiousness as by weakness. In July of 1578 he made a payment of 200 ducats to Andrea Dossena and Andrea's brother Gian Domenico; he undertook to provide a dowry of 150 ducats for Andrea's five-year-old daughter Vecellia; and continued to support the family thereafter. He gave half a farm previously owned by Titian at Tai in Cadore to his sister Dorotea's son Odorico Soldano and the other half to Giovanni Alessandrini, who had helped Titian with his letters in the 1540s and later with business affairs in Cadore over many years. Odorico Soldano

also received 100 ducats in recompense for providing books and documents relating to the estate. Nevertheless, not everyone was satisfied. When Pomponio sold the family house in Pieve on 25 October 1580, Andrea Dossena, on behalf of his daughter Vecellia, Gaspare Balbi and Marco Vecellio all made public declarations of interest.

A condition placed on Sarcinelli's continuing residence at Biri Grande was that all objects of value be placed in a sealed room. His case began to collapse on 19 April 1578 when it was discovered that the seal had been broken and replaced with another. Pomponio demanded compensation for the missing objects: money; three gold chains, one of which, bearing a medal, Titian used to wear; fourteen rings with good rubies and diamonds; a gold medal of Titian and six other medals; two silver bowls and one of copper, and two vases; twenty-five salt-cellars, cups and so on; twelve silver spoons; six silver forks; Flemish shawls and cloth; black cloth; plates and other objects in pewter; two chests; pictures of various kinds; a cross with two jewels in it; and a harpsichord. On 17 May it was agreed that Sarcinelli would compensate Pomponio with a payment of 435 ducats and hand over all Titian's books and papers in his possession, as well as Titian's patent of nobility and some gold cloth that had belonged to the artist. Pomponio let the studio to Jacopo Bassano's son Francesco, who ran the Venetian branch of the Bassano family workshop there until he committed suicide in 1592 a few months after his father's death. There were a few more matters to settle with Sarcinelli, but the dispute over the Biri Grande house and its contents was resolved by 7 September 1580 when Pomponio, his relationship with Sarcinelli evidently much improved, gave him a power of attorney to argue, on the grounds that neither of them lived in Venice, against a government demand that Titian's heirs should pay taxes on all his property. Nevertheless, although the two men had agreed that they had no further claims against one another, Sarcinelli claimed ownership in 1584 of sixteen fields that had never belonged to Titian.

While dealing with Cornelio Sarcinelli, Pomponio had other matters to settle. He went to the ecclesiastical court in order to obtain the arrears of a pension promised to Titian in 1552 by Torquato

Bembo, whose lawyers had agreed in 1574 to pay 160 ducats in return for two pictures, a Rape of Europa and a Flagellation. There was a claim from Gasparo Balbi that Titian had promised to contribute to the dowries of his three daughters in return for Balbi's having served him faithfully in his business affairs from 1549 to 1574. An arbitrator decided that Balbi was entitled to only 100 ducats but that Pomponio must return to him a portrait of his late wife Livia[4] or pay him thirty ducats, that Balbi could keep a Madonna that he said was his, and that, because the relevant documents had been lost and the witnesses were dead, he need not pay Pomponio for a loan of 109 ducats made to him by Paolo d'Anna with the proviso that it be repaid to Titian and Orazio.[5] Celso di San Fior demanded and received compensation for the time spent living in Biri Grande and looking after the estate. Emanuel Amberger, the most important assistant in the studio during the last decade of Titian's life, received 150 ducats for services to Titian and Orazio, and to Pomponio, possibly in connection with finishing some of the pictures in the studio.

On 27 October 1581 Pomponio leased the house in Biri Grande to Cristoforo Barbarigo, a Venetian nobleman and collector, who presumably acquired it for investment purposes because less than a year later he was living on the piano nobile of Palazzo Barbarigo della Terrazza at San Polo, which had been built by his father. Since Barbarigo had acted for Pomponio on previous occasions and had loaned him money it is possible that Pomponio gave him some pictures by Titian in return for his services, but a number of the paintings that had been in Titian's studio at his death had already gone elsewhere – some probably appropriated by Cornelio Sarcinelli, others sold by Pomponio in the process of liquidating the estate. Tintoretto bought the Munich *Crowning with Thorns* (Ridolfi said that he also acquired a Flagellation and a Diana and Callisto), and Palma Giovane took possession of the *Pietà*.

The *Allegory of Prudence*,[6] an intriguing but not entirely successful pastiche mostly executed by the studio and left unfinished at Titian's death, may also have remained in the studio. X-rays indicate that the three animals, the wolf, lion and dog, represented below the faces,

were added after Titian's death, as was the crudely drawn superscription which gives the painting its present title. It reads 'EX PRAETE/RITO' above what looks like a profile of the aged Titian; 'PRAESENS PRVDEN/TER AGIT' above what is probably a portrait of Orazio; and 'NI FVTVRV/ACTIONE DE/TVRPET' above the youngest man (from the past/the present acts prudently/lest it spoil future action). The virtue of prudence, in other words, depends on past experience and the anticipated future. Since the painting was first mentioned in Paris in the eighteenth century, there have been many theories about the meaning of the painting and the identity of the portrait heads.[7] More recently it has been seen as an allegory of art as well as of time, and it has been proposed that the young man on our right is Marco Vecellio.[8] Charles Hope[9] prefers to see three generations of the Vecellio family, in which case the youth might be Titian's eldest grandson who was a closer relative than Marco.

But the only paintings by Titian that can be securely identified in the original Barbarigo collection, and were therefore probably in the studio after his death, are the four 'very famous' pictures listed in Cristoforo's will, which was drawn up in 1600, two weeks before he died, with the provision that they should descend to his heirs by primogeniture. They are *Christ Carrying the Cross*, the *Penitent Magdalen*, both now in St Petersburg, a Madonna in an ebony frame (it has been plausibly suggested that it might be the *Madonna and Child with the Magdalen* in the Hermitage) and the *Venus with a Mirror and Two Cupids* now in Washington, DC. Ridolfi added seven more Titians owned by the Barbarigo family. The unfinished *St Sebastian* and a *Portrait of Pope Paul III* are both now in the Hermitage. The others on his list are mediocre workshop paintings or lost. The *Portrait of Francis I* (Leeds, Harewood House) is perhaps a studio version of the finer portrait in the Louvre; the *Philip II Seated* (Cincinnati Art Museum) is of such low quality that it is unlikely to be by Titian's hand; the studio *Portrait of Doge Andrea Gritti* may be the dismal painting in the New York Metropolitan Museum; the portrait of Doge Antonio Grimani is lost, as is a picture of Syrinx being abducted by Pan, of which nothing is known.

The Barbarigo collection was housed in the palace at San Polo for nearly three centuries, during which Cristoforo's descendants continued to purchase more Venetian paintings. In the eighteenth century admission to the Barbarigo gallery, which was known by then as the School of Titian, was considered an essential privilege by aristocratic tourists stopping in Venice on the Grand Tour. The highlight of the entire collection, which by then included pictures by Tintoretto, Veronese, Jacopo Bassano, Bonifacio and other Venetian painters, was the St Petersburg *Penitent Magdalen*, which Titian had kept in his studio as a model for his many other versions and which was regarded as the most beautiful of all his paintings. In 1850, when the Barbarigo's financial position had been worsened by the fall of the Republic, the Russian Tsar Nicholas I acquired for the Hermitage Palace in St Petersburg no fewer than 102 paintings from the family, seventeen attributed to Titian and thirteen to Giorgione. None of the Giorgiones is accepted today, and the Titians have been considerably whittled down. There have never, however, been any doubts about the authenticity of the *Magdalen*, which was packed for the journey from Venice to St Petersburg with special care in its original frame in an individual double-boarded crate.

The last mention we have of Pomponio is on 28 September 1594 when the Senate determined that a joint supplication by Cornelio Sarcinelli and Pomponio Vecellio against a requirement to pay taxes on Titian's properties should be referred back to the Ten Savi of the Tax office, or Decima, who should see that justice was done. The next day the Senate voted unanimously that Titian's heirs should be absolved of taxes from the date of his death, and its decision was ratified by the Savi a year later. The Senate minute of 1594 does not necessarily indicate that Pomponio, who would have been about seventy, was still alive at the time, but nor is his disappearance from the records after that date evidence that he was dead.

With the deaths of Veronese in 1588, Jacopo Bassano in 1592 and Tintoretto in 1594 the golden age of Venetian painting was suspended until a brief but glorious revival in the eighteenth century. Copies,

prints and forgeries of Titian's paintings continued to circulate around Europe, but he had no immediately posthumous circle of followers: there were no Tizianisti – in the way there would, for example, be Caravaggisti. It was not until the dispersal of the great north Italian ducal collections in the first decades of the seventeenth century that the originals of many of his masterpieces, which had previously been seen only by a privileged few, became accessible to a wider public. They made an immediate and indelible impact on some of the greatest painters of their age.

After Alfonso II d'Este died without a legitimate heir in 1597, the aggressive Pope Clement VIII, the former Cardinal Ippolito Aldobrandini, fulfilled the ambitions of his predecessors Julius II and Leo X by invading Ferrara and annexing it to the Papal States. The ducal castle was occupied by a papal legation, and by the end of 1598 Clement's nephew, Cardinal Pietro Aldobrandini, had stolen the Bacchanals that had been commissioned by Titian's first foreign patron Alfonso I d'Este.[10] The pictures were taken to Rome, where they caused a sensation. Twenty-nine years later the Gonzaga collection, which had been gradually dispersed by the spendthrift fourth Duke of Mantua, Vincenzo Gonzaga, was sold to Charles I of England. Then, in 1630, after the male line of the della Rovere had died out, the Duchy of Urbino was annexed to the Papal States and the collection taken to Florence as part of the dowry of Vittoria della Rovere on her marriage to Fernando de' Medici, Grand Duke of Tuscany. And of all the paintings that were now released from their ducal castles and palaces, it was the Titians that were the most sought after by collectors.

Peter Paul Rubens, the Flemish painter whose artistic development would be most profoundly indebted to Titian's example, was twenty-three in 1600 when he travelled to Italy from Antwerp. In Rome he made sketches of the *Andrians* and the *Worship of Venus* which he later worked up – covering the pudenda of the reclining nude in the *Andrians* with a large figleaf, and changing the boy putti in the *Worship of Venus* into little girls – into his largest painted copies of Italian models (both Stockholm, Nationalmuseum). While in Venice

he was invited to Mantua to be court painter to Vincenzo Gonzaga, whose collection enabled him to become acquainted with the Titians that had been commissioned by Vincenzo's ancestor Federico Gonzaga. In 1603, on an embassy taking pictures and horses from Mantua to Philip III of Spain in Madrid, he may have had his first sight of the Titians in the Spanish royal collection. But it was later, in 1628–9, when he returned to Madrid on another diplomatic mission that he impressed the new king Philip IV with his own large paintings,[11] and gained his permission to make full-sized painted copies of the Titians that were kept in the most private rooms of the Alcázar. With the help of assistants he painted at least twenty-two copies after Titian, which sparked a revived interest among Spanish artists and patrons in Titian and Venetian Renaissance painting. In some cases, as with his copy (Chatsworth, Devonshire Collection) of Titian's full-length *Portrait of Philip II*, Rubens replicated Titian's technique as far as possible. But elsewhere – as with his copies of *Diana and Callisto* (Liverpool, Knowsley Hall, Earl of Derby) and the *Rape of Europa* (Madrid, Prado) – we can see him asserting his own artistic personality.[12]

Rubens's enthusiasm for Titian made a strong impression on two of his younger followers, the Fleming Anthony Van Dyck and the Spaniard Diego Velázquez. Van Dyck, who started his career as Rubens's chief assistant, spent six years in Italy, from 1621 to 1627, studying Italian art and particularly Titian. His *Italian Sketchbook* (British Museum), consisting of 200 sheets of drawings of paintings, prints and sculptures, has been called 'the first illustrated book about Titian',[13] although some of his sketches 'after Titian' were in fact taken from prints, drawings and painted replicas, not all of them actually by Titian.[14] While in Italy he bought four Titians, one of which is actually a pastiche of a buxom woman, possibly an unfinished portrait of a courtesan from the 1530s with a caricature added later of the aged Titian in profile with his hand on her belly.[15] By the time of his death Van Dyck owned nineteen paintings by Titian, and his close study of the Venetian master contributed to the confidence with which he explored the volumetric composition and lush colouring

that made him the great seventeenth-century portraitist of the aristocracy.

As gentlemen painters to the aristocracy and great rulers of their day Sir Peter Paul Rubens and Sir Anthony Van Dyck, both knighted by King Charles I of England, felt a social as well as artistic kinship with the Venetian painter who had been knighted by the emperor Charles V and favoured by King Philip II of Spain. Diego Velázquez, who also hoped for a knighthood at the end of his career,[16] quoted a part of Titian's *Rape of Europa* in his *Fable of Arachne* (Madrid, Prado) painted several years before his death in 1560, 'like a lawyer arguing his case' by providing 'a famous precedent for his own aspirations'.[17] As court painter to the King of Spain and curator of the Spanish royal collection from 1623 when he was twenty-four, Velázquez knew Titian's paintings there by heart. But it was not until Rubens's second visit to Madrid that he began to see, through the Flemish master's eyes, the possibilities that Titian's technique and colouring offered for the development of his own art. A year in Italy in 1631 gave him the confidence to allow himself the liberal use of pentimenti that distinguishes Titian's and Rubens's way of working, and to find ways of adapting and giving added luminosity to the sketchy brushstrokes that can be seen in his most famous later paintings.

Meanwhile, in the chilly Protestant environment of the northern Netherlands, the young Rembrandt van Rijn was, so it has been suggested by a leading authority on Rembrandt,[18] modelling 'his artistic biography, so to speak, on Titian's'. Rembrandt knew the two paintings by the already legendary Titian that were in Amsterdam,[19] the *Flora* and the *Man with a Quilted Sleeve*, on which he based his *Self-portrait at Thirty-Four* (London, National Gallery). He also kept, with his large collection of prints after earlier masters, a book that contained almost all the works of Titian. Two of his teachers,[20] furthermore, had spent most of their careers in Italy where they would have heard the theoretical discussions in studios about the artistic value of visible brushstrokes, which had unsettled Titian's contemporaries but were now increasingly admired as evidence of a painter's creative inner life. Vasari's 'Life of Titian', parts of which had

been translated into Dutch by Karel van Mander in 1604, two years before Rembrandt was born, was as much discussed in the studios of the Netherlands as in Italy. Vasari, who had written that Titian started with a fine, meticulous technique, and only later adopted what he called the 'pittura della macchia', painting with splotches, also warned artists that Titian's later, apparently effortless rough style was more difficult than it looked and should not be attempted without a great deal of knowledge and experience, a caveat that may hold the key to the evolution of Rembrandt's style from the finely wrought illusionist depictions rendered with invisible brushstrokes of his youth to the rough, apparently spontaneous but well-controlled late paintings that give the impression 'that it was not the artist who painted but the painting that painted itself, that it appears to be the outcome of a geological process rather than paint applied by a human hand, that in some elusive way chance plays an important part in this manner of painting'.[21] It is a description that could equally be applied to the late paintings of Titian.

When Carlo Ridolfi's biography of Titian was published in 1648 Rubens and Van Dyck were dead. Rembrandt had another twenty-one years to live, and Velázquez another twelve. Ridolfi concluded his account of Titian's life with a rhetorical flourish written in Latin:

> Time will consume even the sky, but the glory of the great Vecellio will never be consumed by Time.

It was not, of course, intended to be taken literally. But looking back over the centuries since Titian's death at the unceasing admiration his work has attracted from everyone who understands and loves the art of painting, Ridolfi's words do seem to carry a kind of poetic truth.

NOTES

Introduction

1 The question of the size of Titian's autograph oeuvre is complicated by an ongoing debate about the attribution of some of the paintings, by the degree of studio participation especially in the late works, and by pictures that he overpainted or that were overpainted after his death.

2 I have used the second edition, *The Life and Times of Titian*, published in 1881.

3 Investigative techniques such as X-radiography have been used by conservators for nearly a century. Others, such as infrared reflectography, which detects graphic preparation, and gas chromatography with mass spectroscopy for the analysis of paint mediums, have been available in well-equipped laboratories only since the last decades of the twentieth century.

Part I: 1488/90–1518

ONE: MOUNTAINS

1 Pietro Casola cited by (and tr.) Chambers and Pullan 1992.

2 The early sources differ about whether Titian or Francesco was the elder brother, and the debate continues.

3 See Cadorin 1833. The document relates to the sale of the house by Titian's son Pomponio.

4 L'Anonimo di Tizianello 1622.

5 Towards the end of Titian's life he was widely believed to be even older. In 1555 the Spanish ambassador in Venice informed Titian's patron King Philip II of Spain that Titian was over eighty-five (that is, born before 1470), in 1561 that he was over eighty (born before 1481), and in 1564 that he was nearly ninety but didn't show it (born shortly after 1474). Although a new Spanish ambassador writing in 1567 revised his age downwards to eighty-five (born 1482), Titian himself wrote to the King in 1571 that he was ninety-five (born 1576). Both Dolce and Vasari knew him personally and wrote biographies of him. Dolce (who may have wished to emphasize his precocity) implied that Titian was not even twenty in 1507 (i.e. born after 1487); while Vasari, whose life was published in 1568, estimated that he was about seventy-six when he met him in 1566 (born 1490). His death certificate, rediscovered in 1955 in his parish church in Venice, gives his age as 103 at the time of his death in 1576 (born 1473). Nevertheless if he was born much before 1490, the question

arises as to what he was doing with his prodigious talent before his first work in Venice in 1507.

6 There is also a theory that the cap may have had scholarly connotations. Aristotle, St Jerome and some Renaissance humanists are also depicted wearing caps.

7 The two surviving painted self-portraits are in Berlin, 1546–7, and Madrid, Prado, c. 1560. A woodcut of a self-portrait by Giovanni Britto is c. 1550. He may also have portrayed himself as the old, bearded man in the National Gallery *Allegory of Prudence*. Veronese painted him playing the viola, Jacopo Bassano as a moneychanger, and El Greco who may have been in his studio a few years before his death also portrayed him. There is no certain record of what the young Titian looked like although it has been suggested that he could be the subject of the National Gallery *Man with a Quilted Sleeve*, the Pharisee in the *Tribute Money* (Dresden), the Baptist in *Salome* (Rome, Doria-Pamphilj) and the man supporting Christ's legs in the early *Entombment* (Louvre).

8 Vasari invented a similar story about Leonardo da Vinci dying in the arms of Francis I.

9 The sources differ about Conte's other sons. One mentions Antonio and Vecellone, both notaries; another, three others, Michele, notary, Gaspare and Nicolò.

10 Cesare Vecellio, 1590, cited by Fabbro 1976.

11 ASV, Giudici del Proprio, Vadimoni, reg. 25, cc. 41r–44v. I have seen the document, which has not been previously published, courtesy of Charles Hope.

12 Dolce and Anonymous 1622.

13 Puppi 2004.

14 Crowe and Cavalcaselle 1881 confessed that there was no evidence that Titian knew the classical languages.

15 Venice, Accademia; Paris, Musée Jacquemart-André.

16 Kris and Kurz 1979.

17 Hope 1994.

18 J. Gilbert 1869.

19 Ibid.

20 Constable, who like all subsequent landscape painters owed Titian a debt of gratitude, coined the axiom that there is nothing that light and shade may not make beautiful.

21 Vasari said Titian entertained in his house several German artists, 'excellent painters of landscapes and foliage', and tried to paint animals from life to give his work a stronger sense of realism.

22 I have John Steer to thank for some of these observations.

23 *Trattato dell'arte della pittura, scultura et architettura*, 1585.

24 Hazlitt 1856 on *Diana and Actaeon* painted in 1556–9.

25 Camesasca and Pertile 1957–60, vol. 1, pp. 249–52.

TWO: THE MOST TRIUMPHANT CITY

1 Tr. Chambers and Pullan 1992.

2 Cited by Roskill 2000.

3 Dolce said he was nine, Vasari ten.

4 Dolce tells us that the uncle, a brother of Gregorio, was employed 'in one of those distinguished posts which are given out to citizens'. There is a tradition of unknown source that he was Antonio, a notary who served as Venetian magistrate in Brescia. The anonymous biographer and Ridolfi thought that he was a maternal uncle.

5 The word means fields because some of them were literally fields cultivated by horse-drawn ploughs.

6 Tr. Chambers and Pullan 1992.

7 Ibid.

8 He was referring to the sky of the St Peter Martyr, which was itself destroyed by fire in the nineteenth century.

9 Richard Goldthwaite cited by Mary R. Rogers, proceedings of the Renaissance Society of America conference, 2005.

10 Tr. Chambers and Pullan 1992.

11 It was gruelling and dangerous work. Dante, *Inferno*, Canto 21, condemned barrators to be submerged in boiling pitch 'As boils in the Venetians' arsenal'.

12 Crouzet-Pavan 2002.

13 Ibid.

14 His chiaroscuro *St Jerome*, on which he collaborated with the print maker Ugo da Carpi, is the first Venetian example of colour printing, a technique using multiple blocks pioneered in Germany. See I, 6 for his other woodcuts.

15 In one of the most popular, *Arcadia*, a prose and verse narrative by the Neapolitan writer Jacopo Sannazaro, a melancholic court poet escapes from the constraints of urban life to an idyllic countryside in ancient Greece where the community of shepherds, shepherdesses, nymphs and satyrs lives in an atmosphere of perpetual romance while his own love for the nymph Phyllis is frustrated. Sannazaro's *Arcadia* had circulated in manuscript for some twenty years before it was printed in Venice in 1502 in a pirated edition.

16 In *Timaeus*.

17 To the present author by Sir Christopher Pinsent, a painter who has measured the intervals in some of Titian's paintings.

18 Dürer bought a copy on his second visit to Venice in 1505.

19 According to the American bestselling novel *The Rule of Four* by Ian Caldwell and Dustin Thomason, 1988, scholars even today devote their academic careers to unravelling its inner meanings and debating the identity of its author, who gives his name in code as Francesco Colonna. The authors maintain that Colonna may have been not a monk from Treviso but a Roman nobleman of the same name.

20 Although any unmarried but sexually active young woman was classed as a whore, it is probably an exaggeration to suggest as some writers have that as many as 10 per cent of the population were in some way involved in prostitution.

21 Cited by Masson 1976.

22 *La Zaffeta* by Lorenzo Veniero.

23 Tr. Chambers and Pullan 1992.

24 In the *Ragionamenti* (*The Conversations*), 1534 and 1536.

25 Girolamo Priuli, 1509, cited by Laven 2002.

26 Molmenti 1906.

27 Tr. Chambers and Pullan 1992.

28 Ibid.

29 Ibid.

30 The wedding of the daughter of Zuan Battista Foscarini described by Sanudo.

31 Chambers 1970.

32 Ackerman 1982.

THREE: THE PAINTER'S VENICE

1 I owe this identification to Charles Hope. Although Vasari reported that Sebastiano was from Treviso, some recent writers have confused him with a Dalmatian painter referred to in documents as Zuccato, that is by his first name.

2 Francesco was active 1524–70, Valerio 1532–64.

3 I have abstracted some of the material about artists' studios in Venice from Fletcher 2003a.

4 For pigments and the *vendecolori* I am indebted to Matthew 2002; Dunkerton 2003; Oberthaler and Walmsley 2006; Berrie and Matthew 2006; Wald 2009; and Charlotte Hale, conservator of paintings at the New York Metropolitan Museum of Art, who made substantial corrections and suggestions for this chapter.

5 I have Charles Hope to thank for this hypothetical suggestion. The man has also been plausibly identified as Antonio Palma (1510/11–75), the nephew of Palma Vecchio and father of Palma Giovane, who would have been about the right age.

6 Apelles, born c. 370 BC, was the most admired and famous of ancient Greek painters, a gifted portraitist and painter of flesh. Alexander the Great valued Apelles so much that he refused to be portrayed by anyone else and gave him his mistress. In the sixteenth century the two painters most often compared to him were Dürer and Titian, especially for their mastery of colour.

7 Bergamo, Accademia Carrara; Padua, Museo Civico; Merion, Pennsylvania, Barnes Collection.

8 Pater 1877.

9 Both are written as fictional dialogues, a form used by Plato, Cicero and Lucian and popularized in the Renaissance by Erasmus and Castiglione.

10 Tr. Roskill 2000.

11 The Farnese *Danae*, 1545–6.

12 Dolce, who was a prolific writer, translator and editor, insisted that the ancients regarded literature as a higher form of expression than painting.

13 Writing in the seventeenth century, the poet Marco Boschini wrote in his *Carta del navegar pitoresco* about what paintings taste like (spongy bread, marzipan, pasta); sound like (a sweet and loving concert) and smell like (a druggist's shop where he had 'under my nose those aromatic smells which completely comfort the heart': this was said of the Tintorettos in the Scuola di San Rocco).

14 Given by various authorities to Giorgione, Sebastiano or Domenico Mancini, although the majority now support an attribution to Titian.

15 Letter from Dürer to Willibald Pirkheimer in Nuremberg, 7 February 1506.

16 Reproduced in Eisler 1989.

17 Crowe and Cavalcaselle 1881, vol. 1, p. 49.

18 Joannides 2001.

19 A *sacra conversazione* or sacred conversation is a depiction of the Virgin and Child with an informal grouping of saints who are meditating or reading together.

20 In a letter of 1505 explaining Bellini's refusal to provide a secular painting for her collection.

21 Crowe and Cavalcaselle 1881.

22 Valcanover 1995.

23 See Fletcher 2003a.

24 There is an unreliable story that he painted it to fulfil a commission that Giorgione had not got round to before his death in 1510.

25 It has been given dates between 1511 and 1520.

26 Ferino-Pagden, citing Otto Pächt, in Washington and Vienna 2006.

27 Ruskin 1974.

28 *Italian Hours*, 1909.

29 Some authorities place the Jacopo Pesaro later, on the grounds that the monumentality of the figures and the

way the paint is laid on are closer to his work from the early 1510s, notably to the *St Mark Enthroned* of about 1512 and the *Virgin and Child with St Catherine, St Dominic and a Donor* which is usually dated about 1512–13. A cleaning in time for the 2003 Titian exhibitions in London and Madrid has, for some, reinforced that view. Some of those who support the earlier date suggest that the archaic figure of St Peter was actually started by Giovanni Bellini, while those who prefer the later date explain the rigidity of that figure by proposing that it was based on a thirteenth-century statue of the saint that was admired by Alexander VI.

30 The *Pesaro Madonna* will be discussed in Part II, Chapter 4.

31 Including Wethey 1969–75, vol. 1, and Hope in conversation.

32 By A. V. Kuznetsov and V. V. Shatsky.

FOUR: MYTHS OF VENICE

1 Tr. Chambers and Pullan 1992.

2 Eisler 1989.

3 Although the nominating and balloting system did prevent any one individual from seizing power, a large and mutually supportive family could commandeer significant blocks of votes.

4 We know less about the private lives and feelings of the unenfranchised majority of Venetians than we do about their Tuscan contemporaries, whose memoirs reveal the daily preoccupations of ordinary people.

5 *De origine, situ et magistratibus urbis Venetae*, 1493–1530 (Sanudo 1980).

6 First published in Venice between 1879 and 1903, the diaries fill 40,000 pages in fifty-eight volumes with the vivid records he kept from 1 January

1496 to 1 September 1533, three years before his death.

7 Giovanni Caldiera cited by Muir 1981.

8 *Othello*, Act I, scene i. Iago describes Cassio as:

> More than a spinster unless the bookish theoric
> Wherein the togaed consuls can propose
> As masterly as he.

9 Tr. Chambers and Pullan 1992.

10 My chief authority for Venetian dress of the period is Newton 1988.

11 Sansovino 1581.

12 Chambers and Pullan 1992. From a letter written in 1509 after the Venetian defeat at Agnadello.

13 Muir 1981.

14 James Harrington praised the Venetian government in his utopian *Commonwealth of Oceana* (1656) for its 'undisturbed and constant tranquillity and peace ... being that which of all others is the most equal in the constitution ... wherein there never happened any strife between the Senate and the people'. *Oceana* made an impression on John Locke among other philosophers, and through Locke on the founding fathers of the newly independent United States of America who looked to the Venetian model of checks and balances when they drew up their constitution.

15 Chambers and Pullan 1992.

16 Joannides 2001. But the attribution of the *Bravo* (Vienna, Kunsthistorisches Museum) is uncertain. It is often given to Titian only because it is such a good painting.

17 Goffen 1997a maintains that the portraits have flirtatious sexual overtones that may 'represent sexual accessibility, as though these men were available for (male or female) delectation'.

18 Muir 1981.

19 Cited by Hale in London 1983.
20 Rubinstein 1973.
21 Chambers and Pullan 1992.
22 Martino Merlini cited by F. Gilbert 1980.
23 In fact he lived until 1521 and his reputation was restored by his management of the Republic's recovery.
24 Priuli cited by F. Gilbert 1980.

FIVE: THE FONDACO, GIORGIONE
AND THE MODERN MANNER

1 The Fondaco was turned into a customs house by Napoleon, then converted into the central post office in the 1930s. At the time of writing it is owned by the clothing chain Benetton, whose proposals to make the interior a shopping centre have met with resistance from Italian conservationists.
2 The document dated 12 May 1508 is cited in Chambers and Pullan 1992.
3 It is not known why he accepted less than the revalued amount. The theory that it might have been a compromise has been suggested by Charles Hope.
4 These tantalizing fragments were chipped off during a radical restoration of the Fondaco (during which two figures by Giorgione were destroyed), before the building was turned over to the post office in 1930.
5 The dagger is visible in an engraving by Jacopo Piccini of 1658.
6 In his 'Life of Giorgione'.
7 Hope suggests that buildings went up when the new, stone Rialto Bridge was built in 1580.
8 In 1548, long after Giorgione's death, Francesco de Hollanda, a Portuguese painter and writer who had been in Venice a decade earlier, did not even mention Giorgione in his comments about the Fondaco.

9 Reported by Dolce, Vasari and Ridolfi.
10 Examples from Kris and Kurz 1979.
11 Some writers did try to add colour to Titian's life by inventing other rivalries for which there is no evidence. Vasari claimed that Pordenone was a great rival of Titian and that Pordenone's death in Ferrara was due to poison. Boschini 1660 conflated the two anecdotes by asserting that Titian poisoned Pordenone.
12 See Renata Segre, 'A rare document on Giorgione', *Burlington Magazine*, CLIII, June 2011, pp. 383–6, and Lionello Puppi, 'Il cognome di Giorgione è Barbarella, *Corriere Del Veneto*, October 2011. Segre maintains that the document proves that Giorgione's family name was Gasparini, Puppi that she has misinterpreted the document and that the family name was Barbarella as in the seventeenth-century sources.
13 *Notizie d'opere di disegno*, first published in 1800.
14 See Hope 2003b and Vienna 2004.
15 Ridolfi claimed to have access to private collections but most of those he mentions are untraceable.
16 Pater 1877.
17 Crowe and Cavalcaselle's *A History of Painting in North Italy*, published in 1871, was the first scholarly and disinterested attempt to define Giorgione's oeuvre and the first to draw attention to the now famous *Tempesta* (then known as 'The Family of Giorgione').
18 See Hope 2003b.
19 Jaynie Anderson in Washington and Vienna 2006.
20 Pater 1877.
21 Fehl 1957.
22 Charles Hope is an exception.

SIX: MIRACLES AND DISASTERS

1 Cited (and tr.) by D'Elia 2005, p. 23.

2 The documents were not published until the early twentieth century.

3 Puppi suggests that the relevant document, although a forgery, seems to reflect common knowledge.

4 Now usually dated 1511–15. It is the only one of Titian's greatest masterpieces not in a major gallery; the Magnani Rocca collection is now open to the public and the painting often loaned to exhibitions.

5 I am basing my account of the statue on B. L. Brown 2005.

6 It is still preserved in Ravenna's Museo Nazionale.

7 A popular collection of lives of the saints written in the second half of the thirteenth century by an Italian chronicler, Jacobus de Voragine.

8 This chronology of the frescos is Hope's interpretation of the evidence. Not àll authorities agree that the *Speaking Babe* preceded the other two.

9 Edgar Degas, another painter who loved theatre, made a copy of it when passing through Padua on his way to Venice·in 1858.

10 Although the Sistine ceiling was not completed until 1512 and Michelangelo was famously secretive about his work in progress, there was intense curiosity about the project, and sketches of it began to circulate soon after he began it in 1508.

11 In 1969 a *sinopia* (Padua, Museo Antoniano) was discovered under a later fresco by another painter of the *Miracle of the Incense Boat*. Since the *sinopia* is of a different subject and some of the figures are in a style similar to Titian's some scholars maintain that Titian may have started to paint a fourth fresco.

12 Unfortunately he doesn't say where the house was.

13 In subsequent documents and paintings he used various spellings of his Christian name: Tician, Ticiano, or the Latinized Ticianus or Titianus. He never used Tiziano, which was then the Tuscan version and is now, of course, the Italian one.

14 Macone da Ferrara and Serafino da Cagli.

15 Crowe and Cavalcaselle 1881, vol. 1, pp. 127–8. (The documentation turns out to be forged but probably represents the truth.)

16 Ibid.

17 Cited by Chambers and Pullan 1992.

18 Cited by F. Gilbert 1980.

19 Newton 1988.

20 Chambers and Pullan 1992.

21 See D'Elia 2005.

22 Crowe and Cavalcaselle 1881, vol. 1, p. 283. Hope dates the *Entombment* c. 1516 on the grounds that it has features in common with the *Assunta* and looks nothing like any of the pictures Titian is known to have painted in the 1520s, which is when some other authorities would prefer to place it.

23 Crowe and Cavalcaselle 1881.

24 The *Mona Lisa* has now been moved to a free-standing position in the middle of the room.

25 The suggestion is made by Wethey 1969–75, vol. 1.

26 Joseph of Arimathaea is traditionally shown at Christ's head and Nicodemus at his feet, but their positions are sometimes reversed.

27 The five-block version published in 1517 is the earliest to survive, although not all scholars agree that it was the first. My account of the woodcut is based on Bury 1989 and on correspondence with Bury in the

spring of 2006. Some other scholars prefer to date the woodcut and/or the composition for it either to 1508, which is the year Vasari gives, or 1511, which is when Ridolfi said that Titian frescoed the walls of the house where he was staying in Padua with a Triumph of Christ. But the first documentation is de' Gregoriis's application for a privilege, dated 22 April 1516, to print 'the triumph, birth, death, resurrection and ascension of our most pious Redeemer', which suggests that de' Gregoriis intended a larger woodcut, or perhaps several more.

Bury points out that the woodcut is in two parts. The three right-hand blocks, from the triumphant Christ on His chariot to Adam and Eve, are in a graphic style that corresponds to Titian's paintings of around 1516, while the two left-hand blocks of the Apostles and saints who follow the chariot are executed in a very different and less elegant technique. The two left blocks may therefore be earlier or by a different hand (possibly based on rough sketches by Titian). Although Bury believes that Titian planned the composition, or at least the right-hand sections, in the year before the application for a privilege to print, he is more cautious than I am about the idea that the subject of a woodcut intended for sale to a large international market would necessarily relate to Venice or its war.

28 In the chapel of Margaret of Austria in Brou in 1528.

SEVEN: 'SOME LITTLE BIT OF FAME'

1 This is one of the early Titians mentioned by Vasari that has caused subsequent writers much confusion. It was originally in the church of Santa Caterina. Vasari dated it 1507, but his description fits a different much later painting by Titian of the same subject. Ridolfi assigned both pictures to Titian, but Boschini 1966 gave the Santa Caterina one now in the Accademia to a minor Venetian painter, Sante Zago. Wethey 1969–75, vol. 1, p. 171, followed Boschini in disputing the attribution of the Accademia picture to Sante Zago, but this is highly unlikely because Sante Zago was not active in Venice until 1530. Hope 1993 gives it back to Titian and suggests a date of around 1507. Joannides 2001, who sees the pointing hand of the Angel Raphael as a quotation from Michelangelo's Sistine ceiling, prefers 1514, as do Tagliaferro and Aikema 2009.

2 The dog is almost identical to the one in Cima da Conegliano's *Adoration of the Shepherds with Tobias and the Angel*, generally agreed to be 1510, still in the Venetian church of Santa Maria del Carmine.

3 The mosaic portrait of Bembo as a cardinal by the Zuccato brothers in the Florence Bargello Museum was probably also designed by Titian.

4 Puttfarken 2005.

5 The Great Council Hall, which is now dominated by Domenico and Jacopo Tintoretto's enormous *Paradiso* of 1588–92, was gutted by a fire in 1577.

6 It was customary for each doge to have his portrait painted for the series of lunettes in the Great Council Hall; to have another of himself kneeling before the Madonna and saints painted for the Senate Hall; and to supply a shield with his coat of arms to be placed on the *Bucintoro*, the ceremonial state barge.

7 Chambers and Pullan 1992.

8 The building was begun in 1457 by Andrea Corner to an ambitious design by Bartolomeo Bon, of which only the rusticated base was completed. In 1499, during the war with Lodovico Sforza, it was acquired by the Venetian government, which used parts of it for studios during the first quarter of the sixteenth century.

9 Hope 1980c.

10 *Trattato dell'arte della pittura, scultura et architettura*, 1585 (Lomazzo 1974).

11 Campori 1875.

12 Boschini (1660) 1966.

13 with clusters of flowers, sumptuous with crimson, gold-bordered hangings, and luxurious with cushions and perfumes. From the walls peeped pictured fruit and fruit-like faces, between the curtains and in the corners gleamed moonlight-tinted statues; whilst on the easel reposed the beauty of the evening, overhung by budding boughs, and illuminated by an alabaster lamp burning scented oil. Strewn about the apartment lay musical instruments and packs of cards. On the table were silver dishes, filled with leaves and choice fruits; wonderful vessels of Venetian glass, containing rare wines and iced waters; and footless goblets, which allowed the guest no choice but to drain his bumper …

14 See Peter Dreyer, 'Sulle silografie di Tiziano', in *Tiziano e Venezia* 1980.

15 Other versions by the studio or followers are in the Prague Castle Museum, and Barcelona Museo de Artes Decorativas.

16 According to Vincenzo Vecellio, the brothers' first cousin, in the funeral oration he delivered in 1560 after Francesco's death.

17 See Hood and Hope 1977 for a detailed account of the history of this canvas. Titian collaborated with Niccolò Boldrini to make a woodcut of the six saints in which a plug can be seen where he altered the head of St Sebastian.

18 David Landau in London 1983.

19 This was when an application for permission to publish was registered with the Senate. There are no surviving impressions before 1549 when it was published by Domenico dalle Greche with an inscription giving the design to 'the hand of the great and immortal Titian'. Woodcuts were extremely expensive to produce, and it may be that in those lean times the original publisher, Bernardino Benalio, was unable or unwilling to risk investing in what must have been the most complex and costly woodcut ever made.

EIGHT: 'HIS INDUSTRIOUS BRUSH': PENTIMENTI AND PORTRAITS

1 For example Tintoretto, Tiepolo, Rembrandt, Luca Giordano (known as Luca 'Fa Presto') and the Japanese artist Hokusai.

2 Cited by Crowe and Cavalcaselle 1881. The anecdote may be apocryphal.

3 One of the first rules of proper courtly behaviour in the Renaissance was laid down by his older contemporary Baldassare Castiglione, author of the bestselling manual *The Courtier*, which was published in Venice. Castiglione used the word *sprezzatura* to define the gentlemanly art of making hard work look easy, suggesting that great feats were achieved as effortlessly as though they were God-given gifts.

4 The word pentimento means literally repentance, but when used about paintings is closer to deliberate modification. Although pentimenti can be found in most oil paintings Titian was the first artist to use them

so liberally. Traces of his rejected passages are visible in some of his paintings, and probably were in his lifetime. In the seventeenth century many painters trying to achieve similar effects followed his example in allowing themselves pentimenti.

5 Begun c. 1514 or c. 1518–9; completed c. 1535.

6 See Hood and Hope 1977.

7 Probably a bathing scene, a commission from Alfonso d'Este, Duke of Ferrara, which was cancelled in March 1518.

8 The oratory is now incorporated into the state archive next to the church of the Frari.

9 Usually dated between c. 1506 and 1515, although most scholars today place it in the three years after Titian's return from Padua in 1511.The *Noli me tangere* was an unusual subject in Venetian art at the time. The idea of representing it may have been suggested to Titian by the Florentine painter Fra Bartolommeo, who was in Venice in 1508–9, while the twisting figure of Christ seems to have been taken from an engraving by Marcantonio Raimondi after a drawing by Raphael. Although he used the group of fortified buildings in other early paintings, he never again painted his central figures on such a small scale.

10 Ricketts 1910.

11 A branch of the tree thought to have been added in the eighteenth century was removed by a controversial restoration in 1957, when the blue horizon, which was badly abraded, was overpainted.

12 It has been given dates between 1509 and 1516. There are two variants now in the Rome Doria Pamphilj and Borghese Galleries.

13 Wollheim 1987.

14 This important discovery was first published by Humfrey 2003a.

15 Crowe and Cavalcaselle 1881.

16 After seeing the *Three Ages of Man* in the early nineteenth century, William Hazlitt (1856, 'The Marquis of Stafford's Gallery') exclaimed: 'To live or to die in such a chosen still retreat must be happiness.'

17 For example, the *Virgin and Child with the Infant St John and a Female Saint or Donor* (the *Aldobrandini Madonna*) of about 1530 (see II, 6) in which St Catherine is missing both arms; and the *Madonna of the Rabbit*, 1530 (see III, 1) in which the position of the Madonna's right leg is unresolved.

18 Scholars have given it various dates between 1510 and 1517.

19 Hope 1980a places it around 1507; other opinions have ranged from 1511 to 1517.

20 Wilde 1974.

21 R. Huyghe cited by Jean Habert in Paris 1993.

22 It has been dated by various authorities as between c. 1511 and c. 1520, but most now prefer the early date.

23 Since the landscape and composition of the painting are similar to those of the *Gypsy Madonna*, a date of around 1511 would fit with that theory. But some scholars have cast doubt on the authenticity of the Copenhagen man.

24 Now usually dated about 1511–12.

25 Pater 1877.

26 In the eighteenth century it was suggested that the painting represented Mr and Mrs Luther and Calvin.

27 Gentili cited by Pedrocco 2001.

28 A century later the *Concert* was hung next to a portrait of Monteverdi so that the composer should seem to be

listening to the music. More recently Sir Christopher Pinsent, a painter interested in Titian's geometry, has measured the painting with ruler and compass and discovered a geometry based on ancient Greek musical intervals, so that for example half the height of the picture equals the musical length of a fourth within the total width, which is also the distance between the ears of the two musicians and between the onlooker's eyes and the keyboard.

29 The English title of Cartier-Bresson's book of photographs published in 1952.

30 Giulia was godmother to one of Titian's sons who were born in the early 1520s. According to Vasari he also painted her father, Paolo da Ponte, but the portrait (in the hands of a Venetian dealer at the time of writing), although well documented, is rather dull.

31 I have John Steer to thank for this striking comparison.

32 In the *Imagines* by the third-century AD Athenian writer Philostratus, painting is defined as imitation by the use of colours alone and therefore superior to carving, modelling or gem cutting.

33 The Goldman *Portrait of a Man* (Washington, DC, National Gallery of Art), which has been attributed to Giovanni Cariani or Titian; and the *Young Man in a Lavender Jerkin*, which has traditionally been given to Giorgione, although some claim it for Titian.

34 Gould 1959.

35 *Essays and Introductions*, 1961. Yeats especially loved the *Man with a Quilted Sleeve*.

36 Hope, who dates the Dublin picture ?1530s, points out (in *Vittoria*

Colonna: Dichterin und Muse Michelangelos, exh. cat., ed. Sylvia Ferino-Pagden, Vienna, 1997, pp. 165–6) that the two men cannot have met during either of Castiglione's visits to Venice, that the portrait looks nothing like Raphael's portrait of c. 1514, and that the inscription is probably later.

37 See Schupbach 1978.

38 There have been several attempts to describe the powerful personality of Titian's portrait. Burckhardt called him a man 'before whose majestic strength, as the saying goes, "Death would have to take to his heels"'; Wethey as looking 'even more like a barrister awaiting his chance to respond to an argument'. (Both cited by Schupbach 1978.)

39 Cited by Pommier 2006.

40 Sometimes dated 1510s but most convincingly early 1520s from the costume fashionable at that time. See also II, 2 for a theory about the identity of the subject.

41 George Eliot, who saw it in the Louvre in the nineteenth century, made the *Man with a Glove* the physical model for her hero Daniel Deronda.

> Look at his hands: they are not small and dimpled, with tapering fingers that seem to have only a deprecating touch: they are long, flexible, firmly-grasping hands, such as Titian has painted in a picture where he wanted to show the combination of refinement with force. And there is something of a likeness, too, between the faces – belonging to the hands – in both the uniform pale-brown skin, the perpendicular brow, the calmly penetrating eyes. Not seraphic any longer: thoroughly terrestrial and manly; but still of a kind to raise belief in a human dignity which can afford to acknowledge poor relations.

42 Goffen 1997.

43 Dated early 1520s by the majority of scholars, the painting was acquired by the gallery from the Trustees of the 7th Duke of Sutherland in 2003 for £11,414,178. Kenneth Clark in *The Nude* (1956) described it as 'one of the most complete and concentrated embodiments of Venus in post-antique art'.

44 Matthew 14: 1–2 and Mark 6: 22–8.

45 It has been proposed that the subject is actually Judith, and that it was painted for Titian's first foreign patron Alfonso d'Este, Duke of Ferrara as a politically motivated gift warning him not to abandon his alliance with Venice. The first notice we have of it is a sketch by Van Dyck who saw it in Rome in 1622–3. Although the attribution to Titian has never been challenged, different scholars in the twentieth century have given it dates ranging from 1511 to 1517. It became one of Titian's most popular subjects.

46 As described, for example, in Pietro Aretino's pornographic *Ragionamenti*.

47 According to Hourticq, Foscari and Panofsky as cited by Falomir in Madrid 2003.

48 *Dialogo d'amore*, cited by Ferino-Pagden in Washington and Vienna 2006. Paul Valéry made a similar observation when he wrote that for Titian, 'to paint meant to caress, a conjunction of two voluptuous sensations in one supreme act in which self-mastery and mastery of his medium were identified with a masterful possession of the beauty herself, in every sense'.

49 Letter to Jacopo Sansovino, January 1553.

50 The first documented mention of 'Violante' that I know of was discovered by Alessandro Ballarin in 2002 in an inventory of the collection of the dukes of Ferrara. It is dated 1598 when a certain Alessandro Balbi referred to a painting he seems to have stolen from Cesare d'Este, who had bought it from the ducal collection, as 'a Violante, formerly the lover of messer Titian'. In the end Cesare's agent bought the picture from Balbi for 200 scudi and had it sent to him in Modena. Attempts to associate Cesare's 'Violante' with the *Violante* now in Vienna are unconvincing, if only because the Vienna picture, which was probably not by Titian, was never in Modena. The picture in question was probably the one now in Dresden of Titian's daughter Emilia (or according to some his elder daughter Lavinia), which Titian had sent to Alfonso II d'Este in 1561 with a note saying that the subject was the most beloved object of his heart and nothing could be dearer. Balbi was not the last person to interpret Titian's letter as a reference to a mistress rather than a daughter.

NINE: SACRED AND PROFANE

1 The story is summarized by Goffen 1993 and 1997a; and by Mayer 1939.

2 It was reproduced on one of the old Italian banknotes, and in the nineteenth century when the Villa Borghese was first opened to the public there was a seven-month waiting list of artists applying to copy it.

3 Wethey 1969–75, vol. 3, summarizes theories advanced up to 1975.

4 B. L. Brown 2008.

5 By Hood and Hope 1977.

6 I have this attractive speculation from Beverly Brown.

7 Sanudo incorrectly named Laura's first husband Lombardo rather than Borromeo.

8 Thought to have commemorated the marriage of Lorenzo di Pierfrancesco de' Medici and Semiramide Appiani.

9 F. Sansovino said they wore white, with their hair unbound, in imitation of classical brides. But it is clear from Sanudo's many descriptions of the weddings he attended on his frequent social rounds that they wore any colour they chose.

10 The theory advanced by Alice S. Wethey and mentioned in Wethey 1969–75, vol. 3, p. 177, has turned out, on closer technical examination, to be wishful thinking, although Titian's scratches on the dish do seem to suggest a coat of arms.

11 The story is recounted in Colonna's *Hypnerotomachia Polifili* 1998.

12 The results of the technical examination are discussed in Rome 1995, the catalogue of the exhibition held after the cleaning. The restoration remains controversial. Some critics maintain that the cleaning was uneven, that the failure of the restorers to remove the areas of dark varnish that obscures the greens of the mid-distance upset the chromatic balance.

13 The graves have been cemented over.

14 The contemporary documents are contradictory about whether he did or did not receive the *sanseria* at this time. Most art historians have assumed that he did, but see Hope 1980c.

15 Valcanover 1997.

16 It was not until 1950 that the Immaculate Conception of the Virgin became Church dogma and it was therefore heretical to doubt it.

17 Crowe and Cavalcaselle 1881.

18 It was replaced in the Frari with an Assumption by Giuseppe Salviati from a suppressed church.

19 When we think of Titian, we are irresistibly led to think of music. His Assumption of the Madonna (the greatest single oil-painting in the world, if we except Raphael's Madonna di San Sisto) can best be described as a symphony – a symphony of colour … a symphony of movement … a symphony of light without a cloud – a symphony of joy in which the heavens and earth sing Hallelujah.

Symonds 1906

In the 'Assumption' … the Virgin soars heavenward, not helpless in the arms of angels, but borne up by the fullness of life within her, and by the feeling that the universe is naturally her own, and that nothing can check her course. The angels seem to be there only to sing the victory of a human being over his environment. They are embodied joys, acting on our nerves like the rapturous outburst of the orchestra at the end of 'Parsifal'.

Berenson (1930) 1938

20 Luke 20: 21–6. The episode is also recounted in Matthew 22: 17–22 and Mark 12: 14–17.

21 C. Gilbert 1980.

22 The suggestion is from Tietze-Conrat 1976.

23 Giovanni Bellini's *Feast of the Gods*, and possibly a Triumph of Bacchus by Pellegrino da San Daniele.

24 For the *Submission of Frederick Barbarossa before Alexander III* see II, 2.

25 When Rubens 'translated *The Worship of Venus* into Flemish', as Crowe and Cavalcaselle 1881 put it, he turned some of the baby boys into baby girls.

Part II: 1518–1530

ONE: ALFONSO D'ESTE, DUKE OF
FERRARA

1 Tr. Crowe and Cavalcaselle 1881.
2 The date of the portrait could be
anything from 1523 to 1529. The
original is lost but a copy, perhaps of
a copy by Rubens, is in the New York
Metropolitan Museum of Art.
3 Cited by Chambers 2006.
4 Chiappini 1967.
5 The Via Coperta is open to the public,
reconstructed as it was during
Alfonso's reign and hung with
reproductions of the works of art he
placed there.
6 Antonio was the son of Pietro
Lombardo and younger brother of
the better-known Tullio.
7 The majority of Antonio's surviving
sculptures for Alfonso d'Este are in
the Hermitage Museum, St
Petersburg. Others are in Paris and
Liechtenstein.
8 Shakespeare, in *A Midsummer Night's
Dream* (Act IV, scene I), gives the
name Philostratus to Theseus' master
of revels, hired 'to wear away this long
age of three hours, between our after
supper and our bed time'.
9 He still had it in 1515 when she
complained that he hadn't returned
it.
10 See Hood and Hope 1977.
11 Chiappini 1967.
12 Ariosto was employed by Ippolito and
after the cardinal's death by Alfonso
from 1518 to 1522 as unofficial
ambassador, and again from 1525 to
1528 when he was responsible for
court theatrical entertainments.
13 The *Submission of Frederick
Barbarossa*, begun by Giovanni
Bellini, left unfinished at his death
and completed by Titian.

14 Leonardo and Mantegna and the two
Named Dossi, Gian Bellino, he whose skill
In paint and marble may be likened to
The Angel Michael's, Bastian, Raphael,
And Titian to whose mastery is due
Such glory that Urbino shares no more
And Venice shines no brighter, than
Cador ...
xxx, 10–16, TR. Barbara Reynolds

15 Her beauty is indeed beyond compare:
Not only on her brow, her eyes, her nose,
Her cheeks, her mouth, her shoulders and
her hair
The observer's glance may with delight
repose,
But from her breasts descending, down to
where
A gown is wont to cover her, she shows
A miracle of form, so exquisite
None in the world, perhaps, can equal it.

Whiter than snow unstained by the earth's
smutch
The perfect lily-whiteness of her skin,
And smoother far than ivory to touch;
Like milky curds but freshly heaped within
Their plaited moulds, her rounded
breasts, and such
The gently curving space which lies
between,
It calls to mind a valley 'twixt two hills
Which winter with its snowy softness fills.

Her lovely hips, the curving of her thighs,
Her belly, smooth as any looking-glass,
Her ivory limbs, were rounded in such
wise
They might have been the work of Phidias.
Those other parts which to conceal she
tries
I will, as it behoves, in silence pass,
Content to say that she, from top to toe,
Embodies all of beauty man can know.
xi, 67–9, TR. Barbara Reynolds

16 Paolo Giovio, in a translation by the
Florentine Giovanni Battista Gelli,
cited by Chiappini 1967.

17 This is my theory. Hope (in conversation with the present author) believes it was probably one of three things Titian painted for the duke in 1524–5.

18 Laura outlived Alfonso by thirty-nine years, during which she kept her own expensively elegant court of artists, writers, buffoons and beautiful young men. When she died in 1573 she was given a magnificent and well-attended funeral. Her legacy to a nephew was, as well as the Palazzo dei Diamanti – the most magnificent palace in Ercole I's extension of the city – debts of over 200,000 scudi. Some nineteenth-century writers saw a younger Laura as the model for Titian's earlier, more intimate Louvre *Woman with a Mirror*, with Alfonso as the man holding up a second mirror for her. There is in fact a resemblance between the two women. The pose of the Louvre model, wringing her hair like a Venus rising from the sea with her bared right arm – bared arms were considered highly erotic at a time when women did not show their arms in public – could refer to Alfonso's passion for his lovely mistress. Since the Louvre woman looks about seven years younger than the portrait of Laura Dianti, and the painting is consistent with Titian's style in the late 1510s and early 1520s, Titian might have painted it during his first extended stay in Ferrara.

19 Philostratus did not specify a statue of Venus. Titian modelled his on an antique sculpture in the Grimani collection.

TWO: *BACCHUS AND ARIADNE*

1 Tr. James Michie, *The Poems of Catullus*, London 1969.

2 The principal source for Titian and Alfonso d'Este is Campori 1875. Charles Hope has shared with me a number of documents and letters that were not known to Campori.

3 He may also have been working on an altarpiece of the *Virgin and Child with Sts Stephen* [holding a palm], *Jerome and ?Maurice* for a Venetian chapel dedicated to St Jerome, the most prominent saint. Titian must have been pleased with this composition, in which the Virgin and Child are, unusually at that date, on one side as they would be in the finished *Pesaro Madonna*, because he made three variations. The earliest, beneath the surface of which X-rays have revealed his characteristic pentimenti, is probably the one on panel in the Vienna Kunsthistorisches Museum. The Vienna picture was the prototype for the one in the Louvre, which is on canvas and in which St Jerome wears a cardinal's hat, and is without pentimenti. Since this painting can be traced back to an inventory of the Este collection it is probable that Titian gave or sold it to Alfonso d'Este. Examination of a third version (London, Chiswick House) reveals pentimenti similar to those beneath the Vienna picture, a discovery that has led some authorities to speculate that there may have been a lost original from which all three derive.

4 Sanudo described the fire as like the burning of Troy, only worse.

5 D'Elia 2005.

6 In the final version in Brescia the St Sebastian is tied to a tree.

7 It could be the portrait of Tommaso Mosti.

8 Interestingly, sculptures of these two subjects are on the outside of the

Palazzo Ducale where the law courts and prisons were.

9 See Schulz 1982. The house is identified as belonging to the Tron family and as located in the *sestiere* of San Polo in depositions concerning Titian's marriage to Cecilia made in 1550. Anna Jameson, 'The House of Titian', in her *Memoirs and Essays*, 1846, plausibly suggested that it was in the Calle Ca' Lipoli, behind the Frari, but her source is not known and the house is now demolished.

10 Some scholars have seen the pointing to her abdomen as signifying that it is a marriage portrait.

11 See I, 8, pp. 146–9.

12 Both seem to have been painted in the early 1520s in the early years of Titian's work on Alfonso's Bacchanals, although since there is no record of either of them being in the Este collection they were probably done for Venetian patrons who would not have recognized Cecilia since Titian kept her strictly at home.

13 Tr. Hope 1973.

14 While some scholars have proposed 31 May for the unveiling, Hope has demonstrated in an unpublished commentary that Averoldi cannot have been in Brescia on that day and the more likely date is 28 July, which was the feast of Sts Nazzarus and Celso.

15 Averoldi's Resurrection altarpiece is still over the high altar of the Brescian church of Santi Nazzaro e Celso. The church itself, however, was rebuilt in the eighteenth century.

16 The painting, which had suffered over the years from blistering and relinings, was subjected to a controversial restoration by the National Gallery in the late 1960s.

17 In a document of 1598, when Ferrara had passed to the Papacy, the painting was described as 'a Laocoön'.

18 It is not known what this panel painting was. It cannot have been the *Flora*, *Venus Anadyomene* or *Tommaso Mosti*, all of which seem to have been painted around this time, but all on canvas.

19 My principal source for Titian and Federico Gonzaga is Bodart 1998.

20 As imperial commander in the 1527 Sack of Rome he saved the life of his mother Isabella. The following year he was rewarded by the emperor with the dukedom of Ariano (now Ariano Irpino) for having saved Naples from a siege by the French. In 1535 he served as Charles V's viceroy in Sicily, and from 1546 to 1554 as governor and captain general of Milan. He died in Brussels in 1557.

21 Nothing is known for certain about the *Man with a Glove* before Louis XIV acquired it in 1671. Other suggestions about its subject have been Girolamo Adorno, Charles V's ambassador to Venice, or Giambattista Malatesta, Federico Gonzaga's envoy in Venice.

THREE: A NEW DOGE, A RIVER OF WINE AND MARRIAGE

1 *Elder Philostratus, Younger Philostratus, Callistratus*, tr. Arthur Fairbanks, Loeb Classical Library, vol. 156, London 1931.

2 The chronology of the *Andrians* is less certain than for the first two Bacchanals. It is likely to have been painted after his visit to Federico Gonzaga's court because two of the figures are quotations from fragments of Michelangelo's cartoons for his unfinished *Battle of Cascina*, which were in Mantua at that time. I am

following Hope's cogently argued theory about the sequence of the paintings executed for Alfonso d'Este in 1524–9.

3 *Hadriani vita*, 1551, cited by Zimmermann 1995.

4 Titian's official portrait of Gritti with his predecessor Doge Antonio Grimani was painted in 1540 for the frieze of Venetian doges in the Great Council Hall of the doge's palace. The original was destroyed when the hall went up in flames in 1577, but there are several surviving studio copies. The Washington portrait, which would have been taken from a record Titian had kept of his official portrait or from one of the studio copies, was probably painted for Gritti's family. The canvas was not primed and since it has never been relined the very free paintwork has survived in good condition.

5 Destroyed by fire in the 1570s. In 1555 the government commissioned from Titian the posthumous votive portrait now in the Sala delle Quattro Porte, in which Grimani, his sins against the state long since forgotten or forgiven, wears a suit of armour under his ducal robe, his martyrdom symbolized by the cross and the cup before which he kneels in worship. It was still in Titian's studio at the time of his death, and was later completed under the dogeship of Marino Grimani by Titian's younger relative Marco Vecellio.

6 We know the dates from the records of wine supplied to his two assistants during that period, which were discovered by Hope in the 1970s. (See Hope 1987, p. 26 and n. 13.) The only other document that relates to this extended visit is a record in a court account book dated 10 September

1524 about a previous purchase of half an ounce of ultramarine and one ounce of lake to give to Titian, which presumably relates to the work he did for the duke in the preceding spring and summer.

7 The statue, then thought to be of Cleopatra, is now in the Vatican, where it is known as *Ariadne*.

8 Alberto Zio and Marco Luciano Rizzo.

9 For the mosaics see Merkel 1980. Zuccato's St George strikes the same pose, leaning forward with one leg bent, as the men in the Padua fresco of the *Miracle of the Speaking Babe*, the Glasgow *Christ and the Adulteress* (Glasgow, Kelvingrove Art Gallery) and the *Virgin and Child with Sts Anthony of Padua and Roch* (Madrid, Prado). The little angels that surround the tondo of the *Prophet David* are cousins of the angels in the *Assunta* and the rollicking cupids in the *Worship of Venus*. Titian must have been personally responsible for the cartoon for the *Prophet Ezekiel*, the most technically complex and accomplished of the sacristy mosaics signed by Francesco Zuccato, in which the caryatids that support the tondo recall the pose of the bacchant pouring wine in the *Andrians*, while the face of the gorgon between them seems to anticipate the face of the screaming boy in the *Ecce Homo*, which was painted twenty years later. And these are only some of the images from his past, present and future works with which Titian paid his respects to the traditional art form that taught him something about how to make his own oil paintings sing from a distance.

10 All that is known for certain about the birthdates of his two sons,

Pomponio and Orazio, is that they
were born by the time he married
Cecilia in November 1525.

11 Campori 1875 cites a record dated 15
January 1528 of a payment of fifteen
lire to a carter who took Titian, who
was on his way to Venice, from
Ferrara to the port of Francolino.
There are, however, no wine records
for this visit, and Hope has been
unable to find the document in
question.

12 An inscription written much later on
the reverse reads 'Tommaso de' Mosti,
aged twenty-five, in the year 1526, by
Titian'. But Tommaso de' Mosti had
become a priest in 1525, and because
he is not wearing a clerical robe in
this portrait some scholars have
mooted that the sitter was his brother
Vincenzo, while others, on the
grounds that the style is closer to
Titian's portraits earlier in the 1520s,
prefer the theory that it is the date
that is incorrect rather than the
identification of Tommaso.

13 Some scholars maintain that the
portrait was done earlier, possibly
during Titian's first long stay in
Ferrara in 1519–20.

14 I am grateful to Charles Hope for
sharing with me the evidence of an
unpublished record of a payment to a
boatman for bringing Titian to
Ferrara on 22 October 1525.

15 The depositions concerning the
marriage by Francesco and two other
witnesses are published in Ludwig
Gustav, 'Neue Funde im Staatsarchiv
zu Venedig', *Jahrbuch der preuszischen
Kunstsammlungen*, 1903.

FOUR: THE FALL OF A WORLD

1 As reported by Gasparo Contarini,
cited by Tyler 1956.

2 See I, 4, p. 62.

3 A restoration in 1977 revealed the
numerous pentimenti.

4 Goffen 1986.

5 See III, 1 and 4, pp. 293 and 348.

6 Francesco Vettori, *Sommario
dell'istoria d'Italia dell'anno 1512–27*,
cited by Umberto Bile in Naples 2006.

7 For the Sack of Rome, its background
and consequences see especially Hook
1972.

8 His only complete surviving building
from before the Sack is Palazzo Gaddi
in Rome.

9 From Asti, 31 May 1536, and from
Augsburg, 11 November 1550.

10 May 1542.

11 Camesasca and Pertile, September
1552.

12 Ibid., January 1545.

13 Burckhardt 1990.

14 Crowe and Cavalcaselle 1881.

15 Aretino 2003–4, vol. II, no. 386.

16 To Lope de Soria dated 20 March
1542.

17 11 November 1550. Stella 1977
speculates that Aretino's generosity to
the poor may indicate that he had
Anabaptist sympathies.

18 Because the copyright laws in
Renaissance Italy did not prevent
pirated editions, writers earned less
from royalties but more from patrons
to whom they dedicated their books.

19 Camesasca and Pertile, January 1544.

FIVE: THE TRIUMVIRATE OF TASTE

1 To Niccolò Franco, dated 25 June
1537.

2 *Ragionamento de le corti*, 1538.

3 In his first book, *Opera Nova*,
published in 1512, he describes
himself on the title page as a painter.

4 Nine fragments of the originals are
preserved in the British Museum.

5 In his letter to Francis I he describes
the chain as weighing five pounds.

But in his play *Il Marescalco* (*The Stablemaster*) the groom tells a goldsmith that, unlike the flimsy chains made in Venice, they should be 'like the one the king of France sent as a gift to Pietro Aretino as far as Venice, which weighs eight pounds'.

6 A reference to the Old Testament, Jeremiah 9: 5: 'they have taught their tongue to speak lies, and weary themselves to commit iniquity'.

7 Tr. Chubb 1967, no. 12.

8 In a letter to Ippolito de' Medici.

9 *Pronostico* of 1534.

10 1541.

11 Hope points out (in conversation with the present author) that when Aretino wrote the letter for publication on 6 October 1527 there is no evidence that Sebastiano was in Venice, and that Federico never mentioned him or the painting in his reply to Aretino. He believes that Aretino, who often moved material from earlier letters to those intended for publication, transplanted the passage about Sebastiano and the picture from a letter written at the time it was originally commissioned in 1524, and that it was probably never painted or delivered.

12 For Aretino's apartment see Schulz 1982.

13 The letter is dated October 1537.

14 Chubb 1967, no. 38.

15 It has traditionally been assumed that Lavinia was Cecilia's daughter. Charles Hope has, however, provided convincing evidence that after Cecilia's death in 1530 Titian married again (to be discussed in Part III).

16 Laura Giannetti Ruggiero, in a paper delivered at the 2005 joint annual meeting of the Renaissance Society of America and British Society for Renaissance Studies, suggested that the immoderate desire for food, and particularly for edible treats like melons that were considered dangerous, was associated with sodomy in sixteenth-century Italy.

17 In Naples, Gallerie Nazionale di Capodimonte, c. 1544–5, painted for Cardinal Alessandro de' Medici; and Madrid, Museo Nacional del Prado, c. 1549–50, painted for Philip of Spain.

SIX: CAESAR IN ITALY

1 Commissioned by Cosimo de' Medici but not published until 1721. Cited by Hook 1972.

2 Charles Hope has shared with me his unpublished summary of what is known about the commissioning of the St Peter Martyr and the subsequent dispute over payment (see also II, 7).

3 It is often assumed that Pordenone took part in the competition on the basis of his drawing of the subject now in the Uffizi. It seems unlikely because Pordenone is not documented as being in Venice between the petition of November 1525 and the death of Palma in 1528, although there is a gap in the records of his whereabouts between May and September 1525.

4 After joining the Scuola he designed a woodcut of St Roch to raise funds for its building, which was still in progress. The charming if surprisingly conventional *Annunciation* that is displayed in the Sala dell'Albergo was painted much later for a patron who later became a member of the Scuola to which he bequeathed the painting.

5 I have Charles Hope to thank for the notary's document about the sale, dated 3 April 1528, and so far unpublished.

6 The painting is known as the *Aldobrandini Madonna* because it was first recorded in the collection of Pietro Aldobrandini in 1603. Nothing is known about the patron or circumstances of the commission, but, since he probably inherited it from Lucrezia d'Este some scholars have speculated that it may have been painted for Alfonso d'Este.

7 *Titian's Country*, 1869.

8 Alfonso took the opportunity to joke that he would keep Michelangelo prisoner until he had promised to accept an order for a painting or sculpture, whichever he preferred. And Michelangelo did in fact paint for him the *Leda and the Swan*, of which there is an old copy in the London National Gallery. But he was so angered by the lukewarm reaction of Alfonso's Roman agent that he gave it instead to a disciple.

9 Although there is no direct evidence that Titian repainted the *Feast of the Gods* on this extended visit to Ferrara, there is no other known large-scale work that could have detained him there at this time.

10 See II, 3.

11 The location of the *camerino d'alabastro* and the arrangement of the paintings in it has been extensively investigated by Charles Hope, 1971 and 1987. The main evidence is the inventories made of the rooms in 1598, the year in which the Bacchanals were stolen and taken to Rome. Vasari in the second edition of the *Lives* describes them as the best things Titian had ever done, but since his description of the contents of the room is mistaken he must have based it on information provided by someone else. The Via Coperta is now hung with reproductions in what is

thought to have been their original positions and is open to the public.

12 My principal authority for Titian's relationship with Federico Gonzaga is Bodart 1998.

13 In *The Winter's Tale*, Act V, scene ii: 'The princess, hearing of her mother's statue, which is in the keeping of Paulina – a piece many years in doing and now newly performed by that rare Italian master Julio Romano, who, had he himself eternity, would beguile Nature of her custom, so perfectly is he her ape.'

14 Cited by Burns 1981, p. 32.

15 Howard Burns in London 1981.

16 Titian painted three portraits of Federico Gonzaga. The other two are lost. Not all scholars agree with Hope, Bodart and myself that the Prado portrait was painted in 1529. Some date it earlier and some to 1531 when he married Maria's sister Margherita Paleologo.

17 The conference centre on the borders of France and the imperial Netherlands was the setting of several agreements between the Habsburgs and Valois, most famously of the League formed in 1509 with the intention of destroying the Venetian Republic.

18 There is a difference of opinion about whether Titian went to Parma with Federico. Hope has maintained that he did and that the plan for a portrait was rejected; Wethey 1969–75, vol. 2, implies that their first meeting was at Bologna later in the year. I am following Hope's argument in an appendix to Hood and Hope 1977.

19 Boschini (1660) 1966.

20 Cited by Parker 1999.

21 I have the description from Mitchell 1986 and Hook 1972.

22 Cited by Hook 1972.

23 Ibid.

24 A member of the imperial household described the highpoints of the ceremony.

> When they had got as far in the mass as the gradual, the two cardinals came to get His Majesty [and] led him to the pope, to whom he bowed, falling to his knees. Then the pope took the naked imperial sword that the sacristan handed him and put it in the right hand of the emperor, saying: *accipe gladium* etc. Then the deacon took it from the hand of the emperor and put it back into its sheath, and the pope and the cardinal deacon girded it around the emperor. [The latter] rose [and], unsheathing [the sword], brandished it three times, then put it back in its sheath and knelt. And then the pope gave him the orb in the right hand and the sceptre in the left and [put] the crown on his head, while making some prayers. Then the emperor kissed the feet of the pope and ungirded his sword, which he gave to the duke of Urbino. He sat down in a chair on the right hand of the pope and remained there until the offertory.

25 See II, 2, p. 202.

SEVEN: THE MOST BEAUTIFUL THING IN ITALY

1 Jacopo Palma did an inferior version, dated c. 1527, for a small town near Bergamo, possibly based on his design for the competition with Titian that he had instigated.

2 By Luca Bertelli, Giovanni Battista Fontana and Martino Rota.

3 Boschini 1660, cited by Crowe and Cavalcaselle 1881. Boschini may have been referring to an attempt by Daniel Nijs to buy it for Charles I of England for 18,000 scudi.

4 The transfer of paintings from panel to canvas was a radical intervention developed in Paris in the eighteenth century for the treatment of paintings where the original wood panel was considered an unstable support for the paint (for example, if it was riddled with worm channels). After securing the face of the painting, the transfer process involved planing away the wood support from the reverse, usually removing the ground, and then sticking the paint layers to a canvas support and mounting the composite on a stretcher, like a painting on canvas. The practice was largely discontinued early in the twentieth century, in favour of less invasive techniques for the treatment of wood panels.

5 Hazlitt 1856.

6 Burckhardt, *The Cicerone*, 1855.

7 Tr. Hope 1980a.

8 Altarpieces depicting the violence and suffering of the Crucifixion and martyred saints had been fairly usual in the fourteenth century but were abandoned during the Renaissance of classical restraint and the idealization of religious subjects, and were not considered acceptable until the Council of Trent recommended that painters emphasize the suffering caused to Christian martyrs by pagan heretics.

9 Cozzi 1973.

10 Ibid.

11 Soon after the proclamations of the Peace of Bologna the pope had persuaded the Republic of Florence to send delegates to that city. Naively optimistic as ever, they arrived expecting to be received as representatives of a sovereign state only to be stopped at the gate by the police who interrogated them and ransacked their luggage. They received a chilly reception from both pope and emperor, and having

refused the emperor's order to allow Pope Clement's Medici relatives to return to Florence, the Florentines departed the next day. The Republic of Florence held out against a combined papal–imperial siege until August when it finally surrendered and, with the support of some other members of what would become the Florentine aristocracy, was forced to accept the return of the Medici as private citizens and the right of the emperor to oversee the stabilization of its constitution. It wasn't long before the Medici staged an armed coup d'état, and Charles V crushed any latent republican tendencies in the city by creating Alessandro de' Medici the first duke of what would from then on be an aristocratic Florence under imperial control.

12 Mallett and Hale 1984.

13 1537 to Paul Manutius.

14 Boschini 1966.

15 Sperone Speroni, *Dialogo d'Amore*, 1542, cited by Crowe and Cavalcaselle 1881.

16 His three very large portraits of doges – Andrea Gritti 1531, Pietro Lando 1540 and Marcantonio Trevisan 1553–4 – painted for the Sala del Collegio in the doge's palace were said to be the best in the palace but were lost to fire.

17 Lomazzo cited by Wilde 1974.

18 One of many examples of his failures that can be seen in provincial galleries or the basements of major public collections is a very dull but undeniably authentic portrait done in the 1520s or 1530s of Paolo da Ponte, which at the time of writing is with a Venetian dealer.

19 Berenson 1938.

20 D'Elia 2005 gives a useful list of Titian's literary acquaintances and attempts to elucidate their influence on him.

21 See for example Gentili 1988 and 1993.

Part III: 1530–1542

ONE: THE PORTRAIT OF CORNELIA

1 I have abstracted the material about the portrait of Cornelia from Bodart 1998.

2 Unfortunately all but a few are now lost.

3 For Agnello see Chambers 1993.

4 *De civilitate morum puerilium libellus.*

5 None of Titian's portraits of Suleiman is known to have survived, although it is possible that one or more is preserved in copies.

6 Isabella had been secretly betrothed by her stepmother to Ferrante's cousin Luigi Gonzaga of Sabbioneta.

7 David Rosand in 1994 published a signed *St Sebastian* in a private collection, which he suggested was the one Titian sent to Federico Gonzaga. Bodart 1998, who disagrees, believes it might have been a copy of the St Sebastian painted for Averoldo Altobello in the early 1520s.

8 Gregorio held no offices in Cadore after 1527. He was still alive in 1529, but there is no record of him after that year.

9 There is no certain way of dating the portrait, which could have been painted on one of Titian's visits to Mantua or in Venice, where Isabella was frequently to be found.

10 In the *Portrait of Francisco de los Cobos* by Jan Gossaert painted in Flanders between 1530 and 1532, he wears in his hat a cameo portrait of a woman who we can safely assume was Cornelia Malaspina.

TWO: THE HOUSE IN BIRI GRANDE

1 H. C. J. Grierson, *Cross Currents in English Literature of the XVII Century, or The World, the Flesh and the Spirit, their Actions and Reaction*, 1929, cited by Haskins 1993.

2 It is often thought to be the version in the Louvre, although Hope disagrees and questions the attribution of that painting to Titian.

3 Apart from the famous version in the Florence, Pitti Palace, Galleria Palatina, there are examples in Bordeaux, Musée des Beaux-Arts; Milan, Pinacoteca Ambrosiana; St Petersburg, Hermitage; Los Angeles, Getty Museum; a private collection in Busto Arsizio (Varese); a private collection in Tokyo; and Genoa, Palazzo Durazzo-Pallavicini.

4 Scholars disagree about whether the version in the Florence Pitti is identical or similar to the one painted for Vittoria Colonna. It cannot be identical because in the letter Titian sent to Federico with the painting on 14 April 1531 he described his Magdalen covering her breasts with her hands. Nor is the Pitti painting 'as tearful as possible'. Views are also polarized about whether Titian intended the Pitti Magdalen to be high-class pornography or whether she carried a serious religious purpose. Crowe and Cavalcaselle, Hope and Haskins have taken the former position while Goffen and D'Elia argue that she was intended to convey the ambiguities of chaste desire and that Vittoria Colonna would have appreciated her for that reason. It is also possible that d'Avalos kept the painting commissioned on his behalf by Federico Gonzaga and had another more seemly version painted for Vittoria Colonna.

5 Ruskin 1974, vol. II.

6 The principal source for Titian's house is Cadorin 1833. The most useful modern account that I know of is Schulz 1982.

7 A *casa da statio* not on the Grand Canal cost about 4,000 ducats to build. Patricians who preferred to rent rather than buy or build paid between 50 and 200 ducats, while low-paid workers found accommodation for less than ten.

8 Letter to the Duke of Alba, 31 October 1573.

9 The conventional view is that Lavinia was the daughter of Cecilia, born some time between Titian's marriage to her in 1525 and her death in 1530. For the evidence from which Charles Hope has deduced the existence of the second wife see Hope 2007.

10 The owner responsible for the most radical adaptations that transformed Titian's *casa da statio* into a nineteenth-century tenement was Antonio Busetto, who built the railway bridge across the Lagoon, began the commercial development of the Lido and after buying the Fondaco dei Turchi, the medieval Turkish warehouse on the Grand Canal, tore down most of it before the city bought him out.

11 The address is Cannaregio 5179–5183.

12 There is a good deal of confusion and controversy about this painting, which Vasari dated to the 1520s. The most detailed analysis of the two superimposed paintings that were discovered beneath its surface during its transfer to canvas in the early 1960s is Hope and Hood 1977, although not all scholars agree with their conclusions.

13 Wilde 1974 suggested that the prototype was Michelangelo's *Redeemer* of 1521.

14 Ridolfi, who said he had copied the Verona *Assumption*, claimed that the apostle with his hands clasped was a portrait of the architect Michele Sanmicheli, who was working in Verona at the time.

15 Théophile Gautier in his guide to the Louvre of 1867 was the first of many to compare it to Leonardo's *Last Supper*. For much of its history it was known, after the beautifully painted white cloth that covers the table, as 'The Tablecloth'.

16 Titian's underdrawing, discovered when the picture was relined in 1935, reveals a much simpler composition, which Titian may have worked up for d'Avalos.

17 De' Franceschi was elected grand chancellor by a large majority, although one of the electors had asked if it would be possible to re-elect Titian's old patron Niccolò Aurelio (see I, 9) who was still in exile in Treviso even though his name had been unofficially cleared, but was told that having been deprived of all civil rights he could not be considered as a candidate. According to his will, dated 1 March 1535, de' Franceschi owned two portraits of himself by Titian, which he bequeathed to two different nephews. A version of Titian's portraits of de' Franceschi appears again in a much later painting at Hampton Court in which he is accompanied by a portrait of Titian and a copy of Titian's painting of a man known, from the inscription on a letter he holds, as Titian's 'Special Friend' (San Francisco, M. H. De Young Memorial Museum). This triple portrait, now thought to have been painted by a follower of Titian, is the subject of Alan Bennett's play *A Question of Attribution*. Bennett got the idea when a copy of the *Special Friend*, which was blanked out at some time in the painting's history, was uncovered during a cleaning in the late twentieth century.

Ridolfi also identified de' Franceschi as one of the government officials wearing black caps in Titian's *Presentation of the Virgin*, commissioned by the Scuola della Carità, but since he was not a member of the Scuola this idea has to be discounted.

THREE: THE MOST POWERFUL RULER IN THE WORLD

1 Sebastian Franck cited by Hale 1993.

2 Maximilian had made a point of having Albrecht Altdorfer depict him resolving a mutiny among his multilingual troops by understanding what they were all saying.

3 G. R. Elton, in Elton 1958.

4 The subsequent engagements were to Henry VII's daughter Mary Tudor, who later married the widowed Louis XII; to Renée, another daughter of Louis XII, who married Ercole d'Este; and in 1516 to Francis I's daughter Louise, who died the following year at the age of two.

5 After various deductions it actually amounted to 400,000 ducats, still an enormous sum.

6 In the dedication to Charles V of his paraphrase of the Gospel according to St Matthew.

7 He may have drawn it on a visit to Ferrara in July of that year or it may have been based on a lost portrait.

8 In his life of Titian, Vasari dates the first portrait of Charles in armour and the anecdote about Lombardo's

participation in the sitting to 1530, when Charles was in Bologna for the coronation, and says that Titian did another portrait on this second visit to that city. For that reason some scholars believe that there were two portraits, and some that the episode of the one-ducat tip (see II, 6) took place at Bologna in 1530. His reference to Genoa makes it clear, however, that Vasari, as often happened, mixed up his dates. In 1530 Charles travelled from Italy across the Alps to Austria. It was in 1533 that he embarked from Genoa. And it was in 1533 that Alfonso Lombardo was in Bologna.

9 See Hope 2005 for the various theories and for Hope's controversial argument that the Prado portrait was not painted by Titian.

10 The *Portrait of Alfonso d'Avalos*, which was formerly in a private collection and on show in the Louvre, was bought in 2004 by the Getty Museum for $70 million, one of the highest prices paid for an Old Master painting at that time.

11 In the last edition of *Orlando Furioso*.

12 But see Joannides 2001 for a theory that they were by Titian.

13 The three paintings Titian selected for Cobos have never been convincingly identified. Titian may have made a replica for Alfonso of his portrait of him, and he certainly made one later for Alfonso's son Ercole, but the only record we have of the portrait is the copy by another hand in the New York Metropolitan Museum.

14 Most were painted after 1548, when Titian visited the emperor's court at Augsburg.

15 The farmland was finally sold at public auction for thirty-seven ducats per field, having failed to reach a reserve of thirty at two previous auctions.

16 Charles did not in fact come to Italy until June when he launched his crusade from Cagliari.

FOUR: THE *VENUS OF URBINO*

1 Most scholars have followed Vasari in suggesting that the portrait was painted in Bologna in 1532–3, but examination of archival evidence makes it clear that Ippolito actually sat for Titian during his stay in Venice from 18 to 31 October 1532, before proceeding to Bologna.

2 Hazlitt 1856.

3 *Il trentuno di Angela Zaffetta* by Lorenzo Venier, final edition published in 1536.

4 Tr. Chubb 1967.

5 I am convinced by Charles Hope's plausible suggestion in conversation that the face of the *Venus of Urbino* is a portrait of Angela Zaffetta. I also have Guido Rebecchini to thank for his support of Hope's theory and additional information given in a paper, 'New Reflections on the *Venus of Urbino*' delivered at a seminar at the London National Gallery on 17 March 2008. Other scholars have of course advanced different ideas about the identity of the reclining nude, one of which would inevitably have her as Titian's mistress. Another, still in circulation, is that it is a bridal picture commissioned by Guidobaldo della Rovere. Guidobaldo acquired the painting in 1538, four years after his marriage to the ten-year-old Giulia Varano, daughter and heir of the Duke of Camerino. Guidobaldo, who was in love with another woman, Clarice Orsini, had been forced by his father, Francesco Maria della Rovere,

Duke of Urbino, to marry Giulia, who brought with her the Duchy of Camerino. There is no evidence that he commissioned a bridal portrait, and his references to the painting call it simply a naked woman. The most absurd theory, that it is a portrait of Guidobaldo's mother Eleonora Gonzaga, is based on the similarity of the little dog that appears also in Titian's documented portrait of Eleonora.

6 Green or black hangings were standard decorative features in well-off Venetian houses. Such a cloth was itemized in an inventory of Titian's possessions after his death.

7 In, for example, the *Portrait of Clarissa Strozzi*, the *Portrait of Eleonora Gonzaga* and the *Vendramin Family*.

8 Mark Twain, *A Tramp Abroad*, 1880.

9 It was already ruined by 1900 when Charles Ricketts wrote that it had been 'marred by minute and systematic restorations' which made it impossible to judge its original quality.

10 There are a number of contemporary and later engravings, copies and copies of copies.

11 David Rosand who with Rona Goffen is one of the proponents of this theory has written that to deny her mythological status would be 'to turn her out on the streets'.

12 The portrait of Lorraine was still in Titian's possession in 1539. It may have been the one Vasari mentions in his 'Life of Titian' as being in the della Rovere collection, but seems to be lost. It is perhaps worth noting that while Cardinal Lorraine, who evidently shared Ippolito's taste for orgies, was in Venice he attended a party 'with masks and whores, with various furious sounds and lusty carousing'.

13 The copy for Cardinal Lorraine of Ippolito's reclining Venus may be the very similar painting detected by technical investigation beneath the *Danaë* painted for Cardinal Alessandro Farnese in 1544–5. Another possibility is that the painting he did for Lorraine is *La Bella*, which has the same face as the reclining nude.

14 The arousing combination of fur and an exposed breast had been exploited by Giorgione in his *Laura* painted early in the century. Titian's *Woman in a Fur Cloak* was the prototype of Rubens's *Portrait of Helena Fourment in a Fur Wrap* painted a century later. (Both Vienna, Kunsthistorisches Museum.)

15 The ruined full-sized version at Christ Church, Oxford may be the remains of an original painted for Federico Gonzaga.

16 It looks as though he used the same model for the Christ in the two *Suppers at Emmaus*.

17 A pen drawing in Florence (Uffizi, Gabinetto Disegni e Stampe) has usually been thought to be a sketch of the armour requested by Francesco Maria in a letter to Leonardi requesting a 'carta' of an unidentified picture. Charles Hope offers the more likely hypothesis that the *carta* refers to a print of another subject and that the drawing is a later copy of the finished portrait by another hand, probably either as a sketch for a statue of Francesco Maria made for the celebrations in Urbino of the marriage of Guidobaldo della Rovere and Vittoria Farnese in 1547 or in Pesaro in 1571 for the marriage of Lucrezia d'Este and Francesco Maria II della Rovere.

18 The seated pose is based on Raphael's *Portrait of Joanna of Aragon* (Paris, Louvre) of which Titian would have seen a cartoon in Ferrara in 1519.

19 Because Guidobaldo asked for these portraits in 1539 it is sometimes assumed that he commissioned them.

20 The first mention we have of it is in an inventory of the collection of Cardinal Mazarin taken in 1653.

21 There is also a sketchier version without a hat, at Harewood House in Yorkshire. There is no evidence that, as is often said, Titian based the portrait on a medal by Benvenuto Cellini made at Fontainebleau in 1537 (see John Pope-Hennessy, ed., *The Life of Benvenuto Cellini*, 2nd edn 1995), or that Aretino commissioned it as a gift to the French king.

22 The identification was repeated by Ridolfi, who often followed Vasari.

23 In that year after the male line of the della Rovere had died out, the Duchy of Urbino was annexed to the Papal States and the collection brought to Florence by Vittoria della Rovere.

FIVE: THE ROMAN EMPERORS

1 Cited by Zimmerman 1995.

2 All of Titian's portraits of Alfonso are known only from a copy in the New York Metropolitan Museum.

3 Most of the material about Federico Gonzaga and Titian that follows is abstracted from Bodart 1998.

4 Both paintings and the name of the Spaniard are lost.

5 The Scuola della Carità was occupied by the Accademia in 1807.

6 He had brought with him poets, historians and the Netherlandish artist Jan Cornelisz Vermeyen, who made the first-hand sketches of every episode of the campaign, from the first mustering of troops in Barcelona to the embarkation from Tunis, that were the basis of his cartoons (Vienna, Kunsthistorisches Museum) for a set of tapestries (Madrid, Palazzo Real) to be commissioned by Charles a decade later and woven under the supervision of Mary of Hungary.

7 Neither painting survives.

8 From *The Journal of Felix Platter, 1552–7*, cited by Hale 1993.

9 'Da nuovo, il Duca de Marches va a man dritta di Sua Maestà, il qual resta Governatore in Italia de le S.ta. Così se dice.'

10 This is my hypothesis. Charles Hope believes that the postscript is more likely to refer to a person involved in the contest between Charles V and Francis I for the Duchy of Milan, probably not an Italian.

11 The General Council, which was scheduled for May of the following year, never took place because the Protestant leaders refused to attend on the grounds that a Council held in Italy would not be free.

12 Aretino, in an effusive letter of thanks on Titian's behalf to Gonzalez Peréz, a trusted Spanish secretary of the emperor who had helped to negotiate the favour, promised that Titian would paint his portrait, thereby 'nullifying with his effigy the reasons you may think you are mortal'.

13 In 1539, for example, Aretino solicited the help of Ottavio de' Medici, promising that Titian would repay his intervention by going to Florence to paint portraits of himself, Duke Cosimo and his consort the Duchess Eleonora, and the widow of Giovanni dalle Bande Nere.

14 In 1571 Philip II decided to compensate him with a payment of 1,000 scudi.

15 A portrait of Ercole by Titian mentioned in contemporary sources is lost.

16 Cited by (and tr.) Crowe and Cavalcaselle 1881. The officials who drew up the document had neglected to check the records. Titian had not received the *sanseria* until 1523. The amount owing would therefore have been $15 \times 120 = 1,800$ ducats.

17 He was also offering a portrait of Suleiman the Magnificent, which Federico had been requesting for some time. The portrait of Suleiman was almost finished when Agnello wrote on 23 August that Venetians who had met the Turkish sultan in Constantinople were saying that Titian's portrayal of 'Signor Turco' was so like its subject that it seemed to be the living Turk himself.

18 Mendoza was waiting for Titian to return to Venice from Mantua where he hoped he would finish a portrait of his relative Pedro, which he would send to Cobos with his own.

19 It would have been difficult to fit twelve pictures into the room. There were three emperors on each wall, except for the window wall, where there were two. Bernardino Campi, who copied the series in 1562, added the twelfth, Domitian.

20 Bodart 1998, p. 163.

SIX: THE WRITERS' VENICE

1 The entire letter is in Chambers and Pullan 1992.

2 10 March 1536. Tr. Chubb 1967.

3 Cardinals were not expected to be previously ordained as priests until the height of the Counter-Reformation.

4 After Michelangelo's death the genitals were painted over with loincloths, which were not removed until the restoration of the Sistine Chapel frescos in the 1990s.

5 In the *pronostico* for 1534 he had written that Chieti would defect to Lutheranism, the implication being that for blinkered intolerance and pedantry the two of them were as bad as each other.

6 By Cleugh 1965.

7 My main authority for the *poligrafi* is Grendler 1966 and 1969. D'Elia 2005 has a useful list of the writers working in Venice during Titian's lifetime with notes about their contacts with him.

8 According to Montaigne it was because 'the princes and nobles of Italy spent more time in making themselves learned and clever rather than vigorous and warlike' that Charles VIII had been able to take Tuscany and Naples without so much as drawing his sword.

9 I have abstracted the following comments from Hope 2008a.

10 From Horace's *Ars poetica*, c. 10–8 BC.

11 D'Elia 2005 is one valiant attempt.

12 The letter is dated December 1553.

13 The attributions are endorsed by Puppi 2007. There are also three medal portraits of her by Alessandro Vittoria.

14 Tr. Chubb 1967.

15 The model was accepted in 1532, but although the gigantic brick walls were constructed by the time of Sansovino's death the interior and the façade remain unfinished.

16 Although the Mint was Sansovino's first major commission in the Piazza, the third storey was not raised until the 1560s. The fortress-like rustication impressed Jacopo's son Francesco as 'a worthy prison for precious gold'.

17 The library, which was built at the instigation of Bembo and the

procurator Vettor Grimani to house Cardinal Bessarion's collection of Greek manuscripts, was Sansovino's masterpiece, later praised by Palladio as 'the richest, most ornate building since Antiquity'. It took fifty years to build and cost some 30,000 ducats. The original plan was to extend its design along the south side of the Piazza, which was not completed until long after Sansovino's death by Vincenzo Scamozzi.

18 The Loggetta, built between 1537 and 1549, was designed as a sheltered meeting place for patricians. Francesco Sansovino explained the allegorical programme his father devised in praise of Venice for his four bronze statues. Pallas represents the wisdom and good government of the Republic. Mercury signifies eloquence. Apollo stands for the sun, 'just as Venice is a sun in the world', and for music, that is for the harmonious government of Venice. Finally there is Peace, 'so much loved by this Republic, and by which it has grown to such greatness …'.

19 After a fire burned down the old Corner palace in 1532 the family persuaded the government to finance a new palace on the grounds that the state owed them Caterina Cornaro's dowry. But dispute over the estate delayed building until 1545 and the palace was not completed until 1566.

20 Sansovino never finished the façade, which was designed by Palladio. The church was finally consecrated in 1582.

21 See Rudolph Wittkower, *Architectural Principles in the Age of Humanism*, 1952, p. 91.

22 Some writers have been misled by Vasari, who said that the painting was sent to Charles V (rather than the

empress) and that Titian was rewarded with 1,000 scudi.

23 I am reminded by D'Elia 2005 that, curious though it may now seem, it was Aretino's description of the Annunciation in the Humanity of Christ, rather than his pornographic or anticlerical writings, that was singled out in 1558 in a petition to ban his books for being too physical, inventive and public in contravention of the traditional idea that the event must be kept secret to deceive the devil into thinking that it was a normal conception. Titian's painting, however, was considered perfectly acceptable.

24 Tr. Bull 1976.

SEVEN: AN OLD BATTLE AND A NEW WAR

1 See I, 7 and III, 5, pp. 121–4 and 362.

2 See I, 7 for the *sanseria*, pp. 122–3.

3 Most of Pordenone's work in Venice is lost, but the panels in the church of San Rocco give a good idea of his style.

4 The portrait is lost but an engraved portrait of Aretino by Salviati survives.

5 The sketch in Paris may have been owned at one time by Rubens, who made a drawing of the central group (Vienna, Albertina). The Rubens is also very close to a drawing in the Antwerp Museum Plantin-Moretus.

6 In Florence, Uffizi, Gabinetto dei Disegni; Munich, Graphische Sammlung; Oxford, Ashmolean. While the study in Paris is unquestionably authentic there is some doubt about the others.

7 Tr. Bondanella and Bondanella 1996.

8 Tr. Crowe and Cavalcaselle 1881.

9 There seems no reason why Titian's commission would have been an

exception to the scheme of the room in which all other pictures – including those by Veronese, Tintoretto and Orazio Vecellio, which were painted after Titian's *Battle* – represented episodes from the legendary history of Frederic Barbarossa.

10 I owe this observation to Wilde 1974.

11 In 1545 and 1552. But his repeated requests in the 1560s that the *sanseria* should pass to his son Orazio were rejected.

12 Tintoretto, Veronese and Orazio Vecellio were all paid in cash for their paintings in the Hall although Tinoretto was promised a *sanseria* for his painting in commemoration of the Battle of Lepanto.

13 See Hope 1980c.

14 I have abstracted some of the information about the *Presentation of the Virgin* from Rosand 1976 and Hanning and Rosand 1983.

15 In *The Cicerone*, 1855, an historical guide to the art treasures of Italy.

16 Another interpretation of the obelisk would have it refer to ancient Egypt, where St Mark was martyred at Alexandria.

17 The phrase is Ricketts's, 1900.

18 See Hope 1980a.

19 Panofsky 1969.

20 For example, Pater 1877.

21 I have taken the quotations from Ruskin and Taine from Augustus Hare's pocket guide to Venice of 1891. Hare comments that the *Presentation* is one of Titian's earliest works, an error he borrowed from Ridolfi, and that the 'old woman with the eggs is one of his most powerful representations'.

22 It is not known exactly when Titian finished it but it was certainly by March 1539.

23 In the seventeenth century Marco Boschini wrote that he had been poisoned by Titian, an impossible charge that must have been based on exaggerated rumours about the rivalry between the two artists (Boschini 1966).

24 St John the Almsgiver, a wealthy patriarch of Alexandria in the seventh century who was very generous to the poor, was an unusual and engaging saint. He was married and died of natural causes rather than of martyrdom. The dedication to him of the first church on the site, which was probably founded not long after his lifetime, is an example of the close links between the Greek Orthodox and the Venetian Christian Churches.

25 Zanetti, 1733, cited by Crowe and Cavalcaselle 1881.

26 Crowe and Cavalcaselle 1881.

27 Wilde 1974.

28 Including Hans Tietze 1950. Augusto Gentili in Vienna 2008 moves the date forward to 1549–50, the patron to Doge Francesco Donà of whom he suggests the face of the saint is a 'masked image'.

29 The votive portrait in the Collegio was destroyed by fire in 1574, the portrait for the frieze in the Great Council Hall in 1577.

30 Others are in New York, Metropolitan Museum of Art; Kenosha, Wisconsin; and a private collection in Scotland.

31 The date is unknown. Some scholars believe it was painted in the 1530s before Gritti's death; others that the free style suggests a date in the late 1540s.

32 P. Daru, *Histoire de la République Patricienne*, 1828, cited by Norwich 1981.

EIGHT: TITIAN IN HIS FIFTIES

1 Melchizedek was the Old Testament priest to whom Abraham paid one-tenth of the spoils of a victory.

2 The letter is dated November 1537, which gives the impression that the twelve-year-old Pomponio was born in 1525, the year when Titian married his mother in order to legitimize the two boys, who were already born. Since Pomponio, the elder of the two, cannot have been born later than 1523, Aretino may have got his age wrong, but it is more likely that the letter was written earlier than 1537 and is one of the many in the first volume of his letters that he misdated November or December 1537 because the letters were supposed to be in chronological order and by the time he sent copies to the printers that was as far as he had got.

3 All Titian's paintings for Santo Spirito in Isola were removed to Longhena's newly built Salute in 1656. Santo Spirito, which was used by Napoleon's navy for storing gunpowder, no longer survives.

4 For recently discovered documents about the property see Tagliaferro and Aikema 2009.

5 The Hellenistic History of the Loves of Leucippus and Clytophonte by Achille Tatius, of which a Latin translation was dedicated to Mendoza in 1544.

6 The Fable of Adonis, Hippomenes and Atalanta, published in Venice in 1553 but written during his years as ambassador there.

7 The sonnet is in a letter to Mendoza dated 15 August 1542.

8 The sonnet is in a letter addressed to Marc'Antonio d'Urbino which Aretino dated 16 August 1540.

9 Tr. Bondanella and Bondanella 1996.

10 It is for this reason that some scholars have thought that the full-length portrait of a man in Spanish dress (Florence, Galleria Palatina) might be of Mendoza. But the identification remains at best controversial because it is known that the portrait of Mendoza, which was last recorded in Guadalajara in the nineteenth century, was subsequently lost.

11 Crowe and Cavalcaselle 1881.

12 For the arguments in favour of the earlier date see Hope 1993.

13 Burckhardt, 1898, cited by Enrico Castelnuovo in Naples 2006.

14 The similarity of the features to a medal by Domenico Poggini (Washington, DC, National Gallery of Art) has convinced many scholars of its subject. The portrait is not, however, documented, and Vasari, who was a close friend of Varchi, never mentioned it, although it would have been well known in Florence if it had existed.

15 Beverly Brown has suggested to me in conversation that the putti represent Eros and anti-Eros fighting over the erotic destiny of the child.

16 Before the painting was cleaned in 1965–6 and the two men subsequently identified by Michael Jaffé, theories about their identities included Machiavelli and Francesco Sforza, Cosimo de' Medici and his secretary, and a Venetian senator and his secretary.

17 Suggested by Crowe and Cavalcaselle 1881 and by Charles Hope in conversation with the present author.

18 The hypothesis is from Hope, who confesses that it is weakened by a medal portrait of Lando heavily bearded that bears little resemblance to Titian's portrait.

19 I have abstracted information about new research into the Vendramin family and Titian's portrait from Penny in Madrid 2003 and Penny 2008.

20 This self-portrait, which is lost, was the prototype Titian chose for the woodcut self-portrait he commissioned from Giovanni Britto in 1550.

21 See Whistler and Dunkerton 2009. The painting was acquired by the Ashmolean Museum in 2008.

22 There is a theory, mentioned by Hudson 2009 who does not however name his source, that Giorgione's *Tempesta* was a cover for a portrait of the Venetian commander Bartolomeo d'Alviano.

23 Gabriele, who died in 1552, had left the collection to three of his nephews on condition that it remained intact. The inventory, dated March 1569, was ordered because one of the brothers was trying to sell it off to Albrecht V of Bavaria without the consent of the others. This part of it was drawn up by Tintoretto and Orazio Vecellio.

24 Gabriele died on 15 March 1552, two days after Titian had witnessed a codicil to his will.

25 It entered Van Dyck's collection in England in the early seventeenth century and was copied by several English painters including Gainsborough.

26 Bembo had failed to advance his career in the Roman Curia under the papacies of the virtuous Adrian VI and Clement VII, who disapproved of his private life. Paul III, a keen patron of the arts and literature who had kept a mistress while a cardinal, had no such objections. Before accepting his cardinal's hat he had spent nearly two decades in the family house in Padua where he wrote among other works his famous and influential treatise on language, the *Prose della vulgar lingua*, advocating the literary use of vernacular Italian, which was in his view Tuscan.

27 Titian is known to have portrayed Vincenzo Cappello in 1540 from a letter and a sonnet praising the painting and its subject sent by Aretino to his nephew on Christmas Day. The composition is based on the *Portrait of Francesco Maria della Rovere, Duke of Urbino*, but some authorities attribute it to Tintoretto.

28 For d'Avalos see also III, 3.

29 Some authorities prefer to see the source of his inspiration in the architecture of Michele Sanmicheli, who was building the new city gates of Verona and the magnificent fortress on the Venetian island of Sant'Andrea.

30 Like all celebrities that have been around too long the *Laocoön* had become the subject of jokes, and was to some extent discredited after Michelangelo discovered that it was not all of one piece. The design of a woodcut by Boldrini of monkeys 'aping' the statue was attributed to Titian by Ridolfi, but could equally be by, for example, Domenico Campagnola.

31 The other two payments were made in April 1541 and January 1543.

32 Ferragosto, the Italian holiday, which now takes place on 15 August, was an ancient Roman celebration of midsummer, the season of ripening and fertility. Its name derives from the Latin *Feriae Augusti*, the fairs of the (emperor) Augustus.

33 Tr. Chambers and Pullan 1992.

Part IV: 1543–1562

ONE: ARETINO PLAYS PONTIUS
PILATE

1 When it failed to arrive Aretino
published an accusation that the
money had been stolen by the English
ambassador, who had him beaten up
by seven Englishmen. The public
outrage was such that he finally
received his reward.

2 Cited by Zimmerman 1995.

3 See, for example, letters dated 20 July
1538, 15 and 20 March and 21 April
1539.

4 Cited by Flavia Polignano, 'I ritratti
dei volti e i registri dei fatti: L'Ecce
Homo di Tiziano per Giovanni
d'Anna', *Venezia Cinquecento*, no. 4,
1992, pp. 7–54.

5 The painting measures 2.40 × 3.60
metres.

6 Technical investigation has shown
that the *Ecce Homo* was originally
planned as a multi-figure
composition but that Titian altered
the gestures and postures of some of
his figures and that the Roman
soldier who bears the Habsburg
shield at the foot of the steps was a
last addition.

7 The red robe and ermine shawl,
which was worn by Venetian doges,
has persuaded some authorities that
this is the reigning doge Pietro Lando.
But he looks nothing at all like
contemporary portraits of the lean
and ascetic Lando and more like stock
representations of Jews. Woodcuts by
Dürer in which Caiaphas is portrayed
in this way were in circulation in
Venice and would have been known
to Titian. The doge's costume may be
a further suggestion of a rich Jew's
presumptuous ignorance of protocol
in the City of Christ.

8 Cited by Zimmerman 1995 from the
Commentario de le cose de'Turchi first
printed in 1532.

9 See Hope 2007b. Hope is the first
scholar to have found evidence that
Titian married again some time after
the death of his first wife Cecilia in
1530 and that Lavinia, who has
previously been thought to have been
Cecilia's daughter, was born around
1535. Previous authorities, assuming
that Lavinia would have been in her
early teens when Titian was painting
the *Ecce Homo*, have proposed her as
the girl in white. Hope is also the first
authority to suggest that the older girl
might be Cecilia Alessandrini and the
first to have noticed the resemblance
of the little girl to the later portrait of
Lavinia.

10 Polignano 1992, from whom I have
drawn my account with some
reservations.

11 The value of the benefice in the 1540s
is not known, but by Titian's death in
1576 it was worth 400 ducats per
annum.

TWO: THE LAST GREAT POPE OF
THE RENAISSANCE

1 I have this suggestion from Zapperi
1990.

2 To Benedetto Varchi, 12 February
1547.

3 The foundation stone of the new St
Peter's had been laid in 1506 by Julius
II, but his death and the death of his
architect Bramante left the project
incomplete. Michelangelo was
seventy-two in 1547 when he was
appointed chief architect of the
rebuilding. He worked on it for the
rest of his life but only the drum of
his stupendous dome was
completed by the time of his death
in 1564.

4 Rabelais recounted the story of the pope's bastard children in a letter written from Rome in 1536 to a French bishop who had requested information about Paul's private life.

5 They were married after the death of Margaret's betrothed Alessandro de' Medici when she was sixteen and Ottavio fifteen. The marriage proved extremely unhappy. Margaret never thought the grandson of a pope a good enough match for the natural daughter of the emperor. They soon parted, and later in life she became regent of the Netherlands under Charles's son Philip II of Spain.

6 Cited by Brandi 1970.

7 Ibid.

8 The sources about Titian's two portraits of Isabella – the one now in Madrid probably painted at Augsburg in 1548 – are incomplete and confusing. Titian wrote to the emperor on 5 October 1544 that he was dispatching two portraits of the empress and begging him to send word of any faults and failings so that he could correct them. But since there is also a letter from Charles written in April 1545 asking about Titian's progress with a portrait of Isabella it could be that one of the two portraits sent in 1544 was the 'trivial' model, which he had been asked to return.

9 The seven volumes of Vesalius' groundbreaking book *De humani corporis fabrica* (On the Structure of the Human Body) were published in Basel in 1543 with a dedication to Charles V and illustrations by one of Titian's pupils.

10 Giovanni dei Rossi of Pisa.

11 Although Vasari said he painted the portrait for Guido di Santa Fiora shortly after the first some scholars prefer to place it later, during Titian's time in Rome in 1545–6, a view that is supported by its similarity to Raphael's *Portrait of Julius II*, of which Titian made a copy during his Roman visit for Guidobaldo della Rovere.

12 Wethey 1969–75, vol. 1, identifies twelve copies in existence and four more mentioned in literary sources.

13 Vasari in both editions of his 'Life of Sebastiano' said that the pension was worth 300 scudi per annum. But in his 'Life of Giovanni da Udine' he gave the figure as eighty scudi.

14 *I Ragionamenti delle Corti* (The Dialogues about Courts).

15 Alessandrini was living in Titian's house at the time, writing letters for him and making fair copies for Aretino.

16 Charles Hope points out that there is no evidence that Aretino circulated his letters before publication. My own view is that no journalist can resist having his work read as soon as possible.

17 Tr. Symonds 1906.

THREE: A MIRACLE OF NATURE

1 The most famous was *Galateo*, a witty and sensible treatise on proper behaviour in polite society first published in 1558. Although della Casa was inevitably influenced by Castiglione's *The Courtier*, first published in 1528, *Galateo* is more concerned with proper behaviour in polite society, which at the time it was written was composed of people from many different countries and backgrounds.

2 It is not known whether the copy was by Titian's or another hand.

3 A painting very like the *Venus of Urbino* has been detected beneath the finished *Danaë* that Titian revised in

Rome for Alessandro Farnese. Zapperi 1991 maintains that it was a nude previously commissioned by Cardinal Farnese, but there is no evidence that Farnese had ordered such a painting.

4 This letter was first published in 1908 but did not enter the mainstream literature about Titian until republished by Hope 1977.

5 See V, 2.

6 Speroni's dialogues were banned by the Inquisition in the 1570s, but when he went to Rome to defend them the chief inquisitor was sympathetic to his arguments.

7 The father of Torquato Tasso.

8 The famous Manutius press originally founded by Aldo Manutio was at that time run by Aldo's son Paolo.

9 In what was presumably an autobiographical reference he had a character in his play *La Talenta* maintain that the white hairs in his beard are the result of stress, not of age.

10 It is interesting to note that in the nineteenth century when Aretino was regarded as a monster and unworthy of Titian's friendship Crowe and Cavalcaselle, who greatly admired this portrait, described the face as 'disengaged from an atmosphere of corruption'. Evidently surprised by his own reaction he saw it 'as far as such a thing is possible' as 'idealized and ennobled' (1881); while in the twentieth century, when Aretino's behaviour had come to be seen as no worse than that of many modern journalists, Roberto Zapperi (1990) maintained that Titian had been getting his own back for Aretino's mean bargaining about the price and cites Federico Zeri's view of the face as evidence of 'the shameless

arrogance of a moralist nourished by vice, the bombastic capacity for gesticulation of a power built on blackmail, the unpunished cynicism of those who have the means to manipulate public opinion'.

11 Later in the same letter in which he had complained that his portrait was more like a sketch than a finished work of art.

FOUR: ROME

1 For Titian's stay in Rome, and the circumstances surrounding the *Danaë* and *Portrait of Paul III and his Grandsons*, I am especially indebted to Zapperi 1990 and 1991.

2 The underdrawings were revealed by X-rays taken during a restoration of the painting for the 2006 exhibition in Naples. The portrait, which had never been relined, had been in such bad condition that some scholars, including Crowe and Cavalcaselle, Berenson, Zapperi and Hope, doubted that it was autograph. The cleaning, however, has for most authorities vindicated the opinion of Pallucchini, Valcanover and Wethey, among others, that the painting is of high enough quality to have been painted by Titian although spoiled by the heavily overpainted background and green curtain.

3 The portrait of a girl in yellow was one of only three painted in Rome by Titian to be mentioned in subsequent inventories of the Farnese collection. For the plausible hypothesis that it began as the portrait of Angela mentioned by della Casa in his letter to Alessandro Farnese of 20 September 1544, see Zapperi 1991.

4 The change has been detected by X-ray investigation. Crowe and

Cavalcaselle, who were not aware of della Casa's letter, were the first to notice the similarity of the two faces.

5 Titian would have known this from drawings of the Medici tombs Vasari had sent to Aretino in 1535.

6 Which Alfonso d'Este had commissioned in 1530, soon after Titian completed his Bacchanals, and of which Vasari had sold a copy when he was in Venice in 1541.

7 Vasari's *Hall of a Hundred Days*, celebrating Paul III as a peacemaker, commissioned for the Palazzo della Cancelleria by Alessandro Farnese, was completed in 1546. It was while he was in Rome that Paolo Giovio gave him the idea of writing a collection of artists' lives.

8 Tr. Bull 1974.

9 The real Aretino was never antagonistically critical of Sebastiano.

10 Tr. Roskill 2000.

11 The letter, dated 1 January 1546, is signed 'PA Romano'.

12 Paul was familiar, for example, with Melozzo da Forlì's fresco in the Vatican library of *Pope Sixtus IV with the Librarian and Four Grandsons*, one of whom, Giuliano della Rovere, followed Sixtus to the papal throne as Julius II.

13 Although many authorities attribute the very damaged *Portrait of Pier Luigi Farnese in Armour* (Naples, Capodimonte) to Titian, Pier Luigi was not in Rome during Titian's stay there and there is no evidence that he painted him either before or after.

14 Orazio seems to have painted other portraits in Rome including one mentioned by Vasari of a musician, Batista Ciciliano.

15 The monastery was no longer in existence but still provided a handsome income from the land.

16 Ottavio turned to the French for help in carving out a state for himself in that most strategic region, causing Charles to send troops against him. But much later he attached himself to his Habsburg in-laws. Philip II returned Piacenza to him in 1556, and his estranged wife Margaret and their son Alessandro served Philip with distinction in the Netherlands.

17 Later in the century Montaigne took Roman citizenship but said he did it out of vanity and that the ceremony on the Campidoglio made him feel silly.

18 In his 'Life of Perino del Vaga' Vasari had played down Titian's relationship with the Farnese, but in the 'Life of Titian' he probably exaggerated their enthusiasm for the triple portrait.

FIVE: A MATTER OF RELIGION

1 This is excluding the early *Man with a Quilted Sleeve*, the shape of whose nose does not match the known self-portraits. There is disagreement about the date of the Berlin picture, which some associate with a self-portrait Vasari said Titian painted for his children before going to Rome, others with one mentioned by the same author which would have been done around 1562–4. Charles Hope's dating of 1546–7 is endorsed by David Jaffé in London 2003, who also points out that the treatment of the head is similar to the two central figures in the *Vendramin Family* of around the same date, and by Miguel Falomir in Vienna and Venice 2007, pp. 203–4.

2 There are two copies, in the Florence Uffizi and Milan Ambrosiana.

3 For Titian's family see Hope 2007.

4 It is just possible that Pietro Alessandrini was married to Orsa, in

which case she would have been the mother of Giovanni and his sisters.

5 They were not installed there until 1572.

6 In 1547 Titian was paid for painting Donà's official portrait together with that of his predecessor Pietro Lando for the Great Council Hall, where they perished in the fire of 1577.

7 The dating of both is controversial. The Santo Spirito ceiling is sometimes dated 1542, when the commission was transferred to Titian from Vasari, but more compelling circumstantial and stylistic evidence points to a date soon after Titian's return from Rome, after, that is, the resolution of his dispute with the monks of the church over the *Pentecost*. The San Giovanni Evangelista ceiling probably antedates his trip to Rome. A date around 1555, the preference of some scholars (including Humfrey 2007) is less likely because Titian at that time was absorbed by commissions from the Habsburg family.

8 There have been two slightly different attempts to reconstruct the arrangement of the ceiling, by Schulz 1968 and by S. Gramigna Dian (see Washington and Venice 1990).

9 Most recently by Augusto Gentili in Vienna and Venice 2007.

10 The drawing is in black chalk with white highlighting on grey paper. The only other surviving preparatory sketch which can be securely attributed to Titian is the one for The Battle of Spoleto, which was also surely done for the benefit of assistants.

11 One of the paintings was probably the *Pardo Venus* (Paris, Louvre) begun in the 1520s and sent to Philip in 1552. Another may have been the *Crucifixion* (Madrid, Escorial), sent to Philip four years later.

12 Luis de Avila y Zúñuga, *Comentarios de la Guerra de Alemania hecha por Carlo V*, 1546–7.

13 Cesare, who was born around 1521, was the son of Antonio Vecellio, a brother of Titian's grandfather Conte. He is best known for his book about contemporary and antique costume, *Habiti antichi et moderni di diverse parti del mondo*. In 1590 he wrote that he had watched Titian paint the armour of the Elector of Saxony, one of the portraits Titian executed in Augsburg.

14 Sebastiano del Piombo often used slate for devotional images, which suggests that Titian borrowed the idea from him while in Rome.

SIX: AUGSBURG

1 Jacob Fugger had built the first almshouses in Europe in Augsburg, still known as the Fuggerei.

2 Gian Giacomo Leonardo to Guidobaldo della Rovere, 7 April 1548.

3 One of a number of later copies of the lost original is in Paris, Musée des Arts Décoratifs.

4 One of the copies is in Madrid, Prado.

5 There is a division of opinion about whether this damaged picture is the original by Titian or a copy.

6 Tityus was condemned to have his liver eternally devoured by a vulture; Sisyphus to push an enormous rock uphill for ever; Tantalus to be frustrated in his desire for food and drink; Ixion to turn for ever on his wheel.

7 One of the best is the vivid but mysterious *Man with a Clock* (Madrid, Prado), probably of approximately the same date.

8 Caesare Ripa, *Nova Iconologia*, 1616, as cited by Rowlands 1996.

9 Most scholars believe this portrait
was painted at Augsburg in 1548, or,
since investigation in 2004 revealed
that it was painted over a Salome, that
it is a replica by assistants of the
original. Hope (in conversation)
argues that it was commissioned at
Busseto in 1543, along with the
portrait of Isabella in black, and that
it was the nose of this one that
Charles asked Titian to repair. He
bases his argument in part on a letter
written by Titian to the emperor in
October 1544 in which he says that he
had consigned two portraits of the
empress, presumably this one and the
lost portrait in black, to Diego de
Mendoza.

10 Wilde 1974.

11 Ripa, *Nova Iconologia*.

12 It was first recorded as being in the
Fugger collection in 1650.

13 It is displayed in the Madrid Royal
Armoury.

14 There is some debate about whether
the spear is the one he carried into
battle, as Hope argues in 'Obras
Maestras del Museo del Prado', 1996,
pp. 655–7, or the long lance of a
Knight of St George.

15 Aretino to the courier Lorenzetto,
May 1548.

16 Just as Vasari had told of the people
of Bologna bowing to the *Portrait of
Paul III*, both Ridolfi and Titian's
anonymous biographer wrote that
when the *Portrait of Charles V on
Horseback* was placed in a doorway
those who saw it were so fooled by the
horse and rider that they took them
for living beings.

17 The letter from Charles V to Ferrante
Gonzaga dated 5 June 1548, Guastalla,
Biblioteca Maldottiana, Fondo
Gonzaga, b. 2, no. 220 (219 in printed
catalogue, p. 12), was discovered by

Charles Hope, who suggests that the
reference to his wife might be further
evidence of the existence of Titian's
second wife, although he admits that
it could equally be that Charles was
referring to the mother of Emilia.

18 Alessandro Luzio, 'Altre spigolature
tizianesche', *Archivio Storico dell'Arte*,
II, 1890, p. 210, cited by Hope 1980a.

19 Benedetto Agnello to Margherita
Paleologo, Bussolengeo, 20 October
1549, Mantua, Archivio Gonzaga,
busta 1481, cited by Hope 1980a.

20 Lorenzo Campana, 'Monsignor
Giovanni della Casa e suoi tempi',
Studi Storici, XVI, 1907, p. 387, cited
by (and tr.) Hope 1980a.

21 It may have been as a way of thanking
Cosimo for his generosity that in
1553 Titian painted and Aretino sent
to the duke a pair of full-length
portraits of Charles V and Prince
Philip, looking a little older than
Titian remembered him from their
last encounter at Augsburg two years
earlier. (Both are in the depository of
the Florence, Pitti Palace. The *Charles
V* is a ruin, but the *Philip* in
reasonable condition.)

22 The letter, written by the dramatist
Andrea Calmo, is cited by Lepschy
1998.

23 The story inspired paintings in the
early nineteenth century by the
French painters Bergeret and Ingres.

24 Some authorities have expressed
doubts about its authenticity.

25 Vasari, who praised Tintoretto as 'the
most terrific brain that the art of
painting has ever produced', also
criticized him for leaving 'his finished
sketches still so rough' as though
'done more by chance and vehemence
than with judgement and design'.
Ruskin, who regarded Tintoretto as
'the most powerful painter whom the

world has ever seen', had the same reservations about the want of perfection in his work due to 'the very fullness and impetuosity of his own mind' (1974, I, 2).

26 It may be the Junoesque portrait published in Belluno–Pieve di Cadore 2007.

SEVEN: THE PRINCE AND THE PAINTER

1 The Don Carlos invented most famously by Schiller and Verdi's librettists had nothing else in common with Philip's psychopath son, although it is true that Philip briefly considered marrying him to Elizabeth de Valois before marrying her himself, that Carlos developed an unhealthy attachment to his stepmother which he demonstrated by buying her expensive jewels, but it was not reciprocated. Carlos may have been in touch with the rebels in the Netherlands, and was profoundly aggrieved when Philip refused to send him there.

2 The conventional view, supported by most scholars from Crowe and Cavalcaselle 1881 to Miguel Falomir (Madrid 2003), is that the portrait now in Madrid was painted at Augsburg in 1550–1 and the one done at Milan is lost. Falomir's argument that the armour (which still exists in the Madrid Royal Armoury) was made in Augsburg is not convincing because Philip owned several suits of armour by the same maker, who had been sent to Spain from Augsburg before 1549 to take his measurements. Falomir also believes that the full-length portrait that can be seen by X-ray beneath the portrait of Philip represents Charles V, although to this eye at least it looks more like an earlier version of the finished portrait with Philip facing the other way. Such changes were of course characteristic of Titian's working method. The question is difficult to resolve because Titian and his studio painted a number of portraits of Philip, some in armour, some wearing a doublet, about which contemporary descriptions are not in all cases sufficiently detailed to allow us to distinguish one from another. I am following Hope's chronology for reasons that will become apparent in this and subsequent chapters. See also Hope 1990c.

3 According to an inventory of Philip's possessions taken in early 1554. The inventory does not in fact say that the portrait was by Titian. It may have been an enlarged copy because the 1533 portrait of Charles is three-quarter length, while Titian's portrait of Philip is full length.

4 In February 1549.

5 The other two Condemned Men, which were destroyed by fire in 1734, were finished about five years later.

6 Titian to Granvelle, 22 March 1550.

7 Charles Hope has alerted me to an unpublished letter from Benedetto Agnello writing on 28 April 1554 to Cardinal Ercole Gonzaga naming Francesco Vecellio as the cousin to whom Titian wanted the Medole benefice transferred. Francesco Vecellio, who later became a notary, was the son of Vecellone Vecellio and brother of Vincenzo Vecellio.

8 In his letter to Granvelle, 22 March 1550, and again to Giuliano Gosellini, 10 February 1551.

9 The portrait has not been accepted as autograph by all authorities.

10 The second edition published in 1568, which does include a biography of

Titian, is the only one usually read today.

11 The self-portrait is recorded and described in an inventory of the Vendramin collection of 1569.

12 The conventional dating is 1551–3, which would place it after Titian's second visit to Augsburg. In Titian's extensive correspondence with Philip it is mentioned only once, in 1554, as having been finished, which would seem to provide a terminus ante quem for the painting. Paul Joannides ('Titian in London and Madrid', *Paragone*, no. 657, 2004, pp. 19–24) maintains that the original is a picture formerly in London, Apsley House and that the free and open brushwork of the Madrid *Danaë* is more likely to place it in the 1560s, an argument that fails to take account of Titian's ability to work simultaneously in very different styles.

13 Scholars are divided about whether the portrait was painted on this or the earlier visit to Augsburg.

14 The original cannot be identified. There is a three-quarter-length portrait in the Madrid Prado, and full-length versions in Naples, Capodimonte and Florence, Galleria Palatina, which are identical except for the backgrounds. The Madrid portrait could be a studio copy, about which Philip wrote to Titian and to Vargas in June 1553 that it was 'like one of your hand'. But Philip often used this phrase, and it always seems to indicate that he thought that the work in question was autograph.

15 Titian received nothing from the Spanish pension until 1559 when he got a large lump sum to cover the arrears. It was in payment for works done so far.

16 By Boccaccio, for example, in his *Della Geneologia de gli Dei* (Of the Genealogy of the Gods).

17 If there had been a contract it would have been unenforceable, and almost no one at that period made contracts for works destined for private possession.

18 Both paintings were acquired for the nation from the Duke of Sutherland, *Diana and Actaeon* in 2009 for £50 million, *Diana and Callisto* in 2012 for £45 million. They are hung together on a rotating basis for six years in London and four years in Edinburgh.

19 The *Rape of Europa*, acquired in 1898 by Isabella Stewart Gardner on the advice of Bernard Berenson for $100, was the first Old Master painting to enter an American collection.

20 Lodovico Dolce, whose translations were among Titian's primary sources, wrote in an essay published in 1559 that the purpose of classical tragedy was to contrast human frailty with the immortality and blessedness of the gods.

EIGHT: *VENUS AND ADONIS*

1 The *Pardo Venus* was probably the painting that Titian had offered to Alessandro Farnese, who had seen it unfinished in the studio in 1547 shortly before the two fell out over Titian's decision to visit the emperor in Augsburg rather than return to Rome.

2 The anecdote was reported by Philip's chief secretary Antonio Pérez, *Segundas Cartas*, Paris 1603, cited by Hope 1980b.

3 It was recorded as being in the Palace of El Pardo, where it was destroyed in the fire of 1604.

4 Since the painting is not mentioned in any of Mary's inventories many

scholars, on account of the free handling of the paint, prefer a later date of c. 1565–70.

5 Attempts by iconographers to explain what else the burning city would have to do with the legend of St Margaret have been unsuccessful.

6 Tr. Crowe and Cavalcaselle 1881.

7 Venier also commissioned from Titian a votive portrait of Marcantonio Trevisan for the Sala del Collegio, in which the painter was instructed to include not more than seven figures and for which he was paid 171 ducats in 1556. The portrait of Trevisan was lost in the fire in the Collegio of 1574, which also destroyed Titian's votive portraits of Andrea Gritti and Pietro Lando. The votive portrait of Doge Antonio Grimani (Venice, Doge's Palace, Sala delle Quattro Porte), also commissioned by Venier, was saved because it was still unfinished at the time of the fire, and was probably not completed until after Titian's death by Marco Vecellio, who added the two sides. Sansovino's completed library and mint can be detected in the view of Venice in the far distance.

8 Titian's portrait of Filippo Archinto (New York, Metropolitan Museum), the papal legate who succeeded Beccadelli in Venice in 1554, is less impressive. He is seated in the same chair, but Titian – or an assistant – took less trouble with the pleated robe. Several years later an assistant painted a second portrait of him (Philadelphia, Museum of Art, Johnson Collection), this time half concealed by a veil after his nomination to the Bishopric of Milan had been refused because of opposition from the local curia.

9 See Hope 1990c.

10 Tr. Chambers and Pullan 1992.

11 In Ovid's original, Venus warns Adonis by telling him the story of Hippomenes and Atalanta.

12 Penny 2008 argues that Philip's *Venus and Adonis* was completed with studio help and possibly based on an earlier prototype, perhaps the version in the London National Gallery, which was also finished by the studio over what appears to be a brush drawing by the master.

13 London, National Gallery; Los Angeles, J. Paul Getty Museum; Rome, Museo Nazionale di Palazzo Barberini; and a private collection in Lausanne.

14 Washington, DC, National Gallery of Art; New York, Metropolitan Museum; and an engraving by Robert Strange of the version that Ridolfi mentioned as being in the Farnese collection.

15 *Pavonazzo* was a brownish crimson favoured by the Venetian aristocracy.

16 Miguel Falomir in Madrid 2003.

17 Written shortly after the Sack of Rome by the Visigoths in AD 410 to restore the confidence of St Augustine's fellow Christians.

NINE: THE PASSING OF THE LEVIATHANS

1 In a letter to Giovanbattista Coppola.

2 Twenty-four years earlier Catena's will had stipulated twenty ducats for each of his daughters plus five for the poor brothers of the painters' guild, so even allowing for inflation there was a big gap between that sum and Lavinia's dowry, which was, for example, about the same as the total value of the goods of Pietro Gritti's household.

3 See Hope 2007b for the documented source for the names of five of the

children and evidence that they had another daughter, born before Hersilia.

In his will, as drawn up in 1583, Cornelio allocated 1,200 ducats for the dowry of Helena, which gives some idea of his personal wealth. He stipulated, however, that if she chose to become a nun it would be reduced to 300 ducats. The will is one of those rare surviving documents that give a flavour of community life at the time. It was witnessed in Sarcinelli's house on the Piazza Grande by one harness maker, two furriers, one tailor, one goldsmith and two unidentified men who were probably shopkeepers around the square. It provided that his housekeeper must be looked after for life and that his steward be given food for life and should be succeeded in the job by his son unless he proved unsuitable.

4 The inscription 'LAVINIA TIT. V.F.A.B EO P.' (Lavinia, daughter of Titian Vecellio painted by him) is not autograph, but there is no reason to doubt that the portrait, which is usually dated about 1560, is of Lavinia and by Titian's hand.

5 Goffen 1997a makes the attractive suggestion that it is the coat of the man in the previous painting and thus brings Venus closer to a male lover.

6 It was transferred to Milan during the Napoleonic occupation of Venice. The Brera picture may or may not be Titian's first St Jerome. Some scholars identify the Giorgionesque *St Jerome* in the Paris Louvre as a painting requested by Federico Gonzaga in 1531. Others, notably Charles Hope, point out that no painting of St Jerome was listed in the Gonzaga inventories and that the Paris picture looks more like a copy of a lost Giorgione by an unknown hand.

7 Large panel paintings are liable to crack when subjected even to slight changes of temperature. The *St Jerome*, for those reasons, has not been loaned to a public exhibition since 1977.

8 John 1: 14.

9 By Valentina Sapienza, whose account of her discovery, 'Il committente del *San Gerolamo* di Tiziano per Santa Maria Nuova: storie di mercanti, malfattori e penitenti', *Venezia Cinquecento*, XVIII, no. 35, 2008, pp. 175–93, is well worth reading.

10 The Venus with a Mirror and Two Cupids sent to Spain in 1567 is now known only from a copy by Rubens (Madrid, Museo Thyssen-Bornemisza). The *Penitent St Jerome* (Madrid, Escorial) sent in 1575 was one of Titian's last paintings for the king.

11 A Jason and Medea that Titian had offered at the same time as the other paintings never materialized or was mentioned again. It may be that Vargas advised him that the story of a foreign princess not only rejected by her heroic lover but eventually beheaded and her hair turned to snakes would not be appropriate for a Spanish king who had, albeit temporarily, abandoned his English queen.

12 Caranza was later to be tried by the Spanish Inquisition for harbouring Protestant sentiments.

13 Friar José de Sigüenza in his *History of the Jeronemite Order*, 1605, cited by Cremades 1999.

TEN: THE DIANA POEMS

1 Titian or his studio had painted for Pérez, probably some years earlier, the rather awkward *Adam and Eve* (Madrid, Prado) for a fee of 400 ducats. It is in a ruined condition despite a restoration in the early twenty-first century that lightened the overall tone. Rubens's copy, which is also in the Prado, was made during his second stay in Spain in 1628–9, and is the only one of his many copies after Titian that is an improvement on the original.

2 Tr. Bondanella and Bondanella 1996. The letter was published by Ridolfi (1648) 1835–7.

3 Payments to individuals were often collected in metal money, which was less subject to inflation than the bills of account used by commercial banks. The age of negotiable paper money did not begin until 1579 and even then Venice lagged behind Genoa in this respect.

4 The equivalent at the time of twenty-two years' worth of the salary of a university professor.

5 Orazio's letter is lost. We know about it only from Titian's reply.

6 The letter is known from a nineteenth-century copy. Presumably the person who transcribed it used ducats instead of soldi, which would have been appropriate currency in this context.

7 The letter concludes with Titian's greetings to 'my cavalier', presumably Leone Leoni, for whom he is trying to obtain a cast of Michelangelo's statue of *Christ the Redeemer* in the Roman church of Santa Maria sopra Minerva. This is Charles Hope's interpretation in conversation with the present author. The cast is being brought by someone from Rome who has been delayed in Florence. Leoni later owned such a cast, although whether he obtained it through Titian is unknown.

8 Leoni had had a close relationship with Ferrante Gonzaga, Charles V's governor of Milan, who had been recalled in 1554 after charges of corruption by the Senate. He was acquitted and retired to Guastella, but took part in the Battle of Saint-Quentin, and died in Brussels in 1557 after falling from his horse there. Leoni's statue in Guastella of the *Triumph of Ferrante Gonzaga over Envy* was commissioned by Ferrante's son Cesare in 1564.

9 The *Death of Actaeon* was finished many years later and never sent to Spain.

10 For the portrait, now in Blenheim Palace, see Francis Russell, 'A Portrait by Orazio Vecellio', *Burlington Magazine*, CXXIX, 1987, pp. 182–8.

11 Edinburgh, National Museum of Scotland. It is not known who modelled the wax or what its relationship is to a cruder portrait medal of Titian and Orazio (Brunswick, Maine, Bowden College Museum of Art).

12 The *Allegory of Prudence* is a striking pastiche mostly executed by the workshop, which could have been painted at any time from the early 1560s to 1575, and seems to have been worked up to its present state even after Titian's death.

13 The existence of Emilia was not known until 1935 when a scholar discovered records of her marriage in 1568, her children and her death in 1582.

14 Hope 2007b points out that the usual identification of the Dresden girl in yellow with a fan as Lavinia in her

wedding dress is impossible. Lavinia in 1561 would have been about twenty-six (or thirty-one if one accepts the traditional birthdate for her of 1530). In her portrait as a buxom matron painted some time between 1555 and 1560 she looks nothing at all like the slender and much younger girl in yellow of 1561.

15 Joseph because of his senior age and status is usually shown at the head of Christ and Nicodemus at the feet, but their positions are sometimes reversed.

16 John 3: 8.

17 In 2008 when a campaign was under way to save the *Diana and Actaeon* for Britain after it had been put up for sale by its owner the Duke of Sutherland.

18 Cited by Waterhouse 1951.

19 The flanking sections were painted around 1600 by Marco Vecellio.

20 Made by Charles Hope in conversation with the author.

21 According to the anonymous biographer.

22 Critics are divided about whether Titian had a hand in this now very ruined picture. It is mentioned by Vasari, the anonymous biographer of 1622 and Ridolfi as having been painted by Titian; and the Madonna nursing her Child closely resembles the very late autograph *Virgin Suckling the Infant Christ* (London, National Gallery).

ELEVEN: THE *RAPE OF EUROPA*

1 *The Stanze of Angelo Poliziano*, tr. David Quint, University Park, PA, 1993.

2 Cited by Mallet and Hale 1984.

3 Here Verdizotti, who certainly had a hand in this letter, may be taking a clue from Aretino's letter written for Titian to Charles V in September 1554 in which he says he is sending a Grieving Madonna to intercede on behalf of his need for payment.

4 The anecdote and translation of the conversation with Baccio Valori is from Haskins 1993.

5 Wilde 1974.

6 Ridolfi called her History and Wilde an allegory of Poetry.

7 I am grateful to Dr Patrick N. Hunt for pointing out an image of Europa and the bull on a giant red-figure Greek vase of c. 480 BC in Tarquinia on which Europa standing next to the bull fondles one of his horns, which the artist has represented as a penis with pubic hair at its base.

8 Tr. Crowe and Cavalcaselle 1881.

Part V: 1562–1576

ONE: A FACTORY OF IMAGES

1 This must be the portrait that Vasari saw in Titian's studio in 1566 when he said it had been finished four years earlier. It was owned for a time by Rubens, Titian's ardent posthumous disciple, who would have identified with a portrait that showed the artist as a gentleman.

2 Jacopo Tebaldi, the ambassador in Venice of his first foreign patron Alfonso d'Este, who had suffered Titian's procrastinations and demands over many years, is only one of many who knew how difficult he could be. Another was Giangiacomo Leonardi, who in a letter of 18 February 1553 to the Duke of Urbino confessed that although he had spent a great deal of time talking and dining with Titian he had found him charming in every way except when asked to do what he did not want to do.

3 In his Life of Polidoro da Lanciani.

4 *Imprese di diversi principi, duchi, signori, e d'altri personaggi et huomini letterati et illustri ... Con alcune stanze del Dolce chi dicharano i motti de esse imprese* (*Imprese of diverse princes, dukes, lords, and other lettered personages and illustrious men ... With some verses by Dolce that declare the mottos of these imprese*) by the Vicentine painter and engraver Giovanni Battista Pittoni.

5 All were consumed with the rest of the cycle by the fire in the Hall in 1577.

6 Many authorities prefer to associate this drawing with Titian's lost Battle of Spoleto.

7 Tagliaferro and Aikema 2009 give the most complete recent research into the studio at different times.

8 Two are in the Madrid Prado, and one each in the Florence Uffizi, Cambridge Fitzwilliam Museum, Berlin Staatliche Museen and New York Metropolitan Museum.

9 Panofsky 1969, p. 121, wrote that this Venus 'was possibly intended for – although hardly commissioned by – Charles V'.

10 The other Madrid *Venus*, with a cupid, is a variant of this.

11 It was still in Venice when Van Dyck copied it in 1622.

12 Filippo Capponi, *Facile est inventis addere*, Venice, 1556.

13 Michelangelo said the same as Titian. Adrian Willaert said he had less difficulty with singing than with composing.

14 Hope 1980a.

15 In 1563 a canon of San Salvatore described it as finished, but Vasari, in his 'Life of Titian' published in 1568, wrote that it was unfinished.

16 The unfinished *Christ on the Cross with the Good Thief* (Bologna,

Pinacoteca Nazionale) has been implausibly identified as a fragment of this lost painting. But a request by Giovanni d'Anna in his will of 1567 that his son Paolo should have the altar completed may provide a clue to one of Titian's greatest late paintings, the *Ecce Homo* now in Munich which evidence suggests might have been commissioned by Paolo in 1572.

17 Wollheim 1987.

18 See for example Gentili 1993.

19 The frescos perished when the old church was demolished in the nineteenth century. Fortunately a plan and description of them had been made by Taddeo Jacobi which is summarized by Hope 1994.

20 London 2003, Madrid 2003 and Vienna and Venice 2007.

TWO: THE SPIDER KING

1 See Chapter 6 for more about Antonio Pérez, who is best known to historians for his corruption as leader of one of the two factions at Philip's court and for plotting the murder of Juan de Escobedo, secretary to Don John of Austria when Don John was governor of the Netherlands.

2 Alternatively it could be one of the other paintings Titian sent to Pérez, or one of two paintings by Titian, the other a variant of Philip's *Entombment*, given to Pérez by order of the Council of Ten in 1571.

3 A fragment very similar to that first composition (Washington, DC, National Gallery of Art) in which the raised arm of the third figure is visible could be a studio copy or variant of another, lost version of that first plan. In the Washington picture the lady's hair is bound up, and she wears the pearls and costume of a Venetian

noblewoman and twin bracelets like the reclining Venuses.

4 The painting suffered severe damage in the course of its history, during which it was neglected and subjected to numerous destructive attempts at restoration as well as relocations. It was transferred to its present position from the old church of the Crociferi in 1730, taken to Paris by Napoleon in 1797 and returned to Venice in 1815. After being shown at the Titian exhibition in the doge's palace in 1990 it was reinstalled in the church, where it remained crumbling, dimly lit and forgotten. At the time of writing a new restoration is being conducted under the auspices of the Venice Museums Authority, and the scholar Lionello Puppi of the Fondazione Centro Studi Tiziano e Cadore is undertaking in-depth research into the painting.

5 The church was rebuilt in its present form and renamed by the Jesuits in the early eighteenth century. The first surviving reference to the commission is a codicil to Lorenzo Massolo's will dated 18 November 1548.

6 Its appearance is recorded in a small workshop version (Milan, Brera). Titian's original was destroyed in 1571, and was replaced two years later by Veronese's Christ in the House of Simon, now known as the *Feast in the House of Levi* (see V, 6).

7 The tax return is reproduced in Belluno–Pieve di Cadore 2007, pp. 351 and 435–7.

8 Puppi 2004.

9 Ibid.

10 See Gould 1975.

THREE: THE BIOGRAPHER, THE ART DEALER AND THE KING'S ANNUS HORRIBILIS

1 I have abstracted information about the compiling of Vasari's 'Life of Titian' from Hope 1993 and 2007a.

2 The suggestion is from Puppi 2004.

3 In 1568 two of the Vendramin heirs who were determined to honour their father's wish that the collection be kept together commissioned an inventory that was compiled by Orazio Vecellio and Domenico Tintoretto.

4 Cited by (and tr.) Hope 1980a.

5 By Elke Oberthaler at the Vienna Kunsthistorisches Museum.

6 Renoir must have aware of Titian's *Portrait of Jacopo Strada* when he painted his portrait of the French dealer Ambroise Vollard (London, Courtauld Gallery).

7 The Veronese Allegories now in the New York Frick Collection (*Choice between Virtue and Vice* and *Wisdom and Strength*) were in Strada's collection.

8 Roland Krischel, *Jacopo Tintoretto 1519–1594*, Hagen, 2000, mentioned by Mazzucco 2009.

FOUR: WARS

1 For the letters and their background see Puppi 2004.

2 A certificate of Emilia's right to her dowry dated 1572 and a request by her children in 1582 for recognition of their right to inherit from their mother, in both of which she is called Milia, were discovered by a scholar in 1935. Emilia's existence was unknown until then.

3 The buxom younger woman whose breast the aged Titian caresses in a seventeenth-century engraving based on a sketch by Van Dyck and once

known as 'Titian and his Sweeting' may be a reference to Titian's affair with Emilia's mother.

4 It is just possible that the unfinished *Portrait of a Young Woman with a Little Girl* (private collection), which was discovered by a restorer at the end of the twentieth century under an overpainting of Tobias and the Angel, is of Emilia and Vecellia. The costume, however, suggests an earlier date, in which case it could be of Titian's cousin Livia Balbi and a daughter born after her marriage in the mid-1550s, which would date it to the early 1560s.

5 See Chambers and Pullan 1992, pp. 108–13.

6 I have abstracted some of the details of the sieges of Nicosia and Famagusta from Norwich 1981.

7 Andrea was the uncle of the more famous Venetian composer Giovanni Gabrieli.

8 *Don Quixote*, Prologue to Part II, 1615.

9 In, for example, the Milan Ambrosiana and Vienna Kunsthistorisches Museum.

10 Philip lived to see seven United Provinces in the north gain their independence. But it was not until 1658 that the Netherlands gained full independence from foreign rule, by which time Amsterdam was the commercial metropolis of Europe, and France had replaced Spain as the most powerful European nation.

11 Other painted commemorations of Lepanto and the Venetian commanders who had taken part in the victory include Tintoretto's *Portrait of Sebastiano Venier* (Vienna, Kunsthistorisches Museum) with the battle raging in the background, and Veronese's posthumous portrait of

Agostino Barbarigo (Cleveland Museum of Art), Venier's second in command, who was killed in the battle after an arrow pierced his eye. Both show an awareness of Titian's earlier portraits of military men in armour. Venier, who was unanimously elected doge in 1577 at the age of eighty-one, died the following year. His funeral effigy is in the church of Santi Giovanni e Paolo.

FIVE: 'IN THIS MY OLD AGE'

1 In the *Fasti* II, c. AD 8.

2 Canto IV of the *Inferno, The Divine Comedy*, 1308–21.

3 *De mulieribus claris*, 1374.

4 *The Legend of Good Women*, c. 1385–6.

5 In *The City of God*, c. 413–26.

6 The *Declamatio Lucretiae* by Coluccio Salutati.

7 A novella by Matteo Bandello.

8 In a letter of 1537 to a stableman and poet called Malatesta.

9 The closest is a sixteenth-century engraving by the Fontainebleau master Léon Daven.

10 The painting was taken from the Spanish Royal Collections by Joseph Bonaparte on his flight from the Spanish throne in 1813 and passed through various hands before it was given to the Fitzwilliam in 1918 by Charles Fairfax Murray. Until loaned for exhibitions in the early twenty-first century it was one of the most ignored of Titian's late paintings, probably because foreign experts could not be bothered to make the journey to Cambridge before the roads from London were improved.

11 For Titian's technique in this painting see Jill Dunkerton in London 2003.

12 The beautiful drawing of *A Couple in Embrace* (Cambridge, Fitzwilliam

Museum) may be associated with the underdrawing.

13 Frank Auerbach's drawing, *Study of Titian II* (Tate Collection), is based on the Vienna painting.

14 Peter and Linda Murray, *The Penguin Dictionary of Art and Artists*, London and New York, 1981, pp. 448–9.

15 Hope 1980a and subsequently in conversation with the present author maintains that Titian must have been dissatisfied by the late paintings and was prevented only by his deteriorating health from working them up into a more finished state. If, however, the late works should be regarded as underpaintings they do not resemble the preparatory states revealed by technical investigations of his finished works.

16 Crowe and Cavalcaselle, writing two centuries later, echoed Boschini's opinion: 'It is impossible to conceive better arrangement, greater harmony of lines, or more boldness of movement. Truth in the reproduction of nature in momentary action is combined with fine contrasts of light and shade, and an inimitable richness of tone, in pigment kneaded, grained, and varied in surface beyond anything that we know of this time. Such a combination might have thrown into despair three such men as Rubens, Van Dyck, and Rembrandt …' (1881).

17 See Hope 2007b for evidence that Paolo d'Anna might have commissioned the painting in 1572.

18 John 19: 2–3.

19 Sent to Philip in 1575.

20 Although Sylvia Ferino-Pagden in Washington and Vienna 2007 dates the picture c. 1565, Humfrey 2007 maintains that it is always regarded as a late work. The landscape certainly

resembles the background of the very late *Flaying of Marsyas*.

21 It has been suggested by Hans Ost, *Tizian-Studien*, Cologne, 1992 that the *Boy with Dogs* is a fragment of a protective cover for the portrait.

22 There is an unresolved debate about whether or not this painting is finished.

23 As noticed by Gould 1975.

24 The director was Charles Holmes.

25 The painting, which is not good enough to have been sent to Philip, probably entered the Spanish royal collection in the seventeenth century.

26 When it came to the Prado in 1837 the director attributed the *Ecce Homo* to the young Bassano imitating Titian, as did Berenson a century later. Crowe and Cavalcaselle, 1881, were the first scholars to detect Titian's hand.

27 Miguel Falomir in Madrid 2003, from whom I have abstracted my account of the two paintings.

28 Tr. Crowe and Cavalcaselle 1881.

29 Livia Balbi was recorded in 1561 as the daughter of the late Marco Tinto and the wife of Gaspare Balbi. Hope, 2007b, p. 411, suggests that she could have been the daughter of a sibling of Titian's second wife.

30 Whatever Titian was doing he was surely not, as the Dutch Expressionist remarked of his own painting in 1955, 'messing around'.

31 Boschini would have been aware of Pliny's comment that the last unfinished works of famous Greek painters, specifically Apelles' unfinished Venus of Cos, were more admired than their finished ones.

SIX: ANOTHER WAY OF USING
COLOUR

1 The arrangement of the figures is
compatible with Philip's *Perseus and
Andromeda*, in 1556, in which the
naked Andromeda is on our left and
the death-dealing activity of Perseus
slaying the monster is in the middle
distance on our right. Hope 1980
suggests that Titian might have
started the *Death of Actaeon* even
earlier as a companion piece to *Venus
and Adonis*, which is also about
hunting.

2 Gould 1975 proposed that the
resemblance of Diana's head to that
of the angel in his San Salvatore
Annunciation, which was finished at
the latest by 1566, may indicate that
Titian resumed work on it in the early
1560s. But the area around Diana's
head has been heavily restored and
the relatively immobile face looks
more like the work of another hand.

3 Quoted in the *Royal Academy
Magazine*, Winter 2007.

4 For Titian's changes and technique
see Dunkerton 2003 for a brief
account of the results of her scientific
investigation of the painting, and
Penny 2008.

5 Dunkerton 2003.

6 Gould 1975.

7 The *Death of Actaeon* was on a list of
paintings then in Venice drawn up in
the 1630s by the British ambassador
in Venice, Lord Fielding, who
described it as 'A Diana shooting
Adonis in forme of a Hart not quite
finished'. Its first owner was the
Marquis (later Duke) of Hamilton,
one of the great collectors at the court
of King Charles I.

8 See Penny 2008 for this suggestion.

9 Elke Oberthaler, conservator at the
Kunsthistorisches Museum, worked

on the painting from 2002 to 2007. It
was considered to be damaged
without hope of repair after a
previous restoration had been
conducted in the 1930s by Sebastian
Isepp, who remarked that he had
restored it 'without touching it'. For a
more detailed account of Oberthaler's
important conclusions see Vienna
and Venice 2007.

10 The picture had been on loan to the
National Gallery for ten years when it
was sold in 1970 to a dealer by the
trustees of the seventh Earl of
Harewood. After the J. Paul Getty
Museum in Los Angeles offered
£1,763,000 for it, the British
Reviewing Committee on the Export
of Works of Art recommended
delaying the export for a year and
refusing an export licence if the
Getty's price could be matched. A
public appeal launched by the
National Gallery raised the amount
and the painting was secured for the
nation on 6 July 1972.

11 Martin Davies.

12 The only survival was Titian's votive
Portrait of Doge Antonio Grimani,
ordered by the Council of Ten in 1555
– thirty-two years after Grimani's
death – and now in the Sala delle
Quatro Porte for which it was
destined. It may have been rescued or
saved because it remained in Titian's
studio where he had not yet finished
it. The flanking sections were painted
by Marco Vecellio around 1600 under
Doge Marino Grimani.

13 I have borrowed the conceit of 'make-
believe neo-Roman dinner parties'
from Chambers 1970.

14 A longer account of the summons is in
Chambers and Pullan 1992, pp. 232–6.

15 Tintoretto worked on this cycle from
1564 to 1587.

16 A certain Francisco Reinoso, for example, paid Orazio 300 scudi in 1573 for a Noah and a Moses (both lost) painted in collaboration with Titian.

17 Philip would be forced to suspend payments to his bankers on 1 September 1575.

18 The most recent and complete edition of the correspondence about Titian between Ayamonte and de Silva, of which the original letters are preserved in the archive at Simancas, is Mancini 1998, from which I have drawn some of my abbreviated account of the background. Some of the directly quoted passages to follow are taken from Fernando Checa, 'Titian's Late Style', in Vienna and Venice 2007. I am also grateful to Jonathan Keates and Felicity Wakefield for their translations and to Charles Hope for his summaries of the letters, which enabled me to follow the entire correspondence more easily than would have been possible otherwise.

19 For the theory that this Pietà may have been an early state of the painting now in the Venice Accademia see Hope 1994, with the caveat that Mancini 1998 disagrees.

SEVEN: THE PLAGUE AND THE PITY

1 The document, first published by Hope 1994, throws a new light on the history of the Pietà now in the Venice Accademia. It is possible that the painting he withdrew from the Frari was the one he offered to the Marquis of Ayamonte nineteen days later and of which he sent him a sketch and measurements on 27 April 1575.

2 Velázquez used it for his Don Juan of Austria (Madrid, Prado).

3 The additions were masked for the Titian exhibition at the Prado in 2003.

4 A reduced variant of the Brera St Jerome, but with the landscape barely sketched in, and the emphasis on the figure of the saint, who holds a book as in the Escorial painting, is in the Madrid Museo Thyssen-Bornemisza. Scholars differ about the degree of Titian's participation.

5 Tr. Crowe and Cavalcaselle 1881.

6 Ovid 2004, Book 6.

7 Unfortunately, since the painting was first exhibited in western Europe in 1983 its tonal variations have been flattened by the application of what seems to be a coat of waxy varnish, which was presumably intended to protect the surface.

8 X-rays have shown that the instrument was originally an ancient Greek lyre, an instrument with two projecting arms supporting a cross-bar to which the strings were attached, which may indicate that the figure playing it is a second Apollo or Apollo's son Orpheus, or, as some scholars prefer, Olympus who is sometimes given as Marsyas' father or his son and favourite pupil. The figure also plays the lyre in Giulio's drawing and another version of the painting in a private collection in Venice. It may therefore be that the Greek lyre was replaced by the contemporary lira da braccio after Titian's death.

9 Some critics believe the child satyr is a later addition.

10 Melanie Hart, 'Visualising the Mind: Seeing What Titian Saw in 1576', British Journal of Psychotherapy, vol. 23, no. 2, January 2007, pp. 267–80.

11 Thomas Arundel, 21st Earl of Arundel (1585–1646), is best known

as a wealthy Grand Tourist who amassed a large collection of paintings sculptures, books, prints, drawings and antique jewellery.

12 Frank Stella, *Working Space*, Cambridge, Massachusetts and London, 1986.

13 Ibid.

14 The account of the plague written in 1630 by Rocco Benedetti, a Venetian notary, is in Chambers and Pullan 1992.

15 The head of Christ and the head and shoulders of Joseph of Arimathea can be seen in X-ray on the right of the Virgin near her shoulder. For the full explanation of the subsequent enlargement of the painting and its destination in Pieve di Cadore see Hope 1994.

16 The pose of Moses is borrowed from Michelangelo's seated Moses in the church of San Pietro in Vincoli, the Hellespontine Sibyl from the full-length Christ holding His Cross in Santa Maria sopra Minerva.

17 There is a nearly unanimous opinion among scholars – Charles Hope is an exception – that this and perhaps Titian's other *St Jeromes* are self-portraits. The Council of Trent, however, had condemned as unorthodox the representation of living people as saints, and there seems no reason why Titian would have defied that order, least of all in a painting intended for public display in a church.

18 The chapel, now occupied by the nineteenth-century memorial to Titian, is the second on the right. Strangely enough no bones were found when foundations were dug for the monument.

19 *De officiis* (44 BC), III, 3: 'Ut pictor nemo esset inventus, qui Coae Veneris eam partem, quam Apelles inchoatam reliquisset, absolveret.'

Titian's Legacy

1 Van de Wetering 1991.

2 For documented details of Pomponio's management of the estate see Hope 2007b and Puppi 2004, who give very different interpretations of Pomponio's behaviour.

3 Puppi 2004, who dates the withdrawal to 6 September, regards it as a cynical, 'almost revolting' action taken in a spirit of revenge against Titian and Orazio. But thirty ducats was not a large sum and probably represented only a small percentage of the account.

4 The portrait, the last to be mentioned in any surviving document, is the most likely of several candidates for the portrait of a young lady and her daughter discovered by X-radiography in 1948 beneath an overpainted Tobias and the Angel, and revealed by a restoration in the early twenty-first century. The portrait is unsold at the time of writing.

5 Charles Hope has evidence, some of it unpublished, that this clause of the settlement between Pomponio and Gaspare Balbi relates to the Munich *Crowning with Thorns*, which was commissioned by Paolo d'Anna for the church of San Salvatore but left unfinished at Titian's death. Pomponio on several occasions asked d'Anna to let him know if he wanted the picture finished, for a fee, by one of Titian's assistants.

6 See Penny 2008, vol. 2, pp. 236–47 for a full account of the history of this painting.

7 When in Paris it was thought to be an allegory of the dilemma of Alfonso I

d'Este (supposedly the central head) who had to decide whether to support the pope (the old man in a red cap whom we now recognize as Titian) or the emperor, Charles V (the youngest man). When someone remembered that Julius II died in 1513, six years before Charles V was elected emperor, 'Julius II' was changed to 'Paul III', but that didn't work either because Alfonso I d'Este died in 1534, which was the year of Paul III's election.

8 The youngest man (who was originally bearded) is clearly by the same assistant who squeezed the three boys into the left end of Titian's *Vendramin Family* (which hangs next to it in the London National Gallery) in the mid-1550s, which suggests that the youth was painted in Titian's lifetime and that the *Allegory* might have been originally intended for a decorative frieze in the Vendramin palace, or possibly as a cover for another painting in the collection.

9 In conversation with the present author.

10 He acquired much of the rest of the collection legitimately by inheritance.

11 One of them, an equestrian portrait of Philip IV, known only from a copy (Florence, Uffizi), was regarded as better than the one executed by Velázquez in 1626, which was removed to make room for the Rubens.

12 My authority for this brief note about a large subject is Jeremy Wood, *Rubens: Copies and Adaptations from Renaissance and Later Masters: Italian Artists*, vol. 2: *Titian and North Italian Art*, London and Turnhout, 2010.

13 By Erica Tietze-Conrat in 'Das Skizzenbuch des Van Dyck als Quelle für die Tizianforschung', *Critica d'Arte*, VIII, 1949–50, p. 441.

14 See David Jaffé, 'New Thoughts on Van Dyck's Italian Sketchbook, *Burlington Magazine*, vol. 143, no. 1183, October 2001, pp. 614–24.

15 When in the Borghese collection in the seventeenth and eighteenth centuries the painting was famous with English Grand Tourists who knew it as 'Titian and his sweeting'. Van Dyck also made an engraving of it at some time in the 1630s.

16 He was admitted to the Order of Santiago in 1659, but only after attempts by the king's Council of Orders to refuse the knighthood ostensibly on the grounds of his humble family background but in fact because it was not considered a suitable honour for a painter.

17 Jonathan Brown, *The Golden Age of Painting in Spain*, London, 1991, p. 221.

18 Van de Wetering 1991.

19 Both in the collection of Alfonso Lopez, a Portuguese resident.

20 Jacob Isaacsz van Swanenburgh and Pieter Lastman.

21 Van de Wetering 1991.

BIBLIOGRAPHY

Ackerman, James S. 1982. 'The Geopolitics of Venetian Architecture in the Time of Titian', in Rosand 1982.

L'Anonimo di Tizianello (1622) 1809. *Breve compendio della vita del famoso Tiziano Vecellio di Cadore*. Venice.

Aretino, Pietro 1971. *Tutte le opere di Pietro Aretino*, ed. Giorgio Petrocchi. Milan.

Aretino, Pietro (1525–56) 1997–2001. *Pietro Aretino: Lettere*, ed. Paolo Procaccioli, 6 vols. Rome.

Aretino, Pietro (1542 and 1551) 2003–4. *Lettere scritte a Pietro Aretino*, ed. Paolo Procaccioli, 2 vols. Rome.

Ariosto, Ludovico (1532) 1975 and 1977. *The Frenzy of Orlando (Orlando furioso)*, tr. Barbara Reynolds, 2 vols. London.

Bacchanals by Titian and Rubens 1987. Ed. Görel Cavalli-Björkman. Papers given at a symposium at the Nationalmuseum, Stockholm. Stockholm.

Barolsky, Paul 1998. 'Sacred and Profane Love', *Source*, vol. 17, no. 3, Spring, pp. 25–8.

Belluno–Pieve di Cadore 2007. *Tiziano: L'ultimo atto*, exh. cat., ed. Lionello Puppi. Palazzo Crepadona, Belluno and Palazzo della Magnifica Communità, Pieve di Cadore.

Bembo, Pietro (1505) 1991. *Gli Asolani*, ed. Giorgio Dilemmi. Florence.

Benzoni, Gino 1990. 'Venezia ai tempi di Tiziano', in Washington and Venice 1990, pp. 29–34.

Berenson, Bernard (1930) 1938. *Italian Painters of the Renaissance*. Oxford and London.

Bernardini, Maria Grazia and Paolo Spezzani 1995a. '"Amor Sacro e Profano", Roma, Galleria Borghese', in Rome 1995, pp. 355–7.

Bernardini, Maria Grazia and Paolo Spezzani 1995b. '"Salome", Roma, Galleria Doria Pamphili', in Rome 1995, p. 358.

Berrie, Barbara H. and Louisa C. Matthew 2006. 'Venetian "Colore": Artists at the Intersection of Technology and History', in Washington and Vienna 2006, pp. 301–7.

Bodart, Diane H. 1998. *Tiziano e Federico II Gonzaga*. Rome.

Bolgar, R. R. (1954) 1974. *The Classical Heritage and its Beneficiaries*. Cambridge.

Bondanella, Julia Conway, Peter Bondanella et al., trs and eds 1996. *The Life of Titian by Carlo Ridolfi*. University Park, PA.

Boschini, Marco (1660 and 1674) 1966. *La carta del navegar pitoresco* (1660), with *La breve istruzione*, the introduction to *Le ricche minere della pittura veneziana* (1674), ed. Anna Palluchini. Venice.

Boston 2009. *Titian, Tintoretto, Veronese: Rivals in Renaissance Venice*, exh. cat., ed. Frederick Ilchman. Museum of Fine Arts, Boston.

Boucher, Bruce 1991. *The Sculpture of Jacopo Sansovino*. New Haven.

Brandi, Karl (1937) 1970. *The Emperor Charles V: The Growth and Destiny of a Man and of a World Empire*, tr. C. V. Wedgwood. New York.

Braudel, Fernand (1966) 1972. *The Mediterranean and the Mediterranean World in the Age of Philip II*, tr. Siân Reynolds, abr. Richard Ollard. London.

Brown, Beverly Louise 2005. 'Titian's Marble Muse: Ravenna, Padua and the Miracle of the Speaking Babe', in *Studi Tizianeschi*, no. III, ed. Bernard Aikemer et al. Milan, pp. 19–45.

Brown, Beverly Louise 2007. 'Corroborative Detail: Titian's Christ and the Adulteress', *artibus et historiae*, no. 56, pp. 73–105.

Brown, Beverly Louise 2008. 'Picturing the Perfect Marriage: The Equilibrium of Sense and Sensibility in Titian's "Sacred and Profane Love"', in *Art and Love in Renaissance Italy*, exh. cat., ed. Andrea Bayer. Metropolitan Museum of Art, New York, pp. 238–45.

Brown, Patricia Fortini 2004. *Private Lives in Renaissance Venice*. New Haven and London.

Brown, Patricia Fortini 2009. 'Where the Money Flows: Art Patronage in Sixteenth-Century Venice', in Boston 2009, pp. 41–59.

Bull, George, tr. 1974 and 1988. *Giorgio Vasari, Lives of the Artists*, 2 vols. London and New York.

Bull, George, tr. 1976. *Aretino: Selected Letters*. London and New York.

Bull, Malcolm 2005. *The Mirror of the Gods: Classical Mythology in Renaissance Art*. Oxford.

Burckhardt, Jacob (1860) 1990. *The Civilization of the Renaissance in Italy*, tr. S. G. C. Middlemore. London.

Burckhardt, Jacob (1898) 1994. *Il ritratto nella pittura italiana nel Rinascimento*, tr. D. Pagliali. Rome.

Burke, Peter 1999. 'Presenting and Re-presenting Charles V', in Soly 1999a,
pp. 393–475.

Burns, Howard 1981. 'The Gonzaga and Renaissance Architecture', in
London 1981, pp. 27–38.

Bury, Michael 1989. 'The *Triumph of Christ*, after Titian', *Burlington
Magazine*, vol. CXXXI, pp. 188–97.

Cadorin, Giuseppe 1833. *Dello amore ai Veneziani di Tiziano Vecellio, delle
sue case in Cadore e in Venezia, e delle vite de' suoi figli*. Venice.

Cairns, Christopher A. 1966. 'Domenico Bollani, a Distinguished
Correspondent of Pietro Aretino – Some Identifications', *Renaissance
News*, vol. 19, no. 3, pp. 193–205.

Cairns, Christopher 1985. *Pietro Aretino and the Republic of Venice:
Researches on Aretino and his Circle in Venice*. Florence.

Camesasca, Ettore and Fidenzio Pertile, eds 1957–60. *Lettere sull'Arte di
Pietro Aretino*, 4 vols. Milan.

Campori, Giuseppe 1875 (reprint). 'Tiziano e gli estensi', in *Artisti degli
Estensi: I pittori*. Modena, pp. 1–40.

Cartwright, Julia (1903) 1932. *Isabella d'Este*, 2 vols. London.

Castelfranco 2010. *Giorgione*, exh. cat., ed. E. M. Dal Pozzolo and L. Puppi.
Castelfranco Veneto.

Castiglione, Baldassare (1528) 1964. *Il Libro del Cortegiano con una scelta
delle Opere minori*, ed. Bruno Maier. Turin.

Chambers, David S. 1970. *The Imperial Age of Venice 1380–1580*. London.

Chambers, David S. 1981. 'The Gonzaga and Mantua', in London 1981,
pp. xvii–xxiv.

Chambers, David S. 1993. 'Benedetto Agnello, Mantuan Ambassador in
Venice', in Chambers, Clough and Mallett 1993, pp. 129–45.

Chambers, David S. 2006. *Popes, Cardinals and War*. London.

Chambers, David S., Cecil H. Clough and Michael Mallett, eds 1993. *War,
Culture and Society in Renaissance Venice: Essays in Honour of John Hale*.
London.

Chambers, David and Brian Pullan, eds 1992. *Venice: A Documentary
History 1450–1630*. London.

Chiappini, Luciano 1967. *Gli Estensi*. Milan.

Chiari, Maria Agnese, ed. 1982. *Incisioni da Tiziano*, exh. cat. Museo Correr,
Venice.

Chubb, Thomas Caldecot, tr. 1967. *The Letters of Pietro Aretino*. New
Haven.

Ciani, Giuseppe 1862. *Storia del popolo cadorino*. Cadore.

Clark, Kenneth 1956. *The Nude*. London.

Clark, Kenneth 1972. *The Artist Grows Old*. Cambridge.

Clark, Kenneth 1981. *Moments of Vision*. London.

Cleugh, James 1965. *The Divine Aretino*. London and New York.

Colonna, Francesco (1499) 1998. *Hypnerotomachia Polifili*, ed. Marco Ariani and Mino Gabriele, 2 vols. Milan.

Colonna, Francesco (1499) 1999. *Hypnerotomachia Polipfili: The Strife of Love in a Dream*, tr. Joscelyn Godwin. London.

Cozzi, Gaetano 1973. 'Authority and the Law in Renaissance Venice', in Hale 1973, pp. 293–345.

Cozzi, Gaetano 1980. 'La Donna, l'Amore e Tiziano', in *Tiziano e Venezia* 1980, pp. 47–63.

Cremades, Fernando Checa 1999. 'The Image of Charles V', in Soly 1999a, pp. 477–99.

Crowe, Joseph A. and Giovanni Battista Cavalcaselle 1881. *The Life and Times of Titian*, 2 vols, 2nd edn. London.

Crouzet-Pavan, Elisabeth 2002. *Venice Triumphant*. Baltimore and London.

Dean, Trevor and K. J. P. Lowe 1998. *Marriage in Italy*. Cambridge and New York.

D'Elia, Una Roman 2005. *The Poetics of Titian's Religious Paintings*. Cambridge.

de Maria, Blake 2011. *Becoming Venetian*. London.

Dennistoun, James 1909. *Memoirs of the Dukes of Urbino*, ed. Edward Hutton, 3 vols. London and New York.

Dinoisi, Roberto and Anna Marcone, 'Relazione tecnica del restauro', in Rome 1995, pp. 325–35.

Dolce, Lodovico (1557) 1910. *L'Aretino: dialogo della pittura, con l'aggiunta di varie rime e lettere*. Introduction and notes by Guido Bettelli. Florence.

Duffy, Eamon 2006. *Saints and Sinners: A History of the Popes*. New Haven and London.

Dunkerton, Jill 2003. 'Titian's Painting Technique', in London 2003, pp. 45–60.

Dunkerton, Jill, Susan Foister and Nicholas Penny 1999. *Dürer to Veronese: Sixteenth-Century Painting in the National Gallery*. London.

Dunkerton, Jill and Nicholas Penny 1995. '"Noli me tangere", London, The National Gallery', in Rome 1995, pp. 364–7.

Edinburgh 2004. *The Age of Titian: Venetian Renaissance Art from Scottish Collections*, exh. cat., ed. Aidan Weston-Lewis. National Galleries of Scotland, Edinburgh.

Eisler, Colin 1989. *The Genius of Jacopo Bellini*. New York and London.

Elliott, J. H. 2002. *Imperial Spain: 1469–1716*. London.

Elton, G. R., ed. 1958. *The New Cambridge Modern History*, vol. 2: *The Reformation: 1520–1559*. Cambridge.

Fabiani, Giovanni 1963. *Chiese del Cadore*. Belluno.

Fabbro, Celso 1976. *Tiziano*. Cadore.

Fabbro, Celso, 1977. *Tiziano: le lettere*, ed. Clemente Gandini. Cadore.

Fehl, Philipp P. 1957. 'The Hidden Genre: A Study of the *Concert Champêtre* in the Louvre', *Journal of Aesthetics and Art Criticism*, vol. 16, no. 2, pp. 153–68.

Fenlon, Iain 2003. 'Music and Experience in Titian's Venice', in Meilman 2003, pp. 163–82.

Fletcher, Jennifer 2003a. 'Bellini's Social World', in Humfrey 2003, pp. 12–47.

Fletcher, Jennifer 2003b. 'Titian as a Painter of Portraits', in Madrid 2003, pp. 320–6.

Fletcher, Jennifer 2006. '"La sembianza vera". I ritratti di Tiziano', in Naples 2006, pp. 36–50.

Foscari, Lodovico 1935. *Iconografia di Tiziano*. Venice.

Freedberg, David 1989. *The Power of Images: Studies in the History and Theory of Response*. London.

Freedberg, Sydney 1971. *Painting in Italy: 1500–1600*. London.

Freedman, Luba 1995. *Titian's Portraits through Aretino's Lens*. University Park, PA.

Gentili, Augusto 1988. *Da Tiziano a Tiziano: mito e allegoria nella cultura veneziana del cinquecento*. Rome.

Gentili, Augusto 1993. 'Tiziano e la religione', in *Titian 500* 1993, pp. 147–65.

Gentile, Augusto 2003. 'La pittura religiosa dell'ultimo Tiziano', in *Studi Tizianeschi, no. I*, ed. W. R. Rearick et al. Milan, pp. 9–18.

Giebe, Marlies 1995. '"Venere dormiente", Dresda, Gemäldegalerie', in Rome 1995, pp. 369–85.

Gilbert, Creighton 1980. 'Some Findings on Early Works of Titian', *Art Bulletin*, vol. 62, no. 1, pp. 36–75.

Gilbert, Felix 1977. 'Venetian Diplomacy before Pavia', in Felix Gilbert, *History: Choice and Commitment*. Cambridge, MA, and London, pp. 295–321.

Gilbert, Felix 1973. 'Venice in the Crisis of the League of Cambrai', in Hale 1973, pp. 274–92.

Gilbert, Felix 1980. *The Pope, his Banker and Venice*. Cambridge, MA.

Gilbert, Josiah 1869. *Titian's Country*. London.

Gilmore, Myron 1973. 'Myth and Reality in Venetian Political Theory', in Hale 1973, pp. 431–44.

Ginzburg, Carlo 1980. 'Tiziano, Ovido e i codici della figurazione erotica nel "500"', in *Tiziano e Venezia* 1980, pp. 125–35.

Gleason, Elisabeth G. 1993. *Gasparo Contarini: Venice, Rome, and Reform.* Berkeley, CA.

Goffen, Rona 1986. *Piety and Patronage in Renaissance Venice: Bellini, Titian and the Franciscans.* New Haven and London.

Goffen, Rona 1990. 'Tiziano, i donatori e i soggetti religiosi', in Washington and Venice 1990, pp. 85–93.

Goffen, Rona 1993. 'Titian's *Sacred and Profane Love*: Individuality and Sexuality in a Renaissance Marriage Picture', in *Titian 500* 1993, pp. 121–44.

Goffen, Rona 1997a. *Titian's Women.* New Haven and London.

Goffen, Rona, ed. 1997b. *Titian's 'Venus of Urbino'.* Cambridge.

Gould, Cecil 1959. *The Sixteenth-Century Venetian School.* National Gallery, London.

Gould, Cecil 1975. *The Sixteenth-Century Italian Schools.* National Gallery, London.

Goy, Richard 1997. *Venice: The City and its Architecture.* London.

Grendler, Paul F. 1966. 'Religious Restlessness in Sixteenth-century Italy', CCHA, *Study Sessions*, vol. 33, pp. 25–38.

Grendler, Paul F. 1969. *Critics of the Italian World.* Madison, WI.

Hale, J. R., ed. 1973. *Renaissance Venice.* London.

Hale, J. R. 1977. *Florence and the Medici: The Pattern of Control.* London.

Hale, J. R. 1990. *Artists and Warfare in the Renaissance.* New Haven and London.

Hale, John 1993. *The Civilisation of Europe in the Renaissance.* London and New York.

Hale, J. R. (1971) 2000. *Renaissance Europe.* Oxford.

Hanning, Robert W. and David Rosand 1983. 'Titian's "Presentation of the Virgin": The Second Door', *Burlington Magazine*, vol. CXV, p. 603.

Haskell, Francis 1976. *Rediscoveries in Art.* London.

Haskins, Susan 1993. *Mary Magdalen: Myth and Metaphor.* London (New York edns 1994 and 1995).

Hazlitt, William 1856. *Criticisms on Art, and Sketches of the Picture Galleries of England*, ed. by his son. London.

Heath, Michael 1989. 'Unlikely Alliance: Valois and Ottomans', *Renaissance Studies*, vol. 3, no. 3, pp. 303–15.

Hills, Paul 1999. *Venetian Colour: Marble, Mosaic, Painting and Glass 1250–1550.* New Haven and London.

Hills, Paul 2003. 'Titian's Colour', in Madrid 2003, pp. 308–13.

Hills, Paul 2006. 'Titian's Veils', *Art History*, vol. 29, no. 5, pp. 771–95.

Hills, Paul 2007. 'Titian's Fire: Pyrotechnics and Representations in Sixteenth-Century Venice', *Oxford Art Journal*, vol. 30, no. 5, pp. 185–204.

Hirst, Michael 1981. *Sebastiano del Piombo*. Oxford.

Holberton, Paul 1986. 'La bibliotechina e la raccolta d'arte di Zuanantonio Venier', *Atti dell'Istituto Veneto*, vol. CXLIV, pp. 172–93.

Holberton, Paul 1987. 'The Choice of Texts for the Camerino Pictures', in *Bacchanals by Titian and Rubens* 1987, pp. 57–66.

Holberton, Paul 1993. 'The *Pastorale* or *Fête Champêtre* in the Early Sixteenth-Century', in *Titian 500* 1993, pp. 245–62.

Hollingsworth, Mary 1996. *Patronage in Sixteenth-Century Italy*. London.

Hollingsworth, Mary 2004. *The Cardinal's Hat*. London.

Hood, William and Charles Hope, 1977. 'Titian's Vatican Altarpiece and the Pictures Underneath', *Art Bulletin*, vol. 59, no. 4, pp. 534–52.

Hook, Judith 1972. *The Sack of Rome*. London.

Hope, Charles 1971–2. 'The "Camerini d'Alabastro" of Alfonso d'Este', *Burlington Magazine*, vol. CXIII, 1971, pp. 641–50, and vol. CXIV, 1972, pp. 714–21.

Hope, Charles 1973. 'Documents Concerning Titian', *Burlington Magazine*, vol. CXV, pp. 809–10.

Hope, Charles 1977. 'A Neglected Document about Titian's "Danae" in Naples', *Arte Veneta*, vol. XXXI, pp. 188–9.

Hope, Charles 1979. 'Titian as Court Painter', *Oxford Art Journal*, vol. 2, pp. 7–10.

Hope, Charles 1980a. *Titian*. London.

Hope, Charles, 1980b. 'Problems of Interpretation in Titian's Erotic Paintings', in *Tiziano e Venezia* 1980, pp. 111–24.

Hope, Charles 1980c. 'Titian's Role as "Official Painter" to the Venetian Republic', in *Tiziano e Venezia* 1980, pp. 301–5.

Hope, Charles 1981. 'Federico II Gonzaga as a Patron of Painting', in London 1981, pp. 73–5.

Hope, Charles 1987. 'The Camerino d'Alabastro: A Reconsideration of the Evidence', in *Bacchanals by Titian and Rubens* 1987, pp. 25–42.

Hope, Charles 1990a. 'Altarpieces and the Requirements of Patrons', in J. Henderson and T. Verdon, eds, *Christianity and the Renaissance*. Syracuse, pp. 535–71.

Hope, Charles 1990b. 'Tiziano e la committenza', in Washington and Venice 1990, pp. 77–84.

Hope, Charles 1990c. 'Titian, Philip II and Mary Tudor', in E. Chaney and P. Mack, eds, *England and the Continental Renaissance: Essays in Honour of J. B. Trapp*. Woodbridge, pp. 53–65.

Hope, Charles 1993. 'The Early Biographies of Titian', in *Titian 500* 1993, pp. 167–92.

Hope, Charles 1994. 'A New Document about Titian's *Pietà*', in John Onians, ed., *Sight and Insight: Essays on Art and Culture in Honour of E. H. Gombrich at 85*. London, pp. 153–67.

Hope, Charles 1996. 'Some Misdated Letters of Pietro Aretino', *Journal of the Warburg and Courtauld Institutes*, vol. 59, pp. 304–14.

Hope, Charles 1997. 'The Attribution of Some Paduan Paintings of the Early Sixteenth Century', *artibus et historiae*, no. 35, pp. 81–99.

Hope, Charles 2003a. 'I Camerini d'Alabastro', in *Atti del Convegno di Studi: Il progetto della via coperta*, ed. Marco Borella and Angela Ghinato. Ferrara, pp. 31–9.

Hope, Charles 2003b. 'Giorgione or Titian? History of a Controversy', in *The Frick Collection Lecture Series*. New York.

Hope, Charles 2003c. 'Titian's Life and Times', in Madrid 2003, pp. 302–8.

Hope, Charles 2005. 'Titian and Some Portraits of Charles V', in Vienna 2005, pp. 89–99.

Hope, Charles 2007a. 'La biografia di Tiziano secondo Vasari', in Belluno–Pieve di Cadore 2007, pp. 37–41.

Hope, Charles 2007b. 'Titian's Family and the Dispersal of his Estate', in Vienna and Venice 2007, pp. 409–16.

Hope, Charles 2008a. 'The Audiences for Publications on the Visual Arts in Renaissance Italy', in *Officini dell'nuovo: sodalizii fra letterati, artisti, ed editori nella cultura italiana fra Riforma e Controriforma*, Symposium papers, ed. Harald Hendrix and Paolo Procaccioli. Rome, pp. 173–83.

Hope, Charles 2008b. 'Giorgione in Vasari's *Vite*', in *Giorgione entmythisiert*, ed. Sylvia Ferino-Pagden. Turnhout, pp. 15–37.

Howard, Deborah 1975. *Jacopo Sansovino: Architecture and Patronage in Renaissance Venice*. New Haven and London.

Howard, Deborah 1980. *The Architectural History of Venice*. New Haven and London.

Howard, Deborah 1985. 'Giorgione's "Tempesta" and Titian's "Assunta" in the Context of the Cambrai Wars', *Art History*, vol. 8, no. 3, pp. 271–89.

Howard, Deborah 2003. 'Titian's Painted Architecture', in Meilman 2003, pp. 146–62.

Hudson, Mark 2009. *Titian: The Last Days*. London.

Humfrey, Peter 1993. *The Altarpiece in Renaissance Venice*. New Haven and London.

Humfrey, Peter 1995. *Painting in Renaissance Venice*. New Haven and London.

Humfrey, Peter 2003a. 'The Patron and Early Provenance of Titian's *Three Ages of Man*', *Burlington Magazine*, vol. CXLV, pp. 787–91.

Humfrey, Peter, ed. 2003b. *The Cambridge Companion to Giovanni Bellini*. Cambridge.

Humfrey, Peter 2007. *Titian: The Complete Paintings*. London.

Ilchman, Frederick 2009. 'Venetian Painting in an Age of Rivals', in Boston 2009, pp. 21–39.

Joannides, Paul 2001. *Titian to 1518: The Assumption of Genius*. New Haven and London.

Knecht, R. J. 1982. *Francis I*. Cambridge.

Kris, Ernst and Otto Kurz 1979. *Legend, Myth, and Magic in the Image of the Artist*. New Haven and London.

Labalme, Patricia H. 1982. 'Personality and Politics in Venice: Pietro Aretino', in Rosand 1982a, pp. 119–28.

Labalme, Patricia H. and Laura Sanguineti White, eds 2008. *Città Excelentissima: Selections from the Renaissance Diaries of Marin Sanudo*, tr. Linda L. Carroll. Baltimore.

Larivaille, Paul 1997. *Pietro Aretino*. Rome.

Laven, Mary 2002. *Virgins of Venice: Enclosed Lives and Broken Vows in the Renaissance Convent*. London.

Lepschy, Anna Laura 1998. *Davanti a Tintoretto: una storia del gusto attraverso i secoli*. Venice.

Lomazzo, Gian Paolo 1974. *Trattato dell' arte della pittura, scoltura ed architettura*, 1584, in Roberto Paolo Ciardi, *Scritti sulle arti*, vol. 2. Florence.

London 1981. *Splendours of the Gonzaga*, exh. cat., ed. David Chambers and Jane Martineau. Victoria and Albert Museum, London.

London 1983. *The Genius of Venice*, exh. cat., ed. Jane Martineau and Charles Hope. Royal Academy of Arts, London.

London 2003. *Titian*, exh. cat. National Gallery, London.

Madrid 2003. *Tiziano*, exh. cat., ed. Miguel Falomir. Museo Nacional del Prado, Madrid.

Mallett, Michael 2000. 'Venetian Elites in the Crises of the Early Sixteenth Century', in Stella Fletcher and Christine Shaw, eds, *The World of Savonarola*. Warwick.

Mallett, Michael E. and J. R. Hale 1984. *The Military Organisation of a Renaissance State: Venice c. 1400–1617*. Cambridge.

Maltby, William S. 1983. *Alba. A Biography of Fernando Alvarez de Toledo, Third Duke of Alba, 1507–1582*. Berkeley and Los Angeles, CA.

Maltby, William S. 2002. *The Reign of Charles V*. Basingstoke and New York.

Mancini, Matteo 1998. *Tiziano e le corti d'Absburgo nei documenti degli archivi spagnoli*. Venice.

Masson, Giorgina 1976. *Courtesans of the Italian Renaissance*. London.

Matthew, Louisa C. 2002. '"Vendecolori a Venezia": The Reconstruction of a Profession', *Burlington Magazine*, vol. CXLIV, pp. 680–6.

Mayer, August L. 1939. 'Niccolò Aurelio, the Commissioner of Titian's "Sacred and Profane Love"', *Art Bulletin*, vol. 21, no. 1, p. 89.

Mazzotta, Antonio 2012. *Titian: A Fresh Look at Nature*. London.

Mazzucco, Melania 2009. *Jacomo Tintoretto e i suoi figli: Storia di una famiglia veneziana*. Milan.

Meilman, Patricia, ed. 2003. *The Cambridge Companion to Titian*. Cambridge.

Mellencamp, Emma H. 1969. 'A Note on the Costume of Titian's Flora', *Art Bulletin*, vol. 51, no. 2, pp. 174–7.

Merkel, Ettore 1980. 'Tiziano e i suoi mosaistici a San Marco', in *Tiziano e Venezia* 1980, pp. 275–83.

Mitchell, Bonner 1979. *Italian Civic Pageantry in the High Renaissance: A Descriptive Bibliography of Triumphal Entries and Selected Other Festivals of State*. Florence.

Mitchell, Bonner 1986. *Majesty of State: Triumphal Progresses of Foreign Sovereigns in Renaissance Italy (1494–1600)*. Florence.

Molmenti, Pompeo 1906. *La storia di Venezia*. Bergamo.

Muir, Edward 1981. *Civic Ritual in Renaissance Venice*. Princeton.

Naples 2006. *Tiziano e il ritratto di corte da Raffaello ai Carracci*, exh. cat., ed. Maria Sapio. Museo di Capodimonte, Naples.

Neff, Mary Frances 1985. 'Chancellery Secretaries in Venetian Politics and Society 1480–1533', PhD diss., University of California, Los Angeles.

Nepi Scirè, Giovanna 1993. 'Tecniche esecutive di alcuni dipinti di Tiziano', in *Tiziano 500*, pp. 401–13.

Newton, Eric 1952. *Tintoretto*. London.

Newton, Stella Mary 1988. *The Dress of the Venetians 1495–1525*. Aldershot.

Norwich, John Julius 1981. *Venice: The Greatness and the Fall*. London.

Oberthaler, Elke and Elizabeth Walmsley 2006. 'Technical Studies and Painting Methods', in Washington and Vienna 2006, pp. 285–300.

Ovid (Publius Ovidius Naso) (AD c. 6) 2004. *Metamorphoses*, tr. David Raeburn. London and New York.

Pallucchini, Ridolfo 1969. *Tiziano*, 2 vols. Florence.

Panofsky, Erwin 1957. *Meaning in the Visual Arts*. New York.

Panofsky, Erwin 1969. *Problems in Titian, Mostly Iconographic*. New York.

Paris 1993. *Le Siècle de Titien: L'Âge d'or de la peinture à Venise*, exh. cat., ed. Gilles Fage. Paris.

Paris 2009. *Titien, Tintoret, Véronèse: Rivalités à Venise*, exh. cat. Paris.

Parker, Geoffrey 1999. 'The Political World of Charles V', in Soly 1999a, pp. 113–225.

Pater, Walter 1877. 'The School of Giorgione', in Walter Pater, *The Renaissance: Studies in Art and Poetry*. London.

Pedrocco, Filippo 2001. *Titian: The Complete Paintings*. London.

Penny, Nicholas 2008. *The National Gallery Catalogue of Sixteenth-Century Italian Paintings*, 2 vols. London.

Phillips, Claude 1898. *Titian: A Study of his Life and Work*. London.

Philostratus (2nd–3rd centuries AD) 1969. Philostratus the Elder and Younger, and Callistratus, *Imagines and Descriptions*, tr. Arthur Fairbanks. London and Cambridge, MA.

Pietro Aretino nel cinquecentenario della nascita 1995. Conference papers, 2 vols. Rome.

Pino, Paolo (1548) 1954. *Dialogo di pittura*. Milan.

Pommier, Édouard 2006. 'Potere del ritratto e ritratto del potere', in Naples 2006, pp. 24–35.

Pope-Hennessy, John 1996. *Italian High Renaissance and Baroque Sculpture*. London.

Preto, Paolo 1978. *Peste e società a Venezia*. Vicenza.

Pullan, Brian 1971. *Rich and Poor in Renaissance Venice*. Oxford.

Pullan, Brian 1973. 'The Occupations and Investments of the Venetian Nobility in the Middle and Late Sixteenth Century', in Hale 1973, pp. 379–408.

Puppi, Lionello 2004. *Su Tiziano*. Milan.

Puppi, Lionello 2007. *Tiziano e Caterina Sandella*. Rome.

Puttfarken, Thomas 2005. *Titian and Tragic Painting: Aristotle's Poetics and the Rise of the Modern Artist*. New Haven and London.

Richebuono, Giuseppe 1974. *Storia di Cortina d'Ampezzo*. Cortina d'Ampezzo.

Ricketts, Charles 1910. *Titian*. London.

Ridolfi, Carlo (1648) 1914. *Le maraviglie dell'arte, ovvero le vite degli illustri pittori*, ed. Detlev Freiherrn von Hadlen, 2 vols. Berlin.

Robinson, Mark 2003. *Timeless Venice*, with CD-ROM of the Jacopo de' Barbari map. London.

Rome 1995. *Tiziano: Amor Sacro e Amor Profano*, exh. cat., ed. Maria Grazia Bernardini. Palazzo delle Esposizioni, Rome.

Rosand, David 1976. '"The Presentation of the Virgin in the Temple" and the Scuola della Carità', *Art Bulletin*, vol. 58, no. 1, pp. 55–84.

Rosand, David, ed. 1982a. *Titian: His World and his Legacy*. New York.

Rosand, David 1982b. 'Titian and the Critical Tradition', in Rosand 1982a.

Rosand, David 1993. 'So-And-So Reclining on her Couch', in *Titian 500*, pp. 101–19.

Rosand, David 2001. *Myths of Venice: The Figuration of a State*. Chapel Hill, NC.

Roskill, Mark W., tr. and ed. 2000. *Dolce's* Aretino *and Venetian Art Theory of the Cinquecento*. Toronto.

Rothe, Andrea 2003. 'Titian's *Penitent Magdalen* in the J. Paul Getty Museum', *Studi Tizianeschi*, no. I, ed. W. R. Rearick et al. Milan, pp. 39–42.

Rowlands, Eliot W. 1996. 'Antoine Perrenot de Granvelle, 1548', in Eliot W. Rowlands, *Collections of the Nelson-Atkins Museum of Art: Italian Paintings*. Kansas City, pp. 167–78.

Rubinstein, Nicolai 1973. 'Italian Reactions to Terraferma Expansion in the Fifteenth Century', in Hale 1973, pp. 197–217.

Ruskin, John (1851–3) 1960. *The Stones of Venice*, ed. J. G. Links. New York.

Ruskin, John (1843–60) 1974. *Modern Painters*, ed. David Barrie. London.

Sannazaro, Jacopo (1504) 1948. *Arcadia*, ed. Enrico Carrara. Turin.

Sansovino, Francesco 1581. *Venetia, città nobilissima et singolare*. Venice.

Sanudo, Marin (1496–1533) 1879–1902. *I diarii di Marino Sanuto*, ed. Rinaldo Fulin et al., 58 vols. Venice.

Sanudo, Marin (1493–1530) 1980. *De origine, situ et magistratibus urbis Venetae ovvero la città di Venetia*, ed. Angela Caracciolo Aricò. Milan.

Schilling, Heinz 1999. 'Charles V and Religion: The Struggle for the Integrity and Unity of Christendom', in Soly 1999a, pp. 285–363.

Schuchard, Ronald 1989. 'Yeats, Titian and the New French Painting', in A. Norman Jeffares, ed., *Yeats the European*. Gerrards Cross.

Schulz, Juergen 1968. *Venetian Painted Ceilings of the Renaissance*. Berkeley, CA.

Schulz, Juergen 1982. 'The Houses of Titian, Aretino and Sansovino', in Rosand 1982a.

Schupbach, William 1978. 'Doctor Parma's Medicinal Macaronic', *Journal of the Warburg and Courtauld Institutes*, vol. 41, pp. 147–91.

Sohm, Philip 1991. *Pittoresco: Marco Boschini, his Critics, and their Critiques of Painterly Brushwork in Seventeenth- and Eighteenth-Century Italy*. Cambridge.

Soly, Hugo, ed. 1999a. *Charles V, 1500–1588, and his Time*. Antwerp.

Soly, Hugo 1999b. 'Charles V and his Time', in Soly 1999a, pp. 11–25.

Speroni, Sperone 1989–. *Opere*, intro. Mario Pozzi, vols 1–3, 5. Manziana, Rome.

Spivakovsky, Erika 1970. *Son of the Alhambra: Don Diego Hurtado de Mendoza 1504–1575*. Austin, TX.

Stella, Aldo 1977. 'La società veneziana al tempo del Tiziano', in *Tiziano nel quarto centenaria della sua morte* 1977, pp. 103–21.

Storia della cultura Veneta: Dal primo quattrocento al concilio di Trento
1980–1, ed. Girolamo Arnaldi and Manlio Pastore Stocchi, 3 vols. Vicenza.

Symonds, John Addington 1906. *Renaissance in Italy: The Fine Arts*. London.

Tagliaferro, Giorgio 2006. 'La bottega di Tiziano: un percorso critico', in *Studi Tizianeschi*, no. 4, pp. 16–52.

Tagliaferro, Giorgio 2007a. 'Il clan Vecellio: congiunti e collaboratori di Tiziano nell'ultimo decennio', in Belluno–Pieve di Cadore 2007, pp. 163–9.

Tagliaferro, Giorgio 2007b. 'In Tizians Werksatt, 1548–1576', in Vienna and Venice 2007, pp. 68–75.

Tagliaferro, Giorgio 2008. 'La pala di Serravalle e la congiuntura degli anni "40"', in *Venezia Cinquecento*, vol. XVIII, pp. 41–7.

Tagliaferro, Giorgio and Bernard Aikema (with Matteo Mancini and Andrew John Martin) 2009. *Le botteghe di Tiziano*. Florence and Cadore.

Tietze, Hans 1950. *Titian: The Paintings and Drawings*. London.

Tietze-Conrat, Erica 1976. *Tiziano scrittore di lettere*, in Fabbro 1976, pp. 279–98.

Titian 500: Studies in the History of Art 45 1993. Symposium Papers XXV, ed. Joseph Manca, Center for Advanced Study in the Visual Arts. National Gallery of Art, Washington, DC.

Tiziano e Venezia 1980. Papers of the Convegno internazionale di studi in Venice, 1976, ed. Massimo Gemin and Giannantonio Paladini. Vicenza.

Tiziano nel quarto centenario della sua morte 1576–1976 1977. Ed. Giuseppe La Monaca. Venice.

Tyler, Royall 1956. *The Emperor Charles the Fifth*. London.

Valcanover, Francesco 1969. *L'opera completa di Tiziano*. Milan.

Valcanover, Francesco 1977. 'Il restauro dell'Assunta', in *Tiziano nel quarto centenario della sua morte* 1977, pp. 41–51.

Valcanover, Francesco (with Nepi Scirè) 1985. *Gallerie dell'Accademia di Venezia*. Venice.

Valcanover, Francesco 1990. 'Introduzione a Tiziano', in Washington and Venice 1990, pp. 3–28.

Valcanover, Francesco 1995. 'Tiziano: 1510–1515', in Rome 1995, pp. 21–33.

Valcanover, Francesco 1999. *Tiziano: i suoi pennelli sempre partorirono espressioni di vita*. Florence.

Van de Wetering, Ernst 1991. 'Rembrandt's Manner: Technique in the Service of Illusion', in *Rembrandt: The Master and his Workshop*, exh. cat. National Gallery, London, pp. 13–23.

Vasari, Giorgio (1550 and 1568) 1967. *Le vite de' più eccelente pittori scultori e architettori*, ed. P. della Pergola, L. Grassi and G. Previtali, 9 vols. Novara.

Venice 1979. *Venezia e la Peste*, exh. cat. Doge's Palace, Venice.

Vienna 2004. *Giorgione: Myth and Enigma*, exh. cat., ed. Sylvia Ferino-Pagden and Nepi Scirè. Kunsthistorisches Museum, Vienna.

Vienna 2005. *Tizian versus Seisenegger: Die Portraits Karls V mit Hund*, exh. cat., ed. Sylvia Ferino-Pagden and Andreas Beyer. Kunsthistorisches Museum, Vienna.

Vienna and Venice 2007. *Der späte Tizian und die Sinnlichkeit der Malerei*, exh. cat., ed. Sylvia Ferino-Pagden. Kunsthistorisches Museum, Vienna, 2007 and Gallerie dell'Accademia, Venice, 2007–8.

Wald, Robert 2009. 'Materials and Techniques of Painters in Sixteenth-Century Venice', in Boston 2009, pp. 73–81.

Washington and Venice 1990. *Tiziano*, exh. cat., ed. Susanna Biadene. National Gallery of Art, Washington, DC, and Doge's Palace, Venice.

Washington and Vienna 2006. *Bellini, Giorgione, Titian and the Renaissance of Venetian Painting*, exh. cat., ed. David Alan Brown, Sylvia Ferino-Pagden et al. National Gallery of Art, Washington, DC, 2006, and Kunsthistorisches Museum, Vienna, 2006–7. New Haven and London.

Waterhouse, E. K. 1951. *Titian's 'Diana and Actaeon' in the Collection of the Earl of Ellesmere*. Oxford.

Wernham, R. B., ed. 1968. *The New Cambridge Modern History*, vol. 3: *The Counter-Reformation and Price Revolution*. Cambridge.

Wethey, Harold E. 1969–75. *The Paintings of Titian*, 3 vols (vol. 1: *The Religious Paintings*, New York 1969; vol. 2: *The Portraits*, London 1971; vol. 3: *The Mythological and Historical Paintings*, London 1975).

Wethey, Harold E. 1987. *Titian and his Drawings*. Princeton.

Whistler, Catherine and Jill Dunkerton 2009. 'Titian's "Triumph of Love"', *Burlington Magazine*, vol. CLI, pp. 536–40.

Wilde, Johannes 1974. *Venetian Art from Bellini to Titian*. Oxford.

Wollheim, Richard 1987. *Painting as Art*. Princeton.

Woods-Marsden, Joanna 1994. 'Towards a History of Art Patronage in the Renaissance: The Case of Pietro Aretino', *Journal of Medieval and Renaissance Studies*, vol. 24, no. 2, pp. 275–305.

Zanetti, Antonio Maria (1733) 1980. *Descrizione di tutte le pubbliche pitture della città di Venezia*. Bologna.

Zapperi, Roberto 1990. *Tiziano, Paolo III e i suoi nipoti*. Turin.

Zapperi, Roberto 1991. 'Alessandro Farnese, Giovanni della Casa and Titian's *Danae* in Naples', *Journal of the Warburg and Courtauld Institutes*, vol. 54, pp. 159–71.

Zapperi, Roberto 2006. 'Tiziano e i Farnese', in Naples 2006, pp. 51–6.

Zimmermann, T. C. Price 1995. *Paolo Giovio: The Historian and the Crisis of Sixteenth-Century Italy*. Princeton.

APPENDIX

Locations of Paintings

PAINTINGS BY TITIAN

Ancona, Church of San Domenico
 Crucifixion, 563
Ancona, Museo Civico
 Madonna in Glory with Sts Francis and Blaise and the Donor Alvise Gozzi (the Gozzi altarpiece), 178
Antwerp, Koninklijk Museum
 Jacopo Pesaro Presented to St Peter by Pope Alexander, 62
Bergamo, Accademia Carrara
 Orpheus and Eurydice, 49
Berlin, Staatliche Museen
 Portrait of Clarissa Strozzi, 412, 415, 762n7
 Self-portrait, 1546–7?, 474
 Young Woman with a Dish of Fruit (Emilia Vecellio?), 577
Besançon, Musée du Temps
 Portrait of Nicolas Perrenot de Granvelle, 494
Bologna, Pinacoteca Nazionale
 Christ on the Cross with the Good Thief, 781n16
Bordeaux, Musée des Beaux-Arts
 Rape of Lucretia (variant), 672
Boston, Isabella Stewart Gardner Museum
 Rape of Europa, 1559–62, 530
Boston, Museum of Fine Arts
 St Catherine of Alexandria, 1568 (or studio), 617
Brescia, Church of Santi Nazzaro e Celso
 Annunciating Angel, 196
 Risen Christ, 196
 St Sebastian, 196

INDEX

ACKNOWLEDGEMENTS

I could not have written a book of this scope without the advice and encouragement of many people. But my first debt of gratitude is to the Titian scholar Professor Charles Hope, a former Director of the Warburg Institute, who has generously shared with me the primary sources he has been discovering and analysing for more than forty years, some of them published here for the first time. Although I have not agreed with him about every point of interpretation I would not have undertaken a book about Titian without his invaluable co-operation. I am also immeasurably grateful to the Warburg Institute Library, a unique resource for scholars from all over the world, to its librarians Professor Jill Kraye and Dr François Quiviger, and to the scholars with whom I exchanged ideas in the Warburg common room, especially Beverly Brown, Susan Haskins, Helen Langdon and Alessandro Scafi.

The idea of writing a life of Titian was first suggested by Stuart Proffitt. In the end it has been published by HarperCollins where my editor Arabella Pike patiently waited while I exceeded my contractual deadline by six years, and made invaluable suggestions that have greatly improved and tightened the original manuscript. I have also been exceptionally fortunate in my knowledgeable copy editor Peter James, an admirer of Titian, who weeded out errors and verbiage.

Charles Hope, Anne Engel and Jonathan Keates read my manuscript in its embryonic stages, made suggestions, corrected errors, but above all gave me the support and encouragement without which I

might have faltered. Charlotte Hale, Conservator of Paintings at the Metropolitan Museum in New York, shared her expertise about the techniques of scientific investigation of paintings.

Connie Harman and Marina Gelmi were my enthusiastic companions on journeys to and from Venice and Titian's homeland in Cadore. Professor Roy Foster, as well as giving me much support, alerted me to the importance of Titian for W. B. Yeats.

Finally, some of the most stimulating conversations I have had about Titian were with working painters, notably Bernard Cohen, Anthony Eyton, Annie Harris, Sir Christopher Pinsent and Jo Tilson.

ABOUT THE AUTHOR

Sheila Hale has known and often lived in Venice since 1965, when she began work as research assistant to the late John Hale, with whom she worked on *Renaissance Venice* and *The Civilization of Europe in the Renaissance*. Her guidebook to Venice, first published in 1984, was praised by David Lodge as "the best guidebook I have ever used" and by Eric Newby as "deserving a Nobel Prize." She has written other guidebooks, an architectural history of Verona, and articles for a number of papers, including the *New York Times*, the London *Observer*, and the *Times Literary Supplement*. Her book *The Man Who Lost His Language* was described by Brenda Maddox as "enlarging the language of love," and by Michael Frayn as "a triumph." Sheila Hale is a trustee of Venice in Peril and lives in Twickenham, England.